KU-796-655

Digital Compression of Still Images and Video

ANDERSONIAN LIBRARY
★
WITHDRAWN
FROM
LIBRARY
STOCK
★
UNIVERSITY OF STRATHCLYDE

Signal Processing and its Applications

SERIES EDITORS

Dr Richard Green
Farnborough, UK

Professor Doug Gray
CRC for Sensor Signal and Information Processing, Signal Processing Research Institute, Technology Park, Adelaide, South Australia

Professor Edward J. Powers
Department of Electrical and Computer Engineering,
University of Texas at Austin, USA

EDITORIAL BOARD

Professor Maurice G. Bellanger
CNAM, Paris, France

Professor Gerry D. Cain
School of Electronic and Manufacturing Systems Engineering,
University of Westminster, London, UK

Dr Mark Sandler
Department of Electronics and Electrical Engineering,
King's College London, University of London, UK

Professor Colin Cowan
Department of Electronics and Electrical Engineering,
Loughborough University of Technology, Loughborough, UK

Dr David Bull
Department of Electrical Engineering,
University of Bristol, UK

Professor D. J. Creasey
School of Electronic and Electrical Engineering,
University of Birmingham, UK

Dr Henry Stark
Electrical and Computer Engineering Department,
Illinois Institute of Technology, Chicago, USA

Digital Compression of Still Images and Video

R. J. CLARKE

Professor of Electronic Engineering
Heriot-Watt University
Edinburgh
Scotland

ACADEMIC PRESS

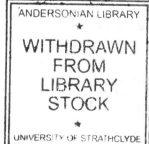

ANDERSONIAN LIBRARY
★
WITHDRAWN
FROM
LIBRARY
STOCK
★
UNIVERSITY OF STRATHCLYDE

Harcourt Brace & Company, Publishers
London San Diego New York Boston
Sydney Tokyo Toronto

ACADEMIC PRESS LIMITED
24/28 Oval Road
LONDON NW1 7DX

United States Edition published by
ACADEMIC PRESS INC.
San Diego CA 92101

Copyright © 1995, by
ACADEMIC PRESS LIMITED

All Rights Reserved
No part of this book may be reproduced in any form by photostat,
microfilm, or any other means, without written permission
from the publishers

A CIP record for this book is available from the British Library

ISBN 0–12–175720–X

This book is printed on acid-free paper

⅃
621·367
CLA

Typeset by Fakenham Photosetting Limited, Fakenham, Norfolk
Printed in Great Britain by The University Press, Cambridge

Series Preface

Signal processing applications are now widespread. Relatively cheap consumer products through to the more expensive military and industrial systems extensively exploit this technology. This spread was initiated in the 1960s by introduction of cheap digital technology to implement signal processing algorithms in real-time for some applications. Since that time semiconductor technology has developed rapidly to support the spread. In parallel, an ever increasing body of mathematical theory is being used to develop signal processing algorithms. The basic mathematical foundations, however, have been known and well understood for some time.

Signal Processing and its Applications addresses the entire breadth and depth of the subject with texts that cover the theory, technology and applications of signal processing in its widest sense. This is reflected in the composition of the Editorial Board, who have interests in:

(i) Theory—The physics of the application and the mathematics to model the system;

(ii) Implementation—VLSI/ASIC design, computer architecture, numerical methods, systems design methodology, and CAE;

(iii) Applications—Speech, sonar, radar, seismic, medical, communications (both audio and video), guidance, navigation, remote sensing, imaging, survey, archiving, non-destructive and non-intrusive testing, and personal entertainment.

Signal Processing and its Applications will typically be of most interest to postgraduate students, academics, and practising engineers who work in the field and develop signal processing applications. Some texts may also be of interest to final year undergraduates.

Richard C. Green
The Engineering Practice,
Farnborough, UK

for

Alexander

Contents

3 Intraframe Transform Coding

4 Intraframe Vector Quantisation

5 Intraframe Sub-band and Wavelet Coding

6 Other Intraframe Techniques. 1: Segmented, Block-truncation and "Fractal" Coding

7 Other Intraframe Techniques. 2: Quadtree, Multiresolution and Neural Approaches

8 Interframe Coding

9 Motion and Motion Compensation

10 Standards for Image Sequence Coding

11 Alternative Schemes for Image Sequence Coding

12 Image Transmission and Error Control

Appendix 1: Variable Length Coding

Appendix 2: The Future – Very Low Bit-rate Video and MPEG-IV

Preface

It is hardly necessary to reiterate here the spectacular advances in technology over the past decade or so which have altered the related disciplines of computing and telecommunications out of all recognition and which have allowed, at the most general level, the effects of these developments to become obvious to even the most casual observer. This is not necessarily true of the "enabling" technologies, however, which have made these advances possible. One of these, the coding of still images and picture sequences (i.e. "video"), is the subject of this book. Our ability to communicate using video-telephones, to transport conventional television material between nations efficiently at rates considerably below that at which it was generated, and even to consider passing high definition television material over channels but a few megahertz in width rests on the similarly spectacular advances in this area over the past two decades or so. Such advances, because of their exclus-ively technical/mathematical nature, have largely gone unsung and unappreci-ated by the non-technical community as extremely difficult to demonstrate (after all, the quality of the "output" picture can be no better than that of the input, and frequently it will be visibly worse, the fact that it is reproduced at a vanishingly small fraction of the original rate notwithstanding). Nevertheless, many very efficient coding algorithms for this purpose now exist, as do several internationally recognised standards, and the time is probably opportune to move the subject from the academic confines of the research laboratory onto the more general stage.

The main object of the present volume is to do just this, and it is hoped that this book will be useful not only in an educational context (as suitable for final year undergraduate/postgraduate study), but also to the rapidly increasing number of technical and professional staff in the industrial environment who, maybe for the first time, are coming to grips with image coding. The book is quite general in its approach, and attempts to cover all recognised coding algorithms; their basic theory in enough detail to understand the principles involved, and thereafter the results which have been achieved with them by workers in all parts of the world, and the myriad modifications which they have all received in the inevitable attempt to reduce the rate, improve the quality, reduce the implementational complexity, and so on.

In this respect the author has been faced with something of a problem. Over the past few years the amount of material published on the topic has increased enormously. Books on specific areas of the subject have appeared, several new journals are in evidence, and the older ones have reorganised

their structures to give more prominence to image coding. As an example of this, an on-line search for relevant papers will produce maybe 10–15 new items per week. In a general text of the nature of the present one, therefore, a balance has to be struck between attention to minute detail and the necessity of being as up-to-date as possible. In this the author can have succeeded only partially, although an attempt has been made to incorporate new material in those sections which would otherwise be of a more "traditional" nature. One area which has had to be bypassed is that of practical implementation. However rapid the development of new algorithms, it is totally eclipsed by that of fast hardware, and this would certainly render any description of a specific implementation out of date by the time that the book appeared (unfortunately, due to the protracted lead times of some of the major journals, this is also true of original professional publications in this area). It has thus been felt more appropriate to concentrate upon algorithms and coding results. In addition, since the discipline is now over 40 years old, a brief historical overview has been included to "orient" those new to the area, and an indication of where in the literature the relevant publications tend to appear is also provided.

The writer apologises in advance for the extensive referencing in this volume of his earlier work on transform coding (Transform Coding of Images, Clarke, 1985a). Not only is the material published therein still relevant (after nearly 10 years) to transform coding as it stands today but, through its adoption in various standards, the technique has influenced, and in turn been influenced by, many of the other methods developed over the past decade or two. In spite of this, the extent to which this ubiquitous approach will dominate the image coding scene over the *next* two decades is highly conjectural, as the reader will see.

Acknowledgements

Any endeavour of the present kind would naturally have been impossible without the massive effort devoted to the subject by research workers all over the world who have imparted their results freely to the rest of the image coding community through publication in the professional journals and by presentation at the many conferences dealing with the topic. It is a pleasure particularly to acknowledge the work of all those with whom I have built up personal contacts in relation to image coding over the past 15 years or so, and who have helped me with stimulating discussions on just about every technique reported here. Especial thanks must go, however, to the members of my research group, past and present, whose efforts have contributed many of the results and illustrations included here, and of whom many are now carrying out their own independent work in the area; in particular (in alphabetical order) D. Allott (predictive coding and vector quantisation), W. K. Cham (transform coding), P. Cordell (recursive spatial methods), B. Moussa (transform coding), M. Soryani (segmented coding and motion compensated interpolation), Q. Wang (motion compensation and vector quantisation) and S. Yao (wavelet decomposition and vector quantisation). It is also appropriate to mention here the work of those not pursuing doctoral programmes but completing an image coding project as part of their post- or undergraduate studies and who have contributed to the present work, A. Hosseinzaman (block truncation coding), C. Ng (pyramidal and multiresolution coding), and those participating in a fruitful exchange programme with Sweden: J. Boch (error correction), M. Karlberg (fractal coding) and J. Otterstrom (wavelet coding and lattice vector quantisation). In a more professional context, I should like to thank Dr Nick Lodge (ITC), for useful discussions on higher rate issues, Dr Joan Mitchell of the IBM Corp. for supplying extensive documentation on the Q-coder and my friend and colleague, Tokumichi Murakami, of the Mitsubishi Corp., who kindly provided the illustrations of model-based coding. David Redmill and Dr Nick Kingsbury (Cambridge University) readily provided pictorial examples of the operation of their EREC error correction scheme. Thanks also to British Telecom Research Laboratories, Ipswich, UK, in particular Ian Corbett, for providing source material for picture coding simulations, and also for the many illuminating discussions that I have had with him and other members of BT staff over the many years of our interaction. Interpretations of all results deriving from the assistance given by those mentioned above are, of course, the sole responsibility of the author.

The Institution of Electrical Engineers has allowed me to reproduce some of the material in Chapter 6 which originally appeared in abbreviated form in the *Electronics and Communication Engineering Journal* (Clarke and Linnett, 1993) as have Professor L. Zetterberg (Royal Institute of Technology, Stockholm) and Dr G. Karlsson (Swedish Institute of Computer Science) in respect of Figures 8.2 and 12.14.

The author gratefully acknowledges the percipience of his Head of Department, Professor George Russell, in not enquiring too closely when one of his members of staff was, yet again, absent when matters departmental were being considered, and is grateful to Kate Brewin and her colleagues at Academic Press for easing the path of the volume through the production process.

Last but not least, thanks to my 8-year-old son Alexander, whose model aeroplane construction activities formed a useful "sink" for much of the paper upon which earlier drafts of this book were written!

Commonly Used Abbreviations

AR	Autoregressive
ARMA	Autoregressive Moving Average
ATC	Adaptive Transform Coding
ATD	Asynchronous Time Division
ATM	Asynchronous Transfer Mode
AWGN	Additive White Gaussian Noise
b.e.r.	Bit Error Rate
B-ISDN	Broadband Integrated Services Digital Network
BTC	Block Truncation Coding
CCITT	International Telegraph and Telephone Consultative Committee
CCIR	International Radio Consultative Committee
CIF	Common Intermediate Format (352×288)
c.l.r.	Cell Loss Ratio
DCT	Discrete Cosine Transform
DFD	Displaced Frame Difference
DPCM	Differential Pulse Code Modulation
D(R)	Distortion–Rate Function
ETSI	European Telecommunications Standards Institute
FSVQ	Finite State Vector Quantisation
HDTV	High Definition Television
HVS	Human Visual System
ISDN	Integrated Services Digital Network
JPEG	Joint Photographic Experts Group
KLT	Karhunen–Loeve Transform
KSOFM	Kohonen Self-organising Feature Map
LBG	Linde–Buzo–Gray
LOT	Lapped Orthogonal Transform
MAE (m.a.e.)	Mean Absolute Error
MLP	Multilayer Perceptron
MPEG	Moving Picture Experts Group
MSE (m.s.e.)	Mean Square Error
NTSC	National Television Systems Committee Television System
PAL	Phase Alternating Line Television System
PCM	Pulse Code Modulation
PSNR	Peak Signal-to-Noise Ratio
PSTN	Public Switched Telephone Network

QCIF	Quarter – Common Intermediate Format (176×144)
QMF	Quadrature Mirror Filter
R(D)	Rate–Distortion Function
RGB	Red–Green–Blue
SBC	Sub-band Coding
SNR	Signal-to-Noise Ratio
YIQ	Luminance/Chrominance Signals (NTSC System)
YUV	Luminance/Chrominance Signals (PAL System)
VBR	Variable Bit-Rate
VQ	Vector Quantisation
WHT	Walsh–Hadamard Transform

1
Image Data Compression

1.1. INTRODUCTION

1.1.1. The Emergence of Image Coding

The early morning rail commuter going "up to town" just before Christmas in 1989 must have been somewhat taken-aback to find, in his copy of the *Financial Times* (1989), a description, complete with block diagram, of a hybrid motion-compensated video-coding algorithm which would not have looked out of place in a set of undergraduate lecture notes on the subject. What he made of motion vectors, quantisation, variable length coding, and so on can only be guessed at, but this was surely a sign that image coding had, at last, "come of age". By one of those curious coincidences which nature occasionally throws up, the application to image coding of the central processing operation of all implementations which have been, or are to be (except for very low-rate applications, see Appendix 2), adopted for standardisation – orthogonal transformation – had indeed been first reported 21 years earlier

(Andrews and Pratt, 1968). So what had caused an area of research which had been more or less a "back room" province for academic and telecommunication organisation laboratory researchers to emerge into the limelight in this way? In any technical paper in a professional journal, it is usual to begin with a paragraph explaining the general background to the work being reported. In the present case it almost became *de rigueur* to talk about the increasing "convergence" of the technologies of computing and telecommunications, how the logical progression from digital speech processing and transmission was a similar application of the technology to images, the more so as a consequence of the fact that the required channel capacity/storage volume was that much greater, and the emergence of a whole host of new application areas – videotelephony, videoconferencing, extended and high definition television services, multimedia, distance shopping/learning/banking and so on. Yet the development was far from being one which happened overnight. Again, to offset the enthusiasm of workers in picture coding, as it is colloquially called, much scepticism was expressed by other interests – the extreme sensitivity to transmission errors of the signals which were generated by coding algorithms, problems with the actual visual quality of the images so produced, the fact that a world overlaid with a network of virtually infinite bandwidth optical fibres would have no place for compression schemes, etc. This has meant that real development (and the associated commercial applications) has only taken place within the past decade, whilst the previous three decades of patient investigation of a whole host of competing approaches – lowering the rate, improving quality and error resilience, etc. – has largely gone unsung (this may, in fact, not have been without its advantages).

It is interesting to observe the way in which developments have taken place throughout this period (a brief historical sketch is given in the next section). It had seemed, by the mid 1980s, that what had come to be called the "classical" techniques of coding, largely based upon prediction and orthogonal transformation of waveforms, i.e. of the amplitudes of successive samples along the rows and columns of a conventional raster scanned image, had reached the limit of their capabilities for efficient coding of image detail, and it was suggested that new directions would need to be explored if progress was to be kept up (Kunt *et al.*, 1985). This has, in fact, resulted in a move to a more "object-centred" view of coding, in which neither separate picture elements nor square blocks of elements are processed but, on the other hand, attempts are made to code actual objects and object detail, surely (how easy to say with hindsight!) the correct path to follow? At this time, however, market interests were just beginning to stir and standardisation activities beginning to get underway. Since any algorithms of the "second-generation" variety were untried, untested and sometimes nothing but vague ideas in the mind of a research worker somewhere, standardisation came about based exclusively upon the older, block or element structured algorithms (prediction and transformation). Subsequent research has provided novel approaches to the prob-

lem which show promise for very low transmission rates and, since this area (tens of kilobits per second) has just become a target for a new standardisation activity (see Appendix 2), we may expect, over the next few years, rapid development of suitable, more "intelligent" algorithms. This, again, raises a major question, at least in the mind of the present author. Given the lightning pace of technological development today, together with an algorithm which works well at, say, $30\,\text{kb}\,\text{s}^{-1}$ and so might be expected to do better than present algorithms at 10 times this rate, do present standards (based, as we have seen, on "old" technology) have a firm enough hold to resist being swept away as only something of a "first try"? Well, only time will tell, but the move from a widespread feeling in the late 1970s that moving image transmission at $64\,\text{kb}\,\text{s}^{-1}$ was impossible, to the commercial products of today, may indicate that the forward thinkers may well hold the day. On the other hand, we *may* soon reach some fundamental limit or other – we can probably say with some certainty that it is never going to be possible to transmit even a low detail image with a single digital bit, and yet not only are there nowadays schemes giving very realistic results with moving head and shoulders images at rates in the kilobits per second region using the sort of scheme outlined in Chapter 11, but also suggestions for "zero bit-rate" video, in which, in the personal (face-to-face) communication environment, all movements of facial detail which contribute to intelligibility are derived from the speech signal alone. Such developments will, at any rate, ensure that image coding and communication remains of absorbing interest and of increasingly significant practical application, notwithstanding those which already exist today (see, for example, Keeley, 1994, on the use of compression algorithms in conjunction with cable networks).

1.1.2. A Brief Historical Overview of Image Coding

It is in fact the case that image coding has a pedigree which is somewhat longer than might be commonly appreciated, and indeed some of the earlier literature can still be consulted to good effect, since techniques described 30 years or so ago, such as contour coding and frequency band separation, lie at the foundation of some of those being actively investigated today (Clarke, 1992b). We can probably date the start of image coding developments as 1950, the original date of the application for the patent on predictive coding (Cutler, 1952), with associated publications by Harrison (1952) on the application of linear prediction to television, and Huffman (1952) on constructing efficient variable length codes. It is also worth mentioning at this point the work of Gabor (1946), which laid the foundation of variable time (space)/frequency resolution analysis which led, in turn, to the massive interest in wavelets in the late 1980s, and that of Shannon (1948) which provided the theoretical basis for efficient coding in general. In the mid 1950s Schreiber

(1956) measured probability distributions of television signals and Kramer and Mathews (1956) demonstrated transform coding (albeit of speech, rather than image data), and at the turn of the decade Shannon (1959) considered the application of a fidelity criterion to his earlier results on coding – of fundamental concern to image coding workers ever since, because at the rates at which they wish to operate coding is invariably "lossy", i.e. it introduces degradation into the reconstructed image. This leads to what might be called the fundamental postulate of image coding – to produce an image having an acceptable level of quality but using the minimum number of bits for transmission or storage. At the same time Schreiber *et al.* (1959) reported the "synthetic-highs" system, a frequency separation scheme with affinities with those developed 30 years later, and Max (1960) showed how to design minimum mean square error quantisers for non-uniform probability distributions (this paper must hold the record for the most often quoted single reference in the coding literature of the 1960s to 1980s). The 1960s was basically the first decade of the transform coder. Huang and Schultheiss (1963) followed Kramer and Mathews (1956) but also demonstrated a bit allocation algorithm which was in widespread use until the mid 1980s. Although not related specifically to the coding of images, this may arguably be considered to be the first comprehensive paper on transform coding; the technique as we know it (applied to images) was introduced by Andrews and Pratt (1968) and Pratt *et al.* (1969). Another paper of significance to later workers was that of Graham (1967) on contour coding. The other area of interest in image coding during the 1960s was the relationship between the visual characteristics of the viewer and the structure of the related coding algorithms, with papers by Limb (1967), Pearson (1967) and Schreiber (1967). During the 1970s and early 1980s transform coding was the algorithm which was the subject of by far the most research and development for image coding purposes. A vast array of (mainly) adaptive approaches was developed, and these have been reviewed by Clarke (1985a). At the end of the 1970s, however, interest in other methods of coding was stirring again. Vector quantisation had been used in speech coding by Dudley in the late 1950s (1958) and Smith in the late 1960s (1969). Activity now increased with the work of Kang and Coulter (1976) and Buzo *et al.* (1980), and this transferred to image coding in, for example, Gersho and Ramamurthi (1982), Murakami *et al.* (1982) and Baker and Gray (1983) (a good review is given by Gray, 1984). Since then it has rivalled transform coding in the amount of work carried out to develop its coding potential and it is still of much interest today. Whilst (apart from the theoretical advantages) it has, intuitively, a more correct "feel" to it than transform coding it has, at least for very low rate applications, the great disadvantage of being a block-structured algorithm and so being susceptible to the appearance of highly visible artefacts. Sub-band coding was introduced for speech coding by Crochiere *et al.* (1976) and first applied to images in the form in which we know it today by Woods and O'Neil (1986), who noted the relationship of the

technique to earlier split frequency band approaches. Since then it, too, has been the subject of much development and theoretical work, and the design work on suitable new analysis and synthesis filters has been intensive. In the late 1980s "wavelet" structures became important with an increase in interest in multiresolution techniques for signal analysis in general (Rioul and Vetterli, 1991), and found application in a sub-band context as an efficient way to provide a hierarchical frequency band split well suited to present day requirements for easy generation of image/video signals at various quality levels. Work in this area is still intensive today. Again, there are strong links back to Gabor (1946) and also the pyramid structure developed by Burt and Adelson (1983).

Of course, other algorithms continue to be developed against the background of this more or less historical progression, for example segmented and so-called "fractal" techniques, but coding interest has over the past decade swung significantly in the direction of video, or image sequence, processing. Prominent in this respect is the work done on movement and ways of mitigating its effects – if object motion can be accurately tracked through a frame sequence processing the residual frame difference signal *should* be a means of achieving low rate coding. Although a vast amount of work on motion and its perception has been carried out and reported by computer vision and human visual perception experts, until some 15 years ago little of it related to the image coding area. Development of algorithms by Netravali and co-workers (for example, Netravali and Robbins, 1979) greatly stimulated this area, since when it has remained an item of considerable importance for efficient image sequence coding. Unfortunately we still do not have a significant input into this area from the computer vision community, with whose help we might well have been further along the road to really efficient video coding than we are at the moment. However, many approaches to motion estimation and compensation have been formulated, and today it is an essential component of any sequence coding scheme which, almost universally, takes the motion-compensated difference between successive frames and subjects this to further (spatial) processing – in the standard algorithms using orthogonal transformation, but with all other possible variants of single frame coding (vector quantisation, wavelet/sub-band decomposition, segmentation, hierarchical/pyramid structures, etc.) having been proposed for this stage as well (see Chapter 11). At present research interest is strong with regard to other methods of coding image sequences, basically in terms of the object detail which they contain. Thus segmentation algorithms (Soryani and Clarke, 1992) can be used to separate the difference signal into areas of significant detail for coding, and one other very promising area of research is model- (or object-) based coding (Forchheimer and Kronander, 1989), in which a model of, specifically, a head and shoulders image or, more generally (and considerably more difficult), any object is established at the receiver and its motion or shape or aspect change signalled in a parametrised way. Such techniques are

expected to be of significance in the next few years when rates in the tens of kilobits per second region are more intensively investigated.

It would be inappropriate to close this section without mentioning the matter of image data transmission. Historically this has been carried out at a fixed rate with appropriate buffering prior to actual passing of the coder output signal to the channel. The severe fluctuations in the output rate of adaptive coders caused by varying object motion are controlled by altering the coding parameters in such a way that the image fidelity is reduced when there is more movement, producing a fixed rate/changing reproduced quality system. With the development of asynchronous transfer mode (ATM) variable bit-rate (VBR) techniques, however, the possibility arises of modifying this relationship. Within limits, the demand for capacity on the network can be allowed to vary and so at times of significant motion the quality can remain substantially constant whilst the rate is allowed to rise. This, again, has been the subject of extensive investigation over the past few years, bringing to the fore topics which, once more, are not entirely new, having been investigated initially some 20 years ago, but which are only now finding their place in the enormously expanded telecommunications environment that exists today. Two useful and fairly recent reviews of the coding area are those of Singhal *et al.* (1990) and Jayant (1992).

1.2. PSYCHOVISUAL CONSIDERATIONS

1.2.1. Introduction

In the vast majority of systems which employ some form of image coding, the final recipient of the reconstructed image signal is the human eye. It is thus natural that attempts should be made to incorporate a measure of the properties of the human visual system (HVS) into the coding chain (a) to ensure that coding bits are preferentially allocated to those components of the output signal which will correspond to structure in the picture to which the eye is most sensitive and (b) to generate an associated numerical measure of quality which would obviate the need for extensive subjective testing as a means of comparing the effectiveness of various algorithms. Despite the wide advocacy of such approaches (see, for example, Carl, 1987), it has to be said that these attempts have met with only limited success, and we are nowhere near mimicking the processing that occurs around the retina and which enables the communications load on the optic nerve to attain what is, to the average image coder, a ridiculously small value. Here we briefly review one or two matters relevant to this area of image coding.

1.2.2. A Model of the Human Visual System

The matter of human visual response in relation to image coding has been considered by Clarke (1985a), and the literature reviewed therein. In brief, the physical properties of the optical transmission pathway through the iris to the retina produce a low-pass spectral response which, when combined with the high-pass characteristic due to interconnection of the receptors (lateral inhibition) gives an overall bandpass response centred somewhere around 4 to 7 or 8 cycles \deg^{-1} in spatial frequency (this quantity is defined in terms of the number of cycles within a sinusoidal spatial luminance pattern expressed as a function of the angle subtended at the eye). Associated with this spatial response is a logarithmic amplitude non-linearity due to adaptation to background luminance necessary for the eye to function over a wide range of average scene intensities. The fact that the eye has preferred regions of spatial frequency response and a non-linear amplitude response mechanism has led to three basic approaches to the modification of coding algorithms to suit, as described below.

1.2.3. Spatial Frequency Response

The bandpass spatial frequency response of the eye has led to numerous attempts to improve coding efficiency by preferentially allocating bits to the frequency region (or to the corresponding transform coefficients) to which the eye is most sensitive. The fact that only the coefficients of the Fourier transform correspond directly to measured spatial frequency has necessitated modifications to be made in order to employ more efficient transforms (Nill, 1985). The principle is simple: the coefficients corresponding to the most sensitive part of the HVS spatial response are preferentially weighted with respect to the others and so receive a higher bit allocation (i.e. more accurate quantisation) than would otherwise be the case. More simply, higher order coefficients can be partially suppressed at quantisation to reflect the lowered response of the eye at high spatial frequencies. Whilst this latter simple low-pass operation obviously allows more accurate coding of lower spatial frequencies, it compounds the problem which besets spatial frequency coding algorithms which is that, at low rates, edge detail becomes blurred in any case, because selective rejection or coarse quantisation of higher order coefficients is how the coder allocates bits in the first place. The problem with the pre-emphasis scheme is that, to be effective, those spatial frequencies pre-emphasised at the time of coding must obviously be those to which the eye is most sensitive, and this implies that the reconstructed picture *must* be viewed at the correct distance for the pre-emphasised spatial detail to be perceived as such. The counter argument that the correct viewing distance has, in any case, a large tolerance, only implies that the effect is not particularly significant,

anyway (older readers may care to reflect upon the "magnification"/band-width properties of a tuned circuit as a function of the "Q" – see Chapter 3). Be that as it may, this constraint for correct perception of spatial frequency detail makes nonsense of any attempt to reproduce so-called "visual model enhanced" images through photographs in the pages of the professional journals.

1.2.4. Masking

The design of a quantiser for the predictive coding error signal can also be influenced by the properties of the HVS. In this case a large luminance transient, or even significant luminance "activity", masks the perception of small imperfections in amplitude reproduction (quantisation error, for example) in the neighbourhood and so can allow the design of quantisers dependent upon a "masking function" which may be based on the weighted slopes of luminance values over a small area (see, for example, Netravali and Prasada, 1977). This effect can also be used to good effect in segmented coding schemes to merge small regions near a sharply defined object bound-ary and so reduce the number of separate regions which have to be coded without compromising visual quality. It is worth noting that more traditional interpretations of masking have recently been reconsidered by Girod (1992) in terms of sub-threshold summation of impairments. In this context, see also Glenn (1993).

1.2.5. Non-linearity

The fact that the eye is non-linear in its amplitude response has occasionally prompted research workers to carry out coding operations within a logarith-mic/exponential domain to attempt to achieve a gain in efficiency (see Clarke, 1985a). Results have, at best, been inconclusive, not least because the effects tend to be over-ridden by the major non-linearity in the processing chain, and this is the conventional display monitor, where the light output/electrical signal input relationship has an exponent of something like 2.5.

1.2.6. Effects of Motion

It has been known for some time that the spatio/temporal response of the eye is non-separable and that, at the occurrence of a scene change, the spatial response is temporarily reduced (Budrikis, 1972). Attempts have been made to make use of this effect by preferentially allocating bits to the temporal change with some success, but have been overshadowed by the bigger prob-

lem posed by such a catastrophic change in scene content causing a massive increase in bit rate in any case. Where motion is rapid but continuous, the extent to which eye tracking of the moving object nullifies the decrease in spatial acuity has never, to the knowledge of the author at least, been fully characterised (but see Girod, 1992). Mitigation of the effects of motion on the performance remains a major research area, nevertheless, and Chapter 9 is specifically concerned with this topic.

1.2.7. Image Quality Assessment

It goes without saying that, if a reliable and accurate model of the HVS could be developed, it would greatly ease the problem of characterising the quality of images reconstructed after processing by assorted coding algorithms. This seems a forlorn hope, however, even given the extensive amount of work which has been done in this area (see Carl, 1987). With a good coding scheme degradations are subtle, and their perception and impact changes from observer to observer, being dependent upon a host of individual and environmental parameters probably impossible to characterise consistently. Interestingly enough, the problem of image degradation caused by the application of lossy coding algorithms has always been seized upon as an effective bar to their use in a medical context, for what were always thought to be obvious reasons. That this reservation may be unfounded is demonstrated by Cosman *et al.* (1994), who found no statistically significant difference in the diagnostic accuracy of three radiologists in image assessment tasks for images coded with tree-structured vector quantisation (Chapter 4) at reasonable levels of compression.

The old arguments about the drawbacks of a mean square error (m.s.e.) measure and its vague relationship with perceived picture quality are still valid, of course, and there are enough reports in the literature to correlate these two quantities in a positive direction to confirm this. Lacking anything else, however, m.s.e. is easy to calculate and appreciate, and has meaning to those concerned with video/television matters when cast in the form of a signal-to-noise ratio (SNR). Ten years ago there was no consistency in the literature regarding an appropriate form of SNR to use for this purpose (Clarke, 1985a); the following three are possibilities:

$$10 \log_{10} \sigma^2 N^2 / \sum_{\text{image}} (x - \hat{x})^2 \text{ dB} \qquad (1.1)$$

$$10 \log_{10} \sum_{\text{image}} x^2 / \sum_{\text{image}} (x - \hat{x})^2 \text{ dB} \qquad (1.2)$$

$$10 \log_{10} x^2_{\text{max}} N^2 / \sum_{\text{image}} (x - \hat{x})^2 \text{ dB}, \qquad (1.3)$$

where there are N^2 elements in the image, x and \hat{x} are arbitrary original and

reconstructed elements, respectively, and σ^2 is the variance of the input image.

Measure (1.1) relates the m.s.e. $(1/N^2) \sum_{\text{image}} (x - \hat{x})^2$ to the image variance; measure (1.2) relates it to image mean square energy; and measure (1.3) to the maximum image energy ($x_{\text{max}} = 255$ for an 8 bit image). With the move to an increased degree of interest in video coding measure (1.3) (peak SNR, PSNR) has become more common although the other two are still occasionally used. Both (1.1) and (1.2) will give substantially lower values in any particular case than (1.3). It is always necessary to check just which definition is being used, although comparisons within any individual paper will be unaffected.

Consultation of the image coding literature will frequently uncover widespread use of the term compression to indicate the operation of reducing the data rate needed to reproduce images or image sequences. So it is used here, but the reader, especially if uninitiated in the mysteries of image coding, is strongly urged to treat any quoted values of so-called compression *ratio* (whose appropriate sphere of influence is properly restricted to that of the internal combustion engine) with extreme caution. It is commonly used for the ratio between the total number of bits used to represent the original image before coding and that needed afterwards, or its temporal equivalent in the case of image sequences, but any coding enthusiast worth his salt will be able, by using sub-sampling, colour coordinate rotation, etc., to generate quite a respectable value for this quantity (particularly as there are no generally agreed quality standards for the reproduced picture – see above) without actually using any of the so-called "compression" algorithms described in this book at all (as a rather naïve example, one could double the figure simply by changing the input resolution from 8 to 16 bits). The only sensible test of a coding algorithm (questions of implementational complexity and speed of processing aside) is to *look* at a side by side comparison of the output picture or sequence with the original as a function of the number of bits per element or bits per second used to reproduce it (also making sure that you take along your own test material!). One very sensitive numerical test is the maximum absolute error incurred in coding $|x - \hat{x}|_{\text{max}}$, although this is likely to be too sensitive. In fact, if it only occurs at one picture element the degradation will probably not be visible in any case. Suffice it to say that the pitfalls in, and opportunities for confusion surrounding picture quality/coding algorithm assessments are legion, and now that such algorithms are coming into much more widespread use commercially, are likely to increase rather than decline. A further caveat is worth mentioning here in connection with the casual inspection of coded picture results. In terms of the overall visual aspect, 4×4 (or even 8×8) blocks represent a relatively small "element of perception" when derived from a 512×512, or larger, image and so, whatever form of processing is applied block by block, most of the broad original detail will be preserved. Thus differences between coding schemes are not always as signifi-

cant as is sometimes made out. On the other hand, Parke (1982) observed that viewer criticism of reconstructed image detail (at least in the context of graphics type portrayals to be discussed in Chapter 11) varied according to their expectations – an obviously crude representation was accepted as such by the observer, whilst he was very critical of flaws in a much better reconstruction that attempted an accurate representation of reality. It thus seems that the degree of acceptance of, or annoyance at, imperfections tends not to vary with any physical parameter associated with the luminance, shape or orientation error but to remain much more nearly constant, i.e. to be compensated for by the expectations of the viewer, a consideration of which those developing image coding systems in general might take heed.

1.3. SIGNAL PROPERTIES – THE INFLUENCE OF THE CODING ALGORITHM

1.3.1. Introduction

Most of the algorithms which have been developed for image coding and are described in this book operate in quite a specific statistical way, the exception being the more recently developed segmentation or object/model-oriented approaches which try to code actual details rather than two- or three-dimensional waveforms. With the more traditional technique, the function of that section of the algorithm from which the method gets its name is to alter the statistical distribution of the input signal in a way which makes it more amenable to subsequent efficient coding rather than to carry out that coding step itself, and we briefly examine this part of the process next.

1.3.2. Modifying the Distribution

The information content of signals in a communication system (in our case an image to be coded) is characterised by the entropy, H:

$$H = - \sum_{\text{image}} p(i) \log_2 p(i), \qquad (1.4)$$

where i represents the luminance value of any element in the image and $p(i)$ its probability of occurrence. If the luminance values were equally likely, then for an 8 bit image (256 possible levels), H would be 8 bits. A typical image captured by an 8 bit analogue to digital converter will have a value of H of something under 8 bits; thus if we allow a few levels (15 say) at the bottom

and top of the range to avoid luminance extremes exceeding the system dynamic range near black level and peak white then the equal probability entropy will be $\log_2 (256 - 30) = 7.82$ bits. The actual entropy will only be 0.3–0.5 bit below this and the image in a statistical sense will correspond most closely (surprisingly) to a uniform distribution. The purpose of the first stage of the coding scheme is to make use of the strong correlation between neighbouring image elements to produce a statistical distribution which can be efficiently coded. Thus in predictive coding the prediction error signal distribution is very highly peaked (see Figure 2.9 later), and can be losslessly coded at this point by using integer quantisation as in the JPEG standard (Chapter 3, Section 3.10). In an adaptive coder very few elements indeed in this signal will have a magnitude greater than 15–20 grey levels, and non-linear quantisation will bring the rate down to maybe 2–3 bits element^{-1} even for a fairly simple scheme. Likewise, the coefficient set in transform coding, or the samples in the sub-bands in sub-band or wavelet coding have a similar distribution. It is important to remember that, in all of these schemes, the number of elements after the prediction, transform, filtering or whatever remains the same as it was before, it is the *distribution* that is altered. In general we wish to skew this distribution so that we have as large a ratio of maximum to minimum values as possible [a good example here is the distribution of Equation (3.24) in the case of transform coding]. We can then drop coefficients or sub-bands entirely if they have small values of amplitude or variance, and non-uniformly quantise the remainder or, as an alternative, uniformly quantise them and apply run length coding as will be described subsequently.

1.3.3. Rate–Distortion Theory

At various points in their study of the image coding literature readers will come across the application of rate–distortion R(D) theory, or its equivalent, distortion–rate D(R) theory. The significant introduction by Shannon (1959) of a fidelity criterion into his work on coding theory led to an extensive body of work which sought to characterise the relationship between coding rate and measured distortion in a consistent way, and this is enshrined in the various appeals to the theory which have historically appeared in the image coding literature. Indeed, the theory was more popular 10–15 years ago than nowadays, largely because it has not proved possible to incorporate an appropriate receiver (viewer) model into the coding process in an acceptable way. Bounds on performance are available, however, with the Gaussian bound having a particularly simple form and also providing a "worst-case" situation in that for a given variance the Gaussian distribution will have the largest entropy and so be the most difficult of any source to code. As such, it is occasionally invoked as a theoretical comparison for coding performance.

The Gaussian result has also been used to allocate bits for the quantisation of transform coefficients [see Equation (3.26)]. The standard text on the topic is by Berger (1971), and the more accessible results specifically related to transform coding have been discussed by Clarke (1985a). Briefly, the general form of the R(D) curve is as shown in Figure 1.1 where, as expected, for smaller

Figure 1.1 Rate–distortion R(D) relationship. For a discrete signal zero distortion coding is achieved when $R(0)$ = the source entropy. For a continuous source the rate rises without limit (- - -).

levels of distortion we require a higher coding rate. If the attainable level of distortion is no smaller than D_{max} then no information need be sent anyway (equivalent to setting to zero transform or sub-band coefficients). For an initially analogue input signal, as the distortion falls to zero the quantisation intervals must have a width which tends to zero and so the rate curve moves towards infinity (dotted curve in Figure 1.1). For a discrete signal we know that we can encode at a rate equivalent to the entropy and incur zero distortion, at least in principle $[R(0) = H]$. We may therefore set our operating point anywhere within the region $0 \le D \le D_{max}$. Deviations between the results achieved with practical algorithms and the theory are to be expected, and are usually due to lack of knowledge of the true source distribution [and

the associated $R(D)$ relation] and an inability to allocate fractional numbers of bits to terms in the coefficient set (some kinds of block schemes, vector quantisation, for example, allow this to be done).

1.3.4. Coding of Colour Data

The reader will not find much explicit information on the coding of colour information in this book or, indeed, in the coding literature generally. This is not to say that attention has concentrated on monochrome images, quite the reverse, in fact; the point is that coding of the colour signals is no different in principle from the coding of the luminance signal and also that we achieve the visual "gain" that colour pictures give us in comparison with their mono-chrome counterparts for very little extra effort (maybe an increase in the bit-rate of some 10%). The reasons are twofold; first, the fine structure within an image is perceived mainly in terms of luminance rather than colour tran-sitions, and it is not necessary to maintain the sampling resolution of the luminance (Y) signal in the case of the colour (U,V or I,Q) data. Thus sub-sampling by at least 2:1 in both horizontal and vertical directions is allowable, and larger factors have often been used. Second, a coordinate rotation from RGB to YUV or YIQ results in a preferential energy transfer to the lumi-nance signal, the energy content of the resulting colour components falling to below 10% of the total (Pratt, 1971). Thus, for example, transform domain bit-allocation matrices can be severely restricted in extent for the colour signals, only the lowest frequency band in a typical wavelet decomposition need be retained for the colour information, and so on. Occasionally it may be useful to carry out some processing in colour space (segmentation, for example) but such cases are not common.

1.4. THE TEST PICTURES

Photographic illustrations of image coding results have always presented something of a problem to authors and publishers alike. Until quite recently the quality of the reproduced images in the pages of books and journals was materially affected by the printing process used, irrespective of the original quality of the image as seen on the screen of the monitor, and the fact that only infrequently was a picture size greater than 256×256 used exacerbated the problem. Likewise colour reproduction was very rare indeed. The situ-ation has now improved, however, and more high quality colour coding pictures can be seen in the literature. Nevertheless, the overall quality is by no means uniformly high (as some of the older results of the author presented

here will testify). Again, as mentioned elsewhere, the coded picture can have a quality no higher than that of the input image and so there is a basic problem with the presentation of results – those with artefacts so obvious as to negotiate the photographic/printing process with little difficulty will probably be so poor as to be unusable in a practical context anyway; where degradation of a more subtle nature is concerned this, though still easily visible on a high quality monitor, may very well not appear on the printed page.

There is a further problem in that there is no recognised set of standard pictures or image sequences for testing and comparison of algorithm performance. This situation is unfortunate, and may be contrasted with that which existed in respect of facsimile coding research some 15 years ago, prior to the introduction of the digital standard. Here a set of eight standard pictures *was* agreed, and this considerably facilitated coding comparisons. Readers who consult the image coding literature as relevant to the present text will find a wide variety of images used, with no standards of input dynamic range, mean grey level, luminance distribution, etc. (on occasion, authors even disagree on the name to be given to a specific image). Again, workers in different bit-rate ranges not unnaturally use pictures differing in area and resolution, spatial activity level or amount of movement. With the increase in standards activity in the past few years some uniformity has (albeit informally) appeared, and in the lower data rate region (with which this book is primarily concerned) there are three sequences which are now widely used for algorithm development: Miss America (abbreviated here to MISSA); CLAIRE; and TREVOR. They have also been used extensively by the author's research group. The sequences have different characteristics which together lead to a reasonable spread of data properties on which to test coder design – MISSA is relatively low in contrast with little movement and is as such relatively easy to code. Some copies in circulation are somewhat noisy, however, but this is not necessarily a drawback; for system development a practical coding algorithm needs to be able to cope with a wide range of source quality, including images with only moderate SNR. CLAIRE is a high contrast good quality sequence, whilst TREVOR contains segments with large amounts of motion.

As far as still pictures are concerned, since the emphasis of work in coding has, of late, been more towards sequences rather than still images, for examples of the latter it is most convenient to take single frames from the sequences referred to earlier. Sometimes, however, other pictures have been used – FLAT and TESTCARD, for example, contain sharp structured luminance discontinuities and diagonal detail, respectively, and so form good test pictures for algorithm properties not fully tested by the average head and shoulders image. GIRL, on the other hand, an image of the latter type, is so well known and has been used in picture coding research over the whole world for so long now that it would be wrong to omit her from any text that aims at even a superficial level of comprehensiveness. One other still image widely used is that of "LENA", a detailed head and shoulders picture to

which reference here is sometimes made, although processed images are not included in this volume.

1.5. PLAN OF THE BOOK

The initial plan of the author was to attempt to parallel the approach of the historical review given earlier in this chapter, starting with the earliest technique (predictive coding) in its single picture (intraframe) form and then moving to more recent techniques and the coding of video data. It has only been possible to approximate this aim, however, due to the inevitable pattern of cross-links which has grown up as individual techniques have evolved, only to be combined with, and influenced by, others. One other point worth noting here is that the book was originally conceived as a text on low-rate coding with the emphasis on the idea of low-rate in absolute, rather than relative, terms. Thus there is a concentration on the coding of still pictures at fractional bit allocations per picture element, but where (interframe) coding video material is concerned, although the rate originally envisaged was in the region of $64 \, \text{kb} \, \text{s}^{-1}$ (requiring rates of the order of 0.1 bit element^{-1} over individual frames), the methods described are also now being used for digital standard and high resolution television, where the term "low-rate" implies several megabits per second, hardly low in terms of the original idea. Nevertheless, where techniques of interest have been reported in that context, they are mentioned here – sub-band coding, for example, has been widely researched for HDTV applications.

Chapter 2 considers intraframe predictive coding in both non-adaptive and adaptive aspects, and also looks at some of the developments which are still being made in this truly "classical" area. Chapter 3 covers still picture transform coding, probably the technique which is best known outside the immediate circle of coding adherents. Transform efficiency and coefficient processing are considered as well as perceptual matters (see Section 1.2 above), and the chapter ends with an examination of the more specifically coding aspects of the still picture (JPEG) coding standard. Chapter 4 introduces vector quantisation, a technique which has become enormously popular over the past 10 years or so. The problems of codebook design and search are covered, and also the multiplicity of modifications which have been made to the basic idea. Chapter 5 deals with the frequency-splitting approaches of sub-band and wavelet coding, involving the subsidiary operations of sub-sampling and interpolation. Theoretical work on filter design is discussed and practical schemes described, and an extension of the wavelet concept opens the way to multiresolution operation. Chapters 6 and 7 cover a multiplicity of subsidiary techniques which have been developed over the past decade or so. Segmentation, block truncation, so-called "fractal" coding and neural techniques are described and the multiresolution operation is revisited.

Chapter 8 introduces image sequences (video) with a general discussion on the various approaches possible. Motion and motion compensation are the subjects of Chapter 9, with early ideas, mainstream techniques and more recent developments considered, together with motion compensated interpolation (important for low-rate operations) and matters such as coding of uncovered background and the application of motion compensation to filtering. Chapter 10 is concerned with standards for image sequence coding – H261, intended for use at rates of $p \times 64\,\mathrm{kb\,s^{-1}}$ (up to approximately $2\,\mathrm{Mb\,s^{-1}}$) for interpersonal communication, and MPEG-I and MPEG-II which have a much richer set of functional capabilities and take the coding rate up to the $10\,\mathrm{Mb\,s^{-1}}$ region. Although details of the bitstream formats have been included, it should be noted that here, as with the JPEG algorithm in Chapter 3, interest in this book focuses primarily on aspects of the algorithm related specifically to coding.

It has been by no means accepted generally that the transform scheme used in all the above sequence coding standards is optimum, and a whole host of approaches exists for processing the motion-compensated frame-difference signal. These are detailed in Chapter 11, as is the totally different approach of model-based coding, which has given very promising results, at least on highly constrained classes of source images, in the very low-rate region. Transmission aspects are covered in Chapter 12, which is divided between fixed rate schemes and suitable methods of error control and the recently proposed VBR approach to ATM transmission.

Appendix 1 covers efficient coding of the typical image coder output signal, either by Huffman or arithmetic coding, whilst Appendix 2 deals with very recent developments in the next stage of the coding enterprise – the satisfactory coding of images at rates significantly below $64\,\mathrm{kb\,s^{-1}}$, and the associated new standardisation activity just established, MPEG-IV.

1.6. GUIDE TO THE LITERATURE

Ten years ago, when the author wrote *Transform Coding of Images* (Clarke, 1985a), it was just about possible, at least in that fairly narrowly defined field, to be reasonably sure that one had not missed any "landmark" references which would have influenced the course of the work profoundly. Ten years on, the explosive growth of reporting of all kinds of technical activity has made it impossible to know of, let alone consult and digest, all the relevant literature – especially so in coding which, once the "Cinderella" area of image processing, is now arguably the area with most commercial application and potential. Whilst the major sources remain, new journals have sprung up, older ones have been revised in scope and a host of new conference "slots" have been introduced into the calendar, with particular growth in this area in

the Asian continent. Landmark papers still remain in the major journals, of course, but, with the lead time for publication in some cases approaching 2 years, it becomes more important, in this very rapidly moving area, to be aware of the conference presentation which often precedes such a publication but comes much closer in time to the conception of the original idea. To help those not acquainted with the literature in the image coding area (with which even the "old-hand" may have trouble keeping up), there follows a list of sources which report the mainstream results, with apologies to those responsible for items, events, etc., overlooked in this compilation. Nowadays, too, more books are becoming available on specific areas of image coding and these are referenced in the relevant chapters. Recent more general texts are those of Pearson (1991) and of Forchheimer and Li (1994).

Journals

IEEE Proceedings.-
IEEE Transactions: Acoustics, Speech and Signal Processing (ASSP), since 1991 renamed Signal Processing Transactions (SP); also the ASSP Magazine, now the Signal Processing Magazine, and Signal Processing Letters; Circuits and Systems in Video Technology (CASVT); Communications (COM); Pattern Analysis and Machine Intelligence (PAMI); Information Theory (IT); Image Processing (IP).
IEEE Journals: Selected Areas in Communications (SAC).
IEE Proceedings: Part F: Communications, Radar and Signal Processing; Part I: Communications, Speech and Vision (from 1989); Vision, Image and Signal Processing (no identifying letter – from 1994).
IEE Electronics Letters.
Eurasip (European Association for Signal Processing) Journals: Signal Processing and Signal Processing:Image Communication (from 1989). Elsevier.
Computer Vision, Graphics and Image Processing (from 1983). Prior to this *Computer Graphics and Image Processing*. Academic Press.
Image and Vision Computing. Butterworth.
International Journal of Computer Vision. Kluwer.
Journal of Visual Computation and Image Representation. Academic Press.
Multidimensional Systems and Signal Processing. Kluwer.
Pattern Recognition. Pergamon Press.
Pattern Recognition Letters. North-Holland.

Conferences

IEEE ICASSP: International Conference on Acoustics, Speech and Signal Processing (yearly).

IEEE ICIP: International Conference on Image Processing (from 1994).
IEE IPA: International Conference on Image Processing and its Applications, from 1982, now every three years.
EUSIPCO: European Signal Processing Conference (every two years).
Picture Coding Symposia, every 18 months or so.
SPIE (Society of Photo-optical Instrumentation Engineers) – various, in the image/image processing area, for example Visual Communications and Image Processing (yearly).

2
Intraframe Predictive Coding

2.1. INTRODUCTION

It is a truism to suggest that pictures of "interesting" scenes relevant to everyday human life are never completely chaotic in nature; indeed some such images are almost totally the reverse – simple portrayals of a relatively small number of well-defined objects against a uniform background. Even scenes which at first sight seem to contain many diverse and highly spatially "active" areas often prove, upon closer inspection, to be made up of areas of significant extent which have almost unvarying luminance (grey-level) values or colour. It is such properties which make image processing using segmentation techniques (Chapter 6), for example, possible, in which direct use is made of such two-dimensional characteristics. This kind of approach, however, is relatively new and is significantly pre-dated by the technique described in this chapter, and which has also historically been dependent upon the fact that images are captured, transmitted and displayed in a sequential, linear, one-dimensional mode – line by line scanning. Digital representation of the varying luminance level along any given line in an image then produces a distinct set of discrete values representing regularly spaced samples of the original continuously varying (analogue) signal. As an example we may take the parameters specified in CCIR Recommendation 601 (1990) (see also Recommendation 656, 1990) for digital coding of studio quality broadcast television: sampled at $13.5\,\mathrm{MHz}$ the $64\,\mu\mathrm{s}$ television line encompasses 864 samples, of which 720 constitute one line of the picture. Allowable signal values are now represented by 8 bit digital words, with black being equivalent to level 16 and white to level 235. Two hundred and twenty out of a possible

256 words thus represent valid luminance levels. Returning now to our orig-
inal conjecture that significant areas of interesting pictures have reasonably
constant luminance or colour signal levels, it follows that, along any particular
image line, there will be sequences or "runs" of picture elements (the words
are nowadays, unfortunately, frequently abbreviated to "pixels" or "pels") of
much the same value. The predictive coding scheme now uses values obtained
during the scanning of such a sequence to estimate the value of the "next"
element along the line. The word "next" is of considerable significance, which
can best be appreciated by considering the use of the technique in the coding
of speech waveforms, where it has had considerable success over the past two
decades or so. Speech is a process which naturally takes place through time,
and so to consider predicting the next sample (in time) is entirely proper. On
the other hand images are of necessity scanned because, as mentioned above,
the one-dimensional time sequence is, at least at present, the only convenient
way of capturing the sample set representing the detail along successive lines
of the image. Again, left to right, top to bottom scanning is purely a matter of
historical convention and yet, if the analogy with speech is pursued, it gives to
the sequence of image samples a temporal significance absent from the orig-
inal scene. Thus, whilst the early samples in the digital sequence representing
a spoken word may properly be considered strongly to influence those coming
later (i.e. in some sense to "cause" them), this causality is not present in the
picture. Objects in the upper left-hand part of a scene in no way necessarily
"cause" the presence of whatever detail exists in the lower, right-hand region,
and yet the same temporal relationship is present as in the spoken word. In
simple predictive coding schemes, this apparent causality is carried over into
the actual processing, for one of the attractive features of the technique is its
small storage requirement, low order predictors (the order of the predictor is
simply the number of previous elements used in making the prediction of the
present one), at least in one dimension, having a minimal storage (or delay)
requirement and thus being at least partly responsible for the early popularity
of the technique when extensive amounts of digital storage were difficult and/
or expensive to achieve. The method is thus referred to as *causal*, in distinc-
tion to methods which do not depend exclusively on elements which have
previously been processed and which are termed non-causal. Inherent in this
mode of operation is one source of inefficiency, since it is a fundamental
intuitive property of a prediction that it has the best chance of being accurate
if the points used in its determination are as close to the element to be
predicted as possible. It follows that elements yet to be processed by a
conventional raster scan (i.e. in the temporal and spatial "future") could well
be of use in improving the accuracy of a prediction and yet, in the simple
scheme, these remain unavailable. Again, the operation of the decoder in
image reconstruction, although extremely simple, depends upon the element
by element processing of picture samples in sequence, earlier reconstructed
values being needed in order to decode the present sample, and so on.

Occasional attempts have been made to circumvent this problem of "built-in" causality, but are complex both theoretically and in implementation (Jain, 1975; Lodge, 1987; Lodge and Clarke, 1991; see also Netravali, 1977b).

Returning to the basic principle of operation of predictive coding, a number of "previous" elements are used to estimate the value of the "present" sample (note again the "time-series" terminology), and the difference between the actual value and the estimate then forms the signal to be transmitted. Obviously, the better the prediction the smaller the transmitted signal and the more efficient the coding process. The function of the decoder (operating in synchronism with the coder) is to make the same prediction, from previously decoded samples, to which the received error signal is added to regenerate the actual present sample value, and so on. The technique was originally described by Cutler (1952), and good general treatments of the method may be found in O'Neal (1966), Musmann (1979) and Jayant and Noll (1984). A further drawback now becomes apparent (and will be discussed more generally later on) which is that, since every sample along a line can only be correctly decoded if the previous sample has itself been properly reconstructed, the system is very sensitive to errors in storage or transmission of the difference signal. This problem is illustrated in Figures 2.1 and 2.2. Figure 2.1 shows the original FLAT image and Figure 2.2 the reconstructed image corrupted by errors affecting the transmitted data in the case of one-

Figure 2.1 Original FLAT image.

Figure 2.2 Effect of transmission errors on one-dimensional predictive coding.

dimensional prediction. These can be mitigated by deliberately reducing the prediction efficiency, as shown in Figure 2.3. This problem is nowadays compounded by the fact that, since extensive digital storage is easy to arrange, prediction may be made not only from previous elements upon the same line as that on which the element to be predicted lies but also from elements on previous lines as well. Such two-dimensional prediction is nowadays universally used in intraframe coding because it fulfils the above-mentioned intuitive requirement of making the prediction from elements as close to the present one as possible, in order to increase the efficiency of coding. Figure 2.4 shows the propagation of errors in this case (note that, in this example, the vertical scanning direction is from bottom to top; errors propagate vertically and horizontally through the scanning time sequence). Unless some form of error correction, or mitigation of the effects caused by errors is undertaken, therefore, a single error will render useless a significant area of the image frame scanned later in time than the point at which it occurs.

Before embarking upon an analytical examination of the operation of predictive coding one further general point is worth making, and that concerns regions of the picture where the luminance or colour values are not reasonably constant; specifically, at the edges of objects where a prediction made on one side of an edge will certainly be a poor estimate of a value or values on the other. In this instance large values of prediction error are generated (as shown in the example of one-dimensional prediction in Figure 2.5) and the system must be able to cope adequately with these. Provided that the dynamic

Figure 2.3 Improvement effected by reducing prediction efficiency.

Figure 2.4 Error propagation in two-dimensional prediction.

Figure 2.5 Large prediction errors generated by strong edge detail.

range of the system is adequate, coding efficiency is maintained in this condition by two factors. First, the number of elements for which a large prediction error exists as a result of the presence of significant edge detail is found to be small even in images which apparently contain large amounts of fine detail. This is amply borne out in practice; experimental determination of the probability distribution of the prediction error signal for a wide variety of naturally occurring image data consistently shows a relationship very highly peaked around zero (see Figure 2.9, later), and the vast majority of error terms are only a few grey levels, or even less, in magnitude (see later). Second, where large magnitude prediction errors indicate the presence of edge detail, the coding accuracy can be significantly relaxed owing to the effect of spatial masking in the human visual system. The human eye is very sensitive to the location of large magnitude changes in luminance (i.e. to edge detail) but is not nearly such a good judge of the actual magnitude of the luminance step (partly owing to the logarithmic nature of its amplitude response), and the presence of such a discontinuity inhibits the detection of small changes in its neighbourhood. This, incidentally, accords with research results which show the greater significance of phase information compared with amplitude data when reconstructing images from their Fourier transforms, for spatial location corresponds to phase via the Fourier phase shift relationship. The outcome is that we can quantise the (relatively few) large magnitude prediction errors far more coarsely than those corresponding to substantially "flat" areas, where the eye is sensitive to small amounts of distortion (error intro-

duced by the quantiser in this region is referred to as "granular" noise). Fine quantiser resolution is thus only needed over a very restricted region of the allowable range of prediction error and, in any case, highly adaptive coder designs (see below) will markedly restrict the maximum magnitude of the error signal.

2.2. BASIC RELATIONSHIPS IN PREDICTIVE CODING

As explained above, the success of a predictive coding scheme rests upon its ability efficiently to predict the value of the present sample from the values of a selection of those which have been processed previously – in one or two dimensions in the present case or, for image sequence coding, discussed later in this volume, three. Picture elements will be serially generated by the camera and converted from analogue to digital form. The corresponding typical layout is shown in Figure 2.6. One point worth noting here is that,

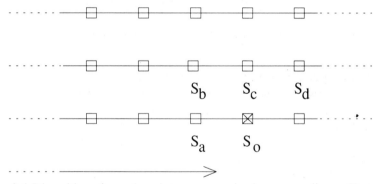

Figure 2.6 Disposition of sample points on successive image scan lines. ⊠ location of present element S_0; ⊟ location of previous elements S_a, S_b, S_c, S_d, etc. - - - - ——— Successive scan lines in a single field.

although S_a and S_c are roughly the same distance spatially from S_0, in time the distances correspond to that of a single sample and of a complete line (typically several hundred samples), respectively. In order to make use of two-dimensional prediction, therefore, the system must be capable of producing a delay of at least one line period (in the real-time case) to access S_c (and possibly S_b also).

Block diagrams of the predictive coder and decoder are shown in Figures 2.7 and 2.8 respectively, together with signal values at appropriate points. The system operates as follows: the analogue input $S(t)$ is sampled to produce a sequence of discrete picture values $S(i)$, typically quantised uniformly to 8 bit resolution. From each of these values a prediction $\hat{S}(i)$ is subtracted to form the error signal sequence $e(i)$

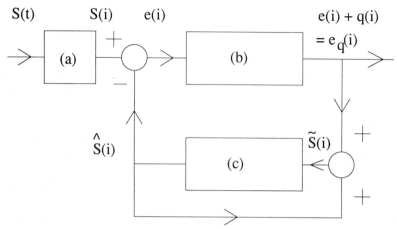

Figure 2.7 Predictive coding scheme (coder). (a) Analogue input sampling; (b) quantiser; (c) predictor; $S(t)$, analogue input; $S(i)$, sampled input; $\hat{S}(i)$, prediction; $e(i) + q(i) = e_q(i)$: output signal with quantisation error.

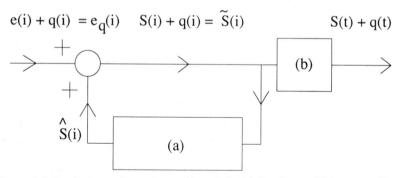

Figure 2.8 Predictive coding scheme (decoder). (a) Predictor; (b) low-pass filter.

$$e(i) = S(i) - \hat{S}(i). \qquad (2.1)$$

This sequence is then (re)quantised with a smaller number of levels (see below) and, approximately at least, the operation is considered to add an amount of quantisation error $q(i)$ to each sample. This signal then forms the coded sequence

$$e_q(i) = e(i) + q(i) \qquad (2.2)$$

which may be subjected to further processing (Huffman coding or maybe addition of an error control code) before being stored or transmitted. At the decoder exactly the same prediction is made [generating $\hat{S}(i)$] and added to $e_q(i)$

$$e_q(i) + \hat{S}(i) = e(i) + q(i) + \hat{S}(i)$$
$$= S(i) + q(i) \qquad (2.3)$$

to form the output digital signal which only differs from that at the input to the coder by the quantisation error $q(i)$. Digital to analogue conversion then yields the analogue output signal, $S(t)$, corrupted by analogue quantisation error $q(t)$ which must be appropriately allowed for in system design. Note that the only signals available to the predictor in the decoder are those which have been processed by the system and so are corrupted by quantisation error $q(i)$. In order for the coder and decoder predictors to track exactly, this same signal must be used as the input to the predictor in the coder, and therefore the quantiser must lie *inside* the coder loop, as shown. It will be noticed that the system output is the same (in discrete form) as the signal at the predictor input and so, in design simulations (neglecting corruption in the transmission channel), it is not necessary to replicate the decoder structure; observation of the input to the predictor of the coder is sufficient.

2.3. DETERMINATION OF PREDICTOR COEFFICIENTS

In the simple non-adaptive case the prediction $\hat{S}(0)$ of the present sample $S(0)$ (S_0 in Figure 2.6) is made up of a fixed linear combination of weighted previous samples:

$$\hat{S}(0) = a_1 S(1) + a_2 S(2) \ldots + a_n S(n), \qquad (2.4)$$

where the indexing generally indicates samples occurring further and further back in the "past" and may be arranged to include those samples actually used in the predictor (S_a, S_b, S_c, S_d in Figure 2.6, for example). For the purpose of analytical predictor optimisation it is conventional to ignore the influence of the (non-linear) quantisation operation. In practice, of course, the input to the predictor consists of a series of *reconstructed* samples, $\tilde{S}(i)$

$$\tilde{S}(i) = S(i) + q(i) \qquad (2.5)$$

each with its own quantisation error component, as in Figure 2.7). This is satisfactory when the number of quantisation levels is large but gives rise to inaccuracies when that number is small. It is the case, however, that values obtained from the simple analysis about to be presented are only a rough guide to those which are actually used in successful systems anyway, for there are many other considerations which influence their choice – inability of the theory to deal with visual optimisation of the coding operation, choice of values to allow convenient digital implementation, etc. We shall carry out the derivation on this basis therefore, before examining the influence of such other considerations.

In the absence of a reliable numerical guide to visual fidelity of image reconstruction, it is usual to optimise the values of the predictor coefficients by minimising the overall mean square prediction error

$$E\,[e(0)^2] = E\,[(S(0) - \hat{S}(0))^2] \qquad (2.6)$$

with respect to each coefficient a_i, where $E[\cdot]$ is the conventional expectation operator. Thus we have

$$\partial\,E\,[e(0)^2]\,/\,\partial\,a_1 = \partial\,E\,[e(0)^2]\,/\,\partial\,a_2 \dots$$

$$= \partial\,E\,[e(0)^2]\,/\,\partial\,a_n = 0 \qquad (2.7)$$

for optimum prediction, where

$$E\,[e(0)^2] = E\,[(S(0) - (a_1\,S(1) + a_2\,S(2) + \dots a_n\,S(n)))^2]$$

and so

$$E\,[e(0)^2] = -\,2\,E\,[(S(0) - (a_1\,S(1) + \dots a_n\,S(n))\,S(i))] = 0 \qquad (2.8)$$

and there are n equations of the form

$$E\,[(S(0) - \hat{S}(0))\,S(i)] = 0 \qquad (2.9)$$

$$i = 1 \rightarrow n$$

since $\hat{S}(0) = a_1\,S(1) + a_2\,S(2) + \dots a_n\,S(n)$. Equation (2.9) contains terms of the form

$$E\,[S(0)\,S(1)] \dots \dots E\,[S(0)\,S(n)] \qquad (2.10)$$

which are seen to be expressions of the correlation between image elements at various spacings. Yet another convention in the present analysis is to assume the input sequence to be zero mean (naturally image data does not satisfy this requirement, being everywhere non-negative, but the adjustment required is small) and thus the general term $E\,[S(i)\,S(j)]$ represents the autocovariance of the input sequence:

$$E\,[S(i)\,S(j)] = R_{ij}\,(= R_{ji}). \qquad (2.11)$$

Equation (2.8) may thus be written as

$$R_{0i} = a_1\,R_{1i} + a_2\,R_{2i} + \dots a_n\,R_{ni}$$

$$i = 1 \rightarrow n, \qquad (2.12)$$

i.e.

$$R_{01} = a_1\,R_{11} + a_2\,R_{21} + \dots a_n\,R_{n1}$$
$$\downarrow \qquad\quad \downarrow \qquad\quad \downarrow \qquad\qquad \downarrow$$
$$R_{0n} = a_1\,R_{1n} + a_2\,R_{2n} + \dots a_n\,R_{nn}$$

or

$$\begin{bmatrix} R_{01} \\ \downarrow \\ R_{0n} \end{bmatrix} = \begin{bmatrix} R_{11} & R_{21} & \cdots\cdots & R_{n1} \\ \downarrow & & & \downarrow \\ R_{1n} & \cdots\cdots\cdots & R_{nn} \end{bmatrix} \begin{bmatrix} a_1 \\ \downarrow \\ a_n \end{bmatrix}. \tag{2.13}$$

Knowledge of the R_{ij} then allows us to solve Equation (2.13) for the vector of prediction coefficients

$$A = [a_1\, a_2\, a_3\, a_4\, \cdots\cdots\, a_n]^T. \tag{2.14}$$

The actual value of the mean square error is, from Equation (2.6),

$$\begin{aligned} E\,[e(0)^2] &= E\,[(S(0) - \hat{S}(0))\,(S(0) - \hat{S}(0))] \\ &= E\,[S(0)(S(0) - \hat{S}(0)) - \hat{S}(0)(S(0) - \hat{S}(0))] \end{aligned} \tag{2.15}$$

and, since the second term in Equation (2.15) is zero for optimum prediction [from Equation (2.9)], the minimum value of the mean square error is

$$\begin{aligned} \sigma_e^2 &= E\,[S(0)(S(0) - \hat{S}(0))] \\ &= E\,[S(0) \cdot e(0)] \end{aligned} \tag{2.16}$$

Expanding Equation (2.16) we obtain:

$$\begin{aligned} \sigma_e^2 &= E\,[S(0)(S(0) - (a_1\, S(1) + a_2\, S(2) \ldots a_n\, S(n)))] \\ &= E\,[S(0)\, S(0) - a_1\, S(0)\, S(1) - a_2\, S(0)\, S(2) - \ldots a_n\, S(0)\, S(n)] \\ &= R_{00} - \sum_{i=1}^{n} a_i\, R_{0i}. \end{aligned} \tag{2.17}$$

One or two properties of the error sequence may be mentioned briefly here. First, it is formed by taking weighted differences of the data samples and thus has a mean value very close to zero, provided that the sum of the weighting (prediction) coefficients is unity (it may be advantageous to depart from this condition, for example, to reduce the effect of storage or transmission errors, thus in Figure 2.3 it is made 15/16), but it must be acknowledged that any significant variation in this respect will result in a large drop in coding efficiency (see Clarke, 1984a). Second, for an efficient prediction the vast majority of error values are very small or even zero, and their probability distribution is at least Laplacian (negative exponential) or even more sharply peaked (see Figure 2.9). It is, in fact, this change in distribution from that of the original image (ill-defined and nearer to uniform than any other classical analytic distribution – hence the initial digitisation of the image using 8 bit uniform quantisation) to one which is strongly *non*-uniform, which is, in part, the reason that coding gain can be achieved in any case, for the absolute maximum range of the error signal is twice that of the signal [consider simple prediction from one previous element only, with $a_1 = 1$, at a step edge of luminance – if the value to be predicted is $S(0) = 255$ and the prediction $S(1) = 0$ then $e(0) = 255$; if $S(0) = 0$ and $S(1) = 255$ then $e(0) = -255$ and the error signal now occupies a range of 9 bits]. In the scheme of Rost and Sayood

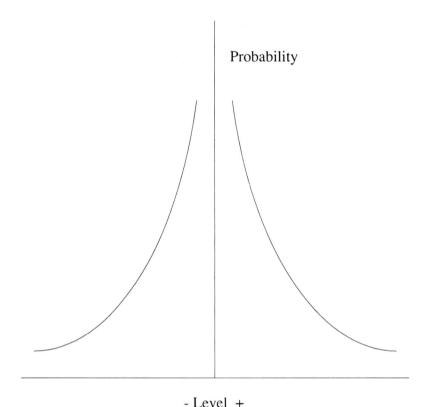

- Level +

Figure 2.9 Schematic representation of the probability distribution of the prediction error.

(1992), the poor reproduction of high contrast edge detail obtained from the conventional quantiser (where the largest quantiser intervals are not sufficient to encompass the element to element luminance change – a situation known as slope overload) is eliminated by allowing the full range quantisation of such signals which, to regain a satisfactory level of data reduction, are then losslessly encoded. Third, the interelement correlation of the error sequence is much lower than that of the original image (reflecting the efficiency of the process in removing redundancy from the data). Fourth, and the spectral domain counterpart of this reduction in correlation, the spectrum of the error sequence is much wider than that of the data – the aim, of course, being to reduce the autocorrelation function of the sequence to an impulse and render the corresponding spectrum "white".

It is now worthwhile examining one or two actual predictor configurations, before considering the wider aspects of the coding operation. Although some workers (Stott, 1987) have suggested that predictors of high orders are useful in improving the efficiency of the predictive algorithm it is generally con-

sidered that a maximum of four elements (S_a–S_d in Figure 2.6) achieve most of the benefit to be gained from the scheme, particularly as non-adaptive schemes are rarely used nowadays. The simplest case is that of first order prediction, from S_a (usually) or S_c in the figure. Equations (2.4) and (2.13) now assume particularly simple forms:

$$\hat{S}(0) = a_1 S(1)$$

and

$$R_{01} = a_1 R_{11}$$

since $R_{00} = R_{11} = R_{22} = \ldots R_{nn} = \sigma^2$, the variance of the input sequence (assumed to be stationary here)

$$a_1 = R_{01}/\sigma^2 = \rho_1, \tag{2.18}$$

where ρ_1 is the simple interelement correlation coefficient of the image data in the direction in which the prediction is taken.

From Equation (2.17) we have

$$\begin{aligned} \sigma_e^2 &= R_{00} - a_1 R_{01} \\ &= \sigma^2 (1 - \rho_1^2) \end{aligned} \tag{2.19}$$

and the maximum prediction gain (the ratio of data to error sequence variance) is

$$G_1 = \sigma^2/\sigma_e^2 = (1 - \rho_1^2)^{-1}. \tag{2.20}$$

For all finite values of ρ_1 ($0 < \rho_1 \leqslant 1$) G_1 is greater than one, and can be substantial if, as in the case of low detail images, ρ_1 is nearly one. In this case it is practical actually to make $a_1 = 1$, when it can be shown that

$$\begin{aligned} \sigma_e^2 &= \sigma^2 (1 + a_1^2 - 2\rho_1 a_1) \\ &= 2 \sigma^2 (1 - \rho_1) \end{aligned} \tag{2.21}$$

and so

$$G_1 = 0.5 (1 - \rho_1)^{-1} \tag{2.22}$$

which is greater than one only if ρ_1 is larger than 0.5 (Clarke, 1984a). Utilising two previous elements for the prediction gives:

$$\hat{S}(0) = a_1 S(1) + a_2 S(2)$$

and

$$R_{01} = a_1 R_{11} + a_2 R_{21}$$

$$R_{02} = a_1 R_{12} + a_2 R_{22}.$$

Thus

$$\rho_1 = a_1 + a_2 \rho_3$$

$$\rho_2 = a_1 \rho_3 + a_2 \tag{2.23}$$

say, where $\rho_1 = R_{01}/\sigma^2$, $\rho_2 = R_{02}/\sigma^2$ and $\rho_3 = R_{21}/\sigma^2 = R_{12}/\sigma^2$ also.
 Solving Equations (2.23) gives

$$a_1 = (\rho_1 - \rho_2\rho_3)/(1 - \rho_3^2)$$
$$a_2 = (\rho_2 - \rho_1\rho_3)/(1 - \rho_3^2). \tag{2.24}$$

The disposition of the predictor elements is now of significance: if we have the one-dimensional case of Figure 2.10 then $\rho_3 = \rho_1$ and

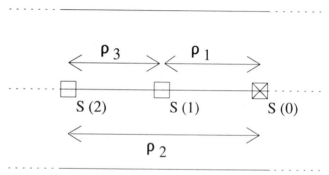

Figure 2.10 Two-element prediction: one-dimensional case.

$$a_1 = \rho_1(1 - \rho_2)/(1 - \rho_1^2)$$
$$a_2 = (\rho_2 - \rho_1^2)/(1 - \rho_1^2) \tag{2.25}$$

and the mean square error is

$$\sigma_e^2 = \sigma^2 - a_1 R_{01} - a_2 R_{02}$$
$$= \sigma^2(1 + 2\rho_1^2\rho_2 - 2\rho_1^2 - \rho_2^2)/(1 - \rho_1^2). \tag{2.26}$$

Note that, if we assume the image data to be well modelled by a first order Markov process (Clarke, 1984b) then $\rho_2 = \rho_1^2$ and

$$\sigma_e^2 = \sigma_2(1 + \rho_1^4 - 2\rho_1^2)/(1 - \rho_1^2)$$
$$= \sigma^2(1 - \rho_1^2)(1 - \rho_1^2)/(1 - \rho_1^2)$$
$$= \sigma^2(1 - \rho_1^2) \tag{2.27}$$

as in Equation (2.19), and there is no benefit to be gained by the one-dimensional extension, as is expected from the theory of Markov processes.
 In the two-dimensional case (Figure 2.11) we have horizontal and vertical

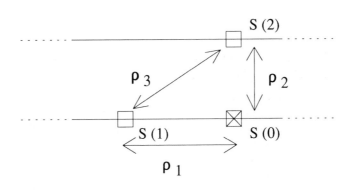

Figure 2.11 Two-element prediction: two-dimensional case.

one-step correlation coefficients ρ_1 and ρ_2 and, in the absence of actual measurements of the diagonal correlation, need to model ρ_3 appropriately. There are two simple ways of doing this (see, for example, Jayant and Noll, 1984); to assume either a separable or isotropic relationship. In the first case (assuming, for simplicity, that $\rho_1 = \rho_2$), we have:

$$\rho_3 = \rho_1^2 \qquad (2.28)$$

and in the second:

$$\rho_3 = \rho_1^{\sqrt{2}}. \qquad (2.29)$$

Letting $\rho_3 = \rho_1^k$, we have, from Equation (2.23),

$$\rho_1 = a_1 + a_2\,\rho_1^k$$
$$\rho_1 = a_1\,\rho_1^k + a_2$$

and so

$$a_1 = a_2 = \rho_1/(1 + \rho_1^k). \qquad (2.30)$$

The minimum error sequence variance is

$$\sigma_e^2 = \sigma^2 - 2\rho_1^2\,\sigma^2/(1 + \rho_1^k)$$
$$= \sigma^2\,(1 - (2\rho_1^2/(1 + \rho_1^k))) \qquad (2.31)$$

and the two-dimensional coding gain is

$$G_2 = (1 + \rho_1^k)/(1 + \rho_1^k - 2\rho_1^2). \qquad (2.32)$$

Since the coding gain for simple first order prediction is, from Equation

(2.20), $G_1 = (1 - \rho_1^2)^{-1}$, the improvement in going to two-dimensional prediction is:

$$G_2 / G_1 = (1 + \rho_1^k) (1 - \rho_1^2)/(1 + \rho_1^k - 2\rho_1^2). \tag{2.33}$$

Letting ρ_1 tend to unity:

$$G_2 / G_1 = 1/(1 - k/4) \tag{2.34}$$

which equals 1.89 dB for the isotropic and 3 dB for the separable cases, respectively. This improvement is maintained as the order of the predictor is increased (Jayant and Noll, 1984), and it is only unfortunate that typical images tend to approximate more to the isotropic than the separable model!

This section has introduced the theoretical basis of predictive coding of intraframe image data and shown how extension from one to two dimensions depends upon the underlying image model. In practice, however, images have strongly varying statistical properties (note that the predictor region of support is a very small fraction of the total image area) and it is common nowadays to employ highly adaptive techniques (including directional as well as purely statistical measures) in order to achieve significant gains in performance. Such techniques will be discussed in greater detail after we have examined the operation of error sequence quantisation.

2.4. QUANTISATION OF THE ERROR SEQUENCE

We saw in the previous section that the range that the values of the error sequence can assume was twice that of the original signal and thus that, in its original form an 8 bit video signal would require up to 9 bits (512 levels) to represent the predictive sequence correctly. A significant reduction from this figure is possible because of the non-uniform distribution of the error signal (Figure 2.9), and there is a significant body of literature dealing with this matter (see, for example, Clarke, 1985a). Basically what we wish to do is to take either an analogue signal, or one which, if it is discrete, has a large enough number of quantisation levels to allow it to be considered as such, and (re)quantise it with a given number of levels such that some constraint is satisfied. This latter is, in the simple case, the minimisation of the mean square error, but it could, for example, also be minimum entropy of the output sequence. A review of work in this area is given by Clarke (1985a). Here it suffices to note the result of Max (1960), who gave results for such quantisation of a Gaussian variable, minimising the m.s.e. and using either uniform or non-uniform level spacing. Later workers have extended these results to other analytic cases such as the Laplacian and Gamma distributions. The basic non-uniform situation is illustrated in Figure 2.12, in which x_i are the *decision*, and y_i the *reconstruction* levels. Thus any input signal with a

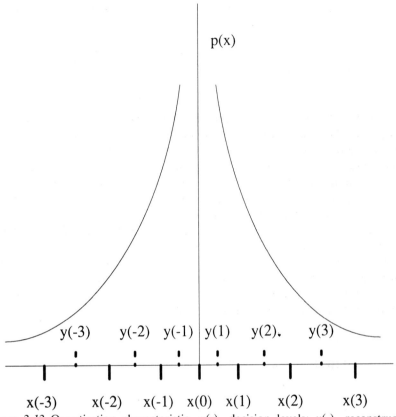

Figure 2.12 Quantisation characteristic. $x(\cdot)$, decision levels; $y(\cdot)$, reconstruction levels.

value between x_i and x_{i+1} will result in a fixed output value y_i being produced. Analysis demonstrates that

$$x_i = (1/2)(y_i + y_{i-1}) \tag{2.35}$$

and the decision levels lie half way between the adjacent reconstruction levels.

Also:

$$y_i = \int_{x_i}^{x_{i+1}} x\, p(x)\, \mathrm{d}x \Big/ \int_{x_i}^{x_{i+1}} p(x)\, \mathrm{d}x \tag{2.36}$$

and the reconstruction levels correspond to the centroids of the areas under $p(x)$ between pairs of decision levels, where $p(x)$ is the probability distribution of the signal in question. Numerical solution of Equations (2.35) and (2.36) leads to tabulated values of x_i and y_i for unit variance signals having

commonly occurring distributions $p(x)$ (Clarke, 1985a). It is worth noting here that the quantiser characteristic of Figure 2.12 is frequently shifted horizontally to allow zero to be one permissible reconstruction level. In this way small quantisation errors in uniform regions of an image can be set to zero, rather than to some finite value which may oscillate between the otherwise symmetrical innermost quantiser levels and give rise to visible distortion in the final picture. This will, of course, necessitate having a total number of reconstruction levels which is odd rather than even.

Intuitively we would expect reconstruction levels to be closely spaced near the origin and to be wider apart for large values of the signal (as mentioned earlier; this fits in very well with the way in which the eye perceives "noise"-type impairments in uniform areas of the picture and is also less sensitive to the absolute amplitude of large luminance transitions, where the prediction is likely to be poor) and this is borne out in practice. One might also expect that the analysis would result in all output levels being equally occupied but this is not the case, and the actual quantiser output entropy is somewhat below $\log_2 N$ bits per word, where N is the number of levels. This being so, additional variable word length coding can be applied to the output sequence to reduce the data rate still further. Alternatively, such coding could be used in conjunction with a design employing uniform level spacing also. In passing it might be mentioned that where non-analytic signal distributions are encountered, training set methods are available for optimum quantiser design, but as the application of such techniques to scalar signals (as in the present case) is but a special case of their widespread use in vector quantisation, further discussion of this point is deferred until Chapter 4.

2.5. ADAPTIVE TECHNIQUES

It is possible to improve upon the performance of the basic predictive coding scheme by allowing system parameters to adapt to various influences. There are basically two interlinked constraints in this approach: the first is the detailed content of the actual input picture – uniform or textured regions, strong spatial luminance fluctuations, etc.; and the second is the way in which these are perceived by the eye. We can allow such influences to affect either the predictor or quantiser characteristics, or both, in the hope that the system will track scanned image data more effectively than in the non-adaptive case.

2.5.1. Adaptive Quantisation

It was noted earlier that the non-uniform quantisation characteristic developed above was in principle well suited to the different ways in which, on the

one hand, the eye perceives fine structure in fairly uniform picture regions and, on the other, abrupt luminance changes. It is widely acknowledged, however, that mean square error is poorly correlated with the visual quality of a reproduced image and therefore, given that the basic "article of faith" of the image coding fraternity is to reconstruct the input image with the best possible *visual* quality, whilst transmitting or storing it with the minimum number of bits, it is not surprising that, since a quantisation characteristic developed on the basis of minimising (numerical) mean square error is only an approximate fit to the perceptual response of the human eye (such quantisers tend to have too many inner levels, where the error is small, and too few outer ones where the error is large), several workers have developed alternative quantisation characteristics based upon subjective tests. Good reviews of the matter can be found in Musmann (1979) and Musmann *et al.* (1985). Thus Sharma and Netravali (1977), for example, determined the visual threshold at an edge with a predetermined slope and then used the data to design quantisers in which the displayed reconstruction error was always below the visual threshold or, if above threshold, was minimised. In the latter case it was found that it was preferable to minimise the sum of the squares of that portion of the quantisation error which was above the visual threshold, but weighted according to a noise visibility function determined by Netravali (1977a) and based upon tests in which a variable amount of random noise was added to picture elements where the luminance detail had a given slope. As a result, it was found that the number of reconstruction levels required for performance equivalent to that of a 35 level minimum m.s.e. quantiser over a variety of 8 bit images was 27. Again, Limb and Rubinstein (1978) considered the matter of determining the visibility function and defined it in terms of a masking function which indicates the reduction of visual sensitivity to small disturbances at an image point caused by the presence of edge detail (i.e. finite slope of the luminance: horizontal/vertical distance relationship).

It might be mentioned here that there are various ways of determining the so-called "activity" of small areas in the image which surround the picture element in question and so influence the visibility function – horizontal element differences, vertical element differences, weighted sums of both, etc.; alternatively the maximum prediction error at surrounding elements may be used. Such a measure directly defines the amount of visual masking present and needs to be determined over a causal area if transmission of additional overhead information is to be avoided.

More sophisticated activity measures may be employed in order to improve the performance of quantisers which employ only small numbers of output levels. Thus Schafer (1983) uses four quantisers, each having 11 levels and switched according to an asymmetric activity function which in some instances masks dark to bright transitions more strongly than those changing from bright to dark. If the attractions of fixed length coding can be dispensed with, still further gains are obtainable by using the activity function to allocate

different variable length codes to the output prediction error. It is worth mentioning here the subjective quantiser design strategy of Girod *et al.* (1987, 1988) although this was devised primarily in the context of $34\,\mathrm{Mb\,s^{-1}}$ transmission of digital television signals. They find that the masking function $m(|e|)$ relevant to the quantisation error for just not visible reconstruction errors has a particularly simple relationship to the prediction error e. Thus:

$$m(|e|) = b \sqrt{|e|}. \tag{2.37}$$

Such quantisers, specified by a single parameter "b", are known as "b" quantisers (see also Girod, 1992).

2.5.2. Adaptive Prediction

It was mentioned at the beginning of this chapter that the predictive coding technique works well in regions of fairly uniform luminance but breaks down when sudden large luminance changes are encountered. Whilst adaptive quantisation schemes can be designed to allow for this, it is natural also to try to modify the prediction scheme in some way to improve performance. Typically such schemes involve multiplying the present prediction by an adaptive scale parameter, whose value is dependent upon the relation between the last prediction error and the quantiser, in an effort to avoid positive or negative quantiser overload, or tracking object contours by examining signal differences between the present element and a number of (causal) surrounding elements and making a prediction from an element on the same side of the contour as the element to be predicted. Such schemes can sometimes involve quite complex selection algorithms which not only recognise contours oriented in different directions but texture also (Zhang, 1982). One more straightforward scheme which nevertheless gives good results is that due to Prabhu (1985). Although intended for interframe image coding the method is also relevant to intraframe operation. The basic operation is as follows. Each of a set of predictors is used to predict S_a, S_b, S_c and S_d in Figure 2.6 and the sum of the prediction error magnitudes at these elements calculated. The predictor giving the least magnitude for this quantity is selected for S_0. This operation is also carried out at the receiver and so entails no transmission of overhead information. Occasionally the predictor selected is incorrect, and in this situation the predictor for S_0 (at the transmitter) is chosen as that having the least magnitude prediction error. In this case information on which predictor has been used must be sent to the decoder. This condition is indicated by the fact that one of the following conditions is not satisfied.

(a) The error values given by all predictors are approximately the same.
(b) The error value given by *one* predictor is significantly less than that given by all the others.

Still more sophisticated methods involve explicit measures of "directiona-

lity" and take account also of the rate of change of such a parameter. Thus Wilson *et al.* (1983) consider an adaptive estimator having three terms – one dealing with stationary, isotropic low-pass components, one with (non-stationary) edge structure having a specific directionality content, i.e. a much higher bandwidth in one direction compared with another and, therefore, anisotropic and high-pass in nature, and one dealing with similar detail but which varies so rapidly with respect to position as to appear isotropic. A binary function is used to indicate, in any particular circumstance, whether an isotropic or anisotropic estimate is appropriate. Since this particular coding structure includes a transform coding operation it is hybrid in nature and results cannot therefore be compared with those of purely predictive schemes. It is of interest, however, in showing how strong non-stationarity in image detail may effectively be dealt with.

It will be apparent to readers that the presence of significant edge detail is a significant problem in the design of efficient predictive coding schemes, and attention has been given to this matter by many workers. A particularly comprehensive approach to the matter is reported by Richard *et al.* (1984) who describe an algorithm which operates in a conventional (line by line) scanning sense and requires little computation, allowing real-time operation. They point out that, in the context of predictive image coding, edges may be defined as contours separating areas of significantly different intensities (more complex regions of large spatial intensity gradient can be considered as texture and treated as such). Such edges are represented by connected sets of horizontal or vertical elements, EH and EV, identified by the differences between appropriate neighbouring picture elements being greater than a threshold. Detail of this nature will (because of the discrete nature of the picture capture process) appear as a "staircase" across the image, and a local estimate of orientation θ can be made by noting the relative numbers of EH and EV at any "tread" on the staircase. Following such "local" preprocessing, a "global" recursive filtering operation is applied to eliminate false edges and to perform a general noise smoothing operation. The edge estimates so obtained are used to select one of a set of prediction functions of various orientations for the adaptive prediction operation. Results show that real-time operation is possible with an algorithm which satisfactorily distinguishes edge detail from texture and is robust to noise.

2.6. OTHER DEVELOPMENTS

The topic of sample estimation in discrete systems is not, of course, limited to the development and analysis of data coding algorithms but covers an enormous range of topics, from general signal estimation in the presence of noise to automatic control, for example. That being the case algorithms generated

in fields other than image processing may be "imported" in an effort to improve performance. One such is the least mean squares (LMS) algorithm (Jayant and Noll, 1984) which has been used extensively in speech coding. Its application to predictive image coding is typically described by Alexander and Rajala (1985). In their scheme the predictor coefficients [the a_i ... of Equation (2.4)] are updated from sample to sample according to the quantised prediction error $e_q(i)$ (the signal to be transmitted to the decoder). Thus:

$$e_q(i) = e(i) + q(i)$$

[Equation 2.2)] and predictor coefficient a_j is updated according to:

$$a_j(i + 1) = a_j(i) + \alpha e_q(i) S(i), \tag{2.38}$$

where α is a gain parameter controlling the convergence properties of the predictor. Comparisons were made, using 8 bit 512×512 image data, between the adaptive algorithm and a fixed two-element two-dimensional predictor, in each case using a non-adaptive Laplacian quantiser with two, four or eight levels (1, 2 or 3 bits element^{-1}). Results were significantly better using the LMS algorithm with a 6–7 dB reduction in mean square distortion at a given bit rate or, alternatively, a reduction of almost 2 bits element^{-1} in the transmission rate for equivalent quality. In each case minimum distortion occurred with a value of α of about 10^{-5}.

An interesting development which also employs LMS updating is due to Sicuranza and Ramponi (1989), in this case applied to image sequence data. Here the adaptive filter is non-linear and so has, in addition to the usual linear coefficients, a quadratic set. For a support of three picture elements, there are three linear and six quadratic coefficients, each updated as before, and the non-linear prediction operation is employed only in active picture areas. The result, in addition to an increase in prediction gain, is a much improved rendering of edge detail, which is visually important, as has been discussed previously (see also Li and Manikopoulos, 1990).

Further analysis of the algorithm mentioned earlier is given in Alexander and Rajala (1984) where statistical source data having known covariance properties are employed. Interestingly enough, a comparison of the two papers indicates that the approach operates more successfully on actual image data than on its first order Markov statistical approximation. At about the same time, Maragos et al. (1984) carried out a comprehensive analysis of such topics as the application of autoregressive two-dimensional models to images, predictor stability and parameter estimation. Here the experimental results are of more direct interest for they exemplify one or two matters as yet unconsidered. Thus, whilst the authors adapt the predictor coefficients by employing the basic analysis over small image regions, to account for non-stationary image properties they also adapt the quantiser which, in this case, has only three levels (Zetterberg et al., 1982). As shown in Figure 2.13, the decision levels are $\pm\theta$ and the reconstruction levels $-\Delta$, 0 and Δ, and so

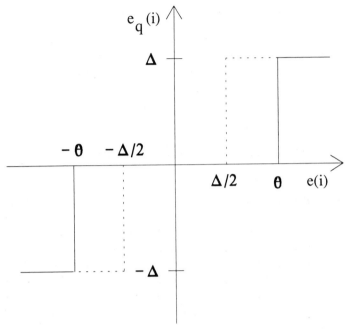

Figure 2.13 Three level quantiser of Maragos *et al.* (1984). —— Centre-clipping; - - - uniform ($\theta = \Delta/2$).

$$e_q(i) \begin{cases} = \Delta & e(i) \geq \theta \\ = 0 & -\theta < e(i) < \theta \\ = -\Delta & e(i) < -\theta. \end{cases} \tag{2.39}$$

If θ is made equal to zero, a two level quantiser results which, with fixed word length coding, yields an output rate of 1 bit element^{-1}. Such an approach is unsatisfactory, however, due to the visible degradation which appears in the reconstructed image (see also Farvardin and Modestino, 1985). With $\theta \neq 0$ however, the resulting central region allows small values of $e(i)$ to be quantised to zero and this, combined with variable word length and simple block coding (typically four samples at a time) gives similar output data rates (making $\theta = \Delta/2$ gives a three level uniform quantiser). If many output samples are zero after quantisation, then the rate can fall below 1 bit element^{-1}. In the present case, Δ and θ are controlled via measurement of the standard deviation of $e(i)$ over regions 16×16 or 32×32 in extent. For such regions, of course, overhead information must also be transmitted regarding the predictor coefficient values and quantiser stepsize (so-called "forward" adaptation). The overhead level is naturally smaller the larger are the "analysis" regions but adaptivity suffers proportionately. In any case, however, the overhead amounts to less than 0.25 bit element^{-1} and overall data rates around 0.7 bit element^{-1} with good quality have been achieved. Another

possibility examined by Maragos *et al.* (1984) is the processing not of the original intensity image but of its equivalent after a logarithmic transformation, i.e. a "density" image. For many years it has been considered by some workers in the field that, since the human eye has a logarithmic characteristic with respect to the perception of intensity, image processing should be carried out in that alternative domain (Stockham, 1972) since the majority of such processing (until fairly recently, anyway) is linear. A subsequent post-processing exponential operation will restore the original intensity characteristics. A further attempt to include a more accurate model of the operation of the human visual system in the coding algorithm was the use of a two-dimensional spatial filter approximately modelling the spatial frequency response of the human eye. The results of these experiments, however, were inconclusive (as have been those of similar experiments carried out by various other workers over the years, see Chapter 1, Sections 1.2.3 and 1.2.5), one kind of visual degradation being substituted for by another and no clear improvement being obtained. Incidentally, the authors made the important point that many of the impairments produced by image coding algorithms are small and subtle in nature and are perceptible only when the reconstructed output is displayed on a high quality, correctly adjusted monitor. It is next to impossible, therefore, to portray such impairments successfully on the printed page.

An investigation of a somewhat similar nature was carried out by Nasseri and Kanefsky (1990), who developed a scheme to determine, for a given image window, the best (causal) region of predictor support in addition to the optimum predictor coefficients. Since increasing the region of support of necessity implies the need to code and transmit more predictor coefficients, which might outweigh the benefit achieved through improved predictor performance, an algorithm is included which maximises the compression factor itself. The standard analysis given at the beginning of this chapter is followed, but the significant point is made that, especially for small windows, the actual (true) and measured values of covariance to be used in the relationships may well be different. It follows that it is important to determine actual, rather than expected, mean square error values in evaluating predictor performance. In fact, there is considerable confusion in the paper with regard to the definitions of actual, measured and theoretical covariance which does not help to advance the authors' case. The scheme, called "doubly-adaptive" DPCM (DADPCM), i.e. adaptive with respect to predictor order and region of support, can select the best region from the total number of possibilities available; thus, if we consider the four nearest neighbours (S_a, S_b, S_c and S_d in Figure 2.6) there is a total of 14 possible first, second or third order regions. Transmission of the appropriate region of support for a given window will then require (for any individual window) four extra bits. An equation is derived which indicates whether an mth order predictor is capable of achieving better data compression than one of order $m + 1$ (note that this never

happens if the window is sufficiently large). Predictors of successively higher orders are then tested using this relationship to determine optimal predictor order. Unfortunately the authors only test their algorithm on a highly artificial set of autoregressive Gaussian random fields with values of covariance which are nothing like those of typical images. Successful practical application of the technique to actual images therefore remains undemonstrated.

Gibson (1985) has examined a more general form of backward predictive loop (i.e. where coefficients are updated using only information available at both transmitter and receiver, here the quantised prediction error – a forward implementation will use update information based upon the input signal, and this will have to be specifically transmitted to the receiver) in spectral terms, and shows that improvement in performance is possible when adaptive schemes are required. Referring to Figure 2.7, the transfer function of the predictor loop in the simple system $\hat{S}(z) / e_q(z)$, can be written as:

$$\hat{S}(z)/e_q(z) = \hat{S}(z)/(\tilde{S}(z) - \hat{S}(z)) \tag{2.40}$$

$$= (\hat{S}(z)/\tilde{S}(z))/(1 - (\hat{S}(z)/\tilde{S}(z))$$

$$= P(z)/(1 - P(z)), \tag{2.41}$$

where $P(z)$ is the transfer function $\hat{S}(z) / \tilde{S}(z)$ of the prediction operation. Since the zeros in Equation (2.41) are determined exclusively by the poles (and so cannot be independently specified) such a predictor is loosely termed "all-pole". If we allow the prediction $\hat{S}(i)$ to be a direct function of $e_q(i)$ also, via a network $B(z)$, such that

$$\hat{S}(z) = P(z)\,\tilde{S}(z) + B(z)\,e_q(z) \tag{2.42}$$

then the prediction operation transfer function becomes

$$\hat{S}(z)/e_q(z) = B(z) + P(z)\,(\tilde{S}(z)/e_q(z))$$

$$= B(z) + P(z)\,(e_q(z) + \hat{S}(z))/e_q(z),$$

i.e.

$$\hat{S}(z)\,(1 - P(z))/e_q(z) = B(z) + P(z)$$

or

$$\hat{S}(z) / e_q(z) = (B(z) + P(z)) / (1 - P(z)) \tag{2.43}$$

and the prediction now contains independent zeros as well as poles. This so-called "pole-zero" predictor is shown to be better at tracking rapid changes in

the input signal. Although Gibson's analysis was directed towards prediction algorithms for speech coding, Sayood and Schekall (1988) have applied such autoregressive moving average (ARMA) predictors in image compression, the rationale being that the performance of traditional prediction schemes degrades rapidly when edge detail is encountered (as mentioned earlier) and the pole-zero structure described by Gibson can provide much improved performance in this respect; also, since it is well known that the performance of non-adaptive predictive coding schemes is strongly dependent upon a good match between the predictor coefficients and the specific overall image statistics, the use of adaptive algorithms is a good approach in any case. The authors compare three different predictors (including a backward adaptive 2 bit quantiser in their simulations): a fixed three-element conventional (all-pole) two-dimensional predictor; an adaptive version of this employing the LMS algorithm in a manner similar to that of Alexander and Rajala described previously; and a pole-zero predictor using the sample directly above the one being coded in the "pole" loop with a prediction coefficient of 0.96, and seven zeros adaptively updated using the same LMS algorithm. Commonly used test images were coded, and SNR gains in moving from fixed to adaptive (all-pole) algorithms varied from 1.3 to 6 dB whilst an additional 1.3–1.4 dB was obtained with the pole-zero predictor. The fact that this figure is not greater is probably accounted for by the fact that the three-element predictor adaptively optimised using the LMS algorithm is fairly efficient to start with. Two-dimensional recursive LMS algorithms using ARMA predictors have more recently been investigated by Chung and Kanefsky (1992), and Das and Loh (1992) have shown that multiplicative AR models can be effective in predictive coding applications at rates below 1 bit element^{-1}.

An alternative to the above approaches to the implementation of adaptive predictive coding is the employment of learning techniques. One such application is described by Griswold and Sayood (1982). The processing system used is hybrid intraframe coding, in which picture elements are one-dimensionally transform coded (see Chapter 3) and the prediction operation is applied vertically to bands of 16 coefficients. This form of coding was proposed by Habibi (1974) at a time when two-dimensional transform coding represented a significant computational load and ways of easing this were sought. Its characteristics are discussed by Clarke (1984a). Although this form of hybrid coding is no longer used, the procedure implemented by the authors is generally applicable in cases where the quantiser input is derived from highly non-stationary data. The technique seeks to identify, from a set of possible input distributions, the one which was the most likely to have formed the source of the present prediction error. The separate distributions are assumed to be Laplacian and to have different variances and probabilities of occurrence. A decision directed estimator using decisions previously made on past samples identifies a particular distribution which has become "active" for the present sample and its parameters are used to scale the range of an

optimum minimum mean square error quantiser. Thus the basic problems of setting the quantiser stepsize and range are equivalent here to the use of an optimum quantiser for the identified distribution. In computer simulations based upon four possible classes in a backward adaptive configuration SNRs at bit rates of 2 and 1 bit element^{-1} were, respectively, 37.6 and 32.7 dB, where the SNR is defined as in Equation (1.2).

An interesting approach to predictive coding is taken by Anastassiou *et al.* (1986) to provide a "freeze" frame videoconferencing facility which, together with an associated entropy coding stage, allows 512 × 480 8 bit grey-scale images to be sent at about 0.5 bit element^{-1}. It was found useful to employ a non-linear noise removal filter (Graham, 1962) as a (one-dimensional) pre-processing stage which, although not introducing any significant image degradation, allowed the data rate to be reduced markedly (see also Sun and Nuevo, 1994). The prediction function used was

$$\hat{S}_0 = S_a + (S_c - S_b)/2 \qquad (2.44)$$

(see Figure 2.6), and the quantiser was made adaptive by forming an estimate of the number of bits needed to code any particular picture element from a consideration of the degree of "smoothness" of the region around the current element. This defines the estimated number of bits for coding. If the actual intensity value lies within the expected range an error bit is set to "0". Otherwise it is "1" and additional correction must be implemented. Most of the image area can be coded with the innermost quantiser levels with a reconstruction level of zero. In this case (smooth regions) only the single error bit need be sent, and adaptive arithmetic coding (Appendix 1) allows the resulting data rate to fall below 1 bit element^{-1}. As a final step, the one-dimensional (horizontal) preprocessing filter is applied vertically to post-process the reconstructed image to remove quantisation artefacts.

It will be evident that many levels of sophistication are possible in the design of predictive image coders. One of the more basic approaches is that of Neagoe (1988), in which the first line of any given image is sent followed by linear approximation of subsequent lines in which, by reference to the previous line, the picture elements have been placed in order of decreasing amplitude. It is found that reasonable quality 6 bit images can be recovered at rates around 1 bit element^{-1}. Performance is roughly comparable with that of block truncation coding (see Chapter 6) with which the algorithm has some affinities.

Image processing is one of the younger of the major disciplines in the electrical engineering/computer science fields and, as such, has been able to take advantage of many of the theoretical advances made in similar, more well-established areas. Two such are general adaptive processing/control and spectral estimation, and in both of these areas lattice structures have been shown to have beneficial properties. Thus Friedlander (1982a,b) points out

the following advantages, amongst others, of a lattice implementation of a (digital) prediction filter:

(a) Round-off noise arising as a result of finite word lengths is "well behaved".

(b) Better performance than the "direct" realisation for a given coefficient quantisation accuracy.

(c) The predictor structure is more general, in that N parameters serve for its characterisation for all orders up to N, whereas $N (N + 1)/2$ are required in the conventional case.

It is not the purpose to review lattice realisations in detail here, and a thorough discussion can be found in the papers just cited. Suffice it to say that the linear predictive filter discussed above forms a finite impulse response filter for which, in addition to the tapped delay line structure, there are alternative realisations, in particular the lattice form. In this case the prediction filter parameters are specified via a set of reflection coefficients (or PARCOR, partial correlation) coefficients which are determined by the data autocorrelation (see, for example, Makhoul, 1977). Traditionally, of course, such development was set in the context of one-dimensional (time-series) analysis, whereas images are naturally two-dimensional. The extension of the idea to the latter case was made by Marzetta (1980) and developed by Parker and Kayran (1984), and prompted subsequent investigations into the application of two-dimensional lattice predictors for image coding. Thus Kwan (1984) and Kwan and Lui (1987) implemented the scheme with up to five lattice stages using a variety of quantisers (15 level non-linear, up to 21 level linear and the three level centre clipping quantiser of Maragos *et al.*, see above) plus Huffman variable word length coding. It was found that performance was virtually the same as for "conventional" predictive coding, one 256 \times 256 head and shoulders picture producing a SNR of 30.5 dB at a rate of 0.8 bit element^{-1}. Better results were obtained by Hsieh *et al.* (1989) who applied a lattice predictor within an adaptive structure. Local properties of the data were catered for by dividing the image into 16×16 blocks and classifying them into one of three categories according to the grey level values x:

(a) Those with a highly peaked histogram $(x_{max} - x_{min}) < T_1$ (an experimentally determined threshold); denoted "uniform" blocks, these were coded by sending the (8 bit) mean value of the block only.

(b) "Homogeneous" blocks were defined by $T_1 < (x_{max} - x_{min}) < T_2$. Such blocks were 2:1 sub-sampled in the horizontal and vertical directions and then processed by a fixed predictor and three-level quantiser.

(c) Remaining blocks were coded using adaptive predictive coding, with the exception of those resulting in significant prediction error greater than a further threshold T_3 (these are coded using straight PCM; since they form only a small fraction of the total number, the necessary addressing overhead information is insignificant). In this case an adaptive three level quantiser is used, with variable stepsize and threshold.

In case (c) above, extracting the poorly predicted elements which result in large values of the prediction error allows the quantiser to be optimised to reduce granular noise in otherwise uniform regions. Results were compared with those of Maragos *et al.* (above) and found to be somewhat better, with good quality images reproduced at around 0.6 bit element^{-1}.

Similar results can be achieved by using other approaches. Thus Yuan and Ingle (1989) used a space-variant random field model with a two-dimensional Markov chain which switches in one of a set of sub-models to account for the inhomogeneity of usual pictures. In order to deal with the problem of unambiguous classification of a given picture element into one of a set of sub-classes, which is sometimes difficult, the switch can select weighted combinations of sub-modes also. For cases in which the prediction error is nevertheless above a threshold, a direct estimate of the Markov state is made at the encoder and transmitted to the decoder, the overhead needing only about 0.1 bit element^{-1}. Apart from this case, all estimation is done in parallel at coder and decoder. Again good performance is obtained at rates around 0.6 bit element^{-1}, with better performance (and sharper edge rendition) being produced by forward adaptations, in which all estimates are made at the encoder and subsequently transmitted, albeit at the cost of an increased transmission rate.

Predictive coding is unquestionably the technique which has been studied for the greatest length of time for the purpose of image data compression. During that time many new techniques have been devised and several of these, too, explored exhaustively. Something it is therefore natural to ask is, how does predictive coding compare with these, some four decades after its inception? This question was addressed by Vivian (1987) in a study of adaptive predictive coding in the context of an ESPRIT project intended to provide a recommendation for a photovideotex image compression algorithm (PICA). He used a predictor based upon an edge detection operation and a quantiser set subjectively optimised with respect to picture activity, with the object of achieving an overall degree of compression which would be as independent as possible of picture content. Over a wide range of source data he achieved excellent results (using a viewing distance of $4\times$ picture height) for colour images at an overall rate of 1.5–1.6 bits element^{-1} for the luminance and 0.4–0.5 bit element^{-1} for the chrominance signals, and noted that more complex systems are needed to achieve lower rates (as discussed elsewhere in this book). This accords with the traditional opinion that predictive coding can achieve very good results with little hardware complexity at rates in the 2–3 bits/element^{-1} region, but cannot compete with other algorithms at the 0.5–1 bit element^{-1} level. With a more analytical approach, Favardin and Modestino (1985) studied the rate–distortion performance of DPCM schemes operating on autoregressive discrete-time sources, with the goal of minimising overall average distortion with a constraint upon data rate. They demonstrated a difference between actual performance and the $R(D)$ bound of

about 0.25 bit sample^{-1} at high rates for the Gaussian case. At lower rates, and also for the Laplacian case at all rates, the difference is larger (Berger, 1971).

Another approach which focuses upon the relation between coding rate and achievable distortion level is that of Modestino and Harrison (1989). In this case regard is taken of the fact that, until comparatively recently, a basic image coding problem was that of interfacing an adaptive algorithm with a highly variable output bit-rate with a fixed rate channel. The natural interfacing device was a buffer of suitable capacity, and the degree of buffer filling was then commonly used as a feedback signal to reduce data flow (usually by modifying the quantisation characteristic) when coding areas of high picture activity (see Chapter 12). A similar scheme is used here. The fixed predictor is globally optimised for a given image, and a 31 level uniform threshold quantiser has its stepsize controlled by fed-back buffer status in order to control the data rate. Performance is described as excellent at a rate of 2 bits element^{-1} with a buffer size of 1024 words.

It was suggested earlier that the LMS algorithm could be used in a general way to update predictor parameters according to data statistics without the constraint that the prediction operation be linear. In such a case the predictor no longer has a strictly low-pass nature and is purely dependent on second order statistics. At the present time the development of data models employing higher order statistics is of great interest and Tekalp et al. (1990) have applied them to predictive coding. Such an approach is useful in cases in which the data statistics are non-Gaussian and a non-linear form of model is used or the use of a distortion criterion other than mean square error is desirable. There are three such cases:

 (a) Non-linear model with m.s.e. criterion.
 (b) Linear model with other than a m.s.e. criterion.
 (c) Non-linear model with other than a m.s.e. criterion.

In each case the predictor had a region of support of four picture elements and the data rate was 1 bit element^{-1}. Case (a) employed the so-called Volterra predictor (Ramponi et al., 1987; see also Mathews, 1991) of order two, but gave little improvement in mean square error over the conventional linear/m.s.e. coder. Case (b) used the complex bi-cepstrum (Tekalp and Erdem, 1989) as a domain in which to match the model to the image data and results in a model with non-causal support. The image that results in this case is markedly improved in quality compared with that of case (a) and, indeed, with that produced by the linear/m.s.e. model, although whether this is due more to the use of higher order statistics than of the non-causal predictor (or vice versa) is as yet an open question. Case (c) has, as its non-linear domain, that obtained via a logarithmic transformation and referred to earlier in this chapter:

$$y(m,n) = \log\left[1 + s(m,n)\right], \qquad (2.45)$$

where $y(\cdot)$ are the transformed and $s(\cdot)$ the original picture elements. $y(\cdot)$ thus approximates a "perceptual" domain corresponding to that of the human visual system. This equalises the perceived intensity of granular noise over the light and dark areas of the picture, which has an overall reconstructed quality which is, however, no better than that produced by algorithm (a).

2.7. CONCLUDING REMARKS

Basic intraframe predictive image coding has traditionally been, for the past three decades, a system capable of very good reproduced quality at rates above maybe 2 bits element^{-1} with, additionally, a not particularly onerous implementational burden as far as hardware is concerned. More complex schemes have enabled the data rate to be reduced to below 1 bit element^{-1} but other, more recent, approaches to low-rate coding have posed strong challenges to its supremacy, especially now that the complexities of implementation, which at one time held them back, are no longer a problem. As far as Vivian's (1987) question "can predictive coding keep up with the younger generation, now that it is approaching middle age?" is concerned, the answer is probably no – at least not in its simply recognisable form (but see Truong *et al.*, 1994). It is, however, still evolving, if slowly, and non-linear and, maybe more important, non-causal predictor structures and various quadtree implementations (dealt with elsewhere in this book) may yet bring still useful gains in performance.

3
Intraframe Transform Coding

3.1. INTRODUCTION

When approaching a signal analysis or system design task, there are two basic ways in which the problem can be formulated: one of these involves representation of the signal characteristics in the time domain, usually in sampled form, when the extensive body of discrete signal and systems theory which has been developed over the past 40 years or so can be brought to bear; the other uses the perhaps more traditional frequency domain, which has the advantage that the signal or system frequency response, in most cases one of the most important design parameters, is readily accessible via a relatively simple product operation, in comparison with the convolution manipulations demanded by the former technique. Of course, on a theoretical level, the two approaches are completely equivalent, and are linked by one of a number of possible Fourier relationships – the series, the transform, etc., in continuous or sampled (discrete) form. It is still the case, however, that approaching a problem from *both* time and frequency perspectives can yield insights which are unavailable when only a single line of attack is contemplated. So it is with image processing in general, and image coding in particular, with the minor

modification that the representation of the image signal takes place in the spatial, rather than the temporal, domain [even this is only partially true, since the conventional line-by-line scanned image can be viewed as a deterministic mapping between the two domains, and (as noted earlier) knowledge of the relation between horizontal and vertical temporal spacings is crucial if we wish to build real-time two-dimensional image filters, for example]. Corresponding to the independent variable time, we thus have a spatial independent variable (or variables, for a two-dimensional image field). Likewise, corresponding to conventional temporal frequency (hertz) we have spatial frequency measured in cycles per degree subtended at the eye of the viewer, as described in Chapter 1, Section 1.2.3, or possibly in cycles per picture width (cpw) in relation to the display. As far as the relevant image processing or coding operations are concerned, we have those in the space domain, where a succession of sample values is directly manipulated by an algorithm such as that described in the previous chapter (predictive coding), and those defined in the frequency (or a "frequency"-like) domain where the initial processing step is via a space–frequency transform producing a set of spectral coefficients which are then suitably coded and transmitted, after which the decoder must perform an inverse transform before the reconstructed image can be displayed. At one time this requirement to carry out a pair of transform operations (possibly two-dimensional) very rapidly presented a significant drawback to frequency domain image processing and, not unnaturally, stimulated the development of a host of "fast" processing routines similar to those which followed the introduction of the fast Fourier transform in the mid 1960s. In parallel with such developments came that of many different actual transform kernel functions, each with its own particular claimed advantage in terms of coding efficiency or simplicity of implementation. The majority of these have been discussed extensively by Clarke (1985a). Nowadays, however, recent advances in high speed integrated circuit technology having been such that fast, real number multiplications no longer present a problem, one transform alone – the discrete cosine transform (DCT) has achieved supremacy. In this chapter, therefore, attention will be concentrated on the DCT, although the simpler though less efficient Walsh–Hadamard transform (WHT) will also be discussed, both to introduce the principles of transform coding and to serve as a performance comparison (for image detail of reasonably high interelement correlation, the usual case, these two transforms represent the achievable extremes of coding efficiency). Again, thorough theoretical treatments of the transform process can be found elsewhere (Clarke, 1985a; Ahmed and Rao, 1975; Elliot and Rao, 1983; Rao and Yip, 1990; Jain, 1989), so here only sufficient detail is given to form a basis for an understanding of the various coding algorithms which have been developed and which have resulted in the incorporation of the DCT into just about every one of the recently proposed or adopted picture coding/transmission standards.

3.2. THE TRANSFORM CODING OPERATION

The basic mechanism of transform coding, like that of predictive coding, is very simple. A set of data samples is taken and the object of the transformation is to alter the distribution of the values representing the luminance levels so that many of them can either be deleted entirely or, at worst, be quantised with very few bits. Nowadays this is carried out universally in two dimensions, but an initial one-dimensional example will prove instructive. Suppose we consider a single line of (image) data and divide it into blocks of two samples each. For most of the data, providing that the image is not too spatially active over large areas, data values will be similar within the separate blocks and only occasionally (where a block crosses a luminance edge) will they be significantly different. A plot of one luminance value (x) in the block against the other (y) will then look like Figure 3.1 with the majority of pairs of

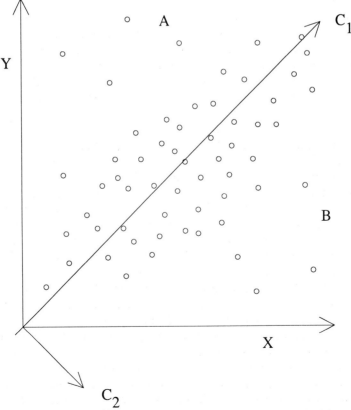

Figure 3.1 Coordinate rotation for blocks of two samples: X, Y original data domain, C_1, C_2 new coordinate domain.

values lying close to the 45° diagonal line and relatively few in the regions A and B, which represent major differences in value. What the operation of the transform does is to rotate the coordinate axes from X and Y to C_1 and C_2 so that, instead of having to retain all data values with equal resolution, as would have been necessary with the original signal, we now have two sets of numbers, one large, one, at least for the most part, relatively small or even zero. The new components are

$$c_1 = \sqrt{2}\,x + (y - x)/\sqrt{2} = (x + y)/\sqrt{2} \qquad (3.1)$$

$$c_2 = -(y - x)/\sqrt{2} \qquad = (x - y)/\sqrt{2}. \qquad (3.3)$$

Similarly, an inverse operation

$$x = (c_1 + c_2)/\sqrt{2} \qquad (3.3)$$

$$y = (c_1 - c_2)/\sqrt{2} \qquad (3.4)$$

recovers the original values x and y. If, for example, $x = 5$ and $y = 7$, then

$$c_1 = 12/\sqrt{2}$$

and

$$c_2 = -2/\sqrt{2}.$$

The total data energy is given by

$$E_D = x^2 + y^2 = 25 + 49 = 74 \qquad (3.5)$$

and, if we wish to retain only one component of the signal, deleting the smallest component (x) in the data domain entails an error of

$$e = 25/74 = 34\%.$$

On the other hand, on deleting the smallest component in the transform domain (c_2), approximate values of x and y on reconstruction are

$$x' = y' = c_1/\sqrt{2} = 6$$

and the error incurred is

$$e = ((x^2 + y^2) - ((x')^2 + (y')^2))/(x^2 + y^2)$$

$$= ((25 + 49) - (36 + 36))/(25 + 49) = 2/74,$$

i.e. approximately 3%. Note that the total transform coefficient energy is

$$E_T = (c_1)^2 + (c_2)^2 = 144/2 + 4/2 = 74,$$

the same as the data domain energy, and the error may equivalently be calculated in the transform domain if desired, $(c_2)^2 / (c_1^2 + c_2^2)$.

Moving to the transform domain for information transmission/storage has therefore allowed us to retain an approximation to the data vector [(6,6)

instead of (5,7)] by employing only one term instead of two, whilst incurring an error only one-tenth as large as would have been the case if only one term had been retained in the data domain. It is intuitively obvious that the best transformation for this purpose is one which in some way "lines up" best of all with the spread of data points. The mathematical form of this is given by the Karhunen–Loeve transform (KLT, Clarke, 1985a) but this has the disadvantage that, as might be expected, the multiplying factors which we need to use (equivalent to the $1/\sqrt{2}$ factors above) are a function of the actual data parameters, entailing recalculation for different data sets. It turns out that, for image data captured from naturally occurring scenes, the DCT is a very good approximation to this transform (Clarke, 1981), with the advantage that the multipliers are predetermined and constant.

Before examining the transform relationship more formally, we might note one or two points in conclusion regarding the simple example given above.

(a) Although such small data blocks have been occasionally used in practice, it is much more conventional to consider two-dimensional blocks 8×8 or 16×16 elements in extent; the above simplification is only really useful for demonstrating the basic ideas behind the transform operation.

(b) One interpretation of coefficient c_2 is to consider it as the (possibly scaled) error signal obtained by simple previous sample prediction of x from y (see the previous chapter).

(c) We may set the transform operation in conventional matrix/vector notation by writing

$$\begin{bmatrix} c_1 \\ c_2 \end{bmatrix} = 1/\sqrt{2} \begin{bmatrix} 1 & 1 \\ 1 & -1 \end{bmatrix} \begin{bmatrix} x \\ y \end{bmatrix} \tag{3.6}$$

with inverse

$$\begin{bmatrix} x \\ y \end{bmatrix} = 1/\sqrt{2} \begin{bmatrix} 1 & 1 \\ 1 & -1 \end{bmatrix} \begin{bmatrix} c_1 \\ c_2 \end{bmatrix} \tag{3.7}$$

or

$$\mathbf{C} = [T_1] \mathbf{X} \tag{3.8}$$

$$\mathbf{X} = [T_2] \mathbf{C}. \tag{3.9}$$

In general $[T_2]$ will be the inverse of $[T_1]$. The properties of the actual transforms used in coding, however, ensure that the matrix inverse is of a particularly simple form and it may even be, as in the present case, identical to the matrix itself (see below).

(d) It was noted that, in the simple example given here, the total energy in both data and transform coefficient domains is the same. This is

ensured by constraining the sum of the squares of all entries in any row of the matrix to be equal to unity, another point discussed further below.

3.3. BASIC TRANSFORM PROPERTIES

3.3.1. The Walsh–Hadamard Transform

The transform matrix of Equation (3.6) is, in fact, of more significance than its use in that simple example would suggest. It is, indeed, the lowest order of the Walsh–Hadamard family (Clarke, 1985a):

$$[\text{WHT}]_1 = 1/\sqrt{2} \begin{bmatrix} 1 & 1 \\ 1 & -1 \end{bmatrix}. \tag{3.10}$$

This family has been widely studied in an image coding context (Pratt *et al.*, 1969; Clarke, 1983, 1985a), and we need only refer to its more practical representation here, where it will serve to illustrate several basic features of the transform operation. Higher orders of the matrix are simply generated by replacing individual entries in $[\text{WHT}]_1$ by the matrix itself, thus:

$$[\text{WHT}]_2 = 1/\sqrt{2} \begin{bmatrix} \dfrac{1}{\sqrt{2}} \begin{bmatrix} 1 & 1 \\ 1 & -1 \end{bmatrix} & \dfrac{1}{\sqrt{2}} \begin{bmatrix} 1 & 1 \\ 1 & -1 \end{bmatrix} \\ \dfrac{1}{\sqrt{2}} \begin{bmatrix} 1 & 1 \\ 1 & -1 \end{bmatrix} & -\dfrac{1}{\sqrt{2}} \begin{bmatrix} 1 & 1 \\ 1 & -1 \end{bmatrix} \end{bmatrix}$$

$$= \frac{1}{2} \begin{bmatrix} 1 & 1 & 1 & 1 \\ 1 & -1 & 1 & -1 \\ 1 & 1 & -1 & -1 \\ 1 & -1 & -1 & 1 \end{bmatrix} \tag{3.11}$$

and so on, generating successively larger matrices of extent $2n \times 2n$, where n is an integer. Such matrices are called basis matrices and the row vectors which they contain are the basis vectors of the transform. It is the sequential multiplication of these basis vectors with the data vector(s) which generates the transform coefficient vector **C**. It is possible to write the discrete Fourier transform (DFT) in this form and the coefficient set so produced will be a sampled version of the frequency spectrum of the data so transformed. Indeed, the DFT has been used for image coding (Pearl, 1973), but the fact that the DCT is more efficient (Clarke, 1985a) and the advantage that it is a

real-valued transform, making data routing within the algorithm more simple, have meant that this application of the DFT has not been pursued. There is a point of some significance here, though, in that the DFT is the only transform which produces a true *frequency* spectrum. All others produce "pseudo-spectra" which have complicated relationships with true frequency (Ahmed and Rao, 1975). It is, nevertheless, useful to retain the notion of rate of change of zero-crossings (as with true frequency) even when considering the operation of such transforms as the WHT and DCT, and it is therefore usual to employ a row reordering of Equation (3.11) in terms of increasing numbers of sign changes as follows:

$$[\text{WHT}]_2 = \frac{1}{2} \begin{bmatrix} 1 & 1 & 1 & 1 \\ 1 & 1 & -1 & -1 \\ 1 & -1 & -1 & 1 \\ 1 & -1 & 1 & -1 \end{bmatrix} \begin{matrix} \text{Sign} \\ \text{changes} \\ 0 \\ 1 \\ 2 \\ 3, \end{matrix} \qquad (3.12)$$

where the right-hand column indicates the number of sign changes in any particular basis vector. Transform coefficients are then produced in order of rapidity of change in the data vector, i.e. corresponding loosely to an intuitive notion of frequency.

Two further properties of the transform may be demonstrated with reference to Equation (3.12). The first, a basic property which ensures that all transform coefficients represent "separate" components in the data spectrum, is that of orthogonality. Thus, if we write a general transform matrix as

$$[T] = \begin{bmatrix} t_{11} & t_{12} & t_{13} & \cdots\cdots\cdots & t_{1n} \\ t_{21} & t_{22} & t_{23} & \cdots\cdots\cdots & t_{2n} \\ \cdot & \cdot & \cdot & & \cdot \\ \cdot & \cdot & \cdot & & \cdot \\ t_{n1} & & \cdots\cdots\cdots\cdots & & t_{nn} \end{bmatrix} \qquad (3.13)$$

orthogonality is represented by the relation

$$\sum_{i=1}^{n} t_{ai} t_{bi} = 0 \quad a,b = 1 \quad \rightarrow n \qquad (3.14)$$
$$a \neq b.$$

This property ensures that each transform coefficient can be determined as the result of one simple calculation, independent of the calculation or values of all the others. The other property is that of orthonormality, which results in the energy invariance between data and transform domains which has already been demonstrated. This is defined by

$$\sum_{i=1}^{n} t_{ai}^2 = 1 \quad a = 1 \rightarrow n. \qquad (3.15)$$

Both of these properties can be seen to be exemplified by the matrix of Equation (3.12). It is worth noting, in passing, that it is not necessary to retain this property in the implementation of a transform algorithm when other considerations such as coefficient dynamic range (Clarke, 1985b) and possible overflow may well take precedence. Without the scale factor, the reason for the popularity of the WHT in the early days of transform image coding is apparent – no multiplications are needed in order to generate the transform coefficients. A modified version of the WHT was developed in the late 1980s in an attempt to improve the efficiency of coding (Section 3.5) whilst retaining ease of implementation by including values of ½ (implementable via a binary shift) in the basis vectors (see Cham and Clarke, 1986, 1987).

We may extend the example given earlier in this chapter to a data block of length four in order to demonstrate the use of Equation (3.12). Thus, suppose that $\mathbf{X} = \{5, 7, 9, 6\}$. Then

$$\mathbf{C} = [T]\,\mathbf{X}$$

$$= \frac{1}{2} \begin{bmatrix} 1 & 1 & 1 & 1 \\ 1 & 1 & -1 & -1 \\ 1 & -1 & -1 & 1 \\ 1 & -1 & 1 & -1 \end{bmatrix} \begin{bmatrix} 5 \\ 7 \\ 9 \\ 6 \end{bmatrix}$$

and the coefficient vector is $\mathbf{C}^{\mathrm{T}} = \{13.5, -1.5, -2.5, 0.5\}$. The energy terms in each domain are identical: $(5^2 + 7^2 + 9^2 + 6^2) = (13.5^2 + 1.5^2 + 2.5^2 + 0.5^2) = 191$, and in this case deleting the half of the coefficients which have the smallest magnitudes (1.5 and 0.5) results in an error of only 1.3%.

There are alternative methods for generating WHT matrices of various orders (Pratt, 1991). For practical experimentation, however, one needs only to programme the basis vectors for the 8 × 8 transform, for example, in order to code real images. Thus:

$$[\mathrm{WHT}]_3 = 1/2\,\sqrt{2} \begin{bmatrix} 1 & 1 & 1 & 1 & 1 & 1 & 1 & 1 \\ 1 & 1 & 1 & 1 & -1 & -1 & -1 & -1 \\ 1 & 1 & -1 & -1 & -1 & -1 & 1 & 1 \\ 1 & 1 & -1 & -1 & 1 & 1 & -1 & -1 \\ 1 & -1 & -1 & 1 & 1 & -1 & -1 & 1 \\ 1 & -1 & -1 & 1 & -1 & 1 & 1 & -1 \\ 1 & -1 & 1 & -1 & -1 & 1 & -1 & 1 \\ 1 & -1 & 1 & -1 & 1 & -1 & 1 & -1 \end{bmatrix} \quad (3.16)$$

The coding efficiency of the WHT is considered below.

3.3.2. The Discrete Cosine Transform

The DCT was developed in the early 1970s (Ahmed *et al.*, 1974) in an effort to overcome problems associated with discontinuities at the ends of a data

segment (block) which are well known in the case of the DFT. It is a real-valued transform whose basis vectors are generated from the relationship

$$C_{nk} = C_0 \sqrt{(2/N)} \; \cos{(n(2k + 1) \pi/2N)}, \tag{3.17}$$

where $C_0 = 1/\sqrt{2}$ if $n = 0$, otherwise $C_0 = 1$, and n and k range between 0 and $N - 1$, for a block length N. The 8×8 matrix in orthonormal form is thus

$$[DCT]_3 = \begin{bmatrix} 0.3536 & 0.3536 & 0.3536 & 0.3536 & 0.3536 & 0.3536 & 0.3536 & 0.3536 \\ 0.4904 & 0.4157 & 0.2778 & 0.0975 & -0.0975 & -0.2778 & -0.4157 & -0.4904 \\ 0.4619 & 0.1913 & -0.1913 & -0.4619 & -0.4619 & -0.1913 & 0.1913 & 0.4619 \\ 0.4517 & -0.0975 & -0.4904 & -0.2778 & 0.2778 & 0.4904 & 0.0975 & -0.4157 \\ 0.3536 & -0.3536 & -0.3536 & 0.3536 & 0.3536 & -0.3536 & -0.3536 & 0.3536 \\ 0.2778 & -0.4904 & 0.0975 & 0.4157 & -0.4157 & -0.0975 & 0.4904 & -0.2778 \\ 0.1913 & -0.4619 & 0.4619 & -0.1913 & -0.1913 & 0.4619 & -0.4619 & 0.1913 \\ 0.0975 & -0.2778 & 0.4157 & -0.4904 & 0.4904 & -0.4157 & 0.2778 & -0.0975 \end{bmatrix} . \tag{3.18}$$

It is this transform in its 8×8 or 16×16 versions which has become the "workhorse" of image coding as applied to both still pictures and image sequences, through the development of several "fast" algorithms for its calculation, its availability in integrated circuit form and its inclusion in the various standards for image compression (see below). It is worth noting that work on this transform has been highly intensive ever since its introduction and many variants exist (see, for example, Ersoy and Nouira, 1992).

3.4. TWO-DIMENSIONAL FORWARD AND INVERSE TRANSFORMATION

The examples in the previous sections have, for simplicity, been based exclusively upon the one-dimensional formulation of the transform operation. In practice this version is no longer employed for images, and the two-dimensional extension is used. In this case the data block is almost always square (8×8 or 16×16) and the transform is carried out in both horizontal and vertical directions. Isolated examples of the use of rectangular (non-square) data blocks exist, but are of little significance, as is the occasionally reported use of different transforms in the two directions.

The first step in the operation is the transformation of the data columns, via a conventional row/column matrix multiplication; see Equation (3.8):

$$[C'] = [T] [X], \tag{3.19}$$

where $[T]$ is the transform basis matrix and $[X]$ is the data block.

Transformation of the rows of $[C']$ can be carried out by a matrix post-multiplication in which, in order to satisfy the rules for matrix multiplication, the transpose of the basis matrix must be used:

$$[\mathbf{C}] = [\mathbf{C'}] [\mathbf{T}]^{\mathrm{T}} \tag{3.20}$$

$$= [\mathbf{T}] [\mathbf{X}] [\mathbf{T}]^{\mathrm{T}}. \tag{3.21}$$

[\mathbf{C}] is now the final two-dimensional transform of [\mathbf{X}] and is of the same dimension.

As far as the inverse transform is concerned, in one dimension the coefficient vector is multiplied by the inverse of the transform matrix which, for the real orthogonal transforms considered here, turns out to be the transpose of the original matrix (Clarke, 1985a). In the case of the WHT this is further simplified since the matrix is symmetric. In two dimensions the relationship for the inverse transform is itself symmetrical with that for the forward operation, Equation (3.21), i.e.

$$[\mathbf{X'}] = [\mathbf{T}]^{\mathrm{T}} [\mathbf{C}] [\mathbf{T}]. \tag{3.22}$$

It is worth pointing out that the arithmetic precision with which the forward and inverse operations are carried out may very well be of some consequence, particularly where standardisation of an algorithm is concerned.

3.5. A MEASURE OF TRANSFORM EFFICIENCY

Experiments carried out in many different research laboratories throughout the world, on widely varying sets of test images, have demonstrated conclusively that the DCT has the best still image coding performance of all those transforms having data-independent basis vectors, and which approaches that of the optimum, data-dependent (KLT) transform. For the theoretical basis of this result, see Clarke (1981). In the practical case the evidence consists of minimum mean square error measures for the reconstructed images, for a given number of bits allocated to the coding of the coefficient set, and also of the visual (subjective) quality given the same constraint, although it should be acknowledged that the two indicators are not well correlated. On a more formal basis, a performance criterion may be based on the application of a simple image model (Clarke, 1984b). A useful indication of relative performance can be obtained by assuming a first order Markov image field of predetermined interelement correlation coefficient and then noting the error resulting from the deletion of a given percentage of coefficients. Transformation of the data covariance matrix also gives us another performance indicator for the transform operation, since under another interpretation the process should reduce the correlation within the data, as this is a source of redundancy which an efficient coding scheme should remove, or at least reduce. Thus we form the covariance matrix of the data, [$\mathbf{C_{XX}}$], according to our chosen model, carry out a two-dimensional transform and examine the

characteristics of the equivalent matrix $[C_{YY}]$ in the transform domain. Suppose that the interelement correlation coefficient is 0.95, a reasonable value for typical, medium activity still images. $[C_{XX}]$ is then, for a stationary, unit variance one-dimensional input sequence:

$$[C_{XX}] = \begin{bmatrix} 1.00 & 0.95 & 0.95^2 & 0.95^3 & \dots \\ 0.95 & 1.00 & 0.95 & 0.95^2 & \dots \\ 0.95^2 & 0.95 & 1.00 & 0.95 & \dots \\ \dots & & & & \\ \dots & & & & \\ \dots & & & & \end{bmatrix}. \qquad (3.23)$$

Using the 8×8 one-dimensional DCT, the diagonal entries in $[C_{YY}]$ are

$$[C_{YY}]_{DIAG,DCT} = \{7.025, 0.575, 0.173, 0.082, 0.051, 0.037, 0.030, 0.027\}. \qquad (3.24)$$

These values represent the variances of the separate coefficient sequences and are markedly dissimilar, indicating that, unlike the situation obtaining in the data domain, the sets of transform coefficients are highly non-stationary (note that the orthonormality of the transform ensures that the sum of the diagonal elements is, in each case, the same). The data compression performance is indicated by the extent that the signal energy is compacted into the earlier (lower "frequency") terms of the series. Thus, for example $(7.025 + 0.575) / 8 = 95\%$ of the data energy now resides in the first two coefficients alone. The equivalent result for the WHT is

$$[C_{YY}]_{DIAG,WHT} = \{7.025, 0.487, 0.152, 0.135, 0.051, 0.051, 0.051, 0.047\} \qquad (3.25)$$

and it can be seen that, in this case, the energy is somewhat more "spread out", indicating a poorer degree of compaction and so of coding performance. The effect of this apparently small difference is, however, readily visible when reconstructed images are viewed on a good quality display. A further point of interest is that the values in Equations (3.24) and (3.25) form the image spectrum as given by the particular transform being employed, and so demonstrate the strongly low-pass nature of such spectra for data which have high interelement correlation.

Other information which can be obtained from $[C_{YY}]$ concerns the correlation remaining between the separate coefficient sequences. This is contained in the off-diagonal entries of the matrix. In the case of the KLT, which produces complete decorrelation of the data, all such entries will be zero. In the present examples, in neither case (DCT or WHT) has any entry a magni-

tude greater than 0.2, indicating that both transforms are quite satisfactory in this respect.

3.6. TRANSFORM COEFFICIENT PROCESSING

So far in this chapter we have concentrated exclusively upon the more mathematical aspects of the transform operation itself. The result of the two-dimensional transform carried out on blocks of the image 8×8 or 16×16 in extent is blocks of transform coefficients of the same size but having entries of widely varying magnitudes, and the task is now to process these for transmission in the most efficient way possible. Up to this point no data compression has been achieved, and an inverse transform operation applied to the coefficient set will result in the exact reconstruction of the data block(s). Compression results from the deletion of any sufficiently small coefficients and the variable bit-rate quantisation of the remainder. In order to carry this out it is necessary to determine a suitable bit allocation and quantisation strategy which will result in suitably small impairments appearing in the reconstructed picture. Image data amenable to a good degree of compression have a relatively high value of interelement correlation coefficient and, consequently, a strongly low-pass (Fourier) spectrum. As we have seen, this property extends to the coefficient set obtained via transforms other than the Fourier transform, and we thus expect to find large magnitude coefficients (the so-called A.C. coefficients) clustered around the zero frequency (or D.C. term) which is situated in the top left-hand corner of the coefficient block, and smaller ones further out towards the bottom right-hand corner (representing the highest spatial frequency in both horizontal and vertical directions). The form of the distribution is shown in Figure 3.2. It should be noted that this distribution will not always hold precisely for every block of coefficients, for some, which correspond to image blocks containing very active spatial detail, will have middle or even high order coefficients of significant magnitude. Hence the introduction of adaptive techniques to be described subsequently. The overall distribution will, however, follow that described. Each coefficient is one instance of a random variable, there being as many coefficients of any particular order as blocks. Thus, for a 512×512 image subdivided into 8×8 blocks there will be $64 \times 64 = 4096$ blocks, 4096 D.C. coefficients [order $(0,0)$], and 4096 coefficients of each order up to $(7,7)$, with the total number of coefficients being the same as the number of image data elements. There have historically been two ways in which selection of coefficients for further processing can be carried out. The first, zonal coding, involves the setting up of a number of zones of predetermined bit allocation, according to some coefficient energy:error relation. Thus (see Figure 3.3) the most significant coefficient (the D.C. term) may be allocated 8 bits, large magnitude A.C.

(0,0) (0,7)

(7,0) (7,7)

Figure 3.2 8 × 8 Block of transform coefficients. (O) Coefficient location in the 8 × 8 array; (x,y) coefficient indexing.

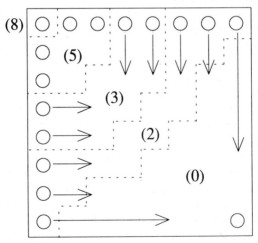

Figure 3.3 Typical block bit allocation. (O) Coefficient location in the 8 × 8 array; - - - bit allocation partition; (·) partition bit allocation.

coefficients 5 bits and so on, small high order coefficients being allocated no bits and hence being effectively deleted [schemes have been devised which set groups of small coefficients which would normally have been deleted, not to

zero, but to some finite representative value; the results obtained are, however, variable (Mensa-Ababio, 1989)]. In the example given in Figure 3.3, a total of 119 bits is thus allocated per block, in comparison with $8 \times 64 = 512$ for the data, an overall reduction of something over 4:1. A basic problem with this method is that, in its non-adaptive form, it takes no account of the local variability of coefficient magnitudes referred to earlier, and the alternative technique, threshold coding, seems a more logical approach. In this method a threshold, or set of thresholds, is established, and coefficients larger than the predetermined level(s) are saved and processed further, those smaller being deleted. Intuitively this is correct, since the larger coefficients may be expected to contribute proportionally more towards good image reconstruction, but there remains the further problem of identifying, for the decoder, those coefficients which have been retained by the transmission of appropriate addressing information. It is this method, nevertheless, which has been chosen for the still picture coding standard, to be described in Section 3.10.

3.7. TRANSFORM COEFFICIENT DISTRIBUTIONS AND "CLASSICAL" BIT ALLOCATION

It was shown in the previous chapter on predictive coding that the actual probability distribution of the error signal has a profound influence upon the design of a suitable quantisation strategy; so it is with transform coefficients, and this has led to much investigation of the matter. In fact, for the construction of coefficient quantisers of the "classical" type the results can be stated very simply (Clarke, 1985a). The D.C. coefficient is simply the (scaled) mean of the luminance values of all elements in the image block, and so has the same, ill-defined distribution. It is therefore uniformly quantised, usually with a word length of 8 bits (although some workers have occasionally used 9 or 10). The A.C. coefficients are formed as weighted sums and differences of elements in the block and so have a characteristic highly peaked distribution which is approximately Laplacian and, in addition, mean values which are very close to zero. Readers might note, however, that for no good reason known to the present author, the distribution of the A.C. coefficients was for a long time (and sometimes still is) taken to be Gaussian. In fact, some low order coefficients can be shown, for certain images, to have distributions which are even more highly peaked than Laplacian and to be better modelled by the Gamma distribution.

Suitably scaled A.C. coefficients can thus be fed to a unit variance Laplacian quantiser of appropriate resolution (number of bits) followed by some form of entropy or Huffman coding. It is worth noting that, although this has been the "traditional" design approach, more complex coefficient coding/quantisation strategies are possible – for example, the trellis encoding/Viterbi

decoding algorithm of Marcellin (1990) which can produce gains of several decibels by comparison.

Given, then, that for a set of transform coefficients we have a previously determined estimate of their variance and a known (or assumed) probability distribution, how should bits be allocated to achieve minimum reconstruction error (the matter is discussed in more detail in Clarke, 1985a)? A standard calculation (Huang and Schultheiss, 1963) albeit based upon an assumption of Gaussian distribution of random variables leads to the relation

$$b_i = M / n \quad + \quad (1/2) \log_2 (\sigma_i^2 / [\prod_1^n \sigma_i^2]^{1/n}), \tag{3.26}$$

where b_i is the number of bits allocated to coefficient i (out of a total of n), having variance σ_i^2, and M is the total number of bits available. M/n is then the average bit allocation and the second term in Equation (3.26) accounts for the unequal variance distribution (if all σ_i^2 are equal, this term is zero). This equation can be shown (Clarke, 1985a) to have the form:

$$b_i = (1/2) \log_2 (\sigma_i^2 / D), \tag{3.27}$$

where D is a constant dependent upon σ_i^2 and M. Thus bits should be allocated according to the coefficient variances, and the quantisation of each coefficient contributes an equal amount to overall distortion. One problem with this approach is that it should really only be applied to Gaussian variables, another is that it usually results in non-integer assignments and round-off, with consequent reduction in performance, is necessary. Equation (3.27) is, of course, Shannon's rate distortion [$R(D)$] equation, applicable to the coding of Gaussian variables with distortion D under the mean square error criterion (Shannon, 1959).

Alternative approaches to the problem are possible. One scheme which has proved quite popular is that of marginal returns (Fox, 1966), in which bits are allocated on a sequential basis to coefficients giving the greatest return (i.e. decrease in distortion). This tends to be a severe load computationally and a modified procedure is described by Tzou (1987). Again, bits may be allocated sequentially to the coefficient with the largest quantisation error (Ghanbari, 1979). Another scheme is that of Pearlman (1990), in which a spectral variance estimate is produced for each block of coefficients and coding takes place under the constraint that the average distortion produced in each block must be the same. Excellent results are reported for this scheme at 0.7–1.0 bit element^{-1} for a variety of input pictures. All these techniques produce bit allocations which, if they cannot be satisfactorily approximated by a few clearly delineated zones as described earlier, must be transmitted to the receiver as overhead information. Optimal allocation of bits in the case of multistage transform coding is discussed by Aghagolzadeh and Ersoy (1991).

3.8. ADAPTIVE INTRAFRAME TRANSFORM CODING

It was noted above that simple fixed bit allocation procedures do not perform particularly well and intensive research over the past 20 years has resulted in a vast array of adaptive techniques (many of which are documented in Clarke, 1985a). It will suffice here to give a single example of the incorporation of adaptivity into the zonal transform coding operation. The scheme of Chen and Smith (1977) uses transform domain total A.C. coefficient energy as a measure of block "activity" (the D.C. coefficient is excluded as representing purely the average block luminance – see earlier) which subsequently determines coefficient bit allocation. Image blocks of size 16×16 are two-dimensionally discrete cosine transformed and their activity determined before being sorted into four equally populated categories (many designs exist with up to a dozen or so activity classes, with results which are, however, only marginally better). A block size of 16×16 represents a compromise between the conflicting requirements of good response to changing image detail (small blocks, say 4×4) and higher values of transform efficiency and reduced overhead requirement (block sizes of at least 16×16). Contemporary practice in fact favours a block size of 8×8. Coefficients in each class are quantised with a non-uniform minimum mean square error quantiser and then coded for transmission. Bit allocations are determined by Equation (3.27) and, for a 1024×1024 monochrome image of quite high activity, are as shown in Table 3.1, where Class 1 has the highest activity:

Table 3.1 Typical bit allocation for adaptive transform coding (ATC).

b_i	8	7	6	5	4	3	2	1	0
Class 1	1	2	4	6	10	25	38	107	63
Class 2	1	0	2	5	11	24	42	102	69
Class 3	1	0	0	3	5	16	29	70	132
Class 4	1	0	0	0	0	4	6	27	218

The total numbers of bits allocated for Classes 1–4 are, respectively, 374, 347, 219 and 59. Since each block contains $16 \times 16 = 256$ elements, the equivalent coding rates are 1.46, 1.36, 0.86 and 0.23 bit element^{-1}, respectively. The average data rate for the picture as a whole is just below 1 bit element^{-1}. In this case allocations for Classes 1 and 2 are not very different and some redistribution in Class 2 would probably have been advantageous. Before quantisation, each coefficient is normalised in order that it may be quantised without clipping using one of a set of eight basic minimum mean square error non-linear quantisers (having between 1 and 8 bits) designed for a Gaussian distribution. All coefficients are quantised in this way – later schemes use a uniform quantiser for the D.C. coefficient and Laplacian quantisers for the A.C. terms.

In addition to the quantised transform coefficients, overhead information must be transmitted to the decoder to establish block classification, normalisation factors and bit allocation tables. The requirements are as follows.

(1) Block classification: 2 bits block^{-1} = 1/128 bit element^{-1} (independent of image size for a given block dimension).
(2) Normalisation factors: negligible.
(3) Bit allocation tables: 4×16^2 entries. If each is a 3 bit word the total number of bits is 3072. This might be approximately halved by Huffman coding.

The total overhead load is thus well below 0.05 bit element^{-1} even for a smaller (256×256) image. As in any well-designed coder, this is a negligibly small fraction of the total data rate. Chen and Smith (1977) extended their design to the processing of colour images by coding the Y, I and Q signal components using the above technique on each. Very good results are achieved at an overall rate of around 1 bit element^{-1} in both monochrome and colour cases, but it is worth pointing out that the small degree of detail in the I and Q (or U and V) colour components would have allowed them to be sub-sampled by a factor of at least 2:1 horizontally and vertically, thereby increasing the efficiency of the colour coding operation. Typical adaptive transform coding results are shown in Figures 3.4–3.6. Figures 3.4(a), 3.5(a) and 3.6(a) are original FLAT, TESTCARD and GIRL images, respectively. Figure 3.4(b) is coded at 1.5 bit element^{-1} with conventional a.c. energy classification, Figure 3.5(b) at just below 1 bit element^{-1} using coefficient magnitude as a classification parameter and Figure 3.6(b) at just below 1 bit element^{-1} using threshold sampling of coefficients. Figure 3.6(c) is coded using fixed zonal selection of coefficients and shows what happens when the scheme "runs out" of bits – the degradation is clearly visible.

The scheme of Chen and Smith may be regarded as being broadly representative of the majority of adaptive intraframe transform coding algorithms developed in the late 1970s and early 1980s [there are, however, many other means of coefficient classification; Mester and Franke (1992), for example, suggested using the so-called "spectral entropy" of the normalised a.c. coefficients for this purpose]. It has the disadvantage, however, that two passes through the image are necessary – one to collect statistics and determine bit assignment arrays, etc., the second to perform the actual coding operation, and methods which circumvent this requirement have been sought. It was pointed out earlier that there is a problem with coefficient addressing in the threshold scheme and this generally prevented its more widespread investigation. In 1984, however, Chen and Pratt (Chen and Pratt, 1984) described a scheme which was to alter the direction of mainstream transform coding development. Their "scene adaptive coder" differs from schemes such as the one described above in several important respects. Undoubtedly one of the important advantages of the scheme is that it does not require a two-stage

(a)

(b)

Figure 3.4 (a) Original FLAT image. (b) Adaptive transform coding of the FLAT image at 1.5 bit element^{-1}. Energy classification of coefficients.

(a)

(b)

Figure 3.5 (a) Original TESTCARD image. (b) Adaptive transform coding of the TESTCARD image at approximately 1 bit element^{-1}. Magnitude classification of coefficients.

R. J. Clarke

(a)

(b)

(c)

Figure 3.6 (a) Original GIRL image. (b) Adaptive transform coding of the GIRL image at approximately 1 bit element^{-1}. Threshold sampling of coefficients. (c) Degradation caused by fixed zonal selection of transform coefficients.

operation on the input data. A 512×512 image is subjected to a 16×16 DCT to generate the coefficient array. With the exception of the D.C. term all coefficients below a predetermined threshold T are set to zero. Those above have the threshold subtracted to give a set $F_T(u,v)$ where

$$F_T(u,v) = F(u,v) - T \qquad \text{if } F(u,v) > T$$
$$= 0 \qquad\qquad\qquad \text{otherwise,} \qquad (3.28)$$

where $F(u,v)$ is the original coefficient magnitude. Since, for the input data used (8 bits element^{-1}), fewer than 10% of coefficients have magnitudes > 3 this results in a relatively small number of coefficients to be processed further. The threshold, if set globally, naturally defines the trade-off between overall bit rate and reconstruction error but it can also be set on a block-by-block basis if desired. This has been investigated for visually "critical" material by Mester and Franke (1987). The set $F_T(u,v)$ is then scaled by a feedback signal D derived from the rate buffer status to give

$$F_{TN}(u,v) = F_T(u,v)/D, \qquad (3.29)$$

where the signal D is obtained via a recursive relation in which, for block m,

$$D(m) = c\, D(m-1) + (1-c)\, D'(m), \qquad (3.30)$$

where $c < 1$. The normalisation factor for the present block is therefore in part an estimate based upon previous measurements $[D'(m)]$ and in part derived from the value from the previous block $[D(m-1)]$. Quantisation now takes place, with the D.C. coefficient $F(0,0)$ being linearly quantised with 9 bits (to minimise interblock luminance discontinuities). The quantisation operation is simply a roundoff process applied to the floating point output of the transform

$$F'_{TN}(u,v) = \text{INT}\,[F_{TN}(u,v) + 0.5]. \qquad (3.31)$$

[It has been shown that using a range of quantisation levels based upon a block activity measure can result in improved performance (Chen and Le Gall, 1988).] The coefficient arrays are now scanned in a zig-zag fashion as shown in Figure 3.7 and the coefficients coded in amplitude and location using Huffman codes derived from histograms of typical transform coefficient distributions. Since low amplitudes and short run lengths predominate, the code tables can in practice have fewer than 30 entries, with fixed length codes being used elsewhere. It has been shown that the efficiency of this simple approach can be improved by the use of transform block segmentation techniques to produce regions with stationary statistical properties (Franceschi *et al.*, 1988), and also by block classification before coding (Lee *et al.*, 1993). To code colour images an RGB/*YIQ* conversion from 8 bit input components compacts most data energy into the Y plane, allowing the I and Q planes to be sub-sampled by factors of 4:1 both horizontally and vertically. The extra data rate required to carry the colour information is thus negligible. Good results

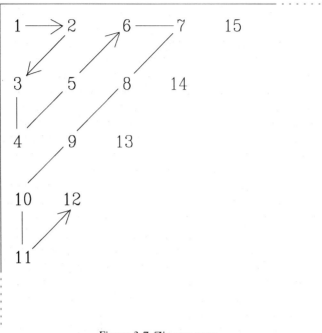

Figure 3.7 Zig-zag scan.

are obtained at an overall rate of about 0.4 bit element^{-1} with a SNR of 33–34 dB.

3.9. PERCEPTUAL CONSIDERATIONS

The vast majority of seemingly new algorithms for adaptive transform coding developed over the past 15 years or so, on close examination, prove to be variations on a relatively few basic approaches, but there is one matter which deserves fuller consideration, and that is the role played by the human observer who, after all, is the "end-user" of almost all image compression schemes. It was seen in the previous chapter that perceptual criteria could usefully be used in the design of quantisation characteristics which took into account the masking of small impairments resulting from the presence nearby of large luminance discontinuities. In a similar way, the spatial characteristics of the HVS have been introduced into transform coding schemes in an effort to minimise visible imperfections caused by inadequate quantisation. In this case, however, the results achieved are much more open to question despite their pronounced advocacy in the published literature. In "perceptual" or "psychovisual" coding the method advocated is to use the measured spatial frequency response of the eye as a simple pre-emphasis filter and thus to

concentrate coding bits (other things being equal) in those spatial frequency regions where the eye is most sensitive (see, for example, the study of Oest *et al.*, 1990). The first difficulty with this approach is that the Fourier transform is the only one which has a true spatial frequency representation, other transforms only corresponding in an approximate way (see earlier in this chapter). Thus some kind of approximation or assumption has to be made in order to give meaning to the spatial *frequencies* of, for example, DCT coefficients. The second problem is that, being a property of the HVS, the actual pre-emphasis curve to be used depends very much upon which particular set of experiments was used to obtain the shape of the curve – peak frequencies between 3 and as high as 6–8 cycles \deg^{-1} having been reported in the literature. The most serious criticism, however, is the fact that the selective emphasis given to certain spatial frequencies is applied to detail at those frequencies in an image observed by the actual eye. Thus no numerical indicators of quality can be determined *unless* an accurate model of the whole perceptual process in the eye is available and, on a subjective level, the image must be observed from a distance which allows the pre-emphasised spatial frequencies to correspond with the actual peak in the eye's response. This latter requirement in turn means that, for the pre-emphasis to work, the image can only be observed from a fixed, predetermined distance (making nonsense, incidentally, of attempts to portray alleged quality improvements obtained in this way via photographs in published journals). As a simple numerical example, consider a 16×16 DCT applied to a 256×256 image. Basis vector eight encompasses approximately four spatial cycles and so, if the peak in the response lies at 6 cycles \deg^{-1}, each block must subtend $2/3°$ and the image as a whole $16 \times 2/3 = 11°$. The appropriate viewing distance is thus about five to six times the picture height. For a 512×512 image (of the same size) half this value will be correct.

A pessimistic view with regard to perceptual transform coding is frequently countered with the response that the viewing distance is not at all critical. The implication of this is, of course, that in that case the advantages to be gained are only slight, in the same way that a low "Q" tuned circuit, on the one hand, does not need critical tuning but, on the other, gives only a small "magnification" of the signal. The application of visual masking to quantiser design for predictive coding does not suffer from this defect, since the dependence upon viewing distance is much less strong. The transform coding implications may be pursued further in, for example Griswold (1980) and Lohscheller (1984), who determined the visibility thresholds of all coefficients in an 8×8 DCT block in terms of their ability to affect the reconstructed picture. These thresholds then determine the order in which coefficients are transmitted to obtain the best reconstructed quality as quickly as possible in a progressive transmission scheme (see also Thomas *et al.*, 1988; Meyer and Gaertner, 1989). Other workers who have contributed to this area are Nill (1985), Seitz and Lang (1990), Chitprasert and Rao (1990) and Ngan *et al.* (1989). The

latter authors obtained good quality visual results for a 512×512 colour image at an overall rate of 0.4 bit element^{-1}, the coding of the chrominance (U,V) components taking advantage of the fact that their spatial bandwidth is significantly reduced compared with that of the Y component. Unfortunately, there is no indication of what measures were taken to ensure that the visual improvement over the result of Chen and Smith, for example, *is* due to perceptual weighting (visual tests at the appropriate viewing distance, for instance), and it is quite likely that it stems from the use of an adaptive Laplacian quantiser and careful attention to the minimisation of block-to-block discontinuities, discussed further below. It is the present author's general opinion that, unless and until viewing and experimental conditions are specified in a much more consistent way than has hitherto been the case, the use of the spatial frequency response of the HVS for transform coding pre-emphasis is open to all kinds of misinterpretations.

It is evident that block coding offers the potential for significantly better performance than element by element coding (simple predictive coding as described in the last chapter) because of the relaxation of the requirement to transmit at least some information directly about every picture element. There is one drawback to the technique, however, which is likely to lead to its being superseded in the not too distant future by other methods, and that stems from the nature of the blocking operation itself, for when attempts to reduce the data rate to an extremely low value are made, the block-to-block transitions in the reconstructed picture become apparent [see Figure 3.6(c)]. Since these have a very regular structure they are easily perceived and very irritating to the observer, and efforts have been made from time to time using various filtering and overlapping operations to minimise or even eliminate their appearance (Pearson and Whybray, 1984; Picard, 1990; Cai and Chen, 1990). Thus Ngan *et al.*, in the paper referred to above, test the block-to-block distortion gradient (difference) against empirically set thresholds and, if such a threshold is exceeded, the block with the greater distortion is requantised more accurately. The process is effective in reducing block boundary visibility, particularly in uniform areas where it would otherwise be particularly noticeable. A more fundamental approach involves modification of the basic transform operation itself. Cassereau *et al.* (1989) have introduced the so-called lapped orthogonal transform (LOT) in which the basis functions overlap in adjacent blocks (see also Malvar and Staelin, 1989; Malvar, 1990a,b, 1992). In comparison with conventional transform coding, which converts (in the one-dimensional case) N data samples into N transform coefficients, the data block in this case is of length L, where $L > N$ (typically $L = 2N$), and adjacent blocks overlap by $L - N$ samples, as would be the case if simple block overlapping were employed to reduce edge effects. This latter would, of course, entail a proportionate increase in data rate; with the LOT, however, L data samples still map into only N coefficients and so there is no increase in rate. Malvar and Staelin show how to generate the transform basis

matrix and compute the transform efficiently and also that a useful reduction in block edge visibility can be achieved in this way. Performance comparisons for several different transforms in their LOT versions have been reported by Akansu and Wadas (1992), and its application to the coding of moving sequences has been considered by Tabatabai (1989). Overlapping is used in a different way by Farrelle and Jain (1986). Here the overlap is one element wide and is used to allow a non-causal decomposition of the original signal into a boundary response (enabling the prediction of internal block values) and a residual (error) process which is transform coded. This seems to have a beneficial effect as far as visibility of block boundaries is concerned. An alternative way forward is suggested by Itoh *et al.* (1992a,b). Here the square block is transformed into an irregular shape which accords with the major image contours. This technique has obvious connections with the work of Gilge *et al.* (1989), which will be referred to subsequently in relation to segmented coding.

An alternative approach to the reduction of the degradation incurred by an image subjected to high levels of data compression and advocated by the present author in the early 1980s is the employment of standard image restoration techniques. Apart from simple low-pass or median filtering (Strobach *et al.*, 1987) to reduce block boundary artefacts, it has only been rarely reported, probably because such algorithms are usually very time consuming. One example is that reported by Baskurt *et al.* (1989), who use constrained deconvolution over blocks of dimension 16×16. Visual quality is enhanced, particularly when the constraint used is on the signs of the DCT coefficients which have been deleted, but the algorithm needs to be run on a dedicated hardware processor if the reported (IBM PC) execution time of 6 h for 15 iterations is to be reduced to manageable proportions.

3.10. THE STILL PICTURE (JPEG) CODING STANDARD

3.10.1. Introduction

Image data compression suffered for many years from being considered something of a "Cinderella" discipline in which, in contrast to, for example, medical or space technology applications of image processing, which rapidly reached public and professional notice, activity was confined largely to the publication of academic papers on the subject and to the exchange of comparative results between small groups of research workers, mainly university-based but also including broadcasting and telecommunications organisations and some of the larger industrial concerns. At the beginning of the 1980s, however, this situation began to change, with the decisions made at the 1982 ISO/TC97/SC2 and 1984 CCITT plenary sessions which resulted in the setting

up, by the first, of WG8 (coded representation of picture and audio information) and by the second, for the 1984–1988 study period, of the New Image Communication (NIC) Group of Study Group VIII. Activities were initially directed towards the definition of common aspects of existing and emerging raster image communication applications and services, to be covered by a network independent "Raster Image Communication Architecture" (RICA) and the standardisation of appropriate coding techniques, with resolutions ranging from bi-level to continuous tone, hard and soft copy output and sequential or progressive picture build-up – a further development of this concept, in ISO, was the "Digital Audio and Picture Architecture" (DAPA), intended as a flexible multimedia standard. More recent work on characterising an Image Communication Open Architecture (ICOA) is reported by Strack et al. (1994).

Further collaboration led to the establishment, at the end of 1986, of the Joint Photographic Experts Group (JPEG), to bring together ISO picture coding and CCITT telecomunications expertise to consider suitable image data compression techniques for such areas as photographic videotex, still picture transmission, black and white and colour facsimile, teleconferencing still picture modes, videophone graphics, etc. The basic grey scale/colour system should have the capability of transmitting good quality CCIR Recommendation 601 image data (720×575 16 bit images) in less than 10 s over a $64 \, kb \, s^{-1}$ ISDN channel and so needed to operate efficiently at around 1 bit element^{-1}.

Initially 12 candidate algorithms were tested, in June 1987, at rates of 4, 1 and 0.25 bits element^{-1}, and these tests resulted in a short list of three selected for further development – the adaptive DCT [ADCT: from the ESPRIT 563 "PICA" (Photovideotex Image Compression Algorithm)], Block Separated Progressive Coding (BSPC: from the Japanese Natural Image Standardisation Group) and Adaptive Binary Arithmetic Coding (ABAC: from IBM). These were tested in January 1988 at rates of 2.25, 0.75, 0.25 and 0.083 bits element^{-1}, with the result that the ADCT produced better quality at all rates (an important requirement), followed by BSPC above 0.25 bit element^{-1} and ABAC below. Technical agreement was reached in October 1989 and a draft specification made available in 1990. Reference material for this standardisation activity is extensive and the following were consulted in preparing this section: PCS (1988, 1990); Wallace (1991); Yasuda (1989); Chen (1993); JPEG (1990).

3.10.2. The Candidate Algorithms

The algorithm finally selected for the draft standard (the adaptive DCT) is subsequently described in more detail. However, it will be of interest first of all to examine briefly the three short-listed candidates.

3.10.2.1. The Adaptive DCT

Here 8 × 8 image data blocks with element values each having had (in the 8 bit "baseline" version) 128 subtracted are two-dimensionally DCT coded to generate one D.C. and 63 A.C coefficients per block. All coefficients are then uniformly quantised with a stepsize defined by a quantisation matrix where entries range from 1 to 255 and are predefined by psychovisual tests. D.C. coefficients are sequentially predicted from their predecessor in the previous block and the difference Huffman coded. The two-dimensional array of A.C. coefficients is reordered into a one-dimensional zig-zag scan and values of run length between finite coefficients and the amplitude values of the coefficients again Huffman coded. This version of the algorithm operates in sequential mode only and has a one-pass capability, in which default or precalculated code tables are used, or a two-pass mode, during the first pass of which the table values are determined. An "extended" algorithm allows increased precision of input data (to 12 bits), and includes an (inherently one-pass) arithmetic coding facility (see Appendix 1), and the capability of progressive picture build-up. There are two ways in which the latter function may be carried out. In the first – successive approximation – the most significant bits of the lower order coefficients are sent first, with more accurate versions following, and this is combined with spectral selection, in which bands of coefficients are sent, lowest first, as separate stages of any particular level of approximation. In the second – hierarchical progression – low-pass filtering and successive 2:1 sub-sampling are used to obtain decimated images which can be transmitted and then approximately reconstructed via upsampling (interpolation). To increase resolution, the difference image at any stage is coded, transmitted and added to the previous approximation. The algorithm also includes a simple DPCM-based lossless compression function using a two-element predictor and either Huffman or arithmetic coding.

3.10.2.2. Block Separated Component Progressive Coding

This technique is based upon generalised block truncation coding (see Chapter 6). Images, low-pass filtered and 2:1 sub-sampled, are divided into blocks which are then classified into three modes according to D, the difference between maximum and minimum luminance values within the block. The modes are:

A: $D <$ threshold T_1, in which case each picture element is allocated the mean level L_a of the block;
B: $T_1 < D < T_2$, when each element is quantised to one of two levels;
C: $D > T_2$, for which each element is quantised to one of four levels.

The signals representing each block are L_a, L_d (related to D), and a 2 bit

signal ϕ_1 ϕ_2 indicating the quantisation level. These are coded by a sub-sampling/prediction/arithmetic scheme. A differential signal D_f, obtained by comparing the original input and a reconstruction based on an expanded image derived from the above parameters, is coded and used in the later stages of image reconstruction.

3.10.2.3. Adaptive Binary Arithmetic Coding

Some features of this algorithm have been retained in the ADCT standard. The basic scheme successively sub-samples an input image by factors of 2:1, 4:1 and 8:1 horizontally and vertically. Coding then starts with the 8:1 sub-sampled image and uses two-dimensional DPCM and adaptive arithmetic coding employing a two-dimensional Markov model. Later stages use a similar technique, with an activity measure based upon the luminance gradient used to classify elements into "smooth" or "active". At an early stage in the coding low frequency spatial textural detail is coded to improve reconstructed picture quality. At a change in resolution predictor values are obtained by interpolation (this is affected by the use of low-pass filtering for which correction must be made). When full resolution is obtained, residual differences are coded until exact reconstruction is achieved. The scheme is basically one-pass since the quantiser characteristic is fixed and the adaptive arithmetic coder does not need the prior collection of statistics – see Appendix 1.

3.10.3. The JPEG Algorithm

There now follows a summary of the main features of the JPEG algorithm. Even a cursory reference to JPEG (1990) will make it abundantly clear that there is a world of difference between developing coding algorithms of sufficient integrity to generate results which may be reported in the professional literature, and the production of a comprehensive specification which will enable a wide choice of image resolutions and formats (spatial and amplitude) to be coded over a significant range of quality levels with successful decoding by a system which may well have been implemented independently of the coder. It is only possible in the space available here to outline the main features of the specification, which is not a set of instructions for building a JPEG system, but rather an indication of what will constitute a valid JPEG bitstream and can be decoded as such. A study of the coding gain aspects of the algorithm has been reported by Chang *et al.* (1992a).

(1) The system should accept grey scale and colour input at between 4 and 16 bits sample^{-1}. It is not intended for bi-level use (for a review of the relevant bi-level standard see JBIG, 1992).

(2) There are two algorithms: (a) the two-dimensional DCT; (b) a predictive coding (DPCM) section intended for lossless coding.
(3) There are two modes of operation – sequential and progressive.
(4) The progressive mode is incremental, i.e. at any stage, only the incremental data between the desired quality level and that representing an initial, lower, level is coded. The only difference is in transmission.
(5) A "baseline" system guarantees a reasonable lower level of performance (for the DCT algorithm only) in sequential mode.
(6) An extended version enhances operation through the use of progressive transmission, higher precision, etc.
(7) General performance criteria for colour images: recognisable at 0.15 bit element^{-1}; useful at 0.25 bit element^{-1}; very good at 0.75 bit element^{-1}; essentially indistinguishable from the original at 1.50 bit element^{-1}. Lossless mode – 2:1 compression.

All are based on CCIR Recommendation 601, Y, C_b, C_r at 16 bits element^{-1}.
(8) The basic system is as shown in Figure 3.8. The entropy coder/decoder

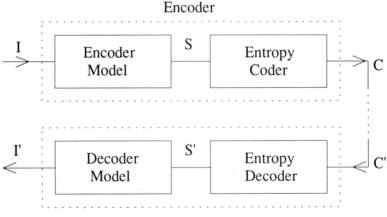

Figure 3.8 JPEG encoder/decoder system. *I*, Input; *I'*, reconstructed output; *C–C'*, channel transmission.

are lossless.

If $C' \neq C$ (the channel output) certain error conditions may be dealt with.
(9) The DCT system is as shown in Figure 3.9. The coefficient to symbol conversion step is lossless.
(10) The predictive coding (DPCM) system is as shown in Figure 3.10. Prediction is from previous values or from the "same" sample in an earlier stage of a hierarchical progression. The difference to symbol conversion and its inverse are lossless.

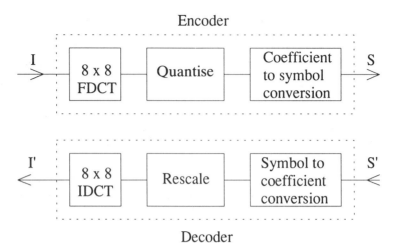

Figure 3.9 JPEG encoder/decoder models for DCT-based systems.

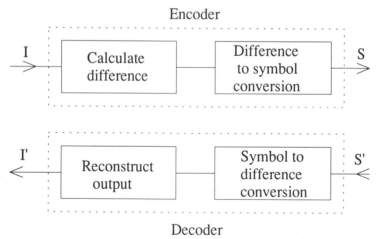

Figure 3.10 JPEG encoder/decoder models for DPCM algorithms.

(11) Two-dimensional transformation: for an input of 720 × 576 samples (*Y*), or 360 × 576 samples (*C*$_b$, *C*$_r$), we have the formats shown in Figures 3.11. *i*,*j* are sample, and *u*,*v* are coefficient indices.
The forward DCT (FDCT) is defined by:

$$F(u,v) = (1/4)\, C(u)\, C(v) \sum_{i=0}^{7} \sum_{j=0}^{7} f(i,j)$$

$$\cos\left[(2i+1)u\cdot\pi/16\right]\cdot\cos\left[(2j+1)v\cdot\pi/16\right]$$

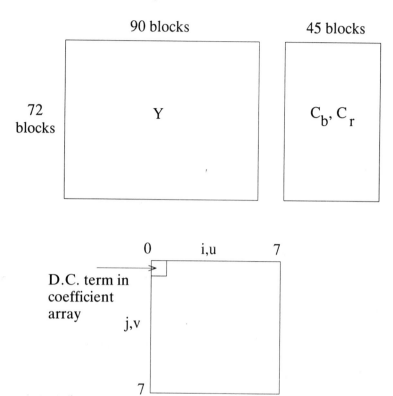

Figure 3.11 Block subdivision and data (i,j) and coefficient (u,v) indexing.

and the inverse transform (IDCT) by:

$$f(i,j) = (1/4) \sum_{u=0}^{7} \sum_{v=0}^{7} C(u)\,C(v)\,F(u,v)$$

$$\cos\left[(2i+1)u\cdot\pi/16\right]\cdot\cos\left[(2j+1)v\cdot\pi/16\right],$$

where

$$C(u) = 1/\sqrt{2} \quad \text{for } u = 0 \text{ else } C(u) = 1$$
$$C(v) = 1/\sqrt{2} \quad \text{for } v = 0 \text{ else } C(v) = 1.$$

The range of the input values $f(i,j)$ in the 8 bit "baseline" system is -128 to 127 (i.e. the data less 128, which value is added back after reconstruction). That of the output values $F(u,v)$ is -1023 to 1023.

(12) Quantisation: the quantiser has a linear characteristic, converting coefficients $F(u,v)$ to their quantised counterparts $C(u,v)$. The decision levels are halfway between integral multiples of the quantisation value $Q(u,v)$.

For $F(u,v)$ zero or positive

$$C(u,v) = (F(u,v) + (Q(u,v)/2)) / Q(u,v).$$

For $F(u,v)$ negative

$$C(u,v) = (F(u,v) - (Q(u,v)/2)) / Q(u,v).$$

The inverse relationship is given by

$$F'(u,v) = C(u,v) \times Q(u,v).$$

[Note that $C(u,v)$ here has nothing to do with $C(u)$ or $C(v)$ in the transform definition above.]

Coarse quantisers are used for the higher order A.C. terms. Example 8×8 quantisation tables are given in the draft standard, of which those in Table 3.2 are typical.

Table 3.2 Typical quantisation scale factors for luminance and chrominance signals.

Luminance								Chrominance					
16	11	10	16	24	40	51	61	17	18	24	47	99
12	12	14	19	26	58	60	55	18	21	26	66	99
14								24	26	56	99	
14							.	47	66	99		
18					etc.			99	99			
24								All other terms = 99					
49	.	.	.	103	121	120	101						
72	92	95	98	112	100	103	99						

(13) Coding of the D.C. coefficient: DPCM, using lossless coding and prediction from the previous D.C. value. Precision can be reduced in the early stages of progressive transmission. First prediction = 0 (note data level shift).

(14) A.C. coefficient coding uses a zig-zag scanning pattern, as in Figure 3.7.

(15) Progressive coding techniques: (a) spectral selection – coefficient vectors are segmented into bands and sent in separate stages; (b) successive approximation – coefficient approximations are sent first; then low order bits plane by plane.

(16) Entropy coding: (a) Huffman coding (baseline coder); (b) one-pass arithmetic coding (Appendix 1).

The baseline system can have up to two tables for both D.C. and A.C. coefficients. In the extended system there is provision for up to four of each. The tables can be predefined or signalled to the receiver.

(17) Lossless DPCM coder: the model is derived from (13) above, using one of seven linear predictors.

(18) The hierarchical mode: the difference between the previous hierarchi-

cal stage and the current source image is coded. This allows resolution increase as part of progressive transmission.

(19) A minimum data unit (MDU) is defined (for non-interleaved data) as one 8 × 8 DCT block in the transform scheme, or one sample in the spatial scheme. Interleaving typically applies to separate colour planes. Here the MDU is a block interleave, i.e. a sequence of 8 × 8 blocks containing one or more block from each component.

(20) Huffman codes for the D.C. coefficients: maximum length is 16 bits (with additional ones if needed). Ability to code any possible difference between the current D.C. coefficient and the prediction. There are 16 categories:

```
0   1   2   4    8   16   32   ......   16 384
        |   |    |    |    |              |
    3   7   15   31   63   ......   32 767,
```

and similarly for negative values.

(21) Huffman codes for the A.C. coefficients: these have the same lengths as indicated above and are described by

$$I = \text{BINARY “NNNNSSSS”},$$

where SSSS is the amplitude category for the next non-zero coefficient in the zig-zag scan, NNNN is the run length from the previous non-zero coefficient, and all "0" is the end of the block (no more finite coefficients).

 End values of ranges as in (20) (for "SSSS"). The composite "NNNNSSSS" is Huffman coded followed by additional bits specifying coefficient sign and exact magnitude.

(22) Arithmetic coding can be used instead of Huffman coding. Both are lossless. Coding is as before, of run length and sign/magnitude.

(23) Statistical model for arithmetic coding: the D.C. coefficient: depends on previous coding decisions for the D.C. coefficients and also the difference value for the previous block. Categories – zero; small positive; small negative; large positive; large negative.

 The A.C. coefficients: the sign probability is taken as 0.5. The other parameter is the run length category in the zig-zag scan.

 There will be one set of estimates for the low order coefficients and one for those of higher order.

(24) Progressive coding: successive approximation – coefficients are divided by 2^{INT}; spectral selection – separate "bands" of coefficients (the D.C. coefficient is kept separate).

 INT is decreased by one at each stage.

(25) Independent lossless coding uses DPCM with selectable one- and two-dimensional predictors. Can be Huffman or (two-dimensional) arith-

metic coded, the latter based on a two-dimensional model, i.e. by using differences from the line above.

Samples	Predictors for "Y"
C B	$A, B, A + (B - C)/2$, etc.
A "Y"	

Note that this is essentially of the form of Figure 2.6; the different notation is irrelevant.

(26) Hierarchical coding: downsampling (2:1) produces reduced resolution images. The preceding (upsampled) lower resolution image is the prediction for the present level. DCT or spatial coding modes can be used for the differential stages.

Upsampling is 1:2 horizontally and vertically.

(27) Adaptive binary arithmetic coding can be used for entropy coding with any algorithm.

3.11. GENERAL REMARKS

In this chapter a brief review of intraframe transform coding has been given. It is a field in which an enormous amount of work has been done since the first experiments on images by Andrews and Pratt (1968) and literally thousands of papers have been produced on the topic, of which naturally only a fraction have been referenced here. Now embodied in both still picture (JPEG) and moving image sequence (MPEG) coding standards (and those for TV also; ETSI, 1991), transform coding has become a standard digital signal processing operation and dedicated integrated circuits are available to carry out the process. It does, nevertheless, have drawbacks, the main one being that, when compression factors are pushed to the limit, the basic 8×8 or 16×16 block structure becomes visible. With a regular structure it is very easily noticed and relatively difficult to remove. A subsidiary problem is that, when too many high frequency coefficients are dropped in order to increase the degree of compression, blurring of object edge detail becomes noticeable.

Murakami and Yamamoto (1984) have investigated the comparative influence of picture statistics on the performance of two-dimensional intraframe predictive and Hadamard transform coding. The causes of reduction in coding performance in the two cases are identified as, respectively, predictor–quantiser mismatch and bit assignment and quantiser mismatch, with quantiser mismatch being the main contributor. Analysis shows that, compared with the variation in prediction error variance (around 10 dB) as the one step autocorrelation coefficient of the input data alters from 0.95 to 0.85, the change in the low order transform coefficients (which predominantly influences coding performance) is about 3 dB as a maximum. In both cases the

result is a mismatch between the quantiser input signal variance and that value for which the quantiser was designed. Since, however, the majority of significant transform coefficients are quantised with a reasonable number of levels (at least 32), the relative degradation is smaller than in the case of predictive coding. This feature of transform coding is underpinned by the fact that, in any well-designed transform coding system, many of the higher order coefficients will have no bits allocated to them in any case. As far as the stability of either system with respect to change in data rate is concerned, it turns out that the effect of varying input statistics decreases with bit allocation, and the results serve to confirm the well-known result that transform coding is more robust to changes in input statistics than predictive coding and that the latter degrades rapidly with decreasing data autocorrelation (Clarke, 1984a), although very good performance is obtainable with a predictive scheme when this parameter is near one, provided that the system is carefully "tuned". In practice, of course, modern designs will have a high degree of adaptivity which will greatly minimise degradation caused by variation in input statistics.

In at least two respects the author feels that more advanced algorithms have the potential to displace the DCT from its present "high-profile" position; first, multiresolution techniques (see later) have the advantages that they do not have a DCT-like block structure whilst being ideally suited to progressive transmission (where a low resolution approximation is initially sent quickly and detailed information can follow if required), second, the use of segmentation techniques to delineate interesting or significant portions of a scene so that they can be coded more accurately is in keeping with more up-to-date ideas of "intelligent" or knowledge-based signal processing, rather than employing arbitrarily placed (with respect to image detail) square blocks for coding.

In the previous chapter we saw that, in 1987, Vivian asked whether predictive coding could keep up with the "youngsters". It is now appropriate to ask the same question of transform coding.

4

Intraframe Vector Quantisation

4.1. INTRODUCTION

The two previous chapters have examined a pair of quite different intraframe compression techniques – predictive and transform coding. The most immediately obvious difference between the two is that the former is a spatial and the latter, loosely speaking at any rate, a frequency domain, technique. We shall encounter this difference again when studying the coding method which is the subject of this chapter; for the present, it is worthwhile dwelling for a moment on another significant difference between the two. The first, at least in its simplest form, is a point technique – picture elements are coded one by one as they appear along the raster scan, and in this form the minimum data rate is 1 bit element^{-1} (ignoring any inclusion of run length or entropy coding) – something must be transmitted to the receiver for every picture element. In contrast, transform coding is a block technique. 8×8 or 16×16 blocks of elements are first transformed and then the coefficients suitably coded, and this allows a much greater latitude in the choice of average bit rate over the block (given an acceptable distortion level). To do this with predictive coding requires some kind of block-based approach, and so increases the complexity

of the method. In this chapter a block spatial domain technique is presented
which has become very popular since the early 1980s and which has a per-
formance which rivals that of transform coding. The approach is of sufficient
generality to be combined with transform or other coding techniques, as has
been frequently reported in the literature (and will be enlarged upon sub-
sequently), in order to increase their efficiency. In this method – vector
quantisation – two-dimensional $N \times N$ blocks of space domain elements are
considered to be reordered into N^2 long vectors and are processed as such.
The name invites comparison with scalar quantisation, and this allows an
appreciation of what is, basically, a technique as simple in concept as predic-
tive coding. The theoretical basis of this move to more than one dimension is
described well by Gersho (1979); see also Gersho and Gray (1992). In image
scalar quantisation we take the input data element by element and compare
its instantaneous value with the decision levels of a one-dimensional uniform
quantiser. An index is then transmitted to the receiver indicating which quan-
tisation interval is appropriate and the receiver then reconstructs an approxi-
mation to the corresponding level. Thus if there are 64 possible quantisation
levels a 6 bit index will allow unambiguous access to one of 64 entries in the
receiver reconstruction level quantisation table (or codebook). In this case
there is no data compression and the process is just a variety of pulse code
modulation. Consider now a 256×256 6 bit image divided into 4×4 blocks
(a typical block size). We could apply a similar approach as follows (a one-
dimensional example is also possible): the total number of allowable combi-
nations of levels making up a block is 64^{16}, and each could unambiguously be
represented by an index $\log_2 64^{16} = 96$ bits long, which could access a 64^{16}
entry codebook (an enormous codebook storage requirement). Since there
are 4096 blocks in the image the total number of bits transmitted $96 \times 4096 =$
393 216. To transmit the image by 6 bit PCM would require the same number
of bits and result in no data compression. The trick is now to make use of the
statistical nature of the image – many of the blocks will encompass uniform
areas or maybe detail having the same general shape or luminance profile.
Conversely, many of the possible reproduction vectors (codebook entries)
will be chaotic in nature and never be called upon to represent naturally
occurring image structure. We can therefore greatly reduce the number of
reproduction possibilities; for example, if we retain only 1024 entries an index
only 10 bits long needs to be transmitted per block, and the overall average
data rate will now be $10/(4 \times 4) = 0.63$ bit element^{-1}. At this level distortion
will be visible in the image reconstructed after being coded with such a simple
scheme, and much research has been carried out over the past few years to
minimise this problem. The other major difficulty is the selection of the
relatively minute number of possible reproduction codebook entries in order
to ensure acceptable picture quality, i.e. the efficient design of the codebook.
Allied to this problem is that of codebook search – fast comparison of each
input block with the codebook entries stored at the transmitter to ascertain

which best represents the data (i.e. minimises in some sense the difference between the two). Following determination of the index corresponding to this selection, however, reconstruction is trivial – the decoder is simply a look-up code table activated by the transmitted index. The computational load is thus strongly biased towards the side of the coder, and this makes the vector quantisation approach very suitable for applications which can have a central powerful computing facility (and large database) whilst requiring the (many) receiving terminals to be as simple and cheap as possible. It is worth noting, in passing, that vector quantisation is theoretically more efficient than its scalar counterpart even for uncorrelated or memoryless data (Berger, 1971; Lookabaugh and Gray, 1989). Basic block transform schemes, for example, are still inherently sub-optimal since they process coefficients with a *scalar* quantiser.

With simple vector quantisation systems of the kind described above the constraints on data block and codebook size are easily comprehended. An extremely large number of codewords cannot be usefully retained, not so much because of storage capacity limitations but because the codebook must be searched as quickly as possible, in on-line applications, for the closest match to every incoming data block. Thus in practice it is necessary to hold down both codebook size and block size since the following relationships obtain (codebook size is usefully retained as an integral power of 2, allowing access via an index word having a whole number of bits).

Let C = number of codebook entries; I = word length of transmitted index; k = block size (number of picture elements per block); R = transmission rate (bits per picture element).

Then

$$C = 2^I \quad or \quad I = \log_2 C \text{ bits} \tag{4.1}$$

and

$$R = I/k \text{ bits element}^{-1}. \tag{4.2}$$

The range of useable values of I is probably 6–12 [note that C is exponentially dependent on the kR (= I) product], giving codebooks of 64 – 4096 entries. For transmission rates in the usual range 1/2–2 bits element^{-1} the range of block sizes is thus 3–24 elements, although not every combination is equally suitable. Typical values are given in Table 4.1, with a very commonly used block size being 4 × 4 which, with a codebook of 256 or 512 entries, gives a rate of around 1/2 bit element^{-1}.

4.2. BASIC CONSIDERATIONS

The theoretical background of vector (or block) quantisation has been covered exhaustively by authors such as Gray (1984), Gersho (1982),

Table 4.1 Relationships between basic parameters in vector quantisation.

Block size k	Rate (bit element^{-1}) R	Index length I	Codebook size C
$2 \times 3 = 6$	1.0	6	64
	1.5	9	512
	2.0	12	4096
$3 \times 4 = 12$	1/2	6	64
	3/4	9	512
	1.0	12	4096
$4 \times 4 = 16$	3/8	6	64
	9/16	9	512
	3/4	12	4096
$4 \times 6 = 24$	1/4	6	64
	3/8	9	512
	1/2	12	4096

Makhoul *et al.* (1985) etc. (the reader interested purely in the image coding aspects of the technique should not be put off by the title of the last reference – the major part of the paper is a clear exposition of the basis of vector quantisation in its general aspects), and a good review of the practical coding aspects of vector quantisation has been given by Nasrabadi and King (1988). It is worth noting that much of the extensive pattern matching and cluster analysis literature is also relevant here, for example Sethi (1981), Yunck (1976), Friedman *et al.* (1975), Fukunaga and Hostetler (1973) and Selim and Ismail (1984). It suffices here to concentrate on those aspects directly relevant to the implementation of vector quantisation schemes and this is best done by extension of the well-known principles of scalar (one-dimensional or element by element) quantisation. Thus we may represent this operation in the way shown in Figure 2.12, in which the input value x_{in} is tested against a set of decision levels x_i such that, as long as it lies anywhere between a given pair x_i, x_{i+1}, it is represented by a fixed output (reconstruction) level y_i. Thus:

$$\text{If } x_i < x_{in} < x_{i+1}$$

$$\text{Then } y_{out} = y_i. \tag{4.3}$$

The determination of what values the x_i and y_i should take on depends upon the total number of levels available, an error criterion and some constraint such as minimum output bit rate or entropy and is well documented (Max, 1960); further references can be found in Clarke (1985a).

Historically, scalar quantiser designs have, almost without exception, been based upon analytic properties of commonly occurring "well-behaved" statistical signal distributions (Uniform, Gaussian, Laplacian, Gamma), and it is a curious fact that an alternative approach (Lloyd, 1957) had to wait until it

became the basis of a generalisation intended for vector quantiser design (the "LBG" algorithm – see below) before receiving widespread recognition.

Vector quantisation is an extension of the above approach to more than one dimension. Since it is difficult to represent in diagrammatic form dimensions greater than two we are restricted to that value in Figure 4.1. However,

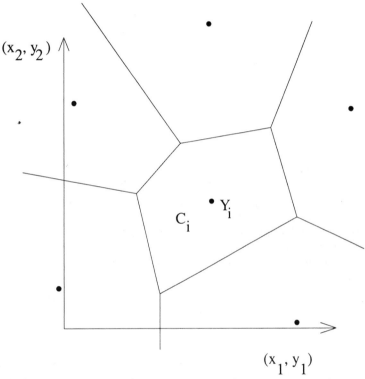

Figure 4.1 Two-dimensional quantisation. Y_i, ith reconstruction value (centroid).

the principle is clear; the input signal is no longer a single data element but a block of elements, or vector, here of length two, but in practice taking the value k as in the previous section. Both elements of the vector $\mathbf{X} = \{x_1, x_2\}$ are jointly quantised, no longer along a line as in Figure 2.12, but into a region in the x_1, x_2 plane (generally in a space of dimension k). The decision levels of Figure 2.12 are replaced by the boundaries of any particular region C_i and the reconstruction level is replaced by a specific point in the region $\mathbf{Y} = \{y_1, y_2\}$, as in Figure 4.1. Thus:

$$\mathbf{X} \to \mathbf{Y}_i$$

$$\text{If } \mathbf{X} = \{x_1, x_2\} \in C_i \tag{4.4}$$

represents the rule for quantisation of the input data vectors. Determination of the decision regions and reconstruction vectors is considered below. Although impossible to visualise in the way portrayed in Figure 4.1 when, as is in practice the case, the dimension of X is much greater than two, the principle is exactly the same, and all vectors lying within a k-dimensional volume C_i are again represented by a single (also k-dimensional) output vector Y_i.

Just as in the case of the scalar quantiser, distortion is incurred in this operation in two ways, and this needs to be kept as small as practicable. First, the reproduction vector Y_i must be chosen to minimise the average distortion for all input vectors which lie in C_i. Second, the coder must choose, for any input vector, the output vector giving the minimum coding distortion, i.e. the "nearest" vector in some sense. The selection of an appropriate distortion measure is thus of some importance. It would be tedious here to relate at length the arguments concerning the (vague) relationship between m.s.e and the perceived distortion in reconstructed image data. The fact remains that m.s.e. is still widely used as a distortion measure (maybe on occasion weighted in some way) for at least three reasons:

(a) it is a measure of error *energy*, rather than of amplitude, and this is a more fundamental quantity;
(b) it can thus readily be related to SNR;
(c) unlike some other measures, it can be straightforwardly differentiated when searching for the condition defining a minimum.

Thus the m.s.e. between input vector X and output vector Y is

$$d_2(X,Y) = 1/k \sum_{n=1}^{k} (x_n - y_n)^2, \tag{4.5}$$

where k is the vector dimension. Summing over all partitions C_i and relating the value so obtained to the total input data (image) energy ($\sum_{\text{picture}} x^2$) will allow the SNR to be determined. Also, minimising this measure corresponds to making Y_i the conventional centre of gravity (centroid) of the input vectors contained within C_i. In passing, it is worth mentioning a decomposition which can be made of the m.s.e. calculation when it is used as a sequential test for a large number of comparisons, as in vector quantisation. Huguet and Torres (1990a) suggest writing the expression as:

$$(x_n - y_n)^2 = x_n^2 + y_n^2 - 2 x_n y_n. \tag{4.6}$$

x_n^2 *and* y_n^2 can be precomputed and stored for use in the comparison and a simple test is proposed for the remaining term $- 2 x_n y_n$.

In general:

$$d_r\left(\mathbf{X},\mathbf{Y}\right) = 1/k \sum_{n=1}^{k} |x_n - y_n|^r, \qquad (4.7)$$

where $r = 1$ implies calculating the mean absolute error (MAE). This widely used measure obviates the need for the squaring operation in Equation (4.5). Mathews and Korchidian (1989) and Mathews (1992), for example, use this L_1 measure to avoid the need for multiplications in the distance calculation and extend it in a piecewise linear sense to approximate other distance measures. $r = 2$ corresponds to m.s.e., and making $r > 2$ gives progressively more weight to the larger errors. In the limit

$$\lim_{r \to \infty} \left(d_r(\mathbf{X},\mathbf{Y})\right)^{1/r} = \max |x_n - y_n| \qquad (4.8)$$

and the distortion measure is now sensitive only to the *maximum* error in any vector (note that, unlike the situation in speech processing, here all such *difference* distortion measures depend only upon the vector differences and not on the vectors themselves). Minimising this error criterion places a bound on the maximum reconstruction error and, as such, has advantages in image coding (Panchanathan and Goldberg, 1991). It is also possible to use weighted measures in a visual domain (Stockham and Xie, 1989) and in more general coding implementations (Lavagetto and Zappatore, 1990b) also.

4.3. CODEBOOK DESIGN

The next step is to design the codebook, and here the approach tends to differ from that adopted for one-dimensional quantisation. Although multi-dimensional analytic distributions have been used in the design of codebooks for vector quantisation, since the statistical distribution of luminance levels in the average picture is extremely ill-defined (Clarke, 1985a), it is more usual to use an extension of Lloyd's so-called Method I (Lloyd, 1957; Linde *et al.*, 1980; Gray and Linde, 1982b) mentioned above as applied to a (multi-dimensional) training sequence of data. Since the value of any useful distortion measure increases with "distance" between input and reproduced vectors, as Gray points out, the optimum output mapping will be given by the "nearest neighbour" rule

$$\mathbf{X} \to \mathbf{Y}_i$$

$$\text{IFF } d(\mathbf{X},\mathbf{Y}_i) < d(\mathbf{X},\mathbf{Y}_p) \qquad \text{for all } p \neq i \qquad (4.9)$$

and this will then define the regions C_i in Figure 4.1. The classical approach in this case is reported by Linde *et al.* (1980) and is known as the LBG algorithm. In its basic form it uses a long (and hopefully representative) training

sequence of vectors whose members are first somehow partitioned into a number of categories equal to the required number of reproduction codewords N. The second part of the operation determines optimum (minimum distortion) codewords for each category, and the algorithm can then be iterated to minimise the overall distortion for a given training sequence and value of N. The criteria for the two parts of this operation are as follows.

(a) Suppose we have the reproduction alphabet $A = \{Y_i; i = 1 \rightarrow N\}$ but not the partition. Then application of Equation (4.9), i.e. the selection of the nearest (in the sense of minimum distortion) member of A to any given training sequence vector X will result in a partition $P(A)$ which is the best possible.

(b) If, on the other hand, we have the partition S [not necessarily $P(A)$ above], we know all the training set vectors which lie in any one region S_i and so can, on the basis of the assumed distortion measure, allow Y_i to be their generalised centroid or "centre of gravity". This then forms the optimum reproduction codeword for S_i, since it is then the case that, within S_i,

$$E(d(X,Y_i)) = \min E(d(X,u)), \qquad (4.10)$$

where u is an arbitrary reproduction vector in S_i.

Iteration between the above two steps now provides an algorithm for the design of the codebook, which proceeds as follows.

(i) We start with iteration index $m = 0$, with an initial N level reproduction alphabet/codebook $A_m = A_0$ (bypassing for the moment the problem of how this might be obtained), a distortion reduction threshold ε and an initial distortion $D_{-1} = \infty$.

(ii) All training vectors $\{X_j; j = 0 \rightarrow n - 1\}$ are now allocated to their nearest member of A_m to give a minimum distortion partition $P(A_m)$ $= \{S_i: i = 1 \rightarrow N\}$.

(iii) The average distortion over all training vectors and partitions

$$D_m = 1/n \sum_0^{n-1} \min_{Y \in A_m} d(X_j,Y) \qquad (4.11)$$

is calculated, and:

(iv) If

$$(D_{m-1} - D_m)/D_m < \varepsilon, \qquad (4.12)$$

i.e. the fractional decrease in distortion between successive iterations, $m - 1$ and m, as D converges to its asymptotic value, is acceptably low, then A_m is the desired codebook. If not:

(v) Determine the centroids of all S_i in A_m to give the optimum set of Y_i

for the partition as it stands. These now form A_{m+1} and, with m replaced by $m + 1$, we can return to (i) and repeat the process. Note that since the \mathbf{Y}_i are now different, training vectors may move between the various S_i as the iterations proceed.

With the codebook generated, new input vectors (outside the training sequence) are now coded by invoking the nearest neighbour rule with respect to the various final \mathbf{Y}_i obtained. One problem remains, however, and that is the selection of the members of the initial trial codebook A_0. There are various possibilities; picking the first N training vectors is unsatisfactory, particularly with image data, since they are not likely to form a representative selection from the actual training set. We might pick N vectors at random, or use some criterion to ensure a well spread out collection. Alternatively a uniform quantiser in k dimensions can be initially applied, or the "splitting" technique of Linde *et al.* (1980) can be used, in which a succession of codebooks is designed, where the level (number of codebook entries) $M = 2^R$, $R = 0, 1, 2$, etc. In this case the algorithm starts by determining the centroid of the whole of the training sequence to give the optimum one level codebook. This single representative output vector is then perturbed by small amounts $\pm \delta$ to give initial guesses for a two level codebook. Partition and centroid determination then follows as described previously to optimise the codebook at this level. The two output codewords are then likewise split into four, and so on. There are other ways of initialising the process. For example, successive starting vectors (codebook entries) can be selected on the basis of maximisation of the estimated quantisation error reduction to be achieved by the inclusion of the next vector, as has been done in the case of scalar quantisation (see transform coding section), but the computational load is likely to be excessive unless some form of fast search/testing algorithm is employed. Again, initial vectors can be chosen such that the cluster sizes are approximately equal to maximise the entropy (Nyeck and Tosser-Roussey, 1992).

Since the usual method of implementing a vector quantisation scheme is via codebook design based upon a training sequence, it is very difficult to establish reliable criteria for performance comparison between various approaches. This problem can be circumvented by applying the design technique to a standard source, i.e. one having a pre-specified probability distribution and correlation. Examples of such are given by Gray and Linde (1982) for the Gauss–Markov source with correlation coefficient 0.8–0.9, and by Fischer and Dicharry (1984) for the memoryless case with Gaussian, Laplacian and Gamma distributed sources. In the latter case best (lowest distortion) performance is found to occur with the (highly peaked) Gamma source, as might have been expected. The authors also consider the matter of source mismatch, where the source probability distribution function (p.d.f.) is different from that for which the quantiser was designed, extending the one-dimensional results of Mauersberger (1979). Here the Laplacian design turns

out to be most robust in terms of changes in source distribution. Yamada *et al.* (1984), again using a Laplacian source, show that vector quantisers are more tolerant to source variance mismatch i.e. when the source variance is different from that for which the quantiser was designed, than are scalar quantisers.

Undoubtedly the LBG algorithm has provided the basis for the majority of vector quantiser design algorithms over the past 10 years or so. Although the processing load is significant codebook generation does not form part of the real-time coding operation as such, in contrast to the search operation (at least in non-adaptive schemes) and, of course, needs only to be done once for any given class of images. Nevertheless, interest has been shown in more efficient codebook generation, and one or two approaches to the problem are described here. The method of Oliveri *et al.* (1986) employs a mapping from the k-dimensional space of the vector quantiser onto the one-dimensional line, generation of the one-dimensional histogram and calculation of the one-dimensional quantiser for the p.d.f. so obtained. The mapping operation uses space-filling (Peano) curves described, for example, by Bially (1969) and Butz (1971). Although promising, this approach to codebook design does not seem to have been developed further. A more widely followed approach is based upon the successive splitting technique of the LBG algorithm described previously. Instead of retaining only the final, full size codebook, vectors, those at intermediate levels are also saved, so that the encoding search process is simplified in a way to be described in the next section, and a so-called "tree structure" results (Gray and Linde, 1982; Buzo *et al.*, 1980). In its simplest form each lower "branch" divides into two higher ones, requiring a simple binary decision at each node on every level, as in Figure 4.2. A variant of this approach is described by Murakami *et al.* (1986) which generates a tree-structured codebook for vectors which have each had their mean values subtracted and individual element values normalised by the vector standard deviation. In this case a symmetric codebook structure can be employed and is generated by successively "folding-back" one training vector subset with respect to output vectors of the previous level. In this particular instance the number of training vectors does not decrease as the various levels of the codebook are generated.

Although a design algorithm giving a binary split at every node has a uniform structure, the equivalent constraint thereby imposed upon the codebook results in poorer performance than could otherwise be obtained by relaxing this requirement. Thus nodes are split whatever the actual value of distortion and independently of the number of training vectors in any particular cluster. If either of these quantities turns out to be small it is inefficient to continue the split at that particular node. Thus Makhoul *et al.* (1985) suggested generating a non-uniform tree where, successively, the node with the largest distortion value is split, and so on. This gives a performance somewhat closer to that of full (or exhaustive) search for a given number of codevectors than does uniform binary splitting. In addition, the number of codevectors

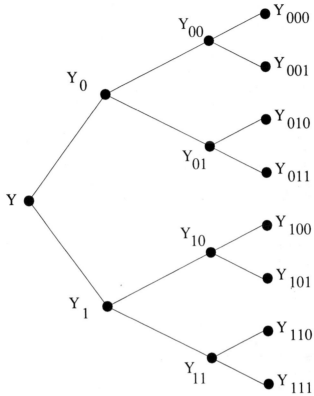

Figure 4.2 Tree structure.

has only to be an integer and is no longer constrained to be a power of two (see Figure 4.3).

A further modification of the design technique is the application of (to develop the botanical metaphor!) "pruning". Here we examine λ_p, say, which is equal to the ratio of distortion increase to transmission rate decrease which results from pruning back a branch of the tree. In the "growing" direction λ_g, say, is, conversely, the ratio of distortion decrease to rate increase, and the tree is produced by successively splitting nodes with the largest values of λ_g and pruning those with the smallest values of λ_p. Significant improvements are shown to be obtained when the technique is applied to a non-uniform tree [compared with processing a uniform tree for rates of 6 bits vector^{-1} and above (Riskin and Gray, 1990)]. A further modification of the tree growing process is to allow any node to be split into maybe three or four branches instead of only two, although the slight increase in performance normally obtained can well be outweighed by the increase in complexity.

The splitting algorithm begins by determining the centroid of the whole of the training sequence, perturbing this single level zero codeword by some

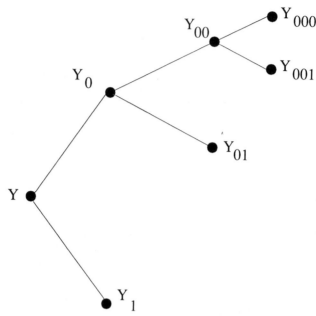

Figure 4.3 Non-uniform tree structure.

suitable small value and using the original and perturbed vectors as starting points for iterative optimisation of the two entry level one codebook, and so on. An alternative approach, the pairwise nearest neighbour (PNN) algorithm (Equitz, 1989), operates in the other direction by clustering nearest neighbour training set entries until the required size of codebook is achieved. For the first merging operation, the new centroid is the centroid of the two nearest neighbours in the training sequence. From this point on, the choice of which clusters to merge next is a trade-off between merging close clusters (which nevertheless may contain many vectors and thus produce a significant net contribution to overall error) and those further apart (which may contain fewer and whose merging thus contributes less overall to the error value). It is shown that the error (m.s.e. is employed here) introduced by merging clusters C_i and C_j is

$$e_{ij} = n_i \, n_j / (n_i + n_j) \cdot |\bar{x}_i - \bar{x}_j|^2, \tag{4.13}$$

where cluster C_i has centroid \bar{x}_i and contains n_i vectors, likewise for cluster C_j, and C_i and C_j are chosen so as to minimise e_{ij}. Merging stops when either the desired number of codevectors is achieved or the distortion rises to a given threshold. This "full search" PNN algorithm is still computationally expensive to implement and a fast algorithm is described which restricts nearest neighbour search to a small region and is reported to reduce computation time to about 5% of that of the LBG algorithm, with little increase in total

distortion. It is also suggested that the algorithm can be used as an initiating step for subsequent application of the LBG algorithm itself. A development of the PNN algorithm by Finamore and de Garrido (1990) optimises the merging step of the algorithm in both a distortion/entropy (or transmission rate) sense such that the best path is represented by a line of maximum slope on a plot of rate–distortion. That the PNN algorithm and other codebook design algorithms are closely related to cluster analysis in statistics is demonstrated in an interesting article by Bottemiller (1992).

One approach to the solution of complex optimisation problems which has been the subject of much research over the past 10 years is stochastic relaxation (Zeger and Gersho, 1989; Zeger *et al.*, 1992). One form of this is "simulated annealing" (Kirkpatrick *et al.*, 1983; Gamal *et al.*, 1987; Cetin and Weerackody, 1988). In the present context, for a given codebook a "temperature" is selected as a control parameter of the algorithm, and the quantity $\exp(-\Delta E/T)$ is determined when some perturbation is made to the codebook, perhaps moving a training vector randomly from one partition to another, or adding some random disturbance (noise) to a selected codevector. The change in energy (distortion) is calculated and if it is negative the new assignment is accepted. If not, the new assignment is accepted with probability $\exp(-\Delta E/T)$. At high temperatures this implies that the new assignment will probably be accepted, even though it results in increased distortion. When the process is considered to be complete at any given temperature either because of a limit on the number of iterations or because the distortion has decreased by an acceptable margin, the temperature is lowered and the process repeated. As temperature decreases the probability of accepting a transition which results in an increase in distortion is reduced [$\exp(-\Delta E/T) \to 0$ as $T \to 0$], and the algorithm can be terminated when a stable codebook results for several successive temperature reductions.

Although the technique has the advantage that it can assist the algorithm to converge to a global rather than a local minimum of distortion, the computational resources needed are very extensive. Thus Flanagan *et al.* (1989) devised a fast distortion calculation to allow codebook generation in a reasonable time and use, as a criterion of acceptance of codebook perturbation, the test $\exp(-\Delta E/T) > r$, where r is uniformly distributed on $[0, 1]$. Zeger and Gersho (1989) add uniformly distributed random noise to each codevector computed via the LBG algorithm, the noise variance being progressively reduced as the calculation proceeds. In this case the new codewords are always accepted and so the the distortion does not need to be calculated at every iteration. Overall, the computational load is much reduced.

At the time of writing (late 1993), neural networks have gained a foothold in many areas of signal processing and, not unnaturally, have been applied to the problem of codebook generation. A typical procedure, using a self-organising feature map, is given by Truong and Mersereau (1990). Here each vector in the codebook W is initialised to be the mean of the training set X

plus some small random perturbation. One member of the set, $x(n)$ (n is the update index, initially $=1$) is then selected and the distance between $x(n)$ and all members of W determined:

$$e_i^2(n) = \sum_{k=1}^{M} (x_k(n) - w_{ki}(n-1))^2 \qquad (4.14)$$

$$0 < i < N - 1.$$

Here N denotes the neighbourhood over which the computation is carried out and M is the vector dimension. The best codeword $w_{j\,\text{min}}$ is defined by the relation

$$e_{j\,\text{min}}^2(n) = \min\{e_i^2(n)\} \qquad 0 \le i \le N - 1 \qquad (4.15)$$

and this codeword and its neighbours are updated. These neighbours lie in a region defined by the L_∞ norm on vectors U such that

$$\|u_j - u_i\|_\infty = \max_k \{|u_{k,j} - u_{k,i}|\} \le r, \qquad (4.16)$$

where r is a predefined real number. The update operation is

$$w_i(n) = w_i(n-1) + g(n)(x(n) - w_i(n-1)). \qquad (4.17)$$

Here $g(n)$ specifies the rate of adaptation and the value of $r(n)$ [$r(n)$ decreasing with n] defines the number of adjusted codewords for any value of n. Results given show that performance is within 1/2 dB of that of the full search LBG algorithm at rates around 2/3 bit element^{-1}.

Another comparison of the LBG and Kohonen neural network (KNN) algorithms has been made by McAuliffe et al. (1990), using the same design algorithm. In this case the authors conclusions are somewhat more positive, and it was found that the KNN algorithm was relatively far more tolerant to the use of a poor initial codebook than the LBG algorithm and, for an equivalent distortion performance, fewer training vectors were needed. Overall, the time for codebook generation can be reduced significantly by the use of a neural network approach to generate an initial codebook for the LBG algorithm, as shown by Giusto and Vernazza (1990) who also use a merge and split operator to make better use of those vectors which are generated but which represent only a very small region of the partition (see also Ma and Chan, 1991). Yet another development in this area is the application to the codebook design problem of psychovisual criteria. Marangelli (1991) uses a masking function (a weighted sum of horizontal and vertical luminance gradients) to account for the reduction is sensitivity of the HVS to errors as scene activity increases. It is difficult to draw firm conclusions with regard to his results, however, as the reproduced images are of very poor quality. Again, Hsieh et al. (1991) used the two-dimensional DCT to provide a feature domain for the training vector partition. The influence of training sequence size on algorithm performance has been studied by Cosman et al. (1991), and

a general comparison of several codebook design methods is reported by Huang and Harris (1993).

It is apparent that the development of algorithms for vector quantiser codebook generation has been, and probably will be for some years yet, a subject of much interest, and one which will benefit in a practical sense from the rapid increase in hardware processing power which is being experienced at the present time, in that it will render obsolete many of the sub-optimal approaches intended to economise on processing capacity.

4.4. CODEBOOK SEARCH

It has already been mentioned that one of the advantages of vector quantisation is the trivial decoding procedure. The disadvantages lie at the other end of the transmission chain: (a) with the codebook generation process just described, not only with respect to the algorithms used and, perhaps more important, the selection of a truly representative set of training vectors which of course must reflect the characteristic features of those images (naturally outside the training sequence) which the finalised coder will be expected to process; (b) with the actual operation of the search algorithm which will decide the reconstruction vector for an input block (vector) on the basis of minimum distortion according to Equation (4.9). Each such block must be tested against every representative vector stored in the codebook at the encoder and the net distortion calculated. Based on the minimisation of the maximum error (the minimax criterion) each input block (k-sample or dimensional vector) needs to be tested against all C codebook entries. This involves:

(a) k differences per block, and so $k - 1$ comparisons per block to determine the maximum block error;
(b) $C - 1$ comparisons over the codebook to determine the minimum of the above.

This is equal to $(k + k - 1) C + C - 1$ differences per input vector.

$$= (2 k C - 1)/k = 2 C - (1/k)$$

which, since $C = 2^I$ [Equation (4.1)],

$$= 2^{I+1} - (1/k) \text{ comparisons per sample,} \qquad (4.18)$$

i.e. approximately 2^{I+1} comparisons per input sample. Additionally, the total codebook storage requirement will be $k \times 2^I$ ($k \times$ the number of codevectors). If the m.s.e. criterion is applied then the above figure for comparisons (additions) remains approximately the same but there will be 2^I multiplications per sample to be carried out also, and it was this last factor which, in the early days of image vector quantisation, prompted the

investigation of less time consuming, if somewhat less optimal, codebook search techniques. One widely used technique is that of tree search (Gray and Linde, 1982). In this case an input block is tested, not sequentially against the complete set of codebook vectors but against a hierarchy of subsidiary vectors (still of length k) which themselves are the optimum reproduction vectors of a set of codebooks of reduced extent, and which may have been produced by the application of the splitting algorithm for codebook generation, for example. The most common form (as shown in Figure 4.2) has a binary split at each level, but this is not mandatory, and more than two alternative paths from any particular node may be allocated. If in this case there are m levels then the number of distortion calculations is $2m$, each requiring k differences and $k - 1$ comparisons, and a total of m comparisons over the whole codebook. This is then equal to

$$(k + k - 1) \cdot 2m + m$$

$$= 4mk - m, \text{ i.e. to } m(4 - (1/k)) \qquad (4.19)$$

comparisons per input sample.

The overall rate will be m bits per vector $= m/k$ bits per input sample. For the earlier example given of a 4×4 input block ($k = 16$) and a 256 entry codebook ($I = 8$ bits) the full search method requires 512 comparisons per input sample, the tree search approach 32. In the latter case it is necessary to store more codewords for the test at intermediate levels, with a total of

$$k \times \sum_{i=1}^{m} 2^i \qquad (4.20)$$

entries, almost doubling the storage requirement. This is of small consequence, however, given today's memory capacities. The coding operation now consists of a sequential path tracing strategy through the tree structure from the root to the outer branches. Performance is somewhat reduced compared with the full search case, since increasingly large sections of the final codebook are "shut off" from possible access by the hierarchy of binary decisions as the coding path progresses through the tree. This degradation must be balanced against increase in speed of search, which is of course heavily dependent in any case upon the state of contemporary integrated circuit technology.

4.4.1. Fast Search Algorithms

Such is the importance of fast, yet efficient, codebook search that this, perhaps even more than fast codebook generation, has been a subject of intense activity over the past 10 years. After all, provided that a good set of representative vectors is available, non-adaptive codebook design has to be

done only once, whereas the codebook must be searched anew for every new image which one wishes to code, and this has a direct bearing on the real time capability of the vector quantisation approach. Thus the number of "fast" search algorithms reported is legion. One very simple method is to test each partial distortion sum (in the case of the m.s.e. calculation between each input vector and a selected codebook entry) against the lowest total distortion found so far. That partial calculation can then be immediately terminated when the partial sum is greater than the previous total distortion. This technique was reported by Cheng *et al.* (1984), only to be reinvented by Bei and Gray (1985). Paliwal and Ramasubramanian (1989) demonstrated that ordering the codebook according to decreasing cluster size is advantageous in reducing further the search effort required, since this increases the probability of finding the actual nearest neighbour codeword early in the search and so allowing subsequent searches to terminate at the earliest possible opportunity. This advantage decreases with vector dimension, however, since the distribution tends to become more and more uniform. A further modification is described by Ngwa-Ndifor and Ellis (1991). Cheng *et al.* (1984) also report experiments on a number of other methods in terms of the number of "macs" (multiplications, additions and comparisons) needed per test vector, using m.s.e. as the error criterion. Each method uses preliminary comparisons to eliminate the majority of the codewords as candidates for any individual input vector so that a much smaller full search then suffices. The methods are as follows: (a) the "projection" method, in which a (hyper-)rectangular partition is overlaid on the codevector space. Comparison then serves to indicate in which cell the input vector lies, and precomputed tables define the small number of relevant codevectors; (b) the "hypercube" method, in which a hypercube is centred at the location of the input vector. Some initial analysis is needed in order to determine the appropriate edge length of the hypercube, after which the nearest codebook vector can be determined straightforwardly; (c) the "minimax" method, in which the L_∞ norm [see Equation (4.8)] is used for preliminary search, followed by conventional Euclidean nearest neighbour search. Simulation results show that, if the precomputation and table storage demands can be accommodated, the projection method results in a vanishingly small number of multiplications and additions, and only 80% more comparisons than exhaustive full search. A somewhat similar approach for speech coding is reported by Cheng and Gersho (1986). The binary hyperplane test (BHT) divides the codevector space into two halves to give a preliminary indication of where the correct vector lies. Subsequent further hyperplane partitions create an (unbalanced) tree structure down to a final "bucket" containing a small number of candidates which is then searched exhaustively. Again a precomputation stage is needed, to construct the binary tree/hyperplane set. A speedup factor of around three over exhaustive full search is achieved, with subjectively the same quality of speech output. The vector dimension of four, however, is lower than that typical for images (16),

which will make the algorithm more complex to implement in the latter case
(see also Kaouri *et al.*, 1987). Madisetti *et al.* (1989) used an energy criterion
to determine which test codewords lie in a similar range, together with a
"bucketing" test similar to that of Cheng (see above). A mean absolute
distortion test eliminates multiplications at very little cost to overall perform-
ance.

The minimax approach of Cheng *et al.* (1984) has been modified by
Soleymani and Morgera (1987) to test the absolute error for each component
of the codevector against the square root of the minimum distortion found up
to that point, so enabling the rejection of a large number of codevectors. This
technique does not require precomputation or extra memory but is not as
efficient as the earlier approaches. The algorithm was later extended as re-
ported by Soleymani and Morgera (1989). Koh and Kim (1988) suggested
using the input vector mean value as a feature for selection of a partial
codebook from a "super" codebook of size L_S generated in the usual way.
The "super" codevectors are ordered with respect to their mean values and
that vector having a mean value closest to that of the input vector is used to
define the central point of a partial codebook "window" of width L_P where,
typically, $L_S = 256$ and $L_P = 32$. In the latter case the performance degra-
dation when compared with full search is negligible; see also Huang and Chen
(1990). Other approaches to fast search are those of Huang *et al.* (1992) and
Nyeck *et al.* (1992).

4.5. OTHER APPROACHES TO THE VECTOR QUANTISATION DESIGN/ IMPLEMENTATION PROBLEM

The basic concept of a vector quantisation scheme is realised by using an
extended, representative training set to generate a large codebook using a
stochastic relaxation algorithm (to avoid the problem of local minima) either
on its own or in combination with the LBG algorithm, followed by a full
search of the codebook for each input vector using the m.s.e. distance cri-
terion, possibly weighted in some sense to accord with the visual perception
of impairments. Considerations of codebook generation/search time (and
possibly of storage capacity) usually render this concept unrealisable, how-
ever, and there have been many developments (other than those already
described) which seek to make the overall process more efficient in the sense
of reducing the computational requirements whilst ensuring that any conse-
quent decrease in performance, i.e. reduction in reconstructed image quality
for a given data rate, is held to an acceptable minimum (in this connection, it
is often possible to employ techniques which "take care of" rapidly varying or
high contrast spatial detail to achieve an improvement in subjective perform-
ance). We can now explore some of the main avenues which have led in this

direction. One interesting technique allied to vector quantisation which may be mentioned here and which does not really fit into any of the categories following is that of "visual pattern" image coding (Chen and Bovik, 1990), in which coding is done with respect to a small set of psychovisually significant patterns. 4 × 4 blocks have their mean values subtracted and are then matched against either a uniform profile or one containing a predetermined edge structure. Coding complexity is minimal, and performance equivalent to that of vector quantisation itself in the 0.5–0.75 bit element^{-1} range has been obtained. The method has subsequently been developed within a hierarchical strategy (Chen and Bovik, 1992), and also has been made adaptive (Silsbee and Bovik, 1991).

4.5.1. Classified Vector Quantisation

The reader will have noticed that the predictive and transform techniques described in the two previous chapters code spatially inactive areas easily but, to achieve acceptable performance, need to expend a significant fraction of available coding capacity on active regions, specifically edges which, although taking up a relatively small physical area of the image, need accurate reproduction in order to satisfy the perceptual criteria of the eye – so it is with vector quantisation. In the basic form of the algorithm there are very few "edge" codevectors and, using the m.s.e. criterion, "edge" input vectors may nevertheless be represented by a uniform (or nearly so) intensity vector which gives the minimum value of distortion as averaged over the whole vector. This problem is particularly severe when images outside the training sequence are coded and result in the vector block structure becoming easily visible. To deal with this drawback Gersho and Ramamurthi (1982) introduced "classified" vector quantisation. Their initial approach classified each training vector as "edge" or "shade" using an edge detection operator, and separate codebooks were designed which together made up the final, overall codebook. The edge detection criterion was whether

$$(M - m)/M > 0.4, \tag{4.21}$$

where M and m are larger and smaller adjacent picture element values, and the edge codebook contained 75% of the total number of codevectors. Better subjective image quality was obtained in spite of increased overall m.s.e. compared with the use of a single, unclassified codebook, the authors making the point that their approach corresponds with results from investigations into the psychophysics of vision in that the early part of the visual perception mechanism contains sensors which are sensitive to edges of varying orientations. Incidentally, the importance of making any codebook as truly representative as possible was also demonstrated experimentally. Subsequently they expanded their work (Ramamurthi and Gersho, 1984), initially to

include a third, mid-range class and to restrict search to only that codebook corresponding to prior classification of any particular input vector, and then to include classification with respect to edge orientation and location within the 4×4 block forming the input vector. Thus, four edge orientations can be distinguished, as well as three edge locations horizontally and vertically and four diagonally. There are now many relatively small codebooks, each with a correspondingly smaller training set. Large overall codebooks can thus be generated with manageable complexity since in this design "mid-range" vectors account for about 50% of the total. Input vector matching is carried out in the DCT domain to reduce search complexity. An alternative, less complex, approach is mean/shape vector quantisation (see later), which is adapted here for those mixed class vectors which are not otherwise identified as "shade", "mid-range" or "edge". At the time of reporting (1984), Ramamurthi and Gersho found the scheme "comparable to any other known coding scheme" at 0.75 bit element^{-1}. They also reported a directional, non-linear spatial filtering algorithm which can effectively be used as a post-processing stage to reduce the visibility of artefacts introduced by the vector quantisation process (Ramamurthi and Gersho, 1986a). A more comprehensive description of their approach is given in Ramamurthi and Gersho (1986b). They deal in detail with the matter of design of the individual codebooks and also extend mean/shape vector quantisation to the edge classes. Good results are obtained at rates in the 0.6–1 bit element^{-1} region with reconstructed edge quality better than that produced by an otherwise comparable adaptive transform coder. Kubrick and Ellis (1990) repeated Ramamurthi's treatment but used a different codebook design algorithm based upon Equitz' PNN approach (Equitz, 1989; see also Po and Chan, 1991).

It is worth noting that, just as input vector matching need not be carried out in the spatial domain, neither need classification be, and Kim and Lee (1991) described an efficient transform domain classification algorithm based upon the relative magnitude of a subset of the coefficients obtained by discrete cosine transformation of 4×4 input blocks. Ngan and Koh (1992) employed a predictive algorithm to determine the classification and so avoid the transmission overhead.

4.5.2. Preprocessing Approaches to Vector Quantisation

Classification of input vectors is one method of coping with the wide variety of shapes and activities, etc., which input blocks possess. Another is to employ some form of normalisation operation. The basic idea is easy to appreciate – if the input data has two (say) particular (independent) properties a and b the total number of possible vectors is $a\,b$. If the properties can be coded separately, however, the total number of different combinations is $a + b$, and this

can be significantly less than *a b*. In mean/shape vector quantisation this procedure is motivated by the assertion that many input vectors have similar shapes but differ by virtue of their average luminance. It is thus natural to subtract the mean value of each vector before quantisation. There are two ways in which this can be carried out. The mean value of vector \mathbf{X} ($= \{x_1, x_2, \ldots x_k\}$) is,

$$m_X = 1/k \sum_{n=1}^{k} x_n \qquad (4.22)$$

and can be subtracted from each element to give a preprocessed vector:

$$\mathbf{X}' = \{x_1 - m_X, x_2 - m_X, \ldots\} \qquad (4.23)$$

with zero mean which can then be vector quantised in the usual way. The separate mean values have to be transmitted, of course, and this can be done using 5 or 6 bit uniform quantisation (Allott and Clarke, 1985). This scheme is illustrated in Figure 4.4. Alternatively, use may be made of the correlation

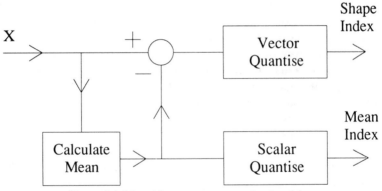

Figure 4.4 Mean/shape vector quantisation (a).

which exists between neighbouring block mean values by using simple predictive coding for mean transmission (Baker and Gray, 1983), or the mean value may be estimated at both coder and decoder from the nearest elements of neighbouring blocks (Nasrabadi and Feng, 1990b). A refinement of this approach is that of mean/residual vector quantisation in which the mean value is subtracted from the vector elements after quantisation (or predictive coding and reconstruction). In this case the error in quantisation and/or coding the scalar mean value is processed as part of the vector quantisation operation; see Figure 4.5 (also Po and Chan, 1990a,b).

Yet another approach is that of interpolative vector quantisation (Hang and Haskell, 1988). One representative picture element for each block is transmitted (by PCM or DPCM). From these, at both coder and decoder, an interpolated surface is derived which is then subtracted from each actual

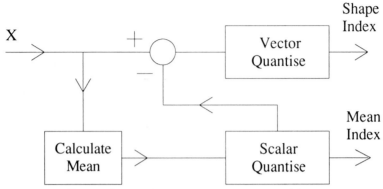

Figure 4.5 Mean/shape vector quantisation (b).

block luminance distribution. The residual signal is then vector quantised. Good results are achieved for colour pictures in the range 0.3–0.5 bit element^{-1}. Interpolative techniques in a more general sense are considered by Gersho (1990), who suggests that, where the input vector dimension is too large for direct vector quantisation, a reduced dimension feature vector be estimated for quantisation, following which non-linear interpolation can be used to estimate from this the reconstructed value of the original vector.

After mean removal, the preprocessed input vectors can be further scaled so that they each have unit variance. Thus Murakami *et al.* (1982) determine the mean [as in Equation (4.22)] and the vector variance:

$$\sigma_X^2 = (1/k) \sum_{n=1}^{k} (x_n - m_X)^2 \tag{4.24}$$

and then vector quantise the zero mean, unit variance vector

$$\mathbf{X}'' = \{(x_1 - m_X) / \sigma_X, (x_2 - m_X) / \sigma_X, ..\} \tag{4.25}$$

transmitting the mean and standard deviation as overhead information (for the latter 3 bit logarithmic PCM has been found to work effectively). This technique is one version of so-called gain/shape vector quantisation in which the value of the standard deviation is a measure of the "gain" or average vector magnitude. An alternative approach is described by Gray (1984). Here the input vector is first correlated with unit variance entries in a shape codebook to determine the best fit for the vector waveform. This done, scalar entries in a gain codebook are successively tested in order to minimise the resulting energy difference between the input vector and the selected codeword (Figure 4.6). Sabin and Gray (1984) have analysed this structure in some detail. Such coders generally come under the heading of "product code" vector quantisers since the output consists of the concatenation of code indices from more than one codebook which, to be efficient, will generally be much smaller in size than the corresponding single one.

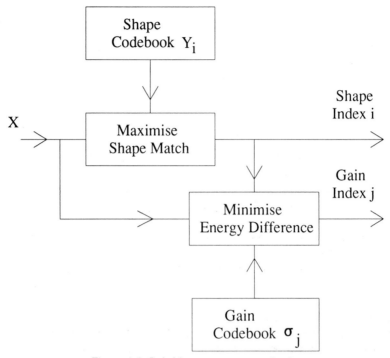

Figure 4.6 Gain/shape vector quantisation.

4.5.3. Multistage Vector Quantisation

An alternative form of product structure, in which the output is again a set of indices from more than one small codebook, is multistage vector quantisation. The principle here is to perform an initial (coarse) quantisation operation and then subject the difference between the output of this first stage and the original image to one or more further quantisation processes, as in Figure 4.7. Such a structure has been described by Allott and Clarke (1984) and Uda and Saito (1986) amongst others, and has been shown to be useful in allowing better coding of images which differ substantially from those in the training sequence. This type of structure is particularly suited to the inclusion of adaptivity, and such an implementation is described in Section 4.5.7.

4.5.4. Finite State Vector Quantisation

It has been noted earlier that computational considerations limit the block size of image vector quantisation systems to, typically, 4×4 elements. For images of reasonable spatial resolution, then (256×256 and above), considerable correlation can be expected to exist between neighbouring blocks,

Gain Index

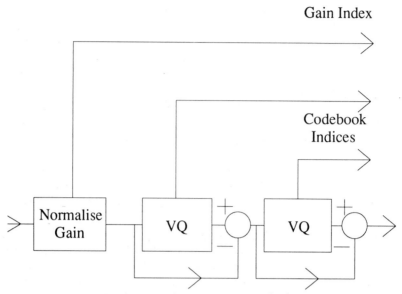

Figure 4.7 Multistage vector quantisation.

and this can be made use of in improving the efficiency of coding (as in the case of mean prediction noted above). In finite state vector quantisation (FSVQ) (Foster *et al.*, 1985; Dunham and Gray, 1985) a collection of small codebooks is used, which one is chosen for any particular input vector being dependent upon the "state" of the coder and decoder (both the same), which is in turn determined by the previous state and the previously transmitted code index. The basic design principle is as follows. Initially a conventional K codeword vector quantiser is designed using a training sequence to give K distinct states. An initial reproduction codebook is then designed in the same way for each state σ using as a training input all those vectors which are the successors of those for which the initial vector quantiser chose state σ. Such a codebook is thus optimal for all vectors following a given state σ, but the decoder in such a so-called "omniscient" finite state vector quantiser cannot, without additional feedforward information (possibly provided as overhead data), track the encoder state sequence yet. In order for it to be able to do so the next state selected is taken to be that which most closely matches the *reproduction* of the input vector (assumed temporarily to be an input vector), rather than the actual current input vector itself. Finally the codebooks can be improved by coding the training sequence using the FSVQ and replacing the entries (state labels) in the initial codebook by centroids in the usual way. Dunham and Gray (1985) additionally show how the technique may be improved by employing a stochastic iteration algorithm.

The basic technique was shown to provide good performance using speech

and Gauss–Markov input data sequences, and an image-specific implementation is described by Aravind and Gersho (1986). Here a perceptual classifier is used to deal with the problems of mean luminance and edge gradient continuity across interblock boundaries, allowing eight classes of both mean and edge detail. The use of weighted m.s.e. as a distortion measure combined with an edge classification test guards against the common possibility of final codebooks which contain too few edge vectors to reproduce this kind of detail accurately. The "omniscient" design technique described earlier is used, and the decoder can thus track the state sequence without the need of overhead transmission (feedback, rather than feedforward, FSVQ). Using 64 entry state codebooks and 4×4 input vectors, a transmission rate of 6 bits block^{-1} (3/8 bit element^{-1}) is achieved, at which rate quality is considered to be equivalent to that given by memoryless classified vector quantisation at 0.7 bit element^{-1}.

The possibility that separate design of the state codebooks might entail needless duplication of codevectors prompted Nasrabadi and Feng (1990a) to develop a dynamic scheme in which a large codebook has its entries permuted during input vector encoding. Each vector is allocated a "score" (conditional probability) dependent upon previously coded adjacent horizontal and vertical blocks and the most probable (i.e. with the highest score) N vectors, where N is the state codebook size, are used to form that particular state codebook. Again, results show a distinct improvement over those using purely memoryless approaches. FSVQ has more recently been investigated by Kim (1992), who uses intervector correlation to try to minimise the visibility of block boundaries, and Chang *et al.* (1992b), who take advantage of the basic finite state principle to speed up codebook design by searching only those vectors which lie close to a training vector in the previous iteration.

4.5.5. Predictive Vector Quantisation

The general principle that coding vector instead of scalar quantities leads to greater efficiency applies, of course, not only to input data vectors but also to residuals formed, for example, by prediction. In this situation we have a predictive vector quantisation scheme such as that of Hang and Woods (1985) (it should be noted that there is some confusion in the terminology here, some schemes of the finite state variety just described using the same nomenclature). The basic idea is to replace the scalar quantiser in the conventional predictive coding scheme (Chapter 2) with a vector quantiser operating over a block of picture elements. Using a tree-structured approach, Hang and Woods develop two techniques – sliding block, and block tree, predictive vector quantisation [for basic material on the tree coding approach see Modestino and Bhaskaran (1981) and Modestino *et al.* (1981a)]. The first of these employs a shift register containing the values from the selected region of

prediction support which determine a vector mapping giving the present output sample reconstruction. Sliding the region of support horizontally across the image gives rise to the name of the method. The second approach divides the image into small blocks and then uses a conventional tree-structured method to construct the codebook whose output drives the reconstruction filter. Both techniques are shown to produce SNR improvements of around 3 dB when two test images are coded at a rate of 1 bit element^{-1}. Extension of the scalar predictor to vector form is described by Cohen and Woods (1989). For a more recent application of adaptive entropy coding to predictive vector quantisation see Modestino and Kim (1992).

4.5.6. Address Vector Quantisation

Finite state and predictive vector quantisation make use of correlation between neighbouring blocks to improve the coding efficiency of the basic technique. Address vector quantisation (Nasrabadi and Feng, 1990b,c; Feng and Nasrabadi, 1991) forms an alternative approach to the use of interblock correlation. The coding operation starts with conventional vector quantisation (using the LBG algorithm) of monochrome or colour images using a classified (edge orientation) approach applied to blocks which have had their estimated mean values removed (as described earlier). The existence of interblock correlation implies that similar patterns of codebook addresses will often exist for larger groupings of four neighbouring blocks. Each such combination (level one) codebook address, if it occurs frequently enough, is then allocated a single address in level two, and the process can be repeated, in a multilayer approach, by combining four neighbouring addresses on this level into a single address on level three. Best results are obtained by making the level two codebook much larger than that for level three since interblock correlation starts to fall significantly for block sizes greater than 8 × 8. If no matching combination address can be found in the codebook then individual block addresses have to be transmitted. Typical implementations use a level one codebook with 128 entries, level two with 16 384 and level three with 1024, for which about 70% of the area of a monochrome image can be coded by the address codebooks at an overall rate of around 0.2–0.25 bit element^{-1} for a peak SNR of approximately 30 dB, about half the rate for a standard (memoryless) vector quantiser. For colour images, each input element is an RGB colour vector of dimension 3 × 1, the LBG codebook size is 512 and the transmission rate about 1/3 bit element^{-1}.

Even with a total of only four neighbouring blocks, if the level one codebook is of only a modest size the total number of combinations is still extremely large (128^4), and although in practice the actual number of address codevectors will be much less than this, some means of selecting the most likely combinations for search when coding individual input blocks is essen-

tial. In a two level implementation Nasrabadi and Feng used an address codebook divided into two distinct regions, active and non-active, of which only the first is addressable by coder and decoder. Four block transition probability matrices derived from the training sequence contain the conditional probabilities of a codevector occurring given a particular horizontal, vertical or diagonal (45° or 135°) neighbour. These turn out to be highly structured and allow the calculation of a score function which is used in reordering all entries in the address codebook to bring the more probable address codevectors into the active region. All entries in the codebook (active and non-active) are thus accessible without the need to allocate codewords to the (much larger) non-addressable region. For colour image coding another three matrices representing intercolour correlation properties (the joint probabilities [R,G], [G,B], [B,R]) can be included. Furthermore, if an appropriate address is either (a) found in the non-active region or (b) not found at all, relevant values in the transition matrices are incremented to increase the probability of finding the appropriate codevector in the active region subsequently. In case (b) the new codeword is added to coder and decoder codebooks. In fact this dynamic updating process reduces the bit rate only marginally but now the address codebook reordering operation results in the vast majority (>99%) of vectors being coded via the address codebook, although the overall bit rate is not quite as low as for the multilayer technique.

4.5.7. Adaptive Vector Quantisation

It is a fundamental principle of data compression systems design that better performance can be obtained by using coding algorithms which can adapt to the changing statistical properties of the input data rather than those which have globally optimised and fixed parameters, provided that the algorithms are well designed in the sense of needing a minimum of overhead information to allow the decoder to track changing coding parameters, and we have already seen that this principle can be implemented in predictive and transform systems. As far as vector quantisation is concerned, a variety of approaches is available to impart adaptivity to such a coder. We have already examined multistage vector quantisation, and this type of structure can be made adaptive by allowing the number of stages used to vary according to input block activity. If scaling of input values by the standard deviation is used, then no extra overhead information need be transmitted to indicate the state of adaptivity to the decoder, since this is implicit in the value of the standard deviation as a measure of block activity. A typical activity control strategy is shown in Table 4.2 (Clarke and Allott, 1986).

Figures 4.8–4.10 compare such an adaptive scheme with one or two of the other approaches described previously (Section 4.5.2). Figures 4.8(a), 4.9(a)

Table 4.2 Activity control of adaptive
multistage vector quantisation.

Vector activity level (3 bit signal)	Number of stages used
1	1
2	2
3	3
4–8	4

(a)

(b)

(c)

(d)

Figure 4.8 (a) Original FLAT image. (b) Images coded using two stage, 16 vector per stage gain/shape vector quantisation (mean 6 bits, standard deviation 3). (c) Images coded using two stage, 16 vector per stage mean/shape vector quantisation (mean 8 bits). (d) Images coded using four stage activity controlled mean/gain shape vector quantisation (mean 6 bits, standard deviation 3; eight stages of adaptivity). All coding rates approximately 1–1.1 bit/element.

(a) (b)

(c) (d)

Figure 4.9 (a) Original TESTCARD image. (b) Images coded using two stage, 16 vector per stage gain/shape vector quantisation (mean 6 bits, standard deviation 3). (c) Images coded using two stage, 16 vector per stage mean/shape vector quantisation (mean 8 bits). (d) Images coded using four stage activity controlled mean/gain shape vector quantisation (mean 6 bits, standard deviation 3; eight stages of adaptivity). All coding rates approximately 1–1.1 bit/element.

and 4.10(a) are the original FLAT, TESTCARD and GIRL pictures. Figures 4.8(b), 4.9(b), and 4.10(b) are coded with two stage, 16 vector per stage gain/ shape vector quantisation, the mean being coded with 6 bits and the standard deviation with 3. Figures 4.8(c), 4.9(c) and 4.10(c) are coded with two stage, 16 vector per stage mean/shape vector quantisation (mean transmitted with 8 bits), and Figures 4.8(d), 4.9(d) and 4.10(d) use four stage, activity controlled, mean/gain shape vector quantisation, mean transmitted with 6 bits and standard deviation with 3 (i.e. eight stages of adaptivity). All rates are around 1–1.1 bit element^{-1}. The quality of reconstruction increases noticeably from group (b) to group (d).

A modification of this approach is to use a variable block size structure also. Thus Uda and Saito (1986) started with 16×16 input blocks, passing the error vector formed by subtraction (as in mean/shape vector quantisation) to

(a) (b)

(c) (d)

Figure 4.10 (a) Original GIRL image. (b) Images coded using two stage, 16 vector per stage gain/shape vector quantisation (mean 6 bits, standard deviation 3). (c) Images coded using two stage, 16 vector per stage mean/shape vector quantisation (mean 8 bits). (d) Images coded using four stage activity controlled mean/gain shape vector quantisation (mean 6 bits, standard deviation 3; eight stages of adaptivity). All coding rates approximately 1–1.1 bit/element.

a second stage in the form of four 8×8 blocks. This may be continued to a final size of 2×2. Setting up an error threshold for each stage according to a predetermined desired overall SNR for the reconstructed picture allows the coder to determine at which stage coding will cease. In the practical case, thresholds can also be related to the fullness of the transmission buffer. Relatively small codebooks can be used at each stage (32 or 64) and the coding complexity is considerably reduced for a picture quality similar to that produced by a conventional scheme. A similar hierarchical approach was used by Po and Chan (1990b).

Intuitively, adaptive vector quantisation would involve changing the actual codebook entries as the input image detail changed as in the approach of Boucher and Goldberg (1984). They coded both monochrome and colour images by dividing the input image into 32×32 sub-images for each of which

a separate vector quantiser based on a 2×2 blocksize was designed. The results were found to be comparable with those of transform coding at around 1.5 bit element^{-1}, although sub-images 128×128 in size and a block size of 3 \times 3 gave better rate–distortion results but at greater computational cost. This work was refined (Goldberg *et al.*, 1986) in a study of a variety of block and codebook sizes. Somewhat surprisingly, in no case was a clear advantage due to adaptivity demonstrated. More sophisticated schemes involve dynamic modifications to an existing codebook in which new input vectors which cannot be coded with a distortion below a predetermined threshold are added to the codebook as new reproduction vectors (Gersho and Yano, 1985). The scheme of Panchanathan and Goldberg (1991) uses a small "primary" codebook made up initially of input vectors themselves. If no appropriate match is obtained the new input vector itself becomes a new codeword. When the primary codebook is full its least recently used codeword is moved to a larger "secondary" codebook which is also searched (after the primary one). When both codebooks are full deletion of the least recently used codeword in the secondary codebook takes place. Such a dynamic update of a codebook containing frequently used codewords is similar to the approach of Nasrabadi and Feng described earlier. Good results in the 0.2–0.7 bit element^{-1} region are obtained with a 4×4 input vector and a primary codebook of size 16. The "pattern matching" approach of Saito *et al.* (1989) is somewhat similar in spirit to such methods – here a frame memory holds recently decoded 4×4 codevectors and future input vectors are coded by simply block by block copying from the memory (subject to an allowed distortion requirement). Adaptivity is included by modifying the distortion criterion according to input vector standard deviation, allowing more distortion when large intensity changes are present. Previously transmitted codevectors are arranged into "near" and "far" search areas which are sequentially searched for a match. If none is found, the block is coded using block truncation coding (BTC, see Chapter 6). Typically, at 0.5 bit element^{-1} 73% of vectors are coded from the near search area, 12% from the far area and 15% by BTC. Performance is quoted as 3 dB better than adaptive DCT, and 6 dB better than 4×4 memoryless vector quantisation, with better edge and texture reproduction.

4.5.8. Lattice Vector Quantisation

A major problem with the design of vector quantisers in general is the fact that the codebook does not demonstrate any long-range structure. Given an allowable number of codebook entries, the generation algorithm will attempt to distribute them over all the vectors of the training sequence in such a way as to minimise some predetermined error function and the computational effort required to do this will increase exponentially with codebook size. Again, when encoding any particular input vector, time consuming search

routines are necessary. We have seen that these considerations have given rise to an impressive array of "short-cut" and "minimally sub-optimal" simplifications to both codebook generation and the coding process, and they have also led other workers to examine the matter of codebook structure in more detail. The lattice quantiser employs a regular array of points in k dimensions as the output set of codevectors, around each of which lie conventional "nearest neighbour" coding regions, all of the same size and translations of the same basic region surrounding the origin to each of the lattice points. Together, these regions fill the available quantisation k-space (Gersho, 1982). In one dimension the structure is identical with the usual uniform scalar quantiser. In two dimensions a regular structure based upon rectangular regions may be envisaged, but the optimal (in the sense of minimum m.s.e. coding) shape tessellating the region is the regular hexagon (Gersho, 1979; Newman, 1982). The idea may be logically extended to higher dimensions, and the associated theory has been reported extensively (see, for example, Conway and Sloane, 1982a). It is apparent that the processes of input vector coding and subsequent decoding using a lattice (or subset of such lattice points) are significantly simplified by this approach (see e.g. Conway and Sloane, 1981, 1982b), the drawback being that such a regular structure will only be optimum for an input variable which is itself uniformly distributed in k dimensions. Traditionally, one method of dealing with this situation is by companding, where a non-uniform input distribution is mapped into one which is uniform, quantised using a uniform quantiser, and an inverse mapping applied. Gersho (1979) discussed this approach as extended to k dimensions and Kuhlmann and Bucklew (1988) reported piecewise uniform implementations which are generally applicable and show that they are robust against moderate changes in input statistics. Sayood *et al.* (1984) present a general design technique for uniform vector quantisation and demonstrate the good performance of a four-dimensional scheme as applied to Laplacian and Gamma distributed sources. They make the point that, since the lattice structure is regular by definition, it is not necessary to store the whole codebook since, as long as the nearest neighbour region C around the origin is defined, outlying input magnitudes X can be scaled into that region and the nearest lattice point X_0 found. Knowledge of the scale factor and X_0 then allows C to be translated to C', and the nearest neighbour point of C' to the original input X found. Simulations show favourable performance at 1–2 bits sample^{-1} when compared with both other techniques and the theoretical rate–distortion bound. More extensive results are reported by Rost and Sayood (1988).

Fischer (1986) has developed a "pyramid" vector quantiser in which codewords correspond to points on a cubic lattice which also lie on a given pyramid. For the independent, identically distributed (i.i.d.) Laplacian distribution a contour of constant probability density is defined by the condition that the sum of the magnitudes of all vector entries itself be constant, and all

vectors which satisfy this criterion define a hyperpyramid in k-dimensional space, which constitutes, for this source, a high probability region in which output vectors ought preferentially to be located. In particular at higher rates (3 bits dimension^{-1}), a significant improvement over the optimum scalar quantiser is demonstrated for Laplacian and Gamma distributed memoryless source data.

It was stated earlier that an advantage of the codebook structure provided by lattice configurations was the faster processing involved. This is exemplified by Chen (1990), who presents a scheme for decomposing higher order lattices into products of their two-dimensional sub-lattices. Compared with full search of a codebook with 4096 entries his scheme allows a computing operation count reduction by a large factor, which increases significantly with codebook size. As before, no actual codebook need be stored, and decoding is simply a series of table look-ups.

4.5.9. Transform/Vector Quantisation

Generally speaking, it is shortsighted to combine different data compression techniques in the hope of achieving an improvement in performance over that given by a single method (operations such as run length coding of coded coefficients or of error samples depend upon the statistical distribution of the samples to be coded and are excluded from this argument). Thus, for example, predictively coding prediction error residuals will not enhance the efficiency of the initial coding step if this has been properly carried out. Again, predictive coding applied to high order transform coefficients may easily lead to a signal to be transmitted with higher variance than that of the coefficients themselves (Clarke, 1984a). The reason is, of course, that, once having removed the correlation in the original signal, it cannot be removed again. There are situations, however, in which such approaches are useful, and one is the combination of transform coding with vector quantisation. Two advantages stem from such a combination. First, as seen earlier, computational complexity limits the block size of conventional vector quantisation to 4×4, whereas significant image correlation exists over a much larger span and is most easily dealt with by 8×8 or 16×16 transform coding. Second, the statistical distribution of luminance values of natural image data is extremely ill-defined, necessitating the use of complex and time consuming codebook design processes (e.g. the LBG algorithm), run on a training sequence of actual image data which, even if extensive, may not be large enough to prevent degradation in performance when images outside the training sequence are coded. On the other hand, in a well-designed adaptive transform coding scheme, although sub-blocks are too large for straightforward vector quantisation, many of the coefficients in each classification category will be negligible, and the A.C. coefficients will have a much more

clearly defined distribution [for the most part, well approximated by the zero mean Laplacian distribution (Clarke, 1985a)]. Thus a natural approach is to employ vector quantisation in the transform domain, and this has become a popular technique. The number of variations upon the theme is, as usual, legion, and only one or two basic implementations can be described here. A more extensive review is given by Nasrabadi and King (1988) who, in 1984 (Nasrabadi and King, 1984), reported a scheme for clustering like transform coefficients from four successive frames of an image sequence. In the same year Sayood *et al.* (1984) described a transform coding/vector quantisation implementation based upon a lattice structure. A typical intraframe system is that described by Aizawa *et al.* (1986). Images are transformed using an 8×8 DCT and classified into four levels of activity (as in conventional adaptive transform coding), the D.C. coefficient being quantised by an 8 bit scalar quantiser. The sub-block coefficient set is then decomposed as shown in Figure 4.11, each vector V_n having its variance determined which is then used

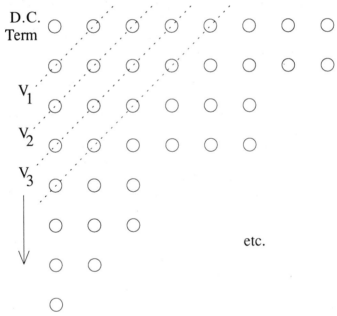

Figure 4.11 Mapping of 8×8 transform coefficients into vectors for subsequent vector quantisation.

for normalisation and bit assignment. Separate vector quantisers are then designed for each vector based upon a model having a Laplacian distribution, zero mean and unit variance. A two stage vector quantisation scheme is employed, assignments of up to 8 bits being coded with a first stage codebook, assignments above 8 bits being coded first by an 8 bit codebook and then a

residual difference vector being coded by a further stage of up to 8 bits. Performance is somewhat better than that of conventional adaptive transform coding but there is a significant increase in computational load.

We have previously seen that one of the more serious drawbacks of basic vector quantisation is its inability to reproduce sharp edge transitions effectively. To overcome this problem classification into various simple structural patterns was introduced, and the same approach can be applied to transform/ vector quantisation. Maresq and Labit (1986) employed a classification system related to the properties of the human visual system and sensitive to horizontal, vertical and diagonal edges, texture, etc., to vector quantise the coefficients resulting from the two-dimensional DCT of 4 × 4 blocks (structural detail such as high horizontal or vertical activity in the spatial domain naturally being reflected in the distribution of the transform coefficients in two dimensions). A somewhat simpler classification approach is that of Kim and Lee (1989) who used the relative magnitudes of the first horizontal and vertical transform coefficients to determine the presence of horizontal, vertical and diagonal edges and of homogeneous regions. Good results are reported in the 0.2–0.5 bit element^{-1} region (see also Kim and Lee, 1992). Classification in the DCT domain is also used by Lee and Crebbin (1994), together with quadtree segmentation to achieve high quality reconstructed images in the 0.3–0.7 bit element^{-1} region.

At very low data rates the need to employ 8 or 9 bits to code each block D.C. coefficient uniformly can be something of an embarrassment. Abdelwahab and Kwatra (1986) used a 4 bit uniform quantiser to code those successive block D.C. coefficient differences which lie in the range ±8 (the majority of such coefficients, in fact). Average bit rate is thus approximately halved for this component (to approximately 4.5 bits). Ho and Gersho (1989) used two stage interpolative vector quantisation to remove the local mean value before transform coding the residual error vector with subsequent adaptive vector quantisation to achieve good quality images at 0.3–0.4 bit element^{-1}. The advantages of a lattice codebook structure for transform/vector quantisation, as far as encoding time is concerned, are demonstrated by Jeong and Gibson (1989); whilst tending to produce a slightly lower PSNR than an LBG design at rates around 0.3–0.5 bit element^{-1} the encoding complexity is reduced by about an order of magnitude. Naturally, all of the multistage, mean and gain separating techniques directly applicable to image data can also be applied to the vector quantisation of transform coefficients. Typical schemes are described by Wang and Goldberg (1991) and Breeuwer (1990). The latter points out that, for comparable picture quality, the tree search technique needs something like a 30% higher bit-rate than a full search design. Finally, it is interesting to note that Ran and Farvardin (1990) vary the basic approach by performing the vector quantisation operation on the data vector first and then two-dimensionally transforming the error vector (i.e. the difference between the vector quantiser input and output signals). Results at

around 0.5 bit element^{-1} seem to be 2–3 dB better (in terms of SNR) than those of several other schemes which operate successfully at about this rate (transform, vector and sub-band schemes, for example).

4.6. GENERAL COMMENTS

For the past 10 years or so image VQ has provided a seemingly inexhaustible variety of avenues for research workers in image coding to explore. Nowadays efficient coding techniques are available, adaptive schemes can significantly improve system performance, and decoder complexity is negligible. There are also theoretical gains, as explored by Lookabaugh and Gray (1989).

Excellent quality reconstructed images are achievable at around 0.3 bit element^{-1} and research activity is still considerable, rivalling that in the field of transform coding in the early 1980s. Whether or not such schemes will be used in the long term is open to question, however. Like transform coding, VQ has the strong disadvantage of being a block-structured technique, and thus being susceptible at low rates to the appearance of block artefacts readily perceptible by the human eye, and it is hard not to conclude generally that, if there is to be a continued future for low-rate image coding, it will lie with those algorithms which are more oriented towards coding of actual object shapes than of regular subdivisions of the image fields into small square blocks.

5

Intraframe Sub-band and Wavelet Coding

5.1. INTRODUCTION: SUB-BAND CODING

When designing coding algorithms it is always a good idea, initially, to dispense with multiline equations and bring intuition to bear in the form of a straightforward examination of the data to be processed. Where images are concerned, it is frequently the case that, although areas of significant spatial activity are immediately apparent, there also exist extensive regions where detail is slowly varying or even substantially uniform. Given that, by standard analytical methods, rapidity of spatial variation can be expressed in terms of spatial *frequency* components, we are led to the conclusion that image data has a strongly low-pass spectrum, and this is borne out by experimental investigation (Clarke, 1985a). In fact, what matters about this result is not so much that the spectrum *is* low-pass, but that it is highly non-uniform, and thus that it is wasteful to expend as much effort coding insignificant segments of the spectrum as on processing those spectral regions in which the data energy is concentrated (much the same reasoning applies to the usefulness of transform coding, described in Chapter 3). A fruitful approach to coding might be,

therefore, to split the image into different frequency bands and apply efficient techniques subsequently to the individual "sub-bands" so produced. Such is indeed the case, and has resulted in the development, since the mid 1980s, of the technique of sub-band image coding, originally applied to the coding of speech signals in the previous decade (Crochiere *et al.*, 1976). It is worth noting that (as might be expected) the technique has connections with ideas put forward much earlier, notably by Schreiber *et al.* (1959); (see also Graham, 1967). In Schreiber's system a "lows" signal derived from the original image by low-pass filtering, and a synthetic "highs" signal derived from edge detail were used to reproduce the original image with a bandwidth reduction of four. More modern schemes carry out a direct multiband frequency decomposition, as described subsequently. For a general reference in this area see Akansu and Haddad (1992).

5.2. BASIC PRINCIPLES

As usual, a good idea of how the technique works can be obtained very simply. Before describing the approach in detail, therefore, we consider a basic outline which nevertheless illustrates well the concepts involved. It is immediately apparent that the image cannot just be filtered into a set of frequency bands, since this would simply multiply the amount of data by the number of bands involved. Fortunately fundamental signal processing relationships (to be described below) indicate that, prior to any sub-band coding operation, individual sub-bands can be sub-sampled in accordance with the reduction in detail due to filtering; it thus turns out that the total number of data elements is neither increased nor decreased by filtering. For the purpose of the present description, let us consider splitting a signal into two frequency bands, low and high. The filtering operation will be carried out as a spatial domain convolution, for which the simplest possible mode of operation is the sequential processing of sample pairs. Thus, if we consider the one-dimensional signal:

$$X = \{x_0, x_1, x_2 \ldots\} \tag{5.1}$$

and perform a convolution with the kernel $[p, q]$ we obtain:

$$Y = q\, x_0 + p\, x_1;\, q\, x_1 + p\, x_2;\, q\, x_2 + p\, x_3 \ldots, \text{etc.} \tag{5.2}$$

It turns out that we are allowed (see below) to sub-sample this signal by a factor of two, giving:

$$Y' = q\, x_0 + p\, x_1;\, q\, x_2 + p\, x_3 \ldots, \text{etc.} \tag{5.3}$$

and to reconstruct the signal by interpolating zeros for the previously deleted samples:

$$Y'' = q\,x_0 + p\,x_1;\ 0;\ q\,x_2 + p\,x_3;\ 0;\ \ldots,\ \text{etc.} \tag{5.4}$$

and then carrying out a convolution with the kernel $[q, p]$ to give

$$Y''' = p\,q\,x_0 + p^2\,x_1;\ q^2\,x_2 + q\,p\,x_3;\ p\,q\,x_2 + p^2\,x_3\ldots,\ \text{etc.} \tag{5.5}$$

A similar process employing the kernel $[k, l]$ will give

$$Y'''' = k\,l\,x_0 + k^2\,x_1;\ l^2\,x_2 + l\,k\,x_3;\ k\,l\,x_2 + k^2\,x_3\ldots,\ \text{etc.} \tag{5.6}$$

and adding signals Y''' and Y'''' will give the reconstructed output, which, in the absence of coding defects, should equal X. Convolution end effects imply that the first correct output value will be x_1, and exact reconstruction of the input sequence will result if

$$p^2 + k^2 = 1 \tag{5.7}$$

$$q^2 + l^2 = 1 \tag{5.8}$$

$$p\,q + l\,k = 0. \tag{5.9}$$

A particularly simple relationship between p, q, k, l results if we require that the high frequency filter $[k, l]$ has zero response at D.C., i.e.

$$k + l = 0 \tag{5.10}$$

we then obtain

$$k = -1,\ \text{i.e. } k^2 = l^2$$

and so

$$p^2 = q^2$$

and, since $l\,k$ is negative, $p\,q$ is positive and hence $p = q$. Also $p\,q = -l\,k = k^2$ and so

$$p^2 + p\,q = p^2 + p^2\ \text{or } p = \pm 1/\sqrt{2}$$

and $q = \pm 1/\sqrt{2}$ also. Thus $k^2 = 1/2$ or $k = \pm 1/\sqrt{2}$ and $l = \mp 1/\sqrt{2}$.
Taking the positive sign for p and q we find that

$$[p, q] = 1/\sqrt{2}\,[1, 1]$$
$$[k, l] = 1/\sqrt{2}\,[1, -1] \tag{5.11}$$

or

$$\begin{bmatrix} p & q \\ k & l \end{bmatrix} = 1/\sqrt{2} \begin{bmatrix} 1 & 1 \\ 1 & -1 \end{bmatrix}, \tag{5.12}$$

the basic orthonormal Hadamard transform matrix (see Chapter 3). Thus processing of the signal with the low-pass filter $(1/\sqrt{2})\,[1, 1]$ and the high-pass filter $(1/\sqrt{2})\,[1, -1]$ allows a rudimentary sub-band operation to be carried

out. Although there are other considerations (such as overlapping filter responses) to which no regard has been paid here, the basic principles are evident. Furthermore, the connection with transform coding is no accident, as can be demonstrated by, for example, a sequential three level decomposition over blocks of eight samples with the above filters. The eight sub-bands so generated can be shown to be those produced by the eight basis vectors of the WHT matrix of Equation (3.16), Chapter 3. Indeed transform coding can, equivalently, be looked upon as a form of sub-band coding in which each sub-band is represented by just one coefficient.

5.3. SUB-SAMPLING AND INTERPOLATION

At this point it is appropriate to examine more formally the steps involved in the coding operation described in a somewhat naïve fashion above. More complete analytical treatments can be found in Crochiere and Rabiner (1981, 1983), Schafer and Rabiner (1973) and Vaidyanathan and Liu (1988).

5.3.1. The Sub-sampling Operation

This operation is alternatively called down-sampling or decimation (the conventional definition of the latter term being ignored) and consists of retaining every Mth sample of a discrete sample sequence. Thus

$$y(n) = x(M n). \qquad (5.13)$$

As far as sub-band coding is concerned M is nearly always 2 and this is a convenient value for illustrating the process in more detail. Figure 5.1 shows

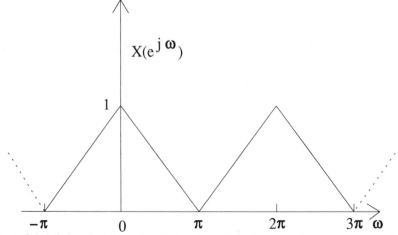

Figure 5.1 Sub-band coding – input signal spectrum for the sub-sampling operation.

the frequency response $X(e^{j\omega})$ of an arbitrary signal sampled at a normalised radian frequency of 2π. The signal can be seen just to satisfy the Nyquist criterion for no aliasing of a low-pass signal of maximum frequency ω_{max} and sampling frequency ω_{samp}, i.e., ω_{max} is not greater than $\omega_{samp}/2$; spectral repeats do not overlap and perfect reconstruction is therefore, in principle, possible. Sub-sampling is most easily considered as a further sampling operation carried out (in the present example) at one half the original sampling frequency, i.e. at π rad. Spectral repeats of the whole pattern of Figure 5.1 now appear every π rad, coinciding with those already present and centred around even multiples of π, but now also appearing at locations given by odd multiples of π, as in Figure 5.2, where the frequency scale is still that corres-

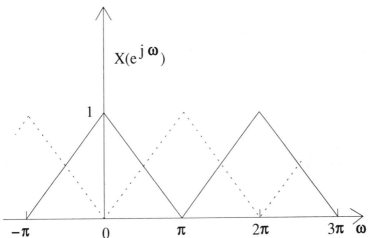

Figure 5.2 Sub-band coding – spectral repeats appear when the signal of Figure 5.1 is sampled at a frequency of π rad.

ponding to the *original* sampling rate. If we rescale Figure 5.2 to correspond to a new sampling frequency of 2π Figure 5.3 results, where A is the original (now relatively "stretched") frequency spectrum and B is the new repeat due to sub-sampling and causing aliasing over the whole $0–2\pi$ frequency band. Note that, since samples have been removed by this operation the maximum rate of change of the signal per *sample* is increased – intuitively explaining the phenomenon of spectral "stretching". Thus

$$A = (1/2)\, X(e^{j\omega/2})$$

and

$$B = (1/2)\, X(e^{j(\omega/2 + \pi)}). \tag{5.14}$$

The frequency domain expression for the output of the operation is thus

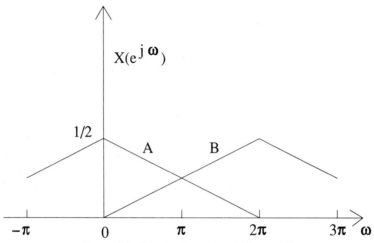

Figure 5.3 Rescaled version of Figure 5.2.

$$Y(e^{j\omega}) = (1/2) \, (X(e^{j\omega/2}) + X(e^{j(\omega/2 + \pi)})), \qquad (5.15)$$

where the second term may alternatively be written as $X(-\,e^{j\omega/2})$.

The factor of 1/2 appearing in the analysis may be accounted for analytically. Intuitively, since there are now twice (in general M times) the number of spectral repeats each can have only 1/2 ($1/M$ times) the magnitude. The general result can be shown to be

$$Y(e^{j\omega}) = (1/M) \sum_{l=0}^{M-1} X(e^{j(\omega - 2\pi l)/M}) \qquad (5.16)$$

(Crochiere and Rabiner, 1981, 1983). The same analysis can be applied to a high-pass signal with a similar result (Vaidyanathan, 1987). The important conclusion to be drawn is that the input signal (before sub-sampling) must be band-limited to satisfy the no aliasing requirement at the *new* sampling frequency *before* sub-sampling is carried out. In the present example this will require that

$$X(e^{j\omega}) = 0 \quad |\omega| > \pi / 2 \qquad (5.17)$$

in the relation of Figure 5.1.

5.3.2. The Interpolation Process

In this operation $M - 1$ zeros are inserted between the original sample locations:

$$y(n) = x(n/M) \quad \text{for } n = 0, \pm M, \pm 2M, \text{ etc.}$$

$$= 0 \qquad \text{otherwise.} \qquad (5.18)$$

Thus the maximum rate of change is reduced by this operation and a *compression* of the frequency scale results. In this case the spectral responses are related by:

$$Y(e^{j\omega}) = X(e^{j\omega M}). \qquad (5.19)$$

There are two further consequences. First the original samples are now M times as far apart, and so, second, spectral repeats are now centred on frequencies which are harmonics of $2\pi/M$. Without mathematical analysis it seems reasonable, therefore, that the process has an associated gain of M in order to match the original amplitudes. Figure 5.4 illustrates the process for

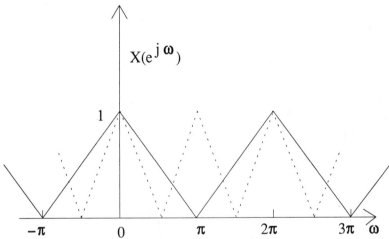

Figure 5.4 Spectral interpretation of the interpolation process for $M = 2$.

the value $M = 2$. Again, a similar result obtains if the original signal is bandpass, rather than low-pass. Following interpolation low-pass or bandpass filtering is required to select the required band and to reject all other spectral images (repeats).

5.4. THE FILTERING PROBLEM

It is evident that ideal initial filtering of the input signal would allow its perfect reconstruction at the output of a decimation/interpolation chain. This is not possible in practice, however (all implementable filters have transition bands of finite widths, see Figure 5.5), and this problem has given rise to a

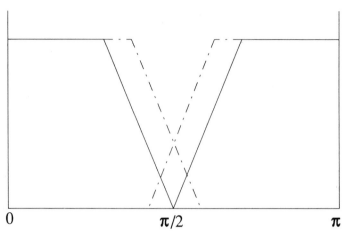

0 π/2 π

Figure 5.5 Practical high-pass/low-pass filter responses. ———— Non-overlapping case –
signal loss around π/2; – · – · – practical case to prevent signal loss – aliasing is
present.

significant volume of literature (Woods, 1991; Vaidyanathan, 1987; Wester-
ink, 1989). Here we concentrate on the case $M = 2$ as representative of the
vast majority of sub-band schemes; extension to other values of M follows
logically. The basic two-channel filtering structure is shown in Figure 5.6. The
input signal $x(n)$ is split into low-pass and high-pass bands by $H_L(z)$ and
$H_H(z)$; 2:1 sub-sampling (decimation) follows, the total number of samples
representing the signal remaining unchanged, and the resulting signals coded
by appropriate means (see later) and transmitted or stored. Decoding initially
involves recovery of the sub-band data according to the actual compression
algorithm used, followed by 2:1 interpolation and low-pass or high-pass filter-
ing of the appropriate spectral repeat by $F_L(z)$ or $F_H(z)$. Recombination of
the two spectral bands results in reconstruction of the full band signal.
Although the channel coding operation is lossy and introduces the same kind
of artefacts as in any other coding scheme, for the present we concentrate on
the filtering problem.

 It is a basic assumption, of course, that the input signal has previously been
properly low-pass filtered to a normalised upper cut-off frequency of π
(Figure 5.1). The job of $H_L(z)$, therefore, is to select input frequency compo-
nents in the range $0 \rightarrow \pi/2$, and that of $H_H(z)$ to select components between
$\pi/2$ and π. With input signal spectrum $X(e^{j\omega})$, filter outputs are:

$$\text{Low-pass:} \quad X(e^{j\omega}) \cdot H_L(e^{j\omega})$$

$$\text{High-pass:} \quad X(e^{j\omega}) \cdot H_H(e^{j\omega})$$

(5.20)

which, after decimation, result in the signals

$$X_L(e^{j\omega}) = (1/2) \left[X(e^{j\omega/2}) H_L(e^{j\omega/2}) + X(e^{j(\omega/2 + \pi)}) H_L(e^{j(\omega/2 + \pi)}) \right] \quad (5.21)$$

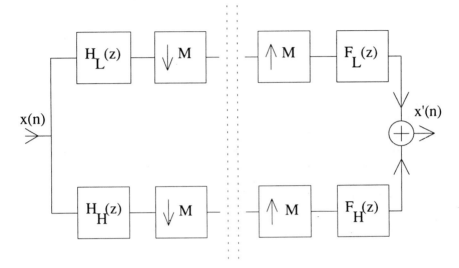

ANALYSIS SYNTHESIS

Figure 5.6 Basic two-channel filter structure for sub-band coding. $H_L(z)$, $H_H(z)$, low- and high-pass analysis filters; $F_L(z)$, $F_H(z)$, low- and high-pass synthesis filters; \downarrow M, M-fold decimation; \uparrow M, M-fold interpolation.

$$X_H(e^{j\omega}) = (1/2)\,[X(e^{j\omega/2})\,H_H(e^{j\omega/2}) + X(e^{j(\omega/2 + \pi)})\,H_H(e^{j(\omega/2 + \pi)})] \quad (5.22)$$

which are then coded and transmitted. At the decoder, the approximations $X'_L(e^{j\omega})$ and $X'_H(e^{j\omega})$ are interpolated to give [see Equation (5.19)] $X'_L(e^{j2\omega})$ and $X'_H(e^{j2\omega})$, with resulting output signal:

$$X'(e^{j\omega}) =$$

$$(1/2)\,[X(e^{j\omega})\,H_L(e^{j\omega}) + X(e^{j(\omega + \pi)})\,H_L(e^{j(\omega + \pi)})]\cdot F_L(e^{j\omega})$$

$$+ (1/2)\,[X(e^{j\omega})\,H_H(e^{j\omega}) + X(e^{j(\omega + \pi)})\,H_H(e^{j(\omega + \pi)})]\cdot F_H(e^{j\omega}). \quad (5.23)$$

In the absence of imaging and aliasing artefacts the output would be:

$$X'(e^{j\omega}) = (1/2)\,X(e^{j\omega})\,[H_L(e^{j\omega})\,F_L(e^{j\omega}) + H_H(e^{j\omega})\,F_H(e^{j\omega})] \quad (5.24)$$

and so an error term exists, and is given by

$$(1/2)\,X(e^{j(\omega + \pi)})\,[H_L(e^{j(\omega + \pi)})\,F_L(e^{j\omega}) + H_H(e^{j(\omega + \pi)})\,F_H(e^{j\omega})] \quad (5.25)$$

and which can be removed by making the synthesis filters obey

$$F_L(e^{j\omega}) = H_H(e^{j(\omega + \pi)})$$

$$F_H(e^{j\omega}) = -\,H_L(e^{j(\omega + \pi)}). \quad (5.26)$$

In this case the overall transfer function becomes

$$X'(e^{j\omega}) / X(e^{j\omega}) = (1/2) [H_L(e^{j\omega}) H_H(e^{j(\omega + \pi)}) - H_L(e^{j(\omega + \pi)}) H_H(e^{j\omega})].$$
(5.27)

To the extent that this function does not represent a pure delay, it indicates the distortion to be expected from the decimation/interpolation/filtering operation.

Although we have not yet specified the actual form of the filters $H_L(e^{j\omega})$ and $H_H(e^{j\omega})$, in sub-band coding their purpose is simply to split the input signal into a low band/high band pair about the crossover frequency $\pi/2$. So-called quadrature mirror filters (QMFs) (Vaidyanathan, 1987, 1993) can be used for this purpose, where the high band response is simply a mirror image of that of the low band filter about $\omega = \pi/2$. In this case, $H_L(e^{j\omega}) = H(e^{j\omega})$ say, and then $H_H(e^{j\omega}) = H(- e^{j\omega})$, implying that

$$F_L(e^{j\omega}) = H(e^{j\omega})$$
$$F_H(e^{j\omega}) = - H(- e^{j\omega}).$$
(5.28)

The transfer function is thus

$$T(e^{j\omega}) = X'(e^{j\omega}) / X(e^{j\omega}) = (1/2) (H^2(e^{j\omega}) - H^2(- e^{j\omega})).$$
(5.29)

Phase distortion in $T(e^{j\omega})$ may be eliminated by making $H(e^{j\omega})$ a linear phase low-pass filter. It can be shown that the filter order must be odd to minimise residual amplitude distortion, which is then given by

$$|T(e^{j\omega})| = (1/2) [|H(e^{j\omega})|^2 + |H(- e^{j\omega})|^2].$$
(5.30)

A desirable property of the filter structure is then that

$$[|H(e^{j\omega})|^2 + |H(e^{-j\omega})|^2] = 1$$
(5.31)

as closely as possible (Johnston, 1980). Alternatively, amplitude distortion may be eliminated (Vaidyanathan, 1987) at the cost of some residual phase distortion or, indeed, the filter pair may be chosen to eliminate both (Smith and Barnwell, 1986); (see also Daubechies, 1988). In this case the relationship between F_L and F_H and F_H and H_L is the same [Equation (5.26)] but the relationship between H_H and H_L is

$$H_H(e^{j\omega}) = - H_L(- e^{j\omega}) e^{-j\omega N},$$
(5.32)

where N is the filter order (note that the notation in Vaidyanathan and in Smith and Barnwell is different in this respect). Although such conjugate quadrature filters (CQFs) allow, within word length limits, exact reconstruction to be achieved, their use in sub-band coding is not essential since the small errors produced by a (conventional) QMF scheme are in practice obscured by the errors introduced by the subsequent lossy coding of the separate sub-band planes (Bocker, 1988).

5.4.1. Approaches to Sub-band Filtering

For some 15 years or so now, interest in the kind of filter structures described above has been significant, for applications in a wide variety of fields. Good reviews are given by Vaidyanathan (1987, 1990, 1993). Likewise, reporting in the literature is extensive, and here we confine ourselves to a brief examination of developments in filterbanks specifically for application to image sub-band coding schemes. We have already seen that the technique reported by Smith and Barnwell (1986) allows Finite Impulse Response (FIR) filters to be designed which permit exact reconstruction free of frequency and phase distortion and aliasing. The authors subsequently presented a unified approach to the topic based on a so-called "generalised filter bank transform" (GFBT) which allows separate treatment, for example, of the effects of aliasing and of spectral distortion (Smith and Barnwell, 1987). Interestingly enough in the same issue another general theoretical treatment of the topic is given by Vetterli (1987). In 1988 Vaidyanathan and Hoang introduced a family of lattice structured two-channel QMFs which are robust in the presence of coefficient quantisation, and they present design details for a range of filters in tabular form.

Filters for sub-band coding are usually based on FIR designs owing to the high sensitivity of the human visual response to phase errors in image reconstruction. Kronander (1988), however, has introduced the recursive mirror filter (RMF) structure, pointing out that, since the computational load will in any case be significant, any technique which allows similar performance with simplified implementation is valuable. This Infinite Impulse Response (IIR) structure yields perfect reconstruction without phase constraints, and elliptic filters of orders five and seven give similar performance to FIR 16 and 32 tap designs. Bleja and Domanski (1990) suggested the use of non-separable recursive filters for sub-band coding and pointed out that, in particular, such filters can be oriented in more visually relevant directions to provide better image reconstruction; also that the phase problem posed by the use of IIR filters may be circumvented by the application of wave digital filters (Fettweis, 1986). Although reported PSNR values (around 27 dB) are some 3–4 dB down on those typically reported by other workers, visual results seem acceptable. The IIR filter sub-band coder reported by Husoy and Ramstad (1990) is implemented as a modulated filter bank structure. Specifically, the kth sub-band (centre frequency $\omega_k = 2 \pi k/N$, where there are N sub-bands in total) is obtained by multiplying the input signal by $\exp(-2\pi kn/N)$, filtering the resulting signal with a low-pass filter such that it occupies the range $\pm \pi/N$ and sub-sampling by a factor on N. It is shown that this is equivalent to a delay/sub-sampling/allpass plus inverse discrete Fourier transform structure as shown in Figure 5.7, where the filters $H_p(z)$ take the form

$$H_p = (a_p + z^{-1})/(1 + a_p z^{-1}). \tag{5.33}$$

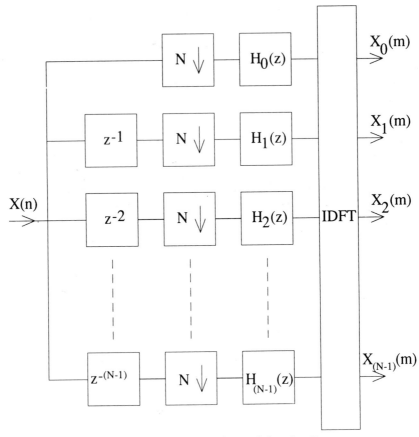

Figure 5.7 Filter bank approach to sub-band coding.

A significant reduction in computational complexity is achieved (up to a factor of 25 for a two-dimensional 8×8 decomposition), and the implementation can be carried out in fully parallel form. An alternative technique for improving the efficiency of the filter structure from the point of view of implementation is given by Lee and Young (1990).

All of the previous discussion has been based upon the idea that the aliasing artefacts which appear in the processing operation and the criteria for their cancellation appear in the frequency domain. An alternative, time domain, approach is, however, possible. Princen and Bradley (1986) describe a block transform structure operating on overlapping time domain windows and thus introducing time domain aliasing. In a similar way to that involved in the basic frequency domain operation, this aliasing can be cancelled to obtain perfect reconstruction. An example of its application to image coding is given by Lookabaugh and Perkins (1990). Here, of course, space replaces time as the independent variable. It may be noted that the overlapping time window

structure relates this approach to that of the LOT (see Chapter 3; Vetterli and Le Gall, 1989; Malvar, 1990b).

5.5. TWO-DIMENSIONAL EXTENSIONS

The basic theory of sub-band filtering is most easily appreciated in one-dimensional form, as presented above. Images are most obviously processed in two dimensions, however, and for that operation the appropriate extensions of the original formulation are required. This can easily be done by sequentially applying the scheme of Figure 5.6 to rows and columns and so splitting the input signal into, initially, two bands vertically and horizontally, as shown in Figure 5.8. In this case, by making the horizontal and vertical

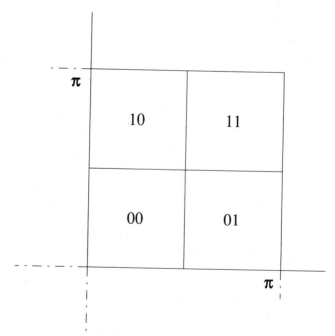

Figure 5.8 Two band horizontal and vertical frequency split.

filters separable, alias-free reconstruction can be obtained. A general discussion of multi-dimensional extensions is given by Vetterli (1984). If a finer frequency band subdivision is required, this can be done by the use of a parallel filterbank structure (Vaidyanathan, 1987; Husoy and Ramstad, 1990, as referenced above), or by organising the decomposition in a tree structure. Thus Woods and O'Neil (1986) repeat the first order operation again on each

sub-band to make a total of 16 individual bands for subsequent coding, as in Figures 5.9 and 5.10(a). Obviously, many combinations of sub-bands are

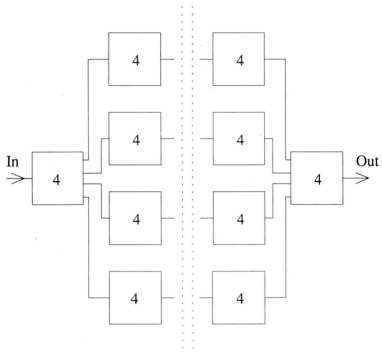

Figure 5.9 Filter structure for a uniform 16 band split (4 represents a 2 × 2 horizontal and vertical frequency split).

possible using a hierarchical tree structure. Westerink (1989) has considered the effect of such variations in band splitting on coding efficiency and concludes that, on the basis of reconstruction PSNR as a function of bit-rate, differences between various configurations are minor. The best scheme for 256 × 256 images is that described above [see Figure 5.10(a)], whilst for a 512 × 512 image a further split of the low frequency quadrant [Figure 5.10(b)] gives best results. A general treatment of non-separable multirate filterbanks is given by Karlsson and Vetterli (1990).

5.6. EDGE EFFECTS

Carrying out the actual filtering operation either necessitates a space domain convolution or the corresponding multiplication process in the frequency domain. In both cases the system response is dependent upon boundary

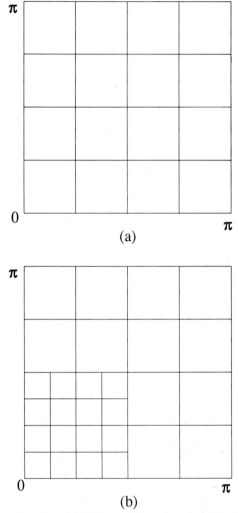

Figure 5.10 Sub-band coding. (a) Uniform 16 band split; (b) further splitting of lowest bands.

conditions. For frequency domain operation the use of the discrete Fourier transform will imply circular extension of the image data (i.e. effectively appending right-hand end of line samples to the start of any given line, etc.). The usual problem with edge value discontinuities then follows. Karlsson and Vetterli (1989a) consider a variety of approaches and suggest the simple expedient of repeating data boundary values. Although conventional symmetric extension techniques can provide a remedy (Smith and Eddins, 1990), Westerink (1989) reported a simple solution to the problem which also results

in a reduction in computational complexity. He generated a sequence consisting of the even numbered data samples followed directly by the odd numbered samples in reverse order. This was then filtered with the even numbered samples of the filter impulse response. This results in minimal discontinuities and improved reconstruction. An alternative approach is described by Martucci (1991), and the symmetric extension method has been developed further by Kiya *et al.* (1994).

5.7. PRACTICAL SUB-BAND CODING SCHEMES

Sub-band image coding was first described by Woods and O'Neil (1986), (see correction by Kumar, 1988). They used a basic QMF structure of the type described in Section 5.4 with the 32 point filter described by Johnston (1980) and a separable two-dimensional structure applied twice to give the 16 band frequency domain decomposition of Figure 5.10(a). Predictive coding based upon a prediction error distribution modelled by a Laplacian density is used to encode the individual sub-bands, in association with conventional bit allocation techniques (Chen and Smith, 1977). The technique is made adaptive by dividing the image into 16×16 blocks and using local variance to categorise the blocks into three equally populated, different, levels of activity. In this case it turns out that, of the total of $16 \times 3 = 48$ bit assignments, with the exception of the four band sub-split of the lowest two-dimensional band (all of which have finite bit allocations), most (27 out of 36) of the bit allocations are zero. Performance over the $0.7-2$ bit element^{-1} range is broadly comparable with that of the adaptive cosine transform and differential vector quantisation approaches. The points are made that the block artefacts to which transform coding is prone are not apparent, and that the technique is well suited to progressive transmission (see Chapter 7, Section 7.2.4). An alternative approach to the coding of the individual sub-bands is that of vector quantisation (Chapter 4). Westerink *et al.* (1988) used the same 16 band filter structure as Woods and O'Neil. Thereafter, however, corresponding samples from the 16 sub-band images are taken to be elements of length 16 vectors and coded using a conventional full search of the codebook (produced using the LBG algorithm). Aligning vectors *across* the sub-bands (instead of within each in the form of 4×4 blocks, for example) avoids the possibility of block artefacts appearing, and visual results are good in the $0.5-0.6$ bit element^{-1} range. SNR results are somewhat worse than those for sub-band coding combined with adaptive DPCM. Application to progressive transmission is described by Westerink *et al.* (1989). The lowest sub-band is coded using DPCM, with scalar quantisation for the rest. The particular band decomposition used is shown in Figure 5.11. Successive sub-bands are sent in such a way as to maximise the ratio of decrease in total m.s.e. obtained by sending

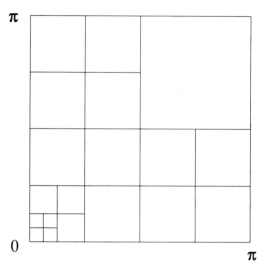

π

0

π

Figure 5.11 Band split in the progressive transmission scheme of Westerink *et al.* (1989).

the next band to the cost of transmission in bits and results are, both subjectively and objectively, better than those for a comparable DCT scheme. The use of adaptive vector quantisation in such a scheme is described by Furlan *et al.* (1991).

As mentioned elsewhere in this book, it has been conventional for some time now to use the properties of the HVS in an attempt to improve the efficiency of image coding algorithms. Sub-band coding is no exception, and many schemes have been reported which take into account the non-uniform sensitivity of the eye in the spatial frequency domain (Clarke, 1985a). Thus Li and He (1989) used a separable QMF and directional filter structure to decompose the input image into a low-pass sub-image and eight directional high-pass images. Although DPCM and vector quantisation are popular methods for coding sub-band detail, the lowest sub-band contains significant image structure (simply the image low-pass filtered, i.e. smoothed in two dimensions), and so it can equally well be coded using transform coding. Details are no different from those relating to transform coding of still images and so do not need to be dwelt upon here. This is the technique chosen by Li and He for the low-pass sub-band, together with magnitude and zero-crossing location of directional edge detail. Lookabaugh and Perkins (1990) weighted their bit allocation algorithm according to the HVS spatial and directional frequency sensitivity in a Princen–Bradley (see earlier) implementation using scalar quantisation based on the Gamma distribution and obtained good results in the 0.25–0.5 bit element^{-1} range. An interesting approach is described by Mahesh and Pearlman (1989) based upon a hexagonal structure using the HVS response to shape the noise spectrum, and Safranek and

Johnston (1989) reported the application of a perceptual masking model to determine allowable quantisation noise levels when a DPCM coding strategy is applied to sub-band outputs. Yet another scheme using HVS weighting of the quantisation error is described by Vandendorpe (1991).

It was mentioned in Chapter 1, Section 1.1, that spectral decomposition techniques have a long history. An extension of these methods is described by Eddins and Smith (1990) who used a three source model representing low-pass signals, edges and texture details, the latter being derived from a Laplacian edge detector which selects, from the input image, appropriate edge or texture information. The low-pass signal is obtained via conventional filtering and downsampling. For decoding, an inverse operation recovers edge and texture structure from the received signal, high-pass sub-bands are generated and added to the (upsampled) low-pass signal. Actual coding is carried out by using DPCM.

A loosely related approach is that of using so-called "morphological" filters (Pei and Chen, 1990) which are considered to have the advantages of direct geometric interpretation and efficient implementation. In this case, instead of the "classical" linear QMF bank, the morphological operator retains details of shape, size, orientation and connectivity. The primitive operators are those of *erosion* and *dilation*, iterative use of which leads to the definition of "opening" and "closing" transformations. Sequential application removes the fine structure, and so corresponds to low-pass filtering. High-pass filtering is then achieved by complementing the low-pass response. Using a separable product structure of the above operations results in the conventional four band (low–low, low–high, high–low, high–high) set. Whilst the authors present pictures showing the effectiveness of the resulting "sub-band" decomposition, unfortunately no comparison with other sub-band approaches is made. The method is interesting, however, as an alternative to just another sub-band/DPCM or vector quantisation implementation.

In fact it would be possible to continue for some time to describe the many variants (or reworkings!) of the basic structure of sub-band decomposition by filtering or filter-like operations, followed by either straightforward PCM or some other form of coding. Differences in the results achieved are not very great, however, and efficient present-day designs will produce good quality reconstruction at something like 0.3–0.5 bit element^{-1}. For example, the advanced design of Jeanrenaud and Smith (1990), which employs recursive filtering, predictive coding and finite state and multicodebook vector quantisation (see Chapter 4) to achieve good results at 0.44 bit element^{-1}. Nanda and Pearlman (1992) applied tree encoding methods to the sub-bands and Kim *et al.* (1989, 1991) used finite state vector quantisation and DPCM in a two stage design. Kim and Modestino (1992) used adaptive entropy coding to achieve rates down to 0.3 bit element^{-1}.

A comparison between transform coding incorporating both vector and scalar quantisation and the sub-band equivalent is given by Fischer (1989).

Results are generally inconclusive, with the exception of the better perform-
ance of sub-band coding with respect to block artefacts.

It is worth making a somewhat more general point at this juncture, which is
that system analysis usually proceeds on the basis that the analysis/synthesis
filter operation is independent of the intervening coding stage. This is a
simplification, however, since, in the presence of coding errors, cancellation
of aliasing error in the reconstruction will be incomplete. The situation is
analysed by Westerink *et al.* (1992), who separate the total error contribution
into four terms: (a) QMF design error; (b) signal error; (c) aliasing error; and
(d) random error. It is in fact shown that, in comparison with contribution
(b), both (a) and (c) may be neglected if the filter used has at least 12 taps (16
is considered optimum as a balance between visual performance and im-
plementational complexity). Furthermore, and particularly at rates below 0.8
bit element^{-1}, the subjective effects of signal and random errors are approxi-
mately equal, and the use of adaptive quantisers is recommended to minimise
these. Generally speaking, in applications where high degrees of data com-
pression are required, perfect reconstruction properties and small imperfec-
tions in filter bank structure are of minor importance.

5.8. INTRODUCTION: WAVELET CODING

The Fourier transform relations between time (or in the present context,
space) and frequency

$$X(f) = \int_{-\infty}^{\infty} x(t)\, e^{-j2\pi ft}\, dt \qquad (5.34)$$

$$x(t) = \int_{-\infty}^{\infty} X(f)\, e^{j2\pi ft}\, df \qquad (5.35)$$

are, in their various forms (continuous, discrete, fast realisations, etc.), absol-
utely crucial to the development of signal processing theory and practice.
They form part of undergraduate and postgraduate university courses in the
discipline and are "regurgitated", frequently without due reflection, in in-
numerable examination questions throughout the whole of higher education.
In order to justify the present flurry of interest in so-called "wavelet theory"
in image processing and other disciplines it will be fruitful to spend a moment
considering just what Equations (5.34) and (5.35) actually represent. The
most significant consideration for present purposes is the fact that the
integrals are defined over the range $\pm\infty$. This immediately implies that the
relationships can never be applied exactly in practice, but even conceptually,
the limitations of their use are clear. Thus, our common sense notion of a
sinusoidal waveform having a specific, precisely definable frequency, in fact

only applies to a waveform which has been in existence since the infinite past and will continue to do so until the infinite future. Any restriction on these limits results in a broadening of the spectrum (and consequent uncertainty about the *actual* frequency). Likewise, the (less common sense) idea of an isolated impulse in the time or space domain has its counterpart in a distribution of energy over all frequencies from $+\infty$ to $-\infty$. Both are theoretical abstractions, therefore. Furthermore, in the latter case the notion of an energy distribution existing over *all* frequencies, the components of which are sine waves of every conceivable frequency, all lasting for infinite time, and conspiring together to produce zero resultant except at a point (of zero extent) in time or space, is somewhat hard to absorb. In practical terms, of course compromises are necessary; the price paid for the use of a finite measurement window to observe the sine wave is a spectral response widened by convolution of the frequency impulse with the transform of the window function, and restricting the spectral distribution in the same way produces broadening of the precisely located temporal (spatial) singularity. In summary, for more precise location in one domain one pays the price of less exact location in the other. Consideration of the temporal or spatial and frequency properties of a signal is therefore more a matter of joint than separate distributions – a topic comprehensively reviewed by Cohen (1989) and Hlawatsch and Boudreaux-Bartels (1992). The fact that arbitrary accuracies cannot independently be specified for both domains has frequently occasioned comparison with the uncertainty principle of quantum mechanics, in which particle position and momentum similarly cannot be arbitrarily assigned. Cohen warns against the dangers of too literal an interpretation in this way, however, for there is nothing "uncertain" in signal theory which is the true counterpart of the probabilistic notions of quantum theory.

The general idea remains true, however, and this led Gabor, in a classic paper (1946), to consider those conditions which would lead to maximum certainty of localisation in both domains simultaneously, i.e. which would minimise the product $\Delta t \, \Delta \omega$ where Δt and $\Delta \omega$ are, respectively, the standard deviations (root mean square values) of the time (space) domain function and its Fourier transform. The outcome is that the minimum value of the product obeys (Cohen, 1989)

$$\Delta t \, \Delta \omega \geq 1/2 \qquad \text{or} \quad \Delta t \, \Delta f \geq 1/4 \, \pi \qquad (5.36)$$

and the function which minimises the product is a sinusoid "modulated" by a Gaussian envelope:

$$\Psi(t) = e^{-\alpha^2 (t - t_0)^2} \, e^{j(2\pi f_0 t + \theta)}. \qquad (5.37)$$

Here t_0 and f_0 are the locations of the maxima of $|\Psi(t)|^2$ and $|\Phi(f)|^2$ on the time and frequency axes, respectively [$\Phi(f)$ is the Fourier transform of $\Psi(t)$], θ is the phase angle of the sinusoid and α determines the width of the time domain "pulse" [readers should note that Gabor's use of scaling constants

leads to a slightly different numerical value for Equation (5.36)]. Gabor called $\Psi(t)$ an elementary signal which allowed generalisation of the basic principle of Fourier analysis. Indeed, conventional Fourier analysis corresponds to the case $\alpha = 0$, when the amplitude of $\Psi(t)$ becomes independent of time, whilst as $\alpha \to \infty$ the elementary function tends to an impulse. The general time/frequency relation is as shown in Figure 5.12, where the crucial

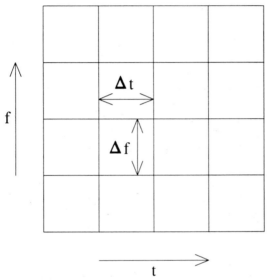

Figure 5.12 General time/frequency representation.

point is that Δt and Δf are fixed for the whole time/frequency diagram. Although f_0 will vary along the frequency axis the extent of the analysis window is determined by α and remains constant in width (Δt). One problem with the use of such an elementary signal is the fact that neighbouring time/ frequency "quanta" are not orthogonal, and their overlap allows only approximate results to be achieved [one way to circumvent this difficulty is to apply some some kind of multivariable optimisation technique to the determination of the coefficients of the expansion, maybe using neural nets as described by Daugman (1988)]. Another problem is that, whilst the analysis does attempt to localise events along the temporal or spatial axis (and thus tries to deal with the non-stationary nature of "interesting" signals, which seems to be a perennial source of concern to those involved in signal and image processing), the use of constant interval width along the frequency axis is counter-intuitive in terms of modelling the aural and visual aspects of human perception, where analysis widths proportional to centre frequency, rather than of constant value, are more appropriate. A more useful division of the frequency axis would therefore seem to be into a set of band-pass filters

of constant "Q" value, using the notation of basic circuit theory [a clear
discussion of this point, and of wavelet analysis in general, is to be found in
Rioul and Vetterli (1991)]. In such a case division of the time/frequency plane
results in long analysis windows at low frequencies, with associated good
frequency resolution, and short windows at high frequencies with correspond-
ingly wide bandwidth and good temporal/spatial resolution, as portrayed in
Figure 5.13. Two considerations now arise: how is this time (or space)/fre-

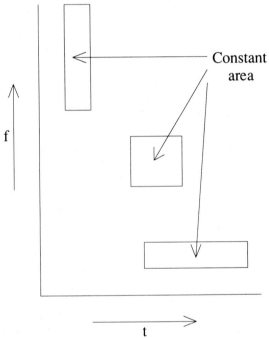

Figure 5.13 Constant "Q" division of the time/frequency plane.

quency "tradeoff" to be realised, and what has all this to do with image
coding in any case?

5.9. BASIC PRINCIPLES OF WAVELETS

The first question posed at the end of the previous section is easily answered,
at least in principle. We select a function $\Psi(x)$ (here x represents the indepen-
dent time or space coordinate) which can be appropriately scaled and trans-
lated to allow for analysis at various locations and levels of resolution
(Grossman and Morlet, 1984). For scale parameter s we thus have

$$\Psi_s(x) = \sqrt{s}\, \Psi(s\,x), \tag{5.38}$$

where the \sqrt{s} term allows for energy invariance over the range of scales used, and $\Psi_s(x)$ is the scaled version of $\Psi(x)$, contracted or expanded (dilated) as $s > 1$ or < 1, respectively. The wavelet transform of signal $f(x)$ is then the inner product

$$W f(s, u) = \langle f(x), \Psi_s(x - u) \rangle, \tag{5.39}$$

where $\Psi_s(x - u)$ is the translated version of $\Psi_s(x)$, or, equivalently, the filtering of $f(x)$ with a bandpass filter whose impulse response is that of the original function reversed, $\Psi_s(x) = \Psi_s(- x)$ (Mallat, 1989a,b). Figures 5.14 (a) and (b) give a simple example of the operation of scaling and translation and also demonstrate energy invariance. In fact the Haar wavelet used in that example was, in the early days of transform coding, employed for just that purpose, in part at least for its properties of spatial localisation, but it was superseded by other transforms which were more efficient in an adaptive block coding environment (Clarke, 1985a). Here its discontinuous nature is something of an embarrassment in terms of efficient localisation of the signal in both domains and more smoothly varying functions are preferred.

As far as digital signal processing is concerned, it is not particularly convenient for scale and translation parameters to assume any arbitrary values and the discrete orthonormal basis wavelet family of Meyer (Mallat, 1989a,b) restricts these to lead to a simple processing algorithm. These have the form

$$\Psi_{2^{j,k}}(x) = \sqrt{2^j}\, \Psi(2^j\, x - k), \tag{5.40}$$

where j and k are integers. The development of such bases has led to intense interest in the general use of wavelets in signal processing, and a good review article (with extensive references) is that already quoted, Rioul and Vetterli (1991). For more extensive theoretical material in this area see Chui (1992) and Meyer (1992). Papers directly relevant to present applications are those of Mallat (1989a,b) and Daubechies (1988, 1990); see also Witkin (1984) and Chapter 7 in Section 7.2.2 this volume. In general wavelet theoretical developments have tended to be highly mathematical in nature and so have been by-passed to a large extent by those with more general signal processing interests. Some have direct practical consequences, however, in particular the orthonormal basis set referred to above, and also Daubechies' development of orthonormal wavelets of compact support. Here we briefly sketch relevant relationships before looking at matters involving the use of wavelets in image coding.

5.10. MULTIRESOLUTION WAVELET ANALYSIS

Digital image data nowadays, in contrast to a decade or so ago, is available in a wide variety of resolutions, and a spectrum of applications exists in which

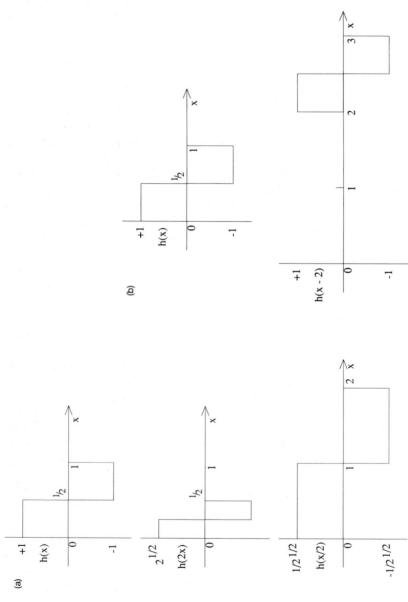

Figure 5.14 (a) A simple example of scaling. The wavelet energy always equals 1. (b) A simple example of translation.

there is a requirement to (re)generate basically the same data at different levels of definition. Thus it may be required (notwithstanding the different aspect ratio) to reproduce high definition television images on standard definition displays, transmit segments of a television or videoconference image at reduced resolution over a videotelephone system, or an image reproduced initially at low resolution may require that resolution to be gracefully improved with time in an image browsing facility. In the latter case, such progressive transmission (Chapter 7, Section 7.2.4) reproduces a low resolution image quickly, after which detail can be built up through time as the viewer desires, and coding schemes can be arranged to process an image broken down into a low detail (smoothed) version together with a signal representing the otherwise lost definition, the two components being added during the reconstruction stage at the receiver (it should be noted that, in general, the two different signals will have markedly different statistical properties and require different coding algorithms). There is general interest, therefore, in developing algorithms which compute versions of the same picture at different resolutions, together with an additional detail signal which represents what is lost in going from one level of resolution to another, lower, one and which, when added to the latter, allows reconstruction of the former. Such ideas, albeit in simple form, go back to the very early days of picture processing, but a significant impetus was given to their development by the algorithm of Burt and Adelson (1983), which will be described elsewhere (Chapter 7, Section 7.2.3). It turns out, as might be expected, that the ability of the wavelet transform to operate at various scales (resolution levels) has afforded an efficient technique, which is closely related to Burt and Adelson's work, for multiresolution analysis and which can, in fact, be viewed as an implementation of a particular kind of sub-band decomposition as described in the first part of this chapter.

Decomposition of the input image takes place in a series of spaces, V_{2^j}, j integral, where the subscript 2^j [s in Equation (5.38)] indicates the resolution level. Approximation of the input data at any resolution 2^j is carried out by an orthogonal projection onto V_{2^j} by operation A_{2^j}. Two points are of importance here; first, that notation for resolution level differs between authors [thus Daubechies (1988), for example, uses $m = -j$ and notates $V_{2^j} = V_{-m}$); second, and more significant, for actual image processing applications that, although mathematical definitions of wavelet functions and associated operators allow decomposition to be developed on any scale desired, however coarse or fine, this is not necessarily relevant to practical coding. The input image contains all the information at the highest resolution level which can ever be achieved (in spite of what devotees of so-called fractal coding methods may suggest – see Chapter 6, Section 6.3.6), and so constructions intended to give any better definition are not possible. All we can do is to move to lower and lower levels of resolution (j increasingly negative) from a base level of $j = 0$ [2^0 = one sample per unit length in the terminology of

Mallat (1989a)], at each level generating (a) a smoother (low-pass filtered) version of the data and (b) a "detail" signal which describes the difference between the approximations at the adjacent levels of resolution.

Mallat now introduces the scaling function, $\phi(x)$, which forms the required orthonormal basis. Allowing $\phi_{2^j}(x)$ to equal $2^j\phi(2^j x)$, [i.e. a scaled, dilated version of $\phi(x)$], he shows that

$$\sqrt{2^{-j}}\phi_{2^j}(x - 2^{-j}n) \tag{5.41}$$

is an orthonormal basis of the resolution space V_{2^j}.

Thus, if $j = 0$

$$\phi_1(x) = \phi(x)$$

with basis $\phi(x - n)$.

If $j = -1$

$$\phi_{1/2}(x) = (1/2)\,\phi(x\,/\,2)$$

with basis $\sqrt{2}\,\phi_{1/2}(x - 2n) = \sqrt{2}\cdot(1/2)\,\phi((1/2)(x - 2n))$

$$= 1/\sqrt{2}\,\phi(x\,/\,2 - n), \tag{5.42}$$

etc.

All very well, but what do we actually *do* to carry out the signal decomposition? Mallat (1989a–c) first shows that $\phi(x)$ is related to the response of a discrete low-pass filter in the following way: the Fourier transform of $\phi(x)$, $\hat{\phi}(\omega)$, is given by

$$\hat{\phi}(\omega) = \prod_{p=1}^{\infty} H(2^{-p}\omega), \tag{5.43}$$

where $H(\omega)$ has the properties

$$|H(\omega)| \neq 0 \quad \text{for} \quad 0 \leq \omega \leq \pi\,/\,2 \tag{5.44}$$

$$|H(\omega)|^2 + |H(\omega + \pi)|^2 = 1 \tag{5.45}$$

[compare Equation (5.31)]; and

$$|H(0)| = 1. \tag{5.46}$$

The filter has impulse response $h(n)$, where, of course,

$$H(\omega) = \sum_{-\infty}^{\infty} h(n)\,e^{-jn\omega} \tag{5.47}$$

(j here being $\sqrt{-1}$ and not the resolution index), and $h(n)$ decays as n^{-2} for large n. If $\tilde{H}(\omega)$ is the mirror filter with $\tilde{h}(n) = h(-n)$, then the signal approximation at resolution 2^j is obtained by filtering with $\tilde{H}(\omega)$ and sampling at rate 2^j [colloquially, if the original sample rate is one per unit distance ($j = 0$), then the first level of the decomposition will have $2^{-1} = 1/2$ sample per original sample spacing this, equivalently, corresponding to sub-sampling by a

factor of two]. The multiresolution decomposition is thus achieved by successively low-pass filtering the approximation on any particular level of resolution with $\tilde{H}(\omega)$ and keeping every other sample of the output. The trick (highly mathematical) is to find $H(\omega)$ such that $\phi(x)$ is well localised in both data and transform domains.

This is not the end of the story, of course, since the lower resolution approximation to the signal *is* only that, after all. Multiresolution image coding requires that, associated with the smoothed, low resolution approximation we retain a detail signal which can be efficiently coded and added, at reconstruction, to the approximation to regenerate the complete signal at the next higher level. This is done via the wavelet function $\Psi(x)$ whose behaviour as an orthonormal basis when scaled and dilated parallels that of $\phi(x)$ above. In this case the orthogonal projection of the data takes place on the orthogonal complement O_{2^j} of V_{2^j} in $V_{2^{j+1}}$. Transforms of $\phi(x)$ and $\Psi(x)$ have the relation

$$\hat{\Psi}(\omega) = G(\omega/2) \cdot \hat{\phi}(\omega/2), \qquad (5.48)$$

where this time $G(\omega)$ is a high-pass filter

$$G(\omega) = e^{-j\omega} H(\omega + \pi) \qquad (5.49)$$

with impulse response

$$g(n) = (-1)^{1-n} h(1-n). \qquad (5.50)$$

Filtering of the approximation to the signal at resolution 2^j with both $\tilde{H}(\omega)$ and $\tilde{G}(\omega)$, followed by sub-sampling, creates a coarser approximation together with a detail signal, both at resolution 2^{j-1}. The process may be iterated if desired, the overall decomposition having the same total number of samples as the original signal, as depicted in Figure 5.15. For J levels, the representation consists of a single low-pass approximation $A_{2^{-J}} f(x)$ and a set of detail signals $D_{2^j} f(x)$ where $-J < j < -1$. After some intermediate coding/storage/transmission operation, reconstruction is achieved by upsampling and filtering with $H(\omega)$ and $G(\omega)$. The process is shown in Figure 5.16.

There are various filter designs for carrying out the above processing. Daubechies (1988), for example, tabulates values of $h_N(n)$ ($n = 0 \rightarrow 2N - 1$) for $N = 2 \rightarrow 10$. Binary fraction approximations to these have also been investigated by Lewis and Knowles (1992) (see also Section 5.12).

5.11. EXTENSION TO IMAGE PROCESSING

For image data decomposition in at least two dimensions is required and can be carried out, as in the case of sub-band coding, using a separable extension of the above one-dimensional treatment applied in horizontal and vertical directions. There will then be low-pass and high-pass outputs in both

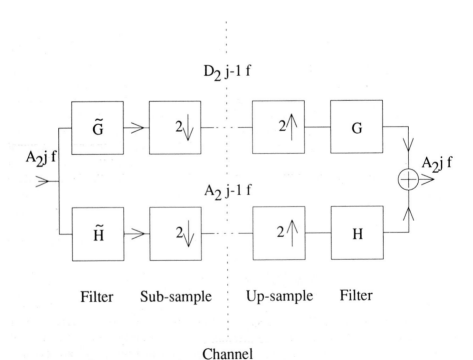

Figure 5.15 Level occupancy of wavelet decomposition (note that only the lowest frequency sub-band is successively sub-sampled).

Figure 5.16 Wavelet decomposition and reconstruction.

directions at each level, as shown in Figure 5.17. At each level the L_HL_V (low-pass horizontal, low-pass vertical) band is further decomposed into a similar set of bands at the next level, and so on. The extension of the one-dimensional diagram is shown in Figure 5.18. Again, irrespective of the number of levels, the total number of elements in the representation is equal to that in the original image. Figures 5.19 and 5.20 show the results for four levels of decomposition in the case of a test pattern and a natural image, respectively. The octagon has high spatial frequencies in horizontal, vertical and diagonal directions generated by the black/white transitions corresponding to Figure 5.17, and these are "picked-up" by their respective directionally sensitive filters. The initial low frequency band in both directions (the top left quarter of the complete picture) is then decomposed again to yield three new detail signals and a smaller "low–low" signal which then undergoes a final similar operation. We are thus left with successive levels of detail signals and a single reduced version of the original. Figure 5.20 demonstrates this procedure as applied to the CLAIRE image (note how little diagonal detail exists in this case).

5.12. PRACTICAL WAVELET CODING

The present high degree of interest in wavelet decomposition of signals in one or more dimensions into subsets at various levels of resolution has naturally led to applications in the area of image coding. It is important to remember, however, that in many other cases, applying the first stage of a coding algorithm does not effect any data compression as such but has, as its object, the production of a signal more amenable to subsequent efficient coding (thus, prior to quantisation, the error signal in predictive coding and the coefficient set in transform coding still contain all the information in the original signal and can be used to reconstruct it exactly). The efficiency of the overall system then depends upon the skill of the designer in representing the (altered) data distribution using a minimum of transmission or storage bits whilst maintaining an acceptably low degree of visible impairment in the reconstructed image – so it is with sub-band and wavelet approaches. At the output of the filtering operation the same number of data points remains as was present in the original input data, and various more or less conventional schemes have been applied to select and retain those corresponding to significant detail at the various resolution levels. This argument applies mainly to the "detail" images generated at the different resolution levels, of course; the low-pass (horizontally and vertically) filtered image at the lowest level, effectively a much smaller, blurred, version of the original (see, for example Figure 5.20) may well be retained in its original format since, even with only two levels of decomposition, it will only have 1/16 the number of elements of the original

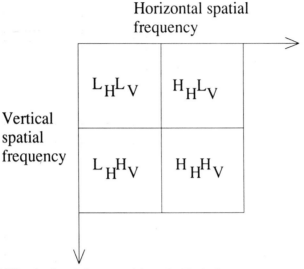

Figure 5.17 Wavelet band decomposition. L_HH_V indicates low horizontal and high
vertical frequencies, and so on. Vertical axis direction corresponds with that of
Figures 5.19 and 5.20.

image. Often at this point appeal also is made to the characteristics of the
HVS in order to remove, or reduce in importance, detail apparently present
but which does not in fact contribute to the quality of the resulting picture
(see, for example, Wong, 1992). One implementation emphasising the sim-
plicity inherent in the wavelet algorithm is that of Lewis and Knowles (1991,
1992), employing a scaled version of the four coefficient filter of Daubechies
(1988) where, initially:

$$h(0) = (1 + \sqrt{3})/4 \sqrt{2} \qquad\qquad h(1) = (3 + \sqrt{3})/4 \sqrt{2}$$
$$= 0.483 \qquad\qquad\qquad\qquad = 0.837$$
$$h(2) = (3 - \sqrt{3})/4 \sqrt{2} \qquad\qquad h(3) = (1 - \sqrt{3})/4 \sqrt{2}$$
$$= 0.224 \qquad\qquad\qquad\qquad = -0.129.$$

Scaling all coefficients by $1/\sqrt{2}$ allows them to be approximated by the values:

$$h(0) = 11/32; \qquad h(1) = 19/32; \qquad h(2) = 5/32; \qquad h(3) = -3/32,$$

using which forward and inverse operations can be carried out without mul-
tipliers (Lewis and Knowles, 1991)). They use a four layer decomposition and
employ the criterion that the presence of significant detail (to be retained) in
the image is indicated by coefficients in a particular location exceeding a
threshold in more than one resolution level, the orientation being determined
by the sub-band (low–high, high–low, high–high – representing horizontal

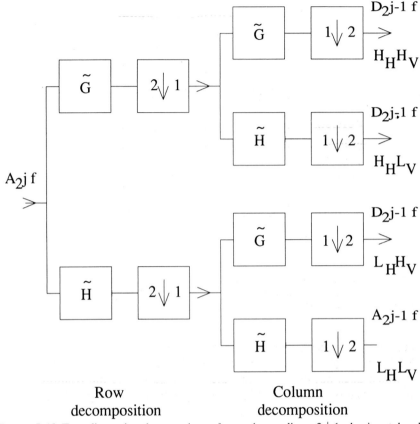

Figure 5.18 Two-dimensional extension of wavelet coding. $2\downarrow 1$, horizontal sub-sampling; $1\downarrow 2$, vertical sub-sampling.

and vertical frequency regions) in which the coefficients appear. To minimise errors due to noise, etc., the threshold value for their recursive algorithm was taken as the sum of the squares of the coefficients in a 2×2 block, which was normalised by an HVS perceptual factor. Having determined which coefficients to retain, the quantiser stepsize for coding is determined by an estimate of HVS noise sensitivity as a function of detail orientation, background luminance, spatial masking and textural activity. Good quality results are achieved at around 1/2 bit element^{-1} for the LENA image (SNR 34 dB), and reasonable results with MISSA at about half this rate, and the authors consider that their system outperforms alternative sub-band approaches. Clarke and Yao (1993) have used the four tap Daubechies filter in conjunction with scalar quantisation and entropy coding for intraframe wavelet coding. Figures 5.21(a)–(c) show the MISSA original picture, the coded result and the error picture obtained using a three level, 10 band structure at a

Figure 5.19 Four level wavelet decomposition of an octagonal test pattern. Appearance of horizontal, vertical and diagonal frequency components in the appropriate bands can be clearly seen.

rate of 1/2 bit element^{-1}. In this case blocks are divided into those considered visually significant and those not by a decision made on the basis of the magnitude of horizontal and vertical luminance gradients.

That wavelet techniques can improve upon now "classical" image coding techniques is also claimed by Akansu *et al.* (1990). They approached the filtering problem from the FIR/QMF point of view, basing their design upon the properties of binomial orthogonal sequences, and generated perfect reconstruction filter banks whose coefficients turned out to be just those of Daubechies' wavelet development. Their assertion that better performance than that of the 8 × 8 DCT is achieved by their six tap realisation is based upon the relative magnitudes of transform and sub-band coefficient variances, using the spectral flatness measure of Jayant and Noll (1984) as applied to first order Markov sources. As mentioned earlier, the contribution of this first

Figure 5.20 The wavelet decomposition of Figure 5.19 applied to the test image CLAIRE.

stage of coding to overall efficiency is far from being the whole story, and although they report that the improvement is maintained for real world images, no actual examples are given. Over the past few years workers on sub-band coding have at times used vector quantisation to code significant sub-band detail (see, for example, Westerink *et al.*, 1988). Not surprisingly, therefore, this is a useful approach for wavelet coding. Antonini *et al.* (1992) have investigated filters based on spline functions [see here the relation to the binomial coefficients; Vetterli and Herley (1990)]. In this case (symmetric) analysis and reconstruction filters have different lengths (typically nine and seven taps, respectively) and coefficient values. Resulting coefficient probability distribution functions are very highly peaked (which should lead to good coding efficiency) with a generalised Gaussian distribution best fit approximation of $r = 0.7$ (for the Laplacian distribution $r = 1$) (see Clarke, 1985a). Vector quantisation using a full search LBG algorithm and the mean

(a)

(b)

(c)

Figure 5.21 (a) The original MISSA test picture. (b) MISSA coded using a three level 10 band wavelet structure at 0.5 bit element^{-1}. (c) The corresponding error picture (difference between original and coded images).

square error criterion is used for coding the sub-band coefficients. Separate codebooks are generated for each sub-band resolution level and orientation with bit allocation influenced by a numerical criterion with parameters experimentally chosen to match the properties of the HVS. Typically the top level diagonal sub-band is deleted, the horizontal and vertical bands coded using 4 × 4 (16) element vectors with 256 codebook entries, as in the next lowest diagonal sub-band. On this level horizontal and vertical sub-bands are coded with 2 × 2 vectors, again with a 256 entry codebook. Differences in filters seem to give minor variations in PSNR (around 0.6 dB at a rate of 0.8 bit element^{-1}), whilst 29 dB can be achieved at 0.21 bit element^{-1} for the 512 × 512 LENA image. The authors reasonably suggest that any technique improving upon their basic VQ algorithm will lead to corresponding improvements in overall performance, and report (Antonini *et al.*, 1991) the use of lattice vector quantisation to achieve the extremely good result of 31dB SNR at a rate of 0.08 bit element^{-1} [the earlier reporting of the better result is a consequence of the publication lead time of Antonini *et al.* (1992), which was originally reported at the International Conference on Acoustics, Speech and Signal Processing (ICASSP) 1990]. They also demonstrate the application of wavelet coding in progressive transmission (see Chapter 7, Section 7.2.4) with a five level scheme covering image sizes from 16 × 16 to 256 × 256 and a total bit-rate covering the range 0.031–1 bit element^{-1}. Work in this area has recently been very intensive. Mallat and Zhong (1991) concentrated on the use of the wavelet transform as an edge detector in their coding scheme, and DeVore *et al.* (1992) presented an analytical development of the wavelet compression process.

5.13. DISCUSSION

At the time of writing sub-band and wavelet coding seem to hold high promise for still picture coding, despite the fact that DCT algorithms have been adopted for standards and chip sets are being produced for their implementation. Sub-band coding can take advantage of the very extensive developments in relevant digital filter analysis which have taken place over the past 10 years, and these have been enhanced by the introduction of wavelet techniques which allow good results with short filters. Implementation is relatively simple, there is an absence of the blocking effects which occur with transform and vector quantisation techniques when used alone at very low rates, and progressive transmission fits naturally into the multiresolution scheme (note that multiresolution schemes are discussed in a more general context in Chapter 7).

What is needed now is the development and application of better techniques for the coding of the individual sub-bands. A similar situation obtains

with respect to the coding of motion-compensated difference images in moving image (sequence) coding – see Chapter 8 and the following. Possibly the techniques to be described in the next chapter(s) may hold the key to such advances.

6

Other Intraframe Techniques. 1: Segmented, Block-truncation and "Fractal" Coding

6.1. SEGMENTED AND TWO-COMPONENT CODING

6.1.1. Introduction

What are pictures "made" of? It is probably superfluous to suggest that such a question has never been far from the minds of workers in the image processing field ever since it began to be developed some 40 years ago. Nevertheless, we are still far from being able to propose consistent, long-range models of spatial structure in images. The reason is not difficult to seek – unlike the situation with speech signals, for example (a vast array of possible sound pressure/time patterns cannot under any circumstances be considered to be valid speech waveforms, in any language), just about any spatial luminance variation might be valid image data; even random noise as used occasionally in television for special effects (it is worth noting, in passing, that this general

argument will have a strong bearing upon the way in which the video element is coded in the next generation of interpersonal communication schemes – it may be that, to reduce the rate to a low enough value, we may have to accept tight constraints on the class of admissible source material; see Appendix 2). That image coding should have achieved such good, not to say remarkable, results in terms of data "compression" is already due, in part at least, to externally imposed constraints – most images which are traditionally used to test coding schemes have no more than moderate levels of spatial detail, and this over relatively restricted regions of the picture, as a whole, leaving large areas of substantially constant luminance which can be coded effectively with few bits. That, for such pictures, significant simple long-range structure does exist is responsible for the success of, for example, transform coding, associated with the most basic image model of all, the first order Markov model, with interelement correlation coefficient of maybe 0.9 or even higher (Clarke, 1985a). Compounding this success, so to speak, is the consideration that, in cases in which we expect extreme levels of compression (videotelephone, for example) we expect some associated degradation to occur and, on the other hand, where we demand high quality images (studio quality television) the amount of compression is not so great. If we wish to base a coding technique more specifically upon some image model, then the class of images which can be coded successfully is consequently restricted (for a good example of this, see Chapter 11, Section 11.6).

The relevance of the comments made above lies in the difference between the coding techniques to be described next and some of those widely used and successful methods dealt with in the previous chapters, in particular transform coding, based upon a square block structure of 8×8 or 16×16 elements, the development of which was undoubtedly stimulated by the availability of a large amount of matrix theory directly applicable for its analysis. A similar situation exists with respect to vector quantisation, where almost universally a 4×4 block size is employed. The corresponding disadvantage of arbitrarily dividing an image up into rectangular or square blocks is that, when the transmission rate is forced lower and lower, the block structure appears in the reconstructed picture and its regularity makes it particularly annoying to the observer. A further disadvantage which attaches especially to frequency-based schemes is that extreme degrees of compression are achieved by deleting high "frequency" coefficients with resultant blurring of fine detail. Sub-band and wavelet coding schemes bypass the first problem (as long as decomposition is started with the whole image and not a large initial sub-block) but not the second.

An alternative approach might be to consider the elementary properties of the image in the spatial domain and attempt to develop a coding method based on these. Can we define such properties, though? An example from the early history of transform coding may be illuminating here. The basic theory of the representation of spatial data demonstrates that the shapes of the basis

vectors used for this purpose should be as close to those of typical data vectors as possible. The "slant" transform (see Clarke, 1985a), whose basis vectors have the form of sampled "ramp-like" waveforms of various slopes, was developed to match the assumed property of picture detail that it was made up of regions of more or less gradually varying luminance. When tested against the DCT, on a wide range of images, however, its performance was found to be inferior, and it has consequently disappeared from the scene. The conclusion is that the DCT basis set, though it is only a data-independent approximation to the optimal (KLT) set, is more "like" the data, and the original assumption regarding the luminance/distance profile fails. It will take us an even shorter time to dismiss the idea that image data are regularly formed into neat 4×4 or 8×8 blocks for independent processing and, returning to a naïve view, perhaps we should consider that images are "of" objects which, as such, are likely to be made up of identifiable sub-regions which, in turn, probably have more or less well-defined contours surrounding areas of substantially uniform luminance, colour, texture or whatever. A coding technique might be devised, therefore, which segmented images into disjoint regions and coded the boundary information on the one hand, and internal luminance or "texture" data on the other. Such schemes break away from the restraint of regular block structure and have the additional advantage that, if well designed, edge detail is maintained even at low data rates. The price to be paid is an unnatural "contouring" effect which can make the detail seem artificial, but which nevertheless may be preferable to blurred, frequency domain processed images overlaid by a regular block structure.

6.1.2. Basic Ideas

It was recognised some time ago that advantages accrued in picture representation through the application of ideas of the kinds just described. Over 30 years ago the "synthetic highs" system was described by Schreiber *et al.* (1959) and later extended by Graham (1967). The image detail is split into a low-pass component and an edge signal, the latter being used to generate a "synthetic highs" signal which, when added to the low-pass filtered signal, reconstructs the original image. Graham generates the low-pass signal using a 3×3 low-pass filter and subsequent sub-sampling. The edge signal is detected using gradient or Laplacian operators and a contour tracing algorithm involving Huffman coding of the eight-connected (see Figure 6.1), contour direction signal. This component is used to synthesise the high-pass signal, which may be artificially accentuated if desired. Graham used a wide variety of 8 bit test materials, and achieved good reproduced quality with a compression factor ranging from 4 for a highly detailed crowd scene to 23 for a head and shoulders image.

The scheme shares some of the characteristics of sub-band coding in that

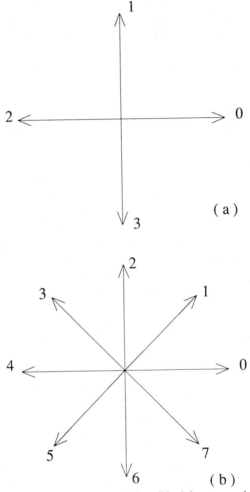

Figure 6.1 (a) Four-connectivity; (b) eight-connectivity.

the low-pass signal is generated by linear filtering of the input image. Instead of a complementary stage of high frequency detail generation, however, this information is only generated by the triggering of the edge detector thresholding operation, which ignores any low contrast fine detail (texture) within the objects themselves, which will also be automatically excluded by the low-pass filter. An alternative approach might therefore be preferable and, 10 years later, one was reported by Yan and Sakrison (1977). Briefly, in this scheme a piecewise linear approximation is fitted to the luminance levels along an image scanline and subtracted from the original detail to leave a residual signal of substantially reduced variance which is then Fourier transformed and coded using zonal selection of the coefficients. In comparison with pure

Fourier transform coding at the same rate (0.8 bit element^{-1}) better picture quality results, in particular with respect to sharpness of rendition of significant edge detail and minimisation of edge reconstruction artefacts. Obviously there is a tradeoff between allocation of coding bits to the edge straight line approximation and to the now "random-like" residual. A theoretical study of the optimum partition has been carried out by Mitrakos and Constantinides (1983).

Turning to ideas more in keeping with those mentioned in the Introduction, an initial problem in coding will be to extract significant objects from the picture, and it is probably true to say that, until very recently, in image processing as a whole more attention has been paid to the location of meaningful detail in images for purposes of object identification and classification than to any other task. An enormous variety of different approaches to this operation of image segmentation exists (see the reviews of Fu and Mui, 1981; and Haralick and Shapiro, 1985), and these can broadly be classified into three groups: thresholding, edge detection and region growing. With the first, image elements are classified according to whether their luminance value exceeds, or otherwise, a threshold determined by one of a number of different methods. A good survey of the approach is given by Sahoo *et al.* (1988) who include comparisons of many of the available approaches. Whilst the technique is easy to apply to images with simple, high contrast detail, it is not usually appropriate for the complex, variable contrast detail found in more typical picture input. Edge detection is another image processing operation regarding which the available literature is extremely extensive (for example Peli and Malah, 1982). Basic operations are described in many texts, for example Lim (1990), and there are also critical reviews of the comparative efficiency of such algorithms (Abdou and Pratt, 1979; Lunscher and Beddoes, 1986). Problems with edge detection in an image coding context are no different from those which affect its use in more general image processing – selection of the "best" threshold, edges more than one picture element wide, broken contours where no such discontinuity actually exists, susceptibility to noise, etc. – and usually necessitate additional pre- or post-processing steps to create an acceptable edge image, which themselves involve, since there is no theoretical basis for dealing with such matters, much *ad hoc* "tinkering" with threshold values, scale factors, etc. Thus, for example, Rajala *et al.* (1987) used a noise stripping filter which maintains edge detail to smooth homogeneous regions and remove isolated noise impulses prior to segmentation.

Such considerations are also relevant to the alternative method of image segmentation – region growing (Rosenfeld and Kak, 1982). In this case picture elements are grouped into regions provided that certain criteria are satisfied: similarity of luminance value to within the notorious "threshold" value, location in colour space, uniformity of texture, and so on. As usual several methods exist (Haralick and Shapiro, 1985). Single linkage schemes test neighbouring elements for similarity to construct regions over which the

chosen criterion is satisfied. Problems with undesired region linkage in the case of complex or noisy data limit the usefulness of this method, however, and hybrid extension of the method which includes a test over all elements in a finite neighbourhood can improve performance. An alternative is centroid linkage, in which the value of the next element in a conventional raster scanned image is tested against the mean value of already partially formed regions. The element is assimilated into the region with the closest mean value and the mean of that region updated, and so on. If no (partial) region has a sufficiently close mean value, the element is considered to be the first of a new region. Tests of varying statistical sophistication can be included in the comparison operation if desired; see, for example, Thyagarajan *et al.* (1987). One problem with the application of segmentation algorithms to image data is that, even with fairly large threshold values, very large numbers of regions tend to be produced. To reduce these numbers to levels which will allow realistic coding, a post-processing operation which merges adjacent regions with similar mean values is often introduced. Moreover, it is also possible to eliminate many of the smaller regions (maybe below 15 elements or so in extent) by including them in neighbouring regions even if the difference in the means is quite marked. Since such regions may constitute up to half of the total produced by the initial segmentation this step can have a significant effect upon the final coding rate.

Many methods for segmentation exist, and can be used separately or even in combination, as detailed by Haralick and Shapiro (1985). Since their paper, work in the area has continued, with, for example, the graph theoretic approaches of Morris *et al.* (1986) (later extended to colour data: Vlachos and Constantinides, 1992), and of Wu and Leahy (1993), and those of Aach *et al.* (1989) and Fouques and Cohen (1989). The application of "fuzzy" techniques is described by Kong and Kosko (1992), and of split and merge/quadtree methods by Benois and Barba (1992). Those which have been used in practice for image coding will be described below in association with their specific coding algorithms.

6.1.3. Practical Coding Methods

Over the past 10 years or so multicomponent coding techniques have experienced a revival of interest with our growing ability to perform high volume computational tasks in ever decreasing amounts of time. There are various approaches to the actual coding operation. Typical schemes will be described here, but it will first be useful briefly to consider the problems involved. There are basically two: having segmented the image into the desired number of regions, both the internal properties and the boundaries of the latter must be coded. Coding of the internal detail turns out to be the simpler operation. This conclusion is a necessary one in any case, since the whole approach rests

on the idea that the important information in the picture resides in the location of object edge detail, which must therefore be coded accurately and will thus use up the bulk of the available transmission/storage capacity. The simplest way of coding internal region information is to assume a constant value of luminance or colour over the area concerned. A more sophisticated approach is to fit a higher order polynomial surface to the region (see Kocher and Leonardi, 1986; Gilge, 1988; Lim and Park, 1988), although this is computationally more expensive and also requires accurate transmission of the polynomial coefficients. Depending upon the complexity of the image data being coded, it may be preferable to use up the additional number of bits in segmenting the image into more regions in the first place. Where a two-dimensional "straight-line" approximation is subtracted from the original image leaving a noise-like residual signal this can be coded using transform coding (but see the comments on coding such low-correlation signals in this way in Chapter 8, Section 8.4.3) or some sort of texture coding operation, maybe using a fractal approach (Jang and Rajala, 1990a,b; Franke and Mester, 1988; Franke *et al.* 1988).

Boundary coding has received much attention over the past 30 years or so as an essential element in the machine representation of all kinds of pictorial information (Freeman, 1961, 1974). The simplest method of boundary following is to use a four- or eight-connected chain code (see Figure 6.1). From a given starting point, a digitised contour can be traced by a sequence of moves in one of four or eight initial directions and thereafter three or seven subsequent onward directions, using 2 or 3 bits per link (connecting adjacent elements), respectively. Naturally, structured shapes do not have purely random boundaries, and therefore runs of the same or only slightly different directions are to be expected and may be more efficiently coded using variable word length run length coding. As mentioned, after the start only relative changes in direction need be coded (differential chain coding) (Freeman, 1978; Kaneko and Okudaira, 1985). Techniques showing further improvements are still being reported (Lu and Dunham, 1991).

An important consideration in the present situation is that coding of adjacent borders, particularly of large, well-defined areas, is redundant in the sense that only *one* need be coded. In such cases the common edge between regions can be coded using a four-connected differential chain code, as described by Rosenfeld and Kak (1982). This so-called "crack" code is shown in Figure 6.2, and it has also been studied by Grzeszczuk *et al.* (1992) in this application.

Influential in this general area has been the work of Kunt *et al.* who, in a much referenced paper (1985), rightly emphasise the significance of the synthetic highs work of Schreiber *et al.* (1959) and the desirability of incorporating HVS models, at least in principle, into coding schemes in order to try to improve their efficiency. After all, such matters as the sensitivity of the eye to edge detail, the masking effect of large, abrupt luminance transitions and the

Figure 6.2 "Crack" code for single boundary representation.

(approximately) bandpass spectral response of the HVS had all been appealed to in such attempts prior to Kunt's paper. Nevertheless alternative coding methods of much interest are described in the drive to reduce coding requirements below those corresponding to the asymptotic level of compression (somewhere around 10:1) which had been reached in the early 1980s. Of particular interest here are two-region based approaches and directional decomposition. To consider the latter first; image detail is analysed by a set of directionally sensitive filters responsible for detection of edge detail of various orientations, together with a low-pass filter responding to slowly varying background information. Edge locations are defined by the zero crossings in the filter outputs, the positions of which are run length coded using a Huffman code, and the low frequency signal is zonally Fourier transform coded with linear quantisation of coefficients. Using eight directional filters favourable results are obtained which demonstrate the enhanced ability of such a technique to retain edge detail at low rates when compared with transform coding. At the same time, however, other artefacts are present, such as contouring and loss of internal detail in coded regions. The method is described in more detail by Ikonomopoulos and Kunt (1985), and a simplified scheme of this type is reported by Lee and Liu (1989). The other technique referred to above is region/contour coding. Here a more conventional region growing and subsequent merging algorithm of the kind described earlier is used. Regions are coded first using a first order polynomial approximation with pseudo-random Gaussian noise added after reconstruction to improve the naturalness of the result. Contours are coded either exactly or by linear or circular arc approximation. Although reconstructed images retain the sharpness of their edge structure, they have an unnatural look caused by the poorer rendition of internal detail due to the use of a first order polynomial com-

pared with the transform coding operation used in the directional scheme. Jang and Rajala (1991) also invoke the characteristics of the HVS in a further application of their texture segmentation strategy.

By the mid 1980s transform coding had reached a high state of development and had become a natural "benchmark" against which to compare other algorithms. In a comparison Biggar *et al.* (1988) (see also Biggar and Constantinides, 1988) segmented their data using a recursive "shortest spanning tree" (RSST) technique (Morris *et al.*, 1986) in which the number of regions in an $N \times N$ image is initially N^2 (i.e. each region is a single element). Progressive removal of links from the associated graph onto which the image is mapped effects the merging of neighbouring regions, and is done against a cost function which minimises the squared error between the original and segmented images. Edge representation is carried out by coding the boundaries between regions using a modification of the method of Kaneko and Okudaira (1985). Internal regions are coded with polynomial approximations of orders 0, 1 and 2. At a given transmission rate, the relatively simple zero order approximation (constant region luminance) was found to be preferable both subjectively and in terms of measured SNR. Comparison with a "classical" DCT coder with Laplacian coefficient quantisation shows that, at rates above 0.4 bit element^{-1}, the transform coder has somewhat better performance, but below that the segmented coder retains edge detail at the cost of some unnaturalness in appearance.

As usual, a multiplicity of alternative techniques is available for the development of segmented coding schemes of varying degrees of sophistication. Nobakht and Rajala (1987) use a low-pass/logarithmic/high-pass HVS model (Hall and Hall, 1977), together with a probability of detection measure to discriminate between areas of high perceptual relevance and inessential background. Coding of the resulting "mask" is done in the form of a binary image for location and zonal transform coding for element intensity. Good compression figures are reported but the scheme is complex. Again, Kwon and Chellappa (1993) reconstruct their texture regions using two-dimensional non-causal Gauss–Markov models. On the other hand, reasonable results are achievable using simpler methods. Soryani and Clarke (1992) considered intraframe segmented coding as part of an investigation into the application of such techniques to head and shoulders image sequence coding (see Chapter 11, Section 11.3). As a first step it was considered useful to concentrate coding capacity in the area where detail is most significant and this was done by using a simple face locating algorithm together with adaptive thresholds for the initial segmentation, region merging and small region deletion steps, in conjunction with a conventional centroid linkage algorithm. Adaptive segmentation is illustrated in Figures 6.3–6.5. Figure 6.3 shows an original image, Figure 6.4 the result given by non-adaptive segmentation and Figure 6.5 by its adaptive counterpart with lower thresholds over the actual face area. Boundary coding was carried out by using the edge coding algorithm

Figure 6.3 The original MISSA image.

Figure 6.4 Non-adaptive segmentation of the MISSA image.

Figure 6.5 Adaptive segmentation of Figure 6.3. Lower thresholds are used over the facial area.

described earlier (a typical edge image is shown in Figure 6.6). Although at very low rates artefacts are clearly apparent, results are better than those obtained by using the DCT. This is shown in Figures 6.7–6.11. Figure 6.3 contains the original MISSA image, Figure 6.7 the same image coded at 0.14 bit element^{-1} using the DCT, and Figure 6.8 segmented coding at the same rate. Figures 6.9–6.11 illustrate the same comparison for CLAIRE. The technique was extended to the coding of colour images, when it was found that utilising the segmentation information derived from the luminance (Y) signal for chrominance (U,V) segmentation was preferable to either independent segmentation of Y U V components or vector segmentation in a three-dimensional colour space. Plate 1 shows a MISSA frame coded in this way at 0.3 bit element^{-1}. An alternative colour image segmentation technique is described by Vlachos and Constantinides (1992), which is an extension of the graph theoretical approach of Morris *et al.* mentioned earlier, and Horita and Miyahara (1991) adopt a clustering technique based on the uniform luminance and chromaticity system (ULCS) colour representation. A somewhat different approach is adopted by Alter-Gartenberg and Narayanswamy (1990). Here a bandpass filter model of the HVS edge detection mechanism is used to respond to edge detail and to generate so-called "edge primitives", which can be coded and subsequently used to reconstruct not only the edge structure but also the intervening intensity values of the image. Encouraging

Figure 6.6 A typical boundary image in segmented coding.

Figure 6.7 MISSA coded at 0.14 bit element^{-1} using the discrete cosine transform.

Figure 6.8 MISSA coded at 0.14 bit element^{-1} using segmented coding.

Figure 6.9 The original CLAIRE image.

Figure 6.10 CLAIRE coded as Figure 6.7.

Figure 6.11 CLAIRE coded as Figure 6.8.

results are obtained on images with simple and well-defined detail. Wu (1992) reports an adaptive tree-structured algorithm which will operate in a progressive transmission environment, and Shen and Rajala (1992a) consider segmentation-based texture coding in a packet video environment (see Chapter 12).

6.1.4. Discussion

Edge/region-based coding techniques represent a logically correct move away from simple block-based schemes towards the coding of real objects in a scene. Unfortunately, they are beset by two major problems which may well prevent any "order of magnitude" increases in efficiency in their application. The first is the extreme difficulty of producing a segmentation of objects in a picture with anything more than a tiny fraction of the competence with which the HVS carries out this operation, even given the enormous volume of past work and published material on the topic. There seems to be no way of building up a coherent mathematical approach to this problem (readers will have noticed the absence of equations and other formal relationships in this section) and most algorithms appear to operate on a basis of "try it – if you don't like the results tinker with the threshold(s)". In comparison with a statistical method such as transform coding, it is probably true to say that no little contribution to the success of the latter is the result of the ready applicability of an extensive array of mathematical results to the design problem. The other difficulty lies with the efficiency of edge coding: we are probably near the minimum rate at which edge detail can be coded (say around 1.5 bit per edge element) and yet, given the accuracy with which the eye demands the reconstruction of this component, and the fact that, to be any use at all, the average image must in all probability contain *some* detailed regions, this represents another bar to really efficient segmented coding. The writer would reiterate his view, however, that coding of objects, rather than of arbitrary block detail, is unquestionably the correct long-term approach to image coding.

6.2. BLOCK TRUNCATION CODING

6.2.1. Introduction

More than one spatial image coding technique is based upon approximation of a small data subset in such a way that it is easier to store and/or transmit. Thus each block coded by vector quantisation, for example, is represented by its closest counterpart in a predetermined and relatively small codebook

known to both transmitter and receiver. During the late 1970s, when vector quantisation was being exploited for the coding of speech signals, a simple technique was developed, specifically for image data, by Delp and Mitchell (1979). This approach is known as block truncation coding (BTC) and has the basic structure of a two-level adaptive quantiser. Whilst not capable of producing extreme degrees of compression, it is very simple to implement and has gained for itself a noticeable, if not particularly significant, niche in the image coding "hall of fame". Whereas vector quantisation relies upon approximation of the data block by a close codebook entry whose structure is already known, BTC operates by converting the block into a simpler form which nevertheless preserves some of the original statistics – in the basic form the first two moments.

6.2.2. The Basic Technique

Consider a small (typically 4×4) data block containing n elements, $\{x_1, x_2, x_3, \ldots x_n\}$. We have:

The mean

$$x_m = (1/n) \sum_{i=1}^{n} x_i \qquad (6.1)$$

The mean square

$$x^2 = (1/n) \sum_{i=1}^{n} x_i^2 \qquad (6.2)$$

and the variance

$$\sigma^2 = x^2 - (x_m)^2. \qquad (6.3)$$

A threshold x_t is set such that

If
$$\begin{array}{l} x_i \geq x_t \quad \text{then} \quad x_i = b \\ x_i < x_t \quad \text{then} \quad x_i = a. \end{array} \qquad (6.4)$$

If we set $x_t = x_m$, with q the number of $x_i \geq x_t$, then to preserve x_m and x^2,

$$n\, x_m = (n - q)a + q\, b \qquad (6.5)$$

$$n\, x^2 = (n - q)a^2 + q\, b^2 \qquad (6.6)$$

with the result

$$a = x_m - \sigma\, (q/(n - q))^{1/2} \qquad (6.7)$$

$$b = x_m + \sigma\, ((n - q)/q)^{1/2}. \qquad (6.8)$$

[Note: the ($^-$) notation used with respect to σ and σ^2 in the original and most

other papers seems spurious.] The data block is thus represented by values of x_m and σ, and a bit map (1 bit – 0 or 1, per element) indicating whether each element lies above or below the threshold. For a 4×4 block the total bit count is thus 8 plus 8 (assigned to x_m and σ) plus 16 for the bit map, giving a rate of 2 bits element^{-1}. Flat areas are represented by blocks with close values of a and b, active ones (regions of large luminance changes) by more widely spaced values (greater effective quantisation intervals) for which the increased luminance activity tends to mask the larger amount of quantisation error. As might be expected with a spatial technique, edge detail tends to be preserved to a greater degree than with transform coding. Good resistance to channel errors is also reported.

It is possible to reduce the reconstruction error somewhat at the cost of more calculation. Thus a fidelity criterion (mean square, or mean absolute, error) may be selected and then a and b found by minimisation over the block by exhaustive search over every possible threshold value. Again, data rate may be lowered by coding x_m and σ with fewer than 16 bits. Ten is suggested as adequate in most cases by Delp and Mitchell (six for x_m and four for σ), giving a rate of 26/16, i.e. approximately 1.6 bit element^{-1}. A further modification is to relax the requirement that $x_t = x_m$ and use instead the constraint that the first three moments be preserved. Additionally a hybrid approach is reported by the authors in which BTC is applied to the difference image which results when a zonally coded DCT image is subtracted from the original, although it should be said that allocating the overall data rate in this situation (1.9 bit element^{-1}) to a pure transform coding operation would probably produce a superior picture.

The results obtained in the simple case have also led other workers to consider whether inclusion of higher moments might result in better performance. Halverson *et al.* (1984) have shown that, whilst preserving pairs of higher moments can sometimes lead to such improvement, it is not worthwhile when using three moments and, in fact, has a detrimental effect in both cases where binary images are concerned. This approach was subsequently made adaptive by the authors (Griswold *et al.*, 1987) by selecting for each block the choice of nth or $2n$th moments ($n = 1 \rightarrow 4$) which individually yielded better performance.

6.2.3. Other Developments

As usual, many variants on the basic theme are possible and have duly been investigated. Arce and Gallager (1983) employed median filtering of the bit plane signal to generate a signal requiring a smaller number of bits for representation than the original (see also Zeng *et al.*, 1991). When applied to a signal, median filtering has the property that, if used repeatedly, the output signal converges to one invariant to further filtering – the "root" signal (Arce

(a) (b)

(c) (d)

Figure 6.12 (a) The original GIRL image. (b) Basic block truncation coding of the GIRL image at 2 bits element^{-1}. (c) Root filter block truncation coding of Figure 6.12a. (d) Table look-up block truncation coding of Figure 6.12a.

and Gallager, 1982). This signal needs only 12 bits instead of the original 16 (for a 4×4 block) and thus its use reduces the bit-rate (using 10 bits for x_m and σ) to about 1.3 bit element^{-1}. An example of this approach is shown in Figures 6.12(c) and 6.13(c). Figures 6.12(a) and 6.13(a) show the original GIRL and FLAT images, Figures 6.12(b) and 6.13(b) the basic BTC scheme operating at 2 bits element^{-1}. The root filter method is shown in Figures 6.12(c) and 6.13(c) and the results of applying a table look-up approach in Figures 6.12(d) and 6.13(d). Here advantage is taken of the fact that some bit patterns are more likely than others and an 8 bit code is used instead of the original 16 bits. Results (at 1.5 bit element^{-1}) are decidedly worse than for the previous method.

An alternative to the preservation of the moments of Equations (6.1) and (6.2) is that of preserving absolute moments (Lema and Mitchell, 1984). Instead of Equation (6.3), for example, we then have:

(a) (b)

(c) (d)

Figure 6.13 (a) The original FLAT image. (b) Basic block truncation coding of the FLAT image at 2 bits element^{-1}. (c) Root filter block truncation coding of Figure 6.13a. (d) Table look-up block truncation coding of Figure 6.13a.

$$\alpha = (1/n) \sum_{i=1}^{n} |x_i - x_m|, \qquad (6.9)$$

the sample first absolute central moment. The resulting equations for quantiser output levels are simpler than in the case of conventional BTC and this leads to faster computation. It turns out that the overall mean square, or mean absolute, error is slightly less also. Colour images have been coded in the YIQ space using 2×2 I, and 4×4 Q, sub-sampling to give an overall rate of around 2 bits element^{-1} for an originally 24 bit RGB image. A comparison between absolute moment block truncation coding (AMBTC) and the classical minimum mean square error quantiser is given by Ma and Rajala (1991b). A similarly simplified approach to ease implementation is that of Udpikar and Raina (1985) who preserve only the separate means of those elements above and below the threshold. In this case the threshold value is taken as the

overall block mean and the quantiser output levels are the separate values of upper and lower means. Zeng (1991) reports an interpolative scheme employing stack filters (Wendt *et al.*, 1986), whilst Hui (1990) imparts adaptivity by classifying 4 × 4 image block activity into three categories – low, medium and high by reference to the block standard deviation. Low activity blocks are represented simply by their mean value, medium activity blocks have BTC applied, and high activity blocks use a four level quantiser. At a rate of 2 bits element^{-1} significant reductions in blockiness and ragged edge reproduction are reported. A similar approach, but separating the blocks according to: (a) uniform areas – coded using the mean value; (b) blocks containing an edge – coded using a quadtree approach (see Chapter 7); and (c) blocks containing texture – coded with BTC, is described by Nasiopoulos *et al.* (1991). Two further improvements to block truncation coding are reported by Kamel *et al.* (1991). First a variable block size hierarchy is used, in which the starting size is greater than usual (8 × 8, for example). BTC then follows, with possible block subdivision dependent upon the level of block activity, down to a minimum size of 2 × 2. Second, the optimal (mean square) minimising threshold is established by generation of a histogram of block values.

At the cost of increased computation, BTC can be combined with other techniques to yield improved performance, as is shown by Udpikar and Raina (1987) who vector quantise the mean values and bit plane of their version of the algorithm referred to above, using 256 entry codebooks for the two- and 16-dimension vectors representing the pair of mean values and the 4 × 4 binary plane. Reasonable results at an overall rate of about 1 bit element^{-1} are reported. BTC/VQ coding is also reported by Efrati and Liciztin (1991). A combination of sub-band coding and absolute moment (AMBTC) is described by Ma and Rajala (1991a), whilst Tzannes *et al.* (1990) apply BTC to the array of retained coefficients in a transform coding scheme.

The originators of the technique returned to the fray with the application of BTC to predictive coding (Delp and Mitchell, 1991). BTC is applied to 8 × 8 blocks of error signals derived from a two-dimensional non-adaptive predictor. The quantiser is allowed to adapt anew for each block. The output signal is an 8 × 8 bit plane together with a 4 and 3 bit representation of error signal mean and standard deviation, respectively, and the data rate is thus around 1.1 bit element^{-1}. Gilding the lily, so to speak, Wu and Coll (1991) combine BTC, VQ *and* transform coding in a scheme which is claimed to combine the advantages of all three methods at compression levels about 10:1 (0.8 bit element^{-1}). Here AMBTC is applied to 4 × 4 blocks of the original $N \times N$ image, the bit maps are coded using VQ as described previously, and the $N/4 \times N/4$ arrays of high mean and low mean values for each block are coded using the adaptive DCT. Reduced computation compared with either VQ or DCT alone results since (a) the bit map is only a binary array and (b) the two mean arrays to be transform coded are only 1/16th the size of the original image. Lu *et al.* (1991) reported a differential BTC scheme, and Nasipuri *et*

al. (1991) implemented a hierarchical pyramid approach. Wu and Coll, in a further development (1992), coded colour images by taking advantage of the correlation between colour planes to generate a single weighted bit map instead of separate ones for R, G and B signals.

6.2.4. Discussion

Block truncation coding is a simple image coding algorithm which produces good results at moderate degrees of compression. Unfortunately, there does not seem to be any way of dramatically increasing its performance to make it competitive with more complex algorithms (except by combining it with such approaches) and its virtue of simplicity, on the other hand, is becoming more and more undermined by the ever increasing speed and flexibility of processing devices which allows those more sophisticated techniques to be implemented with equal ease.

6.3. "FRACTAL" IMAGE CODING

6.3.1. Introduction

Image coding (to the great relief of most of its practitioners) is a discipline which has rarely entered the limelight of public scrutiny. We may be thankful that this is generally true of scientific and engineering research matters, for when the opposite happens and recent "discoveries" are exposed to widespread view the results are almost always, at the very least, unfortunate (high temperature superconductors, fusion in a test tube, apparent discovery of planets outside the solar system, etc.). With the growing interaction between all types of computed imaging and information networks (especially television), however, advances in the picture processing domain have tended more and more to emerge from the research laboratory to be laid before the public. A singularly unfortunate example of this during the past decade has been the coincidence between increasing interest in so-called "fractals" (Mandelbrot, 1983) and the rapidly increasing availability of personal computers with advanced graphics capabilities which allow wonderful, multicoloured "scale-invariant", "self-similar" patterns to be generated, remarkably enough from the simplest of mathematical relations. Such "fractal" images are often said to be geometrically complex and yet have low information content. Whilst such patterns bear no immediate resemblance to natural images, it is but a short step to asking whether or not a similar process might be used to generate such scenes, and thus to open up the way to very efficient representations of natural objects. From that point the move to extremely low-rate transmission of digital

pictures is obvious. Coupled with the emergence of standards (see Chapters 3 and 10) for such applications and the natural desire of commercial organisations to reap the benefits to be achieved in this area, the resulting mass of ill-informed speculation in the popular technical press on a complete solution to the "image coding problem" has generated just that situation referred to at the start of this section, and this has been exacerbated by the fact that, until recently, the only other sources of information on the topic have been highly theoretical papers appearing mainly in mathematical journals. Only of late, however, has more information appeared of actual details of fractal coding algorithms operating on natural images, and the results therein embodied will be discussed in the sections which follow.

It is well known that one of the ideas discussed by Mandelbrot in connection with the notion of a FRACTional dimensionAL space is that of determining the extent of an irregular coastline with measuring devices having a variety of different lengths. Briefly, as the "yardstick" gets shorter it traces more and more accurately the microscopic detail of the land/sea interface, leading to an increase in the apparent length. A good example of this is given by Dennis and Dessipris (1989), where the relation

$$L_k = L_1 \times k^{1 - D} \tag{6.10}$$

defines the length obtained with a measure of length k units in terms of that determined for a measure of length one unit (L_1) and the fractal dimension D. Its justification is experimentally verified by plotting $\log (L_k)$ against $\log k$ and noting that a straight line with slope $1 - D$ results, with D increasing with coastline "roughness". Such an effect does not occur when simple geometric shapes are measured in this way.

Accompanying this observation is that of "self-similarity". Within limits, the "look" of the coastline does not depend upon the distance from which a map of it is viewed – it has the same sort of "wiggliness" whatever scale is considered. This kind of self-similarity can be described as statistical – the wiggles are not exactly magnified or reduced copies one of the other, it is the general impression which remains the same. The alternative kind of self-similarity, deterministic, is a much rarer animal; unfortunately so, because it is upon this kind that the more publicised notion of fractal image coding depends.

6.3.2. Application of Fractals in Image Coding I

Before considering the approach to image coding purporting to use fractals, about which there has been so much commotion recently, it is worthwhile looking briefly at two other ideas in this area, for the first of which there is, given the above relationship, arguably more justification for calling it a "fractal" coding technique. The method of Walach and Karnin (1986) is derived

directly from the coastline measurement concept, which is applied to the sequential luminance values along an image line, looked upon as the vertical (i.e. latitude) coordinates of the "coastline". A yardstick of fixed length is stepped along the luminance profile and the horizontal coordinates of distance travelled and a sign value (up or down) recorded, coded and transmitted. Obviously it is easy for the decoder to reconstruct the discrete luminance profile. The amount of compression can be traded off against the reconstructed picture quality by simply changing the yardstick length. The system is also automatically adaptive, in that spatial resolution is decreased in smooth areas and increased where sudden luminance discontinuities (edges) are present. For a 256×256 8 bit image, with 2:1 vertical sub-sampling, subsequent interpolation and a yardstick length of 15, good quality reproduction of a not too detailed image was achieved with an entropy of 0.6 bit element^{-1}. This idea has been extended by Zhang and Yan (1991) to include a prediction operation vertically between the current line being encoded and the previous decoded one. Additional coding (using the same basic technique) of the resultant error signal brings the amount of compression up from 7.6 to 12.4 (LENA image) and the SNR up from 31 to 35 dB.

The other area in which fractal measures can be applied in the present context is the use of fractal dimension to indicate the roughness of textured areas in an image as a first step in region segmentation for the purpose of coding (see section on segmented coding). Jang and Rajala (1990a,b) segmented regions in this way into those of (a) constant intensity (b) smooth texture and (c) rough texture. Dimension thresholds between (a) and (b) and (b) and (c) are, respectively, 2.16 and 2.33 (contrasted with a value of 2 for a flat surface). Good quality reconstruction is claimed at about 0.2 bit element^{-1}. A similar approach to region segmentation is used by Ma and Vepsalainen (1990).

6.3.3. Application of Fractals in Image Coding II

Undoubtedly the "fractal" coding technique which has created the most interest over the past few years is that involving so-called iterative contractive transformations, of which the main proponent has been Barnsley (see Barnsley and Sloan, 1988). The technique is, on the face of it, very simple. For an image which consists of a single well-defined object one hopefully recognises a large degree of deterministic self-similarity, leading to the conclusion that constituent parts of the representation can be formed by geometric transformations of the object itself. To ensure stability, single transformations should be contractive [collections of such need to be contractive overall; see Jacobs *et al.* (1992)], and they consist of translations, rotations and scalings according to parameters which somehow need to be determined. The notorious "fern" image is a good example. Each of the "fernlets" (and indeed even

the stem) is made up of such transformations of the whole image. Once found, the transformations themselves are sufficient to reproduce the complete image. Where a picture contains a number of different objects the above principle is applied to each. In any case, all regions of the total image need somehow to be reconstructed from the appropriate transformation codes. A critique of the method follows; first we discuss the operations involved. Almost all of the descriptions of so-called "fractal coding" which have been published are either extremely mathematical or excessively trivial; of the rest, by far the most accessible are Waite (1990) and Beaumont (1990, 1991). Here we employ the minimum of mathematical formulation, leaving all proofs to the references.

6.3.4. Iterative Transformations

6.3.4.1. Fixed Points and Contractive Mappings

The first stage in the process (conceptually, at least) is to consider how the original image might be represented by some collection of self-transformations such that together they represent, at least approximately, the image itself. To do this it is not possible to employ transformations of an arbitrary nature. For coding they need to be contractive overall (see above) and result in a unique "sub-image" which consists of the original suitably shifted and distorted geometrically according to the coefficients of the transformation. This "fixed point" or attractor turns out to be independent of the original starting image (once the correct transformation is found) and to be the limiting value of successive iterations of the transformation. A simple example is given by Waite which can be generalised to any operation of the form

$$f(x) = a x + b \tag{6.11}$$

(considering only one dimension for the moment). Suppose we now iterate Equation (6.11) starting with x_0. Then:

$$x_1 = a x_0 + b$$

$$x_2 = a x_1 + b = a^2 x_0 + a b + b$$

and so on. After n iterations

$$x_n = a^n x_0 + b \sum_{r=0}^{n-1} a^r. \tag{6.12}$$

In the case of a contractive mapping $a < 1$ and so, in the limit,

$$\lim_{n \to \infty} x_n = b \sum_{r=0}^{\infty} a^r = b/(1 - a). \tag{6.13}$$

Thus the starting value (starting image for iterative reconstruction) x_0 drops out of the equation and the result is a function of the mapping coefficients only. It is obvious that convergence is more rapid if a is not very close to 1. Furthermore, that $b/(1 - a)$ is indeed the fixed point can be demonstrated by substitution in Equation (6.11):

$$f(b/(1 - a)) = a\, b/(1 - a) + b = b/(1 - a). \tag{6.14}$$

Using the above example, the application of such a transformation to information transmission may be simply demonstrated, although such a one-dimensional approach would hardly be used in practice! Suppose we wish to send the number 15. We could transmit the relationship of Equation (6.11) together with the values $a = 1/3$, $b = 10$. The decoder would then iterate

$$x_n = a\, x_{n-1} + b$$

from any arbitrary x_0. If $x_0 = 0$, x_1 is 10, x_2 is 13 and 1/3, etc.

In the case of (two-dimensional) images the transformations have the form

$$X = a\,x + b\,y + c$$
$$Y = d\,x + e\,y + f, \tag{6.15}$$

where X and Y are the new locations, x and y the original ones and there are six transformation coefficients $a \rightarrow f$. The effect is still the same, however, starting from any arbitrary image (even a blank screen) the iterated transformation, once found, converges to the required sub-image. This is illustrated in Figures 6.14(a)–(c). Figure 6.14 is the original TREVOR picture, Figures 6.14(b) and (c) demonstrate the reconstruction of the image starting from a black screen and the picture of CLAIRE, respectively. Note that, so far, only shape has been considered. In practical coding applications grey scale (the third dimension) needs to be taken into account. This matter is dealt with below.

The contractive transformation has certain properties which are succinctly summarised by Barnsley *et al.* (1986). Indeed, this paper, barely three pages long, contains most of the important results relating to the basic application of contractive mappings in image representation. Thus Barnsley defines an iterated function system (IFS) as a metric space K together with a collection of contractive mappings w_i, $i = 1 \rightarrow n$ such that

$$d(w_i(x), w_i(y)) \le a \cdot d(x, y) \qquad x, y \in K, \tag{6.16}$$

where d is some suitable distance function. The complete mapping of subset A in K is then

$$\underline{w}(A) = \cup\, w_i(A) \tag{6.17}$$

and the contraction mapping has

$$d(\underline{w}(A), \underline{w}(B)) \le a \cdot d(A, B) \qquad A, B \in K \tag{6.18}$$

(a)

(b)

(c)

(d)

Figure 6.14 (a) The original TREVOR picture. (b) Iterated function reconstruction of the TREVOR image starting from a blank screen. (c) Iterated function reconstruction of the TREVOR image starting from the CLAIRE image. (d) Iterated function coding of the TREVOR image at approximately 1.5 bit element^{-1}.

(NB. In fact this is a simplification of the original result. The reader is referred to the original paper for more details.)

Given the transformation, the attractor Θ may be iteratively determined as a function of the w_i, but in terms of arbitrary image representation a much more significant operation is to determine the transformation which will produce a given attractor. In fact it is significantly easier to determine an attractor L which approximates the one desired (Θ), and its validity as a representation of the desired result is established by an important theorem given by Barnsley *et al.* (1986) – the collage theorem.

6.3.4.2. The Collage Theorem

For the above system $\{K, w_i: i = 1 \rightarrow n\}$ if, for subset L

$$d(L, \cup w_i(L)) < e \quad (e > 0) \tag{6.19}$$

then

$$d(L, \Theta) < e/(1 - a). \tag{6.20}$$

Thus, if the distance between L and the totality of contractive mappings $\cup w_i(L)$ is sufficiently small, then L and R will be close to the extent that $e/(1 - a)$ is also small (i.e. a is not too near 1). The name of the theorem derives from the "collage"-like operation of assembling geometrically scaled and shifted copies of the original image to cover, as closely as possible, the original outline. This is an important result for contractive transformation coding for, if it can be achieved with a small number of transformations, then large degrees of compression will be possible, with complex shapes represented by the few coefficients needed. In practice it is not so straightforward, and this limits the degree of compression available.

To summarise the procedure so far: the original image is broken down into manageable regions, each of which is to be separately represented (interesting images are too complex, as single entities, ever to hope that a collage of transformations of the one original image might be used to cover it well enough for the purposes of representation). Each subsection is then covered with a set of transformed versions of itself and the coefficients of each transformation found. These are coded, sent to the receiver and the transformations iterated on any convenient starting image to reconstruct the original. How far success has been achieved in practice is discussed below.

6.3.5. Practical "Fractal" Coding

A critique of the method is given in the next section. However, at this point it is essential to bear in mind the fact that we are concerned here with the coding

of actual natural images such as might have been captured by a television camera, and not computer graphics constructs which, at a cursory glance, look somewhat like natural objects. This has a strong bearing upon the degree to which the collage operation will be successful.

In fact, in all the cases reported in the literature so far, it has been necessary to reduce the contractive mapping operation to a very primitive level; one, in fact, which operates on square image sub-blocks only and this, given the massive publicity which heralded the introduction of the technique and the adverse comments made more than once (here and elsewhere) by the present author and others regarding block-based coding schemes, can only be regarded as very disappointing. The most accessible description of the coding scheme is given by Jacquin, based upon his 1990 ICASSP presentation [Jacquin (1990, 1992); both, unfortunately, containing some notational confusion]. In this implementation an original 256×256 or 512×512 6 bit image is partitioned into non-overlapping square RANGE cells R_i of dimension $B \times B$ (parent) or $B/2 \times B/2$ (child) with B typically eight. This two level division allows adaptivity to be imparted to the coding operation by the use of small blocks in detailed areas. A contractive transformation τ_i has to be determined such that, for every i, its application to a DOMAIN cell D_i results in an acceptably close approximation to R_i. The domain cells D_i are drawn from the original image with size $D \times D$ (parent), $D/2 \times D/2$ (child), where $D = 16$, and are obtained by taking successive (overlapping) 16×16 blocks with new start points separated by B or $B/2$ picture elements horizontally and vertically. τ_i is split into two parts, a geometric part S_i which is a simple 2×2 average over D_i for the usual case when $D = 2 \times B$ and a so-called "massic" part T_i which affects the block luminance values, for example grey-level shift or contrast scaling, or the block element distribution (reflection about various axes of symmetry or rotation through multiples of $\pi/2$). Single blocks can thus give rise to many contributions to the pool of possible candidates for a particular range block match.

Global search for a good match between an arbitrary range cell and the appropriate member of the totality of domain block pool entries is unnecessarily wasteful of time and so an idea is borrowed from the early development of vector quantisation (Ramamurthi and Gersho, 1986b). Domain blocks are classified as shade (predominantly smooth grey scale profile), edge (strong intensity changes, probably at an object boundary) or mid-range (moderate gradient but no definite edge or detail orientation). Shade range blocks are simply coded with their average luminance value, and shade domain blocks thus take no part in the transformation procedure. Mid-range blocks employ a transformation consisting of contrast scaling and luminance shift:

$$T_i(S_j(D_j)) = \alpha_i(S_j(D_j)) + \Delta g_i, \qquad (6.21)$$

where α_i takes on one of the values $0.7, 0.8, 0.9, 1.0$ and Δg_i is set to maintain the average grey level of the range block. Edge block coding employs histo-

gram-based segmentation and a transformation which incorporates contrast scaling, luminance shift and reflection or rotation. Here α_i can take on values in the range 0.2–0.9. Following search of the appropriate segment of the domain block pool to determine the best match, each range block will have associated with it all the parameters of the contractive transform necessary for its reconstruction. These are passed to the decoder, and iteration, as explained above, reproduces an approximation to the original picture. The whole operation may be carried out at the "parent" level, cell size $B \times B$, or on two levels with sizes $B \times B$ and $B/2 \times B/2$, when the original match at parent level may be split into four child level matches. For each of these the distortion is computed which, if found excessive, involves the retention of the child transformation in the coding. Using the 6 bit LENA image, convergence is achieved within eight iterations, and a PSNR of 28 dB obtained at 0.7 bit element^{-1}. Very good fidelity is claimed, but the photographic reproduction in the paper does show a number of significant artefacts, as does the included error image. The overall result appears comparable with that achieved by a medium complexity vector quantiser.

A modification of Jacquin's scheme is reported by Beaumont (1991), who also gives a clear exposition of the basic principles of the technique. He uses 12×12 domain and 4×4 range blocks and starts the reconstruction iteration on an image consisting of 4×4 range block means instead of a blank screen. Only one step is then necessary. The same mean image is used at the coder, being subtracted from the original image so that only the resulting (high-pass) difference image containing edge and other details needs further processing. Similar results to those of Jacquin are obtained. Minor modifications introduced by Oien et al. (1991) have resulted in a somewhat higher PSNR (31 dB) and lower rate (0.5 bit element^{-1}), albeit using an 8 bit image. Monro and Dudbridge (1992a) simplify the coding technique by using a least-squares approach for coefficient determination of a contractive transformation which, in the simplest case, maps an 8×8 grey scale block into four smaller squares whose union is an approximation to the original block. Good results have been achieved at a compressions of 8:1 (see also Monro and Dudbridge, 1992b). Unfortunately, it has not proved possible to achieve good results with the technique in the author's laboratory. Figure 6.14(d) shows the result of coding Figure 6.14(a) with a version of the basic algorithm at 1.5 bit element^{-1}. Degradation of detail is apparent, especially at edges, and it is conjectured that, by optimising this version of the algorithm, the rate could only be brought down by a further factor of two.

Pentland and Horowitz (1991) have invoked the "fractal" idea in relation to the self-similar nature of the various levels of decomposition in a wavelet hierarchy. Using vector quantisation of the different sub-bands, histograms are generated for mappings of the codewords between various levels and conditional probabilities determined by means of which VQ codewords can be recoded utilising interband redundancy. Results are very good at a rate of

0.125 bit element^{-1} (PSNR 32 dB) using a reasonably highly detailed image but, as with other schemes including the magic word "fractal" in the title, the relation between this and what otherwise might just be called another wavelet/predictive VQ scheme is tenuous.

6.3.6. A Critique of "Fractal"-based Image Coding

A naïve observer of the image coding scene might be forgiven if, having read all the glowing reports of the technique in the popular technical press, he gained the impression that the image coding problem had been solved, and that there was therefore nothing more to do. He might further be forgiven, though, for asking, before he folded his tent and disappeared into the night, one or two questions of the "I only ask because I want to know" variety, starting with "what has all this got to do with fractals anyway?" The answer to this question is, of course, "it all depends on what you mean by (a) fractal". Mandelbrot who, after all, coined the term originally, appeared quite reticent when addressing this matter (Mandelbrot, 1983). He refers to ideas of statistical regularity and irregularity, and scaling in the sense that these properties are identical at all scales, and uses the term "natural fractal" to refer to a natural pattern that is "usefully representable" by a fractal set (his p. 5). This latter is defined (p. 15) as a set for which "the Hausdorff–Besicovitch dimension strictly exceeds the topological dimension". It seems clear, then, that the term fractal has no *necessary* connection with the image coding application, indeed the results embodied by Barnsley *et al.* (1986), directly relevant to coding, not to mention the title of the paper itself ". . . . and other sets", bear this out, since he specifically refers to Mandelbrot's above definition of dimension as applied to the fixed point of a contraction mapping (p. 1975) as being only one possibility. Again, one of the simplest examples of such a mapping, that given by Barnsley and Sloan (1988), of a rectangle mapped into the union of four contractive versions of itself has nothing to do with fractals. Readers interested in this aspect of the topic would do well to read carefully Section 1 in the book by Mandelbrot.

It has been mentioned earlier that coding of computer graphics constructs is not of interest here, rather the problem of coding real world imagery – conspicuously absent from many of the available texts containing multiplicities of beautiful colour pictures of fractal figures; seemingly realistic fractal portrayals of moonscapes, mountain ranges, and clouds, yes, but not *actual* pictures of that portion of a natural scene as recorded by a television camera, and there is still, rightly, a large degree of scepticism about the representation of natural, deterministic scenes by fractal constructs. Is a face portrayable in this way? Is that ship, this house, those trees? The latter may be approximated, but all the individual trees are different, all the branches of a given tree, all the twigs on a particular branch, etc. The fern image [much

apparent complexity encoded in an (almost) vanishingly small number of coefficients] is not really like any fern which actually exists in nature (Clarke and Linnett, 1993). Real fernlets are not copies of the whole fern "writ small", and no botanist would ever consider assembling a database of fern species and then storing its contents efficiently by the use of fractal coding. The representation is just not accurate enough – fine for background detail in an office scene, perhaps, but not for representation of a real situation. The comment made by Witkin in his influential 1983 paper on scale-space filtering is relevant here ". . . to the mountain climber, knowing what kind of mountain he is on is of little help. He needs to know where next to place his hands and feet." (Witkin, 1984).

Well then, if the terminology and reconstruction accuracy are open to discussion, what about the enormous compression "ratios" quoted (see here Chapter 1, Section 1.2.7)? Somehow these do not seem to have been quoted in any professional journal paper, at least not without qualification or the need for interpretation. Thus we read in the Byte article of values of the order of 10 000:1 in connection with a high detail aerial photograph, but we are not told explicitly that such figures were achieved with that actual picture, much less given photographic reproductions of original and coded versions. Those which are given are anything but high detail and are specifically referred to by the authors as graphics applications. Again a value of over 1 000 000 is quoted for a sequence video animation, and it is probably the uncritical reading of this reference which is responsible for much of the undeserved hysteria in the popular technical press on this subject (see, for example, Image Proc., 1990; Electron. World, 1992). More informed reporting appears in IEEE Spectrum (1991, 1992) where a ratio of 77:1 for a full colour, still image coded by a commercial implementation of the technique is reported. Given that the input is a 24 bit (RGB) original this represents coding at just over 0.3 bit element^{-1}, performance which can be achieved by present day vector quantisation and transform schemes. As for the algorithms described earlier here (and in the professional literature), performance is worse than that of such schemes. Jacobs et al. (1992) find their "fractal" scheme somewhat poorer than an adaptive DCT algorithm (Chen and Pratt, 1984). Since no information is available on the algorithm used in the commercial version further comparison is impossible.

Jacquin (1990, 1992) percipiently compared his version of contractive transform coding with vector quantisation, and this approach can be used to show what is new about the technique. Both are block coding schemes (an immediate disadvantage), as discussed elsewhere in this book, although the present scheme gains by operating with a block size (8 × 8) too big for the usual range of implementations of vector quantisation. VQ needs a training sequence generated codebook (unless a lattice implementation is used), which also needs to be separately transmitted to the receiver. Furthermore, there are always doubts about the validity of the codebook for coding an image which is

"distant" from the training set, which leads to the introduction of adaptive schemes, with the need for sequentially transmitted codebook updates. Here the contractive transform is at an advantage again, for it does not need a codebook (or we might say that the virtual codebook, which does not need transmission in any case, is automatically present in each image to be coded itself). The image block characteristics are enshrined in the transformation coefficients, rather than as any directly compressed version of the image itself, and this is a novel feature (but, of course, "iterated transforms" are not nearly so "newsworthy" as "fractals"!). Unfortunately, this aspect of the reconstruction has itself given rise to much confusion regarding the actual resolution of the final image displayed. Consider the display of the reconstructed image on a monitor which is capable of adequately dealing with the input image resolution. It is true that the transformation can now be iterated at a finer scale on a higher resolution display and this has given rise to the description of the reconstruction as "resolution independent". This is all very well, but it has been taken to mean that, in this way, new detail inherent in the original image but which could not be detected in the first, lower resolution display can now be seen on the higher resolution one. This is not true – the displayed resolution of the picture can never be greater than that at which the picture was originally coded – the original sampling frequency (f_s) determines (via the Nyquist criterion) the maximum unambiguous frequency of image detail converted into sampled form ($f_s/2$). Detail of higher resolution is simply not present in the coding chain. The higher resolution picture may appear more pleasing to the eye but the finer detail apparently present has no necessary relation to that in the original image, and any connection between them is, as the movie credits have it, coincidental and purely fortuitous!

To sum up – it is apparent that contractive transformation schemes can produce significant amounts of compression for imagery which is "similar" to natural detail in a computer graphics sense. Whether the resulting accuracy of reconstruction which is achieved when natural images are processed in this way is adequate depends upon the individual application. Again, if a contractive transformation could, in practice, map significant areas of an image into a low complexity collage of itself then the prospect of much greater degrees of compression would become a reality. There is no evidence, however, that large-scale natural image detail does have this desirable property.

7

Other Intraframe Techniques. 2: Quadtree, Multiresolution and Neural Approaches

7.1. QUADTREE AND RECURSIVE CODING

7.1.1. Introduction

A "throwaway" comment often made in the context of image coding is that many problems result from the "fact" that image detail is highly non-stationary, and hence improvements in coding efficiency can usually be achieved by various adaptive techniques, the details of many of which have already been described. Leaving aside the pros and cons of the "being stationary" argument, it is certainly true that the amount of detail in any sub-region of a picture of any interest is a strong function of spatial location. Further, it is often the case that relatively uninteresting background material will take up much of the total image field and, as such, be relatively easy to code. Of course, adaptive techniques with constant block sizes of maybe

8×8 or 16×16 can deal with such input data by employing variable bit allocation strategies, but there are (at least) two problems which then arise: first (and more important) the region of adaptivity can never drop below the fixed block size to deal accurately with, for example, very small, very spatially active areas of detail; second, that it is inefficient to code very large, inactive areas of substantially constant luminance or colour with (now relatively small) fixed size blocks. It would thus be of significant advantage to be able to alter the processing block size to take these sources of inefficiency into account. A method of doing this, which at the same time also deals with the matter of efficient addressing of various block sizes, is to make use of the quadtree representation of the image. This allows a structured, variable block size decomposition of an image to be achieved, where the move to a smaller block size in order to represent fine detail more accurately can be carried out in accordance with the outcome of any number of test criteria. The scheme has been widely adopted for image coding applications, and here we describe the basic ideas involved and then consider some of the ways in which they have been incorporated into efficient image coding schemes.

7.1.2. Basic Ideas

Quadtree image decomposition has been widely used in many branches of image processing for shape approximation, segmentation, smoothing, and so on, as well as for coding. A comprehensive survey is presented by Samet (1984) who details many alternative decomposition structures and methods of representation. For coding a very simple structure is usually employed in which a variable resolution "region quadtree" is generated by the successive division of an image into four equal quarters, each of which may again be subsequently divided, and so on, down to individual picture element level if desired. Figure 7.1 shows an 8×8 block so divided, into the four quarters top left (TL1), top right (TR1), bottom left (BL1) and bottom right (BR1). Some test determining the adequacy of the subsequent representation is now applied to each region (it having been previously determined that initially applying the test to the 8×8 block as a whole produces an unsatisfactory result). BR1 is found to be satisfactory (requiring no further subdivision), whilst TL1, TR1 and BL1 are again subdivided to produce TL1(TL2, TR2, BL2, BR2) and so on. This now suffices for all but TR1(TR2) and BL1(BR2) which are subdivided once more (in this example to picture element level) to produce TR1(TR2(TL3, TR3, BL3, BR3)) and BL1(BR2(TL3, TR3, BL3, BR3)). The decomposition is clearly represented by a tree structure, as shown in Figure 7.2. The many variations upon the above theme are well described by Samet; in particular there is no need for restriction to a regular decomposition format using successive 2×2 subdiv-

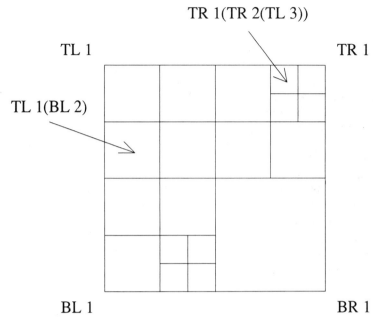

TR 1(TR 2(TL 3))

TL 1 TR 1

TL 1(BL 2)

BL 1 BR 1

Figure 7.1 Quadtree decomposition.

ision of square blocks as shown here. Nevertheless, there seems no good reason, particularly when starting with square 256 × 256 or 512 × 512 images, for example, to depart from this simple structure except that it is pertinent to mention that the "top down" algorithm as described above is sometimes replaced by a "bottom up" version (see later) in which elemental blocks are merged into larger ones (moving upwards through the tree structure as drawn in Figure 7.2), again according to some acceptability criterion. Typically this might be mean square, mean absolute or peak error, or goodness of fit of a low order two-dimensional polynomial approximation to the actual grey-level surface. Instead of a fixed, predetermined criterion for splitting (or merging) it is possible to develop schemes for determining analytically an optimal quadtree structure. Such methods are described by Sullivan and Baker (1991) and Berger *et al.* (1992), and a generalised technique and coding algorithm making use of the orientation of specific feature content of blocks on various levels is described by Wilson *et al.* (1990).

7.1.3. Coding Based on Quadtree Decomposition

At this point the inclusion of quadtree decomposition is perhaps best illustrated by giving examples of specific techniques. Here we examine five in total, three in this section dependent on spatial approximation of block

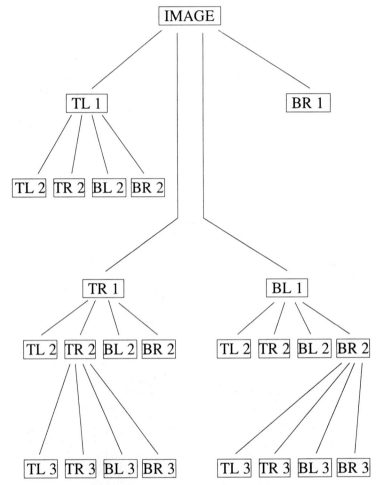

Figure 7.2 Quadtree structure of Figure 7.1 – alternative formulation.

detail alone, and two in the following sections incorporating specific coding techniques which have already been discussed in earlier chapters in their own right.

The obvious way of approaching the image representation problem via a quadtree interpretation is to recognise that, in background regions where the image detail is varying slowly (in a spatial context), large areas can be coded "at a stroke". Thus some kind of activity test needs to be applied to successive regions in the quadtree hierarchy to indicate when further subdivision is necessary. Thus the so-called recursive binary nesting (RBN) technique (Beaumont, 1988; Clarke and Cordell, 1988; Cordell and Clarke, 1989a,b, 1990a,b, 1992) attempts to reproduce square regions of the image with a simple bi-linear interpolation of luminance values tested against a

predetermined threshold. If this is satisfactory no further subdivision is undertaken, and all that needs to be transmitted are the region corner points. By overlapping regions by one picture element horizontally and vertically a saving may be made on even this small amount of transmission. The process typically starts with 33×33 regions (few of which, in fact, satisfy an interpolation criterion precise enough to give good subjective quality) and then divides down to small regions 4×4 or even 2×2 in extent. A typical division structure is shown in Figure 7.3 and original and

Figure 7.3 Typical subdivision structure in the recursive binary nesting technique.

coded images of MISSA at 0.1 bit element^{-1} are shown in Figures 7.4 and 7.5, respectively. The technique has the advantages of not requiring either high accuracy floating point calculations or frequency domain processing and of being automatically highly adaptive to spatial image detail. The idea has subsequently been reinvestigated by Denatale *et al.* (1991). It can also be adapted for image sequence coding (see Chapter 11 Section 11.4.1).

The whole matter of quadtree image representation and analysis has been examined in detail by Wilson *et al.* (1990) and a development of the basic RBN algorithm including orientation selective adaptation with such

Figure 7.4 The original MISSA image.

orientation quantised to one of 31 distinct angles has been reported by Todd
and Wilson (1989).

Whilst it is natural to think of quadtree image decomposition in terms of
the successive subdivision of large square image blocks (Figure 7.6), we
have seen in the previous section that this process can be reinterpreted as a
successive merging operation carried out on blocks initially 2 × 2 picture
elements in extent (Figure 7.7). Strobach (1991) describes such a scheme in
which a linear approximation model:

$$f(x,y) = a + bx + cy \qquad (7.1)$$

is defined by the parameters a, b and c. If a, b and c are known for four
neighbouring $N \times N$ blocks it can be shown that these parameters can be
derived for the $2N \times 2N$ merged block on the next level by a recursive
algorithm, allowing a simple yet efficient coding algorithm to be developed.
Rules for the determination of quantiser stepsize for the parameter vector
are given and rate–distortion relationships allow the optimum values of
these, and the merging thresholds, for a given level of compression to be
found. Interpolation between adjacent blocks is carried out using a cubic
relationship to reduce the probability of blocking artefacts. Interestingly,

Figure 7.5 Recursive binary coding of the MISSA image at 0.1 bit element^{-1}.

Strobach includes comparisons with some dozen or so other schemes reported in the literature and shows that his technique, with low complexity of implementation, compares very favourably in the 1/2 bit element^{-1} region for the picture LENA, with PSNR around 32 dB.

7.1.4. Quadtrees and Transform Coding

We have seen that a quadtree decomposition (top down or bottom up) easily lends itself to various adaptive spatial image coding approaches. The extensive development of all kinds of block coding algorithms over the past 25 years, however, make these (unfortunately) an all too obvious choice for most implementations. Here, at least, the quadtree decomposition offers the possibility of incorporating some block size adaptability into, for example, transform coding schemes. Several of these have been reported in the literature and a typical one is that of Chen (1989). In this case the image is divided into initial blocks of size 16 × 16 or 32 × 32 and a three or four level quadtree split performed down to a block size of 4 × 4. A test is then performed on four adjacent 4 × 4 sub-blocks to determine whether they

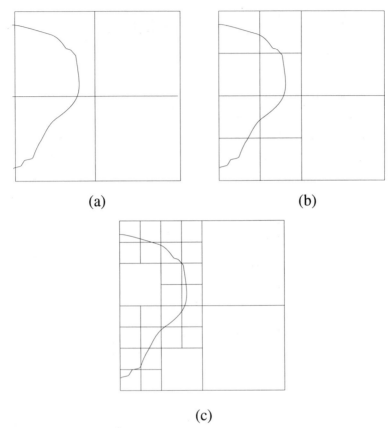

(a) (b)

(c)

Figure 7.6 (a), (b), (c) Successive stages in "top-down" quadtree processing.

should be individually coded or merged in a sequential "bottom up" process; the test is of the form:

$$\text{If: } |m_k(i) - m_k(j)| > t_k$$
$$\text{for any } i = j$$
$$\text{DO NOT MERGE}$$
$$\text{Else: MERGE.} \tag{7.2}$$

Here the terms $(i, j = 1 \rightarrow 4)$ represent separate block means on the kth level and t_k the decision threshold (typically about 10 for an 8 bit image). DCT coding employs the run length/amplitude approach described in Chapter 3, with different codebooks and quantiser stepsizes for the various levels. All signalling information is automatically contained within the quadtree structure overhead which, in any case, is very small (< 0.02 bit element^{-1}). Results for a head and shoulders image (LENA) are very good at

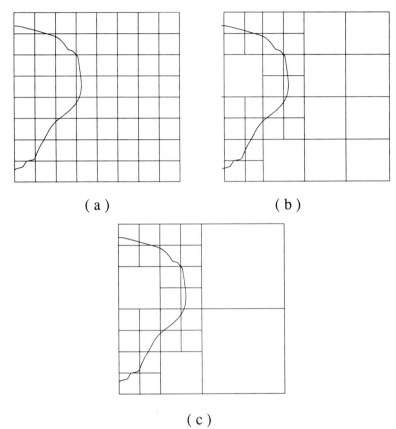

(a) (b)

(c)

Figure 7.7 (a), (b), (c) Successive stages in "bottom-up" quadtree processing.

just over 1 bit element^{-1} and, interestingly enough, the same for a text image at 2.25 bits element^{-1}. This confirms just how poor DCT coding is for images of this nature (see also Clarke, 1985a).

Although most obvious, a variable block size strategy is not the only way in which the quadtree decomposition may be associated with transform coding schemes. Thus Baskurt and Goutte (1989) used it in conjunction with a 16×16 block size threshold coding scheme to code the locations of above threshold coefficients in each block, where it is shown to perform somewhat more efficiently than either zig-zag or orthogonal scanning.

7.1.5. Quadtree/Vector Quantisation Coding Schemes

A more flexible and attractive scheme than that described in the previous section is achieved by combining quadtree processing with vector quantis-

ation (see Chapter 4), for it is more convenient after decomposition to stay in the spatial domain using simple matching techniques than go to the trouble of high precision multiplication and scaling operations. The basic idea is very simple. After imposition of the quadtree structure separate vector quantisation coding schemes are set up for each individual block size. Since region spatial activities (usually defined by block variance) are different for different sizes (as indeed are visual perceptual thresholds for impairments) some care must be exercised in the choice of codebook size, training sequence material and testing thresholds. Indeed, attempts have been made to formalise the merge/split decision in terms of $R(D)$ (rate–distortion) criteria and also to remove the constraint imposed by the necessity to make one square $N \times N$ block from four square $N/2 \times N/2$ blocks, or vice versa (despite the attraction of such a simple regular structure with regard to overhead requirements).

Thus Boxerman and Lee (1990a, b) emphasised that, whilst still satisfying some detail or variance criterion, the object should be to segment an image into as few vectors as possible. At the same time large uniform regions should not require large codebooks, and the structural signalling overhead should be kept to a minimum. The scheme that results is called unconstrained tiling vector quantisation (UTVQ) and contains an algorithm which ensures that the image, without overlap or missing regions, is covered with a set of rectangular and square blocks of size $N \times N$ or $N \times N/2$ (horizontally and vertically), where $N = 4, 8$ or 16. Their optimum algorithm sequentially covers the image with the blocks, starting with the largest and ensuring that, by the last pass, it is completely covered. Mean/residual vector quantisation with 256 entry codebooks completes the coding operation. In fact, although the scheme results in a saving of over 20% in terms of the number of blocks compared with "conventional" quadtree VQ, the SNR difference at all rates between 0.3 and 0.9 bit element^{-1} is minimal (<0.5 dB) and a typical overall result (with LENA) is 31 dB at 0.4 bit element^{-1}.

Given that the advantages of departing from a conventional quadtree scheme appear slight, can this mechanism be placed on a more quantitative footing? Sullivan and Baker (1991) developed a formal algorithm for deciding whether or not to merge four $N \times N$ sub-blocks into one $2N \times 2N$ block by the use of an objective function:

$$F = \{d_k + \lambda \, b_k\}, \tag{7.3}$$

where d_k is the distortion in any given region, b_k the assigned number of bits and λ the Lagrange multiplier. It is required that F be minimised for each separate region. This function trades off the distortion increase resulting from a move to the next highest level against the saving in rate achieved by so doing. A related scheme is described by Chou *et al.* (1989). Results given for optimal and non-optimal strategies in a video application show broadly similar trends. Finally, we mention a more comprehensive approach to

quadtree coding which employs both vector quantisation and transform coding. Vaisey and Gersho (1988, 1992) initially quadtree segment the image in a conventional manner according to image detail and vector quantise the resulting block mean values. These values, when interpolated, form a basic low quality, low-rate image which is subtracted from the original to produce a residual image. This image, in turn, is segmented into three categories: (a) low detail; (b) high detail, needing high reconstruction quality; and (c) high detail but only needing low quality of reconstruction (random texture). Low detail blocks may be up to 32 × 32 in size, whilst high detail blocks are 4 × 4. Large low detail regions are then coded using hybrid transform coding/vector quantisation, high detail regions with classified VQ. The actual design of this coder is considerably more complex than can be reported here – full details, including a comprehensive comparison with other high performance schemes are included in the 1992 paper. Typically a PSNR of 31 dB at a rate of 0.3 bit element^{-1} is obtained for a 512 × 512 version of LENA.

7.1.6. General Comments

The inclusion of quadtree decomposition into block based image coding has produced a welcome diversity of schemes and new approaches compared with straight 16 × 16 transform coding or 4 × 4 vector quantisation. It has to be said, however, that in no case do the results stand head and shoulders above those achieved by a good sub-band or hybrid sub-band/VQ scheme (Kim *et al.*, 1989, for example). If rate is the main constraining factor, then it is expected that these schemes will be just as subject to those block artefacts which accompany any other approach based upon the subdivision of arbitrary image detail into regularly shaped blocks. A recent investigation into optimal threshold choice and bit allocation procedures is reported by Shusterman and Feder (1994).

7.2. MULTIRESOLUTION CODING

7.2.1. Introduction

It will not have taken a very close reading of the text of this volume to discover more than one of the authors prejudices, developed over the years as a result of his involvement in digital image coding. One of the most obvious of these is a negative attitude towards block based coding schemes, in which images are arbitrarily divided into, say, 8 × 8 or 16 × 16 blocks and coded without regard for actual picture detail, edges, shading and so on.

We should not be surprised at the result, of course – continual complaints about block edge artefacts (to which regular structure the eye is particularly sensitive), and the associated appearance of the results of the application of many only partially successful boundary smoothing algorithms. Despite the apparent success of block-structured schemes in hardware implementation and their enshrinement in standards (JPEG, MPEG, etc.) any real advance in the discipline will necessarily involve a move from block based to *image* based schemes (one of which has already been described – segmented image coding). In the present section we examine one far more logical method of image decomposition, of which, in a sense, quadtree processing formed a preliminary step by separating high detail and low detail regions in terms of block size. Instead of carrying out this selection on a purely spatial/single level basis, however, the technique of multiresolution processing substitutes a set of levels of different resolutions, and through these the coding operation logically pursues a hierarchical path from highest to lowest resolution.

At this point it should be noted that the technique of wavelet coding, described previously (see Chapter 5, Section 5.8), is closely associated with this approach. Unfortunately it is not possible in a volume of the nature of the present one, which attempts to be, to some degree at least, all embracing to maintain a strictly logical order through an extended set of interrelated topics. Thus it was felt more satisfactory to discuss wavelet processing as a natural consequence of sub-band coding (it is, after all, oriented towards the frequency domain), whereas the initial impetus to the multiresolution idea lay strongly in the spatial domain (although a frequency domain interpretation was always present just beneath the surface). Now, therefore, we step back to ideas which pre-dated the present extensive interest in all aspects of wavelet processing to consider the fundamental ideas underpinning multiresolution techniques.

7.2.2. Scale Space

The idea of "scale space" is clearly described in a fundamental paper by Witkin (1984); (see also Schalkoff, 1989). Basically we can examine any scene at a variety of resolution levels (scales) and progression through these scales in a logical manner will result in the appearance/disappearance of detail in a particular range of sizes. A set of maps of a particular region of the world gives a simple demonstration of this – a very coarse scale map will probably only show even large towns as dots and small towns and villages not at all, and yet a fine scale map, of necessity of a small area, may even identify individual houses. Where images are concerned the same effect is generated by low-pass filtering. In Witkin's development this is achieved by convolution of the spatial detail with a Gaussian function whose standard deviation σ forms the "scale" parameter. As σ tends to zero we see the

maximum resolution (input) image, and as σ tends to ∞ the response is simply the average value of the whole image. As we move in from a very large value of σ, more and more detail appears which, once in being, does not disappear as σ is decreased further. In one dimension the location/resolution (*x*, σ) plane forms the "scale space", as shown in Figure 7.8. It is

Figure 7.8 A one-dimensional waveform observed at different scales, coarsest at the bottom, finest at the top. σ decreases upwards.

convenient to consider the zero crossings of the derivative of the convolution operation which then represents extreme values/turning points of the data. There will be few of these at coarse resolution – as σ is decreased new ones will appear, and once having done so, may move along the *x* axis but will not subsequently disappear (see Figure 7.9). It is thus possible to characterise the one-dimensional data or two-dimensional image in terms of such a scale space representation.

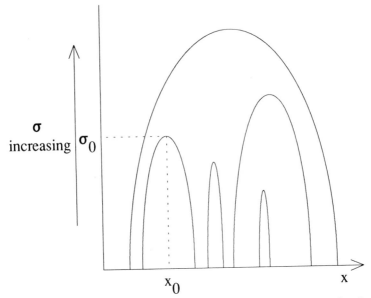

Figure 7.9 Scale space zero-crossing contours in one dimension. σ_0, scale of contour having x_0 as its true location.

7.2.3. Pyramidal Coding

How then are scale space ideas to be employed in a coding application? The basic idea is to convert the full resolution input image into two alternative signals, one, a heavily low-pass filtered (coarse scale) representation of the data can be coded with relatively few bits and the other, an error (difference) image, can be coded in an efficient way appropriate to its low energy (variance) and highly peaked probability distribution. Since this is best done over more than two levels, and the sub-sampling of the coarse scale image consequent upon the strong degree of low-pass filtering results in such images reducing in size by a factor conveniently made 2×2 over those levels, a "pyramid" structure is created with the original, high resolution input image at "ground level" as in Figure 7.10. Undoubtedly the fundamental reference here is to the work of Burt and Adelson (1983) whose scheme set the scene for the active work in multiresolution coding which has continued to the present day. In their implementation the input image (level G_0) is low-pass filtered using a 5×5 Gaussian kernel such that the number of output points at level G_1 is half that of the original each way. Repeated processing in this way produces a series of images forming the "Gaussian" pyramid G_0, G_1, \ldots, G_n, each approximately $1/2 \times 1/2$ the size of its predecessor. The kernel $w(m,n)$ is:

(a) separable $w(m,n) = w'(m) \times w'(n)$;

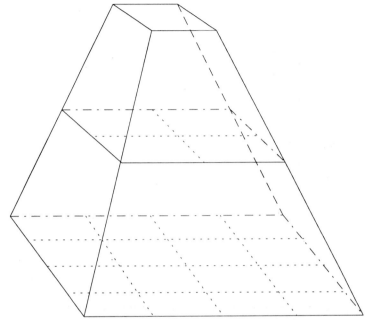

Figure 7.10 Pyramidal coding structure.

(b) normalised in each dimension

$$\sum_{p=-2}^{2} w'(p) = 1,$$

where $p = m$ or n;

(c) symmetric $w'(i) = w'(-i)$ $i = 0, 1, 2$;

and the weights are arranged so that

(d) each node on any level contributes an equal amount to nodes on the next, i.e.

$$w'(0) + 2\,w'(2) = 2\,w'(1)$$

(see Figure 7.11). Thus, for total weight $= 1$,

$$w'(0) + 2\,w'(2) + 2\,w'(1) = 1$$

and so

$$4\,w'(1) = 1 \text{ or } w'(1) = 1/4.$$

Therefore

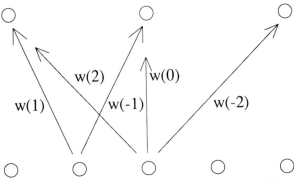

Figure 7.11 Weighting coefficients in pyramidal coding.

$$w'(0) + 2\,w'(2) = 1/2 \text{ or}$$
$$w'(2) = 1/4 - w'(0)/2.$$

Typically the value of $w'(0)$ is set at between 0.4 and 0.6.

At any level (apart from zero) the reduced size image is interpolated using the same weighting function to produce an approximation to the next higher resolution level. This forms a prediction for that level and the difference (prediction error) image forms one level of the associated Laplacian pyramid L_0, L_1, ..., etc. Recall that any differencing or prediction of correlated data will give rise to an error signal (image) with a distribution closely approximating to the Laplacian (negative exponential) – hence the name. Two of the levels of such a scheme are shown symbolically in Figure 7.12. For any number of levels the top level (coarsest scale) Gaussian image is coded and transmitted together with the hierarchy of Laplacian error images. Since the weighting function at any level has effectively twice the extent of the same function at the next level below, the generation of the Laplacian image may alternatively be seen to be achieved by a single filtering operation using the difference of Gaussian (Laplacian) operator applied to the lower level image. The efficiency of the scheme derives from the facts that (a) it is only necessary to retain a relatively small top level image at full grey-scale resolution, whilst the lower level error images have a form amenable to efficient coding (variable resolution quantisation and entropy coding). This efficiency is significant, despite the fact that some expansion of the data volume is incurred – for reconstruction at any level we need the error signal at that level as well as the quarter size low-pass image from the next level which is to be expanded before the two are summed. The total number of data points, for an $N \times N$ image is thus:

$$N_T = N \times N + N/2 \times N/2 + N/4 \times N/4 \dots$$
$$= (4/3)\,N^2. \qquad (7.4)$$

This contrasts with the closely allied wavelet structure in which, since the

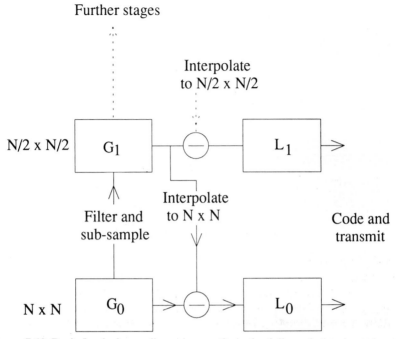

Figure 7.12 Basic Laplacian coding scheme. G_0 is the full resolution input image.

detail signal is, like the low frequency signals, generated by a sub-sampling/ filtering/interpolation process, no such data expansion occurs (see Kronander, 1987). Another drawback sometimes mentioned with regard to this algorithm is the correlation which remains between the various levels of the pyramid after processing. To the best knowledge of the present author, however, this effect, if indeed significant, has never been quantified.

Burt and Adelson demonstrated that reasonable quality images can be reconstructed by their technique at rates around 1 to 1.5 bit element^{-1}. Figure 7.13 shows various stages in the scheme. Figure 7.13(a) is the original 256 × 256 TREVOR image. Figure 7.13(b) shows the result of filtering, subsampling (to 128 × 128) and subsequent interpolation back to 256 × 256, with Figure 7.13(c) the corresponding (Laplacian) difference image. The same relations exist between Figures 7.13(b) (initially 128 × 128) and (e) and (d) and between Figures 7.13(e) (initially 64 × 64), (f) and (g). Somewhat improved results were obtained by Martens (1990), who modified the filter structure so that it was asymmetric, and Martens and Majoor (1989) who emphasised the need for perceptual evaluation in the design of a quantisation strategy for such a coder.

It is apparent that the pyramid structure is very general, and can be combined with a variety of other coding techniques. In addition, many modifications to the basic structure, involving generalised sampling schemes and

Figure 7.13 (a) The original TREVOR image. (b) Result of lowpass filtering, sub-sampling and interpolation of Figure 7.13a. (c) The corresponding difference (Laplacian) image. (d) Result of lowpass filtering, sub-sampling and interpolation of Figure 7.13b. (e) The corresponding difference (Laplacian) image. (f) Result of lowpass filtering, sub-sampling and interpolation of Figure 7.13e. (g) The corresponding difference (Laplacian) image.

adaptive approaches have been reported. Sallent-Ribes *et al.* (1988) combined these ideas by using a power spectrum technique to segment the original image into 64×64 sub-blocks, each of which is separately coded. For each such sub-block, an optimum sampling latice is defined by reference to the distribution of spectral energy within that block. Park and Lee (1991) used a DCT/classified vector quantisation approach to code the Laplacian planes and proposed a new method for design of the weighting filter. At 0.4 bit element^{-1} a PSNR around 34 dB is achieved for the LENA image. An analysis of the basic structure in terms of rate–distortion criteria is given by Salinas and Baker (1989), and a two-dimensional DCT pyramid structure is reported by Tan and Ghanbari (1992). In this case the error signal appears in the DCT domain, and sub-sampling is achieved by performing an N point DCT followed by an M point inverse transform using the first M coefficients ($N > M$). Interpolation can be carried out using an M point DCT followed by padding with zeros and an N point IDCT. An important feature of the scheme is claimed to be the significant reduction in blocking effects which is achieved, compared with the use of the DCT alone at a comparable bit-rate. Interestingly enough, the technique has similarities with the scheme reported some years ago by Ngan and Clarke (1980, 1982), in which transform techniques were used to achieve sub-sampling and filtering.

The closeness of pyramid and wavelet structures has been mentioned previously and it is perhaps worthwhile noting here that a comprehensive analysis of the Burt and Adelson scheme is given by Daubechies (1988) who points out how the algorithm of Mallat (1989a,b) provides a link between the two. The whole area of multiresolution decomposition of images for the purpose of coding/storage, whether by general pyramid or wavelet schemes is at present of great interest, and this interest is reflected in the voluminous amount of work being published on the topic.

7.2.4. Progressive Transmission

Unlike the situation with moving image sequences, in which a certain maximum frame rate update interval must be defined in order that some semblance of motion be preserved, when transmitting a still image a channel of very low capacity can be used, provided that the user is prepared to wait the necessary time for the complete result to appear. On this premise so-called "slow scan" systems were implemented, in which the full resolution data was transmitted, line by line, at a low rate. It is readily apparent that this is by no means the optimum format for such transmission and it would be much more useful to use the same low bandwidth channel to transmit an approximation of detail relatively quickly, to be followed by sequential updates gradually increasing the resolution. This is particularly useful when search of a database of images is involved, for any given display build-up

can be terminated as soon as the approximate image is seen not to be the one desired, thus minimising channel access time and cost.

Often, in the coding of images for low rate transmission as described in this book, data will appear in a suitable form for such a mode of transmission to be used. Historically, transform coding schemes have allowed this to be done, and one method is incorporated in the JPEG still picture standard (see Chapter 3, Section 3.10). Where transform coefficients are concerned, the obvious approach is to send, first of all, just the block D.C. coefficients. The resulting image then comprises 8×8 or 16×16 blocks, each having a uniform luminance value equal to the block mean. The quality of the resulting image is anything but acceptable (the effect is the same as that employed by those who wish to be heard, seen, but not recognised in some present-day television inteviews), and the question now arises, how best to transmit the other coefficients. Ngan (1984) has considered this and finds, not surprisingly, that the best order is that in which, at any stage, adding another coefficient produces the greatest decrease in overall normalised mean square error (albeit at some computational cost). For images of a general nature, transmission and reconstruction following the conventional zig-zag scanning profile is found to be almost as efficient, whilst for those images with significant edge detail, which causes large magnitude coefficients to cluster along the horizontal and/or vertical borders of the coefficient domain, it is best to send coefficients in those locations first. An alternative technique is to design bit allocation maps and associated quantisers for different rates and send the lowest rate information followed by successive quantised coefficient differences which are decoded and added to the existing approximate image (Elnahas, 1988). Generally speaking, progressive transmission schemes based upon conventional block transform coding are not particularly flexible (see the study by Sridharan *et al.*, 1992) and the advent of hierarchical pyramid schemes for coding has enabled such transmission to be achieved in a much more logical manner. From the multiplicity of approaches described in the literature we briefly review four here. The algorithm of Gonzales *et al.* (1988) is based upon the conventional Laplacian pyramid scheme in conjunction with predictive coding of the lowest resolution image and also the difference images. Simple averaging of element values to the left and right of an interpolation location serves to generate the corresponding interpolated samples in the horizontal direction, and a similar operation is carried out vertically. The prediction differences are coded using a Markov model to determine appropriate states for adaptive binary arithmetic coding (Appendix 1). A lossless mode is also possible, as is sequential operation in the manner of the JPEG standard. The coder of Park and Lee (see previous section) employed a combination of transform coding and vector quantisation for progressive image transmission. It is also possible to stay in the spatial domain with vector quantisation alone, as in the scheme of Wang and Goldberg (1989). Here a "mean" pyramid struc-

ture is built up by successive 2 × 2 averaging over the image and the lower resolution levels so formed. A "difference" pyramid is then obtained by taking differences between levels and each level of this is vector quantised using blocks of 2 × 2 or 4 × 4 samples. Errors introduced by the vector quantisation operation at higher (lower resolution) levels of the difference pyramid are carried down the pyramid by virtue of the inverse of the sequential mean forming coding operation but lossless (entropy) coding of the final (full size) residual error image enables the image to be reconstructed perfectly. In this mode a nominally 8 bit image can be coded at about 5 or 6 bits depending upon the level of detail. In lossy (conventional) mode good results are achieved at around 0.6 bit element^{-1} (see also Wang and Goldberg, 1992). Goldberg and Wang subsequently compared (1991) several pyramid techniques (including the basic Gaussian/Laplacian implementation) for progressive transmission. The best approach was found to be the "reduced-difference" pyramid, in which levels are formed by taking differences between *neighbouring* samples in the same level of the mean pyramid. Retaining only three of these four values (for a 2 × 2 block) is sufficient to recover the mean pyramid [incidentally, cancelling the 4/3 factor in Equation (7.4)]. To expand any of the lower resolution approximations to full size at an intermediate stage in the progressive process, a 5 × 5 Gaussian-like interpolation function was found to be suitable. A more general survey and comparison has been carried out by Zhou (1987) of progressive approaches involving spatial (vector quantisation, predictive coding, bit plane) techniques, and transform and pyramid methods. Clear leaders in terms of qualitative performance were wavelet or Gaussian pyramid approaches and a bit-slice/transform coding method, although the latter of necessity contained significant block structure artefacts at early stages of transmission when the effective rate is very low (less than 1/8 bit element^{-1}).

Finally, adaptivity can, of course, improve the efficiency of any coding scheme and progressive transmission is no exception. In the scheme of Mongatti *et al.* (1992) the pyramid of Burt and Adelson is modified by the inclusion of an activity function to indicate which of the Laplacian sub-images corresponds to a significant area of image detail, in which case they will be transmitted, otherwise the reconstruction sub-image at the next level will simply be the prediction (the interpolated lower resolution block) only. The activity function is made up of a test for a significant number of zero crossings in the Laplacian image (i.e. edges in the original) plus an entropy test over a given 2 × 2 block and its eight neighbours at two consecutive levels. Unfortunately, the visual quality of the reproduced images is not sufficient to draw definite conclusions on the efficiency of the criteria, and the authors emphasise that visual assessment and numerical measures are here, as so often, at variance. Normalised mean square error figures indicate that the entropy criterion gives the best result, with the zero crossing test

contributing little. The view of the authors is that, for high compression factors the combination of the two tests is optimum where the purely visual quality of the result is concerned. Using an interesting combination of approaches, Wu and Fang (1993) have developed an adaptive tree-structured segmentation-based coder for progressive transmission, whilst Chitprasert and Rao (1990) returned to the adaptive transform method and included an HVS model in the processing chain to develop an effective progressive coding strategy.

Progressive transmission is nowadays regarded as an important branch of image coding. There is little doubt that schemes based on pyramidal decomposition, especially when combined with a coding technique which will give high efficiency and also support a lossless capability will become of increasing significance as compared with traditional, fixed rate systems.

7.3. NEURAL TECHNIQUES IN IMAGE CODING

7.3.1. Introduction

The 1980s saw a significant broadening in approaches to computing techniques, particularly where high volumes of data were concerned. The traditional serial, single processor, von Neumann structure was recognised as having distinct disadvantages in this context and many schemes for parallel/distributed processing involving interconnections of many, simpler, processors were developed. At the same time there was renewed interest in parallelism of another kind – that between software and hardware computer structures and the functional mechanisms of the brain. In a loose sense, the application of "fuzzy" techniques to control systems and the enshrining of human decision making mechanisms in so-called "expert systems" are examples of this. In the context of this book, "neural" techniques, mimicking low-level biological operations, have been applied to image coding tasks (and indeed more generally in image processing – pattern recognition and feature extraction, for example). Here we examine one or two such implementations, after giving a very brief introduction to the structure and operation of neural networks.

7.3.2. The Neural Network

At the outset it should be said that the literature in this field is truly vast, and cannot be encompassed in the space available here. Conferences, journals and books now abound and the reader is referred to a comprehensive review, now somewhat dated, unfortunately (Lippmann, 1987), but

which has more recently been selectively updated (Hush and Horne, 1993), for information on the general literature in the field, and to the more recent applications oriented discussion of Hammerstrom (1993). In the same way, introductions to the area are numerous and the author implies no criticism of other authors when suggesting Schalkoff (1992), Beale and Jackson (1990) and Pau (1989) as possibilities. Basic articles by Kohonen (1988) and Grossberg (1988) are also rewarding, and a broad perspective of where the subject stood at the end of the 1980s is provided by the special issue of IEEE Transactions (IEEE, 1989).

Lippmann classified neural network topologies into six subdivisions in the context of pattern classification, according to whether or not "learning" was supervised, etc. In the present context two of these in particular are of importance – the multilayer perceptron (MLP) and the Kohonen self-organising feature map (KSOFM), although the Hopfield network has also been used (see below). A brief summary of the three approaches will be given below, after considering the mode of activation of the nodes which constitute the network.

7.3.2.1. Neuron Activation

As has been mentioned elsewhere, popular imagination in the late 1980s was captured by many new, indeed revolutionary, developments in science and technology (some, it has to be said, more apparent than real). In the present context, it was the mimicking of brain function by multiply organised computer processors. Bypassing the more strictly biological aspects of this situation, two novel attributes of such systems were the massively parallel, highly interconnected processing and the use of non-linearities in the inter-node couplings. In general the latter produce an output based upon the non-linear thresholding of a sum of input signals. Thus, if inputs x_1, x_2, \ldots, x_N are applied to a summing junction via weighting coefficients w_1, w_2, \ldots, w_N, as in Figure 7.14, the output y is a linear function of the inputs:

$$y = \sum_{i=1}^{N} w_i x_i. \tag{7.5}$$

If, however, we pass the junction output through a non-linearity $F(\cdot)$, the value of y can, for example, be made to equal one when the weighted sum of inputs is greater than zero, and zero otherwise, i.e.

$$y = F(\sum_{i=1}^{N} w_i x_i) \tag{7.6}$$

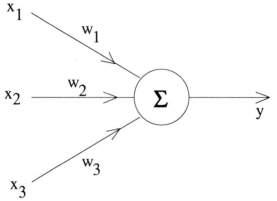

Figure 7.14 Weighted input summation.

$$\text{If } F(x) = 1 \qquad x > 0$$
$$\qquad\quad = 0 \qquad x \leqslant 0 \tag{7.7}$$

and this response can be referred to a given threshold θ

$$y = F(\sum_{i=1}^{N} w_i x_i - \theta) \tag{7.8}$$

if desired. Various other forms of the non-linearity $F(\cdot)$ are possible, thus:

Hard limiter: $\qquad F(x) = 1 \qquad x > 0$
$$\qquad\qquad\qquad\quad = -1 \qquad x \leqslant 0. \tag{7.9}$$

Piecewise linear: $\qquad F(x) = 0 \qquad x < x_a$
$$\qquad\qquad\qquad\quad = 1 \qquad x > x_b \tag{7.10}$$
$$\qquad\qquad\qquad\quad = (x - x_a)/(x_b - x_a)$$
$$\qquad\qquad\qquad\qquad x > x_a \tag{7.11}$$
$$\qquad\qquad\qquad\qquad x \leqslant x_b.$$

Sigmoidal: $\qquad F(x) = 1/(1 + \exp(-\lambda x))$
$$\qquad\qquad\qquad\qquad \text{for all } x. \tag{7.12}$$

Here λ controls the slope of the characteristic in the active region.

7.3.2.2. The Multilayer Perceptron

Couplings of arrays of elements as described above, in a single layer, are

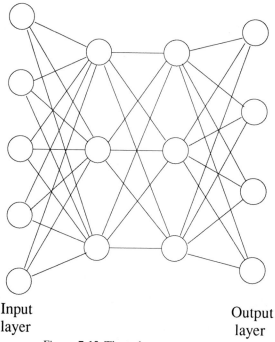

Input
layer

Output
layer

Figure 7.15 Three layer perceptron.

called perceptrons (Rosenblatt, 1959) and in this form with a hard-limiting non-linearity can be used for pattern recognition. Limitations in flexibility of classification led to the adoption of the MLP, in which signals are fed forward from input to output via one or more intervening (hidden) layers. Figure 7.15 shows a three layer perceptron (the input layer is not normally counted as it takes no part in the summing and thresholding operations). In the single layer perceptron, supervised learning allows the weights to be changed so as to reinforce the correct classification. For the MLP a sigmoidal non-linearity is used and the learning procedure is somewhat more complex. Presentation of an input pattern results in the operation of nodes in successive layers from input to output in accordance with Equations (7.8) and (7.12). An error function is formed between the desired and actual outputs and this allows the weight on the output layer to be adjusted in a straightforward way. For elements in the hidden layers weight adjustment is carried out by "back-propagating" the error sequentially from the output to the first hidden layer. A detailed analysis can be found in any of the references already cited.

7.3.2.3. The Kohonen Self-organising Feature Map

This algorithm sets up a correspondence with the cellular organisation that it

is thought may well develop during certain higher level learning activities in the brain. All input nodes are connected to all output nodes, which have variable weights corresponding to the connections to each input – note that the term "weight" has here a somewhat different connotation from that used previously, for the weight vectors, after optimisation is complete, *are* the actual output codewords of the classifier. Sequential presentation of input vectors results in the (unsupervised) formation of a "feature map" by the updating of those nodes which satisfy a minimum distortion (distance) criterion with respect to the input, together with their neighbours over a pre-specified surrounding area which gradually decreases in size as time evolves. The process is basically that of vector quantisation, the detailed operation of which is described in Chapter 4.

7.3.2.4. The Hopfield Net

This network is usually used for binary signals (but see Pau cited above) in a supervised mode. All nodes are connected to all others and a hard-limiting non-linearity is used. Following assignation of weights according to the respective patterns for a particular class, and presentation of an input to all nodes, the network cycles through consecutive states until convergence is achieved. This network has been used occasionally in image coding as described below.

7.3.3. Neural Network Applications in Image Coding

From the classification of the six approaches to neural network structures given by Lippmann (1987) two have been found to be particularly applicable in image coding, the MLP and the KSOFM. The former is appropriate to updating weighting values in accordance with changing input data properties, and so finds application in predictive coding, the latter has classification properties which align its structure and operation closely with those of vector quantisation. We concentrate upon these two techniques here with a brief reference to alternative proposals which have been reported.

7.3.3.1. Neural Networks and Vector Quantisation

Krishnamurthy *et al.* (1990) give a good description of the general application of neural methods to vector quantisation. They consider so-called "competitive learning" algorithms which are unsupervised training approaches which cluster vectors from the training data into representative regions. Here all the weight vectors (note, these form the codewords at any

node) \mathbf{W}_i are initialised to small random values and are adjusted following the presentation of each input vector \mathbf{X} in parallel to all the neural nodes. The distortions between \mathbf{X} and all \mathbf{W}_i at time n are computed and the "winning" unit is that with the smallest $d(\mathbf{X}, \mathbf{W})$. If this unit has weight vector \mathbf{W}_{i^*} it is updated at time $n + 1$ using:

$$\mathbf{W}_{i^*} (n + 1) = \mathbf{W}_{i^*} (n) + \epsilon(n) [\mathbf{X}(n) - \mathbf{W}_{i^*} (n)], \qquad (7.13)$$

where $\epsilon(n)$ is a parameter between 0 and 1 and determines the speed of convergence. The operation is now repeated for all training vectors.

One problem with this algorithm is that it is unlikely that all nodes will be used to the same degree. This is overcome in the KSOFM approach by defining a neighbourhood around the "winning" unit over which the weights are updated and for which the parameter ϵ is now a function of distance from that unit $- \epsilon = \epsilon (n, D)$, where $D <$ some D_{\max}. D_{\max} is now periodically decreased until it is zero. An alternative approach is via the frequency sensitive competitive learning (FSCL) algorithm. Here a count u_i is kept of the frequency of use of all neural nodes and the effective values of all $d(\mathbf{X}, \mathbf{W}_i)$ are increased in proportion to this count, making it more likely that other neural nodes will "win" the distortion competition. This latter algorithm was used to design codebooks in a comparison test with the LBG algorithm (see Chapter 4). ϵ was set to $0.01 \exp(-u_i / 10^4)$ and a 2×2 block size was employed with codebook sizes of 4–64. Results were found to be comparable for the two approaches. McAuliffe *et al.* (1990) implemented a similar KSOFM scheme for the more conventional vector quantisation parameters of 4×4 block size, 256 codebook entries (and thus a rate of 0.5 bit element^{-1}). Overall results again were found to be similar to those for the LBG algorithm and advantages are claimed to lie more in the directions of flexibility of the KSOFM algorithm given a poor starting codebook and also its need for fewer training vectors.

Truong and Mersereau (1990) improved the search efficiency by decomposing the KSOFM codebook into a two level tree and testing distortion values on a sequential closest root/closest leaf basis. This considerably reduces the search complexity but the overall results in terms of bit-rate as related to PSNR are very close to those for the LBG algorithm (difference less than 0.5 dB), at rates around 0.7 bit element^{-1}. Truong (1991) subsequently examined codebook design incorporating the constraint of logarithmic search complexity and found this approach effective in comparison with the PNN algorithm (see Chapter 4, Section 4.4.4).

A more wide-ranging approach is that of Lee and Peterson (1990). They report an algorithm which dynamically modifies the structure of the network in response to changes in data statistics. Their space–partition network (SPAN) has a lattice structure which operates as a KSOFM as far as weight updates are concerned; however, the structure can adapt in a variety of ways. Thus new neurons can be generated if certain of the original set

contribute too much to overall distortion, inactive ones can be removed and similar ones merged, or they can migrate to new, more favourable, sites. Associated with their network is a technique which only codes displacement vectors between codewords representing adjacent source inputs and so gives a further reduction in bit-rate, and a fast search algorithm which tests a local area around the previously used codeword. This latter significantly improves search efficiency, and it is these two additions which give the scheme its advantage over a full search LBG algorithm. Adaptivity can be included by using a side channel to convey a residual signal, which is the difference between the actual input vector and its closest representative codeword. As a final example of the application of competitive learning and the KOSFM algorithm to vector quantisation we quote Lech and Hua (1992) who compare the methods with several involving simulated annealing. It is suggested that these latter may be competitive with the neural approach whilst obviating the need for parameter estimation in the latter.

7.3.3.2. Neural Networks and Predictive Coding

The advantages of using neural classifiers in vector quantisation-like algorithms, seem somewhat ephemeral, and more benefit has apparently been obtained in their application to predictive coding, where they can, unlike the conventional predictor, take advantage of non-linear terms in the prediction determining equation. Li and Manikopoulos (1992) have explored the application here of the MLP (with one hidden layer) and the so-called "functional link network" (Pau, Chapter 8), which has no hidden layer, and effectively maps the input into a larger pattern space and to one-dimensional DPCM. In comparison with the conventional linear prediction function,

$$\hat{x}_n = \sum_{i=1}^{p} a_i x_{n-i}, \tag{7.14}$$

where the a_i are the prediction coefficients, p is the order of the prediction and \hat{x}_n is the predicted value of sample n, the generalised non-linear predictor will contain terms of the form:

$$\sum_i \sum_j a_{ij} x_{n-i} x_{n-j}$$

and

$$\sum_i \sum_j \sum_k a_{ijk} x_{n-i} x_{n-j} x_{n-k} \tag{7.15}$$

(see also Chapter 2, Section 2.2.6).

For a fourth order predictor there will be 15 coefficients in total (one for

the threshold and 14 for all combinations 1, 2, 3, 12, 13, 123, etc., except 134 which is not used) to which the four prediction samples are mapped. Using a sigmoidal activity function the network is trained on a complete still image (LENA). The prediction error is quantised with a 1 bit quantiser and, in comparison with standard linear DPCM, an improvement of around 4 dB in PSNR is achieved. It is also shown that a single hidden layer MLP produces virtually the same results for a wide range of numbers of nodes in the hidden layer (between 3 and 30).

This work was further reported by Manikopoulos (1992) and extended to a two-dimensional adaptive scheme using a ninth order linear predictor with, additionally, two second and three third order terms. With a three level quantiser followed by Huffman coding and allowing the predictor to adapt over a 32 × 32 block size a PSNR of 29.5 dB was achieved at a rate of 0.42 bit element^{-1} plus 0.1 bit element^{-1} overhead. This is indeed a very good result and, as the authors point out, comparable with the best alternatives available (see Chapter 2). Non-linear prediction using a multilayer neural network is also considered by He and Li (1990). No quantitative results are given but it is pointed out that it is important to use the quantised prediction in the error function which is to be minimised during the training operation. Dianat *et al.* (1991) pointed out that the neural network predictor is more robust in the presence of noise than is the conventional design.

7.3.3.3. Other Approaches

Vector quantisation and predictive coding are the main areas in which neural networks have been applied in image coding. They have occasionally, however, been included in other schemes. Daugman (1988) has reported a scheme using a three layer network to optimise the determination of the coefficients of a two-dimensional Gabor image representation. The problem is different because, in distinction to the situation which obtains with respect to more conventional commonly used transforms in image processing, the decomposition is non-orthogonal (i.e. the coefficient values are not independent) and straightforward coefficient calculation operations cannot be employed (see Chapter 3, Section 3.2). Interestingly enough, the author stresses the relevance not only of the general idea of an interconnected neural network model for optimisation but also of the use, in the fixed weight layers of the network, of two-dimensional elementary Gabor functions which model very closely actual (anisotropic) receptive field profiles obtained from experimental measurements on the mammalian visual cortex. This anisotropy allows orientational selectivity to be incorporated into the coding algorithm. Readers interested in pursuing this approach should note the comments of Yan and Gore (1990) and Melissaratos and Micheli-Tzanakou (1990). Another transform approach is reported by Chua and Lin

(1988) who treat the transform/quantisation/binary coding operation as an optimisation problem which can be solved by the application of neural networks.

The neural network can, of course, be employed in any overall scheme which incorporates a stage of optimisation (of prediction coefficients, codebooks, transform coefficients, etc.). One such is vector quantisation, this time in its application to process wavelet or transform coefficients (see earlier). Thus Antonini *et al.* (1990) compared LBG and Kohonen neural network (KNN) generated codebooks for vector quantisation of the subimage outputs of a wavelet decomposition. No particular advantage in terms of SNR is reported but the KNN takes only 1/15th of the time of the LBG algorithm to generate the codebook.

A simple approach to image coding using neural networks is to make use of the fact that not all layers need have the same number of nodes, nor need all the various layer signals be quantised to the same degree of accuracy. Sicuranza and Ramponi (1990) used a conventional perceptron with one hidden layer, a sigmoidal non-linearity and back-propagation, in which input blocks, typically 4×4 in size, are presented to the network which has only four neurons in the hidden layer. Training involves minimisation of the mean square error between the training image and the decoder output and, with intermediate values quantised with 4 bits, an overall compression factor of 8:1 can be achieved. A similar scheme is reported in more detail by Kohno *et al.* (1990). Here the block size is 8×8 and the hidden layer has either four or eight neurons. An adaptive implementation gives PSNRs around 30 dB for eight neurons at about 1 bit element^{-1} and 28 dB for four at 0.5 bit element^{-1}.

The Hopfield net is usually more appropriate for binary than for multilevel signals. It has been employed for block truncation coding (see Chapter 6, Section 6.2) by Qiu *et al.* (1991). Here a 4×4 image block is applied to a 16 neuron network so that each picture element may be classified into one of the two quantisation states. Over a variety of images small gains are achieved when compared with the algorithm of Udpikar and Raina (1985). The same authors also report an edge classification MLP scheme (Qiu *et al.*, 1993), and Pinho (1993) describes the application of artificial neural network techniques to image coding using a quadtree image decomposition. Finally, Kim and Rajala (1992) use this network to develop an efficient segmentation operation which may be applied to image coding.

7.3.4. General Comments

So far, neural networks have been shown to be of only peripheral interest in image coding, and their success has not been so much to produce any marked improvement in compression performance as to facilitate the im-

plementation of various coding strategies. Thus they enable the use of non-orthogonal transform representations, and are one method of reducing the training time for vector quantisation codebooks. Of more interest is the improvement in predictive coding performance obtained, not by their use directly, but by the fact that they allow predictor optimisation to be made over a wider range of intersample correlation, both linear and non-linear. Whether they will take more than a transient place in the image coding "hall of fame" remains to be seen.

8
Interframe Coding

8.1. INTRODUCTION

Undoubtedly one of the major influences upon the development of society throughout the world during the second half of the 20th Century has been the prevalence of television. The ability to pass live, moving, images over significant distances (nowadays, with the advent of satellite channels, across the world) has strongly shaped our perceptions of, and attitudes to, contemporary events. In a technical text of the nature of the present work, it would be inappropriate to enter into arguments as to the relative advantages and disadvantages of this ability; whether it is really worthwhile setting up systems capable of transmitting tens or hundreds or more millions of bits per second merely to allow the viewing of the latest quiz show (or maybe the earliest black and white cinema film!). More to the point is that advances in digital signal processing and computer technology have now given us the possibility of doing similar things at much lower data rates, and it can only be hoped that their introduction into the new areas of application (educational, business/industrial, medical, etc.) which are being opened up will prove to be of less equivocal benefit. On audiovisual communications generally, see Kenyon and Nightingale (1992).

The perceptual impact of "moving" pictures is very much greater than that of still images and, since the introduction of television, there has always been interest in reducing the transmission rate [for an early example, see Pratt, 1967; also the special issue of IEEE Proceedings (IEEE, 1967), of which one or two papers are referenced in Chapter 1, Section 1.1.2], given the constraint that, unlike the case with the transmission of still pictures, a certain minimum picture rate per second will be required to maintain the impression of smooth

object motion. As digital signal processing techniques became more readily available and the associated theory more widely understood, predictive, and later transform, techniques led to the wide range of still picture systems described earlier in this book and, at the same time, to approaches to the coding of moving imagery, with which we are presently concerned. Historically, the first technique to be used in a consistent manner for image sequence coding was predictive coding, other early techniques (interpolation, contour coding and synthetic highs, for example), although investigated and reported in the literature, had to wait for modern interpretations (wavelet, segmentation and "two-component" decompositions) before becoming more widely known. Since the development of transform coding of speech and image signals in the 1960s the range of available techniques has become extensive; most of those which are applicable to still pictures can also be applied to moving images, as will be shown below. It is possible to code moving sequences on a "per-frame" basis (using, maybe, the JPEG standard, Chapter 3, Section 3.10) but the majority of sequence coders make use of the extra information to be gained by comparing neighbouring frames and processing the residual difference. This difference is usually small, and can be made smaller by trying to take into account the motion of the objects in the image from frame to frame. This operation – motion compensation – has developed into an area of study in its own right and will be considered in some detail in the next chapter (unfortunately it is not always possible to follow a strictly logical progression of topics in a volume of this general nature, and motion compensation has had to be introduced into this chapter before it is dealt with specifically in the next).

Advances in computer graphics techniques in the past decade have also, to some extent, had an influence on image coding. The major result is probably the appearance of analysis/synthesis (model based) methods for the transmission of head and shoulders images in a videophone context. Here a wire frame model is used as the basis of the head and shoulders representation at transmitter and receiver and is made realistic by the application of various shading techniques. In such a situation there is (hopefully) little extensive motion and that which does take place is transmitted in the form of motion parameters rather than as a compressed waveform. These are then used to update the receiver model appropriately. Although the transmission rate can be made very low the situation is highly constrained and the approach is not at present suitable for coding general scenes.

Most interest to date has centred on hybrid schemes, typically a combination of motion-compensated prediction and transform coding, and this has been incorporated in standards for moving sequence transmission. Research continues, however, to surmount the various problems which beset this kind of implementation, and also to produce useful schemes at rates which were widely thought impossible at the end of the 1970s.

8.2. INTERFRAME PREDICTIVE CODING

We have already seen that predictive coding was the first image coding technique to achieve any widespread acceptability, having the virtues of very easy implementation, reasonably good performance and the absence of a block-structured image format. These qualities also apply to the three-dimensional extension, which became possible to implement when the ability to store more than one frame of an image sequence at a time was achieved. However, because it is basically a sample by sample technique, it is inefficient when coding at very low rates is attempted, and it has found most application in the region around and above 1 bit element^{-1} (as examples, see Westerkamp, 1982; Tziritas and Pesquet, 1989). Adaptation of prediction/quantisation schemes has already been described in an intraframe context in Chapter 2; in three dimensions an additional "degree of freedom" is incorporated since we have the option of making a prediction either from the previous frame alone or in conjunction with some modification of the spatial prediction – the situation is somewhat complicated in the case of coding conventionally scanned television sequences, for there is the additional option of taking a temporal prediction from either the previous field or frame. Each has advantages and disadvantages: previous field prediction has the advantage that the line (or lines) from which the prediction is taken is closer to the predicted element in time, and the disadvantage that it is displaced by one line vertically unless interline interpolation is carried out; previous frame prediction has the advantage that elements used in the prediction are in the correct spatial location but the disadvantage that they are twice as far away temporally. The consensus seems to be that previous field prediction is preferable overall. For very low-rate coding input data is likely to be a sub-sampled single field of a higher resolution video signal in any case. Thus Common Intermediate Format (CIF), 352 elements × 288 lines, is a 2:1 sub-sampled version of the CCIR Recommendation 601 for standard display format, and this can itself be sub-sampled to provide one quarter CIF (QCIF) at 176 elements on 144 lines for videotelephone systems. The basic frame repetition rate is 25 or $30\,\mathrm{s}^{-1}$, but allowance is made for 2:1 or 3:1 temporal sub-sampling. Generally speaking, it is likely that more complex spatio-temporal picture element formats will be found suitable for television/video applications in the future and this may well complicate the selection of appropriate elements for prediction; see Dubois (1985) and Rahgozar and Allebach (1992).

Early work in this area is reviewed by Haskell (1979) in the context of the technique of conditional replenishment (see also Musmann, 1979). Here successive frame detail is not retransmitted if it is not judged to have changed significantly since the last frame, but simply redisplayed from the buffer at the receiver that holds that frame. Changed areas are retransmitted but with a resolution dependent upon subjective considerations and also on the

available bit-rate (over a fixed rate channel extended periods of significant motion cause potential overflow problems which can be mitigated by sub-sampling, coarser quantisation and so on). Segmentation into changed/unchanged areas is critical to the success of the algorithm and robustness of the segmentation algorithm in the presence of noise is achieved at the cost of making the operation more complex than simply testing the frame difference against a fixed threshold. Thus spatial and temporal moving area correlation is taken into account, and tests involve threshold hysteresis, etc. Nowadays, of course, the idea of conditional replenishment has considerably broadened in scope, and many modern coding schemes include tests to distinguish between significantly changed and unchanged regions (see Brofferio, 1989). Nevertheless it is interesting to see the number of newly (re!) discovered ideas – spatial/temporal filtering and two level thresholding, for example, which were, in fact, around 20 years ago.

As far as the predictive operation is concerned various choices exist. For example,

(a) The previous element spatially – along the same scan line in the same field.
(b) The previous element along the time axis, i.e. in the last frame.
(c) The average of the nearest elements above and below the location of the present element but in the previous field.
(d) The previous element in the same field modified by interelement luminance gradients derived from the previous field.

Experimental results show that, at low moving area speeds, any form of interframe prediction is better than one-dimensional intraframe prediction (a). As speed increases, the prediction error entropy within the moving area rises for all interframe predictors, whilst it falls for intraframe prediction. Up to a motion level of four elements per frame predictor (d) performed consistently better than all the others, in the context of a 1 MHz videotelephone signal coded using a 35 level quantiser. The efficacy of switching between intra- and interframe prediction is demonstrated by Yamamoto et al. (1981) who, admittedly in a higher rate context, employed a block adaptive scheme, in which the prediction error is calculated for both an intra- and an interframe prediction for blocks of eight elements and the one giving the smallest value is chosen.

Intraframe prediction gives poor results as the moving area speed rises and so the choice is between an intrafield predictor

$$\hat{X} = D + 3/4(A - E), \tag{8.1}$$

where D is the element vertically above X on the nearest line in the same field (in this composite video coding application having also the same colour sub-carrier phase angle) and A is the previous element on the same line as X. E has the same relation to D; or an interfield predictor

$$\hat{X} = F + 3/4(A - G), \tag{8.2}$$

where F is the closest element vertically aligned with X but in the previous field (and again with the correct phase) and G is the previous element on the same line as F (see Figure 8.1). Only if the smallest prediction error over the

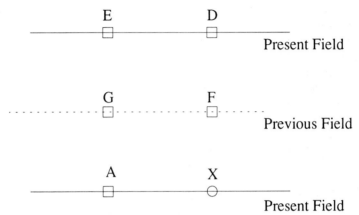

Figure 8.1 Schematic representation of the predictor of Yamamoto *et al.* (1981).

block is greater than a threshold is it quantised and transmitted, together with overhead information regarding the predictor chosen.

For the coding of videoconference pictures Zetterberg *et al.* (1982) studied a variety of predictors in association with an adaptive three level quantiser together with "delayed decision" (effectively a look-ahead capability) and arithmetic coding (Appendix 1). The optimum predictor for the present element X was found to be:

$$\hat{X} = \alpha X_1 + c_1(a - \alpha a_1) + c_2(b - \alpha b_1), \tag{8.3}$$

where a is the previous element on the same line with respect to X; b is the element on the previous line nearest to X; a_1, b_1, X_1 are the corresponding elements in the previous frame; and α, c_1 and c_2 are weighting coefficients.

Since $c_1(a) + c_2(b)$ is a good intraframe prediction for X, as is $c_1(a_1) + c_2(b_2)$ for X_1, the above predictor is effectively an intraframe prediction of the difference signal $X - \alpha X_1$. In simulations optimum values of c_1 and c_2 were found to be approximately 0.5 and for α, 0.89. Since this is less than one, some protection against the effects of transmission errors is given. The quantiser needs to have different properties depending upon whether moving area or background is being coded. In the background granular noise is readily visible and so the levels need to be close together. On the other hand, a small dynamic range is needed. For moving areas, a large dynamic range is necessary to cope with large prediction errors but visual masking can be exploited to mitigate the effects of coarse stepsize. This adaptation is achieved with

fixed quantisation levels by scaling the prediction error by $1/g$ and the result-ing quantiser output by g, where the gain parameter g is derived from infor-mation already transmitted (backward estimation), requiring no extra over-head, or from the input signal (forward estimation), in which case the transmitter must make g known to the receiver.

A "look-ahead" capability allows the examination of the consequences at a future time of having made a decision on a particular quantiser output for a given input element. This necessarily involves a delay equal to the amount of look-ahead, λ samples. The actual value transmitted is then that which minimises the overall error over the next λ values. For L quantised values and λ sample delay, the coder needs to search a tree of L^λ branches, which drastically limits the value of λ in the practical case (even when using a Viterbi algorithm for search), but the technique significantly improves the coder performance on a luminance edge, even for a delay of a single sample.

The final stage in the coder is arithmetic coding (see Appendix 1) which reduces the output signal entropy from the equal probability value of $\log_2 3 = 1.6$ bit symbol^{-1}. Overall conclusions are that although delayed decision produced visible improvement, the best scheme subjectively was forward estimation (three gain parameters 8, 16 and 32; block size for estimation eight elements, overhead approximately 0.2 bit element^{-1}). This also gives the best SNR. The total data rate was about 1.5 bit element^{-1}. It was suggested that three quantisation levels are insufficient for acceptable picture quality of complex scenes, and that this number also gives problems when the decay constant α is less than one since the prediction error is not then close to zero in background regions. Such is the price to be paid for an otherwise simple way of dealing with transmission errors.

This work was later extended to take in estimation procedures over two-dimensional instead of one-dimensional regions and quantisers with more ($L = 5$ or 7) levels (Zetterberg et al., 1984). The quantisers all had uniform stepsize and the characteristic for $L = 5$ is shown in Figure 8.2. Best perform-ance was produced by the adaptive forward estimation scheme using a 4×4 block for estimation of one of four gain values (1/8 bit element^{-1} overhead). The PSNR was 37 dB at a total rate of 2 bits element^{-1}, although this was nearly equalled by a two-dimensional backward scheme (no overhead) at 1.75 bit element^{-1} (35 dB). As might be expected, square blocks were found in every case to be optimum for estimation purposes as compared with other aspect ratios, and subjective performance was much better for schemes adapted with respect to two dimensions rather than one. Zetterberg et al. successfully showed that adapting the quantisation procedure was beneficial in improving the efficiency of three-dimensional predictive coding. It would not be surprising if adaptation of the prediction mechanism similarly im-proved coding performance, and this topic is included in the general review of Musmann et al. (1985). Two-dimensional predictors can be adapted to deal with flat areas, contours (edges) and texture of various orientations by switch-

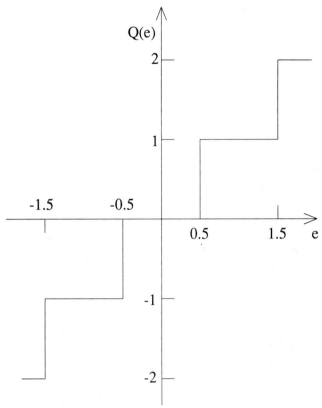

Figure 8.2 Quantisation characteristic with $L = 5$ (from Zetterberg *et al.*, 1984 with permission).

ing on the basis of previously transmitted interelement/interline differences, but we have seen that for sequence coding three-dimensional prediction is appropriate and so adaptive intra/interframe predictors are more attractive. Accordingly Pirsch (1982) suggests switching between an intraframe prediction:

$$\hat{X} = X_1 = 1/2\,a + 1/8\,b + 1/4\,c + 1/8\,d, \qquad (8.4)$$

where X, a, b, c and d are as shown in Figure 8.3, and a simple previous frame prediction:

$$\hat{X} = X_2 = X_0, \qquad (8.5)$$

where X_0 has the same location as X but in the previous frame. Selection of the prediction depends upon an activity function A, the sum of the prediction error magnitudes over a small window of neighbouring elements. Alternatively, activity functions determined by the maximum of interelement differ-

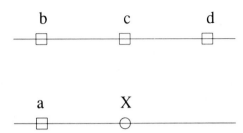

Figure 8.3 Two-dimensional intraframe prediction.

ences in the same or in present and previous frames over a small area can be used. Such schemes may be modified to include interfield prediction, if appropriate, and also a modified predictor:

$$\hat{X} = X_3 = 1/4 \, a + 1/8 \, c + 5/8 \, X_0. \tag{8.6}$$

Prabhu (1985) suggested a predictor switching scheme based on a test applied to the sum of the magnitudes of the prediction errors at elements a, b, c, d in Figure 8.3. The best overall predictor is used to predict the present element. If the probability of incorrect prediction choice is high, the best prediction (at the transmitter) is still used, and the selection conveyed to the receiver using a separate overhead signal. This is considered necessary unless (a) all prediction values are similar or (b) one prediction is very much better than the rest. It is claimed that a substantial reduction in root mean square error is produced by this technique but the author's figures show an improvement of around 15% and interpretation is obscured by the false origins on the scales of his graphical results.

It is worth mentioning here that considerations of simplicity of implementation usually dictate that prediction should be fairly simple, and with relatively few elements. On a purely intuitive basis predictions are most efficient when they are made from locations as close to the element to be predicted as possible (in the absence of a colour subcarrier or like signal), since there the image detail is most likely to be the same or similar. Nevertheless, some experiments have been carried out with very large predictors and two examples may be quoted here. The first is reported by Stott (1987) in the context of predictive coding of composite PAL colour television signals sampled at twice the subcarrier frequency (sub-Nyquist PAL). The simplest prediction in this case is that taken from the *second* previous sample, and two-dimensional predictors up to order $N = 19$ and three-dimensional (intra/interfield) predictors up to order $N = 50$ were studied. With the former prediction gain rises only slowly after N reaches a value around eight, in the latter case this occurs at about $N = 14$ (seven elements in the present field, seven in the previous one). Practical schemes with eight and 14 element three-dimensional predictors are reported, but extreme rate reduction was not attempted, broadcast picture quality being of prior concern.

The second scheme is described by Ericsson (1985) in the course of predictor analysis for the purpose of hybrid transform coding (to be discussed later), in particular to determine an upper bound on the prediction gain achievable with a fixed linear predictor. With 40 elements from four previously transmitted fields gain was about 3 dB higher than for pure frame difference prediction, but very dependent upon image statistics. In changed areas two elements in the previous field give a 3 dB increase over simple frame difference, and a move to 18 elements over four previous fields increases the gain further by less than 1 dB. It seems, therefore, that the use of high order predictors is conjectural, at least, and in practice they do seem to be "conspicuous by their absence" from the multiplicity of algorithms reported.

Motion compensation will, of course, markedly improve the performance of interframe predictive coding, and many algorithms have been reported (see, for example, Sabri, 1983). The algorithm of Kwatra *et al.* (1987) uses a basic motion compensation block size of 8×8 subdivided into four 4×4 blocks for transmission. Testing with respect to a threshold indicates which 4×4 blocks should be quantised, coded and transmitted. "Inactive" sub-blocks are not updated. The motion detection algorithm operates over a variable number of stages. Initially the sum of absolute differences is calculated for zero displacement. If below a threshold T_1 (the noise tolerance threshold is 2–3 grey levels for 8 bit data), then no further search is needed. If above T_1, the same calculation is carried out for eight other search locations symmetrically located on the perimeter of an 8×8 square centred at (0,0). If the test is satisfied at any point the search is terminated. If not, a new search starts from the location of the first stage minimum. An additional test against an "improvement" threshold T_2 (1–2 levels) can also terminate the search if moving to the next stage results in little improvement, the overall objective being to carry out as few computations as possible consistent with acceptable search results. Elements of active (4×4) sub-blocks are now quantised with a 17 level Max quantiser optimised for the Gamma probability density.

As usual, the ingenuity of research workers has resulted in a wide variety of schemes for inter/intraframe predictive coding, sometimes involving principles from other areas of the image coding discipline. As an example the scheme of Ng and Schiff (1989) splits the image into high and low frequency signals and invokes the idea of HVS spatial masking to obviate the necessity of sending high frequency components where motion is present. A two level sub-sampling structure (2×2) is used to generate a low frequency component which is coded using a switched intra/interframe spatio/temporal predictor. An interpolated, full size low frequency image is now regenerated and subtracted from the input frame to give the high-pass signal which is encoded by an interframe prediction. To this point coding is similar to that which could be applied to the various levels of a pyramidal decomposition (see Chapter 7, Section 7.2.3). However, in the present case, the interframe difference for every low-pass picture element is tested against a threshold to determine

whether the corresponding 2×2 block of difference values driving the high-pass coder should be coded or the coder output set to zero. The coder, suggested for video applications, demonstrates an interesting application of very early ideas (the high/low band split) in coding together with dependence upon masking to reduce the visibility of spatial detail in the presence of object movement.

Three-dimensional predictive coding has, as expected, many of the properties of its two-dimensional counterpart. It has the virtues of simplicity, and of reasonable performance when the predictor/quantiser are switched adaptively. Although at medium levels of compression it can produce very good decoded pictures, it has been overtaken by other more complex techniques in the never ending quest for the very minimum bit-rate for any given reconstructed image quality. It remains of interest, however, for higher rate applications.

8.3. INTERFRAME FREQUENCY DOMAIN APPROACHES

We have seen that three-dimensional predictive coding can be a simple and effective method of image sequence coding provided that absolutely minimal output rates are not a requirement. The technique requires storage over a frame (or field) interval for the interframe (field) prediction and this step, difficult in the early days of coding, is now readily achieved. Experiments using predictions from more than one previous frame seem almost non-existent; in any case the additional coding gain which might be achieved is certainly small and arguably not worth the extra storage involved.

At more than one place in this volume parallels have been drawn between spatial and frequency domain interpretations of the coding operation, and it is natural to ask in the present context whether a three-dimensional approach might be applied in the frequency domain (we include transform coding techniques in this category, although no transform other than the Fourier transform operates in the true frequency domain). In this case there is a problem concerning the extent over which the time domain operation is intended to be active. We have just seen that the present and previous frames are all that are required for interframe predictive coding. A block length of two is hardly adequate for efficient transform coding, however, and values of four or eight are more usual (see Chapter 3). Thus three-dimensional transform coding, for example, requires the storage of this number of frames to make the transform along the time axis worthwhile. Whilst storage of eight frames is nowadays no problem, the delay incurred may well be, depending, of course, on the particular application. Good results can be achieved, but the technique has not been widely used. Some of the early reported results are reviewed by Clarke (1985a). That the technique has nevertheless not been

entirely ignored is shown by the work of Akiyama *et al.* (1990) on motion-compensated three-dimensional transform coding. Motion compensation is necessary in the presence of even moderate degrees of motion since otherwise the temporal correlation is reduced and with it the efficiency of the transform. In this case, for "significant" motion (panning or zoom) full frame motion vectors (averaging over all spatial blocks) are used for compensation, whilst for localised motion, zonal coefficient sampling is adapted according either to the motion information available or to the distribution of coefficient energy. A DCT with block size 16 × 16 × 8 was used and performance was markedly improved by the inclusion of motion compensation. Kronander (1989) has considered three-dimensional sub-band coding as an alternative to the use of the DCT in such a context.

Although for nearly 20 years now there have been advocates of pure three-dimensional processing of the kind just described, any widespread increase in this form of coding seems highly unlikely, given the almost unassailable position now held by the technique to be considered next – hybrid transform coding.

8.4. HYBRID TRANSFORM CODING

After its introduction in the late 1960s, transform coding rapidly established itself as an efficient technique for coding still pictures at data rates which were lower than even adaptive predictive schemes could achieve. With the growing interest in image sequence coding, it was natural in the early/mid 1970s to try to apply it in this area also, but the problems of complexity of implementation and delay previously referred to were soon recognised and alternatives to a complete three-dimensional implementation, which nevertheless still retained its inherent advantages, were sought. In a sense, this constituted a "return visit" to intraframe coding in which, in order to reduce the problems associated with pure two-dimensional transform coding, combinations of one-dimensional transform and predictive coding had been examined (Habibi, 1974). For various reasons, simple image sequence coding algorithms were investigated with some thoroughness in the 1970s and this hybrid technique was also considered in the same context. A brief review is given by Clarke (1985a). Extension to the three-dimensional case seems (at least with hindsight) a logical step, and has given rise to what has become a more or less standard approach to the coding of any image sequence at rates from the videotelephone level to those adequate for high quality television transmission. Indeed, the amount of material published on hybrid/transform coding of image sequences in the past 10 years or so is so enormous that extreme selectivity is necessary even to discuss the most significant developments in a volume of the general nature of the present one.

8.4.1. Basic Ideas

To return briefly to intraframe coding, it is apparent that image data has significant correlation in both horizontal and vertical dimensions and that for coding there is no necessity to use the same technique in both of these. Thus a one-dimensional block of data (for example, 16 picture elements along an image line) could be transform coded and the same process carried out on similar blocks of data on the next line. To the extent that two such closely aligned (in a vertical direction) blocks of data might be expected to have very similar luminance profiles (and thus transform coefficients), predictive coding could provide an efficient technique for removing redundancy in the vertical direction when applied either to the data blocks *or* to the transform coefficients (but see Clarke, 1984a). In the latter case a two-dimensional redundancy removing (decorrelation) operation will have been carried out – transform coding horizontally, predictive coding vertically and since, in the absence of quantisation, both of these operations are linear, it is evident that either operation could have been done first (i.e. vertical prediction followed by horizontal transform coding of the prediction error). Reconstruction at the decoder would obviously need both reconstruction of the transform coefficients from the prediction differences followed by inverse transformation, or vice versa.

The extension to three dimensions is obvious – either use the previous frame as a prediction for the present one and transform code the difference frame so produced, or carry out the two-dimensional transform coding operation first and then predict the transform coefficients frame to frame. Again, in the absence of quantisation effects, the operations are equivalent.

The paper of Jain and Jain (1981) signalled the start of the widespread use of block matching motion detection/compensation methods in image coding (see Chapter 9). What is less frequently noted with respect to this paper is the discussion of the two approaches to motion-compensated hybrid coding. The two techniques are depicted in Figures 8.4 and 8.5. In Figure 8.4 we have, initially, a two-dimensional transform of successive frames (possibly fields) of the video sequence. Following this a conventional predictive coding loop generates a quantised error signal $e_q(x, y, t)$ based upon the use of a coefficient or weighted sum of coefficients from the previous transformed frame to provide the prediction (signal "B"). This scheme is perfectly satisfactory until it is required to include motion compensation. The vast majority of motion estimation/compensation schemes operate in the spatial domain (as, indeed, does the Jain and Jain algorithm), but there is nowhere in Figure 8.4 from which a previous (spatial) frame signal can be obtained. In order to maintain the transform as the initial operation Jain and Jain suggested an independent displacement measure based upon separate present and delayed input signals $[f(x, y, t); f(x, y, t - \tau)]$, generating a displacement vector which can be applied to a predictor driven by a spatial signal derived by inverse transform

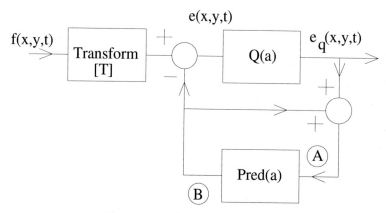

Figure 8.4 Hybrid coding scheme (a).

of the signal at *A*. The prediction must then be reconverted to the transform domain by a further transform at *B*. The inclusion of three transform operations makes the scheme somewhat complex, of course, and, as long as a prediction independent of transform coefficient order is adequate, usual practice is to carry out the spatial operations first as in Figure 8.5. Here the inverse

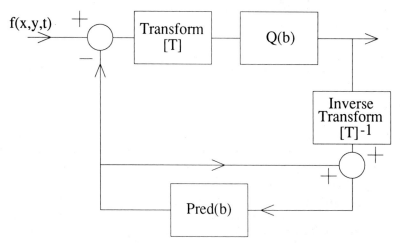

Figure 8.5 Hybrid coding scheme (b).

transform is still required to generate a spatial domain error signal and prediction and initial error signal generation operate in the spatial domain, making the inclusion of motion compensation straightforward. In this case the transmitted signal is a quantised version of the coefficients generated by two-dimensional transformation of the motion-compensated error signal.

Ericsson (1985) analysed the two structures in some detail, pointing out

that the second of these allows the simple introduction of either linear or non-linear temporal filtering in the prediction loop to achieve noise reduction without blurring of high contrast edges. He also showed that the structures are equivalent provided that the quantiser remains unchanged:

$$Q(b) = Q(a) \tag{8.7}$$

and that the prediction functions are related by:

$$\text{Pred}\,(b) = [T]\,\text{Pred}\,(a)\,[T]^{-1}. \tag{8.8}$$

An experimental set-up was investigated using 8 bit data and a two-dimensional 16×16 DCT applied to the motion-compensated frame difference signal. Transform coefficients were diagonally scanned and quantised with the characteristic of Figure 8.6, i.e. a uniform quantiser of stepsize g but

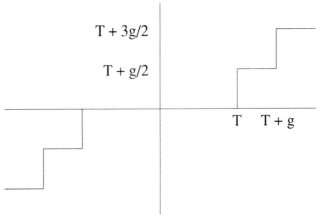

Figure 8.6 Offset quantisation characteristic of Ericsson (1985). T = offset, g = stepsize.

offset from zero by a threshold T (equal to $1.5\,g$). Run lengths and quantised values were coded using Huffman code tables. This scheme is similar to the intraframe scheme used by Chen and Pratt (1984). It was found that motion compensation with 1/8 element accuracy gave a significant improvement over simple previous frame prediction, with good results at around $33\,\text{dB}$ PSNR.

8.4.2. Other Developments

The second half of the 1980s saw extensive activity directed towards the definition of a standard technique for low-rate coding of image sequences for videotelephone and teleconferencing. The scheme just described is, in

essence, the structure which was adopted and which will be described in more detail later. Nevertheless, whilst retaining the basic outline of hybrid transform coding (motion-compensated prediction and the DCT), all sorts of variants of, and major or minor modifications to, the principle were developed and reported in the literature. There is only space here to indicate one or two of the ideas out of literally hundreds in the now voluminous image coding literature.

The work of Rao and his colleagues on motion compensation is described in Chapter 9. Srinivasan and Rao combined their "one at a time" motion estimation search method with an approximation to the DCT based upon an integer conversion matrix applied to the WHT in a videoconference coder design (1987). The transform block size is 8×8 with maximum displacement ± 5 elements in a frame of extent 128×192. As distinct from the coefficient processing scheme introduced by Chen and Pratt and used by Ericsson, completely "classical" techniques are employed here; non-uniform minimum mean square error quantisation, assumed Laplacian probability density of the transformed error sequence and bit allocation dependent upon coefficient variance.

Significantly, Srinivasan and Rao (1987) point out that the coefficient variances do not fall off rapidly as one moves away from the D.C. and low order terms as is the case with a still picture coder, and this is an indication of the lower correlation of motion-compensated frame difference signals – a point which will be taken up again subsequently. At 0.5 bit element^{-1}, the PSNR is very dependent upon scene activity: 18 dB for rapid movement as a result of camera panning to over 30 dB for a more typical videoconference sequence.

Traditionally, adaptive transform coders divide the two-dimensionally transformed blocks into a number of different categories based upon some criterion (maybe block variance) reflecting the degree of spatial activity. Kato *et al.* (1987) used a similar approach by matching the block coefficient power distribution to one of a predetermined set derived from a test sequence by a clustering technique similar to vector quantisation. Following this step a (uniform) quantiser stepsize and variable word length codewords are assigned. Performance, however, is only marginally higher than that of the scene adaptive coding algorithm.

The point made earlier about the low spatial correlation of motion-compensated prediction errors is mentioned again by Kaneko *et al.* (1987), in the course of an attempt to improve coding of such signals. Here the problem of significant coefficient distributions produced by large discontinuities in the motion-compensated difference signal is attacked by separating the large prediction errors from the rest of the difference signal using a median filter. The large errors are then directly scalar quantised (and given Huffman address codes) and the residual, relatively "smooth" motion-compensated signal is transformed, the coefficients classified, and linearly quantised and coded. Although this approach does not significantly enhance the SNR for a

given coding rate, the scheme is effective in reducing the visibility of artefacts at the edges of moving objects.

A basic problem with simple low-rate systems is, of course, the very poor resolution, which usually results from sub-sampling higher resolution input data at source. Chiariglione *et al.* (1987) suggested a more general approach in which spatio/temporal resolution exchange is possible which allows for higher levels of resolution provided that the input image does not have too much rapidly changing detail. Grotz *et al.* (1989) presented a modification of the (by that time, one might almost say) conventional motion-compensated difference prediction/DCT scheme which processes every third frame of a CIF (see above) input signal, and uses segmentation over a block size of 16 × 16 to distinguish between changed and unchanged areas, for the former of which a motion vector is derived and sent to the decoder. Since frames not transmitted are reconstructed by motion adaptive interpolation, accurate, true motion vectors are needed and these are obtained, to an accuracy of 0.5 element, by using an iterative algorithm applied to 8 × 8 blocks taken from successive transmitted frames sub-sampled by a factor of four horizontally and vertically. The prediction errors of changed blocks are then sequentially coded with an 8 × 8 DCT starting with those blocks with the largest displaced frame differences (DFDs – see Chapter 9). Coefficients are scaled according to a visibility impairment criterion, linearly quantised, and variable word length coded and transmitted. When all available capacity has been used up, block processing stops. For fast image build-up, a facility for direct DCT coding of the source frame sub-sampled by a factor of four is available. Quality was found to be acceptable by the authors at $48 \, \text{kb s}^{-1}$.

Almost every possible aspect of the conventional hybrid coding scheme has been investigated in an attempt to improve coding efficiency. Yu *et al.* (1990) suggested the use of variable size blocks in the range 8 × 8–32 × 32 defined by a quadtree data structure. Large, nearly uniform blocks allow efficient processing and low overhead, whilst small blocks allow coding performance to adapt to changing image detail. Hui and Kogure (1993) classified blocks using a variance measure into "edge" or "non-edge" categories, processing only the latter with a two-dimensional DCT. The former are coded using spatial or spatio/temporal prediction with the prediction errors non-linearly quantised using the quantiser design of Girod *et al.* (1988). Interestingly, close-ups of simulation results show clearly the improvement achieved by this approach, even though the measured SNR is somewhat worse than that of an unmodified hybrid coder! Seferidis and Ghanbari (1992) applied temporal co-occurrence matrices to the problem of region classification in order to impart adaptivity to their hybrid transform coding design.

Traditionally DCT coefficients have been coded with a variance-dependent bit allocation scheme (Clarke, 1985a) or, more recently, by thresholding followed by run length/amplitude variable word length coding. An alternative to these is vector quantisation, which can be applied to the transformed

motion-compensated difference block. In the course of their comparison of Walsh–Hadamard and discrete cosine transformation of motion-compensated difference signals Akansu and Kadur (1989) applied vector quantisation to the first 16 or 32 significant coefficients produced by the 8×8 DCT or WHT with codebooks of 256, 512 and 1024 entries. Results are very similar for the two transforms (to within 0.5 dB) with reasonable quality of reconstructed images. A more comprehensive scheme is reported by Picco *et al.* (1990) in a higher rate application. This is based upon block classification, normalisation and adaptive bit allocation of the Chen and Smith type (1977) applied to the 8×8 coefficient block resulting from transform coding of the motion-compensated difference signal. The probability distribution of these coefficients corresponds quite well with the Laplacian density (Clarke, 1985a) and so a pyramid vector quantisation scheme was used (see Fischer, 1986, and Chapter 4) to match this with the intersection points between the pyramid and an integer cubic lattice used as the codewords, scaled according to bit-rate. Coding scheme effectiveness is demonstrated by the absence from the input/ output difference image of any significant artefacts. The cost is, of course, a certain increase in the complexity of coding.

8.4.3. The Efficiency of Hybrid Transform Coding

Since its inception in the early 1980s, the justification for combining transform and predictive coding into a single scheme for image sequence compression has been a matter of concern to some workers in the field. The basic problem stems from the interaction between the two operations, for any coding technique will only operate efficiently on a signal which has the appropriate statistical characteristics – no coding scheme could ever be devised which could cope deterministically (i.e. with regard to a distortion measure which operated by comparing input and output images element by element) with a signal which is purely random; some degree of similarity or likeness (correlation) must be present if a satisfactory representation is to be achieved at a reduced data rate. Neither is the situation helped by naïve descriptions, which appear all too often in the literature, of the kind "....the temporal prediction removes data redundancy along the time axis, and intraframe transform coding that in the spatial plane", which take no account whatsoever of the fact that the (motion-compensated) prediction operation profoundly influences the statistical distribution of the signal which is passed to the transform coder.

It was perceived early in the development of image coding algorithms that one did not achieve better performance simply by following the application of one technique by another – indeed the overall result might well be worse. Even in hybrid coding as originally envisaged in two dimensions, one-dimensional transformation horizontally and vertical prediction of the

coefficient sequence, the higher order terms have low correlation and the resulting prediction error terms can easily have higher variances than the original coefficients (Clarke, 1984a).

In two dimensions the DCT is a very powerful means of reducing spatial redundancy in signals which have high correlation to start with (Clarke, 1985a). In the present context, its application to difference frames can be called into question, however, especially when they are motion compensated, for such frames most emphatically do not have the kind of statistical characteristics on which conventional redundancy reduction is based. They are, rather, noiselike (this has been, after all, the goal of predictive coding since its introduction – to generate a difference signal whose correlation function was impulse-like, and so having a flat spectrum), and with edge detail enhanced by the differencing operation. If this latter is efficiently motion compensated then the structure has fragmented line detail quite unsuitable for transform coding (see also Chapter 9, Section 9.10). In such circumstances differences in transform type (between DCT and WHT, for example) become irrelevant, and accurate motion compensation may even become an embarrassment rather than an aid. Girod (1987) has analysed the hybrid configuration in detail and makes the specific point noted above with respect to the prediction error signal power spectrum. He also notes that, with a reasonably accurate motion estimate, any gain to be achieved by intraframe (rather than memoryless) coding of the prediction error is small. Again, depending upon the accuracy of the estimate, motion-compensated prediction may be worse than the optimum intraframe coder. Further analysis by Strobach (1990) also demonstrates the inefficiency of transformation of the motion-compensated difference signal by expressing the energy compression efficiency of the transform in terms of the higher moments of the error (e) and transformed (\hat{e}) error signals [i.e. the relative values of the sums of $(\hat{e})^k$ and $(e)^k$ over the transformed signal for $k > 2$, noting that the energy invariance property of the transform gives $\sum(\hat{e})^2 = \sum(e)^2$].

More recent work has shown the variation in performance of the hybrid scheme with respect to transform type and input data activity (Clarke, 1992a; see also Akansu and Kadur, 1989), and results obtained from an analytical model by Chen and Pang (1992) broadly support the reservations expressed above with respect to hybrid transform coding. In view of these conclusions, it is not surprising that many alternative versions of hybrid coding have been developed, and these will be considered below. First of all, however, we examine the matter of motion estimation and compensation, and also the various standardisation activities which have grown up around the hybrid coding technique for processing video information at different rates.

9
Motion and Motion Compensation

9.1. INTRODUCTION

A jaundiced observer of the frenetic activity in the area of still picture coding over the past 20 years or so might with some justification have wondered what all the fuss was about – after all there was no bar *in principle* to sending high quality image data over low bandwidth channels, one just had to wait longer to achieve the final result, which might have been no bad thing anyway. Unfortunately the same could not have been said in the case of the transmission of "moving" images; there is no practicable way of maintaining the illusion of motion without presenting the eye with update information at a rate greater than a certain minimum – at lower rates the resulting artefacts caused by the failure of the eye's "persistence of vision" to accommodate too great a temporal span makes the resulting picture quality simply unacceptable. If the frame rate is too low the consequent flicker is objectionable and, without other measures, artificially increasing the update rate of the display to eliminate this effect does nothing to remove the jerkiness displayed by moving object detail when the actual incoming information rate is too low. There is therefore a very real constraint on data rate for satisfactory transmission, and this has been reflected in the continuing interest in finding ways of sending enough information, albeit at a low rate, to provide a satisfactory "moving" picture. Hence the many schemes reported 30 or more years ago,

before any form of sophisticated digital signal processing and storage facilities were available for doing just this (Seyler, 1962; Schreiber *et al.*, 1959; Harrison, 1952, etc. – see the historical overview, Chapter 1, Section 1.1.2) in a television context. Subsequently, with the growth of interest in what would now be called "multimedia" applications, and the widening requirement to send many not simply entertainment television transmissions but also such data as surveillance and videophone and videoconference signals as cost effectively as possible, came the pressure to apply what by now had become sophisticated still picture coding algorithms to image sequences, and also to take advantage of the large degree of temporal correlation possessed even by moving images having apparently significant amounts of spatial activity. This can be done in two ways: either implicitly, since this correlation will allow a prediction or transform coding operation along the temporal axis to be efficient in any case, or explicitly, by including a frame differencing step in the coding algorithm (the advantage of this step had in fact been recognised during the earliest days of picture coding). Whilst schemes of the first kind were initially found to be advantageous for image sequence coding (and were discussed in Chapter 8), interest over the past 10 years or so has focused on the latter approach (effectively a frame-to-frame prediction with a prediction coefficient of unity), with a variety of techniques derived from still picture coding used to process the difference signal so produced. The rationale behind this step is not always obvious (Chapter 8, Section 8.4.3), and just what constitutes effective processing of this signal will be considered again subsequently.

It is naïve to suggest that the problem of motion in coding image sequences is just that; objects move from frame to frame and so, if still picture techniques are all that is available, as pointed out above, each frame must be coded, transmitted and reconstructed in not more than a predetermined interval (it is, indeed, possible to use still picture algorithms for coding sequences in just this way). Nevertheless, this suggestion does (a) highlight the constraints which arise and (b) indicate what may be done about the situation – take account of the fact that pictures are *of* things (to reiterate a point emphasised earlier in this book with reference to segmented coding techniques) and these things are, by and large, reasonably rigid and do not move very far in the interframe interval (this approximation is becoming increasingly unrealistic with the advent of HDTV, where motion over many tens of picture elements is quite possible). We thus have to deal with three-dimensional object detail which is subject to rotation, translation and scale change as it appears in a two-dimensional projection of these changes on the image plane. Until very recently the topic of general motion has received little attention in the coding literature (see Section 9.8), and for those algorithms which work on a single element basis the exact form of the motion is of no consequence in any case, but the majority of algorithms have a block structure for which the projected effect of rotation

and scaling is assumed to be subsumed under an approximation to translation.

There are, of course, other effects which contribute to variation in image detail from frame to frame, for example change in lighting and the uncovering of previously hidden background by a moving object. The first of these is a completely unknown quantity and its possibility needs to be minimised in any very low-rate system; the second can be dealt with in a highly constrained videophone or videoconference situation by the use of a prestored background data signal keyed into the bitstream by the motion parameters.

We are left, then, with a sequence of frame difference signals which can be processed by a spatial algorithm. Since the small-scale motion of objects is (one assumes) approximately translational and frequently coherent over several frames, the possibility exists of estimating where the detail at a given location in one frame will have moved to by the time that the next frame comes to be processed. If this can be done the frame difference signal can be formed not by taking differences orthogonally along the temporal axis but between the last location and the estimated present one, and the motion can thus to some extent be compensated for. Exact prediction of all motion between frames would, of course, leave nothing to transmit, and all that the receiver would need to do would be to copy the moved detail from frame to frame. We can reliably expect, however, that this will never be the case (a) because we shall never be able to get the motion estimate exactly correct over the whole frame and (b) even if we could, it is likely that the need to convey exactly to the receiver all the necessary motion parameters would be a greater burden on transmission than that of sending the coded residual signal which will result from the differencing operation. A balance needs to be struck, therefore, between the no motion compensation situation, when the frame difference signal will be quite substantial, and an attempt to compensate very accurately for all or most of the motion in a scene at the cost of the transmission of large sets of motion parameters as overhead information. In the event, worthwhile reductions in the information content of the motion-compensated frame difference signal can be achieved in a well-designed system without an excessive motion parameter transmission burden. For a general examination of this area see Sezan and Lagendijk (1993).

9.2. EARLY APPROACHES TO THE PROBLEM

Interest in some way of estimating and accounting for object motion in an image sequence dates from the early 1970s and was first reported by Rocca and Zanoletti (1972), Haskell (1974) and Limb and Murphy (1975). Whilst the vast majority of estimation algorithms operate in the spatial domain

frequency domain techniques have also been developed from time to time and Haskell's algorithm is of this kind. It makes use of a basic property of the Fourier transform which is known to every undergraduate student in Electrical Engineering – that the transform of a signal displaced in time (or, in the present context, space) is the same as that of the undisplaced signal save for a (spatial) phase shift linearly proportional to the displacement. Thus, assuming reasonably uniform motion from frame to frame, the Fourier transform of a given frame difference signal should be the same as its previous counterpart when the two-dimensional phase shift term is taken into account. Over the moving area, therefore, motion compensation takes the form of a phase shift adjustment, and taking the average shift allows compensation by a nonintegral number of picture elements. It is suggested that this be combined with predictive coding of the frame difference signal by using the phase shift term to adjust the Fourier transform of the previous frame difference signal which then, upon inverse transformation, provides a motion-compensated prediction for the present frame difference. This operation is best carried out over sub-areas of the picture which relate to specific moving objects and using frame differences is preferable to taking the Fourier transform of successive frames themselves since the problem of accurate definition of the changed area is to some extent circumvented. No actual performance results are quoted by Haskell, and there does not seem to have been any significant attempt by other workers to follow up his suggestion, although one related algorithm is that of Mahmoud *et al.* (1988), which uses the Fourier spectrum to estimate object velocity.

On the other hand spatial domain processing has been consistently used since the early days for motion estimation. Limb and Murphy (1975) described a basic speed estimator for moving object detail. They began by calculating the magnitude of the frame difference (*FD*) by summing the absolute values of the differences (*FDS*), over the moving area, between the "same" picture elements in successive frames:

$$FD = \sum | FDS |. \qquad (9.1)$$

This quantity will be approximately proportional to speed but will also depend on the size of the moving area. If the latter changes so will the value of the frame difference. Thus a normalisation factor is included, and this is the element difference signal *ED*, where

$$ED = \sum | EDS | \qquad (9.2)$$

and *EDS* is the element-to-element difference in the present frame, which should depend on the size of the moving area but be independent of speed. The overall measure is thus:

$$S = FD/ED \qquad (9.3)$$

and was shown by the authors to be quite accurate for object speeds up to three picture elements per frame.

Cafforio and Rocca (1976) established a theoretical basis for spatial domain displacement estimation involving a segmentation algorithm, followed by linear estimation over the moving areas so obtained. One practical consequence of their analysis is that it is better, if the segmentation algorithm is unreliable, to exclude parts of the moving area rather than include stationary background. They also make the point, often resubstantiated since their original work, that low-pass filtering, here of the frame difference signal (effectively the observation on which the segmentation and estimation are based), is valuable both in improving the segmentation and making the estimation more precise. Up to displacements of three picture elements per frame they achieve an accuracy of about 0.1 element.

9.3. ELEMENT RECURSIVE TECHNIQUES

The profile of motion estimation and compensation for image sequence coding was significantly raised by the publication, at the end of the 1970s, of a series of papers by Netravali and co-workers (Netravali and Robbins, 1979; Stuller and Netravali, 1979; Netravali and Stuller, 1979; Stuller *et al.*, 1980) in which the application of a recursive steepest descent algorithm to minimise the frame-to-frame prediction error of each picture element was reported, and interest in this approach to motion compensation has continued to the present day. Their development starts with a re-examination of the algorithms of Limb and Murphy and Cafforio and Rocca referred to earlier. Defining $I(\mathbf{x}, t)$ to be the luminance at location $\mathbf{x} = \{x, y\}$ in the present frame existing at time t, then if \mathbf{D} is the translation vector which obtains over the interframe interval τ since the last frame,

$$I(\mathbf{x}, t) = I(\mathbf{x} - \mathbf{D}, t - \tau) \tag{9.4}$$

and the frame difference is

$$\begin{aligned} FD(\mathbf{x}) &= I(\mathbf{x}, t) - I(\mathbf{x}, t - \tau) \\ &= I(\mathbf{x}, t) - I(\mathbf{x} + \mathbf{D}, t). \end{aligned} \tag{9.5}$$

A one-dimensional interpretation of these relationships is given in Figure 9.1. $I(\mathbf{x}, t)$ is also the value of the luminance at the shifted location $\mathbf{x} - \mathbf{D}$ in the previous frame at time $t - \tau$. The frame difference is the difference between luminance values at the *same* location \mathbf{x} in the two frames but is also (approximately) the difference between the luminance values at locations \mathbf{x} and $\mathbf{x} + \mathbf{D}$ in the present frame (at time t). By rewriting Equation (9.5) in terms of the gradient of the luminance function $\nabla I(\mathbf{x}, t)$, which can in turn be written as a vector of element-to-element and line-to-line differences, an estimate, \mathbf{D}', of

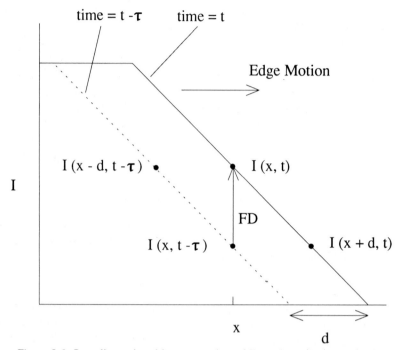

Figure 9.1 One-dimensional interpretation of Equations (9.4) and (9.5).

D can be made, and it is shown that this is the same as one version of the algorithm of Limb and Murphy [note that the higher order terms which appear in this analysis are normally neglected – see, however, the work of Biemond *et al.* (1987) referred to later in this section]. Netravali and Robbins now suggest that an iterative procedure can be employed, given an initial estimate of **D**, to improve this estimate. Thus:

$$\mathbf{D}'^{i} = \mathbf{D}'^{i-1} + \mathbf{U}^{i} \tag{9.6}$$

relates a new estimate, \mathbf{D}'^{i}, to a previous one \mathbf{D}'^{i-1} as modified by an update term \mathbf{U}^{i}. It should be noted here that some confusion of notation exists in the literature regarding these equations. Initially, Netravali and Robbins used *i* as a frame/field index: an estimate for the present frame *i* is thus based upon one for a previous frame *i* − 1. Subsequently *i* has been used generally to denote a stage in the iteration process, and not the specific frame-to-frame operation indicated above. A so-called displaced frame difference (DFD) is now defined:

$$DFD\,(\mathbf{x}, \mathbf{D}'^{i-1}) = I(\mathbf{x}, t) - I(\mathbf{x} - \mathbf{D}'^{i-1}, t - \tau). \tag{9.7}$$

Comparing this equation with Equation (9.4), it can be seen that, as the estimate of **D**, \mathbf{D}'^{i-1} approaches the true displacement **D**, the DFD falls to

zero (note that in general \mathbf{D}'^{i-1} will not have integral components, and interpolation will be needed to calculate the DFD).

The displaced frame difference can be used to modify Netravali and Robbins' version of the original algorithm of Limb and Murphy, but their main objective is to develop a fully recursive algorithm operating over a small area or even on an individual picture element. They suggest that this will circumvent the problem of multiple moving objects in the image frame, and that it is particularly suitable for predictive coding, since the DFD is the prediction error signal in any case, is just the signal which needs to be transmitted, and its minimisation is a logical step in any coding algorithm. Thus a gradient approach is used:

$$\mathbf{D}'^{i} = \mathbf{D}'^{i-1} - (\epsilon/2)\,\nabla_{\mathbf{D}}\,(\text{DFD}\,(\mathbf{x}, \mathbf{D}'^{i-1}))^2, \qquad (9.8)$$

where $\nabla_{\mathbf{D}}$ indicates the gradient with respect to \mathbf{D} and ϵ is a positive constant controlling the rate of convergence. Differentiating and using Equation (9.7) to define $\nabla_{\mathbf{D}}\,(\text{DFD}\,(\cdot\,)$ in terms of $\nabla\,(\text{DFD}(\cdot\,))$ results in:

$$\mathbf{D}'^{i} = \mathbf{D}'^{i-1} - \epsilon \cdot \text{DFD}\,(\mathbf{x}, \mathbf{D}'^{i-1})\,\nabla\,I\,(\mathbf{x} - \mathbf{D}'^{i-1}, t - \tau), \qquad (9.9)$$

where the components of \mathbf{D}'^{i-1} may be rounded to integers for ease of calculation. Netravali and Robbins now determine their new estimate of \mathbf{D} from the above equation by using picture elements in the neighbourhood of $(\mathbf{x} - \mathbf{D}'^{i-1})$ in the previous frame (at time $t - \tau$) to estimate the horizontal and vertical gradient terms. Thus (see Figure 9.2)

$$\nabla_{\text{H}} = (I_{\text{C}} - I_{\text{B}})/2 \qquad \nabla_{\text{V}} = (I_{\text{A}} - I_{\text{D}})/2. \qquad (9.10)$$

Other configurations are possible but do not affect performance significantly.

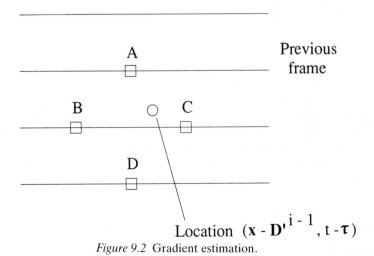

Figure 9.2 Gradient estimation.

In their experiments ϵ is set to $1/1024$ and a maximum limit is set on the error estimate of $1/16$ horizontally and vertically in order to avoid problems due to noise. Picture element z_0 is classified as moving if

$$
\begin{array}{ll}
& |FD(z_0)| > T_2 \\
\text{or} & |FD(z_0)| > T_1 \\
\text{and} & |FD(z_1)| > T_1 \\
\text{and} & |FD(z_2)| > T_1,
\end{array}
\tag{9.11}
$$

where z_1 and z_2 are elements neighbouring z_0 in present, previous and future frames and T_1 and T_2 are one and three, respectively. Since the receiver does not have the displacement estimate the value determined for the element directly above the present one in the same field is used. Further, moving areas identified by the segmentation of Equation (9.11) are divided into compensatable and uncompensatable, according to whether the motion-compensated prediction is adequate, and no update transmission of prediction error is needed, or the magnitude of the motion-compensated prediction error is greater than 3 (for 8 bit data), respectively.

Many other modifications and simplifications (to enable real-time operation) are detailed in the authors' paper. Overall it is shown that, depending on scene content, a reduction of one quarter to one half the bit rate per element required for simple frame difference coding can be achieved. In later work (Netravali and Robbins, 1980) the authors modify the update term to include a weighted sum of DFDs from neighbouring picture elements. This has the effect of smoothing the update term and gives an additional bit-rate reduction of 10% for natural images. That this is not greater was attributed to the possibility of averaging what are, in any case, initially different values of the DFD anyway.

It was mentioned earlier that a problem with the detection of moving detail and estimation of the motion involved will be influenced by variations in incident illumination. Stuller et $al.$ (1980) extended the recursive algorithm described above to deal with this, treating a change in illumination, L, as a multiplying factor, or gain, applied to the object reflectance R. There are three conditions.

(1) L is spatially constant but time varying, $L = L(t)$, R is fixed through time but spatially varying, $R = R(\mathbf{x})$ (shadows caused by a moving object).

(2) L is fixed through time but spatially non-uniform, $L = L(\mathbf{x})$, R varies with both \mathbf{x} and t, $R = R(\mathbf{x}, t)$ (object motion).

(3) As (2) but with the roles of L and R reversed, $L = L(\mathbf{x}, t)$, $R = R(\mathbf{x})$.

Condition (1) gives rise to a temporal change only from frame to frame characterised by

$$
I(\mathbf{x}, t) = \rho_1 I(\mathbf{x}, t - \tau)
\tag{9.12}
$$

whilst (2) and (3) also involve displacement:

$$I(\mathbf{x}, t) = \rho_2 I(\mathbf{x} - \mathbf{D}, t - \tau). \tag{9.13}$$

Here ρ_1 and ρ_2 may be estimated using gradient algorithms of the type already discussed. Results depend strongly on the type of scene coded. For a scene with reasonably constant illumination, both gain and displacement compensation applied separately reduce the bit-rate by about one half compared with straightforward frame difference coding, with their combination contributing only a few per cent more. For an image with large regions of non-uniform illumination and moving shadows, however, gain compensation has more to contribute in lowering the bit-rate (40% as against 15% for displacement) whilst a combination of the two only gives a few per cent more once again. The impression is gained that a combination of the two techniques would enable a bit-rate more robust to strong changes in illumination and shadow content to be achieved for arbitrary scenes. A more recent approach to the problem of motion estimation in the presence of illumination changes is reported by Moloney and Dubois (1991).

Reference was made above to the proposal to use spectral domain techniques for motion estimation. In the course of their work on element recursive schemes, Stuller and Netravali (1979) investigated the application of the algorithm in the transform domain. Space permits only a brief reference to this technique here, which is relevant to a form of hybrid transform coding no longer in favour (see Chapter 8 for a more detailed discussion of this point). In this approach, separate image frames are first transform coded and the prediction operation takes place between like coefficients frame to frame. The element recursive algorithm is then applied to this coefficient set, i.e. the kth coefficient of the jth block in the present frame is predicted from the kth coefficient of the *displaced* jth block in the previous frame. Various block sizes and transforms were used by the authors in the development of the algorithm, and an actual coder implementation is described in Netravali and Stuller (1979). Their results show that operation in the transform domain does not result in any significant gain in bit-rate reduction compared with the use of a separate spatial motion estimation stage before coefficient prediction. Nowadays it is preferred, in any case, to take the motion-compensated prediction *first* i.e. before transform coding of the residual error signal (for further discussion on this matter, see Chapter 8, Section 8.4). It is worth noting, however, that recently a frequency domain motion estimation scheme has been reported with several advantages when compared with more conventional methods (Young and Kingsbury, 1993a,b).

Netravali and Robbins not only opened up a new direction in the search for an efficient motion compensation algorithm but reinforced the view that there were solid gains to be achieved through its use. However, it soon became apparent that the basic algorithm left something to be desired, and modifications were not thereafter slow in appearing. Walker and Rao (1984) reviewed the technology, concentrating on the behaviour of the update term

over the number of allowable iterations, pointing out that the restriction on the maximum value of this term at each iteration leads to slow convergence which may not be allowable if real-time operation is required. They stress the fact that the largest correction is needed when the magnitude of the DFD is large and, on the other hand, when this is small only a small correction is required. This can be completely upset by the variation in the gradient term, and can be allowed for by making ϵ [in Equation (9.8)] an inverse function of that component. In this case, if the update term is less than 1/16 in magnitude it is set to that value (with the appropriate sign), and if it is greater than 2 it is likewise clipped. If the gradient should ever be zero, then this value is assigned to the update (a similar approach is reported by Cafforio and Rocca, 1983). In all cases, if $|DFD|$ is less than 3 then the algorithm is considered to have found an acceptable prediction. In the usual implementation no data need be transmitted in such a case, but addresses of all unpredictable elements must be sent. In Walker and Rao's coder, the DFD is sent, even if it is less than a given threshold, when it is replaced by zero. Strings of such zeros can be run length coded. The algorithm is shown to be effective even around one iteration per element and more iterations give little improvement. A specific implementation is reported by the authors (Walker and Rao, 1987) and simulation results presented.

Many papers have been published on element recursive motion estimation/compensation over the past few years and a critical analysis of the technique is presented by Moorhead *et al.* (1987), focusing mainly on the criteria which need to be satisfied for convergence of the algorithm. Their analysis shows that clipping of the update term is not a necessary part of the algorithm and they also derive bounds on the value of ϵ for typical sequences. They also point out the dangers of the calculation falling into a local minimum of the $|DFD|$: displacement relation and also of starting the iteration at a point of zero gradient (uniform luminance) in which case no correction term will be generated.

In considering the suitability of various choices for an initial estimate (spatial or temporal adjacency), they conclude that the most suitable and logical choice is projection along the motion trajectory (PAMT). This will allow detection of uncovered background (see also Section 9.9.1) and, since it should provide a better initial estimate, it will provide a better estimate in any given number of iterations. Obvious as it may seem, this conclusion was not borne out by their simulation results, one reason for which is suggested to be noise affecting the displacement estimates. They also seem to have refuted an earlier claim that differential transmission of successive prediction errors is of benefit by achieving a 12–14% improvement by coding the individual terms directly. This would imply that successive values are largely uncorrelated, a conclusion that would need to be substantiated by experiment.

An extensive attack on the problems which surround element recursive motion estimation algorithms has been mounted by Biemond and his col-

leagues at Delft University of Technology (Biemond *et al.*, 1987). A Wiener-based approach is taken to the estimation problem to which it is shown that previous algorithms (Cafforio and Rocca and Walker and Rao) are related. Using N observations at points $\mathbf{x}\ (j)\ j = 1 \rightarrow N$ the equation relating the displaced frame difference, $DFD\ (\mathbf{x}, \mathbf{D}^{i-1})$ to the true displacement \mathbf{D}, the previous estimate \mathbf{D}^{i-1} and the gradients $\nabla\ I\ (\mathbf{x} - \mathbf{D}^{i-1}, t - \tau)$ is written

$$\mathbf{z} = G\ (\mathbf{D} - \mathbf{D}^{i-1}) + \mathbf{v}$$
$$= G\ \mathbf{U} + \mathbf{v}, \tag{9.14}$$

where \mathbf{z} is the $N \times 1$ observation vector, G the $N \times 2$ gradient matrix, \mathbf{U} the 2×1 update vector and \mathbf{v} the $N \times 1$ vector of truncation errors appearing in the original development but usually neglected (see above). The task is now to find estimator L where $\mathbf{U}' = L\ \mathbf{z}$ under the condition that the expected square norm of the error $E\ \{\|\ \mathbf{U} - \mathbf{U}'\ \|\}$ is minimised given Equation (9.14). The new estimate is then given by Equation (9.6). The actual value of \mathbf{U}' involves the covariance matrices of \mathbf{U} and \mathbf{v} about which little is known. Accordingly these variables are considered to be uncorrelated. The ratio of the variances of \mathbf{v} and \mathbf{U}, σ_v^2 and σ_U^2, forms a "damping" term which affects the magnitude of the update term and is typically between 50 and 100. Since σ_U^2 and σ_v^2 vary over any individual frame, adapting μ using a total least-squares approach is advantageous (Boroczky *et al.*, 1990; see also Driessen *et al.*, 1991). An alternative approach to the constraints determining μ is reported by Efstratiadis and Katsaggelos (1990). Values of N between three and nine are effective, performance increasing somewhat, as might be expected, with N. Typically, seven elements can be used as shown in Figure 9.3. Note that the

Figure 9.3 Typical element set used in displacement estimator of Biemond *et al.* (1987). (□) Locations at which observations are made; (○) current element.

elements used in the estimation process must already be available at the receiver in this implementation. Results show a marked improvement, on both real and synthetic scenes, in terms of root mean square prediction error and speed of convergence.

Problems with the correct classification of areas over which any motion compensation algorithm has to operate led Driessen *et al.* (1989) to develop further the algorithm of Biemond *et al.* described above. Frames are segmented into three distinct regions – unchanged, predictable and

unpredictable. The segmentation scheme uses a first stage of detection which examines the frame difference signal to distinguish between changed and unchanged (zero motion) regions on the basis of a variance test. The test is not, however, based simply on a threshold (which would simply repeat the approaches used previously) but by modelling regions of the image as Markov random fields and making an associated maximum *a posteriori* estimate which defines an initial approximation motion vector and analysis window. Following displacement of changed elements a second detector differentiates in the same way between predictable and unpredictable regions (where the variance of the DFD is large and the estimate is not accurate enough). Determination of "predictable" regions is also used to update the first window estimate. A noticeable improvement over the use of a simple threshold test is achieved. These ideas were subsequently implemented in a "backward" predictive coding structure (Driessen *et al.*, 1990). In this algorithm all estimates must be derived at the receiver from previously transmitted data. The advantage is that motion information does not need to be transmitted (as would be the case in a "forward" scheme), the disadvantage is that no original image material is available and so estimates are likely to be poorer – an efficient estimation scheme is therefore vital.

Element recursive motion estimation has been shown over the past 15 years or so to be an effective technique for increasing the efficiency of image sequence coders (a further review of the method is given by Wang and Clarke, 1992a). Nevertheless, problems such as changed area detection, initial estimate suitability and implementation have fostered the parallel development of alternative methods, one of which, although a less subtle approach, has become the most widespread in use today.

9.4. BLOCK MATCHING MOTION ESTIMATION

At the time of its initial development, tracking of the history of individual picture elements using recursive algorithms of the type described in the previous section seemed a sophisticated approach and more straightforward techniques were sought. Making the assumption that, for the kinds of scenes that were expected to be transmitted by low-rate coding schemes (videotelephone/videoconference) the amount of moving detail from frame to frame would not be very great, schemes based upon estimation over small rectangular image blocks were proposed, since over such areas motion could be approximated by translation only – a move which proved appealing since a majority of actual data reduction algorithms are block-based in any event.

Interest in this approach was stimulated by Jain and Jain (1981) who simply matched element luminance values $u(m,n)$ in a given block of size $M \times N$ in

the present frame with those of a similar $M \times N$ region in the previous frame which is part of a (reference) block of dimension $(M + 2p) \times (N + 2p)$. Here p is the allowable maximum displacement and the matching criterion is some average error measure:

$$D(i, j) = 1/(M \times N) \sum_{m=1}^{M} \sum_{n=1}^{N} g\left[u\,(m, n) - u_R\,(m + i, n + j)\right] \quad (9.15)$$
$$-p \leq i, j \leq p.$$

$g[\cdot]$ here may be $[\cdot]^2$, in which case $D\,(i, j)$ becomes the mean square error. This has traditionally been used as the error function, but mean absolute error (MAE), where $g\,[\cdot] = |\cdot|$ has also been regularly used to minimise the computational burden.

Full search motion estimation (i.e. of every possible two-dimensional shift within the range) then involves a total of $(2p + 1)^2$ error evaluations, and this has led to the reporting of numerous schemes intended to reduce the number whilst not sacrificing the reliability of the estimate too much – full search being, of course, the only technique which will guarantee to find the correct global minimum of $D\,(i, j)$ and thus the optimum displacement vector. One such scheme is proposed by Jain and Jain and is illustrated in Figure 9.4. This so-called "logarithmic" search (the stepsize reduces by a constant factor, usually two, at each stage) tests $D(i, j)$ at five initial locations, moves to the one with the lowest $D(\cdot)$, retests, involving three new locations and, if this is still the location of the lowest $D(\cdot)$, reduces the stepsize and tests all adjacent locations (Δ) in the figure. The authors note that the variance of the interframe difference signal varies significantly without motion compensation and that after compensation this variation almost completely disappears. This naturally eases the subsequent coding problem as far as variations in output bit-rate are concerned. Overall, the variance reduction between the no motion compensation and motion-compensated cases is approximately 8 dB. In addition, the authors discuss applications in interframe hybrid coding.

It is unnecessary here to review exhaustively the multitude of alternative reduced search schemes that have been proposed, mainly because modern practice favours, and the power of present day computation allows, the performance of full search procedures. Brief details only are included here for completeness, and the reader is referred to Srinivasan and Rao (1985, 1987) and Kappagantula and Rao (1985), for example, for a fuller discussion. The alternatives basically vary the number and disposition of points searched at each level and the change in resolution from level to level (usually by a factor of one half). "One at a time" search looks for a minimum in one direction with the other axial coordinate remaining fixed. The procedure is then reversed – grey-bearded electrical engineers (like the author) will see here a close analogy with balancing the in-phase and quadrature

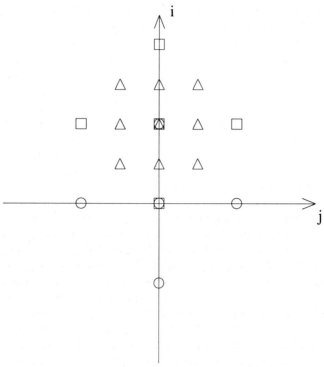

Figure 9.4 Two-dimensional logarithmic search. (O) Initial locations; (□) next stage
locations (three of which are new); (△) final locations.

components of a measurement bridge when determining the value of an
unknown impedance. Conjugate direction search expands on this operation
by extending the possible search directions, for example along a line joining
the minimum so far obtained with the original approximate location of that
minimum. Ghanbari (1990) compared the efficiency of several such
schemes. In all cases assumptions are made concerning the smoothly varying
and monotonic nature of the error function with respect to two-dimensional
displacement. This is (using the mean square error measure) equivalent to
monotonic decay of the correlation coefficient with displacement, a con-
dition which only obtains with very "well-behaved" image detail (Clarke,
1985a).

It is usual to test the initial value of MAE against a threshold (3–4 levels
for 8 bit data). If the MAE is less than this value then the block can be
classified as unchanged and no motion compensation is necessary. Gharavi
and Mills (1990) used a similar approach to classify each element in a block
as "matched" or "mismatched", and regarded the best overall match as that
with the largest number of matched elements. They show that this approach
achieves a PSNR almost as high as that obtained when using mean square
error (MSE), and significantly better than that produced by the use of

MAE. There is a curious discrepancy here with Ghanbari's results, which show that the performance of MAE is close to that of MSE in this application.

As usual, modifications to the basic scheme abound. Bowling and Jones (1985) used a two-step procedure to determine, initially, the integer component of the displacement vector using a maximum *a posteriori* estimate; the non-integer component is accounted for by modelling the element in the present frame by a weighted linear combination (prediction) of luminance values from elements nearest to the displaced location in the previous frame. Kwatra *et al.* (1987) presented an adaptive algorithm which terminates the search whenever the MAE falls below a threshold and uses a test which checks how much improvement is achieved in moving from stage to stage. If this latter quantity is small (with the MAE still above the lower threshold) then the data is probably very noisy and the search stops. Yamaguchi (1989) has applied a block structure to the gradient approach of Cafforio and Rocca (1976, 1983; earlier in this chapter). Gradients are estimated by using spatially coincident blocks in the present and previous frames and are used to produce an initial motion estimate. The appropriate block (i.e. that displaced by the calculated value) is then used to improve the estimate and further block shifts can make this more accurate still. Orchard (1993) used information from segmentation of the motion field of previous frames to predict moving object boundaries and discontinuities in the present frame and so improve the accuracy of estimation. Genetic algorithms have recently been introduced into block motion estimation by various workers – Franich *et al.* (1993) used one to produce smooth vector fields at small block sizes, and Chow and Liou (1993) found that such an algorithm is more robust in finding the global optimum and yet is simpler than full search. A technique which allows more accurate motion field determination at the edges of objects is reported by Dufaux and Kunt (1992). As in so many other areas improvements appear to be endless.

9.4.1. General Comments

Criticisms of block matching of the nature that it is a "brute force and ignorance" method are largely misdirected. True it operates basically on the assumption of translation, other varieties of motion being catered for by their approximation as, for example, translation of a relatively small sub-block. Full search can nowadays be implemented at reasonable real-time rates and will ensure that the search process does not converge to a local minimum, and access to neighbouring distortion values can allow interpolation to sub-element accuracy. It is a simple and practically implementable technique and, as far as reducing the variance of an interframe prediction is concerned, there is no doubt that it can be made to function efficiently. As far as improvements

are concerned, these are more likely to come from the area of general three-dimensional object tracking through a series of frames than from what can probably now only constitute minor improvements to the basic block matching algorithm.

9.5. CORRELATION TECHNIQUES

Block matching, as described above, can be regarded as one method of correlating an image sub-block in the present frame with the optimally located corresponding block in the previous frame via minimisation of some appropriate cost function (MSE or MAE). More formally defined correlation operators can, of course, be used, as in applications which pre-date the interest in motion compensation for image sequence coding (see e.g. Pratt, 1974), where the cross-correlation function is calculated in order to determine the displacement between two images. In the present context, Bergmann's algorithm (1982) is a good example of the technique. Here, instead of computing the discrete cross-correlation function directly the peak in the function (indicating the required value of displacement) is determined via the zero crossings of its derivative with respect to distance. In this case an initial displacement estimate is made using a small window centred on the picture element in question (this requires calculation of the first and second order derivatives of the two-dimensional correlation/distance function within two successive frames). This value is now iteratively updated by using the estimate for one element as a prediction of the next. Performance is shown to be much better than that of the basic form of the element recursive algorithm for displacements around 4–5 elements per frame.

Thomas (1987) has suggested improvements to a correlation technique originally reported by Pearson et al. (1977). His algorithm uses a two-dimensional Fourier transform to perform the necessary calculations, reducing the computational load and also allowing filtering to be carried out upon the correlation result in order to reduce the effect of noise. What would normally be considered to be large blocks in the context of image coding (64 × 64) are used in the operation. The initial manipulation is to take the two-dimensional transform of blocks in two successive image frames. It is a fundamental Fourier theory result that correlation may be carried out by initial Fourier transformation, multiplication of one spectrum by the complex conjugate $(\cdot)^*$ of the other, and subsequent inverse transformation. It is no different, of course, in two dimensions. Therefore a correlation surface may be achieved by applying the operation

$$Z = G_1 \cdot G_2{}^*, \tag{9.16}$$

where G_1 and G_2 are the two-dimensional spectra, and taking the inverse

transform of Z. In order to overcome the problem of possibly significant variations in spectral amplitude over the frequency range, it is advantageous to normalise Z by its magnitude and work with Z' instead,

$$Z' = Z/|Z|, \qquad (9.17)$$

to increase the sharpness of the correlation peak. Thomas now suggests that more than one peak may be detected in a single block, representing the motion, within the block, of more than one object. Each motion vector (corresponding to a different peak) can now be used as a trial displacement in a (possibly variable size) block matching operation. Simulation shows that very accurate results (root mean square error below 0.1 element) for shifts up to 40–50 elements could be achieved, even without the inclusion of inter-polation of results at half element spacing, for simple translational motion. Using a raised cosine window improves the results further, but the increased computational load to gain this improvement is probably not justified in a practical application. The technique was, in addition, judged to work success-fully on more complex motion, to be robust in the presence of noise and to be able to detect very small moving objects.

9.6. HIERARCHICAL TECHNIQUES

One advantage of the phase correlation technique described above is its ability to deal with large displacements frame to frame. There is also a requirement that, for motion-compensated interpolation (see later) as opposed to motion compensated prediction, it is not sufficient simply to seek a minimum in the displacement cost function, it is that minimum correspond-ing to the *true* displacement which is required, and these may by no means be the same. This matter is taken up by Bierling (1988) who describes a hier-archical block matching approach. A weakness of the basic block matching algorithm is that it employs a fixed block size. Thus large displacement cannot be accommodated on the one hand, whilst on the other, it is not possible to obtain very accurate motion vectors as needed for interpolation. This is circumvented by starting with a large window to obtain a first estimate of the displacement and successively refining this estimate over lower levels of the hierarchy using smaller and smaller windows. Bierling starts with a window size of 64 × 64 and estimates displacement every eighth element horizontally and vertically. This estimate (or a bi-linear interpolation from four nearest neighbours, if one is not directly available from the higher level) is used to start the next stage, when the window size is 28 × 28 and the stepsize four. At the third level the corresponding parameters are 12 × 12 and two and a final

bi-linear interpolation will allow a motion vector to be obtained for every picture element. At each level a logarithmic search technique (see Section 9.4) is used. In addition, averaging over a small region surrounding the picture element in question provides a rudimentary form of low-pass filtering which decreases the risk of incorrect convergence of the algorithm. A simplified version of the algorithm was applied by Bierling to a $64\,\text{kb}\,\text{s}^{-1}$ videotelephone codec, using two levels with windows 64×64 and 16×16 and stepsizes of 32 and 16, respectively. Again bi-linear interpolation was used to obtain a motion vector for every picture element so that motion-compensated interpolation could be carried out. Since the amount of complex motion in a videotelephone sequence is small even this simple implementation was capable of good performance.

Wang and Clarke (1990a) presented a hierarchical technique which is in part similar to that of Bierling. An image pyramid is constructed by successive averaging over regions at any level. Thus an initially 256×256 image is averaged over neighbouring 4×4 regions to provide a 64×64 image at the next higher level and the procedure is repeated once more to obtain a reduced resolution 16×16 top level as in Figure 7.10. Element by element estimation then proceeds (using direct matching) from the top to bottom layer, at each stage taking the motion vector obtained as the initial estimate for the next. A total displacement of ±26 picture elements can be accommodated and good results are obtained for the procedure in comparison with the use of an element recursive algorithm (if frame differences below 3 or 4 levels in magnitude are set to zero after motion compensation then the difference frame entropy falls from about 1.2 bit element^{-1} in the element recursive case to around 0.5 bit element^{-1} for the hierarchical method for typical videotelephone images). The incorporation of the technique into a coding algorithm was subsequently described by the authors in more detail (Wang and Clarke, 1992a,b) in the context of a more general review of motion estimation and compensation. The algorithm cannot be used as it stands since the overhead required to transmit one motion vector per picture element would be excessive. The top level (16×16) image is transmitted by interframe DPCM and motion vectors obtained. Using these as initial estimates, motion-compensated prediction errors are calculated for the middle level, coded and transmitted so that this level can be reconstructed at the receiver, and so on. For the current picture element, the average of the previous horizontal and vertical elements is used for the motion vector. Results are illustrated in Figures 9.5 and 9.6. Figure 9.5(a) is an original frame of the CLAIRE image, and Figure 9.5(b) shows the frame difference signal with no motion compensation (since frame differences can be equally positive or negative the conventional way to display them, as used here, is to clip them at ±128 and then add a 128 grey-level offset). Figure 9.5(c) shows the result for element recursive motion compensation and Figure 9.5(d) that for the pyramid approach. Figure 9.6(a) shows the motion-compensated difference frame in the practical coding case

Figure 9.5 (a) One frame of the original CLAIRE sequence. (b) Frame difference signal, no motion compensation. (c) Frame difference signal, element recursive motion compensation. (d) Frame difference signal, pyramid motion compensation.

(a)

(b)

(c)

Figure 9.6 (a) Frame difference signal, as Figure 9.5c, practical case. (b) Frame difference signal, block matching, practical case. (c) Frame difference signal, pyramid motion compensation, practical case.

(element recursion) and Figure 9.6(b) that for block matching. Finally, Figure 9.6(c) gives the pyramid result.

In general, hierarchical methods offer a simple way of extending the capabilities of fixed size block matching, and they are also in the spirit of multiscale, multiresolution approaches to coding which are of so much interest today.

9.7. MOTION-COMPENSATED INTERPOLATION

Low-rate coding of image sequences places great demands upon the system or algorithm designer, and he will generally use any technique which will ease the transmission burden, even at the cost of some greater complexity of implementation. Thus, in the early days of television, the use of interlace halved the bandwidth requirement of an otherwise full sequential scan (although at the cost of the introduction of visual artefacts, creating substantial problems for those who, many years later, sought to digitise the output signal from a conventional television system). In a similar way a data rate reduction can be achieved by dropping one or more frames in the transmitted sequence, subsequently to be reconstructed by either frame repetition or interpolation at the receiver. Given the relatively small degree of temporal activity present in videotelephone/conference sequences for a lot of the time such techniques can be quite successful, but they produce unacceptable artefacts whenever there is rapid motion, and the jerkiness/blurring with which originally clear movement is portrayed can be extremely disconcerting. An obvious improvement would be to interpolate taking object motion into account, and this can be achieved by reference to frame motion vectors [providing that these do represent true motion, rather than simply a minimum in the prediction error – all that is necessary for motion-compensated prediction; see Jain and Jain (1981)]. As a result, it is now usual to adopt frame skipping and motion-compensated interpolation for low-rate coding schemes.

Musmann *et al.* (1985) described the basic requirement. In Figure 9.7 the rectangle A B D C in frame $k - 1$ has moved in one-dimensional translation from A_1 B_1 D_1 C_1 in frame $k - 2$ and will reach A_2 B_2 D_2 C_2 in frame k. Frames k and $k - 2$ are available at the receiver and it is desired to interpolate frame $k - 1$. It is evident that only area A_2 B_1 D_1 C_2 can be correctly recovered by simply interpolating at fixed spatial locations across frames k, $k - 2$, and even then only if the object has substantially constant luminance overall. The luminance values in areas A_1 A_2 C_2 C_1 and B_1 B_2 D_2 D_1 will consist of averages over moving object and background, whereas A_1 A C C_1 and B B_2 D_2 D should have entirely the background value and A A_2 C_2 C and B_1 B D D_1 entirely that of the moving object. The correct course of action is to interpolate with regard to the motion trajectory of the object. If constant

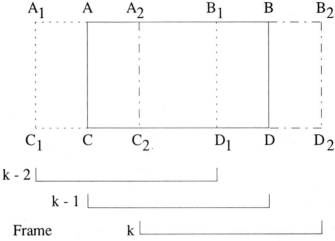

Figure 9.7 Frame-to-frame translation in one dimension.

object velocity is assumed, the displacement vector obtained between frames k and $k - 2$ will have half the value at frame $k - 1$, equidistant in time from both k and $k - 2$.

It is evident that there are four distinct regions which have to be taken into account in a reliable implementation of motion-compensated interpolation.

(a) The moving object or objects.
(b) The stationary background.
(c) The areas (for example A_1 A C C_1) uncovered by the moving area between frames $k - 2$ and $k - 1$.
(d) Areas (for example B B_2 D_2 D) which will be covered by the moving area between frames $k - 1$ and k.

(a) is reconstructed by interpolation between frames k and $k - 2$, taking the displacement estimate into account; (b) is reconstructed similarly with the assumption of zero displacement between frames; (c) is reconstructed by backward extrapolation from frame k; and (d) by forward extrapolation from frame $k - 2$.

It is obvious that successful implementation of interpolation/extrapolation operations of the kind just described is crucially dependent upon the successful segmentation of moving detail and background, and a practical example of the application of the technique is shown in Figure 9.8. Figure 9.8(a) is MISSA frame 19 coded using the segmentation algorithm described in Chapter 11, Section 11.4, and Figure 9.8(b) similarly portrays frame 21. Frame 20 in Figure 9.8(c) has been obtained by motion-compensated interpolation and Frame 20 in Figure 9.8(d) directly from the coded sequence.

The matter is dealt with in some detail by Thoma and Bierling (1989), who employed the hierarchical algorithm described earlier for motion estimation.

Frame 9.8 (a) MISSA frame 19 coded using a segmentation algorithm. (b) MISSA frame 21 coded using a segmentation algorithm. (c) MISSA frame 20 derived by motion-compensated interpolation. (d) MISSA frame 20 coded using a segmentation algorithm.

Changed/unchanged decisions are made dependent upon the frame difference signal:

$$FD\ (\mathbf{x}_0) = S_k\ (\mathbf{x}_0) - S_{k-2}\ (\mathbf{x}_0)$$
$$\mathbf{x}_0 = \{x_0, y_0\} \qquad\qquad (9.18)$$

for frame sub-sampling where S_k is an arbitrary frame. $FD\ (\mathbf{x}_0)$ is then compared with a threshold to generate a binary change detection mask with value "1" for changed or "0" unchanged for each \mathbf{x}_0. As is usual for any segmentation operation, correct choice of threshold and elimination of very small (more or less random) regions are important. To combat frame noise threshold testing is carried out as an average over a small region surrounding \mathbf{x}_0 by testing the mean value of $FD\ (\mathbf{x}_0)$, $FD_\mathrm{m}\ (\mathbf{x}_0)$:

$$FD_\mathrm{m}\ (\mathbf{x}_0) = 1/(N \times M) \sum_{i=-n}^{n} \sum_{j=-m}^{m} |\ FD\ (x_0 + i, y_0 + j)\ |, \qquad (9.19)$$

where $N = 2n + 1$ and $M = 2m + 1$ are typically three, against the threshold. Then a 5×5 median filter is used to smooth the changed region boundaries. Further threshold testing eliminates small regions less than 2% of the largest individual region or, alternatively, less than 0.2% of the total picture area in extent.

The change detection mask and the estimated displacement field are now used to determine the actual segmentation. Changed regions in both frames belong to moving detail, covered background in frame $k - 2$ is identified by displacement vectors relating the changed region in that frame with the unchanged region in frame k, and vice versa for uncovered background in frame k. Thus the segmentation mask for a frame to be interpolated will contain all four possible regions, that for a transmitted frame will lack either covered background ($k - 2$) or uncovered background (k). Results demonstrate that, under favourable circumstances, it is possible to skip more than one intervening frame in a sequence and still obtain satisfactory results.

Cafforio et al. (1990) have also proposed an interpolation scheme for image sequences. In this implementation an element recursive algorithm is used for motion field estimation together with both forward and backward motion tracking (obtained by reversing the temporal order of image frames). An element A in field $k - n$ is tracked in the forward direction to its location A' in frame k. In the immediate vicinity of A' a search is carried out for that element which, when tracked backwards to frame $k - n$, corresponds with B' which is a minimum distance from A. Linear interpolation is then carried out over the intervening skipped frames (in the application described, n is four) between these so-called "connected" elements. There are difficulties with covered/uncovered background, where connected elements cannot be mean-

ingfully identified, but useful results appear to have been achieved when, as in this case, only one in four frames is actually transmitted.

Generally speaking, some form of motion-compensated interpolation is an essential ingredient of any low-rate image sequence coding scheme, the benefits greatly outweighing any requirement for increased complexity of implementation.

9.8. GENERAL MOTION

Algorithms investigated for motion compensation in connection with image sequence coding generally consider the "microscopic" detail of frame content – element recursion attempts to track individual elements, block matching makes the assumption that, over the chosen block size, motion can be assumed to be approximated as pure translation, giving one vector per block. In fact object motion covers a much greater range of scales and is more general than most present work might imply. What we see in an image sequence is a two-dimensional projection of the three-dimensional motion of objects not only in translation, but also subject to rotation and scale change. Whether or not such considerations are relevant in the present context is, however, open to question. Early work by Huang *et al.* (1982) using synthetically generated frame pairs demonstrated that a significant reduction in frame difference entropy could be observed but only by carrying out the estimation procedure globally, and the conclusion was reached that a moving rigid body in general motion had to be at least 50×50 elements in extent for an appreciable benefit to be obtained. Despite the vast amount of interest in object motion evinced by the computer vision fraternity (see, for example, the special issue of IEEE Proceedings, IEEE, 1988), little of the associated theory and few of the algorithms seem to have filtered through to the image coding community until comparatively recently.

One approach to the problem is that of Wu and Kittler (1990). Their algorithm has the advantage that it is not necessary to establish a correspondence between object features in succeeding frames, i.e. particular characteristics of the object, a specific spatial arrangement of luminance values, for example, does not have to be identified and then unambiguously tracked through the sequence. On the other hand, it is first necessary reliably to segment the frame(s) into meaningful regions and then to apply the algorithm to each.

From a general six parameter matrix model, where the new picture element locations x' and y' are related to their previous ones x and y by

$$
\begin{aligned}
x' &= a_1 x + a_2 y + a_3 \\
y' &= a_4 x + a_5 y + a_6,
\end{aligned}
\tag{9.20}
$$

the authors derive a four parameter model

$$x' = a_1 x - a_2 y + a_3$$
$$y' = a_2 x + a_1 y + a_4$$
$$\text{(9.21)}$$

which can deal with rotation, scale change and translation, although not with non-rigid motion. As the authors point out, this represents a good compromise between a large degree of flexibility which probably can be used to effect only part of the time and a useful improvement over the representation of simple translation which can yet be implemented without excessive complexity.

If the intensities in the kth and $(k + 1)$th frames corresponding to the element locations are $I_k (x, y)$ and $I_{(k + 1)} (x,y)$ then, ignoring any contribution to intensity change other than motion:

$$I_{(k + 1)} (x',y') = I_k (x, y) \qquad \text{(9.22)}$$

and a Taylor series expansion up to the second order allows the frame-to-frame luminance difference to be written in terms of a_1, a_2, a_3, a_4, and the average gradients, approximated from neighbouring picture element differences on each side, in the x and y directions of the luminance function:

$$G_x (x, y) = 1/2 \, (\partial/\partial x \, I_{(k + 1)} (x, y) + \partial/\partial x \, I_k (x,y)) \qquad \text{(9.23)}$$

with a similar result for $G_y (x,y)$. The coefficients $a_1 \rightarrow a_4$ may be found by applying the derived relationships to several picture elements and then using linear regression. This algorithm is applied in conjunction with a multi-resolution/sub-sampling technique which uses an initial estimate obtained at a low resolution to start off an iterative operation at the next higher resolution level. An example is given using real motion in an image sequence where the algorithm (without sub-sampling) is applied to 48×48 element blocks within a frame size of 192×192. A general reduction in frame difference magnitude is visible in the results presented although no figures on frame difference entropy or variance are given.

Wang and Clarke (1990b, 1994) have applied the Fourier descriptor technique to the estimation of general motion. For an object contour lying in the x,y plane, the Fourier descriptor is just the discrete Fourier transform of the sequence of values of $\{x + j \, y\}$ obtained by tracing the object contour. This can be obtained both for the original contour and that of the object after undergoing some combination of translation, rotation and scaling. The motion parameters can then be estimated using the properties of the discrete Fourier transform: rotation, for example, is equivalent to multiplication of the sequence by a unit vector of phase angle ϕ_r; $\exp (j\phi_r)$. Good results are achieved for images extracted from a typical videotelephone sequence (CLAIRE), but it is necessary to identify at least two unambiguous points on the contour, a requirement not imposed by the algorithm of Wu and Kittler (1990). A method closer to the spirit of general object tracking and involving

motion trajectory following over more than two frames was reported and applied to interframe predictive coding by Lee and Nadler (1989), who subsequently used it in a vector quantisation image sequence coding context (Lee and Nadler, 1990), and estimation of two-component image motion using three consecutive frames has been studied by Bergen *et al.* (1992).

9.9. OTHER CONSIDERATIONS

This chapter has attempted to cover the major aspects of the topic of motion estimation and compensation, in the context of low-rate image sequence coding. The field is an extremely extensive one, however, and algorithm development has consequences in many other areas of image processing. Likewise, there are aspects of the subject not referred to above which merit consideration, and one or two of these are dealt with below.

9.9.1. Uncovered Background

In normal motion, objects in motion progressively cover up regions of the background next to their leading edges, and similarly uncover areas next to their trailing edges. It is conventional, and efficient, in low-rate coding where the background area is static (head and shoulders images against a wall, for instance), simply to replenish the buffer holding the frame about to be coded from the previous frame. As far as the moving object is concerned, the motion estimation algorithm should have provided suitable motion vectors to indicate from where in the previous frame to take the prediction. The remaining area is that which was covered by the moving object in the last frame but is uncovered in the present one. Information for this area must be generated in order to complete the details of the frame. In motion-compensated interpolation (Section 9.7) the problem is solved by extrapolating the required data backwards from the most recently transmitted frame. In the general case, one obvious solution (if the background is truly unchanging) is to store a reference frame before transmission starts and use regions of this as appropriate – indicated by a frame-to-frame change detector. Any changes which do occur in the background render this method ineffective, of course, and Mukawa and Kuroda (1985) pointed out that a possible alternative which generates a "pseudo-background" frame, averaging signals along the time axis, will be affected by the moving object itself. This problem can be overcome by using an adaptive algorithm which considers individual areas as background if they remain constant for a significant length of time. Thus, when the quantised interframe difference is below a threshold, the area is taken to be background and the background store is updated. In order that the store

contents not be disturbed by the moving object, updating is controlled by a convergence factor $1/m$ (where m is approximately eight) with a threshold (L) of one grey level (8 bit data). The algorithm therefore generates a background signal for the present frame, k, $x_b(k)$, from that for the previous frame, $x_b(k-1)$, using

$$x_b(k) = x_b(k-1) + 1/m \operatorname{sign}[(x(k) - x_b(k-1)) u(x(k) - x(k-1))], \tag{9.24}$$

where $x(k) - x_b(k-1)$ is the (quantised) present signal value less the previous background value, and $x(k) - x(k-1)$ is the quantised interframe difference.

The background detection function is

$$\begin{aligned} u(\cdot) &= 1 \text{ if } |\cdot| < L \\ u(\cdot) &= 0 \text{ if } |\cdot| > L \end{aligned} \tag{9.25}$$

applied to the function $x(k) - x(k-1)$. More details of the system and the associated coder are reported by Kuroda and Hashimoto (1986).

Another approach to the problem is reported by Brofferio (1989), who developed a three state model (object, background, new scene) in which the state transition diagram is driven by luminance differences. Thus at any picture element location in the present frame:

(a) The DFD initiates a transition to the object state.
(b) The intraframe prediction error initiates a transition to "new scene".
(c) A large difference with respect to the background luminance in the previous frame uncovers already stored background.
(d) The uncompensated interframe difference signal retains the starting state of "object" or background, otherwise it drives a transition from new scene to background.

The algorithm operates by minimising a cost function which depends upon the conditional probability of the prediction errors, and can be used to update the background information for coding or interpolation operations. Uncovered background prediction has been further studied by Hepper (1990).

9.9.2. Motion Vector Transmission

Any but the most basic form of non-adaptive coding scheme will, of necessity, have to have some method of updating the processing parameters (quantiser stepsize, prediction coefficients, thresholds, for example) at the receiver so that correct image reconstruction is possible. In the early days of coder design emphasis was placed upon the development of "backward" algorithms (see Chapter 2), in which all decoding parameters could be set up by reference to previously transmitted (quantised) data, or the image reconstruction based

thereon. This eliminated all but the most basic signalling information and reduced the transmission almost completely to that of actual data alone – a desirable feature where absolute minimum transmission rate was the objective. Unfortunately any corruption of this data not only appeared as an artefact in the reconstructed image itself but, since the correct receipt of that data was crucial for establishing the correct decoding parameters, most probably rendered all subsequent decoding steps invalid also. Therefore, whilst such schemes are still valid for well error protected channels, interest was stimulated in those systems in which the switching/signalling information was sent as an additional "overhead" bitstream. Provided that this was sufficiently well protected, the actual data transmission was (somewhat surprisingly) of lesser importance since corruption would result in only local, and not catastrophic, image degradation. The associated problem is that the amount of overhead information can, in some cases, rise to maybe half of the total data transmitted, and so it has become of interest to consider efficient ways of coding, not only of the actual image data but also of the coding parameters. In the present context it is the motion vectors which need to be coded in this way, and several researchers have given attention to this topic. Koga and Ohta (1987) showed that, for moderate amounts of motion, individual coding of motion vectors is slightly better than relative coding [i.e. differentially coding the values of successive vectors with respect to the previous one(s)]. The reverse is the case for active sequences. Again, two-dimensional coding of the vector set is somewhat more efficient than one-dimensional coding of horizontal and vertical components, but the difference is small. Choi and Park (1989) reassessed these results, first by examining six different approaches to vector coding, including two-dimensional individual coding, two-dimensional coding of the differential motion vectors between frames, one-dimensional coding with the same, and different, code sets for horizontal and vertical components, etc. Their simulation results show that individual, rather than differential, two-dimensional coding of the motion vectors gives results clearly better than any other scheme. Also that smoothing of the vectors is advantageous as it increases intervector correlation. This is done by examining the vectors occurring with a 3×3 window; if a certain vector occurs more than two or three times then this vector is taken as the smoothed vector [otherwise considered to be zero $(0,0)$], unless the mean absolute block difference with respect to the block in the previous frame is less than a threshold of maybe two or three grey levels, in which case the vector is set to zero anyway. It is possible that smoothing of the motion vector field will lead to an increase in prediction error, and to counter this the smoothed vector is only transmitted if the mean square error between the present block and the corresponding block in the previous frame is greater by a threshold than the equivalent quantity calculated using the displaced block (i.e. only if the motion vector is doing its job properly). This allows a significant reduction in transmission rate (maybe 50% on average) with a minimal reduction in

picture quality. Schiller and Chaudhuri (1990) investigated the efficiency of side information (overhead) in a more general context. Their hybrid coding scheme (of the motion-compensated DCT type discussed in more detail in Chapter 8) uses 8×8 blocks for the coding operation, but 16×16 blocks for motion compensation. The hierarchical algorithm of Bierling (1988) is used for the estimation function, as it produces accurate vectors which change smoothly from block to block, enhancing the efficiency of the differential coding scheme used. Again something like a 50% reduction in overhead for motion vector transmission is achieved (compared with that of the basic motion-compensated hybrid structure). Generally speaking, considering the last two or three algorithms reported above, there seems to be some difference of opinion as to whether differential transmission of motion vectors is better or not.

9.9.3. Motion-compensated Filtering

There are many areas where temporal or combined spatio/temporal filtering of image sequence detail is advantageous. Whilst this can be carried out without reference to object motion it is more efficient to carry out the time axis operation along the motion trajectory. Dubois (1992), as well as reviewing current motion estimation algorithms, discusses such applications in detail. We have already met prediction and interpolation in this context, and filtering for noise reduction is another operation which can be carried out successfully in this way. Since, given a good motion estimate, the signal should vary quite slowly along the motion trajectory, strong low-pass filtering may be applied to reduce noise. Such a filter may have the recursive form:

$$\hat{u}\,(\mathbf{X}, k) = \gamma\, g(\mathbf{X}, k) + (1 - \gamma)\, \hat{u}\,(\mathbf{X} - \mathbf{D}, k - 1) \qquad (9.26)$$

considering location $\mathbf{X}\,\{x,y\}$ in frame k with interframe displacement \mathbf{D}. \hat{u} is the output signal and is made up of fraction of the noisy input signal $g\,(\,\cdot\,)$ and $(1 - \gamma)$ of the previous estimate in frame $k - 1$. γ can be made a non-linear function of the prediction error e in order to suppress the filtering effect when e is large (i.e. the displacement estimate is poor).

9.10. GENERAL COMMENTS: HOW EFFICIENT IS MOTION COMPENSATION?

Obviously the incorporation of motion compensation into a low-rate coder, however easy to justify on intuitive grounds, involves extra system complexity and expense, and so needs justification on the basis of enhanced efficiency

also. It does not take long to do this in the case of predictive coding (see, for example, Musmann *et al.*, 1985). Clarke (1992a) measured the variance of the interframe difference signal for various motion compensation conditions and found the gain in efficiency very obvious (a variance reduction of a factor of about 3). Ericsson (1985), in the course of an extensive set of experiments on prediction functions, demonstrated a prediction gain of 3–5 dB for 8×8 blocks using the algorithm of Jain and Jain (1981), which increased to 5–7 dB for 4×4 blocks (showing, incidentally, the importance of small block size for good motion estimation with a block matching algorithm). These values increased again by approximately 2 dB when the nominally integer element accuracy was increased to 1/8th element (the estimate being formed by linear interpolation). Generally speaking, a reasonable improvement in performance can be achieved even by moving from integer to one half element accuracy.

One of the main areas in which motion compensation has found application is hybrid transform coding, in which a motion-compensated difference frame is subjected to a two-dimensional intraframe transform coding operation (see Chapter 8, Section 8.4). Suffice it to say here that the application of such a coding operation to this motion-compensated prediction image is, at the very least, ill founded theoretically. Transform coding schemes rely for their efficiency on having input data which is reasonably well correlated (Clarke, 1985a), and this is just what a well-designed motion estimation/compensation scheme is intended to eliminate! Obviously, if motion can be well predicted over the whole image frame (a distant ideal, admittedly), then the difference frame will become noise-like in nature, with a flat power spectrum, for which further processing is irrelevant as far as data compression is concerned (Jayant and Noll, 1984). Results using various source images in such a scheme are presented by Clarke (1992a), and a detailed analysis is presented by Girod (1987).

The overall consequence seems to be that the more efficient the motion estimation/compensation step is made, the less point there is in any further spatial processing of the motion-compensated difference signal. This in turn implies that present development of hybrid motion compensated/transform image sequence coding schemes is leading to a dead end, for the system as it is at present only works because the motion compensation algorithms which are incorporated are in a very rudimentary state of development, leaving a substantial amount of residual correlation within the difference frame.

Undoubtedly, the field of motion estimation and compensation has provided a rich source of topics for the exercise of much ingenuity by researchers over the past 15 years, and it is only to be expected that further improvements in algorithms, different approaches (see, for example, the mean field annealing algorithm of Abdelqader and Rajala (1992) and, more generally, in tracking the two-dimensional projections of three-dimensional objects through a sequence of image frames will appear. Given the consequences of the

previous sub-section, however, it is obvious that more work is necessary to determine the optimum form of processing to be applied to the motion-compensated difference signal. Various approaches to this question are discussed in subsequent sections.

10
Standards for Image Sequence Coding

10.1. INTRODUCTION

It will have escaped no one's notice that the past two decades have encompassed a revolution in electronic signal processing. The development of digital techniques has been to a large extent responsible for this, giving us a growing ability to sample analogue signals at higher and higher rates, to store enormous numbers of samples on silicon, and to complete computer instruction cycles in seemingly vanishingly small intervals of time. Combining these capabilities has given us the "information revolution" of popular media acclaim. With growing emphasis on communications, where complex coding/decoding systems are concerned, it is not possible (as it was in the "good" old days) to establish contact on a casual basis, and this problem is exacerbated by the requirement to use a given channel hierarchy for a multiplicity of

services. Furthermore, the economics of the market-place dictate that any product intended for communications applications must have the maximum capability of operation with similar equipment designed elsewhere. Thus a common communications format has to be established, together with means of generating and decoding the datastream. An impressive example of the consequences of the setting up of standards in terms of the resulting increase in usage is that of digital facsimile, a service which in the last decade or so has changed from being a relative rarity to something to which few people do not have access [we do not consider here the work of the Joint Bi-level Image Experts Group (JBIG) in establishing a standard for the progressive coding of bi-level images; for those interested, a description can be found in Hampel *et al.* (1992)]. For the research community, the setting-up of standards is very much of a mixed blessing, since such a move is inevitably accompanied by a drop in interest in new algorithm development in the face of the production by industry of hardware to satisfy the agreed specification. There is then a significant lead time until the next major advance in the area. In a wider context, there are, of course, many considerations to be taken into account in the timing of such a move. The technology, both in terms of algorithm development and their implementation in hardware, must be sufficiently mature to provide an efficient service, and yet too long a wait for the next significant advance may cause parts of the industrial community to set up *de facto* standards of their own. Although this is just the criticism which (with hindsight) might be levelled at the development and introduction of image coding standards the fact is that the second half of the 1980s has seen significant activity in this area, at rates from $64\,\mathrm{kb\,s^{-1}}$ for videotelephone, etc. to services up to $140\,\mathrm{Mb\,s^{-1}}$ for television. Standards proposals have come from the ISO, CCIR and CCITT. It is not the purpose here to describe these in exhaustive detail regarding protocols, channel interfacing, etc. (although, since the bitstream syntax is crucial, some information on this is included). In the context of the present volume it is the coding algorithms which are relevant, i.e. the way in which data compression is carried out using approaches which were tried and tested at the time. Indeed, it is already becoming apparent (note the comment on timing above) that system requirements (for example, scalability) are emerging which are not adequately catered for in the standards as they exist at the moment.

Material in this area is extensive (for a general view of the video-conferencing area see Sabri and Prasada, 1985). As well as the actual proposals/standards documentation, to which reference may be made, more general references in the area are ACM (1991), IMAGE COM. (1989, 1993), Morrison (1992), Ang *et al.* (1991), Jurgen (1992), IEEE SPECTRUM (1993), BT TECHNOL. (1990), Clark *et al.* (1993), Chen (1993), Corbett (1990) and Mohrmann (1987).

The first system we examine is that for coding videotelephone, etc. signals at multiples of $64\,\mathrm{kb\,s^{-1}}$. This is CCITT Recommendation H261, "Video Codec for Audiovisual Services at $p \times 64\,\mathrm{kb\,s^{-1}}$", and represents a merging of

two approaches, one at $m \times 384 \, \text{kb s}^{-1}$ ($m = 1 \dots 5$), more suitable for videoconference material, and a later one intended for $n \times 64 \, \text{kb s}^{-1}$ ($n = 1 \dots 5$). As approved in 1990 the recommendation covers $p \times 64 \, \text{kb s}^{-1}$, where $p = 1 \dots 30$, i.e. rates up to approximately $2 \, \text{Mb s}^{-1}$. At the lowest values of p (1,2) videotelephone operation is envisaged. A brief introduction to this standard is given by Liou (1991), and a good "layman's" introduction is (remarkably) the *Financial Times* (London) of 15 December 1989, reflecting the growing importance of the area as seen by the financial institutions and business interests (see Chapter 1).

10.2. CCITT RECOMMENDATION H261: VIDEO CODEC FOR AUDIOVISUAL SERVICES AT $p \times 64 \, \text{kb s}^{-1}$

The coding/decoding system has the following brief description (H261, 1990): a hybrid of interpicture prediction to utilise temporal redundancy and transform coding of the residual signal to reduce spatial redundancy. The decoder has a motion compensation capability (optionally included in the coder). It is recommended mainly for use between $40 \, \text{kb s}^{-1}$ and $2 \, \text{Mb s}^{-1}$, with the bitstream containing a BCH(511, 493) forward error correcting code (use of which by the decoder is optional).

10.2.1. Source Format

4:3 aspect ratio pictures are coded as luminance and colour differences, Y, C_B, C_R at a rate of approximately $30 \, \text{s}^{-1}$ and are based on CCIR Recommendation 601 values:

Black = 16 zero colour difference = 128
White = 235 peak colour difference = 16 and 240

with a format which is half that of CCIR 601 each way, i.e. 352 elements per line and 288 lines. The colour difference signal resolution is half of this again. This overall sample layout is called Common Intermediate Format (CIF) and, since operation at the lowest rate ($p = 1$, i.e. $64 \, \text{kb s}^{-1}$) presents a challenge to the algorithm at this resolution, all codecs must be able to use one quarter CIF (QCIF) – half of the above quoted values each way, and there is provision to skip up to three pictures between those actually transmitted. Samples are located as shown in Figure 10.1.

10.2.2. The Source Coder

The basic structure (omitting control strategies) is shown in Figure 10.2 and is basically (with the switch in the lower position) that discussed earlier (see

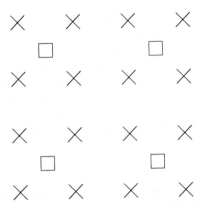

Figure 10.1 Location of (×) luminance samples and (□) chrominance samples.

Video in

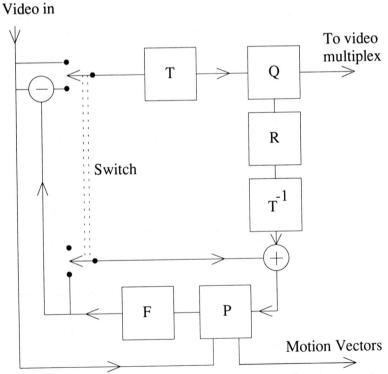

Figure 10.2 Basic H261 coder configuration. T, transform; T^{-1}, inverse transform; Q, quantiser; R, rescaling; F, loop filter; P, picture memory (predictor).

Figure 8.5). The scheme has a predictive loop (possibly motion compensated) within which the difference signal is two-dimensionally intraframe transform coded and quantised before transmission. The prediction loop may include the horizontally and vertically separable non-recursive smoothing filter F, with coefficients (1/4, 1/2, 1/4) modified as necessary near block edges. Note that the block labelled R in the figure represents the rescaling of the quantised coefficients before inverse transformation to complete the loop. It is singularly unfortunate that all of the formal literature describing this (and suchlike) algorithm(s) calls this operation "inverse quantisation". There is, of course, no such thing (its existence would imply that, in some mysterious fashion, the error introduced by quantisation can somehow be eliminated by an inverse operation akin to the inversion of the transform step). This is particularly confusing to students and those new to the area and is to be strongly deprecated. With the switch in the upper position (INTRA mode) the loop is disabled, and input pictures are processed directly. Thus either the difference signal or the input frame are subdivided and subjected to an 8 × 8 DCT.

In INTERframe mode, motion compensation may be applied over a group of four luminance blocks and their two associated colour difference blocks (called a Macroblock – see Figure 10.3 and below) by the inclusion of one integer vector having components in the range ±15 elements.

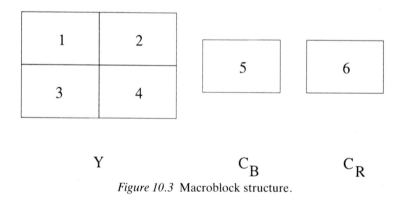

$$\text{Y} \qquad\qquad C_B \qquad\qquad C_R$$

Figure 10.3 Macroblock structure.

10.2.2.1. The Transform

The two-dimensional 8 × 8 DCT is specified in its inverse form as:

$$f(x, y) = 1/4 \sum_{u=0}^{7} \sum_{v=0}^{7} C(u)\, C(v)\, F(u,v) \cos(\pi(2 \cdot x + 1)u/16) \cos(\pi(2 \cdot y + 1)v/16), \tag{10.1}$$

where $f(x,y)$ is the reconstructed data block, $F(u,v)$ is the block of coefficients, and $C(u)$ and $C(v) = 1/\sqrt{2}$ if $u,v = 0$ and $= 1$ otherwise. It is required to meet peak, mean and mean square error specifications as detailed in the recommendations.

Note the range of values encountered in the transform/inverse transform operations. With full range 8 bit data the maximum possible range of the prediction signal is ± 255 (i.e. 9 bits). The $N \times N$ transform expands this by N (Clarke, 1985b), i.e. adding $\log_2 N$ bits to the digital representation. Thus we arrive at the 12 bit range ± 2048 which, after inverse transformation, should revert to the original.

10.2.2.2. Quantisation

There is one quantiser for the INTRA D.C. coefficient (the coefficient is linearly quantised with a stepsize of 8 and no central "dead" zone to give an 8 bit representation), and 31 for the other coefficients, basically linear but with a central dead zone and stepsize an even value between 2 and 62.

10.2.2.3. Forced Update

This is carried out by the use of the INTRA mode. To control error build-up this should happen for each macroblock at least once every 132 times that it is sent.

10.2.3. Video Multiplex

The multiplex has a hierarchical format made up of four layers; these are: (a) PICTURE; (b) GROUP OF BLOCKS; (c) MACROBLOCKS; (d) BLOCKS.

(a) The Picture Layer.

Picture Start Code	20 bits	PSC
Temporal Reference	5 bits	TR
Picture Type Information	6 bits	PTYPE
Extra Insertion Information	1 bit	PEI
(Signals the presence of the following optional data field.)		
Spare Information	0/8/16 . . . bits	PSPARE

(b) Group of Blocks (GOB) Layer.
A GOB is one twelfth of CIF or one third of QCIF, i.e.

$$176 \times 48 \; Y + 2(88 \times 24) \; C_B, C_R.$$

See Figure 10.4.

48 lines (Y)

176 elements (Y)

Figure 10.4 Group of blocks in QCIF.

GOB start code	16 bits	GBSC
Group Number	4 bits	GN
(Indicates position of GOB in CIF or QCIF format.)		
Quantisation Information	5 bits	GQUANT
(Indicates quantiser used.)		
Extra Insertion Information	1 bit	GEI
Spare Information	0/8/16 . . . bits	GSPARE

(c) Macroblock Layer.
One GOB = 33 Macroblocks – see Figure 10.5.

1 \longrightarrow	11
12	22
23	33

Figure 10.5 Macroblock ordering in a group of blocks.

Macroblock Address	VLC (variable word length code)	MBA

(Indicates the location of the
Macroblock in a GOB. For the first
MB sent the address is the absolute
value. Subsequent addressing is by
reference to the last MB sent.)

Type Information	VLC	MTYPE

(Indicates INTRA/INTER, use of
motion compensation, filter, etc.)

Quantiser	5 bits	MQUANT
Motion Vector Data	VLC	MVD

(Differentially coded with respect to
the previous MB motion vector.)

Coded Block Pattern	VLC	CBP

(Indicates blocks in the Macroblock for
which at least one transform coefficient
is transmitted:

$$CBP = 32\,P_1 + 16\,P_2 + 8\,P_3 + 4\,P_4 + 2\,P_5 + P_6$$

where $P_n = 1$ if a coefficient is transmitted, else $P_n = 0$.)
(Block numbering is as Figure 10.3.)

(d) Block Layer.
 A Macroblock = four luminance blocks and one each C_B and C_R block.
 (Figure 10.3.)

 Transform Coefficients + End of Block TCOEFF + EOB

Present for all six blocks in a
Macroblock when MTYPE indicates
INTRA. Otherwise signalled by
MTYPE and CBP.

Coefficients are zig-zag scanned (as in Figure 3.7), and successive most
frequent (RUN/LEVEL) combinations variable length coded. Others by
a 20 bit word.

Quantiser Reconstruction Levels REC (other than INTRA – see above,
and clipped to -2048, $+2047$)

REC = 0 if LEVEL = 0.

REC = QUANT $(2 \times$ LEVEL $+ 1) - 1^*$	LEVEL > 0	(10.2)
REC = QUANT $(2 \times$ LEVEL $- 1) + 1^*$	LEVEL < 0	(10.3)

* If QUANT = EVEN.
QUANT = 1–31 (half stepsize) and is sent using GQUANT or
MQUANT.

Example: QUANT = 5, i.e. STEPSIZE = 10 and characteristic starts at 3 × QUANT, i.e.

$$0, 15, 25, \ldots, \text{etc., symmetrical about zero.}$$

10.2.4. Other Considerations

(1) The displayed picture can be "frozen" until a release signal is received or a timeout interval has expired.
(2) Fast update is achieved by coding the next picture in INTRA mode.
(3) The output bitstream must comply with the requirements of a specified "hypothetical reference decoder" (HRD) governed by the capacity of the buffer. This buffer has a size of $256 + B$ kbit, where $B = 4 R_{MAX}/ 29.97$ and R_{MAX} is the maximum video rate used.

10.2.5. General

Even from the brief review given above it can be seen that in no way is the recommendation intended as an "instruction book" or "set of plans" enabling one to construct a videotelephone/videoconference coder/decoder system. What it does do is to specify a set of parameters, concentrating on the bitstream and the decoder, which will enable compatibility with similar systems to facilitate interoperability and consistency of quality across a network. It is this general agreement on bitstream syntax, together with a wide range of possibilities of varying quantiser stepsize according to buffer fullness, including motion compensation, loop filtering, etc., which represents a significant advance in technology [not forgetting the associated possibility of implementation in very large-scale integration (VLSI)], rather than the application of the basic hybrid/DCT structure, which already seems somewhat unadventurous. Some comparative pictorial results for the H261/hybrid DCT algorithm and one or two other interframe coding techniques are shown in Chapter 11.

10.3. MPEG-I

As mentioned earlier, activity in the setting up of image/video encoding and transmission standards became intensive towards the end of the 1980s, and such developments as CD-ROM and DVI demonstrated that a requirement existed for coding/storage in a more commercial environment. This led to the establishment of the Moving Picture Experts Group (MPEG) in 1988

(Morrison, 1992). The basic requirement was for coding of moving pictures (and associated audio) for digital storage with transfer rates up to about $1.5\,\mathrm{Mb\,s^{-1}}$, an equivalent task to that which concerned JPEG in respect of still images (see Chapter 3). Given that work in ISO, JPEG and also CCITT (H261) had resulted in algorithms using basically the same transform coding/ variable word length coding of coefficient structure, it was hardly surprising that this approach should also assume a high significance in the MPEG programme, although an algorithm would be needed which was considerably more sophisticated than the basic H261 structure to cope with the requirements for random access, fast forward/reverse editing, etc. In the event, although the output data streams of H261 and MPEG coders are not compatible, many of the features of the two systems are identical. Given the diversity of applications compared with H261, MPEG is to be regarded as a *generic* standard, i.e. whilst it does not ignore the requirements of a particular application, it is in fact independent of it. There are three parts to the standard (ISO 11172): (a) coding of combined audio/visual information; on the systems layer multiplex issues involved see MacInnis (1992); (b) coding of moving picture information; and (c) coding of audio information. A good review of the video algorithm and its likely applications is given by Le Gall (1991, 1992), see also MPEG-I (1990). These applications include CD-ROM, and writable optical discs as well as networking making use of ISDN and local-area networks (LANs), etc. Le Gall divides applications into asymmetric (one coding and many decoding operations), for example education and training and entertainment areas (maybe electronic games) and symmetric (roughly equal use of coding/decoding), for example interactive face-to-face operation in the videotelephone and videoconference fields. Requirements for high quality video coding standards are given special attention by Okubo (1992).

10.3.1. Features of the Algorithm

As a consequence of the wide variety of possible applications of a standard delivering good quality video at the above rate, it needs more flexibility than does H261. Features identified as important are as follows.

(a) Random access.

This is essential for video in stored form. Any frame must be decodable in a given (small) amount of time, maybe 0.5 s. Availability is via access points, i.e. frames coded without reference to any other (see below).

(b) Fast forward/reverse search.

It is desirable to scan the data stream quickly and display a selection of decoded pictures to give an acceptable search sequence.

(c) Reverse playback.

This is desirable for some applications, even at the cost of reduced quality. Groups of decoded pictures can be stored in memory for display.

(d) Audio/visual synchronisation.

Consistent synchronisation to a parallel audio stream is essential – this problem has been addressed by the MPEG Systems Group (MacInnis, 1992).

(e) Good error behaviour.

The algorithm should be robust to errors, apart from the use of error control coding in the channel.

(f) Delay.

Performance should be good over an acceptable range of delays – maybe 0.15 s for face-to-face communication up to perhaps 1 s for interactive use. There is the possibility of trading longer delay against improved quality.

(g) Editing.

It is desirable to code short edit units without reference to other frames. There is a conflict here with the requirement for high compression.

(h) Format.

Video windows within a larger display frame are desirable.

10.3.2. General Structure

In essence, the coding structure is the same as for H261, i.e. a macroblock format with temporal prediction followed by two-dimensional DCT/VLC of the output (see Figure 10.6). The actual picture coding format is more complex, however, and makes much more use of the various combinations of motion-compensated prediction, interpolation and intraframe coding which are allowable.

The input format will usually have CCIR 601 resolution, 720 elements per line and 576 lines at 50 Hz (480 at 60 Hz). This can be converted to so-called source input format (SIF) by filtering and sub-sampling. This is 360×288 (240 at 60 Hz), of which the four left-most and right-most elements are discarded to give 352×288 (or 240). Half this resolution is used for the chrominance signals C_B and C_R. Because there is such a wide range of format possibilities a so-called "constrained parameter bitstream" has been defined (see Table 10.1), and the basic system has been "tuned" to work well at rates around $1–1.5\,\mathrm{Mb\,s^{-1}}$ with 350 elements \times 250 lines and 24–30 pictures $\mathrm{s^{-1}}$ (note – pictures are progressively scanned, i.e. non-interlaced).

Four types of picture are defined (of which the first three are portrayed in Figure 10.7): (a) I, Intrapicture coded; (b) P, coded using motion-compensated prediction from the previous I or P picture; (c) B, coded from both past and future I or P pictures using motion-compensated bi-directional predic-

Figure 10.6 MPEG-I coder block diagram. B, buffer; D, data stream; F/P, framestore/
predictor; FR, frame reorder; ME, motion estimation; MP, multiplex; Q, quantiser;
R, rescale; RC, rate control; S, source; T, transform; T^{-1}, inverse transform; V,
VLC.

Table 10.1 Constrained MPEG-I coding parameters.

Maximum number of horizontal elements	768
Maximum number of lines	576
Maximum picture area in macroblocks	396
Maximum element rate in macroblocks s^{-1}	396×25
Maximum picture rate	$30\,s^{-1}$
Maximum motion vector range	± 64 elements
Maximum buffer size	330 kbit
Maximum bit-rate	$1.856\,Mb\,s^{-1}$

tion/interpolation. Not used as a basis for the prediction of other pictures; (d)
D (DC), allows simple fast forward mode.

Macroblocks comprise six 8×8 blocks in total, as in H261, and can be
intracoded or forward predicted, backward predicted or bi-directionally pre-
dicted in B pictures. Motion vector information is differentially encoded. An
8×8 two-dimensional DCT is used for the intraframe coding step (with D.C.
coefficients differentially coded block to block) followed by two-dimensional
run length/amplitude coding. To code B pictures, reordering of the input
sequence is necessary since the next I or P (reference) frame is needed for
decoding. The decoder eventually reconstructs the correct display order.

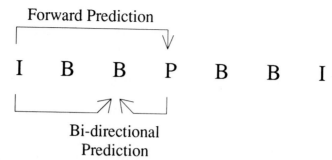

Figure 10.7 MPEG-I frame and prediction format.

Since different types of picture employ different numbers of bits (the most complex being the B pictures), a fixed rate system needs an output buffer whose status controls the quantisation strategy in such a way that the bit-stream can be decoded with a known buffer size by reference to a Video Buffer Verifier – a decoding model intended to ensure this.

10.3.3. Bitstream Format

In contrast to H261 the bitstream comprises six layers arranged in a similar hierarchical fashion (see Table 10.2), details of which are given below.

Table 10.2 Layered structure of bitstream syntax.

(a) Sequence	Header initialises decoder state
(b) Group of pictures	Random access point
(Header plus one or more pictures – the smallest unit which can be independently decoded)	
(c) Picture	Single frame (four types as above)
(Header plus one or more slices)	
(d) Slice	Resynchronisation
(Header plus one or more macroblocks)	
(e) Macroblock	Motion compensation plus quantiser scale parameter
(Header plus six blocks)	
(f) Block	DCT unit

(a) THE SEQUENCE.
 Sequence header code:
 Start code Unique 32 bit string
 Vertical size 12 bit Vertical resolution
 (Typically 240 for 525 line
 NTSC, 288 for 625 line PAL,
 also a multiple of 16.)

Horizontal size	12 bit	Horizontal resolution (Typically 352, i.e. one half CCIR (720 rounded to a multiple of 16.)
Picture element aspect ratio	4 bit	(Shape of element on screen) (Covers 1:1, i.e. square, through values including 16:9 and 4:3 aspect ratios.)
Picture rate	4 bit	Covering rates from about 24 to 60 pictures s^{-1}.
Bit-rate	18 bit	Channel bit-rate in multiples of $400\,b\,s^{-1}$ (all "1"'s implies VBR – variable bit-rate).
Marker	1 bit	Prevents confusion with start codes.
VBV (video buffer verifier size)	10 bit	Minimum size of input decoder buffer in units of 16 kbit.
Constrained parameter flag	1 bit	Indicates conformity or otherwise with constrained parameter set – see Table 10.1.
Load intra quantisation matrix	1 bit	

"1" indicates the presence of an 8×8 weighting matrix for DCT coefficient quantisation (zig-zag ordering). The first term must be 8 (D.C. coefficient).

"0" indicates a default matrix which has values between 8 (D.C. term) and 83 (highest horizontal and vertical term). The values are derived from experiment via JPEG to reflect the variation in sensitivity of the human visual response to quantisation noise.

Load non-intra quantisation matrix	1 bit	

"1" as above except that the first term is not necessarily 8.
"0" as above; default is 16 for all entries.

Extension/User Data	32 bit each	Reserved for future MPEG extension/user information.

(b) THE GROUP OF PICTURES (GOP).
 Set of pictures in display order consisting of, or containing, at least one I picture.

Start code	32 bit	
Time code	25 bit	
Closed GOP	1 bit	Indicates whether or not the decode operation needs pictures from the previous GOP for motion compensation.
Broken link	1 bit	Indicates whether the previous group of pictures can be used to decode the current group.
Extension/User Data	32 bit each	As above.

(c) THE PICTURE.

All coded information for one picture.

Header: Start Code	32 bit	
Temporal Reference	10 bit	Indicates picture display order (not necessarily the order of transmission – see above).
Picture Coding Type	3 bit	I, P, B, D plus future extensions.
VBV Delay	16 bit	Specifies VBV buffer status
Full Element Forward Vector	1 bit	For P and B pictures only. Indicates forward motion vector accuracy.
Forward F Code	3 bit	Maximum motion vector size.
Full Element Backward Vector	1 bit	As above but for B pictures only.
Backward F code	3 bit	As above.
Extra Information/ Extensions/User	Any/32/32 bit	As before.

(d) THE SLICE.

An integer number of macroblocks in scanning order. Any way of dividing pictures up with complete coverage and no overlap is allowable. Assists in error recovery in the presence of noise.

Slice Header: Start Code	32 bit	Last 8 bits indicates the vertical position of the first macroblock in the slice. Horizontal position is calculated from the macroblock address increment [see (e)].

Quantisation Scale	5 bit	1–31. Used to regenerate DCT coefficients from transmitted values.

Extra information for extensions.

(e) THE MACROBLOCK.

16×16 picture elements. Address differentially coded with respect to previous macroblock by VLC with length between 1 and 11 bits.

Macroblock types.

(i) In I pictures.

(1) Intra – d (default): use current quantisation scale.

(2) Intra – q : header contains 5 bit quantiser scale.

DCT as defined previously

Quantisation – uniform.

Q (coefficient) = (coefficient/stepsize) rounded to integer.

Stepsize is 8 for the D.C. coefficient; a function of the intra quantisation weighting matrix and quantiser scale for the others.

Coding.

D.C. coefficients – lossless DPCM/VLC.

A.C. coefficients – run/level zig-zag scanned as before (and H261), followed by end of block (EOB) code.

(ii) In P pictures.

Here the motion-compensated difference macroblock is transformed and coded. If the motion vector is zero then the "skipped" macroblock can be copied from the previous picture.

Macroblock types.

Eight possible, depending upon whether or not motion vectors, quantisation scale information, etc. are to be transmitted.

Coded block pattern (CBP).

Indicates which of the six blocks in the macroblock are coded – see H261 example (note that here the block index is one less, i.e. P_1 in H261 = P_0 here).

Macroblock type selection.

This may be done on a sequential basis, i.e.

(1) Motion compensation or no motion compensation. Used only if its inclusion gives a significant drop in mean absolute error.

(2) Intra-/non-intracoding. Even with good motion compensation low activity blocks can still be intracoded.

(3) Coded/not coded. If all coefficients are zero the block is not coded.

(4) Is quantisation satisfactory? Perhaps change quantiser scale.

DCT as before (note that for non-intra blocks the input signal is

comprised of element differences, not elements, and the D.C. term is always approximately zero).

Quantisation.
Intra blocks in P and B pictures as for I pictures.
Non-intra blocks in P and B use quantisation scale and weight matrix. The quantiser here has a dead zone around zero similar to that in H261.

Coding.
Intra blocks as for I pictures but prediction value equals 128 unless previous block was intracoded (non-intra blocks have D.C. terms approximately zero).
CBP transmitted as above.

(iii) In B pictures.
In this case the use of motion compensation is more complex to reconstruct forward, backward or interpolated macroblocks.

Macroblock types.
There are 12 possibilities, more than in the case of P pictures due to the possible presence of backward motion vectors.

CBP transmitted as before.

Macroblock type selection.
(1) Motion compensated – use forward/backward or interpolation. Encode as a skipped macroblock if possible, i.e. is motion compensation good enough? If not test all three possibilities on the basis, perhaps, of m.s.e. of luminance difference between motion-compensated macroblock and current macroblock.
(2) Intra- or non-intra. Test as for P pictures.
(3) Coded or not. If all coefficients equal zero do not code.
(4) Perhaps change quantiser scale.

DCT, quantise and code as for P pictures.

(iv) D pictures. For location purposes in fast search. Coded as block D.C. coefficients (low frequency information only).

(f) THE BLOCK.
8×8 input to the DCT stage, details as before.

10.3.4. Other Considerations

(a) Rate control.
This can conveniently be carried out by varying the quantiser scale factor. As a start I pictures may be allocated three times the number of bits for P pictures and the latter two to five times the allocation for B frames. The main

indicator is buffer fullness but subjective improvement can be obtained by selectively decreasing the quantiser stepsize in more uniform regions of the picture.

(b) Motion compensation.
P pictures are usually coded employing motion compensation. This is done by using the last I or P picture in the forward direction. Motion vectors are differentially transmitted using variable length coding. One half element accuracy B pictures may be motion compensated in the forward or backward directions, or both (interpolation). Typical search strategies have been described in the chapter on motion estimation and compensation.

10.3.5. General Comments

The skeleton outline of the MPEG-I standard given above hardly captures the richness of the spread of system possibilities included in the complete specification. It is still immediately apparent, however, that there is a considerable step up in sophistication from the (relatively) simple form of H261 to MPEG-I. We move from a specific, to a generic, application area and so the possible uses of the standard expand accordingly. It is still too early to judge what place it will finally assume on the rapidly evolving video transmission/storage scene. In this volume, of course, we are primarily concerned with the operation of image coding algorithms *per se*, and in this respect intra/interframe coding using the DCT holds few surprises.

10.4. MPEG-II

10.4.1. Introduction

It can be seen that the so-called MPEG I proposal is a very sophisticated and flexible specification for bitstream/decoding to support image storage and transmission in the $1.5 \, \text{Mb s}^{-1}$ region. Having produced a scheme operating upon a picture of size approximately equal to one quarter of the digital component standard for television (CCIR 601), however, a natural follow-up goal became that of processing a full size image, accepting the corresponding increase in bit-rate. Thus, in 1990, attention moved to this area to encompass rates up to approximately $10 \, \text{Mb s}^{-1}$, and this development has become known colloquially as MPEG-II (MPEG-II, 1992). Interest in this higher rate alternative is at the moment very intensive, and an overview of recent work can be gained from the various articles in the special issue of Image Communication (IMAGE COMM, 1993) devoted entirely to this topic. Whilst

building upon the approach adopted for MPEG-I, a broader range of considerations is relevant, including scalability and, especially, compatibility with the earlier proposal. A brief exposition of these matters is given below, in the course of a description of the requirements for MPEG-II (video). Whilst MPEG-I was directed towards storage media which only incidentally might be connected to the decoder via LANs or telecommunications links, more emphasis is given to the latter aspects in MPEG-II.

Thus, in addition to applications involving interactive storage media (ISM) and database services, use in electronic news gathering (ENG), satellite, terrestrial broadcasting and cable television (STV, TTV and CTV) is envisaged, as is transmission not only using fixed rate channels (requiring buffering), but over VBR ATM systems also (see Chapter 12 for this approach to video transmission).

10.4.2. Requirements

(1) Picture format.
Obviously, for such general applications as those mentioned above, full resolution picture capability is required, and this is based upon CCIR Recommendation 601. Thus, for the 4:2:2 version (luminance sampled at 13.5 MHz, chrominance signals C_B and C_R 6.75 MHz each) there will be 576 lines for the 625/50 Hz scheme (483 for 525/50 Hz) with 720 elements for luminance and 360 for chrominance. An alternative is the so-called 4:2:0 version, where the chrominance signal is vertically sub-sampled to 288 lines, and applications are envisaged, such as high resolution graphics, or where repeated coding/decoding is involved, where full resolution chrominance both vertically and horizontally (4:4:4) will be required. Use with film and EDTV (16:9 aspect ratio) is also considered.

Good quality (up to CCIR 601) is a requirement of the proposal, and the algorithm must be tolerant to the presentation of input sequences with extremely high levels of spatio/temporal activity. System delay is required to be less than 0.15 s for conversational sequences, and less than 0.4 s for access to an arbitrary point within some storage facility.

(2) Scalability.
A system which simply transmitted or stored full resolution video input (albeit in a compressed format) would sacrifice many of the advantages to be gained within the wide range of possible applications noted earlier. Thus the notion of "bitstream scalability" is introduced as an MPEG-II requirement, and it is hardly possible to encapsulate this idea in a definition which is more apposite and concise than that given in the requirement document – "... where you can neglect some of the bits in the bitstream, and still decode a useful picture". Thus it should be possible to extract a lower rate bitstream

which will reproduce a lower resolution (or smaller) image, one having reduced frame rate, or one which can be decoded using a simplified decoder, etc. Applications in this case include picture on picture inserts, reduced rate cable transmission of satellite video, and multipoint desktop videoconference, and imply a significant range of scaled rate options with suitably spaced intermediate values.

A somewhat different, but related, consideration is that of complexity. Elsewhere in this volume reference to the matter of relative coder/decoder processing requirements has been made (particularly in connection with vector quantisation). Usually, where widespread user access is required, coding can be complex and high performance, but decoding needs to be economic (broadcast television, database storage). For videotelephone/conference the complexity requirements of coder and decoder are likely to be more similar, whilst in ENG coding performance may be basic, but decoding complexity is no problem. Thus the scheme should ensure that a range of complexity/performance options can be provided.

(3) Compatibility.
With lower resolution standards (MPEG-I, H261) already in place, and with widespread activity in the definition phase of coding/decoding procedures for extended and high-definition television, the matter of interworking is of extreme importance, and various compatibility profiles have been defined. There are two basic compatibility subsets:

(a) Upward/downward – as a function of picture format: in an upward compatible system the decoder can reproduce pictures generated by a lower resolution encoder. Downward compatibility implies that the decoder can reproduce pictures generated by a higher resolution encoder – either as the full picture at a lower resolution or as a window segment at full resolution.

(b) Forward/backward – as a function of evolving standards: here a forward compatible, new standard decoder can decode a useful picture from an existing standard encoder. The system is backwards compatible if the reverse is the case.

Although various possible schemes are suggested to implement (a) and (b) – simulcast, switchable systems, etc. – a hierarchical scheme transmitting higher resolution extension data in addition to that for the original lower resolution standard ("layered" coding) seems attractive, in view of developments in variable resolution coding. Extension input points are indeed available in the bitstream syntax of MPEG-I (see earlier).

10.4.3. General Characteristics

(a) Source format.
In distinction to MPEG-I, MPEG-II is more oriented towards television

applications and the input data is interlaced. CCIR 601 data is converted to "active" 4:2:0 format by selecting the central 704 picture elements (352 for chrominance), prefiltering and vertically sub-sampling the chrominance information by two and merging the luminance and chrominance fields to form a frame. Exactly half these horizontal and vertical resolutions give active source input format (SIF) for compatibility with MPEG-I, and this latter spatial resolution is the same as that of the active CIF of H261 (with a different frame rate, however). Following processing, interpolation/filtering is used to restore the input format.

(b) Video sequence layers.
These are basically the same as those of MPEG-I except that provision for field/frame motion compensation and DCT processing, and scalability, are included.

(c) Macroblocks.
The usual six block format is retained, except that for 4:2:2 input format, there are two additional chrominance blocks. For DCT processing both chrominance blocks are always in frame order. Luminance macroblock format follows the merged frame structure for frame coding but for field processing lines are separated out into their original field structure.

(d) Blocks.
These are basically 8×8, but in scaled format may be 1×1, 2×2 or 4×4 instead. Associated with these are "slave" blocks which are present for resolution enhancement.

(e) Motion compensation.
For P and B frames there are now frame and field motion vectors – one of the former for an area 16×16 and two of the latter, each corresponding to data from one field (16×8). One half element accuracy is obtained by interpolation from an initial full search single element estimate. As before motion vectors are differentially coded with respect to previously coded vectors.

(f) Coding mode selection.
As with MPEG-I there are several different coding modes from which selection can be made to enhance coding efficiency. In addition, compatibility and field/frame processing are other options. Thus, for example, frame/field motion compensation and prediction decisions are taken on a least-squares basis, whilst intra/inter and frame/field DCT operations use a variance criterion.

(g) DCT/quantisation/rescaling.
Basically these are as described previously with weighting parameters for each coefficient contained within intra/non-intra quantisation matrices.

(h) Coded block pattern (CBP).
As for MPEG-I for 4:2:0 mode, 8 bit fixed length code for 4:2:2.

10.4.4. Bitstream Syntax

Syntax Variations.

(1) Sequence header.
 After extension start code 32 bit
 [see MPEG-I,
 Section 10.3.3(a)]
 Compatible 3 bit
 (MPEG-I, H261, reserved, etc.)
 Interlaced *Y/N* 1 bit
 Scalable *Y/N* 1 bit
 Chroma format 4:2:2; 4:2:0 1 bit
 Sequence type frame/field 1 bit
 Scale code 8 bit
 (Defines DCT size for scaled layers.)

(2) GOP Layer.
 As MPEG-I.

(3) Picture layer.
 After extension start code 32 bit
 Picture structure frame/field 1 bit

(4) Slice layer.
 After quantiser scale 5 bit
 Extra bit slice 1 bit
 DCT size 8 bit

(4a) Slave slice layer.
 Includes data on quantiser scale values for slave 5 + 1 bit
 layers

(5) Macroblock layer.
 After macroblock type 1–6 bit
 Compatible (*N*/field 1/field 2) 2 bit
 Interlaced macroblock type 1 bit
 (Macroblock frame or field DCT)
 Interlace motion type 2 bit
 (Frame/field, etc.)
 Field interlace motion type 1 bit
 Field based prediction/dual field prediction
 Also information on motion vectors, CBP and slave macroblocks.

(6) Block Layer.
 Includes data on scaled/slave block coefficients.

10.4.5. Scalability

As described above, the various DCT block sizes allow a pyramid type of approach to multiple resolution operation by using only subsets of the transform coefficients (for alternative approaches, see IMAGE COMM, 1993). Differential coding of coefficients corresponding to higher resolutions can be used to improve efficiency, and all such data is multiplexed at the slice layer. The scheme works by using the lower resolution coefficients to predict those in the next higher resolution layer. The prediction error differences are calculated, and these, with other coefficient data, coded along the usual zig-zag block scan. Quantisation accuracy can be controlled at the slave slice layer level. Motion vectors are as calculated for the non-scaled case, and must be appropriately scaled for use at other resolutions. VLC of DCT coefficients is based on MPEG-I and JPEG models.

10.4.6. General Comments

Even from the brief review given above, it can be seen that MPEG-II represents a considerable advance on the already sophisticated specification for MPEG-I (a comparison of the two is given by Wong and Chen, 1993). At the time of writing it remains to be seen if optimism with respect to the wide range of possible applications (for further discussion see Puri, 1993) is justified and also, and more specifically, with regard to the mode of variable resolution scaling which has been proposed. It seems, however, that the use of the 8×8 DCT of motion-compensated prediction signals is set to be the cornerstone of digital image sequence coding for the forseeable future, since a very similar structure (DCT followed by quantisation using a visibility matrix with buffer fill as a control parameter and then VLC, with differential coding of motion vectors, etc.) has been proposed for coding of component television signals of contribution standard in CCIR 601 format in the range 34–45 Mb s^{-1} (ETSI, 1991). Although quality is critical in this application, the higher bit-rate implies that the demands on the algorithm as regards the amount of compression are less severe than for coding at 10 Mb s^{-1} and below.

Whether this blanket application of the algorithm will stifle the development of better approaches to the general problem of low-rate image coding is, as has already been pointed out, an open question, although recent developments in the very low (tens of kilobits per second) rate region at the moment show a welcome diversity of techniques (see Appendix 2).

11
Alternative Schemes for Image Sequence Coding

11.1. INTRODUCTION

We have seen that motion-compensated hybrid transform coding is by no means the complete answer to efficient low-rate image sequence (video)

transmission/storage, and the ingenuity of research workers has been actively applied over the past 10 years or so in developing alternative schemes. It has already been noted that intraframe transform coding of motion-compensated difference frames rests upon a very insecure theoretical basis, and just about every other form of intraframe coding method has been used in this context, as will be described subsequently. A further technique, model-based coding, is one of the few really novel approaches to have been introduced and shows much promise for application at very low rates (significantly below $64\,\mathrm{kb\,s^{-1}}$ – see Appendix 2). This too is considered below.

11.2. INTERFRAME VECTOR QUANTISATION

11.2.1. Introduction

We have previously seen that, over the past 10 years, vector quantisation has been extensively developed into an efficient and versatile coding technique for still pictures. With the increasing interest in the coding of image sequences, it was natural that VQ should find a part to play in this endeavour, although the dimensionality problems are no different from those which make it disadvantageous to apply any pure block technique in three dimensions, and it has been employed most often as a substitute for the two-dimensional DCT in the conventional hybrid scheme detailed earlier. Some three-dimensional schemes have been developed, however, and these are considered first.

11.2.2. Three-dimensional Vector Quantisation

The logical extension of two-dimensional VQ of rectangular or square blocks to three dimensions is to code "cubes" made up of small two-dimensional spatial blocks taken from a few successive frames. Examples of this approach are not common, but one such is that of Huguet and Torres (1990b), who give a straightforward comparison of two-dimensional and three-dimensional coding. With 4096 codewords (i.e. a 12 bit index), the bit-rate is $12/16 = 0.75$ bit element^{-1} for two-dimensional coding of 4×4 blocks (PSNR 39 dB), for $4 \times 4 \times 4$ three-dimensional blocks the data rate is 1/4 of the above figure whilst the SNR is lower by less than 1 dB for the MISSA image. Unfortunately no comparison is made with an 8×8 two-dimensional structure which would have had the same number of codewords and data rate. The three-dimensional scheme is likely to be better, however, due to the increased overall value of element-to-element correlation.

A more sophisticated three-dimensional scheme involving the application of the DCT prior to VQ is reported by Thede and Kwatra (1989). Here initial $32 \times 32 \times 4$ blocks are classified with respect to an activity threshold and

subdivided into four blocks of size $16 \times 16 \times 4$. Further testing and subdivision may follow down to a minimum size of $4 \times 4 \times 4$. Subsequently each block is three-dimensionally discrete cosine transformed and the coefficients zonally sampled, with the D.C. coefficients assigned 8 bits and others made up into blocks of 1×8 vectors. These are then vector quantised with the codebooks generated using a modified simulated annealing algorithm (which, however, gives visual results hardly any better than those produced by application of the LBG algorithm). PSNRs of 37–39 dB (outside/inside the training set) at rates of about 0.4 bit element^{-1} were obtained.

11.2.3. Frame Sequence Vector Quantisation

A straightforward approach to interframe vector quantisation is to code two-dimensionally the incoming frames directly, after they have been segmented into a regular block structure (say 4×4) and a representative set of such blocks has been taken to form a training sequence (the considerations here are just the same as those for intraframe vector quantisation discussed in Chapter 4). However, some form of adaptivity or codebook update will undoubtedly improve the performance for sequence coding and, since search time needs to be kept to a minimum, this implies that codebook size should be minimised also. Goldberg and Sun (1986) coded the first frame of a video sequence in this way, either using the original spatial domain blocks or the equivalent blocks of (scalar) quantised coefficients after 4×4 WHT (the D.C. coefficient having been separated out). For the next frame, blocks are initially checked against the original codebook. In low activity areas, the "same" representative block (codeword) in the previous frame will probably be the correct one for coding the present block. Alternatively, a different codeword, still from the original codebook, may suffice, and all that is needed is to transmit a different index (label). If no codeword is found which will give a small enough error, a new codeword must be found. If interframe change is small, codewords can be simply updated; if changes are more significant, old codewords are replaced by new ones. It turns out that, for the sequence used, at low rates the best overall result is obtained by simple label replenishment, i.e. the use of the original codebook. Visually, codeword update produces improvement, as might be expected, in regions of rapid detail variation. A generalisation of this technique is also reported by the authors (Goldberg and Sun, 1988).

Various alternative approaches to interframe vector quantisation have been reported. Baker and Shen (1987) described an interframe finite state scheme operating on the residual vector generated by prior subtraction of the predicted mean value. A motion detector determines whether the predictor and state function should be determined from the previous frame or the present one, giving inter/intraframe adaptivity. An adaptive finite state

approach is described by Chen *et al.* (1992). Monet and Labit (1990) worked in the DCT domain with coefficents subjected to visually determined thresholds, tree-structured vector quantisation and codebook replenishment to develop an algorithm which has been proposed for television transmission at $34\,\mathrm{Mb\,s^{-1}}$. Lavagetto and Zappatore (1990a) have a multiresolution layered structure, with a base (low resolution) layer operating with a block size of 16 × 16 (very large by usual vector quantisation standards) producing a SNR of 20 dB. Higher order layers encode successively the difference between the reconstructed picture and the original with block sizes of 8 × 8, 4 × 4 and 2 × 2. Applications are envisaged involving VBR networks (see Chapter 12). The same authors also describe (1990b) the application of an HVS weighted m.s.e. measure to a DCT/frame adaptive VQ scheme where the error measure is used to allocate bits during the tree-structured codebook design process.

An adaptive tree-structured vector quantiser is also proposed by Chang *et al.* (1992c). In distinction to Goldberg, they use a sub-tree extracted from a large pre-designed fixed codebook, arguing that small codebook update needs significant overhead information to transmit the new codewords. They also advocate the use of a multi-path, rather than single path, search algorithm. Here again, the 4 × 4 block mean vector is removed and 8 bit PCM encoded before vector quantisation of the residual. Summarising their results for sequences CLAIRE and MISSA, adaptive tree-searched VQ (TSVQ) is better than fixed TSVQ by some 2–2.5 dB at a rate of 1 bit element^{-1}, whilst moving to 8-path search improves PSNR by only 0.5–0.7 dB, but increases coding time by a factor of approximately six. Adaptive tree-structured VQ is also reported by Moresco *et al.* (1992).

11.2.4. Hybrid Interframe Vector Quantisation

With the advent of hybrid motion compensated DCT coding of image sequences interest also turned to the use of other techniques, either as a replacement for the DCT step or as alternatives for coding the DCT coefficients themselves. The reader who has persevered this far will have little difficulty in predicting the form of the algorithm which results, and is to be considered below. The motion-compensated interframe predicted (difference) signal forms a two-dimensional image field which can be intraframe coded by any one of these methods, and this usually includes a conditional replenishment step in which interframe blocks are tested against some criterion to check whether they contain sufficient new detail to be coded afresh. An early paper here is that of Bage (1986) who used a two stage vector quantiser inside the prediction loop (see Figure 11.1) with a block size of 3 × 3. The two stage vector quantiser consists of a conventional LBG VQ with a small number (32) of codewords, followed by a lattice VQ stage whose input

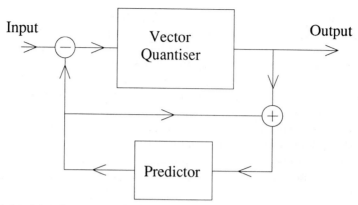

Figure 11.1 VQ/predictive coder scheme of Bage (1986). The predictor is the "same" block of elements in the previous frame.

is the difference between the input block and the output of the first vector quantiser. The lattice VQ codebook is defined by integer points in k-dimensional space and is included to overcome the problem of the poor representation of input vectors by the higher levels of the LBG codebook. The scheme can be made adaptive in terms of both resolution and dynamic range of the lattice VQ.

A more sophisticated implementation using adaptive gain/shape VQ is reported by Watanabe and Suzuki (1989). Three stage block matching motion compensation with a block size of 16 × 16 is used with the motion-compensated difference signal being divided into 4 × 4 blocks. Significant blocks are those with activities greater than a threshold and their average values are subtracted before they are gain/shape vector quantised. For this normalised vectors are obtained by scaling the zero mean vectors by their standard deviations. The maximum size of the codebook is 4096 entries (12 bits), and it has an eight branch tree structure (as in Chang's method discussed earlier) and so can be searched at four levels corresponding to 3, 6, 9 and 12 bits. There are four parameters which must be transmitted for each block – average value, gain scale factor, search level and vector index. The first three of these are combined and coded with a VLC code at 3–12 bits, and the index is directly coded with a fixed word length. PSNR of around 40 dB at $64\,\text{kb s}^{-1}$ was achieved using the MISSA sequence. The system contains several refinements of which lack of space here prevents description. Many similar schemes have been reported in the last few years. Thyagarajan and Sanchez (1989) tested for block motion by checking how many elements in a block satisfy a brightness change criterion from frame to frame, then, for moving blocks, optimum prediction coefficients are determined using an autoregressive model and the error vector coded using classified full search VQ. Othman and Wilson (1989) distinguished between (inactive) blocks which do not need recoding frame to frame, those which can be sufficiently

compensated by displacement defined by the relevant motion vector (i.e. in areas where motion is substantially translational) and those which need an actual VQ update of the residual error block. Block status is transmitted to the decoder as a three state mask which is variable length coded.

More recently Sampson and Ghanbari (1992) have returned to the lattice vector quantiser in a scheme which uses straight (no motion compensation) frame-to-frame block prediction. Lattice VQ has advantages in real-time sequence processing, since the codebook is predetermined by algebraic operations rather than from an arbitrary training sequence and so does not need to be transmitted to the receiver, and efficient fast algorithms can be used for search. Separation of the codebook from a given training sequence also minimises problems which arise when coding images with widely varying properties. Their scheme has two stages, each of which has two components: one is a scalar "gain" factor dependent upon the vector energy and the second is a "shape" vector which is the input vector scaled by the gain term (the similarity with "conventional" product gain/shape VQ is obvious). Depending upon the gain factor and also the angle between the input vector and the closest codeword, the second stage vector quantiser is brought into play. Using the gain factor alone as a criterion a rate of 0.7 bit element^{-1} yields a SNR of about 37 dB for an active sequence whilst the use of both criteria raises the rate to 1 bit element^{-1} and the SNR to nearly 40 dB. With further refinement of the scheme, these figures could probably be significantly improved. Wang and Clarke (1992b) reported an interframe coder operating at 64 kb s^{-1} – here background/foreground segmentation is performed, foreground information is motion-compensated using hierarchical blockmatching and, together with significantly changed background information is subsequently processed using mean/residual vector quantisation.

It has been demonstrated that VQ is a suitable technique for the intraframe processing of motion-compensated interframe difference signals in hybrid coding. Although it is a block-based scheme, at least it does not suffer from the other limitations discussed earlier regarding the application of transform coding schemes to such signals, which have low values of spatial correlation and cannot thus benefit from the high efficiency of which transform coding is capable when applied to still pictures. Whether further research in this area will be worthwhile given the recent standardisation of the DCT technique remains to be seen.

11.3. INTERFRAME SUB-BAND AND WAVELET CODING

11.3.1. Three-dimensional Sub-band Coding

The reader will recall that sub-band coding involves splitting up the frequency domain occupied by the input image into various bands so that the problem of

matching the bit allocation of the following process to the statistical proper-
ties of the particular ranges of frequency components present is eased. Two-
dimensional techniques have been discussed in Chapter 5, but there is
obviously no problem in principle to extension of the idea into three dimen-
sions by including an operation along the temporal axis, and basic schemes
are described by Karlsson and Vetterli (1988a). The incorporation of motion
compensation in such an implementation to improve performance is discussed
by Kronander (1989), who also points out the advantages which accrue if it is
possible to include a longer temporal filter (in this case a four or eight tap
DCT). Podilchuk *et al.* (1990) used the same filter layout as Karlsson and
Vetterli. Naturally, the various spatio/temporal frequency bands differ
greatly in significance as regards their contribution to the reconstructed image
and not all need be retained and coded. Here high and low temporal bands
are split into two both horizontally and vertically and the "low–low–low"
band is further split 2×2 spatially. It turns out that, of the 11 sub-bands so
produced, only the four way low–low–low split and the low–low band of the
high-pass temporal channels need further processing. The latter acts as a
motion detector, the high-pass temporal filter being sensitive to changes in
edge detail and location in the sequence. A three-dimensional switched pre-
dictor is used for coding, choice of either pure spatial or spatio/temporal
prediction being dependent upon an energy measure calculated over a 9×9
block. The error signal is coded with variable bit allocation (according to
sub-band importance) using a Max quantiser and assuming a Laplacian prob-
ability distribution. In fact the high frequency sub-bands which contain per-
ceptually significant detail tend to do so in a highly structured form, and this
can be taken advantage of in the design of a pre-structured vector quantis-
ation codebook (one not dependent upon generation via a training sequence).
This consists of 960 9×9 binary codevectors representing the most likely
patterns (horizontal and vertical rectangular blocks, lines or dots) taken on by
the sub-band data. Using this approach and retaining the switched predictor
for the single lowest sub-band only, the data rate can be lowered significantly.
A morphological approach to three-dimensional sub-band decomposition is
reported by Pei and Chen (1994).

11.3.2. Hybrid Sub-band Schemes

As in the case of transform coding, three-dimensional sub-band coding
schemes have not proved of widespread interest, and hybrid schemes are
more popular. With hybrid DCT coding, we have seen that it is possible, in
principle, to carry out the operations of transformation and prediction in
either order. Since motion compensation is more involved in the DCT
domain it has become usual to predict first and then transform the (motion-
compensated) difference frame. With sub-band coding, however, the output

of the filtering/sub-sampling operation is a spatial image corresponding to the sub-band in question (for example, the lowest sub-band in horizontal and vertical directions gives a lower resolution – blurred – copy of the original image). Thus motion compensation can be carried out after sub-band coding, and several such schemes have been reported. Gharavi (1991a,b), for example, described such a system which is intended for high quality videoconferencing and yet, at the same time, to be compatible (at reduced resolution) with H261. A seven band split is used (see Figure 11.2) and an interesting

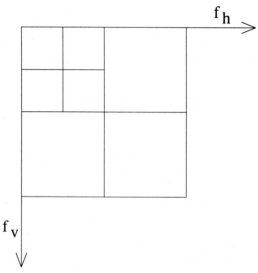

Figure 11.2 Seven band split in the interframe sub-band coder of Gharavi (1991a,b).

initial experiment using the first layer only was intended to evaluate the use of motion compensation on each of the four bands individually, as compared with using a simple low band estimate, none at all or even pure intraframe coding. It was found best to code the diagonal band using intraframe PCM, the horizontal/vertical and vertical/horizontal bands using interframe coding, and the low–low band using a hybrid DCT/DPCM H261 compatible scheme. In all the interframe cases the motion estimate from the low–low band was used (16 × 16 full search block matching). In the two layer case the first layer horizontal/vertical and vertical/horizontal are coded without motion compensation. A symmetric uniform quantiser with central dead zone was used, together with VLC of amplitudes/run lengths as described earlier. PSNR in the region of 46–47 dB was achieved at around 1.5 Mb s^{-1}.

A sub-band scheme of a similar type was submitted to the 1991 MPEG-2 trials by Schamel and de Lameillieure (1993). In this case a rectangular 16 band split [similar to the original Woods split of Figure 5.10(a)] is obtained using a nine tap filter. In the coder a full frame is resynthesised and motion

compensation applied overall before sub-band coding and subtraction from the newest sub-band decomposed frame. This is in distinction to schemes which motion compensate each sub-band separately. A group of pictures (see Chapter 10) consists of 10 pictures, the first intracoded, the remainder inter- or intracoded depending on scene activity. One set of quantisers consists of 16 distinct linear quantisers, one for each sub-band, and there is a total of 32 sets. The highest resolution quantiser is used, consistent with a given bit-rate, and testing starts at the highest resolution. Two sets of VLC codebooks are generated, one for intra- and one for inter-use. Since, in several cases, sub-band statistics are very similar across bands, only four distinct groups need be identified for coding. The lowest frequency sub-band, of course, has quite different statistics from all the others and is two-dimensionally DPCM coded. Picture quality is quoted as comparing favourably with DCT approaches, with the attendant advantages of sub-band coding which have been detailed before.

We have seen that sub-band coding is not a data reducing scheme in itself, its success relying upon the fact that the sub-bands have different statistical properties compared with the original image, which renders them more amenable to efficient coding. It is open to us to use a variety of post-sub-band decomposition coding techniques, therefore, and one of these is vector quantisation. Barba and Hanen (1991) suggested that, with a colour video signal, high luminance signal quality is more easily achieved using adaptive predictive coding, and confined the use of VQ to the chrominance signal, where only six of the lowest 16 sub-bands contribute to visual quality. Coding the lowest of these using adaptive DPCM, elements from corresponding locations in the remaining bands are made into vectors for VQ. Design of the latter component of the system employs an HVS spatial frequency response model as a component of the distortion measure, together with thresholds relating to the visibility of impairments. Adaptive and non-adaptive schemes are developed using the LBG algorithm but with a modified splitting technique and the inclusion of classification by vector norm and directionality. Obviously the use of such sub-band sample coding schemes as this involves substantial complexity but allows, on the other hand, coding of detailed video sequences with vanishingly small degrees of impairment.

It is, of course, possible to substitute sub-band coding for the DCT stage in a conventional hybrid structure, and the frequency decomposition will then apply to the motion-compensated interframe difference signal. In another scheme by Gharavi (1989) 16 × 16 input blocks are block matching motion-compensated before interframe prediction and application to a seven band sub-band decomposition. Quantisation uses a symmetric uniform quantiser with central dead zone, after which non-zero values are VLC/run length coded. For the first frame and also situations in which violent spatial activity is encountered (scene cuts), intraframe coding is possible using direct sub-band decomposition of the input frame and coding of the lowest band using two-

dimensional spatial DPCM. Higher bands use the interframe scheme. The technique is suitable for rates from those for videotelephone through to high definition videoconference ($1.5\,\text{Mb}\,\text{s}^{-1}$).

Westerink *et al.* (1990) also considered sub-band coding of the interframe difference signal as a means of achieving low-rate coding without the artefacts introduced by the use of a block algorithm (DCT or VQ) for the spatial coding operation. The high–high band of the first 2:1 sub-band split is discarded, leaving 12 sub-bands (the remaining first three, each split 2:1 horizontally and vertically) to be coded. The scheme, however, is made spatially adaptive to avoid automatic allocation of bits to sub-band regions for which the difference signal is very small. Thus conditional replenishment is invoked over a 4×4 sub-band region. Since this operates separately from the following bit allocation procedure, it can happen that some blocks to be transmitted as having significant sub-band samples in fact lie in a sub-band which receives no bits, resulting in visible artefacts. Varying the conditional replenishment threshold as a function of the bit allocation would solve this problem, but a simpler method is to set these blocks in the reconstructed frame to zero. Interestingly, Westerink points out that motion compensation is not necessarily always desirable, since otherwise the bits that were to be used for the motion vectors can be reallocated to the coding of more sub-band blocks. Considerable simplification also results.

Vector quantisation is a natural candidate for the coding of motion-compensated difference frame sub-bands and several such schemes have been reported. Ahmad Fadzil and Dennis (1990) decomposed the error image into 16 luminance and eight chrominance sub-bands of which 10 luminance and six chrominance bands are regarded as significant, and samples in corresponding locations in these 16 bands are formed into length 16 vectors for VQ. A selection mechanism based upon the spatial activity of successive areas of the error image determines whether the corresponding sub-band vectors are to be coded or not. The threshold for this test is made a function of buffer fullness to regulate the output data rate. PSNR for MISSA is approximately 34 dB over a frame area of 288×360 at 10–15 frames s^{-1}. Akansu and Kadur (1990) also described a sub-band/VQ scheme with a four band split (of which the high–high band is again discarded) and VQ applied to the sub-bands over 4×4 regions made adaptive through the use of a block variance measure. The authors point out that, as has been noted previously, the motion compensated difference frame has a low correlation coefficient (nowhere significantly greater than 0.5, and usually 0.2–0.3), for which the energy packing gain to be achieved from transform coding is small, and this is the justification for their use of the combination of sub-band coding and vector quantisation to achieve a PSNR of 38–40 dB at a rate of about 0.3 bit element^{-1}, which rate is well below that obtained when VQ is applied directly to the motion-compensated difference signal.

The general outline of the application of hybrid sub-band coding will now

be clear, and many other implementations could be cited, maybe including HVS characteristics in the processing algorithm (Kim *et al.*, 1993). As a last example we note the work of Husoy *et al.* (1990), who applied low-complexity recursive (IIR) filters in place of the more usual FIR designs, in addition to a hierarchical motion compensation scheme. Their method applies a two band split sequentially in a tree configuration to provide a total of eight bands both horizontally and vertically, i.e. 64 in all. By taking corresponding samples in the 64 sub-bands to form vectors 64 samples long, thresholding/quantisation and run length coding of (run/level) pairs in the same way as for the conventional 8×8 DCT hybrid coder can be carried out to achieve a PSNR of about 37 dB for the MISSA sequence.

Overall, such techniques form a viable alternative to hybrid DCT coding, without the blocking artefacts introduced by the latter, and with increased flexibility if adaptive coding of the sub-bands is included.

11.3.3. Three-dimensional Wavelet Coding

Wavelet and sub-band coding are of course very similar, with the main difference being that wavelet schemes use a sequential decomposition of the lowest frequency band at every level in order to achieve a multiresolution hierarchy of images. As in the case of sub-band coding, although hybrid schemes for image sequence coding are more common, pure three-dimensional coding is also possible. An early example of this is the algorithm of Lewis and Knowles (1990), who pointed out the advantages of the absence of blocking effects which occur with, for example, the DCT, and the possibility of using shorter filters (fewer taps) than is generally the case with sub-band coding. Spatially they used a conventional three octave high/low frequency decomposition applied to each frame using the four tap Daubechies (1988) filter (Low-pass coefficients 0.683, 1.183, 0.317, −0.183; High-pass coefficients 0.183, 0.317, −1.183, 0.683) – note that in the literature these values may sometimes be scaled by $1/\sqrt{2}$. A one-dimensional three octave decomposition is then performed along the temporal axis, this time using the basic Haar wavelet, $H = \{1/2, 1/2\}$, $G = \{1/2, -1/2\}$, processing eight frames at a time with an equivalent storage requirement and delay constraint. Coefficient selection is based upon the supposition that edges have components (spatially and temporally) at all frequencies and thus appear at all levels in the decoding. Components in the upper octaves are sent, therefore, if there exists a corresponding component in the previous octave. It is difficult to judge reconstruction quality from the illustrations in the paper, but virtually identical reproduction of the original is quoted at a reduction ratio of 8:1, and reasonable quality at twice this figure.

11.3.4. Hybrid Wavelet Schemes

As with other frequency domain techniques true three-dimensional wavelet implementations have been overshadowed by hybrid schemes which allow simplified time domain processing. The approach is to decompose the difference frame (maybe motion compensated) and then to apply some form of more or less conventional intraframe coding algorithm to the wavelet sub-bands. Occasionally, frame by frame decomposition is implemented, with conditional replenishment indicating significantly changed coefficients which need retransmission frame to frame. Yao and Clarke (1992) have applied the two-dimensional four tap Daubechies filter structure to successive image frames in a two level structure, following which the sub-images are adaptively vector quantised in the manner reported by Goldberg and Sun (1986). The first frame of the sequence is used to generate the initial codebooks, which are used in a conditional replenishment mode by subsequent updating according to significant detail change. Following "received opinion" regarding the sensitivity of the HVS to diagonal frequencies, reduced accuracy is allowed for coding the corresponding sub-bands. Thus block sizes are 4×4 on the first level and 2×2 on the second, with corresponding codebook sizes of 64 horizontally and vertically (32 diagonally) and 128 (64 diagonally). Accurate reproduction of the upper level is essential as it forms a major element in the subsequent reconstruction. Coding of successive frames with the first frame codebook results in a varying degree of error which, if it exceeds a threshold, results in codebook update and new codewords being sent to the receiver. In unchanged areas (background, for example), codewords for given blocks will not usually change frame to frame, with the codebook indices remaining the same. A 20 frame average for the sequence CLAIRE gave a PSNR of 36 dB at a rate of 0.35 bit element^{-1}.

We have seen previously than it can be advantageous to implement motion compensation in a hierarchical fashion. Since the wavelet decomposition automatically produces sub-images at various resolutions it seems appropriate to combine the two schemes, as reported by Zhang and Zafar (1992); (see also Zafar *et al.*, 1993). They compare application of conventional block matching motion compensation followed by wavelet decomposition and either direct quantisation of the sub-images or the use of the DCT followed by thresholding and uniform quantisation, with initial wavelet decomposition followed by multiresolution motion compensation and the direct or DCT quantisation schemes. Figures 11.3(a) and (b) show simplified versions of the two approaches. Best performance is obtained by the use of initial multi-resolution motion compensation with direct quantisation of the sub-bands, the additional inclusion of the DCT step doing nothing to improve the result. The authors point out, however, that there is an unknown factor in this conclusion in that, in the implementations which included the transform operation (using the JPEG–still picture algorithm), default quantisation

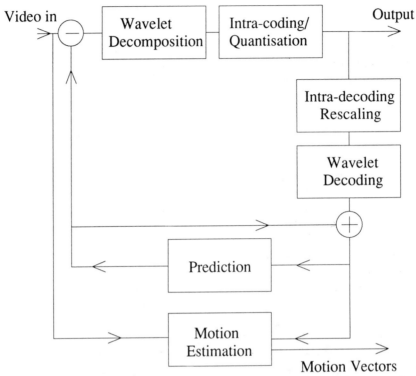

Figure 11.3 (a) Wavelet decomposition of the motion-compensated difference frame (conventional motion compensation).

tables were used for quantising the transform coefficients, even though the input sequence consisted of difference frame samples having a completely different statistical distribution from that of the original video frames.

In any case, a further comparison by the authors which used classified VQ to code the difference frames in the multiresolution case gave a significant performance increase (3–4 dB), confirming the usefulness of this approach, and Yao and Clarke (1993) subsequently presented a modified version of the scheme involving their previously reported adaptive VQ approach, and also an implementation of hierarchical motion compensation (Wang and Clarke, 1992a,b) extended to code colour images. U and V information was processed by coding only the lowest frequency band on the second level (i.e. effectively after sub-sampling by a factor of two horizontally and vertically). Again the benefit of the inclusion of multiresolution motion compensation was apparent, the rate for CLAIRE (0.32 bit element^{-1}) being about 2/3 that (0.47 bit element^{-1}) for the scheme in which conventional block matching motion compensation was used (PSNR = 37 dB). Results are shown in Plates 2 and 3. Plate 2 shows a frame of the CLAIRE sequence coded using the scheme of

Video in

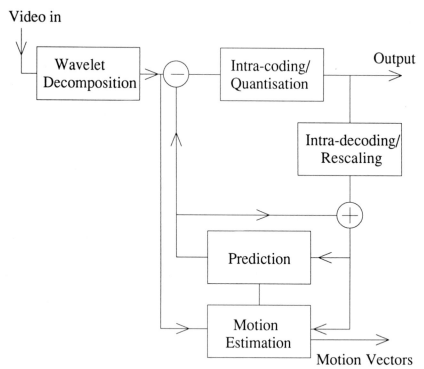

Figure 11.3 (b) Wavelet decomposition of input video and multiresolution motion compensation.

Figure 11.3(a) and Plate 3 that of Figure 11.3(b). Although the above results apparently demonstrate the advantage of carrying out multiresolution motion compensation in the wavelet domain some reservations have been expressed owing to the fact that the wavelet-transformed image is not translation invariant (see Simoncelli *et al.*, 1992 – I am grateful to Fritz Seytter of the Siemens Corp. for bringing this paper to my attention).

As usual, a multitude of variations upon the theme is possible. Improvement of coding efficiency by variation in the order of coefficient scanning is considered by Ohta *et al.* (1991). Thus coefficients may be scanned from layer to layer (low frequency to high frequency) in a similar way to that used in the standards for DCT coefficients (zig-zag plus end of block word), or separate sub-bands may be scanned through the whole frequency range before moving on to the next. Unfortunately no numerical comparisons are given. The authors also consider the blocking artefacts which may arise when block matching motion compensation is applied prior to a wavelet decomposition (even though the wavelet process produces no blocking itself), and their reduction by overlapping and windowing techniques. Again, although the low order Daubechies wavelet filter is commonly used other structures are poss-

ible, and Ebrahimi *et al.* (1990a,b) reported that expansion of video frames in terms of (non-orthogonal) Gabor functions, whose coefficients are only transmitted if they differ significantly frame to frame, can give bit-rates appropriate for operation in the $64\,\mathrm{kb\,s^{-1}}$ region. A further motion-compensated hybrid wavelet implementation is reported by Ohta and Nogaki (1993).

11.4. SEGMENTATION IN IMAGE SEQUENCE CODING

11.4.1. Introduction

Segmentation has already been suggested as a coding technique for still pictures with the advantage that the artefacts that it generates are less objectionable than the edge blurring/block structures produced by transform coding. It is natural, therefore, that it should be considered for image sequence coding, and various workers have investigated this application using more or less sophisticated techniques. The reported literature in the segmentation field generally is enormous, of course, and only relevant work will be quoted here.

11.4.2. Region Segmentation

Segmentation is a technique which is closely connected to image sequence coding irrespective of the actual coding algorithm used. Block-based motion compensation procedures "segment" the image into regular blocks, more "detail-oriented" methods require a prior segmentation operation to locate moving areas and to separate them from still background. This is usually done on a frame difference basis, although more subtle variants are possible. Indeed, there is a close link between segmentation and motion detection in moving images, since we naturally wish to determine the (coherent) motion of individual distinct objects for which unambiguous segmentation is therefore desirable, whilst it is just such objects that will have an approximately uniform motion field distinguishable from that of the surroundings. The operations of segmentation and motion detection are thus strongly interlinked (Hotter and Thoma, 1988; see also Musmann *et al.*, 1989).

Leonardi and Kunt (1987) described a square block decomposition with adaptive subdivision based upon an error measure between the original data and a two-dimensional polynomial approximation followed by a merging operation between suitable neighbouring regions. Mester and Franke (1988) used a merging technique based upon a generalised likelihood ratio measure whilst Lettera and Masera (1989) reported a foreground/background segmentation scheme specifically to detect the moving speaker against a fixed

background in videotelephone sequences, with the object of obtaining a continuous separating contour. They suggested using the algorithm of Cafforio and Rocca (1976) to obtain changed regions on an interframe basis, in which regions intraframe edge detection with Sobel or Laplacian or Gaussian filters can be carried out. Gaps in the latter detail can be filled in with interframe information.

Guse *et al.* (1990) used a binary mask derived by change detection/filtering of the interframe difference signal to modify the traditional block matching motion estimation scheme so that the match criterion is calculated only for those elements in a block belonging to specific objects, whilst outside the object mask still background may be copied to the new frame from background memory. If the match criterion shows no sharp minimum, segment merging may be carried out. Updated regions are coded using the generalised orthogonal transform (see below). Li (1992) employed an affine model of image motion derived either from the velocity field between consecutive frames or from intensity values to separate the motion of the head from that of the shoulders in a typical videotelephone scene. The important facial region can then be isolated. Although this method is intended for model-based coding (see Section 11.6) applications, it obviously has more general application wherever segmentation of image detail is desired. An interesting algorithm involving a split and merge operation in three dimensions is described by Willemin *et al.* (1991).

11.4.3. Segmented Coding

Whatever method of initial segmentation is employed, its efficacy will strongly determine the success or failure of a subsequent coding operation. Of these there are several. The basic scheme, as usual, is simple – identify distinct regions in the picture, code their shapes (boundaries) and locations and send these to the receiver as efficiently as possible. Additionally, choose some technique for representing the detail within the regions – for this polynomials of various orders, or maybe transform coefficients, can be used. There are, of course, problems, which have been dealt with with varying degrees of success. Moran and Morris (1989), dealing with still pictures as a prelude to the processing of television pictures, segmented the frame into regions represented by their mean luminance value with which is associated a texture signal obtained by taking the difference between the input image and its segmented approximation, see Figure 11.4. The segmented image is coded with boundary coding and the residual signal using the 8×8 DCT [this technique is related to the early method of two-component coding, see in particular, Yan and Sakrison (1977)]. The texture component will have high frequency components, of course, and will not automatically be trivial to code. Various forms of pre-filtering can be used to deal with false contours

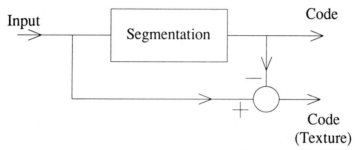

Figure 11.4 Segmented coding.

(where a gradual luminance gradient is incorrectly segmented into two distinctly different regions) and jagged edges may be caused by image noise interfering with the segmentation operation. About 1 bit element^{-1} was needed for good picture quality, and there is no indication that such still frame processing techniques are appropriate for image sequences.

Franke and Mester (1988) have considered various ways of representing the detail of objects. Their conclusions are that approximation with zero, first or second order polynomials or interpolation from the luminance boundaries is satisfactory for smooth detail, whereas for higher quality transform or spectral estimation methods are to be preferred.

Transform coding techniques are not at first sight obviously applicable to the segmented regions themselves (as distinct from the "texture" residual generated by an algorithm such as that of Moran and Morris) since they have arbitrary shapes. The generalised orthogonal transform, however, has been developed specifically for this purpose (Gilge *et al.*, 1989). This paper describes in detail the steps leading to the derivation of an orthogonal set of basis functions for the shapes generated by the segmentation operation. Transform (approximation) coefficents are transmitted and play the same part as in conventional transform coding. The basis function set does not need to be coded since, on the basis of the coded shape which has been transmitted and the starting polynomials chosen, it can be reconstructed at the receiver (using this approach, progressive transmission of still pictures is easily implemented since the basis set is orthogonal). The authors have applied this method to the coding of image sequences, not by representing the motion-compensated interframe prediction signal directly, but by thresholding and noise smoothing it, removing small segments only a few elements in extent, and using it as a mask to indicate where an update is needed to the current frame (motion compensation having failed). This is done using a "post-segmentation" operation but only where required. The data rate is around 12–13 kbit per 352 × 288 element frame, and a transmission rate of 15 frames per second is used.

Segmentation has strong links with scene analysis and object recognition

techniques, operations usually considered to be on the "computer vision" side of the image coding discipline. Rajala *et al.* (1988) suggested applying the three-dimensional properties of the HVS [the "just noticeable difference" (JND) of the contrast sensitivity according to Weber's law, and the spatio/ temporal impulse response or its frequency domain equivalent] to control a region growing segmentation operation by merging "below visibility" segments with their neighbours. Region mean values, quantised to 5 bits, are coded with an adaptive arithmetic code, as is the segmented boundary image. Overall rate for head and shoulders pictures is 0.04 bit element^{-1}, but detailed quality assessment is not possible on the basis of the published images. Subsequently Shen and Rajala (1990) related a motion estimation operation to the segmentation procedure by matching regions in successive frames using mean value, variance and number of picture elements, resulting in one motion vector per segmented region. They later (Shen and Rajala, 1992b) reconsidered segmentation-based algorithms in the light of their use in a packet video environment.

The method of Lee *et al.* (1990) has similarities to that of Gilge *et al.*, in that segmentation is carried out on the image frames only in regions where significant motion has occurred. Two change masks are generated, one conventionally, as in any predictive loop, between the present frame and the reconstructed previous one, the other between original current and previous frames. Mask one contains false motion due to the approximation, but not error build-up, whilst mask two may have error accumulation but contains true motion detail. Meaningful regions are then considered to be those where mask one overlaps significantly with mask two. Segmented regions are represented by an 8 bit mean luminance value. Reasonable results for the MISSA sequence at coding rates in the region 0.02–0.03 bit element^{-1} are reported. A Bayesian block-wise approach to interframe difference segmentation is taken by Sauer and Jones (1993).

It is possible to apply segmentation in a straightforward way to the interframe difference signal as reported by Biggar and Constantinides (1988). Without using motion compensation, they used a region merging algorithm, considering regions to be four- (not eight-) connected, and code region luminances by their mean values. Channel rate control is achieved by varying the number of regions appropriately. Observing that false contours in the frame difference signal lead to significant artefacts in the reconstructed sequence, they modified their algorithm by attaching a spatial weighting function to the merging criteria so that merging in the present frame difference signal near region boundaries in the previous one is discouraged. A noticeable improvement in picture quality at videoconference data rates was observed.

That reasonable results can be achieved with relatively simple schemes is shown by Soryani and Clarke (1989a). Here a coarse initial segmentation is used to derive the approximate location of the facial detail in a head and shoulders videotelephone frame. This region is then adaptively segmented

with lower threshold than the rest selectively to obtain higher visual quality. The segmentation algorithm is centroid-linkage region growing followed by a merge operation (where the threshold can be adjusted by a buffer status signal to control the transmission rate), and a final elimination of small regions. Boundaries are thinned and coded using an eight-connected differential chain code and entropy coding. Region interiors are represented by an 8 bit mean luminance value. Motion-compensated frame interpolation at the receiver allows the frame rate to be reduced. This technique, although simple and effective, is impaired by sudden luminance changes in the background which occur where gradual luminance gradients in the original image meet the segmentation threshold values at varying locations from frame to frame, and it can be improved by processing not original frames but the motion-compensated frame difference signal (Soryani and Clarke, 1989b, 1990) as shown in Figure 11.5. Here adaptive segmentation of this signal instead reduces the

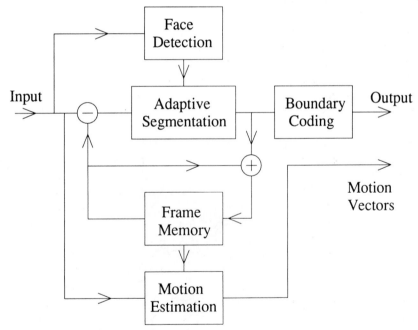

Figure 11.5 Interframe segmented coding.

data rate to approximately $8\,\mathrm{kb\,s^{-1}}$ per frame and significantly mitigates the luminance change problem. Figure 11.6(a) shows a typical frame difference signal and Figure 11.6(b) its segmented counterpart. Figures 11.7(a) and 11.7(b) show similar results in the case of a motion-compensated difference signal. The use of a "crack" code (Figure 6.2) instead of the eight-connected

(a)

(b)

Figure 11.6 (a) A typical frame difference signal. (b) Segmented version of Figure 11.6a.

(a)

(b)

Figure 11.7 (a) A typical frame motion-compensated difference signal. (b) Segmented version of Figure 11.7a.

chain code improves boundary coding efficiency (the effect of adaptive thresholding in the intraframe case is shown in Figures 6.3–6.5). These results were subsequently extended and summarised by the authors (Soryani and Clarke, 1992), and a comparison of the results of the technique with those obtained by using the DCT are shown in Figures 11.8 and 11.9. Figure 11.8(a) portrays a typical frame resulting from the application of the hybrid/DCT algorithm to the CLAIRE sequence (rate 0.07 bit element^{-1}) and Figure 11.8(b) the result at the same rate using the segmentation approach. Figures 11.9(a) and (b) show the same results at 0.09 bit element^{-1} for the TREVOR sequence. Colour image coding was included and various segmentation procedures investigated for this operation: independent segmentation of Y, U and V signals, segmentation of Y only and its results applied to the other two signals, and three-dimensional segmentation of $\{YUV\}$. Experiments showed that segmentation of Y alone and the application of the results to the U and V signals also produced the best picture quality. Plate 4 shows a typical frame from the coded CLAIRE sequence at a rate of 0.1 bit element^{-1}. Segmentation of motion-compensated differences has also been reported by Liu and Hayes (1992).

It was mentioned earlier that there is an intimate connection between segmentation and motion detection and that each technique can be used to aid the other in processing an image sequence. In the algorithm of Chae *et al.* (1993) both the motion vector field and the frame difference are segmented in regions of significant change as determined by a change detector, consisting of adaptive thresholding of the frame difference signal. Motion estimation is carried out by block matching over 2×2 blocks within the changed areas. The motion vector field is smoothed and then segmented. Where motion compensation has failed, the prediction error signal is large and this too is segmented and transmitted. Contours are coded based upon the 2×2 blocks at about 0.8 bit element^{-1}. In a numerical comparison with the Biggar/Constantinides algorithm described above, however, little difference for CIF sequences was observed and again, the quality of the reproduced figures in the paper does not allow detailed visual comparison.

11.4.4. General Comments

There can be little doubt that segmented coding of images and image sequences is beset by severe problems where complex scene detail is involved (as indeed is the basic operation of segmentation itself, on which a vast amount of research effort has been expended over the past decades). Neither can there be little doubt that segmentation and coding of actual objects in the frame, as opposed to the coding of arbitrary rectangular or square blocks, is the correct long-term approach to efficient image coding, and further advances in this direction will certainly be forthcoming.

(a)

(b)

Figure 11.8 (a) Decoded frame from the CLAIRE sequence; hybrid/DCT algorithm, 0.07 bit element^{-1}. (b) As Figure 11.8a but using a segmented coding algorithm.

(a)

(b)

Figure 11.9 (a) Decoded frame from the TREVOR sequence; hybrid DCT algorithm, 0.09 bit element^{-1}. (b) As Figure 11.9a but using a segmented coding algorithm.

11.5. HIERARCHICAL/RECURSIVE SCHEMES FOR INTERFRAME CODING

11.5.1. Introduction

Throughout the earlier sections of this book we have seen how it is advantageous to adapt the allocation of coding capacity to image detail, in both still picture and image sequence coding situations. Just as this can conveniently be done for the former by structured quadtree or Laplacian methods, so these can be applied to the latter to produce flexible, efficient interframe coding schemes which do not have the inherent disadvantages of the hybrid/DCT approach and yet are easier to implement than, for example, high quality segmentation schemes. Many algorithms have been developed, and a selection of these will be described below.

11.5.2. Recursive Binary Nesting

This simple space domain algorithm has already been described in its application to still picture coding (see Chapter 7, Section 7.1), and it can also be used successfully to code image sequences (Clarke and Cordell, 1988; Cordell and Clarke, 1989a,b, 1992). Coding of separate frames of the sequence is liable to be affected by visible artefacts due to the effect of noise on the block corner points used for the interpolation, and the most effective way of minimising this source of degradation is to predict the optimum corner values using the original input data, combined with a check on the values in the previous frame. Of course, for sequence coding, interframe processing is desirable, and in the present algorithm either interframe or intraframe coding can be implemented, depending on the image detail present. In the latter case interframe operation is limited to a copying operation, under the influence of motion vectors generated by a hierarchical scheme (Wang and Clarke, 1992a) operating in parallel with the quadtree decomposition. The scheme is shown in Figure 11.10. Comparison with a hybrid motion-compensated/DCT implementation show that results are at least as good as those of the latter at rates around 0.08 bit element^{-1} for the 256 × 256 MISSA sequence (64 kb s^{-1}), with generally sharper edge detail, and somewhat better performance at higher rates (TREVOR sequence). The scheme does have the advantage of very simple spatial domain implementation with low precision arithmetic. Typical results and comparisons with H261 are shown in Figures 11.11 and 11.12. Figures 11.11(a), (b) and (c) show, respectively, the original MISSA image, its coded counterpart coded using an H261 implementation at 0.08 bit element^{-1}, and the result obtained with the recursive algorithm. Figures 11.12(a)–(c) portray the same results for

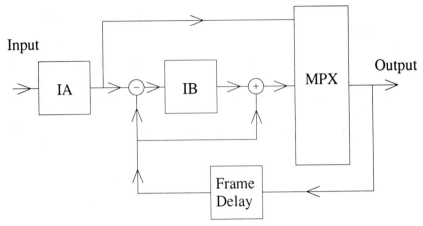

Figure 11.10 Recursive binary nesting for image sequence coding (Cordell and Clarke, 1992). IA, intraframe coding; IB, interframe coding; MPX, multiplex.

TREVOR at 0.19 bit element^{-1}. Figures 11.11(d) and 11.12(d) show the hybrid grid structure – black regions indicate where the algorithm uses interframe interpolation and grey regions where intraframe interpolation has been employed.

11.5.3. "Bottom-up" Quadtree Processing

Conventional decomposition of a quadtree structure proceeds "downwards", i.e. large blocks are successively divided into a larger number of smaller ones. We do not need to proceed in this way, however (Chapter 7, Section 7.1), and the reverse operation has been implemented in an adaptive video design by Strobach (1990). After a further convincing demonstration (if one were needed) that the DCT is not an appropriate approach for the coding of fragmentary, line-like motion-compensated frame difference images, the author suggests an algorithm based upon the successive merging of small square blocks based on some coherence criterion – here a test involving the successive block means. This mode of operation is shown to have advantages in minimising the number of arithmetic operations needed. A typical merge operation is shown in Figure 7.7. Motion estimation is carried out by a hierarchical technique involving an initial 4 × 4 sub-sampling operation to give a rough first estimate by the use of 4 × 4 block matching with the mean absolute difference criterion, with search interval ±4 elements at this level. The first estimate initialises the next level test – over 8 × 8 blocks at ±2 elements displacement. This gives a more accurate motion vector which defines the previous 16 × 16 block which, together with the present one, is used to generate the 16 × 16 motion-

compensated prediction error image. After sub-sampling the resulting 8×8 block is quadtree processed. As an additional refinement, it is observed that the complexity of the quadtree processed block is dependent upon the displacement of the image block from the previous frame. There thus exists the possibility of optimising, jointly, the displacement and the quadtree structure to yield the minimum bit-rate. Should more than one displacement give a minimum bit-rate, that minimising the mean absolute distortion also is selected. The resulting algorithm, quadtree structured DPCM (QSDPCM), produces good quality results, lacking the block artefacts typical of transform schemes at $64 \, \text{kb s}^{-1}$ using standard CIF head and shoulder colour sequences (see also Strobach, 1989).

11.5.4. Pyramidal Image Sequence Coding Schemes

The two-dimensional scheme introduced by Burt and Adelson (1983) for Gaussian/Laplacian pyramid decomposition of still pictures (see Chapter 7, Section 7.2.3) can be extended to the coding of image sequences by the introduction of a three-dimensional pyramid formulation. Additionally the rectangular lattice configuration can be relaxed to allow for non-orthogonal sampling structures as found in digital television applications, and as described by Sallent *et al.* (1990a,b). In this case the input sequence $S_0(l, m, n)$ has both spatial and temporal indices and is three-dimensionally low-pass filtered to form a sequence of lower resolution (three-dimensional) levels $S_i(l, m, n)$, $S_{i+1}(l, m, n)$, etc. At any level i, the corresponding difference (bandpass) signal $D_i(l, m, n)$ is obtained in just the same way as in the two-dimensional case: $S_{i+1}(l, m, n)$ is interpolated and filtered to give $S'_{i+1}(l, m, n)$, whence:

$$D_i(l, m, n) = S_i(l, m, n) - S'_{i+1}(l, m, n). \tag{11.1}$$

Gaussian filters are used as a consequence of their optimal space/frequency domain characteristics. Properties of good reconstructed quality, low complexity and suitability for parallel operation are claimed at reduction rates of up to 60:1, but unfortunately little can be ascertained from the reproduced images in the papers. A pyramidal decomposition approach to interframe predictive coding is also suggested by Timson *et al.* (1992). In this case interest centres on the real-time realisation of the algorithm by employment of a set of T800 transputers, intended to operate over a wide range of data rates and image formats and with a view to eventual VLSI operation. Morrison and Parke (1993) also described the application of a modified spatial pyramid technique to hierarchical coding, and Nasrabadi *et al.* (1990) have reported a hierarchical block truncation approach for HDTV coding.

(a)

(b)

(c)

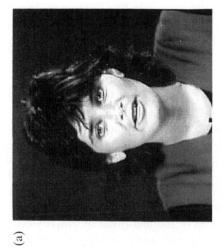

(d)

The application of transform and sub-band coding in a hierarchical environment is considered by Vandendorpe (1992).

11.5.5. Hierarchical Vector Quantisation

Vector quantisation has been successfully used for direct coding of both still images and image sequences for the past 10 years or so now. Being a block-structured, basically spatial domain technique, it can also be incorporated into recursive quadtree-like decomposition schemes, and such have been reported by several authors. The obvious approach is to take the image or, in the present case, the interframe difference image (motion compensated or not) and decompose it using a quadtree algorithm using some form of test of uniformity (variance maybe, or maximum absolute difference), to detect those blocks which can satisfactorily be represented by their mean value only. Other blocks can then be vector quantised using appropriately sized (and maybe classified) codebooks. Hammer *et al.* (1987) used gain/shape vector quantisation (see Chapter 4, Section 4.5.2) with the gain represented by the maximum difference of input block values, as an element of a pyramid coder in which the signal to be vector quantised is the difference between the input signal at that particular resolution level and the interpolated output from the VQ operation at the next lower level of resolution, see Figure 11.13. Interpolation is carried out with a six tap FIR filter in a two pass operation designed to minimise visibility of block boundaries. In all, six stages are used, with an initial block size of 32×32. With the inclusion of motion compensation and coding of significant interframe differences, colour signals (Y, U, V with sample ratios of 4:1:1 horizontally and vertically) can be coded with good quality at $61\,\text{kb\,s}^{-1}$ (approximately 0.06 bit element^{-1}).

The scheme of Corte-Real and Alves (1990) segments the difference image (not motion compensated) initially into 4×4 blocks which are first classified as active or inactive, of which the former are coded individually. The latter are then grouped to form larger square or rectangular blocks, in one of nine categories, in the size range 8×4–32×32. Three separate vector quantisers suffice for coding, since larger blocks can be reduced to 4×4 by subdivision and the use of sub-block average values. For the MISSA sequence PSNR is 36–37 dB at 0.1 bit element^{-1}.

Many schemes of the above kinds have been reported over the past few

Figure 11.11 (a) A frame from the original MISSA sequence. (b) A frame from the MISSA sequence coded using the H261 algorithm at 0.08 bit element^{-1}. (c) As Figure 11.11b but using Recursive Binary Nesting. (d) Hybrid grid structure – black indicates interframe interpolation, grey intraframe interpolation.

(a)

(b)

(c)

(d)

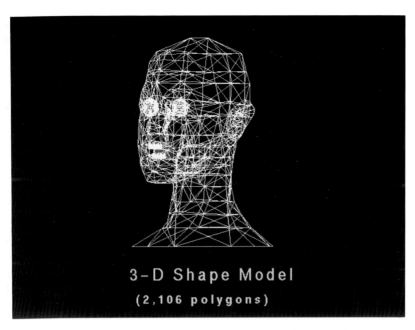

Plate 5 Typical polygonal three-dimensional shape model.

Plate 6 Wire-frame mapping applied to the MISSA image.

Plate 7 As Plate 6, but for the CLAIRE image.

Plate 8 Contour points fitted to facial detail on the CLAIRE image.

advances made in artificial scene modelling via computer graphics technology, some of the results of which are nowadays all too evident upon our domestic television screens.

Although a more recent development than the vocoder, the idea of employing such methods for low-rate image communication is not exactly new, and is outlined by Parke (1982), Collins (1983) and Forchheimer and Fahlander (1983). Parke suggests the use of so-called "parametrized" facial models (which idea itself dates back even further to the early 1970s) in other applications as well – surgical or dental procedures, and the generation of "identikit" models of criminals. He also gives a good basic description of the concepts involved and reviews many of the criteria which apply to the acceptable representation of facial feature animation in such a scheme. The underlying idea is to determine a sufficient set of parameters which describe or define a given object (here the human head) and its possible range of movement and variation in significant feature detail (eyes and mouth are most important in this context, but realism is greatly heightened by paying attention to other features as well). Development of the parameter set can proceed on one of a number of bases – experimental observation of practically occurring "surface" features, study of underlying anatomical phenomena giving rise to feature variation (Platt and Badler, 1981), or a mixture of the two. Parameters can then be categorised into two, partially overlapping, classes – those controlling the "conformation" (structure) of the individual face (for example, eye location, separation, iris size, nose length and width, chin disposition and the forehead/eyes/nose/mouth relationship with respect to the face being considered), and those involved in "expression", for example mouth width and corner location, degree of eyelid opening, eye direction and general head orientation. One parameter set which has been developed for the latter class is the facial action coding system (FACS) (Ekman and Friesen, 1977), which consists of a set of "action units" which describe separate facial expressions, and this has been used more recently by workers in the field to animate their implementations.

In the practical case it is now necessary to transmit feature change to the receiver and to resynthesise the input image. The usual approach here is to generate a polygonal wire frame model (normally with several hundred facets) see Plate 5, which is matched to the face/head image in question. This will typically consist of a triangular mesh in which areas of high spatial detail (curvature) will be covered by a relatively dense array of small triangles and more uniform areas covered by a lower density of larger ones. Transmitted parameters now vary the locations of the vertices of the triangles to produce the feature variation through operations such as positional offset, scaling, rotation and interpolation. Plate 6 shows a typical view of the wire frame mapping of MISSA. Plate 7 shows a corresponding view for CLAIRE. An alternative approach is the "cut and paste" technique (Aizawa *et al.*, 1989), in which the shapes of specific regions of the input image, or those derived from

a predetermined and prestored "eye" or "mouth" codebook are mapped into the correct locations on the model, the latter operation being somewhat akin to vector quantisation. This method generally requires a higher data rate (see below). The final operation is to render the reconstruction lifelike via some sort of shading (Phong, 1975; Gouraud, 1971).

In addition to a comprehensive discussion of the underlying concepts, examples of the basic operation are shown by Forchheimer and Kronander (1989) from a scheme using only about 100 triangles and 30 action units (to allow real-time operation) from the FACS scheme and applied to the MISSA sequence. The authors indicate some of the problems associated with various component parts of the system such as motion estimation and facial feature identification and location, and point out the advantages of coupling the estimation of shape and motion because of their close mutual relationship, particularly in the more interesting (and probably only partially soluble!) case of the presence of unknown objects in the image field. Musmann *et al.* (1989) also stress this point. Additionally, Welsh *et al.* (1990a) give more general information on the principles of the technique, and Pearson (1989) gives a good general overview.

11.6.2. Feature Identification and Tracking

To achieve naturalness in model-based image coding it is necessary reliably to identify and track at least the major features of the detail which makes up the facial image, and also the general location and orientation of the head. In an experimental situation, basic information regarding these parameters can be sent to the receiver in the form of the first complete frame (subsequent detail change being conveyed as coded update parameters as described above); in a local area videotelephone system, this basic structure could have been scanned into the database when the new participant is initially incorporated into the network.

As far as the features are concerned, eyes and mouth take priority with regard to changes in expression but the nose is significant also if the question of speaker identity arises. An early example of identification of these important features is given by Sexton and Dennis (1988), who employed a morphological approach to the detection of small dark areas within the (generally lighter) facial image, it having been previously determined that such regions of contrast characterise the location of major features. Subsequently, all significant areas (clusters) are reduced to single points. Features are then identified by using a hierarchical tree structure. The starting point (top level) is taken to be the left eye. The next level considers all points which satisfy some given criterion – here the right eye will lie on a line extended to the right from the starting point and deviating from the horizontal by not more than 10 degrees. Other criteria (for example, knowledge of feature separation ratios)

can also be used. The technique was successfully applied to the MISSA sequence.

Over the past 10 years or so, there has been interest in the image processing applications of artificial neural networks (ANNs, see Chapter 7, Section 7.3) and the feature identification operation needed in model-based coding would seem to be a suitable task for such an algorithm. Hines and Hutchinson (1989) have applied multilayer perceptrons to the problem of the location of facial features (specifically the eyes). They used a general head and shoulders database, males and females, different races, beards and glasses, and a sub-sampled 32×32 image within which a 7×5 window was used to cover the eye region. A two layer MLP with 35 inputs and one output was trained on a small but representative set of windows from five original images and subsequently correctly located the eye positions in all of them, but also generated significant outputs when regions of hair and beard were encountered. Results obtained for images outside the training set were judged to be unacceptable, however, and a modified approach was developed. This used all possible 5×5 windows, raster scanned, from a 16×16 sub-sampled image but did not perform well on images other than that used for training. When trained upon five frames from the MISSA sequence, however, the network was effective in feature location over the whole sequence (over 100 frames). A further development with 256 input nodes (16×16 blocks), 16 hidden nodes and one output node trained on up to 165 faces to locate the right eye subsequently found this feature in 26 out of a further 32 facial images, but problems of convergence remained.

The experiments referred to above show how difficult it is to design algorithms to do what the human eye does effortlessly. Musmann *et al.* (1989) described a more general scheme intended to apply to either two- or three-dimensional moving objects, and also emphasised (as earlier) the mutual interaction of shape and motion in this context. In two dimensions analysis begins by detecting non-zero differences between luminance signals s'_k and s_{k+1} of two successive frames to locate moving regions which are indicated by a binary mask. Here s'_k represents the (transmitted and) synthesised approximation to s_k. For each of these, mapping parameters are determined using synthesised image s'_1 and the actual image s_{k+1}, and a new synthesis performed. Any parts not correctly synthesised are analysed in the next step of the hierarchy, and so on. The technique can be extended to three dimensions by including estimates of depth to give a source model which will allow the portrayal of object rotation (see Section 11.6.3). It is clear that substantial advantages in using the method can be achieved as is demonstrated by the comparison of the difference images produced by the technique and by conventional block-based hybrid coding. Furthermore the overall geometrical distortion which results is considered to be less obtrusive than the usually visible quantisation errors. A similar more general treatment is given by Morikawa and Harashima (1990, 1991). Aizawa *et al.* (1989), in their model-

based analysis/synthesis image coding (MBASIC) system, also estimate depth information from a knowledge of two successive frames of an image sequence. Using a rigid body approximation, the displacement from point \mathbf{V} = $P(x, y, z)$ to $\mathbf{V}' = P'(x', y', z')$ can be written as

$$\mathbf{V}' = R\,\mathbf{V} + T, \tag{11.2}$$

where R is the rotation matrix and T the translation matrix. On the assumption of small amounts of displacement between frames, iteration based upon successive approximations of depth values and motion parameters allows the determination of each. Further development is expected to obviate the need for the prior marking of reference points on the subject's face. This has proved to be something of a problem in general and several research groups have found it necessary to use some artificial method (for example manual determination), of fixing the initial locations of significant features at the start of the sequence for subsequent tracking.

Forchheimer's work has previously been mentioned in the model-based coding context. He suggests estimation of the parameter vector by testing over a hypercube (in the six degrees of freedom related to rigid body rotation and translation) whose volume is related to the uncertainty of the measurement. For feature location the resulting two-dimensional areas may range in size from a significant fraction of the image area down to a close approximation of the actual feature size as the hierarchical search proceeds. Welsh *et al.* (1990a) determined initial feature location by using a Laplacian (second derivative) operator to detect the head outline (see also Pearson and Robinson, 1985), followed by eyes and then the vertical axis of the face, after which the bottom of the nose, the lips and chin can be found. Again the algorithm is not absolutely reliable and, in addition, glasses/beards, etc. prove to be stumbling blocks. Subsequently, feature tracking is carried out by a template matching operator applied to the Laplacian images. If shape change causes the value of the matching criterion to fall below a certain fraction of its previous maximum value the template is replaced by the feature area in the current frame.

An alternative location procedure for the boundary as a whole is that involving so-called "snakes" (Kass *et al.*, 1987). The snake is a curve which is attracted to edge detail in the image by the influence of the luminance gradient. In the present context a closed contour located at the perimeter of the image field would hopefully iterate its location so that finally it neatly encompassed the head region. In fact, although the concept gives rise to a large amount of sophisticated mathematics, its performance can be marred by becoming trapped on external features (for example, shirt collars) or ignoring the face/background boundary and becoming aligned with interior facial features (Waite and Welsh, 1990). Fukuhara and Murakami (1993) have also used the "snake" approach in model-based coding. They locate a total of 28 feature points, all lying on significant facial details (global contour, mouth,

eyes, etc.) using prior knowledge of the approximate positions of the latter, together with a set of snakes having up to 100 points, see Figure 11.14.

Figure 11.14 Contour points derived using the "snake" technique.

Following initial detection in frame one, five of the 28 feature points are selected and tracked by a template matching algorithm (see below). Plate 8 shows the fitting of feature points to facial detail in the case of the CLAIRE image.

A basic difficulty with the model-based approach which relies upon the estimation of parameters in a three-dimensional space in order to impart naturalness to the reconstructed image when general motion is involved is that, for the conventional image sequence, everything in the third dimension must be estimated from projections in two dimensions. Agawa *et al.* (1990) used both front and side views of the head, taken in colour (RGB) and then converted to hue, luminance and saturation space. Segmentation then follows – large regions being recursively segmented in a hierarchical manner. Using prior knowledge about colour and situation of spatial detail windows are now located in the appropriate places for eyes, nose and mouth feature extraction. Any differences which result from the independent processing of the views from the two angles can be compensated for by matching common feature points, and the use of the two independent views allows decoupling of face

size and tilt. The advantages of observing the head profile from more than one direction are also stressed by Braccini *et al.* (1993).

Approaches to feature detection are legion and there is only space briefly to mention one or two more here. Seferidis (1991) used a morphological approach to produce a simple edge detector which generates an image which, after thresholding, will have a binary format. The outline of the synthesised model is then matched to the actual image by searching for a minimum using a binary distance measure. A somewhat more sophisticated (and complex) scheme is described by van Beek *et al.* (1992a,b) which involves both inter-frame and intraframe analysis and the use of an integrated square distance metric. Choi *et al.* (1991) used a gradient method to estimate head motion and facial expression parameters. The former are estimated from the constraint on velocity and spatio/temporal luminance gradient between successive frames. Using these to synthesise an initial approximation, the difference between this and the next frame is caused by the individual facial expression changes which can then be estimated similarly. This operation may be iterated for improved accuracy. Kokuer and Clark (1992) used template cross-correlation, after initially locating features manually in the first frame. Three-dimensional information may now be (approximately) inferred from the two-dimensional results. In addition, the authors usefully confirm that a prior edge detection operation is of no help in improving the accuracy of the template matching step. Tracking and analysis are also considered more generally by Huang *et al.* (1991).

11.6.3. Motion Estimation

Although it is obvious that correct identification of significant facial features is crucial to the success of model-based coding, robust estimation of their subsequent motion through the frame sequence is a further problem which has given investigators much cause for thought. The basic problem has been stated by Forchheimer (1987) as having two main aspects – (a) the estimation of global motion parameters to determine the gross translational and rotational features of complete head movement, only after which can the matter of (b) the detailed motion of the selected facial features be addressed. Yau and Duffy (1989) used image blocks centred on the main features, eyes, nose and mouth, and tracked these from frame to frame by using a logarithmic search technique (see Chapter 9, Section 9.4) to minimise the mean square error between the given feature block and a region in the present frame. To reduce the problem of feature motion (blinking, for example) affecting the matching operation, only the outer thirds of the block (containing the more invariant areas – corners of eyes and mouth, for instance) are used in the matching process. As far as long-term motion is concerned, there arises the problem of which reference blocks to use. Those extracted from the first

frame of the sequence will give a poor match result when significant feature change is encountered, suggesting that use of blocks derived from the previous frame would be a better approach. In this case, however, the build-up of small positional errors (due to the open loop nature of the process) causes problems of gradual feature block drift with respect to the correct location as the sequence progresses and a hybrid technique is preferable, in which a previous block is retained for tracking until a new feature block has to be chosen as a result of poorness of match with the one currently being used. In this case it is preferable to select a new block not from the current frame but from feature codebooks which are generated by taking features in the sequence which differ from those already in the codebooks by more than some threshold value.

The motion estimation operation can now be carried out. There are basically six parameters to be estimated of which one (motion along the line joining face and camera, the z axis) is assumed constant. x and y shifts are determined via the movement of the centroid defined by the eye and mouth locations, rotation around the z axis via the changing angle in the x, y plane of the line joining the centres of the eye feature boxes. The remaining two rotations, around the x and y axes, are estimated from the relative disposition of a nose feature box taken to lie a known distance in front of the mouth/eye plane. Successful tracking over sequences of aproximately 150 frames was demonstrated. More details can be found in Yau (1989). Forchheimer and Kronander (1989) also considered the problem of selection of a suitable reference feature, and likewise show that error accumulation results whatever reference element is used (for the case of attempting to track the facial area in the MISSA sequence) whether it is the first frame of the sequence or is adaptively selected using degree of motion as a criterion. They suggested using a combination of shape and motion estimation, in which labelled feature points are used to generate three-dimensional depth estimates as well as those of the incremental frame-to-frame motion. The latter are used to update knowledge of the total motion of the feature from an initial starting point, and this motion is then, in turn, applied to the depth estimates to determine shape. Comparison of the input feature point set with a synthesised set obtained from the estimated motion parameters allows an "observer" to check the validity of the operation (see also Roivainen and Forchheimer, 1990).

Mussman *et al.* (1989) have considered the extension of their two-dimensional approach described in the previous section to three dimensions. The basic concept here is to develop a relationship betwen a "model" image, which is a two-dimensional projection of an (artificial) three-dimensional model world and a "real" image which is a view of the corresponding three-dimensional "real" world. The "model" image is synthetic and is an approximation to the "real" one, and modelling has the object of making the two as alike as possible. Here we are mainly concerned with the analysis of motion

needed by the approach. Inputs to the motion analysis algorithm are P'_k, the current "model" world generated by earlier processing, S_{k+1} the "real" new image, and the area over which motion is to be estimated. The first stage has, as output, a set of six (three translational, three rotational) estimates of motion parameters which, together with the current model world, allow the synthesis of a motion-compensated model image \hat{S}_i. As in Forchheimer's scheme there is a verification test, and here the frame difference between S_{k+1} and \hat{S}_i is compared with the frame difference between S_{k+1} and the model image derived from the new model world. If the frame difference has decreased the updated model world is accepted, if not the motion estimates are rejected and re-estimation takes place over subdivided object regions. The advantage of such an approach is demonstrated using as a test the generation of a frame difference signal from two consecutive frames of the CLAIRE sequence. Three-dimensional motion is also employed by Diehl (1991) to facilitate a hierarchical approach to object segmentation.

More recently the problem has been attacked by Fukuhara and Murakami (1993) whose application of the "snake" method of contour extraction was described earlier. The five selected feature points (chosen for their invariance to changes in expression) are now used for a two-dimensional estimate. Templates are updated as in Equation (11.3).

$$T_k = a\, T_{k-1} + (1 - a)\, A_k \qquad\qquad (11.3)$$
$$k = 1, 2, \ldots,$$

where new template T_k is calculated from the previous one T_{k-1} and A_k, the block providing the best match in frame k. Typically "a" is around 0.7. Two-dimensional displacements are now normalised by a face size measure derived from the separation of feature points and used as input to a neural network with 10 input nodes (five sets of x, y displacements) and five output nodes (three rotations and two translations, that in the z direction being assumed zero). The network is trained on a set of approximately 400 possible patterns, and 40 nodes are found to be sufficient in the hidden layer. Performance is based upon a measure of estimation error (a comparison with the manually estimated feature point locations). This shows that the neural network approach gives better estimation than a least-squares technique for extraction of the motion parameters when head motion is large and, although the reverse is the case for small movement, the overall consistency and robustness of the neural result is better.

Generally speaking, the image analysis step is likely to remain the awkward operation to perform reliably and accurately in a model-based coding situation – improvements in modelling and synthesis of the reconstructed image will be relatively susceptible to the ready availability of more and more computing power but, as always, mimicking the initial visual observation step remains the sticking point.

11.6.4. Image Synthesis

Given that the (decidedly non-trivial!) operations of feature identification, tracking and global three-dimensional head motion estimation considered above can be achieved satisfactorily, the overall success of the coding operation now stands or falls by the acceptability of the resultant picture as seen by the viewer. Thus the head image overall should change orientation in a natural manner and the features consistently retain their respective locations, with the projections of their basically three-dimensional structure onto the image plane reflecting that orientation change and, in turn, their localised variations being consistent with changing facial expression of the (input) subject. Many points of detail remain to be considered to make the portrayal truly natural, but there seem to be only two or three ways in which expressive detail can be (re-) synthesised at the receiver. One obvious way is to identify the regions responsible for the major characteristics of facial expression (predominantly eyes and mouth), and then maintain a codebook of possible instances from the range of commonly encountered expressions, extracts from which can then be mapped onto the basic decoder model. Alternatively, regions of significant expressive change can be identified and overwritten on the general model present at the decoder (the "clip and paste" method). A more subtle approach is to adjust facial expression by moving the vertices of the underlying wire frame model which forms the basis of the reconstructed image after it has been texture mapped from the first frame of the sequence. Aizawa *et al.* (1989) describe and compare the second and third of these approaches. They start with a three-dimensional wire frame model (as described earlier), with approximately 400 triangles, which is then geometrically transformed so that initially four "feature points" (point of chin, a point between the eyebrows and two points, one on either side of the head, on the same horizontal level) match those of a two-dimensional image which is the projection of the actual subject onto the image plane. The model can be adjusted to improve the fit and then the full face image mapped back onto the (now adjusted) three-dimensional wire frame model, which can now be rotated (within limits) and still appear essentially natural. This model is then rotated and translated as required to follow general head motion through successive frames. Regions of expressive variation are then identified and "clipped" from the actual input image and the *difference* between such regions and their notional two-dimensional reconstruction from the original three-dimensional facial model transmitted to the decoder and "pasted" onto the equivalent image also synthesised at the receiver, together with a suitable weighting function to smooth the boundary transition (typically a 50%/50% mix of both signals over a border three picture elements wide).

The alternative method uses the FACS scheme mentioned earlier, in which facial actions are decomposed into action unit (AU) combinations. For this purpose a more finely detailed wire frame model is needed initially, since no

vertex can be displaced which does not initially exist in the representation; also, a greater number of control points is required to define eyes, eyebrows, nose and mouth. Comparison of the approaches shows that the latter scheme is advantageous in terms of bit-rate since it is only necessary to transmit parameters relating to changed expressions, whereas the clip and paste operation requires actual transmission of clipped area detail. A later development by Nakaya *et al.* (1990) suggests that it is also necessary to update the texture in the areas around the eyes and the mouth. This can be done by using typical patterns stored at both transmitter and receiver and selecting an appropriate example, or indeed by the use of conventional waveform coding. Updating of the facial model is also described by Choi *et al.* (1991). Texture mapping *per se* is considered by Pearson (1990b).

The codebook approach has been investigated by Yau (1989) and Welsh *et al.* (1990a). Yau's codebook has eye and mouth entries extracted from full face images in a training sequence. It should be noted that these are not the same as the codebook entries referred to earlier used for feature tracking which are taken from the sequence to be coded, and they may have variations in orientation. There is a strong link between the two, however, in that all tracking sub-pictures with the same mouth shape (for example), but with possibly different orientations should map to the *same* feature codebook entry for it is this feature that is mapped onto the polygon model, the latter being subsequently reoriented to reproduce the original image. Yau discusses the problems which arise in choosing a match function for this purpose, and suggests that, instead of a simple sum of squared picture element differences, an approach based upon the use of feature vectors (describing degree of eye closure, pupil dilation, width and depth of mouth, etc.) might be more successful.

Welsh *et al.* generated a feature codebook by sequential examination of an image sequence. The particular feature in the first frame is the first entry and the same feature in subsequent frames is also included if it differs from previous entries by more than a predetermined sum of absolute element differences. In a comparison with the FACS approach, they point out several disadvantages of the codebook method – the number of entries must be large to prevent obvious discontinuities in expression over the sequence, they must be transmitted to the receiver (and the code book searched), and feature tracking needs to be very accurate to avoid jitter in the displayed image.

It seems that there is reasonable agreement that the FACS scheme is superior to codebook and clip and paste schemes for facial expression coding and synthesis. Thus Choi *et al.* (1991) used the head motion parameters (HMPs) and facial expression parameters (FEPs) mentioned earlier to control the deformation of the underlying wire frame model which has been overlaid by the texture mapped first frame. Here the HMP control general head motion and the FEP facial expression in the same way as the AU in the

basic FACS system. Although no specific rates are quoted, their algorithm gives good results for a reasonable degree of translation, rotation and expression change, provided that care is taken to update the facial model originally derived from the first frame only.

11.6.5. Speech Input

Given that the human race does not communicate exclusively via mimed gestures, the major driving force behind the establishment of low-rate video-telephone systems has been enhancement of the basic information exchange mechanism – speech. The majority of significant facial expression changes are thus related to movements of the mouth in the course of speech generation, and it is natural to ask if analysis of the speech so produced could generate parameters which would animate the facial expressions directly, without an intervening stage of image analysis; indeed, this idea was advanced by Parke two decades ago (Parke, 1975). As far as direct application to image coding is concerned, work in this area is described by Morishima *et al.* (1989) . They suggested two approaches – rule-based synthesis and parameter-based synthesis, used with an underlying wire frame model which is set up as described previously (Aizawa *et al.*, 1989). In the first method, rules for the displacement of eight feature points on the model are derived from analysis of a training sequence which includes a speech phoneme component. There is a total of 17 different mouth shape categories, and control of the main feature points also extends to the subsidiary control of surrounding regions of cheek and jaw. With parameter-based synthesis, a joint codebook (5 bit, i.e. 32 entry) is generated by standard vector quantisation techniques from a long (over 1000 frames) training sequence which has both speech and image components, and the decoded speech signal is used to define the entries in the image section. Since speech recognition is an essential feature of the rule-based approach the latter method is preferred for low-rate communication. In a subsequent paper Morishima *et al.* (1990) tested a three layer neural network scheme for the speech/image mapping and found that more natural motion can be achieved. They also described a text to image conversion system in which the input is text or sentences entered via a keyboard to an analysis stage which generates the corresponding phonemes, and so can make use of the rule-based algorithm. Further details of the scheme can be found in Morishima and Harishima (1992). A very similar text/mouth expression system is described by Panis *et al.* (1992). Here the mouth is represented by 14 feature points and 12 areas of constant chrominance. A voice–text–phoneme conversion drives the animation via a look-up table.

A more basic approach is described briefly by Welsh *et al.* (1990b). Here a set of parameters which correlate with lip movements is extracted from the speech signal and is used to generate the corresponding AUs. The system is

designed to produce a 176 × 144 element image at up to 25 frames per second.

It is apparent that the successful development of robust and natural speech/facial expression conversion will find application in areas other than low-rate coding. Many problems still bar us from that realisation, however, not least the difficulty that changes in mouth geometry are not *necessarily* associated with the production of speech and indeed those that are often have an initial transient phase before any sound is uttered (Yau, 1989).

11.6.6. Combining Model-based and Waveform Coding

As an isolated coding technique, the model-based approach has some promise for transmitting very low-rate images of facial/head detail, largely because of the very constrained nature of this class of images (efficient coding using this method in the general case is a long way off). Most of the area of a typical picture of this type, of course, contains detail which is largely irrelevant to the kind of communication for which this approach to coding is intended (videotelephone) – the background, maybe the shoulder regions, etc.; in any case not requiring the rapidly changing subtle variations of the facial expression, and this can be coded by conventional methods. Again, there are parameters such as shape and colour which are derived in the course of the analysis operation and which have to be transmitted to the decoder at low rate. It is also possible to try to compensate for errors in the model-based coding by carrying out a synthesis operation at the transmitter, testing the acceptability of the result and then, if desired, generating an image which is the difference between the original and the reconstruction, to be sent, again in a conventional way, to the decoder for addition to the resynthesised image there. In the scheme of Yokayama *et al.* (1993) moving objects are detected in a locally decoded picture and motion-compensated prediction errors transmitted using transform coding.

In all these cases it is thus possible to employ a standard waveform coder in conjunction with the model-based scheme. Looked at in a slightly different way, model-based, or, to be more precise in this case, knowledge-based scene analysis can be used to define the various regions for which the different coding approaches are valid (Forchheimer and Kronander, 1989; see also Soryani and Clarke, 1989a,b).

As an example of waveform coding for parameter transmission Musmann *et al.* (in the scheme referred to earlier, 1989) used predictive coding techniques to code the motion parameters, a predictive contour coding algorithm for the shape parameters, and finally a motion-compensated hybrid/intraframe coder for the colour data (the use of such a motion compensated scheme of course necessitating the prior transmission of motion and shape). The decision as to whether to transmit motion and/or shape parameters is determined by the

analysis stage (motion is omitted for objects which are not described well by the source model, shape may be omitted for small objects, etc.). Colour parameters are transmitted using the motion-compensated hybrid scheme for normal objects, otherwise intraframe coding is used. In a $64\,\text{kb}\,\text{s}^{-1}$ 10 frame per second application, about 200 bits are used for motion parameters, 500 for shape and 5000 to update the colour information in each frame.

In an interesting development of model-based coding Fukuhara *et al.* (1990) initially used a variance measure to drive a hierarchical division of the wire frame model to represent more accurately regions with high levels of spatial activity. Thereafter each facet is divided into 16 triangles and the Y, C_b, C_r values at each of the 15 intersections defined as 15 dimensional vectors. These are subsequently normalised, and then coded and transmitted using vector quantisation.

The use of waveform coding as illustrated above to transmit motion, shape or colour parameters is an adjunct to the basic model-based algorithm. In the scheme of Nakaya *et al.* (1991) the waveform coder is an integral part of the active coding algorithm, and is used to code unmodelled regions and also to try to account for errors produced by the model-based coder. The facial region of the image is coded using the model-based technique; the shoulder area is taken to be a single object and motion-compensated/DCT hybrid coded, and the background coded using the waveform coder (motion compensation/DCT). There are three possibilities for coding the facial region: (a) model-based alone; (b) model-based plus error cancellation by using the hybrid coder based upon the decoded previous frame; and (c) as (b) but with hybrid coding based on the original first frame image. Results are interesting: using the MISSA sequence at 10 frames per second, at a transmission rate of $64\,\text{kb}\,\text{s}^{-1}$ error compensation has little effect and quality is better with model-based coding of the facial area since there are no block artefacts in that region and, because of the efficiency of the method, more bits can be allocated to the waveform coding of other regions. SNR is significantly worse, though, and this is caused by small deviations in head location which do not, in fact, affect the *look* of the reconstructed image. At $16\,\text{kb}\,\text{s}^{-1}$ motion-compensated hybrid coding is, on its own, very poor, and model-based coding of the face area provides the best result. The inclusion of error cancellation has a deleterious effect since there are not enough bits to perform this compensation operation on all blocks processed by the hybrid coder, and there are obvious discontinuities at the boundaries between blocks which have been corrected and those which have not. Nakaya *et al.*'s contribution in this case is valuable in that they show that combination of the techniques is not as straightforward as might at first sight be thought, and that numerical measures of quality of reproduction must be developed and interpreted with some care if they are intended to reflect the effect of knowledge/model-based processing schemes on image data.

11.6.7. General Comments

It is unlikely that anyone with a knowledge of the capabilities of "conventional" coding schemes could fail to be impressed (as indeed was the present author some years ago) when first shown a demonstration of model-based coding and then told of the associated data transmission rate necessary (a few kilobits per second). On closer inspection, however, the technique poses several major problems, particularly in the analysis stage. Nevertheless, we have recently seen significant advances in three-dimensional modelling and the associated reproduction of images via computer graphics, and there is little doubt that similar developments at the "front end" of the system will allow the fulfilment of its promise of becoming a major force in the very low-rate coding field (see Appendix 2) and in related areas of application (see Davidson, 1994). At the very least, its further development is not "shut-off" by those fundamental problems which seem to bar block-based algorithms from success in this area.

12

Image Transmission
and Error Control

12.1. INTRODUCTION

The algorithms described in the preceding chapters of this book all have the
objective of, in the words of the fundamental principle of picture coding,
"(re)presenting the original image or image sequence with the minimum
number of bits whilst preserving an acceptable level of reconstructed qual-
ity". For many active in the research field over the past decades, this in itself
has been the only aim, and algorithms are compared on this basis using
measures of mean square error, (peak) signal-to-noise ratio and also subjec-
tive (visual) quality, acknowledging the fact that it is difficult to do justice to
the latter via photographs of images on the screen of a monitor subsequently
reproduced through a printing process. In a practical context, however, the
compressed bitstream is of little use unless something is done with it, and
frequently this requirement imposes stringent limitations on the efficacy of
the algorithm as measured in the protective environment of the research
laboratory. There are basically two major effects in this context: (a) the fact
that, by its nature, the bitstream generated by an efficient image coder is
highly variable in rate, with the problems this brings in matching this rate to
the channel; and (b) the influence of errors on reconstructed picture quality

for, just as the coding mechanism changes, say, constant 8 bit per sample input data into variable rate output information, so it removes most of the natural redundancy which helps to protect reconstructed image quality against the effects of transient errors.

The interaction between these two fundamental factors influencing system performance is complex and application dependent. For still picture transmission and storage there is no real-time requirement beyond that to allow an image of the requisite quality to be transmitted in a reasonable time or stored in a suitably compact form. In the latter case error protection is straightforward, as it is also in the moving sequence case where dedicated low error digital links are available. This latter application, however, has a constraint upon frame transmission rate in order for the adequate portrayal of object motion to be possible. This, in turn, raises the question of the inefficiency of allocating a fixed bandwidth link to a source in terms of its internal peak output rate, when the average rate may be only a fraction of this. Again, new application areas are appearing in the very low-rate area, with requirements to transmit image data to moving vehicles over radio channels, for example, bringing back the problems associated with transmission errors. In this chapter we examine some of the approaches which have been taken to the general problem of how best to deal with the data after source coding, and make a broad division of the area into two sub-sections dealing with, respectively, (traditional) fixed rate, and more recently proposed asynchronous, systems of transmission.

12.2. FIXED RATE TRANSMISSION

Until recently, no form of image transmission was envisaged other than by the use of a fixed rate channel and indeed, where no compression algorithm is included in the signal chain from source to observer, this is entirely appropriate, since only fixed length digital words generated at a constant rate are involved. Inclusion of a coding operation alters this situation, however, since to transmit image sequence material efficiently it is necessary preferentially to code only significant interframe changes, and even in the case of still pictures prediction errors or transform coefficients, for example, will be quantised using a variety of different word lengths and subsequently variable length coded. Data is thus generated at a highly variable rate and the use of a fixed bandwidth transmission system without some kind of matching operation between source coder and channel quite inappropriate. This interface takes the form of a store, or buffer, which has the function of smoothing out the fluctuations in source coder output. The extremes of buffer capability in this respect are easy to define – with no buffer the channel must accept the peak rate offered by the coder, leaving it under-utilised for most of the time. In the

(theoretical) case of an infinite capacity buffer the channel need only have a capacity equal to the long-term average output rate of the coder. Unfortunately, in this case we shall also have to wait an infinite amount of time for any output to emerge! In the practical situation, then, compromises must be made, and there are two ways in which this can be done. First, measurements suggest that the relation between appropriate buffer size and a parameter such as channel rate, when parametrized by overflow probability, is not uniform. Thus break points occur where the buffer is (a) large enough to smooth data over a full picture frame and (b) where smoothing takes place (in the longer term) over the full extent of the significant motion of a large object. There is thus a trade-off involving useful buffer size, transmission delay and noticeable improvements in picture quality. Second, where this trade-off cannot be satisfactorily accomplished, more "brute-force" methods can be invoked, such as changing the quantiser stepsize or, in extreme cases, the use of data sub-sampling, as a function of buffer fullness (status), i.e. by feedback control, or of picture activity – feedforward control. The general situation is as shown in Figure 12.1. A good review of the basic considerations

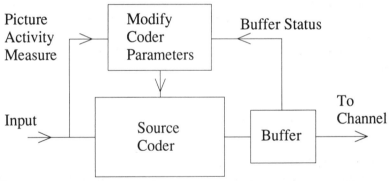

Figure 12.1 Control of output rate in a fixed capacity system.

involved is given by Limb (1972), in the context of a $2\,\mathrm{Mb\,s^{-1}}$ videotelephone simulation (248 elements \times 271 lines, 30 frames $\mathrm{s^{-1}}$, 2:1 interlace). Samples were coded as segments having above threshold levels of motion which are updated against a stationary background. The mean number of segments per line was approximately one and the maximum about eight, independent of sequence activity, whilst the mean number of elements in the moving areas changed from 18 to 75 with maxima of 119 and 224 (the whole line) as activity increased. Results indicated that, for medium activity data, maximum changes could be accommodated with a buffer size of about 15 kbit at an output rate of 400 bits line^{-1}. This represents the turning point of the curve, below which the buffer ceases to smooth data over a whole field, and above which the required capacity/output rate curve falls at a much lower rate.

Thus, moving to a rate of 500 bits line^{-1} allows buffer size to fall to about 5 kbit, whilst above this point a similar percentage rate change to 300 bits line^{-1} requires a buffer 50 times as large. For active data at this rate a 50 kbit buffer is required, and this halves the rate of the equivalent, unbuffered transmission.

As mentioned earlier, buffer feedback (see Figure 12.2) can be used to

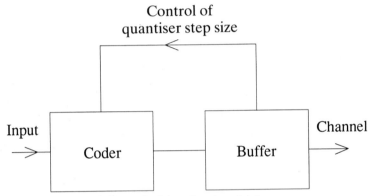

Figure 12.2 Control of data flow in a fixed rate system.

reduce the rate at which the buffer fills during periods of high activity by reducing the quantisation accuracy of values within the changed areas or by coding fewer samples (sub-sampling) in these regions. Overall the channel rate will reduce, and the extent of this reduction will be strongly influenced by the fraction of time for which operation in the lower resolution mode is found acceptable. Limb found it important, in keeping buffer size to a minimum, to be able to change mode (sub-sampled or not) at more frequent intervals than represented by the change from one frame to the next.

An alternative form of control is to determine the amount of data generated within a field and use this to initiate, if required, sub-sampling of the following field. In this case where the data activity is measured is of importance, since if based upon the sub-sampled data in one field, the next may not be sub-sampled, as a consquence of the reduction in data rate, and an oscillatory condition set up. Hysteresis can be built into the threshold settings for sub-sampling to prevent this, and this method may be combined with the buffer feedback approach to allow a more all-embracing control of rate for active sources together with control of peaks in data generation where the overall amount of activity is only moderate. Limb also proposes a further method of reducing buffer size by the use of data interleaving, since its rate of generation is highly non-uniform over the vertical extent of the picture. 4:1 interleaving (splitting each field into four equal depth horizontal bands and taking lines sequentially from the four) markedly changes the buffer size/rate relation in the (small buffer) region in which smoothing normally takes place

over less than one field (this is just the region in which the slope of the buffer size/rate relation is significantly reduced). For a medium activity sample, at a rate of 400 bits frame^{-1} the buffer size is reduced by a factor of 4–5.

Over the two decades since the work of Limb buffer status control of coding parameters (quantisation stepsize followed by data sub-sampling) has overwhelmingly remained the favoured technique for data rate control. It has recently been reinvestigated by Zdepski *et al.* (1991) who used it as a comparison by which to assess the advantage of employing conditional expectations of coding mode switching statistics in a fixed rate environment. They focus upon an adaptive intra/interframe scheme using a uniform quantiser which may have a central dead zone with threshold T followed by variable length coding. A coding mode is characterised by the triplet (sample density, T, number of quantisation levels), and eight modes were investigated, with values of $T = 0, 2, 4, 6$ and 8, where the first three values could be used in a direct coding mode to give the best image quality, whilst all five were available with vertical 2:1 line sub-sampling (with reconstruction by interpolation) to allow lower rate operation. Average rates could thus be varied from 18 down to 3 Mb s^{-1}. Statistical distributions were then obtained, over a series of 45 160 field sequences, of rate (bits per line), intermode conditional rates (i.e. the prediction of rate r_b in mode b, given that the present operation is in mode a at rate r_a) and intramode expectation (i.e. the probability of mode a having rate r_a^f over the next x lines if it had rate r_a^p over the previous y lines). These are then used in a comparison of three approaches to coder control. In the first, a simple control over coding mode is exercised by the buffer status level alone. In the second, a target is set for the output rate as a function of buffer content, and intermode statistics are used to select the new mode to which operation will be switched at the first available opportunity. In the third, intramode statistics are used to determine the best mode which will allow the maintenance of a constant probability of buffer overflow. Performance is characterised by the distribution of the operating time spent in each mode, better performance being indicated by more time being spent in higher quality modes (the optimum being $T = 0$, with no sub-sampling). Parameters are buffer size (0.25–2 Mbit), update interval (2–32 lines) and channel rate. For a 32 line update interval, buffer size was only of consequence if below 0.5 Mbit for the simple buffer control algorithm. For a 1 Mbit buffer, only the overflow probability algorithm was sensitive to update interval, performance increasing with this parameter. For this buffer and an update interval of 16 lines both statistics-based algorithms were better than the simple feedback loop control.

Statistical characterisation of data is also the basis of the algorithm of Ortega *et al.* (1990). In this case a hybrid-transform algorithm is employed, with coefficient scaling, quantisation and variable word length coding. Performance is defined in terms of a cost function which is partly based upon conditional frame to frame expectations of bit-rates. Thus there is typically a cost associated with basic image quality, one based upon buffer status, and

one upon subjective quality change, which latter might be weighted to ensure small changes in quality in television applications, for example. Alternatively, in a videotelephone application, the cost function relating to buffer status is most significant. Coder mode of operation is now optimally that which minimises overall cost. A more recent development of the buffer/quantiser rate control strategy is reported by Chen and Wong (1993).

The above discussion has given a brief review of techniques developed to ensure satisfactory image coder operation using a fixed rate channel. Such schemes are quite traditional in nature, and recently channel sharing by several coders, each with highly variable output rate, has been recognised as being an advantageous operating mechanism. Based upon the ATM, such schemes are considered in more detail later in this chapter.

12.2.1. Transmission Errors

As we have noted more than once before, efficient image compression schemes of necessity include, as a final stage of processing, a variable word length coding (VLC) operation – entropy or arithmetic coding (see Appendix 1) – which takes into account the different probabilities of occurrence of various data output levels, lengths of symbol runs, etc. The bitstream transmitted by the channel thus consists of words which can only be unambiguously decoded at the receiver if they correspond with members of the predetermined codetable. In such a situation transmission errors will have a potentially catastrophic effect upon the reconstructed image, and much effort has been expended over the past 15 years or so in the development of systems which attempt to minimise this problem. The situation is complicated by the fact that not all data may have the same degree of significance; typically coding/decoding control information (overhead) is most vital (paradoxically more so than the actual picture data!) and will need to be heavily protected. Then, in transform and sub-band schemes, for example, some spectral coefficients or frequency bands are of more importance than others – generally the loss or corruption of higher order terms matters less than that of D.C./low frequency information. Again, the effect of errors upon the decoded picture will differ with algorithm – simple predictive schemes have no natural error limiting capability, whilst transform schemes limit the effect of a coefficient value error to one particular block and, additionally, spread the effect of the error over that block (which may or may not be a good thing). If, following loss, resynchronisation takes place at some arbitrary following point in the scan, reconstructed data may be displaced within the image frame. The use of conventional forward error control can represent a not insignificant increase in the number of bits transmitted, and such a scheme needs to be designed, of course, for the worst case bit error rate (b.e.r.) and also maximum burst error length. In cases where bursts are common, data or bit interleaving will reduce

their effect, but increase the complexity of implementation. It is also possible dynamically to allocate bits between source and channel coding according to the channel error behaviour, and it is often the case that good error protection of a basically low quality coded image (few bits available for source coding) will give better results than those obtained by using more bits to give a higher quality picture and making the error protection correspondingly poorer. Such "source/channel" coding schemes have achieved some popularity and one or two implementations are described subsequently.

An alternative is to include (more or less) frequent unique synchronisation words in the transmission to enforce correction, but again this represents an increase in overall transmitted data. Thus, simple schemes may reset every line or group of lines, or blocks or, in applications which demand a high quality of reproduction, hybrid schemes may be used where every few samples fixed length PCM, instead of variable length coded, words represent the data. This naturally represents an extreme in the trade-off between picture quality and achievable compression.

It is, of course, possible to attempt to mitigate the effect of errors in reconstruction simply on the basis of an estimate of what the correct data should have been. Thus a few wrongly predicted samples may be replaced using some sort of interpolation or smoothing operation, and incorrectly decoded transform blocks may be subjected to boundary checking procedures (with respect to the edge data in neighbouring blocks) to adjust wrongly received transform coefficients and allow correct reconstruction. Such techniques may be useful (see later) if the error rate is not too large, but they cannot cope with major transmission problems.

As far as loss of synchronisation is concerned, some work has been carried out on the resynchronisation properties of variable length codes. Knee (1987), basing his work on that of Maxted and Robinson (1985), has shown that certain principles may be established which can lead to the design of codes with good error recovery properties. Briefly, the analysis proceeds by finding the expected resynchronisation time for a code following an error by prior determination of the transition probabilities for each ordered pair of decoded states, which are calculated by examining the effect of an error in each bit of each codeword. It is found that two design rules result in minimisation of the resynchronisation time: (a) short codewords should be suffixes of longer words; (b) bit reversal errors in codewords should produce other codewords. An example is given of coding the output of a 19 level quantiser intended for 34 Mb s^{-1} coding, and it is also pointed out that a somewhat suboptimal code with a set of word lengths different from those of the optimal (Huffman) design can offer substantial improvement.

More recently Cheng and Kingsbury (1992) have examined the problem of error resilient coding of locations and values of a sparse set of data samples – a common requirement in image coding. Their error resilient positional code (ERPC) is designed to carry out this process in an efficient manner which also

exhibits graceful, rather than catastrophic, breakdown performance as the channel error rate increases. It operates by dividing a total of N possible samples into blocks in such a way that each block contains, on average, only one sample which it desired to retain. Blocks are now classified as active or inactive according to whether or not they actually contain a retained sample or samples, and that sample (or the largest, if more than one exists in a given block) is coded in location and value in that block, to be followed by a terminating bit indicating whether or not there are more samples to be retained within the block. Given that the average block occupancy is one single retained value, some blocks will contain more than one of these and some none at all, and a second stage of the algorithm now tries to place "left-over" samples from blocks with more than one in the empty blocks. It is shown that a random search for an empty location gives better performance than directed search methods, and that performance in positional encoding is within about 0.5 bit of the entropy bound when the block size is a power of two. If this is not the case, a simple modification may be made. Overall, the technique has a positional coding efficiency comparable with that of the best of other known schemes but with the additional property of error resilience. This comes about as a consequence of the fact that most samples are coded in their default ("home") position, independent of other samples, and this is more likely for the larger and thus more significant samples in any case. The use of ERPC in a sub-band/VQ implementation is described subsequently. A later development is the error resilient entropy code (EREC, Redmill and Kingsbury, 1993) which operates upon data variable length coded into blocks which form prefix codes to allow unambiguous block decoding in the absence of transmission errors. In this case, in a similar manner to that governing ERPC coding, variable length words are assigned to a set of (usually) constant length slots. Bits left over from longer words are then placed in locations which contain complete words shorter than the slot length. Again, error resilience stems from the fact that decoding start locations are known and that important data preferentially occurs near the beginning of blocks and so is less likely to undergo error propagation when errors do occur. The application of such a scheme can result in significant improvement (around 10 dB in SNR) in the 0.1–0.3% b.e.r. region. Thus, Figure 12.3(a) shows a frame of CLAIRE coded at 0.5 bit element^{-1} with no errors, in Figure 12.3(b) the b.e.r. is 10^{-3} (random bit errors), in Figure 12.3(c) the EREC is included, as it is in Figure 12.3(d) where the b.e.r. is 10^{-2}. At this error rate the picture, without some form of error protection, would be completely unrecognisable.

12.2.2. Specific Implementations for Error Control

It was mentioned earlier that the specific effect of transmission errors is in general dependent upon the coding algorithm being employed. In this section

(a) (b)

(c) (d)

Figure 12.3 (a) The CLAIRE image coded at 0.5 bit element^{-1}, no errors. (b) As Figure 12.3a but at b.e.r. 0.1%. (c) As Figure 12.3b but with the inclusion of error resilient entropy coding (EREC). (d) As Figure 12.3c but at b.e.r. 1%.

we review one or two examples of error control techniques applied to the more popular coding schemes.

12.2.2.1. Predictive Coding

Predictive coding, simple to implement and providing good reconstructed quality at rates above maybe 1.5 bit element^{-1}, affords an excellent example of the somewhat curious trade-off between coding accuracy and reconstructed picture quality in the presence of channel errors. Modestino and Daut (1979) carried out experiments on two-dimensional predictive coding schemes in the

presence of channel noise in order to design an efficient and yet error resilient coder. Their results show the futility of providing fine quantiser resolution in an attempt to maintain reconstructed SNR. With a two-dimensional Gauss–Markov model of a typical scene, a Gaussian uniform quantiser and binary phase shift keying (BPSK) modulation over an AWGN channel, at channel SNRs of 20 dB and above a 5 bit quantiser gave an output SNR some 20 dB above that provided by 1 bit quantisation (26 dB). At a channel SNR of 10 dB the 5 bit quantiser SNR had dropped to some 25 dB *below* that of the 1 bit quantiser (still 26 dB). Furthermore, the performance was in all cases well away from the rate–distortion $[R(D)]$ bound (Stuller and Kurz, 1977). In a comparison, use of a rate 1/2 code and 2 bit quantisation allowed the error free SNR (32 dB) to be maintained down to a channel SNR of 5 dB, at which point the operating point was approximately 3 dB away from the $R(D)$ bound. It was shown that this behaviour is dependent upon applying some error protection to all transmitted bits, protecting the most significant bit (MSB) alone being of little use. In general the conclusion is that source/channel coding is an effective way of maintaining performance of a predictive scheme in the presence of high channel error rates by preferentially allocating the spare bandwidth obtained by reducing quantisation accuracy to the provision of error protection.

More recently predictive coding has been used as an example to demonstrate how residual redundancy in the output of the source coder can be used to provide error protection. The basic premise of Sayood and Borkenhagen (1991) is that redundancy in the output (due to the quantisation process, or the fact that real data is non-stationary whilst the design is usually based upon its being otherwise) indicates that certain codeword-to-codeword transitions will be more likely than others. The decoder can then be designed to maximise the probability of making a correct detection, i.e. that the transmitted symbol at time i, θ_i, is the optimum value α_j given knowledge of the previously transmitted symbol $\Theta_{i-1} = \alpha_m$ and of the presently detected (corrupted) symbol $\hat{\theta}_i = \alpha_n$. This can be done on the basis of channel statistics, $P[\Theta_i = \alpha_j / \hat{\Theta}_i = \alpha_n]$ and of source and coder statistics $P[\Theta_i = \alpha_j / \hat{\Theta}_{i-1} = \alpha_m]$ over the source coder output alphabet, the former assuming say, a binary symmetric channel, the latter using a training sequence. With a 3 bit quantiser, performance improves by 6–8 dB for error rates between roughly 1 and 10% [note that the authors' definition of SNR is not in accord with that conventionally used for image data (PSNR) and that their actual values are artificially low – the above relative figures for improvement are unaffected, of course].

Overall performance can be improved still further by reoptimising the predictor in the manner of Chang and Donaldson (1972). This brings the one step prediction coefficient down from 0.97 to 0.78, a move which in itself will bring significant error effect limitation (and also adversely affect the coding performance).

12.2.2.2. Transform Coding

The previous section reviewed the way in which joint source/channel coding can be used to optimise the performance of a predictive scheme in the presence of transmission errors. For reasons which it would be tiresome to reiterate, transform schemes are of more immediate interest, and much work has been reported on their use in an error-prone environment. Modestino *et al.* (1981b) repeated the predictive study mentioned above using a two-dimensional DCT implementation. The same basic results are apparent – coding at 2.5 bits element^{-1} produces an output SNR of about 30 dB as long as the channel SNR is above 20 dB. By the time this has fallen to 10 dB the output SNR is approximately 0 dB, at which point a 1/2 bit element^{-1} implementation is still maintaining an output SNR of around 15 dB. Again all results are well away from the rate bound. The inclusion of a trade-off between quantisation accuracy and convolutional error-control coding allows performance to be increased in much the same way as with the predictive scheme. In this case there is the additional flexibility of providing selective error protection to those transform coefficients with the largest energies, or to the most significant bits of the coefficient set overall. In this way performance can be maintained at much lower channel SNRs and to a point much closer to the rate bound. Some years later Brewster and Dodgson (1988) investigated the problem again and arrived at broadly the same conclusions regarding coding at a low rate and the employment of convolutional coding, seemingly unaware of Modestino's earlier work.

More recently further interest has been shown in joint source/channel coding schemes to mitigate the effects of transmission errors. Vaishampayan and Farvardin (1990) considered the problem of optimising (minimising) the overall mean square error over a noisy channel given a constraint upon average transmission rate and showed that the problem may be divided into two components. The first consists of the design of an encoder/decoder pair, where the encoder implements a mapping from the transform coefficient array to binary codewords for channel input via an N level scalar quantiser and subsequent codeword assignment, and the decoder (re)maps the channel output symbols into the reconstruction level set. The second part is an optimal bit allocation operation which here uses a steepest descent algorithm with a constraint upon the maximum number of bits which can be allocated to each coefficient. The system has the same basic outline as more conventional source coder/decoder pairs (Clarke, 1985a) but the bit allocation process now depends upon the channel transition probabilities as well. Results are given for a separable two-dimensional Gauss–Markov model based upon measured image parameters of correlation and variance, a reference model using conventional quantisation assuming a Gaussian source and the distortion–rate $[D(R)]$ relation for the assumed model and the given rate. Not surprisingly there are wide divergences between the figures and results are well away from

the rate bound for values of bit error rate of 1% and higher. More seriously, the two-dimensional Gauss–Markov figures predict performance gains over the non-optimised system which are just not realised in practice (4 dB instead of about 9.5 for a head and shoulders image with block size 8×8 at a rate of 1 bit element^{-1} with b.e.r. 1%) and the authors (correctly) surmise that inappropriate modelling of the source is the problem. This is certainly the case, not least because of their assumption that "... since the source is assumed to be Gaussian, each of the transform coefficients is also Gaussian"! (for an examination of the application of image models to transform coding see Clarke, 1984b). Their study does reinforce one point noted earlier, however, and that is that operation over a noisy channel requires fewer quantisation levels than does the noise-free case and so leads to simpler implementation. Operation over a widely varying range of b.e.r., though, still compromises the performance obtainable from an optimal design for a noise-free channel in just the same way that Modestino's earlier figures indicate.

Fazel and Huillier (1990) implemented a combined scheme which has both an equal error protection (EEP) and an unequal error protection (UEP) component. The former depends upon the nature of the channel impairment (random/burst errors) and employs BCH or RS coding; the latter is designed to take into account the fact that bit errors in the source coded output have very different influences upon the reconstructed picture quality depending on their individual location. Thus the amount of protection allocated to different bits will vary, and will be such that, under optimum conditions, all bits subsequently contribute equally to impairment [allocating different BCH codes in this way to different bit levels can also be applied to sub-band coding, see Boekee *et al.* (1990)]. The scheme of Perkins and Lookabaugh (1990) jointly optimises the quantiser/signal constellation pair for each transform coefficient to be transmitted over an AWGN channel. Comparison is carried out between the optimised coder and a basic coder using Max quantisers designed for a Gamma distribution (full marks!), with a bit allocation algorithm that maximises the marginal reduction in mean square error achieved by sequentially allocating the next available bit (see Clarke, 1985a) and with a JPEG coder which incorporates mechanisms to check for loss of synchronisation. The optimised coder itself is similar to the basic one except that the mean square error measure D is now dependent upon the number of signalling dimensions n_d and SNR, i.e. $D = D(n_d, \text{SNR})$. The optimal quantiser/constellation pair is now that which minimises D, and the marginal allocation algorithm now operates by allocating signalling dimensions rather than bits. Performance gains are substantial in the 10^{-3}–10^{-2} b.e.r. region where the performance of the JPEG algorithm is quite unsatisfactory. Finally, although joint source/channel coding is a favoured option other approaches are available, and we note that Redmill and Kingsbury have applied their EREC (described in Section 12.2.1) to an H261 structured coder and achieved useful gains in PSNR (> 6 dB) over the b.e.r. range 0.01–1%.

It is, of course, possible to design "receiver only" techniques to implement an error correction operation. Thus Mitchell and Tabatabai (1981) developed a block boundary checking algorithm which attempts to determine which coefficient is in error following which the corresponding basis picture (Clarke, 1985a) can be removed from the block. Useful improvements in picture quality and reduction in mean square error are achieved at an error rate of around 1%, even though at this rate there are on average 2.5 errors per 16 × 16 block. Boch (1990) developed block boundary checking algorithms in order to try to mitigate transmission error effects. Figure 12.4(a) shows an original frame of MISSA and Figure 12.4(b) a corresponding heavily corrupted version. Testing the accumulated absolute values of elements in a difference sub-block with those of neighbouring sub-blocks gives the result of Figure 12.4(c), whilst a test for abnormally large values of high order transform coefficients produces the picture of Figure 12.4(d). Combining the last two tests results in the picture in Figure 12.4(e), which is in many other cases very successful also. In each instance, correction takes the form of replacement of the corrupted block by the equivalent one in the previous frame. It remains a problem with this approach, however, that the error detection algorithm will occasionally indicate blocks as being in error when they are in fact correct, and only contain some peculiarity of luminance detail.

12.2.2.3. Sub-band Coding

Here we examine two detailed investigations into the transmission over noisy channels of, respectively, still picture and video data. Tanabe and Farvardin (1992) developed two entropy coded sub-band schemes based upon the original Woods and O'Neil (1986) regular two-dimensional separable QMF 16 band split. These employed memoryless quantisation for all bands other than the "low–low" band which was coded either using three previous element two-dimensional predictive coding or 4 × 4 two-dimensional transform coding. The paper gives a good resumé of the properties of the sub-bands so produced – the "low–low" band contains over 95% of the total picture energy, with finite mean equal to that of the original and similar correlation coefficients; all other bands have mean approximately zero, energy small and variable (depending, of course, upon picture content) but generally decreasing as band order increases, and insignificant values of correlation coefficient. The generalised Gaussian distribution (Clarke, 1985a) was used to characterise the sub-band coefficient distributions for the purpose of quantisation and in each case [higher sub-bands, "low–low" band prediction residuals (errors) or transform coefficients] symmetric uniform threshold quantisers (equispaced decision levels and reconstruction levels the quantisation interval centroids) with associated Huffman codes were matched to the appropriate generalised Gaussian distribution shape parameter. This latter is 0.7 for higher sub-bands, 0.6

(a)

(b)

(c)

(d)

(e)

for the prediction error and the 4×4 DCT coefficients and 2 for the Gaussian approximation to the D.C. coefficient. Bit allocation follows the general principle of dependence upon coefficient variance (Clarke, 1985a pp. 177–178) but now no longer needs to be approximated since the distortion–rate relations for each case are known explicitly. The algorithm follows that of Shoham and Gersho (1988). For an 8 bit 512×512 image both schemes showed an improvement over the original algorithm of Woods and O'Neil, with DCT coding of the "low–low" band giving a numerically slight, but subjectively greater, benefit at the lowest rate (0.25 bit element^{-1}). No improvement was gained by increasing DCT block size. Both schemes showed extreme sensitivity to transmission errors (with the predictive scheme worse than the DCT for coding the "low–low" band), whereas the Woods and O'Neil scheme was much more error-resistant. To improve performance in this respect, source/channel coding was implemented. As a first step codeword sequences were collected into packets to limit error propagation. These have a fixed length "length" word followed by a variable length sequence of binary codewords (average 1024 bits). Bit allocation now depends upon the error incurred in source coding *and* channel transmission (assuming a binary symmetric channel with given b.e.r.) via distortion–rate evaluation of a quantiser/ Huffman coder pair after inclusion of a selected error correcting code. The latter was chosen from a set of rate-compatible punctured convolutional codes (Hagenauer, 1988), which have the advantage that alteration in rate is simple. Results were considerably improved compared with those of the original schemes, again with better performance given by the scheme involving transform coding, which also showed better resilience to mismatch between actual channel b.e.r. and that for which the coder was designed.

Although it is not so far possible actually to indulge in James Bond style video communication via matchbox-sized videotelephones strapped to our wrists whilst being driven around exotic locations in luxurious cars, Stedman *et al.* (1993) have shown that we are in fact well on the way to an ability to do just that! They describe a motion-compensated ten/seven sub-band scheme error protected by BCH codes and using 16 level quadrature-amplitude modulation (QAM) for transmission. Motion compensation is carried out using 16×16 blocks up to a displacement of ± 7 elements horizontally and vertically using the reduced search block matching algorithm of Jain and Jain (1981). Non-uniform sub-band splitting then initially yields a 10 band structure as shown in Figure 12.5.

For low rate transmission the three highest frequency bands can be ignored

Figure 12.4 (a) The original MISSA image. (b) A version of Figure 12.4a, heavily corrupted with coefficient errors for test purposes. (c) Block boundary checking via testing of accumulated absolute values of element differences. (d) As Figure 12.4c but employing a test for abnormally high values of high order transform coefficients. (e) Result of combining the tests of Figures 12.4c and d.

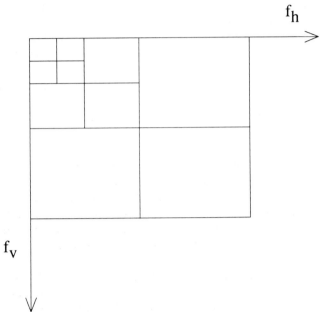

Figure 12.5 Ten band subdivision of Stedman *et al.* (1993).

(equivalent to 2:1 sub-sampling horizontally and vertically of the original 320 × 256 image). Coefficients are scanned horizontally, vertically or in zig-zag fashion depending upon the degree of horizontal, vertical or diagonal frequency information which the sub-bands contain, and quantised using a uniform quantiser with a dead zone and positive and negative peak clipping. Scanned outputs are run length coded, with an end of line (EOL) word which gives a measure of error protection. Output rate is inherently variable, of course, and control is exercised by varying the quantisation dead zone dependent upon buffer status. Overall error protection is provided by the inclusion of 63 bit binary BCH codes, and the datastream is split into two components, motion vectors and low frequency band coefficients, and those remaining. The former uses a channel with a higher degree of protection, which eliminates the error problem for a channel SNR of around 20 dB, where the latter has a residual b.e.r. of about 10^{-3}. To cope with lower channel SNR protection can be applied to this channel also. Overall the system allows transmission at 22 kBd of 320 × 256 frames at $10\,s^{-1}$ at channel SNRs greater than 16/18 dB. Reduction of image resolution to QCIF allows operation at 7 kBd.

12.2.2.4. *Vector Quantisation*

The reader will recall that VQ operates by the division of the input data into

small (usually 4 × 4) blocks. They are tested against a local set of representative codevectors to find the best match and the transmission of a corresponding index which will allow the selection and display of the same codevector (block) extracted from a copy of the codebook held at the receiver. Transmission errors thus have a somewhat different effect than is the case for the schemes discussed earlier. In the usual situation, the codebook, after generation at the coder, is passed off-line to the receiver, and can thus be assumed to be error free. An error in transmission may then affect the index, causing the wrong representative block to be selected and displayed, or the overhead information, causing coding parameters (mean, standard deviation, etc., in the case of gain/shape or other variants of VQ), to be wrongly decoded. In the case of adaptive VQ, the codebook updates are carried out in real time and so in this case the codevectors themselves may be received incorrectly. Even if index and scale parameters are subsequently transmitted correctly, each time the codevector in error is selected, decoding artefacts will be present and this will be the case until, for example, a new codebook update removes the faulty block.

As far as code index errors are concerned, it is sensible to arrange the codebook such that single bit errors, for example, cause minimum change in the codebook vector pattern. This can be done by arranging the mappings from codeword to codevector so that such a (random) error results in minimum average shift between vectors in the codevector space. Kingsbury *et al.* (1989) did this by sequentially combining codevectors in pairs, squares, cubes and so on, in the vector hyperspace and attempting to arrive at a minimum overall separation at each stage. Results were significantly better (at 1% b.e.r.) than random assignment of codewords to codevectors but the gain over an LBG designed codebook using the splitting algorithm was smaller. Farvardin (1990) has considered the application of the simulated annealing technique to the assignment of codewords to codevectors, and his paper also gives a useful description of the simulated annealing technique itself. In the case of the noisy channel the cost function to be minimised includes information on the channel error properties which, in the practical case, may need to include the effects of unequal error protection via error control coding (most protection given to the most significant bit). Results substantiate those given earlier – that although the optimised algorithm is quite a bit better than the random assignment, the splitting/LBG algorithm is almost always within 1 dB of optimum in any case. In the case of the noisy channel the channel optimised VQ shows better performance at high b.e.r. (>1%). As usual, one trades degradation in performance at low values of b.e.r. for more robust performance in this region. The channel-optimised scheme is described further by Farvardin and Vaishampayan (1991). With a Gauss–Markov source model ($\rho = 0.9$) at a rate of 1 bit sample^{-1} channel-optimised VQ is superior to the (noiseless) LBG algorithm once b.e.r. rises above about 1%. In this region also, the number of active coding regions is lower than the

actual codebook size. Thus for vector dimension eight, at a b.e.r. of 5% only about 40% of the coding regions are active, and coding complexity is reduced.

Nowadays, of course, interest is centred on more sophisticated transmission schemes than binary symmetric channels, and Woerz and Perkins (1990) have compared a wide range of possible coding/transmission implementations for a 4 × 4 VQ scheme using 16 codevectors for 512 × 512 8 bit images with a reference scheme using quaternary phase-shift keying (QPSK) and maximum-likelihood detection. Techniques included Hamming and convolutional coding, maximum-likelihood and maximum *a posteriori* detection, and soft and hard decision Viterbi decoding, and also the use of simulated annealing to assign vectors so as to minimise the effect of errors resulting from incorrect receipt of transmitted bits, followed by application of a modified LBG algorithm to optimise the codebook. Best performance at high error rate was achieved through the use of convolutional coding and soft decision decoding, although it is conjectured that Hamming coding associated with simulated annealing based vector assignment could have produced better results, as would the inclusion of symbol interleaving in the convolutional coding case.

VQ has often been used, of course, in conjunction with other coding schemes to provide a further (post-processing) stage in transform or sub-band coders. Alparone *et al.* (1990) considered a DCT/VQ scheme operating over a binary PSK channel in the presence of AWGN, in cases where transmission errors may affect correct receipt of codevector indices, actual codevectors (the codebook) or both. Here good performance at low channel SNR is achieved by using a Hamming (31,26) code and soft decision decoding. Unfortunately the authors have made comparison with other results impossible by basing their SNR definition on signal variance instead of peak energy. Their values therefore appear artificially low compared with what otherwise might be expected. Rosebrock and Besslich (1992) used a modified LBG algorithm in which the distortion measure incorporates the channel transition probabilities to design a gain/shape VQ for 8 × 8 blocks of DCT coefficients. The adaptive transform coder has 13 possible classes, most dependent upon directional activity. The D.C. coefficient is scalar quantised with 8 bits and vectors consist of subsets of the remaining coefficients, selected on the basis of a Gaussian (i.e. worst case) $R(D)$ measure. Transmission is via a memoryless binary symmetric channel (BSC) at 1% b.e.r. Some 3 dB of improvement can be achieved over a conventional design at the cost of (as usual) poorer performance in the noise-free case. The ERPC of Cheng and Kingsbury (1992) described earlier has been employed in a filter-bank SBC/VQ scheme, where, as in Rosenbrock's transform coder, vectors are made up of sub-band coefficients corresponding to different orientations of image activity. The 25% most active vectors are coded in location using the ERPC, and quantised using a gain/shape scheme with 4 bits for gain and 7 for shape for the lower order terms, and 3 and 8, respectively, for higher order coefficients. Using a

31 frame 6 bit 128 × 128 element intraframe coded image sequence (CLAIRE), performance was better (in terms of average SNR and visual quality) at 1% b.e.r. with the ERPC at 0.55 bit element^{-1} than it was for positional coordinate coding of the coefficients at 0.77 bit element^{-1}.

Finally, we might note that "decoder only" error control techniques have the advantage that their operation is independent of the way in which the initial error occurred (at least for moderate b.e.r.). A test is carried out to determine whether or not a block is in error (by comparison of selected parameters with those of neighbouring blocks – as in Boch's transform scheme described in Section 12.2.2.2) and then interpolation is used to reconstruct the block detail; since VQ is usually carried out using a small block size (4 × 4) this can be quite successful, and Chua *et al.* (1990) describe such a scheme. Here classified gain/shape VQ is used, and blocks are tested for continuity of class, mean, standard deviation and boundary vector element continuity. The erroneous block is then reconstructed by averaging or element replacement across the boundary. At a b.e.r. of 1% an improvement of about 6 dB in SNR is obtained (note that the authors base their SNR definition upon signal mean square, and not peak, energy, although this does not affect the size of the increase achieved; also that their statement that the improvement corresponds to a *factor* of 0.0013 in normalised mean square error is not only incorrect but meaningless – this value should be four, and it is unsatisfactory that the paper's reviewers should have let such an elementary confusion pass). Picture quality is visually improved but, as in the case of transform coding, at high error rates there are occasional problems with such schemes in that they sometimes fail to correct blocks in error which are immediately apparent to the eye.

12.2.2.5. General Comments

It is obvious that considerable ingenuity has been exercised by researchers in the quest for efficient error protection schemes for "fragile", highly compressed image data. Whilst the transmission quality of digital links is constantly being improved, and many important services use links with very small and controlled error rates in any case, all the time new areas of interest are evolving which will make use of such techniques. Thus asynchronous transmission, to be considered subsequently, can make use of error concealment mechanisms to mitigate the effect of lost data, whilst in the case of very lowrate systems, the desire for image transmission services to be provided over radio links and the PSTN, for example will, if anything, see activity in the area of error protection/correction intensify over the coming years.

12.3. VARIABLE RATE TRANSMISSION

12.3.1. Introduction

It is apparent that a logical approach to information communication is to convert the input data into a digital bitstream, decide upon a suitable transmission rate, and then select a channel having the corresponding (fixed) capacity. With sources which have the nature of data files this is straightforward and with constant word length transmission at a constant rate, the channel may be utilised to the maximum degree. In such circumstances all parameters can be predetermined, adequate protection against channel errors built-in, and nothing left to chance. As we have seen above, however, where we wish to communicate using compression techniques (especially when applied to speech or video) the situation is not so simple. Throughout this volume it has been emphasised that there are definite advantages to be achieved by the use of adaptive techniques in image coding – variable word length coding of prediction errors or of transform coefficient amplitudes, replenishment of only those areas undergoing significant motion, etc. In such cases the rate at which data appears at the output of the coder is highly variable, and measures are necessary to match the bitstream fluctuations to the fixed rate of the channel. Short-term variations can be absorbed by the use of a buffer between the coder output and the channel, but this is only satisfactory up to a point, especially as it turns out that, particularly with videotelephone/conference applications, fluctuations, once initiated, tend to last over a period of several frames. There is, moreover, the matter of whether the delay introduced can be accommodated in an interactive, real-time situation. Beyond this, more drastic measures are needed. Adaptive frame skipping can be carried out, but the most common method is to use a signal derived from the buffer status to control the quantisation process, specifically, the quantiser stepsize, as shown in Figure 12.2. In any case the outcome is, almost inevitably, a drop in reconstructed picture quality at times of significant detail change (due to motion or other factors) in the picture.

With the proliferation of new network services, however, it became apparent in the second half of the 1980s that the isolated (circuit) switching of separate coded video sources onto predetermined fixed bandwidth channels was not the only transmission possibility. At that time the CCITT had under consideration the technique of asynchronous time division (ATD), later to be renamed asynchronous transfer mode (ATM), as that which would underpin the integration of services into B-ISDN (Tabatabai, 1993; see also Popple and Glen, 1994). This would remove the restriction on the use of fixed rate transmission and allow quality to be maintained by letting the bandwidth change in sympathy with the coder output rate. In addition, by allowing several sources simultaneous access to the channel advantage could be taken

of the statistical properties of the various rates of the (presumably uncorre-lated) inputs to achieve a gain in performance through statistical multiplex [thus Kishino *et al.* (1989) found, for example, that the standard deviation of the bit-rate distribution is inversely proportional to the square root of the number of channels – a result familiar from signal averaging theory]. On the other hand data would be transmitted in fixed size packets (cells), and cell loss would result in the disappearance of several hundred data bits, with poten-tially catastrophic effects as far as synchronisation and reconstructed picture quality were concerned. Such problems notwithstanding, the topic of VBR transmission has provided a rich field for coding research over the past 7 years or so and this seems well set to continue. For a general text in this area see Ohta (1994).

12.3.2. Basic Ideas

Despite its relatively short lifespan to date packet video, as it is colloquially called, has already attracted an extensive literature, including at least two special issues of *IEEE Transactions*. Good introductory references are Verbiest (1987, 1988), Verbiest *et al.* (1988), IEE (1989), Morrison (1990), and to ATM in general, Lane (1994). Pearson (1990a) gives an excellent concise non-mathematical review and Karlsson and Vetterli (1989b) discuss in detail the relationship between packet video and the associated network architecture. "Where we were" in mid 1993 is briefly reviewed by Tabatabai (1993).

In distinction to the fixed bit-rate approach, the variable bit-rate method dispenses with the buffer (a certain amount of buffering is still needed how-ever, see later) and the rate control feedback loop, and in principle offers the user selectable image quality (or rather control over the quality /transmission cost trade-off). It is still necessary, of course, for some rate management (or network "policing") to be carried out. Corrective action will be needed in cases where the source parameters diverge from those presented during the call set-up procedure, and may take the form of cell dropping or, in extreme cases, call interruption (Verbiest *et al.*, 1988). The typical situation envisaged is one where a channel capable of supporting a much higher (fixed) bit-rate than that produced by a single variable rate coder accepts input from a large number of low-rate sources, with statistical multiplexing operating to make best use of the relationship between individual coder mean output rate and its variability and the allowable overload probability. Typical figures for such a set-up are given subsequently. This method of operation relies, of course, upon a good knowledge of the parameters defining the fluctuating bitstream generated by an individual coder and this has led to a resurgence in experi-mental measurements of image sequence data properties, otherwise neg-lected for many years.

As far as sources of degradation are concerned, there are three: packet delay, packet delay jitter and outright packet loss. Overall delay may or may not be a problem in all circumstances (excessive delay may render a packet useless, even if it eventually does arrive), but jitter makes synchronisation more problematic if the system clock is derived from timing data within the packet stream and loss can result in the complete breakdown of decoding. Various approaches have been developed to deal with these defects and are described below. One in particular, which has been intensively studied since the inception of VBR techniques, is "layered" coding. In this case a hierarchical approach is taken, with low resolution image information and other essential data being coded and transmitted on a "guaranteed" channel (possibly of fixed rate) and high resolution or coding error information being conveyed on another "enhancement" channel for which packet arrival is not guaranteed and which, indeed, is designed to operate under conditions of high loss rate.

The general relationship between rate and picture quality can be portrayed in a number of ways. Pearson graphically illustrates this (note that his Figure 4 is mislabelled) with a diagram of the form of Figure 12.6 where (a) represents fixed and (b) variable bit-rate systems. Whenever object motion increases the quality will fall in a fixed rate system (to the extent that the system could be allowed spare capacity to accommodate such eventualities this capacity is idle for most of the time and thus a source of inefficiency), whereas in a VBR system this will be taken into account by a rise in transmission rate maintaining, if the system is correctly designed, reconstructed picture quality. A rate distortion (Berger, 1971; Clarke, 1985a) portrayal, Figure 12.7 (see Verbiest et al., 1988; Maglaris et al., 1988), illustrates the difference by displacement of the "operating point" parallel either to the rate or distortion axis as the degree of activity of the video sequence varies.

Naturally the development of VBR image coding systems would not be viable without the availability of the associated network to support data transmission. This relation is considered in detail by Karlsson and Vetterli (1989b). They make the point that, in contrast to fixed bit-rate (FBR), circuit switched systems, it is not possible to isolate network, coder and decoder. Network capacity as presented to the coder varies depending on total network load, and receiver/network interaction needs to occur when, for example, packets are lost. The OSI model is used as the basis for their discussion. In this the top four layers reside with the customer, the lower layers within the network. Layer one, the application layer, interfaces with the analogue source (the video camera) and output (the monitor), provides analogue to digital and digital to analogue conversion and has control over information format. Layer two, the presentation layer, is responsible for compression proper, error recovery (adding synchronisation flags to the bitstream to limit error propagation, for example), and resynchronisation. Layer three, the session layer, deals with session control – set-up, cost/quality trade-off via decisions regarding just which signals in a hierarchical coding operation are to

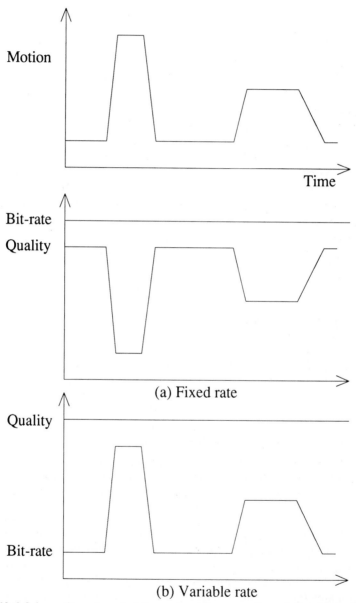

Figure 12.6 Schematic portrayal of the motion/picture quality relationship in fixed and variable bit-rate systems (not to scale).

be sent, and multiplex. Layer four, the transport layer, controls the formation of packets, error control coding, and lost packet detection at the receiver, etc. The lower layers – network, data link and physical link – can, the authors

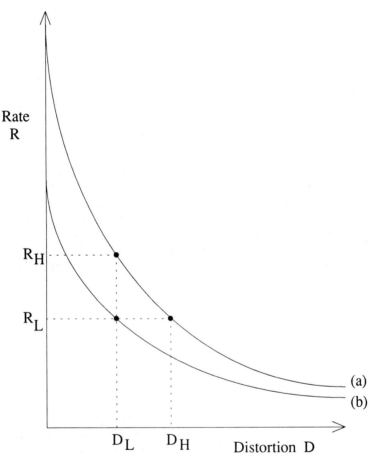

Figure 12.7 Rate–distortion portrayal of fixed and variable bit-rate systems: (a) large
degree of motion; (b) small degree of motion. Original operating point is (R_L, D_L),
moving to (R_L, D_H) or (R_H, D_L), for fixed and variable rate systems, respectively.

suggest, be designed to support real-time transmission without reference to
the exact nature of the signals to be sent. Thus the function of the network is
to act as a "real-time packet pipe" where packets inserted at one end emerge
in order at the other, some with errors, however, and some lost. The network
layer insulates the four higher layers from the physical transfer process and
deals with routing and congestion control, the latter via transmission pri-
orities. The authors' preferred compression technique is sub-band coding,
which will be described subsequently. However, their mapping of a general
VBR scheme onto a notional OSI model serves, at this point, to demonstrate
the major considerations which need to be addressed in moving to a practical
wide-scale application of packet video transmission.

12.3.3. Data Statistics

Acknowledging that improvement in transmission efficiency could be possible through the multiplexing of several variable rate sources onto a single channel, much work has been done in the past few years on the experimental statistical characterisation of the video source, and on the development of theoretical models which reflect data properties and can be used to guide system design. Probably the best introduction to this area, however, dates from much earlier in the reporting by Haskell (1972) of experiments in channel sharing carried out in connection with the "Picturephone" system, which used a conditional replenishment coder operating at about $2\,\mathrm{Mb\,s}^{-1}$, with 271 lines per picture at 30 frames per second. Long-term average measurements were made of two parameters directly relevant to transmitted bit-rate – the distribution of the number of element changes per field and the number of clusters of changed elements which need to be sent (and so addressed). It was found that the plot of the probability of the number of changes n' per field exceeding some value n as a function of n was closely exponential, following the relation:

$$P(n' \geqslant n) = e^{-\lambda n} \tag{12.1}$$

with $\lambda = 4 \times 10^{-4}$, where the number of elements per field $= 27\,000$. This distribution had a mean of 2500 and the same value of standard deviation. Seventy per cent of the data related to insignificant amounts of motion (less than 11% of the picture changing), 24% to significant motion (11–25% picture change) and the remaining 6% to violent motion (more than 25% picture change). Haskell points out that the large change in fractional motion in the output of a single source (from almost none to almost all of a frame or frames) is one factor which leads to buffering problems in constant rate systems. Another stems from the large value of temporal autocorrelation function typical of videotelephone/videoconference scenes, basically exponential (see later) and still above 0.5 for a separation of 60 fields (1 s). Whilst this property, of course, makes interframe prediction efficient for such sources, it does mean that peaks in data rate, although relatively infrequent, tend to last for several fields when they do take place.

Haskell's data show an approximately linear relationship between fractional field change and duration in fields which can be approximated by

$$D = 26\,(1 - 1.1\,T), \tag{12.2}$$

where D is the peak duration in fields and T the fractional change in elements in the field over the range 0.2–0.75. Thus a 20% field change lasts, on average, about 20 fields whilst a 75% change lasts for five fields. The author points out that, in fact, significant changes can last for a few seconds (the above figures are averages) which makes adequate buffering impossible

because of the delay introduced. The application of Haskell's simple exponential model to the multiplex situation will be noted subsequently.

Ghanbari and Pearson (1988, 1989) reported experiments carried out on both television and videoconference sequences to assess the long-term statistics of such different kinds of video sources. They recorded 48 frame sequences every 6 min during a total of 72 h of off-air UK television (ITV) reception, reducing random noise by simple spatio/temporal averaging within single pictures. Results were obtained for individual frame and 48 frame sequence mean bit-rates for coding of the data using a conditional replenishment structure (as in Haskell's experiments). The long-term mean rate was found to be 50 kbit frame^{-1}, with one and 48 frame mean peaks of about 240 and 200 kbit, respectively. Corresponding peak/mean ratios are approximately 4.8 and 4, with the one frame mean to long-term mean ratio being greater than 4.2 for 0.1% of the time; this, together with the closeness of the 48 frame mean to that of a single frame, substantiating Haskell's finding that peaks last for relatively long periods. In addition, the results show that even 48 frame buffering (about 2 s of transmission) will leave substantial variations in bit-rate (although this might be tolerable in a broadcast application, it would certainly not be so for any interactive system – inter-personal communication, for example).

For the videoconference experiments two 36 frame sequences were used (TREVOR and "SPLIT SCREEN", the latter a multiple window image containing a typical videoconference scene). Luminance resolution was 336 × 288 and chrominance resolution half of this. Two different conditional replenishment coders were used, one employing predictive and the other transform coding for the moving areas, for which results were found to be broadly similar. For the luminance signal, peak-to-mean ratios decline quite rapidly with buffer size up to the point where the latter is approximately 10% of a frame (roughly the point at which the buffer is storing, and thus smoothing, data from more than one significant picture area). Thereafter a proportionally much larger buffer is needed to produce a worthwhile reduction in peak/mean ratio. At a buffer size of one frame, this value is around 1.2–1.5 for the luminance signal (the chrominance signal shows both larger values and variability, but since the chrominance data rate is typically only 10% of the total this is not of major consequence), the difference between these values and those obtained for the television sequences reflecting the difference in the type of source material and the amount of motion that may be expected.

Other work broadly substantiates the results of Haskell and Ghanbari and Pearson (individual figures, however, are subject to wide variations dependent upon individual experimental circumstances). Thus Verbiest et al. (1988) measured peak/mean ratios of around three for a 30 min videoconference sequence and 2.6 for 3 h of cable television (CATV) (averaged over one frame). Even when averaged over 500 frames the latter figure is still around 1.8. The authors identify two factors contributing to the bit-rate fluctuations –

a short-term high energy process reflecting local image detail and a long-term, low energy process resulting from basic scene content. Maglaris *et al.* (1988) used a head and shoulders sequence 300 frames in length for their statistical measurements. Averaging length was again one frame. Maximum and minimum coded bit-rates are 1.41 and 0.08 per element, with mean 0.52 and standard deviation 0.23. Peak-to-mean ratio is thus about 2.7. Bit-rate distribution is found to be roughly Gaussian, and temporal correlation approximately 0.3 at a 10 frame separation with an exponential trend [but of much greater decay rate than an exponential fit made to Haskell's autocorrelation measurements: $\exp(-3.9\tau)$ as opposed to $\exp(-0.7\tau)$, where τ is measured in seconds]. Chin *et al.* (1989) carried out measurements on seven sequences containing a variety of picture material and obtained peak-to-mean ratios of 2–3 without, and approximately 5 with, the inclusion of scene changes. Peaks, when present, lasted for at least several frames and sometimes up to 1 s or more. Nomura *et al.* (1989) examined the coding of two videoconference sources (active and inactive, the bit-rate of the former being twice that of the latter), 256 lines × 240 elements in extent at 15 frames per second and lasting 20 s, using predictive, and both motion-compensated predictive and transform coding. In addition to the conventional measures of statistical distribution and autocorrelation they included a determination of the coefficient of variation $C(n)$, which shows how the buffering process affects the ratio of standard deviation to average data rate:

$$C(n) = [(n + 1) \, \sigma^2 \, \{x\}]^{1/2} / E \, \{x\}, \qquad (12.3)$$

where $\{x\}$ is the buffered sequence. Signal averaging theory would indicate that $C(n)$ will remain constant for uncorrelated frames but will otherwise increase. Results showed that the rate distributions were approximately Gaussian and similar for all three coding algorithms, with a standard deviation-to-mean ratio of about 0.3, and that the autocorrelation function was approximately exponential out to about 0.5 s, again being little affected by choice of algorithm. The coefficient of variation increased from 0.3 to values in the region of 0.5–0.8 (the latter for the more active sequence) for $n = 15$ (1 s). Peak-to-average ratios lay in the range 2.5–3.5 for the predictive algorithms and somewhat below 2 for the transform case, this lower value being in agreement with one of the conclusions of Ghanbari and Pearson (1989) regarding the experiments discussed earlier. Using a 6 MHz (CCIR Recommendation 601, 525 line system) video input of dimension 490 × 720 elements representing high quality videoconference services, Kishimoto *et al.* (1989) studied the data generated by a motion-compensated intra/interframe prediction algorithm with entropy coding in terms of the various components of the system output which have to be transmitted, for three sequences having, individually, large, medium and small degrees of motion. They found that the maximum prediction error entropy for large amounts of motion was approximately 10 times the average value for an image with a small degree of

motion ($0.42{:}0.04$ bit element^{-1}). Entropy of the motion vector information was constant at about 0.15 bit element^{-1}, and that of the quantiser selection information very small (0.006 bit element^{-1}). Maximum total entropy for large degrees of motion was 0.6 bit element^{-1}, the average for small amounts of motion around 0.17 bit element^{-1}, and the ratio thus about 3.5.

More recent studies of image data statistics have been oriented towards the provision of transmission capacity for coding systems conforming to recently introduced standards (see Chapter 10). Generally, packets conform to the CCITT value of 53 octets, with 5 octet header and 48 octet (i.e. 384 bit) data field, although variations have been reported. Heeke (1993) measured the cell distribution statistics for a 9 minute head and shoulder sequence (about 16 000 frames) with a standard packet. Mean and standard deviation of the number of packets per frame were 114 and 32, respectively (one packet per frame representing about 11.5 kbit s^{-1}). Two separate 1 min sequences gave corresponding values of 129 and 32, and 92 and 24, showing the long-term variability in rate noticed earlier.

Pancha and El Zarki (1993) considered the application of the MPEG-I standard to a 3 min 40 s laser disc quality (512×480 elements) sequence taken as representative of high and low degrees of motion from the film "Star Wars". Here the 53 byte packet contains a data field of 44 bytes. Depending upon the intra/interframe coding ratio and quantiser scale parameter peak to mean cell arrival ratios vary from 1.8 to 4 per frame, and the standard deviation-to-mean ratio between 0.27 and 0.74. Per "slice" (512×16 elements) the corresponding values are 3–8.75 and 0.4–0.7. Jabbari *et al.* (1993) studied a CCIR601 MPEG-I coding scheme with blocks classified as having little or no, medium and high levels of motion (types 0, 1 and 2) over a sequence of 350 fields. There was an essentially constant number of type 2 blocks/fields over the sequence (mean $= 63$, standard deviation $= 14$) and just about perfect negative correlation between type 0 and type 1 classes; standard deviation-to-mean ratios for the latter being 0.13 and 0.1, respectively. In each case distributions were considered to be reasonably close to Gaussian. Interfield correlation coefficients for types 0, 1 and 2 were 0.93, 0.94 and 0.72, respectively.

What are we to make of the statistical measurements reported above? Well, certain characteristics are source material dependent, whilst others are more all-embracing in nature. All single source coders produce significantly variable data rates, and this variability may have different (short-term and long-term) components. Peak-to-mean ratios tend to be higher for television-type material with more widely varying scene content and frequent scene changes. This factor also has a strong and direct bearing upon temporal characteristics, as measurements of frame-to-frame correlation show but, in any case, long peaks tend to last for at least several frames, making short-term buffering impossible. As far as characterisation of video sources for network purposes is concerned, opinions differ as to just what statistical

properties need specifying. Thus Pancha and El Zarki (1993) suggested that peak, mean and standard deviation will be those most likely to be available *in practice* to specify source properties, a parameter such as burst length, for example, being dependent upon the implementation chosen. On the other hand, Bae and Suda (1991) considered burst length to be a desirable property to characterise, and additionally, properties such as burst factor (peak bit-rate – average rate) × average burst length. They suggest the use of an "effective" rate, which is a predetermined fraction of the peak rate, just what the fraction should be for various types of traffic being a matter for further study.

12.3.4. Data Modelling

The intense recent interest in VBR techniques for the transmission of coded video data has naturally given an impetus to the development of models which accurately characterise the very variable measured properties of such sources which were discussed in the previous section. As in that case, an easy introduction to the topic is given by Haskell (1972) whose basic change statistic model for a single source has already been mentioned [see Equation (12.1)]. Applying this to situations in which between two and 20 individual source outputs are combined, the distribution gradually becomes Gaussian, with significantly reduced standard deviation (and thus probability of change, on *average*, involving a substantial number of picture elements). This is taken up in the next section with regard to multiplex, as is the matter of Haskell's second parameter – duration of peaks in the number of changes per field. For a single source this is given by Equation (12.2). A similar approximate linear fit to the data gives the results of Table 12.1, where D is the peak duration in

Table 12.1 Extension of Equation (12.2) to multiple sources (derived from the data of Haskell, 1972).

Number of sources combined	D/T relation	Range of validity of T
1	$D = 26(1 - 1.1\,T)$	0.2–0.75
2	$D = 28(1 - 1.8\,T)$	0.2–0.45
5	$D = 32(1 - 3.2\,T)$	0.15–0.3
12	$D = 34(1 - 4.2\,T)$	0.1–0.2
20	$D = 58(1 - 6.6\,T)$	0.1–0.15

fields and T is the fractional change per field. The significant feature here is the rapidly increasing negative slope of the D/T relation. For a single source a 75% field change lasts, on average, five or six fields. For 20 sources and durations in the same range no average field change exceeds 15%, and the data rate fluctuation is reduced significantly.

One of the earliest of the more recent papers on video transmission in a

VBR environment is that already cited by Verbiest *et al.* (1988). They give two plots of bit-rate probability distribution functions, one for videoconference and one for video broadcast which show differences not always captured by later workers (see Figure 12.8) and a temporal bit-rate/buffering interval

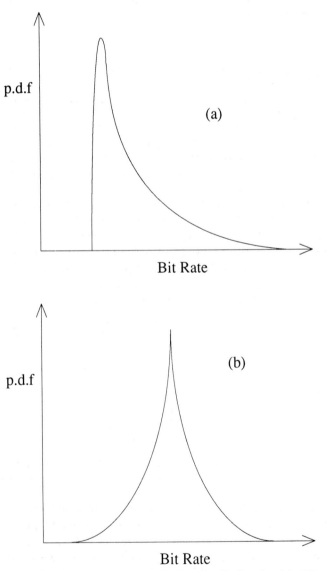

Figure 12.8 Schematic representation of bit-rate distribution for (a) videoconference and (b) television signals.

relation previously referred to, with a peak-to-mean ratio significantly greater than one even after 500 frame averaging. Maglaris *et al.* (1988) sketched a probability distribution for their videotelephone sequence source which, in general outline, lies between (a) and (b) of Figure 12.8 and which, nevertheless, they consider to be Gaussian. Their exponential autocorrelation result for the temporal (frame to frame) response has already been mentioned. They propose a general continuous state model in which a first order Markov process is generated by the relation

$$\lambda(n) = a \lambda (n-1) + b w(n), \tag{12.4}$$

where $w(n)$ is a sequence of independent Gaussian random variables of specified mean and unit variance, n is the frame index and a and b are constants. Mean $E(\lambda)$ and frame-to-frame autocovariance C_n are as determined in the previous section:

$$E(\lambda) = 0.52 \text{ bit element}^{-1}$$
$$C_n = \sigma^2 e^{-0.13 n}$$
$$(= \sigma^2 e^{-3.9 \tau} \text{ for a rate of 30 frames s}^{-1})$$

and allow the calculation of values $a = 0.88$ and $b = 0.11$. Values simulated by this model matched the results obtained with a discrete state, continuous time analysis in terms of queueing behaviour, in spite of the different distributions assumed in the models, indicating the insensitivity of this characteristic to such factors. This analysis (see Figure 12.9) divides the bit-rate range

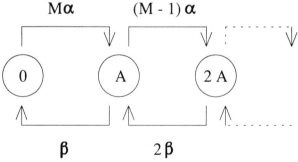

Figure 12.9 State transition diagram for the source. There are $M+1$ possible bit-rate levels, with uniform increment A bit element^{-1}. α and β are interstate transition parameters.

into finite (quantised) segments with exponentially distributed transitions between segments occurring at time intervals governed by a Poisson distribution. Such a source model is equivalent to that consisting of a set of so-called "minisources", each switching independently (and exponentially at different rates) between an "OFF" state (0 bit element^{-1}) and an "ON" state

(a finite, predetermined number of bits per element). Results are quite insensitive to the actual number of finite levels, and 10 seem to be quite adequate.

Autoregressive modelling is also an approach to the characterisation of sources adopted by Nomura *et al.* (1989), who found that a first order model of the kind proposed in Equation (12.4) also models their data, which is generated from two representative (one active, one inactive) conference scenes using three different algorithms, interframe DPCM, motion-compensated DPCM and motion-compensated transform coding, reasonably well. As in the case of that investigation, however, the exponential correlation model breaks down for large frame-to-frame separations (six to seven in this case), and both of these results seem to show that, taking frame rate into account, it is this model as used with the original video signal which is inapplicable for temporal separations exceeding 0.5 s.

Kishimoto *et al.*'s (1989) measurements of data statistics based upon the application of an adaptive motion-compensated intra/interframe predictive coder to videoconference scenes having three levels of activity was extended to the distribution of output data in the form of packets where the three components to be sent – prediction errors, motion vectors and quantiser selection data – utilise separate packet streams. It turns out that quantiser selection information is essentially constant over a frame and it is, moreover, fixed length coded. Thus the two other contributions are more significant. For the medium motion case, the generation interval distribution can be modelled well by an Erlang distribution. For the large and small motion cases, however, there are two and three different distributions, respectively, as a result of the different types of entropy and run length codes used. The overall interval distribution is, therefore, a complex combination of these. The work of Maglaris *et al.* (1988) was subsequently expanded by Sen *et al.* (1989) to cover both long- and short-term correlation behaviour (as noted by Verbiest – see the previous section) and also to deal with the multiplexing of statistically different sources. Throughout this development they stress the validity of the exponential representation of the correlation behaviour of the frame-to-frame process, and this is satisfactory for frame separations up to about 10. The authors propose a division of the single (quantised) source bit-rate into two components – a low-rate A_1 with $M_1 + 1$ levels and a high rate A_h with $M_2 + 1$. Figure 12.9 is now extended into two dimensions, as shown in Figure 12.10, and again a "minisource" interpretation is possible. Unfortunately the authors have created confusion in their development of the earlier paper by transposing, in the later one, the symbols N and M representing, initially, the number of sources and rate quantisation levels (whilst still retaining one diagram with the original labelling!). The puzzled reader is referred to the overview paper by Bae and Suda (1991) wherein the confusion is dispelled and, in addition, a useful overview of the topic given.

It will be apparent to readers interested in the wider developments in science and technology that, in the past few years, an increasing number of

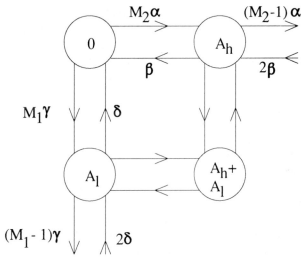

Figure 12.10 State transition diagram for the high/low-rate combination. α, β, γ and δ are interstate transition parameters.

technical papers have had the word "fractal" in the title. We have earlier seen that this is true in the field of image coding, and McLaren and Nguyen (1991, 1992) have ensured its incorporation into the field of variable bit-rate video traffic modelling. Their 1991 contribution details a model based upon the output of a transform coding scheme for low-rate (up to $5\,\mathrm{Mb\,s^{-1}}$) transmission which switches between three different levels of activity with the system parameters being such that for each sub-block either one cell, or no cell at all, is produced. A simple two state (active/inactive) model is proposed, with time-dependent transition probabilities $p(t)$ obeying the relationship

$$p(t) \propto t^{D} \tag{12.5}$$

where D is some parameter. It is suggested that "the longer the system remains inactive, the more likely it is that a cell will be produced after processing the next block" (for which no evidence is given) and that somehow the independent variable t can take the place of the scale variable in Equation (6.10). On this basis their description of the source model as "fractal" rests. As far as results are concerned, the authors demonstrate that their switched source model is more successful than either a simple probability or time invariant Markov model in predicting the cell delay/channel use relation for two scenes of differing spatial complexity. In their second paper the authors' enthusiasm for all things fractal is somewhat tempered, since they acknowledge the tenuous connection between their state transition probability relationships and "fractal behaviour" (whatever that is) but they nevertheless report a five source, picture activity switched model which produces an output

very similar to that actually generated when coding real data. In addition they suggest that, for higher rate $(5–20\,\mathrm{Mb\,s^{-1}})$ applications, multiple cell generation per block is common (and the characteristics of the cell generation process different), and formulate a switched, 10 activity level Markov model which again provides a good representation of the cell delay/traffic intensity relation.

In spite of the obviously poor correspondence between the bit-rate distribution and the Gaussian profile (see, for example, Figure 12.8), this model has been widely used to portray source properties. Heyman et al. (1992), however, after briefly reviewing previous work in the area point out that videoconference data, at least, has a profile which accords much more closely with the Gamma distribution and substantiate this suggestion by an examination of a 30 min sequence (48 500 frames), without scene cuts, panning, etc., using hybrid predictive/transform coding without motion compensation. The authors studied a number of models intended for the prediction of cell traffic statistics, finding that the AR(I) model gave a good fit to the autocorrelation function, but that other properties were better modelled by an AR(II) process [a move to AR(III) was found not to be worthwhile]. The fact that this model performed poorly in a traffic simulation context provoked a move to a Markov chain model, similar to those mentioned earlier where, in the two state case, probabilities are defined for transitions to and from each (high or low) rate state. A two state model did not perform well in cell loss simulations, however, but a more complex chain model was more successful in this as well as in giving a good fit to the frame-to-frame autocorrelation profile and to the steady-state data distribution. Heeke (1993) also examined a multistate Markov chain model ($M = 8$) noting that, for H261 coding of a head and shoulders sequence, such representation can be very accurate and also that, as other workers have pointed out, transitions between any other than neighbouring states are very rare. As far as a decision on the number of states to be considered is concerned, in the absence of other criteria (switched coder modes, etc.), one approach is to use the ratio of peak rate to standard deviation of cell arrivals (Pancha and El Zarki, 1993).

Combinatorial/switched source models obviously have the potential to characterise a wide spectrum of source statistics and thus to be of use in simulations for an extensive range of types of traffic. Yegenoglu et al. (1993) examined the properties of a switched three mode system for full motion video which used interframe hybrid predictive/transform coding for small, interframe motion-compensated hybrid predictive/transform coding for medium, and intraframe transform coding for high levels of motion. In this case modelling was based upon a Gaussian AR(I) process whose parameters are fixed by the state of a finite Markov chain in the case in which there is no state change from frame to frame. If a state transition occurs the number of bits in the next frame is generated randomly. In the present case, with three motion states and three corresponding coding strategies, it seems logical to

suppose that three distinguishable states exist. The bit-rate histogram supports this supposition with clear peaks at three separate locations between 35 and 75 kbits frame^{-1} (overall data average and standard deviation are 55 and 18 kbits frame^{-1}, respectively), as sketched in Figure 12.11. This can be well

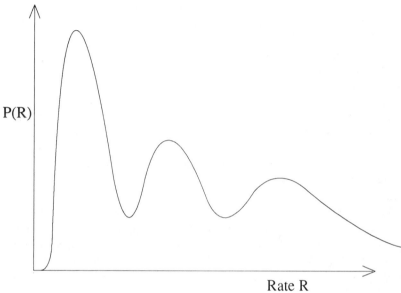

Figure 12.11 Form of bit-rate distribution for the three mode case (Yegenoglu *et al.*, 1993).

fitted by a model which is the sum of three separate Gaussian distributions G (μ, σ^2), each weighted by their respective steady state Markov chain probabilities:

$$P(R) = p_1\, G(\mu_1, \sigma_1^2) + p_2\, G(\mu_2, \sigma_2^2) + p_3\, G(\mu_3, \sigma_3^2), \qquad (12.6)$$

where $p_1 = 0.34$, $p_2 = 0.48$, $p_3 = 0.18$, $\mu_1 = 37.5$, $\mu_2 = 57.0$, $\mu_3 = 85$, $\sigma_1^2 = 2400^2$, $\sigma_2^2 = 7300^2$ and $\sigma_3^2 = 11\,300^2$.

This approach was later developed to model not only the bit-rate/field distribution but also the intrafield properties (the number of blocks of a particular type/field and the number of bits per block in each field) in an MPEG context (Jabbari *et al.*, 1993). Here the MPEG implementation is applied to a CCIR 601 (not SIF) image sequence to generate data relevant to higher resolution applications, and only I and P field modes are used, B fields (bi-directional motion estimation) being excluded in this real-time/interactive context. Again a three mode motion classification is applied, here to separate P field blocks, which are coded using, respectively, interframe (no motion compensation) coding, interframe coding plus motion compensation and

intrafield coding. I (refresh) fields use only the latter technique. As in the previous experiment a multimodal bit-rate histogram is again obtained with the separate components being approximately modelled by individual Gaussian densities.

Recently, modelling of VBR video sources has been a matter of much interest. Disregarding reference to "fractal" properties, it does seem that multistate Markov chain models can represent the data well, but practical implementation is not yet advanced enough to determine whether these will be adequate in a more general sense.

12.3.5. Statistical Multiplexing

Allocating as much bandwidth as is necessary to a video transmission ensures that the problems of coding the source are minimal or even non-existent. Unfortunately, of course, the whole rationale for image compression is based upon the fact that in many circumstances this is just not possible, and conventional systems, as we have seen, opt for the fixed rate and hence time-variable quality solution. The significant feature of a VBR system is that N coders in simultaneous operation need not occupy N times the peak bandwidth required for each of them, a situation which could only be approximated in the fixed bandwidth case by using very large buffers with consequent significant (and probably unacceptable) delay. The matter was described well by Haskell (1972) over 20 years ago, "... different users are rarely in rapid motion at the same time. Thus, when the data from several sources is averaged together prior to transmission, it is much more uniform than that from a single source ... peaks are smaller ... less buffering is required and the channel rate ... is much closer to the average rate generated". The basic configuration is shown in Figure 12.12. Separate variable rate source outputs are stored in a small (approximately one frame) pre-buffer and then switched (not necessarily sequentially or at constant rate) to the main buffer and then transmitted. Haskell shows that a 2:1 benefit in transmission capacity usage may be achieved by allocating 12 sources to share a single channel. We have already seen how the relationship between the average duration of peaks in the number of changes per field and the number of changes itself is influenced by multiplexing and a similar relationship applies to the buffering requirements. Briefly, when system parameters are arranged so that a 70 kbit buffer for each source is adequate at a 2 Mbit s^{-1} transmission rate, this suffices at rate of 0.9 Mbit s^{-1} or less per source for 12 multiplexed coders. The slope of the relationship increases sharply also. For a single source a 10% rate increase allows a roughly fourfold decrease in buffer size. For 12 multiplexed sources the buffer requirement falls by a factor of approximately 10 for the same rate increment.

Verbiest *et al.* (1988) give figures which present a similar picture. In this

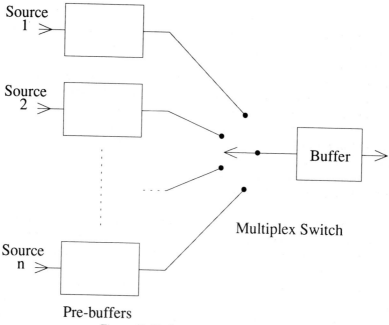

Figure 12.12 Statistical multiplexing.

case the probability of 16 sources, which each have a peak data rate of 14 Mbit s^{-1}, of reaching this value simultaneously (224 Mbit s^{-1}) is vanishingly small (if this *were* to happen, network congestion would be very severe (Bae and Suda, 1991), and no significant decrease in performance will occur if each channel is allocated half its single source rate. The multiplexing gain is thus about 2:1. It may be worth noting at this point that different authors may use somewhat different definitions of multiplexing gain. Thus Heyman *et al.* (1992) define it in terms of the ratio of the numbers of VBR and CBR (constant bit rate) sources which can use the channel, in order to take account of the effect of differing cell loss rates on different sources. For very large numbers of sources, the required allocation tends towards the average single source rate. Figures of cell loss probabilities obtained by Maglaris *et al.* (1988) bear out the conclusions of Haskell and Verbiest *et al.* Moving from one to 10 sources at a channel utilisation factor (average source rate divided by channel capacity per source) of 0.8 reduces the loss probability by nine or 10 orders of magnitude, and the probability of needing to buffer more than three frame periods falls to 10^{-5} from something above 10^{-1} (see also Sen *et al.*, 1989).

In a slightly different approach to variable bit-rate transmission, Nomura *et al.* (1989) examined the quality improvement obtainable during active motion (compared with fixed rate transmission) by not having to degrade coding parameters in order to control peak transmission rate. They found that

between 5 and 10 dB improvement in the minimum value of SNR calculated on a frame-to-frame basis is achievable, as is an increase of one point on a five point mean opinion score (MOS) of subjective quality for two scenes, one active, one inactive.

Haskell suggested that the overall transmission of data from several multiplexed coders should be much more uniform than that from a single source. Yegenoglu et al. (1993) used the three state model discussed in the previous section to obtain combined traffic statistics with model parameters obtained from 500 frames of full motion CCIR 601 video. The coded source had an average output rate of 1.66 Mbit s^{-1} with standard deviation 0.53 Mbit s^{-1} and peak-to-mean ratio about 2:1. Ten multiplexed sources had a per source rate of 1.66 Mbit s^{-1} with standard deviation 0.16 Mbit s^{-1}, and peak-to-mean ratio 1.44. One hundred such sources had a rate of 1.66 Mbit s^{-1}, a standard deviation of 0.06 Mbit s^{-1} and a peak-to-mean ratio 1.15. The aggregate histogram, even for only 10 sources, looked very closely Gaussian. Such results are extremely "well behaved" despite the fact that the underlying model is based not upon low motion videotelephony/conferencing but on full motion, high-rate video.

It is not the purpose of a volume concerned mainly with the technical aspects of coding algorithms to consider in detail the more "administrative" aspects of the coding discipline. It is worth mentioning, however, that some control has to be exercised over the variable bit-rate transmission operation. The call originator must provide the network operator with sufficient statistical data for the connection to be established within the cell loss parameters offered by the network and the call must be monitored to ensure that the network is not asked to accept more than the agreed cell rate, etc. This monitoring procedure is described in terms of a "policing" function by Verbiest et al. (1988), and Bae and Suda (1991) discuss admission control and bandwidth enforcement procedures. Admission control is based upon a decision taken on whether or not to accept a newly offered connection. This depends upon various factors such as cell transmission statistics, peak and average rates, present network loading and the characteristics of the offered source. Bandwidth enforcement results from a violation of the call traffic flow agreed at set-up time. Cells may be discarded or buffered, or they may be tagged so that they will be preferentially dropped if they arrive at a congested node. An additional factor is the level of intersource correlation which exists, and which may vary from negligible for low-rate videotelephone/conference services to possibly significant for multicast operations. All these matters make the efficient management of the multisource ATM network considerably more complex than appears at first sight, and an analytical approach to network policing is described by Heeke (1993), in which the significant cell parameters which must be conveyed from the source to the network are the mean on/off times of the various states of the Markov chain model which describes the cell generation process. An example of a simple bandwidth

requirement prediction scheme for an MPEG coder is given by Pancha and El Zarki (1993).

12.3.6. Cell Loss and Error Compensation

We have already seen that widespread application of a multiplex system in an ATM environment will require the application of flow control protocols based upon accurate measures of traffic statistics via the implementation of so-called "policing" strategies. In addition to such externally imposed limitations, network "transparency" can also be affected by problems of a more technical nature, specifically cell delay and delay jitter, and also outright loss (Verbiest *et al.*, 1988; for practical considerations see Verbiest and Pinoo, 1989). Whether cell loss is a problem in itself depends, of course, on the cell loss ratio, as well as what precautionary measures have been taken to mitigate its influence over the reconstruction of subsequent image/video data (recognising the recursive nature of most decoding operations), and Verbiest and Pinoo point out the greater problems which exist for higher rate services, with a loss ratio of 10^{-8} resulting in average intervals between losses varying from minutes to days in the cases, respectively, of systems operating at 140 Mbit s^{-1} and 64 kbit s^{-1}. They also emphasise the disparity (for higher performance services, at least) between frequency of service interruptions and the bit error rate at which the codec itself gives good reproduced quality, the former being by far the most stringent requirement. An interesting observation is made in this context by Lee *et al.* (1990) that the eye is much less tolerant to image degradation through data loss than is the ear to voice signal corruption, and so the packet loss control strategy needs to be more strict in the former case. As far as delay is concerned, jitter represents a variable component to be added to the basic cell transmission time, and can be eliminated by buffering all packets to the maximal delay value at the receiver (Karlsson and Vetterli, 1989). With regard to transmission delay itself, its importance depends upon the application. In one-way communication it is (if not excessive) of little importance; for two-way, interactive operation long delay can be equivalent to complete cell loss, if arrival is too late to allow participation in the reconstruction process. This may be due to queueing delay at the multiplex buffer which results in losses of packets in clusters rather than totally at random as is the case as a consequence of some transient transmission error. Reorganisation of queueing priorities can reduce this problem (Zhang *et al.*, 1991). In a specifically video context, the fact that frames from any individual source arrive at a very regular rate (the interframe period) can exacerbate this problem. Heyman *et al.* (1992) termed this the "source-periodicity" effect and showed that it results in widely differing cell loss rates for the different sources feeding the multiplex. Again, reorganising buffer scheduling so that cells are dropped from whichever source has the lowest accumulated loss rate,

rather than from the one which has just sent the last arrival, can significantly equalise cell loss. Application also has a strong bearing upon the possible techniques used for error recovery. Cell loss may be caused by packet address bit errors (note that there may be data field errors which do not affect packet receipt but which may nevertheless cause errors in decoding), but if it is caused by network congestion retransmission upon request will only make the congestion worse and lead to still higher levels of loss. In any case network loading will be increased. Additionally, retransmission is not an option in a broadcast context.

Possible techniques for lessening the effect of packet loss upon image reconstruction are legion, and several will be discussed below. Conventional forward error correction can be used, of course, but a packet typically contains several hundred bits making this approach complex. Karlsson and Vetterli (1989b) suggested applying an (n,k) code *across* a group of k aligned packets to achieve bit interleaving in conjunction with some sort of spatial and/or temporal (interpolative) reconstruction of image blocks making use of the properties of the HVS. Another approach, which has found widespread application, is that of layered coding, which is treated separately in the next section. Again, periodic intraframe "refreshment" will limit the temporal effects in hybrid schemes. Wada (1989) has proposed a method whereby the receiver detects the decoded picture areas which are faulty, uses an error concealment technique and notifies the transmitter so that coding can continue without the use of this (locally decoded) region. The extent of the problem with a conventional hybrid coder is demonstrated by Wada's results which show that, depending upon video sequence activity and quantiser stepsize, the loss of one (16×16) picture block can generate a total of up to eight affected blocks over the next 10 frames, this number naturally increasing if several consecutive initial blocks are lost by their inclusion in the same lost packet. Error correction (concealment) is carried out by replacing the incorrect block by the "same" block from the previous field. By using the motion-compensated previous frame block for replacement the performance of the algorithm was, as one might expect, improved significantly. In this case the average of the motion vectors of blocks surrounding the corrupted one was used for displacement. This approach has been reinvestigated more recently by Ghanbari and Seferidis (1993) who showed the importance of having the actual motion vector available for the replaced block (in their case transmitted via a guaranteed layer of a two layer coder, see later), compared with an average derived from surrounding blocks. As was mentioned in Chapter 9, Section 9.7, with regard to motion-compensated interpolation, here *true* motion vectors are needed, and not just those giving a minimum in the displacement cost function.

In a transform coding context the LOT has already been mentioned as a way of mitigating block boundary artefacts. Since block overlapping is a fundamental characteristic of the LOT operation, coefficient array interleav-

ing before packet transmission will, if the cell loss ratio (c.l.r.) is not too severe, leave neighbouring coefficients of a lost block intact and at least partial recovery of the lost block should be possible – some success in this direction has been achieved by Haskell *et al.* (1989) and Haskell and Messerschmidt (1990).

Yamazaki *et al.* (1993) investigated quality of service considerations as a function of bit-rate and cell loss ratio for a wide variety of transmission rates. They found that a cell loss ratio of better than 10^{-6} is necessary to achieve good videoconference quality at about $2\,\mathrm{Mbit\,s^{-1}}$, and that, around this figure, the bit-rate is a more significant indicator of quality than c.l.r. Error correction and concealment form part of the proposed HDTV codec developed by Kinoshita *et al.* (1993). Here correction operates on a cell "matrix" in which j rows each containing i cells have a further row of parity check cells appended to give a $(j + 1) \times i$ array. If $i = 10$ and $j = 100$, one cell in 10^3 can be corrected at a cost of a rate increase of $j^{-1}\%$ (here 1%). This scheme is reminiscent of Karlsson's "stacked" cell approach mentioned earlier. Block interleaving and interpolation are used as the concealment techniques.

A sophisticated, adaptive approach is taken to cell loss recovery by Zhu *et al.* (1993). They used a combination of spatial block interleaving and transform coefficient segmentation to conceal errors in JPEG and MPEG implementations; variable weighting factors in the interpolation algorithm depend upon motion content and spatial detail. Interleaving fills packets with data, first from even-indexed, and then from odd-indexed blocks (8×8) in each macroblock slice (512×16). Temporal interleaving, although possible, may cause excessive delay and is not included. Block information is now split into four bands in the sequence overhead information, motion vectors and zig-zag scanned transform coefficients. For intra- (or still) image coding band one contains overhead, motion vectors and the first three low frequency coefficients, the other three contain, in order, the next five, seven and 49 coefficients. For intercoded blocks band one contains overhead, band two motion vectors and, in bands three and four there are 10 and 64 transform coefficients, respectively. Packets are then made up from interleaved data as above, with the exception of the first two bands for intercoded frames, which are sequentially assembled.

Packet loss now results (hopefully) in the loss of only partial block information. Motion vectors are reconstructed via vertical interpolation from blocks above and below, and transform coefficients or prediction errors by mixed spatio/temporal interpolation with a smoothing constraint. In the spatial domain, minimisation of the weighted sum of squared element differences over the block and its boundary elements outside the block boundaries is the criterion, along the temporal dimension a minimum in the error vector energy is sought. Solution of the problem produces three linear interpolations – from the boundary vector (spatial), prediction block (temporal) and from the received coefficients (frequency domain). Iterative application of the

algorithm can result in an acceptable reconstruction when more than one neighbouring block is impaired. The algorithm is shown to perform much more satisfactorily than the simple motion-compensated copying operation even with a scene change in a sequence containing significant motion. The subjective aspects of cell loss within an ATM network have been studied by Hughes *et al.* (1993).

It is apparent that algorithms like the one just described can go far to mitigate the coding/decoding problems associated with packet loss when transmitting variable bit-rate video. For a review with more emphasis on the network specific aspects of error control, the reader is referred to Bae and Suda (1991).

12.3.7. Layered Coding

12.3.7.1. Introduction

In the past few years the use of multiresolution and scale-related decomposition techniques has become popular in image coding, with various wavelet and pyramid, etc., schemes being proposed. Other algorithms, too, have an inherent "hierarchical" aspect which must be reflected in the bit allocation in order to achieve good compression efficiency. Thus, low order transform coefficients need to be retained with a reasonable degree of accuracy, low order sub-bands, containing most of the image energy, also. It follows that this hierarchical aspect must be preserved for optimum image reconstruction under adverse transmission conditions and, in the present context, this has led to the proposal of a number of schemes for the mitigation of cell loss defects by so-called "layered" coding (Verbiest *et al.*, 1988; also Zhang *et al.*, 1991). In such a scheme video components to be transmitted are allocated a priority ordering in the data, or, more usually, source coded data, domain with highest priority information being allocated a "guaranteed" channel where cell loss is at a minimum or even zero. In this way essential signals (synchronisation, addresses, motion vectors, quantiser selection parameters, etc.) are assured of transmission to the decoder whilst higher order terms which only contribute marginally to the basic information flow may be exposed to network imperfections (congestion) and hence possible cell loss. One or two such schemes are described below.

12.3.7.2. Data Hierarchies in Layered Coding

Zhang *et al.* (1991) give a brief survey of some of the possibilities for allocation of data priorities in layered coding. Bit plane separation of the original PCM input data is one approach, followed by VBR coding of all the separated

planes, or a subset of the lower order planes may be hybrid transform coded and the resulting coefficients themselves given a priority ordering. It is more usual, however, to process the whole of the spatial data and then operate purely on the coded output prediction errors, transform coefficients or subbands, according to the specific coding technique used. A typical coding strategy is described by Kishino *et al.* (1989). Here 8×8 DCT coefficients are separated into lower and higher order terms corresponding to higher and lower priority partitions, respectively. Only the latter are discarded under conditions of network congestion. The separation between partitions can be determined by a threshold (a fixed fraction of the total coded bitstream length within a block) on the accumulated bit length over the sequentially scanned coefficients or, alternatively, by a similar test between overall block SNR and accumulated coefficient energy along the scan path. Where all low priority data is lost, the latter method is shown to be preferable. Alternatively a fixed allocation may be made – Lee and Tzou (1990) classify the upper 12 coefficients in an 8×4 transform coded block as having low priority in a $135 \, \text{Mbit s}^{-1}$ television application. Kinoshita and Nakahashi (1991) found it satisfactory simply to allocate the D.C. coefficient of an 8×8 block, as well as synchronisation information, high priority, and consequently error-free transmission. This scheme was subsequently extended to provide adaptive, two layer coding, using an 8×8 intrafield DCT (Kinoshita *et al.* (1993)). Here the adaptivity criterion is the condition that a specified SNR is achieved given that, as in Kishino *et al.*'s coder (1989) referred to above, all low priority data has been lost. There are four coding modes, selection of which depends upon the ratio r of the energy in a 3×3 low order block of coefficients to the total energy in the 8×8 transform block. If $r > 0.8$ then the D.C. coefficient has high priority, and successive range divisions at 0.5 and 0.2 include 3, 10 and 36 transform coefficients, respectively. For effective operation, of course, coder parameters cannot be determined without reference to the network, and Pancha and El Zarki (1993) suggested a way in which this may be done. They describe an implementation of a layered MPEG coder in which the fraction of coder output in the high priority stream of a two partition allocation is predicted based upon the previous frame output. This prediction is then compared with the amount of guaranteed bandwidth allocated, and the fraction changed accordingly.

Ghanbari (Ghanbari, 1989; Ghanbari and Seferidis, 1993) has conducted an extensive investigation into layered coding, in which a somewhat different approach is used. Here the output of an adaptive hybrid coder forms the high priority bitstream (first layer) and the input to the second layer coder is the difference between the video input and the first layer output, as in Figure 12.13 (note that a locally decoded output from a scheme involving prediction can be obtained from the predictor input terminal – see Figure 2.7). The author points out that there is a fundamental mismatch in the two basic requirements on the guaranteed channel rate. It needs to be high enough not

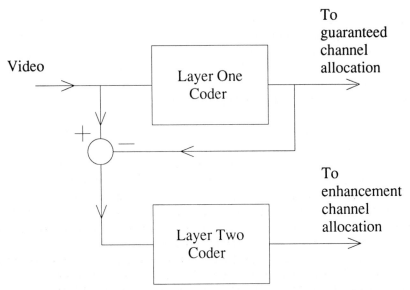

Figure 12.13 Basic structure of Ghanbari's two layer coder.

to cause the enhancement channel to code unnecessary detail and yet low enough to allow the enhancement channel adequate flexibility in channel sharing given a fixed overall rate. The conclusion is that the first layer coder should, in fact, be capable of high quality at low rate. As usual, this layer will also have to process addresses, motion vectors and general overhead information which must be transmitted unimpaired to the decoder.

The second layer coder in Ghanbari's first realisation employed prediction with a seven level non-uniform quantiser. In a subsequent implementation (Ghanbari, 1992) transform coding was used for the enhancement layer, and it was shown that it is not necessary to include a further transform operation for this signal, since the linearity of the transform operation allows a signal already in the transform domain to be extracted following the main DCT in the first layer coder and its counterpart (to be subtracted) before the inverse DCT driving the predictor (see also Morrison, 1990). It is only then necessary to requantise this signal, and this is done with a uniform quantiser with a stepsize of around eight (note that the maximum signal range is -2048 to $+2047$, following 8×8 transformation of the 9 bit, -256 to $+255$, motion-compensated difference input). Zig-zag scanning, thresholding and variable word length coding are carried out as usual. A recent application of sub-band coding and pyramidal techniques to layered coding is described by Guillemot and Ansari (1994).

Such schemes form an elegant and attractive method of transmitting coded image data over a variable bandwidth network There are, however, draw-backs. The overall rate is not necessarily any better (lower) than for similar

quality signal layer coders, and the idea of coding residual distortions (not confined to layered VBR coding!) is suspect from a theoretical viewpoint (Ohm, 1993).

12.3.8. Specific Implementations

Finally, in this section on asynchronous transmission of coded image/video data, we briefly examine one or two specific system implementations. A variety of coding algorithms have been used in this context, although interest is now coming to be focused more upon H261/MPEG-type implementations using the hybrid DCT structure, as these represent standards set for coding/decoding. Any scheme, however, which generates a highly variable output rate (due primarily to motion of scene detail relative to the camera axis) is amenable to use within the ATM environment.

A basic predictive VBR algorithm has been described by Verbiest and Pinnoo (1989). This uses an intra/interfield prediction, non-uniform quantisation and variable length coding, and coding can be switched between three modes, intrafield prediction, interframe prediction and no conditional replenishment, depending upon a sum of absolute interframe differences per block (16×8). Every 100th block is intrafield coded to limit interframe error and to allow correct start-up. Error propagation is also limited by coding a horizontal strip of blocks as a single unit within multiple ATM cells. Two quantisers are included, a fine one for video distribution use (15 levels) and a coarser one for video communication (seven levels). Nomura *et al.* (1989) also investigated a predictive algorithm–interframe prediction and motion-compensated prediction, in comparison with motion-compensated hybrid transform coding. Peak-to-average bit-rate ratio was 2.5–3.5 compared with less than 2 for the transform algorithm, for two 20 s videoconference scenes (active and inactive) 256×240 elements in extent, at 15 frames s^{-1}. Detailed descriptions of the algorithms used were not included by the authors.

Turning to other algorithms, Dixit and Feng (1989) described an adaptive vector quantisation implementation which can be applied to still pictures or intra/interframe coding of video data in a packet switched environment. A large codebook is divided into two parts – one with "common" characteristics of a group of sequences and one with characteristics "specific" to a sequence. These have, typically, 128 and 2048 vectors, respectively, for a block size of 4 \times 4 using 512×512 images. If a good match cannot be found in the common (higher priority) section it is sought in the other. At each stage a count is kept of vector usage in the two sections and, periodically, the codebook is reorganised accordingly. In the video application separate YIQ codebooks are used for the inter- and intraframe modes. The finite state vector quantisation implementation of Manikopoulos and Sun (1989) uses an initial 8×8 block separated into four 4×4 interleaved sub-blocks. Intersub-block correlation is

thus very high, allowing interpolative recovery of missing data in the case of lost packets even when the loss ratio is very high. As is the case with fixed rate systems, vector quantisation is a popular adjunct to other coding algorithms, and a further VBR application which employs it is described subsequently.

Sub-band coding has proved a more popular algorithm for coding image data for VBR/ATM purposes and several implementations have been reported. Karlsson and Vetterli (1988b, 1989b) use an 11 band spatio/temporal split (see Figure 12.14) where the temporal filters are simple two frame

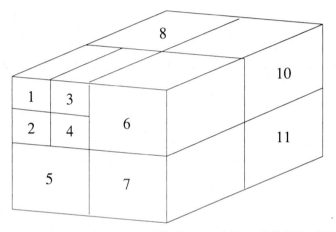

Figure 12.14 Eleven band split of Karlsson and Vetterli (1988b, 1989b).

averaging and differencing operations (allowing a delay of one frame) and the spatial filters are also of low complexity with a maximum of five taps. The "low–low" band obtained via the first stage of spatial filtering is further decomposed into sub-bands 1–4 as in the figure. This results in two basic components of the output datastream; one of relatively constant rate deriving from bands which have been temporally low-pass filtered (1–7) and one of highly variable rate from the temporal high-pass band (8–11). These of course are suitable for efficient transmission over a VBR network. Band one carries the overall low-pass information and has its data rate reduced by being one-dimensionally predictively coded (recall that the sub-band decomposition *in itself* produces no data compression; see Chapter 5) using a wide range symmetric uniform quantiser followed by run length coding. The other 10 bands are PCM encoded. Again the quantisers are symmetric and uniform, but with a central "dead zone" to limit reconstruction of image noise components: the outputs are also run length coded. To limit error propagation all packet contents are independent (i.e. data from different sub-bands is never contained within the same packet). When higher band PCM data is lost the effect is a minor one which affects transient reproduction of texture and detail, and it is suggested that error recovery for the important, DPCM coded band one

be handled by motion-compensated copying of values from the previous frame. The scheme was found to work well for input sequences 512×480 elements in extent at a rate of 15 frames s^{-1} (about 30 Mbit s^{-1}), with coded output rate of approximately 1.6 Mbit s^{-1} and PSNR of 37 dB which varied by less than 1 dB whilst the total rate varied over a range of approximately 3:1. Darragh and Baker (1989) used a similar scheme to code still images for packet switched transmission. They compared several different band-splitting schemes using uniform threshold quantisation and entropy coding for the high frequency sub-bands and predictive coding for the "low–low" band. A seven band split, in which this latter band is split into a further four bands, and a uniform 16 band split (as Woods and O'Neil's original sub-band scheme) gave very similar performance but with PSNR only about 1 dB better than that given by a simple four band split. Likewise, a four band wavelet split with the lowest band 8×8 DCT coded was found to be adequate by Argenti *et al.* (1993) in an HDTV application. Again, lost non-baseband packets have only a minor effect upon image quality but the effect of loss of those containing the "low–low" band information is significant and is countered by using a sequential even, then odd, line scan technique (as interlaced fields form a frame in television) to allow lost data on one scan to be interpolated from neighbouring scans.

A combination of sub-band coding and vector quantisation was investigated by Ohm (1993) for packet video coding. He compared sub-band schemes followed by LBG and lattice based vector quantisation with a conventional DCT/scalar quantisation implementation. The second of the three schemes performed best on CCIR 601 colour data sequences and was subsequently combined with a time axis sub-band decomposition and motion compensation. This configuration showed best performance in terms of PSNR/rate when compared with a variety of predictive and interpolative schemes in both single and two layer versions and also in the presence of significant cell loss in the enhancement layer in the latter case. As a final example, the scheme of Simon and Bruyland (1993) is intended to reduce signals originating at HDTV rates to the 30–60 Mbit s^{-1} region. It uses an MPEG-like format to generate motion-compensated prediction error frames which are split into 19 sub-bands (a uniform 4×4 split followed by a 2×2 split of the lowest, as in Figure 12.15) by separable one-dimensional 14 tap QMFs. The first 2×2 split (the top left quarter of the Figure, i.e. bands 1–7) allows normal television reproduction, and the remaining bands produce the enhancement information for HDTV. Quantisation uses a fixed 255 level quantiser and successive bit planes of the output values are run length coded. Packets, with fixed size of 2048 bits containing a 32 bit identification header, are generated in a hierarchy according to their individual importance for accurate image reconstruction and are sent in this order according to the desired bit-rate (information from the four lowest bands is always sent). Quality is very good at 60 Mbit s^{-1} and acceptable at 30 Mbit s^{-1}.

1	2	5	8	9
3	4			
6		7	10	11
12		13	16	17
14		15	18	19

Figure 12.15 Nineteen band split (Simon and Bruyland, 1993).

An interesting alternative to the many sub-band or transform algorithms proposed for VBR transmission is that reported by Zhang *et al.* (1993) which uses the "bottom-up" quadtree merging procedure described by Strobach (see Chapter 11, Section 11.5.3) in a design for motion-compensated coding. The merging threshold for the bottom quadtree layer is allowed to be adaptive according to sequence activity, and this adaptivity is controlled by reference to the mean square error of reconstruction of the previous frame and to the contrast level of the previous block. Thresholds for higher levels are controlled by the deviation of element luminance from the block mean value, and they also increase with increasing block luminance in the original image, in accordance with the perception of luminance level variations as given by Weber's law. Recovery from cell loss due to network congestion depends upon receipt by the encoder of a feedback signal from the network. In such a situation the encoder carries out a gradual frame replenishment by transmission of a few filtered and sub-sampled image blocks per frame, possibly accompanied by an increase in quadtree bottom layer threshold, instead of a complete frame refresh in one operation (which might lead to further network congestion). Results for the MISSA sequence show this error control strategy to be effective and the overall coder efficiency to be broadly comparable with that of a standard H261 implementation.

With the recent introduction of standards for image transmission based upon the use of the DCT in a hybrid, motion-compensated format, it is not surprising that the majority of reported coding system designs for use in the ATM environment involve transform techniques. Typically this involves dividing the transform coefficient array into regions, or zones, of varying priority (which will naturally include overhead, motion vectors, etc. in the highest category). Several of these schemes have already been referred to in relation to the capture of data statistics or to the development of cell loss

resistant techniques (Nomura *et al.*, 1989; Kishino *et al.*, 1989; Ghanbari, 1989, for example). Kishino *et al.* zig-zag scanned the 8×8 block of transform coefficients in their layered coder and divided the scan into a most and a least significant part (MSP, LSP) on the basis of coded bit length or accumulated coefficient energy. Lee and Tzou (1990) used an intrafield 8×4 DCT scheme to transmit HDTV information ($1440 \times 1152/2{:}1$ format) at $135 \, \text{Mbit s}^{-1}$. The 20 lowest order coefficients in the block were given high priority, with the D.C. coefficient being predictively coded. All coefficients are non-linearly quantised and variable word length coded. Kinoshita *et al.* (1993) used a two layer scheme with four possible coding modes for HDTV transmission at around $20 \, \text{Mbit s}^{-1}$. The basis of the algorithm is an 8×8 intrafield DCT with a variable number of coefficients classified as high priority dependent upon the ratio of the energy in the lowest order 3×3 coefficient block to that in the whole block (see also Kinoshita and Nakahashi, 1991).

It is, of course, simplistic to imagine that source coder outputs can just be connected, *ad hoc*, to an ATM network. As mentioned earlier, data transfer parameters must be agreed at call set-up and so the coders must exercise some control over their own bit-rates. Instead of buffering and feedback rate control the scheme of Kinoshita employs feedforward control of quantisation and variable length coding to limit the peak and average bit-rates. Frame skipping may also be used to control the latter, and control can vary between the two, according to whether high quality, low motion pictures or natural motion video is required. Pereira and Quaglia (1990) have considered adaptation of the CCITT Reference Model (the basis of H261) to operate in an asynchronous environment. Again average and peak bit-rate are the control parameters, and the scheme allows periodic intraframe refresh for error recovery and increase in quality, depending upon the number of bits available, for fixed images. Average rate control is based upon the relation between the actual rate of data generation and that initially negotiated at set-up. This can change the quantiser stepsize, spatial resolution (via sub-sampling) or use one in two temporal sub-sampling (in fact spatial and temporal sub-sampling give poor results and quantiser stepsize is the best parameter to vary). Peak rate control is dependent upon the number of bits used to code a group of blocks (GOBs) compared with that allowable. Depending on the sign of the difference, either the calculated allowable value for all other GOBs in the same frame is decreased, and the quantiser stepsize increased for the next GOB, or the surplus is distributed amongst the other GOBs in the frame. Within a GOB, if the allowable value is exceeded then remaining macroblocks are not coded. Yamazaki *et al.* (1993) also applied rate control to an H261 codec in their experiments on quality of service capability in B-ISDN. Here conventional feedback loop control of quantiser stepsize is used, based upon the average output rate for previously coded frames, but the loop gain is not large, the output rate is still variable (no bit stuffing or frame skipping is

involved), and maximum and minimum quantiser stepsizes need to be defined.

The JPEG/MPEG coder of Zhu *et al.* (1993) has already been mentioned in connection with cell loss/recovery schemes and has an information segmentation hierarchy which is broadly similar to that of other implementations – overhead, motion vectors and then transform coefficients in zig-zag scanned order are separated into four bands and packets made up in interleaved order as described previously. Some changes to the basic JPEG and MPEG algorithms have to be made, such as allowing for D.C. coefficient prediction for still pictures or intracoded blocks in interleaved order, and although this leads to a very small increase in the total overall number of bits, it in any case improves the error resilience of the system as a whole.

12.3.9. General Comments

Transmission of compressed video over variable bit-rate networks presents an intriguing challenge to those involved in digital communications in general. Arguably, the algorithms already developed by the coding fraternity are already sufficiently flexible and adaptive to cope with the demands of statistical multiplex working, and the problems lie more in the network management area, where difficulties concerning large-scale control and consistent error recovery still remain to be solved.

Appendix 1: Variable Length Coding

A1.1. INTRODUCTION

The output of the predictive, transform, sub-band or whatever kind of image data coding algorithm that actually has been used as a first stage of processing will consist of a finite set of finite amplitude levels produced by the quantiser which have to be passed to the decoder. For digital transmission, these levels have to be converted to distinct channel symbols, and a simple method is to allocate the same, fixed wordlength to each. Since the object of the coding algorithm is to reorganise the distribution of levels in the image to make it as non-uniform as possible (see Chapter 1), this approach is very inefficient (although it does make transmission more straightforward), and a knowledge of the level probabilities allows us to improve this stage of the operation. There are basically two usual ways of doing this, Huffman coding and arithmetic coding, both of which come into the general category of so-called "entropy" coding, and are considered in this Appendix (for a recent brief overview of this area see Weiss and Schremp, 1993).

A1.2. HUFFMAN CODING

This algorithm is due to D.A. Huffman (1952) and starts by stacking the level probabilities in descending order. It is best illustrated by means of an example. Figure A1.1 lists, in the second column, the notional probabilities associated with the output levels of a seven symbol source. In the next column the two smallest probabilities have been added and the combined probability

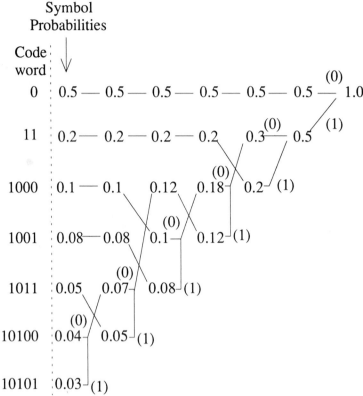

Figure A1.1 Huffman coding. Fixed word length = 3 digits ($\log_2 7$ = 2.81); average word length = 2.17 digits; entropy ($-\sum p \log_2 p$) = 2.15 bits symbol^{-1}.

included in the (now reordered) column. The procedure continues towards the right-hand side until the single probability 1.0 is reached. Each probability entered into a combination and which was moved to the next column to the right is now allocated a "1" or "0" as shown, and the codeword (shown in the first column) read off by following the sequence from right to left. A fixed length code for this example would have a word length of 3 bits (in theory \log_2 7 = 2.81 bits symbol^{-1}). The average word length is, in fact, 2.17 digits symbol^{-1} and the entropy ($H = -\sum p \log_2 p$) 2.15 bits symbol^{-1}, below which value it is not possible to design a code of this type in any case. Further discussion of this method of coding can be found in any undergraduate/graduate text on digital signal processing/coding, for example, Jayant and Noll (1984). A modified code with a simple decoding procedure which can ease the problems associated with the use of several code tables in cases where the probabilities are time varying is described by Lu and Chen (1990); see also Gallager (1978).

A1.3. ARITHMETIC CODING

Huffman coding is a commonly used adjunct to many image compression schemes, and, as shown above, can result in useful increases in coding efficiency. It is only truly optimum, however, if all symbol probabilities are integral powers of (1/2) (i.e. 1/2, 1/4, 1/8 and so on) as the reader can readily verify, and there is no really effective way of adapting it to cope with changing source statistics (probabilities). There is another technique however, arithmetic coding, which has its origins in an alternative interpretation of symbol representation dating back some three decades, and which has been subject to intensive development over the past 10 years or so – not least by workers at the IBM corporation, who concentrated on a binary form, the so-called "Q-coder", as part of a proposed standard for image compression. It has the advantage that the restriction on conversion of coder output symbols to specific, integer length codewords (a source of inefficiency in Huffman's algorithm) is removed, and it can be designed to be adaptive and so to be able to track varying source statistics, given a suitable model and means of estimating its parameters. Literature in the area is extensive and the best introductions are by Witten *et al.* (1987), Langdon (1984) (with an interesting brief history of the approach) and IBM-1 and IBM-5 – note that these latter are two out of five linked papers which appeared in 1988 and were specifically directed at reporting the development of the Q-coder mentioned earlier; see also Langdon and Rissanen (1981).

The fundamental idea behind arithmetic coding is that the output can be regarded as a pointer to a magnitude lying in a certain interval of the real line, usually taken, for convenience, as being 0–1. The general idea is best illustrated by Witten *et al.* (1987). Consider, for example, four symbols a, b, c, d with respective probabilities 0.4, 0.3, 0.2, 0.1. To avoid ambiguity each is represented by a half-open interval, thus a lies within $0 \le p_a < 0.4$, written $[0, 0.4)$. The initial range is then $[0, 1)$, and messages are coded by successive division of the ordered range of cumulative probabilities $[0, 0.4, 0.7, 0.9, 1)$. Note that the representation is unique, independent of the division of the line in accordance with the probability set (IBM-5). It turns out, however, that such division results in maximum coding efficiency. Consider the message b, a, c, d. b lies within $[0.4, 0.7)$, the next symbol a lies within $[0, 0.4)$ and so restricts the current range to $[0.4, 0.4 + (0.7 - 0.4) \times 0.4) = [0.4, 0.52)$. The following symbol, c, lies in the interval $[0.7, 0.9)$ which, when scaled into $[0.4, 0.52)$ gives $[(0.4 + 0.12 \times 0.7), (0.4 + 0.12 \times 0.9))$, i.e. $[0.484, 0.508)$ and the last, d, originally in $[0.9, 1)$ gives the final interval $[0.5056, 0.508)$. Decoding proceeds by checking the final interval for its location on the line $[0, 1)$ and its scaled versions. Thus $[0.5056, 0.508)$ clearly lies within the range $[0.4, 0.7)$, indicating that the first symbol was b. This range will be divided by the (scaled) initial probability ordering into $[0.4, 0.52, 0.61, 0.67, 0.7)$; the second

symbol was consequently a, and so on. Obviously, any number in the final range [0.5056, 0.508) will suffice to represent the string b, a, c, d. Conventionally, but not necessarily, this is taken as the leftmost (lowest) end of the interval. At the end of coding, some means of indicating that the message has terminated is necessary, and although the general principle implies coding of the complete message followed by its transmission and then complete decoding, in practice a progressive mode of coding, transmission and decoding is preferable. Furthermore, as the coding proceeds and the current interval narrows, more precision (i.e. longer word length) is required for its representation; this is dealt with in the manner described below. At the same time, the most significant bits of the current interval become the same, and so can be transmitted anyway. With regard to possible under- and overflow effects, Witten *et al.* (1987) showed that there are simple relationships between the lengths of the words representing probability values, those representing code values and the overall arithmetic precision of the implementation which, if satisfied, guarantee that these conditions can never occur.

Langdon (1984) exposed the techniques and analysis of both multisymbol and binary arithmetic coding in some detail, and before considering the latter case more closely, it is worthwhile examining his binary fraction exposition of the four level case where $p_a = 1/2$, $p_b = 1/4$, $p_c = p_d = 1/8$, i.e. $p_a = .1$, $p_b = .01$, $p_c = p_d = .001$. The 0/1 line is divided as in Figure A1.2, where the

Figure A1.2 Binary fraction division of the 0/1 line. $p_a - 1/2$; $p_b - 1/4$; $p_c = p_d = 1/8$.

codewords again correspond to the cumulative probabilities (P_i) of the preceding symbols (note that Langdon's Figure 3 does not correspond with his Table 2 and textual discussion). Coding of the string a a b c gives the following values, where C indicates the code point and A the interval width, where C new = C old + A old × P_i; A new = A old × p_i.

Start: $C = 0$; $A = 1$.
Code "a": C new = $0 + .011 = .011$
 A new = $1 \times .1 = .1$
Code "a": C new = $.011 + .1 \times .011 = .1001$
 A new = $.1 \times .1 = .01$
Code "b": C new = $.1001 + .01 \times .001 = .10011$
 A new = $.01 \times .01 = .0001$
Code "c": C new = $.10011 + .0001 \times .111 = .1010011$
 A new = $.0001 \times .001 = .0000001$.

For decoding, an inverse operation similar to that described earlier is carried

out. Since the final string is .1010011, the first symbol must have been a, since the string lies wholly within the a interval .011–.111. We now subtract the a endpoint, .011 giving .0100011, and multiply by two to cancel the scaling which occurred in coding to give .100011. Thus the second symbol was also a, and so on.

It was mentioned earlier that one advantage of arithmetic coding is that it can be made adaptive and so track changing input statistics. A simple fixed model in which probabilities are taken on the basis of a training sequence (or even values which approximate to these, in which case the technique is still relatively efficient) can be replaced by an adaptive one with a resulting increase in performance. In this case both coder and decoder must have the same starting assumption (all initial probability values equal, for example), and use the same update algorithm.

Undoubtedly the most intensive study of the arithmetic coding concept has taken place in the binary context with the development by workers at IBM of the Q-coder (IBM 1–5, 1988). The binary application is not as restrictive as it may at first appear, of course, since selection of a symbol from a multisymbol alphabet can be decomposed into a series of binary decisions anyway. In this case there is a more and a less probable symbol (MPS, LPS), with respective probabilities P_e, Q_e. There are variants of the basic successive subdivision operation to suit either hardware or software implementations, but the general idea is as shown in Figure A1.3 for $P_e = 3/4$, $Q_e = 1/4$ and the sequence MPS, LPS, MPS, LPS. Fixed precision arithmetic is used, which means that a renormalisation step must be applied to both code string and interval, at coder and decoder, to maintain the present interval with sufficient accuracy. Carry propagation effects are controlled by bit-stuffing, a zero being inserted when a detected run of "1" bits reaches a predefined length. The scaling operation (multiplication) after each coding step can be avoided by keeping the renormalisation interval in the range $3/2 > A \geq -3/4$ and approximating $A \times Q_e$ by Q_e and $A \times P_e = A \times (1 - Q_e)$ by $A - Q_e$. This has a minimal effect on coding efficiency. Probability estimates for adaptivity are revised at renormalisation times only, as a compromise between estimating once per byte of compressed data and once per symbol coded, and the way in which renormalisation operates allows the coder to track changes in the LPS probability estimate. Allowed values of this estimate are extracted, via a 5 bit index, from a table of 30 constructed on the basis of modelling of binary and continuous grey-scale images. The word length is 12 bits and hence the smallest value is approximately 2^{-12}. In a hardware implementation completed (8 bit) bytes of code are buffered, and a 32 bit register contains low order bits of the string. Such an implementation is described in IBM-2 and a VLSI chip version in IBM-5.

Arithmetic coding has been used in numerous (too many to consider in detail here) image compression schemes as an alternative to Huffman coding for processing the final output datastream. Suffice it to mention only one or

Figure A1.3 Binary arithmetic coding for the sequence MPS, LPS, MPS, LPS.

two here. Vincent (1989) has used it to process the output of a Laplacian pyramid coder. One element of this in Vincent's implementation is a three level "sketch" signal which corresponds to the sign of the image components, -1, 0 or 1. This is decomposed into a stream of two variables indicating (a) whether the element is zero or not and (b) if it is non-zero whether it is positive or negative. For each decision the context (the values of neighbouring elements on the same or previous pyramid level) determines the estimated value of symbol probability, which is then approximated, for the least probable symbol, by 2^{-Q}, where Q is the so-called "skew" value. Useful quality images were achieved with this scheme at rates below $1/4$ bit element^{-1}. Gonzales *et al.* (1990) have used adaptive binary arithmetic coding in a

motion-compensated hybrid DCT/predictive scheme for storing compressed video to obtain better efficiency than that achieved by Huffman coding. Ghanbari (1991) used a locally adaptive arithmetic coder to process the output of an interframe predictive scheme with a seven level non-uniform quantiser and his results show interesting comparisons between Huffman coding (giving a constant rate of 1.57 bit element^{-1}), arithmetic coding and the signal long-term entropy $H = 1.37$ bit element^{-1}. In this case the number of symbols buffered, M, determines the degree of adaptivity of the coder. If this is large, the performance approaches H, as expected. As M reduces, local adaptivity comes into play, and the coding rate reaches a minimum (0.93 bit element^{-1}) for $M = 64$. Reducing M to small values degrades the probability estimate severely, and for $M = 4$ performance is worse than that of the Huffman scheme, reaching 2.2 bit element^{-1} for $M = 1$. For a reasonable amount of buffering, however, the figures graphically demonstrate the improvement to be gained over the long-term first order entropy by the use of adaptive arithmetic coding.

Appendix 2: The Future – Very Low Bit-rate Video and MPEG-IV

A2.1. INTRODUCTION

The whole thrust behind image coding over the past 40 years or so has been, not unnaturally, the desire to reduce the storage capacity or channel requirement for images or image sequences of even moderate resolution – the numerical details do not need to be restated here. During the decade of the 1980s it became apparent that successful image communication could be established at rates around $64\,\mathrm{kb\,s^{-1}}$ (despite the fact that it had been thought impossible prior to this), and it is somewhat surprising to be reminded nowadays (1994) that systems now available which achieve this in a commercial environment represent, in some respects at least, "old" technology! In parallel with this development came MPEG-I and MPEG-II, with coding rates up to $9–10\,\mathrm{Mb\,s^{-1}}$, hardly corresponding to the low-rate goal of the traditional image "coder" (and indeed removing the requirement for an originally postulated MPEG-III for low-rate coding of HDTV signals) but intended to satisfy the needs of users with a much wider range of applications in mind than H261 and yet, at the same time, to be far less "application specific" and so represent, in present day terminology, a "generic" coding strategy.

The ultimate goal of the picture coding enthusiast has always been to push the rate down to the minimum possible level whilst retaining at least usable image fidelity and it might be thought that, given what appeared to be a generally agreed lowest practicable rate for this operation, attention might shift to other areas of interest. Over the past few years, however, further areas of application have appeared which have led to a sustained interest in

very low-rate transmission, i.e. at rates even lower than $64\,\mathrm{kb\,s^{-1}}$. One obvious example is the provision of videotelephone facilities over the PSTN, rather than via an ISDN link; another is visual communication with mobile terminals (and portable devices generally). Two recent activities have served to highlight operation in this projected data rate region and are described below.

A2.2. VERY LOW BIT-RATE VIDEO (VLBV)

In March 1994 a 2 day workshop on very low bit-rate video was held at Essex University (UK) under the chairmanship of Professor Don Pearson of the Department of Electronic Systems Engineering with the involvement of British Telecom. This workshop derived both from the continuing series of highly successful Picture Coding Symposia and from a series of workshops on $64\,\mathrm{kb\,s^{-1}}$ coding of moving images which had ended as interest moved to coding at lower rates. Approximately 70 participants from 16 countries attended the workshop, presenting a total of 35 papers, the meeting starting with addresses from four keynote speakers and ending with a six member panel-led discussion session. General points emerging from the initial and final sessions were as follows.

(a) It was recognised that all-digital systems were the only ones properly satisfying all requirements (this is a general point relating more to the various proposals for enhanced/high definition television made over the past few years).

(b) There probably needs to be a "rethink" regarding approaches to coding rather than proceeding by making incremental changes to existing algorithms. This is more important than trying to meet the 1998 deadline for MPEG-IV (see below).

(c) At very low rates one should code image content and not individual picture elements (this is already recognised, of course, and arguably should apply to coding at all rates).

(d) The present concentration on coding head and shoulder images needs to be broadened to allow a much wider range of possible input material.

(e) Very low bit-rate video development would benefit greatly from input from experts in computer vision/animation, speech coding, etc. (this was emphasised at more than one point throughout the workshop – techniques such as three-dimensional motion estimation, feature extraction, stereoscopic approaches, study of facial expressions and personal gestures would all benefit from further examination).

(f) Applications might include security/surveillance (maybe making use of a higher spatial resolution, lower frame rate option), communication with

automatic teller machines in the personal financial services area, sign language communication for deaf people, teletext captions and games, as well as the two already mentioned, videotelephone over the PSTN at around $20\,\mathrm{kb\,s^{-1}}$ (with a question mark over the widespread availability of the suggested $28.8\,\mathrm{kb\,s^{-1}}$ rate on the network in general) and mobile video.

(g) The audio element is very important in the person-to-person context. Moreover the speech signal could be used to aid motion-compensated interpolation to lower the frame rate or even to drive the receiver model in a model-based context to give "zero-bit-rate" video!

(h) A particularly important consideration is the acceptable amount of delay in interactive usage.

(i) Acknowledging the explosive increase in the use of video, the boundaries between the different classes of communication are all the time becoming more and more blurred and, unlike the case of H261, where direct interworking is the norm, the MPEG standards represent "toolkits" which need "profiles" to aid specific applications. MPEG-IV should be no exception.

(j) With the rapid increase in availability of computing power, there is now the possibility of software decoding in which the decoder program is itself downloaded at the start of transmission.

As far as the papers presented at the workshop are concerned, classifiying them is in some instances conjectural, since often more than one technique is used in a given implementation. However a rough division is as shown in Table A2.1.

Table A2.1 Paper topics at the 1994 Very Low Bit-rate Coding Workshop.

Technique	Numbers of papers
Transforms	2
Prediction	1
Wavelets	3
Wavelet/VQ	3
Model-based (including all variants – object oriented, semantic, etc.)	12
Segmentation	7
Motion estimation	4
Iterated functions	1
Other topics	2

This division reflects various more or less fundamental considerations in moving to very low rates:

(1) For constrained applications model-based (analysis/synthesis etc.)

techniques already offer rates in the kilobits per second region – the challenge here is to widen the spread of possible input material.

(2) Segmentation algorithms have the advantage of being non-block based and [as for (1) above] may be expected to benefit strongly from more input from computer vision specialists.

(3) Motion estimation techniques will benefit from further attention – specifically, accurate tracking of three-dimensional object motion, maybe with the help of stereoscopic techniques.

(4) Block-based techniques (transforms, vector quantisation, etc.) have little role to play in this bit-rate region, even if combined with wavelet or sub-band decomposition.

(5) Given the overwhelming recent interest in iterated function ("fractal") algorithms, one might have expected more representation here.

Certainly at the moment very impressive results have been demonstrated using analysis/synthesis of head models with computer animation techniques. It was salutary to be reminded by Professor H. Musmann (University of Hannover, Germany), however, that in 1851 (yes – 1851 not 1951!) a facial mask model was demonstrated, the expression of which could be varied by electrical excitation of embedded magnetic strips to allow the spelling-out of the alphabet. Maybe it really is true that there is nothing new under the sun!

A2.3. MPEG-IV

A2.3.1. Introduction

The other recent activity of significance in the low-rate context is the setting-up of the MPEG-IV activity for coding at rates between 4.8 and $64\,\mathrm{kb\,s^{-1}}$, ideas for which began to take shape in 1991, with formal approval in July 1993. A first call for proposals is expected in November 1994 and the projected date for standard status is November 1998 (note that an ITU rec-ommendation is expected to be made in 1995 for low bit-rate visual tel-ephony). As in previous MPEG standardisation activities MPEG-IV is intended to be generic (i.e. application independent), with the video coding closely associated with parallel audio coding in an integrated development. Again, standardisation concentrates upon the decoder with the minimum requirements which will permit interworking, and is intended to take place *a priori*, i.e. in advance of possible market competition between various more or less *ad hoc* developments by separate industrial or telecommunications concerns. The basis for the call for proposals is the first draft of the MPEG-IV requirements (WG11 N0711, March 1994, kindly made available at the VLBV94 meeting by Professor L. Chiariglione of CSELT, Italy), which are briefly sketched out below, although at this stage (April 1994) many details

remain to be filled in, and the tentative items mentioned here may or may not remain after the formal definition stage (July 1994). It is unlikely, however, that the more basic "mainstream" requirements will change significantly.

A2.3.2. System Requirements

(1) Audio and video to be roughly "matched" in quality.

(2) Delay should be significantly reduced (if possible) from the present typical value of 500–700 ms (noted as important at VLBV94).

(3) Differential delay between audio and video should be controlled as it is, if over 300 ms, detrimental to conversational applications.

(4) Audio/video rates should be exchangeable.

(5) If applications include use of digital storage media (DSM) then pause/forward/backward/slow motion modes should be available (as before), possibly with editing facilities.

(6) Interworking with PSTN and mobile voice-only systems is essential, also with LANs.

(7) Security provision for applications such as tele-banking and tele-shopping should be possible.

A2.3.3. Video Requirements

(1) Input must not be specific, i.e. a wide variety of scenic material should be acceptable to the (generic) algorithm which may include, however, special modes for head and shoulders scenes, groups of people (videoconference) and graphics, text and drawings (graphics primitives should be directly decodable).

(2) Resolution could be CIF or QCIF with possibly a smaller "fall-back" mode. Spatial and temporal resolutions need to be exchangeable, with a higher resolution still picture facility and a minimum frame rate (7 Hz?) for conversational use.

(3) Colour and black and white modes should be available.

(4) Quality should be significantly better than that provided by "conventional" schemes at the same rate(s). For conversational use recognition of faces and associated emotional states could be a useful measure.

(5) Decoder complexity should be as low as possible.

(6) A stereoscopic video mode should be available.

A2.3.4. Audio Requirements

Similar (tentative) parallel requirements to the above exist in the case of audio covering speech (usually interactive), music (normally non-interactive),

artificial speech and computer-generated music [instrument control via decoded musical instrument digital interface (MIDI) interface signals]. The single most important requirement is quality – intelligibility, naturalness (fidelity), voice/emotion recognition, maybe speaker verification (a demanding requirement).

A2.3.5. General Comments

It is obvious that there is more than enough even in these tentative requirements to exercise to the full the skills of research workers over the next 4 years or so. Maybe, however, some of the desirable features are incapable of realisation in any case for more or less fundamental reasons – only time will tell.

References

Aach, T., Franke, U. and Mester, R. (1989) Top-down image segmentation using object detection and contour relaxation. *ICASSP Proc.* pp. 1703–1706.

Abdelwahab, A. A. and Kwatra, S. C. (1986) Image data compression with vector quantization in the transform domain. *Int. Commun. Conf. ICC86 Proc.* 41.2.1–41.2.5.

Abdelqader, I. M. and Rajala, S. A. (1992) Energy minimization approach to motion estimation. *Signal Process.* **28**, 291–309.

Abdou, I. K. and Pratt, W. K. (1979) Quantitative design and evaluation of enhancement/thresholding edge detectors. *IEEE Proc.* **67**, 753–763.

ACM (1991) Special Issue: Standards and the emergence of multimedia systems. *Commun. ACM* **34**, April.

Agawa, H., Xu, G., Nagashima, Y. and Kishino, F. (1990) Image analysis for face modeling and facial image reconstruction. *SPIE Proc.* **1360**, 1184–1197.

Aghagolzadeh, S. and Ersoy, O. K. (1991) Optimal adaptive multistage image transform coding. *IEEE Trans. Circuits Syst. Video Techn.* **1**, 308–317.

Ahmad Fadzil, M. H. and Dennis, T. J. (1990) Sample selection in subband vector quantization. *ICASSP Proc.* pp. 2085–2088.

Ahmed, N., Natarajan, T. and Rao, K.R. (1974) Discrete cosine transform. *IEEE Trans Comput.* **C-23**, 90–93.

Ahmed, N. and Rao, K. R. (1975) *Orthogonal Transforms for Digital Signal Processing.* Springer, Berlin and New York.

Aizawa, K., Harashima, H. and Miyakawa, H. (1986) Adaptive discrete cosine transform coding with vector quantization for color images. *ICASSP Proc.* pp. 985–988.

Aizawa, K., Harashima, H. and Saito, T. (1989) Model-based analysis synthesis image coding (MBASIC) system for a person's face. *Signal Process: Image Commun.* **1**, 139–152.

Akansu, A. N. and Haddad, R. A. (1992) *Multiresolution Signal Decomposition: Transforms, Subbands and Wavelets.* Academic Press, San Diego.

Akansu, A. N., Haddad, R. A. and Caglar, H. (1990) Perfect reconstruction binomial QMF-wavelet transform. *SPIE Proc.* **1360**, 609–618.

Akansu, A. N. and Kadur, M. S. (1989) Discrete Walsh–Hadamard transform vector quantization for motion-compensated frame difference signal coding. *ICASSP Proc.* pp. 1862–1865.

Akansu, A. N. and Kadur, M. S. (1990) Subband coding of video with adaptive vector quantization. *ICASSP Proc.* pp. 2109–2112.

Akansu, A. N. and Wadas, F. E. (1992) On lapped orthogonal transforms. *IEEE Trans. Signal Process.* **SP-40**, 439–443.

Akiyama, T., Takahashi, T. and Takahashi, K. (1990) Adaptive three-dimensional transform coding for moving pictures. *Proc. Picture Coding Symp.* Cambridge, MA, 26–28 March, Paper 8.2.

Alexander, S. T. and Rajala, S. A. (1984) Optimal gain derivation for the LMS algorithm using a visual fidelity criterion. *IEEE Trans. Acoust, Speech, Signal Process.* **ASSP-32**, 434–437.

Alexander, S. T. and Rajala, S. A. (1985) Image compression results using the LMS

adaptive algorithm. *IEEE Trans. Acoust. Speech, Signal Process.* **ASSP-33**, 712–714.

Allott, D. and Clarke, R. J. (1984) Activity controlled multi-stage gain shape vector quantisation of images. *Proc. Int. Conf. on Comput. and Signal Process.* Bangalore, India, December, pp. 428–431.

Allott, D. and Clarke, R. J. (1985) Shape adaptive activity controlled multi-stage gain shape vector quantisation. *Electron. Lett.* **21**, 393–395.

Alparone, L., Benelli, G. and Fabbri, F. (1990) Performance evaluation of high resolution image compression in presence of transmission noise. *EUSIPCO Proc.*, pp. 869–872.

Alter-Gartenberg, R. and Narayanswamy, R. (1990) Image coding by edge primitives. *SPIE Proc.* **1360**, 1608–1619.

Anastassiou, D., Mitchell, J. L. and Pennebaker, W. B. (1986) Gray scale image coding for freeze-frame videoconferencing. *IEEE Trans. Commun.* **COM-34**, 382–394.

Andrews, H. C. and Pratt, W. K. (1968) Television bandwidth reduction by encoding spatial frequencies. *J. SMPTE* **77**, 1279–1281.

Ang, P. H., Ruetz, P. A. and Auld, D. (1991) Video compression makes big gains. *IEEE Spectrum Magazine,* **28**, October, pp. 16–19.

Antonini, M., Barlaud, M. and Mathieu, P. (1991) Image coding using lattice vector quantization of wavelet coefficients. *ICASSP Proc.* 2273–2276.

Antonini, M., Barlaud, M., Mathieu, P. and Daubechies, I. (1992) Image coding using the wavelet transform. *IEEE Trans. Image Proc.* **1**, 205–220.

Antonini, M., Barlaud, M., Mathieu, P. and Feauveau, J. C. (1990) Multiscale image coding using the Kohonen neural network. *SPIE Proc.* **1360**, 14–26.

Aravind, R. and Gersho, A. (1986) Low-rate image coding with finite-state vector quantization. *ICASSP Proc.* pp. 4.3.1–4.3.4.

Arce, G. R. and Gallagher, N. C., Jr. (1982) State description for the root-signal set of median filters. *IEEE Trans. Acoust. Speech, Signal Process.* **ASSP-30**, 894–902.

Arce, G. R. and Gallagher, N. C., Jr. (1983) BTC image coding using median filter roots. *IEEE Trans Commun.* **COM-31**, 784–793.

Argenti, F., Benelli, G. and Mecocci, A. (1993) Source coding and transmission of HDTV images compressed with the wavelet transform. *IEEE J. Selected Areas Commun.* **11**, 46–58.

Bae, J. J. and Suda, T. (1991) Survey of traffic control schemes and protocols in ATM networks. *IEEE Proc.* **79**, 170–189.

Bage, M. J. (1986) Interframe predictive coding of images using hybrid vector quantization. *IEEE Trans. Commun.* **COM-34**, 411–415.

Baker, R. L. and Gray, R. M. (1983) Differential vector quantization of achromatic imagery. *Proc. Picture Coding Symp.* Davis, CA, March 1983. pp. 105–106.

Baker, R. L. and Shen, H. (1987) A finite-state vector quantizer for low-rate image sequence coding. *ICASSP Proc.* pp. 760–763.

Barba, D. and Hanen, J. (1991) The use of a human visual model in sub-band voding of color video signal with adaptive chrominance signal vector quantization. *SPIE Proc.* **1605**, 408–419.

Barnsley, A. D. and Sloan, A. D. (1988) A better way to compress images. *BYTE Magazine*, January, pp. 215–223.

Barnsley, M., Ervin, V., Hardin, D. and Lancaster, J. (1986) Solution of an inverse problem for fractals and other sets. *Proc. Natl. Acad. Sci.* **83**, 1975–1977.

Baskurt, A. and Goutte, R. (1989) Encoding the location of spectral coefficients using quadtrees in transform image compression. *ICASSP Proc.* pp. 1842–1845.

Baskurt, A., Prost, R. and Goutte, R. (1989) Iterative constrained restoration of DCT-compressed images. *Signal Process.* **17**, 201–211.

Beale, R. and Jackson, T. (1990) *Neural Computing – an introduction.* IOP Publishing, Bristol.

Beaumont, J. M. (1988) The RIBENA Algorithm – Recursive predictive still picture coding. British Telecom Memo RT4343/88/14.

Beaumont, J. M. (1990) Advances in block based fractal coding of still pictures. IEE Colloq. *The Application of Fractal Techniques in Image Processing.* London, December 1990, pp. 3-1–3-6.

Beaumont, J. M. (1991) Image data compression using fractal techniques. *BT Technol. J.* **9**, 93–109.

Beek, P. J. L. van, Reinders, M. J. T., Sankur, B. and van der Lubbe, J. C. A. (1992a) Semantic segmentation of videotelephone image sequences. *SPIE Proc.* **1818**, 1182–1193.

Beek, P. J. L. van, Sankur, B. and van der Lubbe, J. C. A. (1992b) Contour extraction and matching for image sequence coding. *Proc. Fourth IEE Conf. on Image Process.* Maastricht, Netherlands, 7–9 April, pp. 109–114.

Bei, C. D. and Gray, R. M. (1985) An improvement of the minimum distortion encoding algorithm for vector quantization. *IEEE Trans. Commun.* **COM-33**, 1132–1133.

Benois, J. and Barba, D. (1992) Image segmentation by region-contour cooperation as a basis for efficient coding scheme. *SPIE Proc.* **1818**, 1218–1229.

Bergen, J. R., Burt, P. J., Hingorani, R. and Peleg, S. (1992) A three-frame algorithm for estimating two-component motion. *IEEE Trans. Pattern Anal. Machine Intell.* **14**, 886–896.

Berger, T. (1971) *Rate Distortion Theory.* Prentice-Hall, Englewood Cliffs, New Jersey.

Berger, L., Mariot, J-P. and Launay, C (1992) A new formulation for fast image coding using quadtree representation. *Patt. Rec. Lett.* **13**, 425–432.

Bergmann, H. C. (1982) Displacement estimation based on the correlation of image segments. *IEE First Int. Conf. on Image Processing.* York, 26–28 July, pp. 215–219.

Bially, T. (1969) Space filling curves: their generation and their application to bandwidth reduction. *IEEE Trans. Inf. Theory,* **IT-15**, 658–664.

Biemond, J., Looijenga, L., Boekee, D. E. and Plompen, R. H. J. M. (1987) A pel-recursive Wiener-based displacement estimation algorithm. *Signal Process.* **13**, 399–412.

Bierling, M. (1988) Displacement estimation by hierarchical blockmatching. *SPIE Proc.* **1001**, 942–951.

Biggar, M. J. and Constantinides, A. G. (1988) Segmented video coding. *ICASSP Proc.* pp. 1108–1111.

Biggar, M. J., Morris, O. J. and Constantinides, A. G. (1988) Segmented-image coding: performance comparison with the discrete cosine transform. *IEE Proc. Part F. Commun. Radar, Signal Process.* **135**, 121–132.

Bleja, M. and Domanski, M. (1990) Subband coding of monochrome images using nonseparable recursive filters. *EUSIPCO Proc.* Barcelona, Spain, 18–21 September, pp. 841–844.

Boch, J. (1990) The influence of transmission errors on the reconstructed quality of transform coded image data. Final Year Honours Project Report. Heriot-Watt University, Department of Electrical and Electronic Engineering.

Bocker, G. J. A. (1988) Conjugate quadrature filters as an alternative for quadrature mirror filters for subband coding of images. M.Sc. Thesis, Technische Universiteit Delft.

Boekee, D. E., Westerink, P. H., Weber, J. H. and Limpers, J. W. (1990) Adaptive channel error protection of sub-band coded images. *Proc. Picture Coding Symp.* Cambridge, MA, 26–28 March, Paper 10.4.

Boroczky, L., Driessen, J. N. and Biemond, J. (1990) Adaptive algorithms for pel-recursive displacement estimation. *SPIE Proc.* **1360**, 1210–1221.

Bottemiller, R. L. (1992) Comments on "A new vector quantization clustering algorithm". *IEEE Trans. Signal Process.* **SP-40**, 455–456.

Boucher, P. and Goldberg, M. (1984) Color image compression by adaptive vector quantization. *ICASSP Proc.* pp. 29.6.1–29.6.4.

Bowling, C. D. and Jones, R. A. (1985) Motion compensated image coding with a combined maximum "a posteriori" and regression algorithm. *IEEE Trans. Commun.* **COM-33**, 844–857.

Boxerman, J. L. and Lee, H. J. (1990a) Variable block-sized vector quantization of grayscale images with unconstrained tiling. *SPIE Proc.* **1360**, pp. 847–858.

Boxerman, J. L. and Lee, H. J. (1990b) Variable block-sized vector quantization of grayscale images with unconstrained tiling. *ICASSP Proc.* pp. 2277–2280.

Braccini, C., Curinga, S., Grattarola, A. and Lavagetto, F. (1993) 3D modelling of human heads from multiple views. *Conf. Image Process. Theory and Applic.* San Remo, Italy, 14–16 June, pp. 131–136.

Breeuwer, M. (1990) Full-search versus tree-search vector quantization of discrete cosine transform coefficients. *EUSIPCO Proc.* Barcelona, Spain, 18–21 September, pp. 1095–1098.

Brewster, R. L. and Dodgson, T. E. (1988) Effect of channel errors on source coded image data and the provision of adequate protection of transmission bits. *IEE Proc. Part F, Commun. Radar, Signal Process.* **135**, 528–538.

Brofferio, S. C. (1989) An object-background image model for predictive video coding. *IEEE Trans. Commun.* **COM-37**, 1391–1394.

BT TECHNOL. (1990) Special Issue on Audiovisual Telecommunications. *BT Technology J.* **8**, July.

Budrikis, Z. L. (1972) Visual fidelity criterion and modelling. *IEEE Proc.* **60**, 771–779.

Burt, P. J. and Adelson, E. H. (1983) The Laplacian pyramid as a compact image code. *IEEE Trans. Commun.* **COM-31**, 532–540.

Butz, A. R. (1971) Alternative algorithm for Hilbert's space filling curve. *IEEE Trans. Comput.* **C-20**, 424–426.

Buzo, A., Gray, A. H. Jr., Gray, R. M. and Markel, J. D. (1980) Speech coding based upon vector quantization. *IEEE Trans. Acoust. Speech, Signal Process.* **ASSP-28**, 562–574.

Cafforio, C. and Rocca, F. (1976) Methods for measuring small displacements of television images. *IEEE Trans. Inf. Theory.* **IT-22**, 573–579.

Cafforio, C. and Rocca, F. (1983) The differential method for motion estimation. In: *Image Sequence Processing and Dynamic Scene Analysis* (edited by Huang, T. S.), pp. 104–124. Springer-Verlag, Berlin.

Cafforio, C., Rocca, F. and Tubaro, S. (1990) Motion compensated image interpolation. *IEEE Trans. Commun.* **COM-38**, 215–222.

Cai, D. and Chen, Y. (1990) DS-DCT – Double shift DCT image coding for low bit rate image transmission. *SPIE Proc.* **1360**, 879–887.

Carl, J. W. (1987) Quantitative fidelity criterion for image processing applications. *SPIE Proc.* **858**, 2–8.

Cassereau, P. M., Staelin, D. H. and de Jager, G. (1989) Encoding of images based on a lapped orthogonal transform. *IEEE Trans. Commun.* **COM-37**, 189–193.

CCIR (1990) *Encoding Parameters of Digital Television for Studios.* CCIR Rec-

ommendation 601, **XI**, pp. 95–104. *Interfaces for Digital Component Video signals in 525 and 625-line Television Systems.* CCIR Recommendation 656, **XI**, 105–117.

Cetin, A. E. and Weerackody, V. (1988) Design vector quantizers using simulated annealing. *IEEE Trans. Circuits. Syst.* **CAS-35**, p. 1550.

Chae, S. B., Kim, J. S. and Park, R. H. (1993) Video coding by segmenting motion vectors and frame differences. *Opt. Eng.*, **32**, 870–876.

Cham, W. K. and Clarke, R. J. (1986) The application of the principle of dyadic symmetry to the generation of orthogonal transforms. *IEE Proc. Part F, Commun. Radar Signal Process.* **133**, 264–270.

Cham, W. K. and Clarke, R. J. (1987) Dyadic symmetry and Walsh matrices. *IEE Proc. Part F, Commun. Radar Signal Process.* **134**, 141–145.

Chang, K. Y. and Donaldson, R. W. (1972) Analysis, optimization and sensitivity study of differential PCM systems operating on noisy communication channels. *IEEE Trans. Commun.* **COM-20**, 338–350.

Chang, M., Langdon, G. G. and Murphy, J. L. (1992a) Compression aspects of JPEG image compression. *SPIE Proc.* **1657**, 159–168.

Chang, R. F., Chen, W. T. and Wang, J. S. (1992b) A fast finite state-algorithm for vector quantizer design. *IEEE Trans Signal Process.* **40**, 221–225.

Chang, R. F., Chen, W. T. and Wang, J. S. (1992c) Image sequence coding using adaptive tree-structured vector quantisation with multipath searching. *IEE Proc. Part I, Commun. Speech, Vision.* **139**, 9–14.

Chen, C. F. and Pang, K. K. (1992) Hybrid coders with motion compensation. *Multidimen. Syst, Signal Process.* **3**, 241–266.

Chen, C. T. (1989) Adaptive transform coding via quadtree-based variable blocksize DCT. *ICASSP Proc.* pp. 1854–1857.

Chen, C. T. (1993) Video Compression: Standards and Applications. *J. Vis. Commun. Image Repres.* **4**, 103–111.

Chen, C. T. and Wong, A. (1993) A self-governing rate buffer control strategy for pseudoconstant bit rate video coding. *IEEE Trans. Image Proc.* **IP2**, 50–59.

Chen, C. T. C. and Le Gall, D. J. (1988) Adaptive transform coding for high- fidelity reconstruction of still images. *Proc. Picture Coding Symp.* Torino, Italy, 12–14 September, Paper 6.2.

Chen, D. and Bovik, A. C. (1990) Visual pattern image coding. *IEEE Trans Commun.* **COM-38**, 2137–2146.

Chen, D. and Bovik, A. C. (1992) Hierarchical visual pattern image coding. *IEEE Trans. Commun.* **COM-40**, 671–675.

Chen, T. C. (1990) A lattice vector quantization using a geometric decomposition. *IEEE Trans. Commun.* **COM-38**, 704–714.

Chen, W. H. and Pratt, W. K. (1984) Scene Adaptive Coder. *IEEE Trans. Commun.* **COM-32**, 225–232.

Chen, W. H. and Smith, C. H. (1977) Adaptive coding of monochrome and color images. *IEEE Trans. Commun.* **COM-25**, 1285–1292.

Chen, W. T., Chang, R. F. and Wang, J. S. (1992) Image sequence coding using adaptive finite-state vector quantization. *IEEE Trans. Circuit Syst. for Video Techn.* **2**, 15–24.

Cheng, D. Y. and Gersho, A. (1986) A fast codebook search algorithm for nearest neighbour pattern matching. *ICASSP Proc.* pp. 6.14.1–6.14.4.

Cheng, D. Y., Gersho, A., Ramamurthi, B. and Shoham, Y. (1984) Fast search algorithms for vector quantization and pattern matching. *ICASSP Proc.* pp. 9.11.1–9.11.4.

Cheng, N. T. and Kingsbury, N. G. (1992) The ERPC: an efficient error-resilient

technique for encoding positional information or sparse data. *IEEE Trans. Commun.* **COM-40**, 140–148.

Chiariglione, L., Fontolan, S., Guglielmo, M. and Tommasi, F. (1987) A variable resolution video codec for low bit-rate applications. *IEEE J. Selected Areas Commun.* **SAC-5**, 1184–1189.

Chin, H. S., Goodge, J. W., Griffiths, R. and Parish, D. J. (1989) Statistics of video signals for viewphone-type pictures. *IEEE J. Selected Areas Commun.* **7**, 826–832.

Chitprasert, B. and Rao, K.R. (1990) Human visual weighted progressive image transmission. *IEEE Trans. Commun.* **COM-38**, 1040–1044.

Choi, C. S., Harashima, H. and Takebe, T. (1991) Analysis and synthesis of facial expressions in knowledge-based coding of facial image sequences. *ICASSP Proc.* pp. 2737–2740.

Choi, W. Y., Park, R-H. (1989) Motion vector coding with conditional transmission. *Signal Process.* **18**, 259–267.

Chou, P. A., Lookabaugh, T. and Gray, R. M. (1989) Optimal pruning with applications to tree-structured source coding and modeling. *IEEE Trans. Inf. Theory.* **IT-35**, 299–315.

Chow, H. K. and Liou, M. L. (1993) Genetic motion search algorithm for video compression. *IEEE Trans. Circuits Syst. Video Techn.* **3**, 440–445.

Chua, K. C., Wong, W. C. and Ngan, K. N. (1990) Error detection and correction of vector quantised digital images. *IEE Proc. Part I, Commun. Speech, Vision,* **137**, 417–423.

Chua, L. O., Lin, T. (1988) A neural network approach to transform coding. *Int. J. Ckt. Theory Appl.* **16**, 317–324.

Chui, C. K. (1992) *Wavelets: A Tutorial in Theory and Applications.* Academic Press. San Diego.

Chung, Y.S. and Kanefsky, M. (1992) On 2–D recursive LMS algorithms using ARMA prediction for ADPCM coding of images. *IEEE Trans. Image Proc.* **1**, 416–422.

Clark, W. J., Lewis, D. E. and Lee, B. (1993) ISDN desktop conferencing with the multipoint interactive audio-visual system. *BT Technol. J.* **11**, 19–27.

Clarke, R. J. (1981) On the relation between the Karhunen–Loeve and Cosine Transforms. *IEE Proc. Part F: Commun. Radar Signal Process.* **128**, 359–360.

Clarke, R. J. (1983) Spectral response of the discrete cosine and Walsh–Hadamard transforms. *IEE Proc. Part F: Commun. Radar Signal Process.* **130**, 309–313.

Clarke, R. J. (1984a) Hybrid Intraframe Coding of Image Data. *IEE Proc. Part F: Commun. Radar Signal Process.* **131**, 2–6.

Clarke, R. J. (1984b) The application of image covariance models to transform coding. *Int. J. Electron.* **56**, 245–260.

Clarke, R. J. (1985a) *Transform coding of Images.* Academic Press, San Diego.

Clarke, R. J. (1985b) On the dynamic range of coefficients generated in the transform processing of digitised data. *Proc. IEE Part F: Commun. Radar Signal Process.* **132**, 107–110.

Clarke, R. J. (1992a) On transform coding of motion-compensated difference images. *Proc IEE Part I, Commun. Speech, Vision.* **139**, 372–376.

Clarke, R. J. (1992b) Low rate coding of multilevel image data – an overview. *Proc. Fourth IEE Int. Conf. on Image Processing and its Applications.* Maastricht, Netherlands, 7–9 April, pp. 9–12.

Clarke, R. J. and Allott, D. (1986) Adaptive vector quantisation of monochrome and colour images. *Proc. 2nd IEE Int. Conf. on Image Processing and its Applications,* London, 24–26 June, pp. 17–20.

Clarke, R. J. and Cordell, P. (1988) Coding of moving image sequences by recursive

binary nesting. *Proc. Int. Picture Coding Symp.* Torino, Italy, 12–14 September, Paper 13.11.

Clarke, R. J. and Linnett, L. M. (1993) Fractals and image representation. *IEE Electron. Commun. Eng. J.* **5**, 233–239.

Clarke, R. J. and Yao, S. (1993) Image compression with visual features using wavelets. *Proc 6th Canadian Conf. on Electrical and Computer Eng.* Vancouver, 14–17 September, pp. 159–162.

Cohen, L. (1989) Time–frequency distributions – a review. *IEEE Proc.* **77**, 941–981.

Cohen, R. A. and Woods, J. W. (1989) Sliding block entropy coding of images. *ICASSP Proc.* 1731–1734.

Collins, P. V. (1983) Segmentation and texture analysis for very low bit-rate coding. *Proc. Picture Coding Symp.* Davis, CA, 28–30 March, pp. 111–112.

Conway, J. H. and Sloane, N. J. A. (1981) Fast 4- and 8-dimensional quantizers and decoders. *Proc. IEEE Natl. Telecomm. Conf.* November/December 1981, pp. F4.2.1–F4.2.4.

Conway, J. H. and Sloane, N. J. A. (1982a) Voronoi regions of lattices, second moments of polytopes, and quantization. *IEEE Trans. Inf. Theory*, **IT-28**, 211–226.

Conway, J. H. and Sloane, N. J. A. (1982b) Fast quantizing and decoding algorithms for lattice quantizers and codes. *IEEE Trans. Inf. Theory*, **IT-28**, 227–232.

Corbett, I. (1990) Moving pictures – image processing for telecommunications. *IEE Review*, July/August, pp. 257–261.

Cordell, P. J. and Clarke, R. J. (1989a) Use of recursive binary nesting for coding moving image sequences. *Electron. Lett.* **25**, 362–363.

Cordell, P. J. and Clarke, R. J. (1989b) An interpolative spatial domain technique for coding image sequences. *ICASSP Proc.* pp. 1917–1920.

Cordell, P. J. and Clarke, R. J. (1990a) Block testing in a variable resolution spatially interpolative moving image sequence coder. *SPIE Proc.* **1360**, pp. 503–511.

Cordell, P. J. and Clarke, R. J. (1990b) Efficient structures for a hybrid spatial domain moving sequence coder. *Proc. Int. Picture Coding Symp.* Cambridge, MA, 26–28 March, Paper 10.5.

Cordell, P. J. and Clarke, R. J. (1992) Low bit-rate image sequence coding using spatial decomposition. IEE Proc. Part I. Commun Speech, Vision, **139**, 575–581.

Corte-Real, L. and Alves, A. P. (1990) Vector quantisation of image sequences using variable size and variable shape blocks. *Electron. Lett.* **26**, 1483–1484.

Cosman, P. C., Davidson, H. C., Bergin, C. J., Tseng, C.W., Moses, L. E., Riskin, E. A., Olshen, R. A. and Gray, R. M. (1994) Thoracic CT images: effect of lossy image compression on diagnostic accuracy. *Radiology.* **190**, 517–524.

Cosman, P. C., Perlmutter, K. O., Perlmutter, S. M., Olshen, R. A. and Gray, R. M. (1991) Training sequence size and vector quantizer performance. *Conf. Rec. 25th Asilomar Conf. on Signals, Syst. and Comp.* Pacific Grove, CA, 4–6 November, pp. 434–438.

Crochiere, R. E. and Rabiner, L. R. (1981) Interpolation and decimation of digital signals – a tutorial review. *IEEE Proc.* **69**, 300–331.

Crochiere, R. E. and Rabiner, L. R. (1983) *Multirate Digital Signal Processing.* Englewood Cliffs, NJ. Prentice-Hall.

Crochiere, R. E., Webber, S. A. and Flanagan, J. L. (1976) Digital coding of speech in sub-bands. *Bell Syst. Tech. J.* **55**, 1069–1085.

Cutler, C. C. (1952) Differential Quantization of Communication Signals. U.S. Pat., No. 2,605,361, 29 July.

Darragh, J. C. and Baker, R. L. (1989) Fixed distortion subband coding of images for packet-switched networks. *IEEE J. Selected Areas in Commun.* **7**, 789–800.

Das, M. and Loh, N. K. (1992) New studies on adaptive predictive coding of images using multiplicative autoregressive models. *IEEE Trans. Image Proc.* **1**, 106–110.

Daubechies, I. (1988) Orthonormal bases of compactly supported wavelets. *Commun. Pure Appl. Math.* **41**, 909–996.

Daubechies, I. (1990) The wavelet transform, time-frequency localization and signal analysis. *IEEE Trans. Inf. Theory.* **IT-36**, 961–1005.

Daugman, J. G. (1988) Complete discrete 2–D Gabor transforms by neural networks for image analysis and compression. *IEEE Trans. Acoust. Speech, Signal Process.* **ASSP-36**, 1169–1179.

Davidson, C. (1994) Darlings, clones, you were wonderful. . . . *New Scientist* **142**, 14 May, pp. 31–33.

Delp, E. J. and Mitchell, O. R. (1979) Image compression using block truncation coding. *IEEE Trans. Commun.* **COM-27**, 1335–1342.

Delp, E. J. and Mitchell, O. R. (1991) The use of block truncation coding in DPCM image coding. *IEEE Trans. Signal Process.* **39**, 967–971.

Denatale, F. G. B., Desoli, G. S. and Giusto, D. D. (1991) Hierarchical image coding via. mse-minimising bilinear approximation. *Electron. Lett.* **27**, 2035–2036.

Dennis, T. J. and Dessipris, N. G. (1989) Fractal modelling in image texture analysis. *IEE Proc. Part F. Commun. Radar, Signal Process.* **136**, 227–235.

DeVore, R. A., Jawerth, B. and Lucier, B. J. (1992) Image compression through wavelet transform coding. *IEEE Trans. Inf. Theory.* **IT-38**, 719–746.

Dianat, S. A., Nasrabadi, N. M. and Venkataraman, S. (1991) A non-linear predictor for differential pulse-code encoder (DPCM) using artificial neural networks. *ICASSP Proc.* pp. 2793–2796.

Diehl, N. (1991) Object-oriented motion estimation and segmentation in image sequences. *Signal Process: Image Commun.* **3**, 23–56.

Dixit, S. S. and Feng, Y. (1989) Adaptive vector quantization of video for packet switched networks. *ICASSP Proc.* pp. 1870–1873.

Driessen, J. N., Belfor, R. A. F. and Biemond, J. (1990) Backward predictive motion compensated image sequence coding. *EUSIPCO Proc.* pp. 757–760.

Driessen, J. N., Biemond, J. and Boekee, R.E. (1989) A pel-recursive segmentation and estimation algorithm for motion compensated image sequence coding. *ICASSP Proc.* pp. 1901–1904.

Driessen, J. N., Boroczky, L. and Biemond, J. (1991) Pel-recursive motion field estimation from image sequences. *J. Visual Commun. Image Repres.* **2**, 259–380.

Dubois, E. (1985) The sampling and reconstruction of time-varying imagery with application in video systems. *IEEE Proc,* **73**, 502–522.

Dubois, E. (1992) Motion-compensated filtering of time-varying images. *Multidimen. Syst. Signal Process.* **3**, 211–239.

Dudley, H. (1958) Phonetic pattern recognition vocoder for narrow-band speech transmission. *J. Acoust. Soc. Amer.* **30**, 733–739.

Dufaux, F. and Kunt, M. (1992) Multigrid block matching motion estimation with adaptive local mesh refinement. *SPIE Proc.* **1818**, 97–109.

Dunham, M. O. and Gray, R. M. (1985) An algorithm for the design of labeled-transition finite-state vector quantizers. *IEEE Trans. Commun.* **COM-33**, 83–89.

Ebrahimi, T., Reed, T. R. and Kunt, M. (1990a) Sequence coding by Gabor decomposition. *EUSIPCO Proc.* pp. 769–776.

Ebrahimi, T., Reed, T. R. and Kunt, M. (1990b) Video coding using a pyramidal Gabor expansion. *SPIE Proc.* **1360**, pp. 489–502.

Eddins, S. L. and Smith, M. J. T. (1990) A three-source multirate model for image compression. *ICASSP Proc.* pp. 2089–2092.

Efrati, N. and Liciztin, H. (1991) Classified block truncation-vector quantization: an

edge sensitive image compression algorithm. *Signal Process: Image Commun.* **3**, 275–283.

Efstratiadis, S. N. and Katsaggelos, A. K. (1990) A model-based pel-recursive motion estimation algorithm. *ICASSP Proc.* pp. 1973–1976.

Ekman, P. and Friesen, W. V. (1977) *Manual for the Facial Action Coding System.* Consulting Psychologist Press, Palo Alto, CA.

Electron. World (1992) FRACTALS transform image compression. *Electronics World and Wireless World* **March**: 208–211.

Elliot, D. F. and Rao, K. R. (1983) *Fast Transforms, Algorithms, and Applications.* Academic Press, New York.

Elnahas, S. E. (1988) Receiver operating characteristics for transform progressive coding. *Proc Picture Coding Symp.* Torino, Italy, 12–14 September, Paper 13.3.

Equitz, W. H. (1989) A new vector quantization clustering algorithm. *IEEE Trans. Acoust. Speech, Signal Process.* **ASSP-37**, 1568–1575.

Ericsson, S. (1985) Fixed and adaptive predictors for hybrid predictive/transform coding. *IEEE Trans. Commun.* **COM-33**, 1291–1302.

Ersoy, O. K. and Nouira, A. (1992) Image coding with the discrete cosine-III transform. *IEEE J. Selected Areas in Commun.* **10**, 884–891.

ETSI (1991) European Telecommunication Standard; Digital coding of component television signals for contribution quality applications in the range 34–45 Mbit s^{-1}.

Farrelle, P. M. and Jain, A. K. (1986) Recursive block coding – a new approach to transform coding. *IEEE Trans. Commun.* **COM-34**, 161–179.

Farvardin, N. (1990) A study of vector quantization for noisy channels. *IEEE Trans. Inf. Theory.* **IT-36**, 799–809.

Farvardin, N. and Modestino, J. W. (1985) Rate–distortion performance of DPCM schemes for autoregressive sources. *IEEE Trans Inf. Theory.* **IT-31**, 402–418.

Farvardin, N. and Vaishampayan, V. (1991) On the performance and complexity of channel-optimized vector quantizers. *IEEE Trans. Inf. Theory,* **IT-37**, 155–160.

Fazel, K. and Huillier, J. J. (1990) Transmission of images over bursty and random channels. *EUSIPCO Proc.* **1360**, 853–856.

Feng, Y. and Nasrabadi, N. M. (1989) A dynamic address-vector quantization algorithm based on inter-block and inter-color correlation for color image coding. *ICASSP Proc.* pp. 1755–1758.

Feng, Y. S. and Nasrabadi, N. M. (1991) Dynamic address-vector quantization of RGB colour images. *IEE Proc. Part I, Commun., Speech, Vision.* **138**, 225–231.

Fettweis, A. (1986) Wave digital filters: theory and practice. *IEEE Proc.* **74**, 270–327.

Finamore, W. A. and de Garrido, D. P. (1990) A clustering algorithm for entropy-constrained vector quantizer design. *SPIE Proc.***1360**, pp. 837–846.

Financial Times (1989) "Squeeze the picture, soak up the quality", 15 December, p. 11.

Fischer, T. R. (1986) A pyramid vector quantizer. *IEEE Trans. Inf, Theory.* **IT-32**, 568–583.

Fischer, T. R. (1989) A comparison of vector quantization and transform coding of imagery. *Proc.IEEE Int. Symp. on Circuits and Syst.* pp. 1520–1523.

Fischer, T. R. and Dicharry, R. M. (1984) Vector quantizer design for memoryless Gaussian, Gamma and Laplacian sources. *IEEE Trans. Commun.* **COM-32**, 1065–1069.

Flanagan, J. L. (1972) *Speech Analysis, Synthesis and Perception.* Springer, New York.

Flanagan, J. K., Morrell, D. R., Frost, R. L., Read, C. J. and Nelson, B. E. (1989) Vector quantization codebook generation using simulated annealing. *ICASSP Proc.* 1759–1762.

Forchheimer, R. (1987) The motion estimation problem in semantic image coding. *Proc. Picture Coding Symp.* Stockholm, Sweden, 9–11 June, pp. 171–172.

Forchheimer, R. and Fahlander, O. (1983) Low bit-rate coding through animation. *Proc. Picture Coding Symp.* Davis, CA, 28–30 March, pp. 113–114.

Forchheimer, R. and Kronander, T. (1989) Image coding – from waveforms to animation. *IEEE Trans. Acoust. Speech, Signal Process.* **ASSP-37**, 2008–2023.

Forchheimer, R. and Li, H. (in press) *Digital Image Coding.* John Wiley and Sons, UK.

Foster, J., Gray, R., M. and Dunham, M. O. (1985) Finite-state vector quantization for waveform coding. *IEEE Trans. Inf. Theory.* **IT-31**, 348–359.

Fouques, J-Y. and Cohen, P. (1989) Partition filters: a new class of morphological operators for segmenting textured images. *ICASSP Proc.* pp. 1707–1710.

Fox, B. (1966) Discrete optimization via. marginal analysis. *Manag. Sci.* **13**, 210–216.

Franceschi, O., Shtar'kov, Y. and Forchheimer, R. (1988) An adaptive source coding method for still images. *Proc. Picture Coding Symp.* Torino, Italy, 12–14 September, Paper 6.5.

Franich, R. E. H., Lagendijk, R. L. and Biemond, J. (1993) A genetic algorithm for smooth vector field estimation. *Proc. 14th Symp. on Inf. Theory in the Benelux*, 17–18 May, pp. 192–197.

Franke, U. and Mester, R. (1988) Representation of the texture signals in region-based image coding schemes: a comparative study. *Proc. Picture Coding Symp.* Torino, Italy, 12–14 September, Paper 2.1.

Franke, U., Mester, R. and Aach, T. (1988) Constrained iterative restoration techniques: a powerful tool in region oriented texture coding. *EUSIPCO Proc.* pp. 1145–1148.

Freeman, H. (1961) On the encoding of arbitrary geometric configurations. *IRE Trans. Electron. Comput.* **EC-10**, 260–268.

Freeman, H. (1974) Computer processing of line-drawing images. *Comput. Surveys.* **6**, 57–97.

Freeman, H. (1978) Application of the generalized chain coding scheme to map data processing. *Proc. IEEE Comput. Soc. Conf. Patt. Rec. Image Proc.* Chicago, IL, pp. 220–226.

Friedlander, B. (1982a) Lattice Filters for Adaptive Processing. *IEEE Proc.* **70**, 829–867.

Friedlander, B. (1982b) Lattice methods for spectral estimation. *IEEE Proc.*, **70**, 990–1017.

Friedman, J. H., Baskett, F. and Schustek, L. J. (1975) An algorithm for finding nearest neighbours. *IEEE Trans. Comput.* **C-24**, 1000–1006.

Fu, K. S. and Mui, J. K. (1981) A survey on image segmentation. *Patt. Rec.* **13**, 3–16.

Fukuhara, T., Asai, K. and Murakami, T. (1990) Hierarchical division of 3–D wireframe model and vector quantization in a model-based coding of facial image. *Proc. Picture Coding Symp.* Cambridge, MA, 26–28 March, Paper 7.2.

Fukuhara, T. and Murakami, T. (1993) 3–D motion estimation of human head for model-based image coding. *IEE Proc. Part I, Commun. Speech, Vision.* **139**, 26–35.

Fukunaga, K. and Hostetler, L. D. (1973) Optimization of k-nearest neighbour density estimates. *IEEE Trans Inf. Theory.* **IT-19**, 320–326.

Furlan, G., Galand, C., Lancon, E. and Menez, J. (1991) Sub-band coding of images using adaptive VQ and entropy coding. *ICASSP Proc.* pp. 2665–2668.

Gabor, D. (1946) Theory of communication. *J. IEE.* **93**, 429–457.

Gallager, R. G. (1978) Variations on a theme by Huffman. *IEEE Trans. Inf. Theory.* **IT-24**, 668–674.

Gamal, A. A. El., Hemachandra, L. A., Shperling, I. and Wei, V. K. (1987) Using

simulated annealing to design good codes. *IEEE Trans. Inf. Theory.* **IT-33**, 116–123.

Gersho, A. (1979) Asymptotically optimal block quantization. *IEEE Trans. Inf. Theory.* **IT-25**, 373–380.

Gersho, A. (1982) On the structure of vector quantizers. *IEEE Trans. Inf. Theory.* **IT-28**, 157–166.

Gersho, A. (1990) Optimal nonlinear interpolative vector quantization. *IEEE Trans. Commun.* **COM-38**, 1285–1287.

Gersho, A. and Gray, R. M. (1992) *Vector Quantization and Signal Compression.* Kluwer, Dordrecht.

Gersho, A. and Ramamurthi, B. (1982) Image coding using vector quantization. *ICASSP Proc.* 428–431.

Gersho, A. and Yano, M. (1985) Adaptive vector quantization by progressive codeword replacement. *ICASSP Proc.* pp. 133–136.

Ghanbari, M. (1979) Real time transform coding of broadcast standard television pictures. Ph.D Thesis, University of Essex.

Ghanbari, M. (1989) Two-layer coding of video signals for VBR networks. *IEEE J. Selected Areas Commun.* **7**, 771–781.

Ghanbari, M. (1990) The cross-search algorithm for motion estimation. *IEEE Trans. Commun.* **COM-38**, 950–953.

Ghanbari, M. (1991) Arithmetic coding with limited past history. *Electron. Lett.* **27**, 1157–1159.

Ghanbari, M. (1992) An adapted H261 two-layer video codec for ATM networks. *IEEE Trans. Commun.* **COM-40**, 1481–1490.

Ghanbari, M. and Pearson, D. E. (1988) Variable bit rate transmission of television signals. *Electron. Lett.* **24**, 392–393.

Ghanbari, M. and Pearson, D. E. (1989) Components of bit-rate variation in video-conference signals. *Electron. Lett.* **25**, 285–286.

Ghanbari, M. and Seferidis, V. (1993) Cell-loss concealment in ATM video codecs. *IEEE Trans. Circuits, Syst. for Video Technol.* **3**, 238–247.

Gharavi, H. (1989) Differential sub-band coding of video signals. *ICASSP Proc.* pp. 1819–1822.

Gharavi, H. (1991a) Multilayer subband-based video coding. *IEEE Trans. Commun* **COM-39**, 1288–1291.

Gharavi, H. (1991b) Subband coding algorithms for video applications: videophone to HDTV-conferencing. *IEEE Trans. Circuits Syst. Video Techn.* **1**, 174–183.

Gharavi, H. and Mills, M. (1990) Blockmatching motion estimation algorithms – new results. *IEEE Trans. Circuits Syst.* **CAS-37**, 649–651.

Gibson, J. D. (1985) Backward adaptive prediction as spectral analysis within a closed loop. *IEEE Trans. Acoust. Speech, Signal Process.* **ASSP-33**, 1166–1174.

Gilge, M. (1988) Coding of arbitrarily shaped image segments using moment theory. *EUSIPCO Proc.* pp. 855–858.

Gilge, G., Engelhardt, T. and Mehlan, R. (1989) Coding of arbitrarily shaped image segments based on a generalized orthogonal transform. *Signal Process: Image Commun.* **1**, 153–180.

Girod, B. (1987) The efficiency of motion-compensating prediction for hybrid coding of video sequences. *IEEE J. Selected Areas Commun.* **SAC-5**, 1140–1153.

Girod, B. (1992) Psychovisual aspects of image communication. *Signal Process.* **28**, 239–251.

Girod, B., Almer, H., Bengtsson, L., Christensson, B. and Weiss, P. (1987) Noise Shaping DPCM in a 34 Mb/s Broadcast Codec. *Picture Coding Symp. Proc.* Stockholm, Sweden, Paper 3.15.

Girod, B., Almer, H., Bengtsson, L., Christensson, B. and Weiss, P. (1988) A subjective evaluation of noise shaping quantization for adaptive intra/interframe DPCM coding of color television signals. *IEEE Trans. Commun.* **COM-36**, 332–346.

Giusto, D. D. and Vernazza, G. (1990) Colour image coding by an advanced vector quantizer. *ICASSP Proc.* pp. 2265–2268.

Glenn, W. E. (1993) Review of video compression which depends on visual perception limits. *SPIE Proc.* **1976**, pp. 118–126.

Goldberg, M., Boucher, P. R. and Shlien, S. (1986) Image compression using adaptive vector quantization. *IEEE Trans Commun.* **COM-34**, 180–187.

Goldberg, M. and Sun, H. (1986) Image sequence coding using vector quantization. *IEEE Trans. Commun.* **COM-34**, 703–710.

Goldberg, M. and Sun, H. (1988) Frame adaptive vector quantization for image sequence coding. *IEEE Trans. Commun.* **COM-36**, 629–635.

Goldberg, M. and Wang, L. (1991) Comparative performance of pyramid data structures for progressive image transmission. *IEEE Trans. Commun.* **COM-39**, 540–547.

Gonzales, C. A., Pennebaker, W. B. and Mitchell, J. L. (1988) Algorithms for progressive transmission of color images. *EUSIPCO Proc.* pp. 75–78.

Gonzales, C. A., Allman, L., McCarthy, T. and Wendt, P. (1990) DCT coding for motion video storage using adaptive arithmetic coding. *Signal Process: Image Comm.* **2**, 145–154.

Gouraud, H. (1971) Computer display of curved surfaces. University of Utah Computing Science Dept, Report. UTEC-CSc-71–113.

Graham, D. N. (1967) Image transmission by two-dimensional contour coding. *IEEE Proc.* **55**, 336–346.

Graham, R. E. (1962) Snow-removal, a noise-stripping process for picture signals. *IEEE Trans. Inf. Theory*, **8**, 129–144.

Gray, R. M. (1984) Vector Quantization. *IEEE ASSP Mag.* April, pp. 4–29.

Gray, R. M. and Linde, Y. (1982) Vector quantizers and predictive quantizers for Gauss–Markov sources. *IEEE Trans. Commun.* **COM-30**, 381–389.

Griswold, N. C. (1980) Perceptual coding in the cosine transform domain. *Opt. Eng.* **19**, 306–311.

Griswold, N.C. and Sayood, K. (1982) Unsupervised learning approach to adaptive differential pulse code modulation. *IEEE Trans. Patt. Anal. Machine Intell.* **4**, 380–391.

Griswold, N. C., Halverson, D. R. and Wise, G. L. (1987) A note on adaptive block truncation coding for image processing. *IEEE Trans Acoust. Speech, Signal Process.* **ASSP-35**, 1201–1203.

Grossberg, S. (1988) Nonlinear neural networks: principles, mechanisms, and architectures. *Neural Networks* **1**, 17–62.

Grossman, A. and Morlet, J. (1984) Decomposition of Hardy functions into square integrable wavelets of constant shape. *SIAM J. Math.* **15**, 723–736.

Grotz, K., Mayer, J. U. and Suessmeier, G. K. (1989) A 64 kb/s videophone codec with forward analysis and control. *Signal Process: Image Commun.* **1**, 103–115.

Grzeszczuk, R., Eddins, S. L. and DeFanti, T. (1992) Filling regions using a crack code boundary description. *SPIE Proc.* **1778**, 226–237.

Guillemot, C. and Ansari, R. (1994) Layered coding schemes for video compression on ATM networks. *J. Visual Commun. Image Repres.* **5**, 62–74.

Guse, W., Gilge, M. and Stiller, C. (1990) Region-oriented coding of moving video–motion compensation by segment matching. *EUSIPCO Proc.* pp. 765–768.

H261 (1990) Draft revision of CCITT Recommendation H261, video codec for audio-visual services at p x 64 kb/s.

Habibi, A. (1974) Hybrid coding of pictorial data. *IEEE Trans. Commun.* **COM-22**, 614–624.

Hagenauer, J. (1988) Rate-compatible punctured convolutional codes (RCPC Codes) and their applications. *IEEE Trans. Commun.* **COM-36**, 389–400.

Hall, C. F. and Hall, E. L. (1977) A non-linear model for the spatial characteristics of the human visual system. *IEEE Trans. Syst. Man, Cyber.* **SMC-7**, 161–170.

Halverson, D. R., Griswold, N. C. and Wise, G. L. (1984) A generalized block truncation coding algorithm for image compression. *IEEE Trans. Acoust. Speech, Signal Process.* **ASSP-32**, 664–668.

Hammer, B., v. Brandt, A. and Schielein, M. (1987) Hierarchical encoding of image sequences using multistage vector quantization. *ICASSP Proc.* pp. 1055–1058.

Hammerstrom, D. (1993) Working with neural nets. *IEEE Spectrum Magazine.* July, pp. 46–53.

Hampel, H., Arps, R. B., Chamzas, C., Dellert, D., Duttweiler, D. L., Endoh, T., Equitz, W., Ono, F., Pasco, R., Sebestyen, I., Starkey, C. J., Urban, S. J., Yamazaki, Y. and Yoshida, T. (1992) Technical features of the JBIG standard for progressive bi-level image compression. *Signal Process: Image Commun.* **4**, 103–111.

Hang, H. M. and Haskell, B. G. (1988) Interpolative vector quantization of color images. *IEEE Trans. Commun.* **COM-36**, 465–470.

Hang, H. M. and Woods, J. W. (1985) Predictive vector quantization of images. *IEEE Trans. Commun.* **COM-33**, 1208–1219.

Haralick, R. M. and Shapiro, L. G. (1985) Survey: Image segmentation techniques. *Comp. Vis. Graph. Image Proc.* **29**, 100–132.

Harrison, C. W. (1952) Experiments with linear prediction in television. *Bell Syst. Tech. J.* **31**, 764–783.

Haskell, B. G. (1972) Buffer and channel sharing by several interframe Picturephone coders. *Bell Syst. Tech. J.* **51**, 261–289.

Haskell, B. G. (1974) Frame-to-frame coding of television pictures using two-dimensional Fourier transforms. *IEEE Trans. Inf. Theory.* **IT-20**, 119–120.

Haskell, B. G. (1979) Frame replenishment coding of television. In: *Image Transmission Techniques* (Advances in Electronics and Electron Physics, Suppl. 12) (edited by Pratt, W. K.), pp. 189–217. Academic Press, New York.

Haskell, P. and Messerschmidt, D. (1990) Reconstructing lost video data in a lapped orthogonal transform based coder. *ICASSP Proc.* pp. 1985–1988.

Haskell, P., Tzou, K. H. and Hsing, T. R. (1989) A lapped-orthogonal-transform based variable bit-rate video coder for packet networks. *ICASSP Proc.* pp. 1905–1908.

He, Z. and Li, H. (1990) Nonlinear predictive image coding with a neural network. *ICASSP Proc.* pp. 1009–1012.

Heeke, H. (1993) A traffic control algorithm for ATM networks. *IEEE Trans. Circuits, Syst. Video Techn.* **3**, 182–189.

Hepper, D. (1990) Efficiency analysis and application of uncovered background prediction in a low bit rate image coder. *IEEE Trans. Commun.* **COM-38**, 1578–1584.

Heyman, D. P., Tabatabai, A. and Lakshman, T. V. (1992) Statistical analysis and simulation study of video teleconference traffic in ATM networks. *IEEE Trans. Circuits, Syst. Video Techn.* **2**, 49–59.

Hines, E. L. and Hutchinson, R. A. (1989) Application of multi-layer perceptrons to facial feature location. *Proc. Third IEE Conf. on Image Processing.* Warwick, UK, 18–20 July, pp. 39–43.

Hlawatsch, F. and Boudreaux-Bartels, G. F. (1992) Linear and quadratic time-frequency signal representations. *IEEE ASSP Magazine.* April, pp. 21–67.

Ho, Y. S. and Gersho, A. (1989) Classified transform coding of images using vector quantization. *ICASSP Proc.* pp. 1890–1893.

Horita, Y. and Miyahara, M. (1991). Image segmentation based on ULCS color difference. *SPIE Proc.* **1606**, 607–620.

Hotter, M. and Thoma, R. (1988) Image segmentation based on object oriented mapping parameter estimation. *Signal Process.* **15**, 315–334.

Hsieh, C. H., Lu, P. C. and Liou, W. G. (1989) Adaptive Predictive Image Coding using Local Characteristics. *IEE Proc. Part I: Commun, Speech, Vision.* **136**, 385–390.

Hsieh, C. H., Lu, P. C. and Chang, J. C. (1991) A fast codebook generation algorithm for vector quantization of images. *Proc. IEEE Int. Symp. on Circuits and Syst.* pp. 288–291.

Huang, C. M. and Harris, R. W. (1993) A comparison of several vector quantization codebook generation approaches. *IEEE Trans. Image Process.* **IP-2**, 108–111.

Huang, C. M., Bi, Q., Stiles, G. S. and Harris, R. W. (1992) Fast full search equivalent encoding algorithms for image compression using vector quantisation. *IEEE Trans. Image Process.* **1**, 413–416.

Huang, J. J. Y. and Schultheiss, P. M. (1963) Block quantisation of correlated Gaussian random variables. *IEEE Trans. Commun.* **COM-11**, 289–296.

Huang, S. H. and Chen, S. H. (1990) Fast encoding algorithm for VQ-based image coding. *Electron. Lett.* **26**, 1618–1619.

Huang, T. S., Hau, Y. P. and Tsai, R. Y. (1982) Interframe coding with general two-dimensional motion compensation. *ICASSP Proc.* pp. 464–466.

Huang, T. S., Reddy, S. C. and Aizawa, K. (1991) Human facial modeling, analysis, and synthesis for video compression. *SPIE Proc.* **1605**, 234–241.

Huffman, D. A. (1952) A method for the construction of minimum redundancy codes. *IRE Proc.* **40**, 1098–1101.

Hughes, C. J., Ghanbari, M., Pearson, D. E., Seferidis, V. and Xiong, J. (1993) Modeling and subjective assessment of cell discard ATM video (1992). *IEEE Trans. Image Process.* **2**, 212–222.

Huguet, J. and Torres, L. (1990a) Fast codebook search algorithm in vector quantization. *SPIE Proc.* **1360**, 1750–1755.

Huguet, J. and Torres, L. (1990b) Vector quantization in image sequence coding. *EUSIPCO Proc.* pp. 1079–1082.

Hui, L. (1990) An adaptive block truncation coding algorithm for image compression. *ICASSP Proc.* pp. 2233–2236.

Hui, L. and Kogure, T. (1993) An adaptive hybrid DPCM/DCT method for video coding. *Signal Process: Image Commun.* **5**, 199–208.

Hush, D. R. and Horne, W. G. (1993) Progress in supervised neural networks. *IEEE SP Magazine* **10**, 8–39.

Husoy, J. H., Gronning, H. and Ramstad, T. A. (1990) Subband coding of video employing efficient recursive filter banks and advanced motion compensation. *SPIE Proc.* **1360**, 546–557.

Husoy, J. H. and Ramstad, T. A. (1990) Application of an efficient parallel IIR filter bank to image subband coding. *Signal Proc.* **20**, 279–292.

IBM 1 (1988) Pennebaker, W. B., Mitchell, J. L., Langdon, G. G. and Arps, R. B. An overview of the basic principles of the Q-coder adaptive binary arithmetic coder. *IBM J. Res. Devel.* **32**, 717–726.

IBM 2 (1988) Mitchell, J. L. and Pennebaker, W. B. Optimal hardware and software arithmetic coding procedures for the Q-coder. *IBM J. Res. Devel.* **32**, 727–736.

IBM 3 (1988) Pennebaker, W. B. and Mitchell, J. L. Probability estimation for the Q-coder. *IBM J. Res. Devel.* **32**, 737–752.

IBM 4 (1988) Mitchell, J. L. and Pennebaker, W. B. Software implementations of the Q-coder. *IBM J. Res. Devel.* **32**, 753–774.

IBM 5 (1988) Arps, R. B., Truong, T. K., Lu, D. J., Pasco, R. C. and Friedman, T. D. A multi-purpose VLSI chip for adaptive data compression of bilevel images. *IBM J. Res. Devel.* **32**, 775–795.

IEE (1989) *IEE Colloq. on Packet Video.* London, 16 May.

IEEE (1967) Special issue on redundancy reduction. *Proc. IEEE* **55**, March.

IEEE (1988) Special issue on computer vision. *IEEE Proc.* **76**, August.

IEEE (1989) Special issue on neural networks. *Trans. Circuits Syst.* **CAS-36**, May.

IEEE Spectrum (1991) Squeezing animation into your personal computer. *IEEE Spectrum Magazine,* **28**, June, p. 68.

IEEE Spectrum (1992) Packing them in. *IEEE Spectrum Magazine* **29**, September, pp. 80–81.

IEEE Spectrum (1993) Special report: interactive multimedia. *IEEE Spectrum Magazine* **30**, March, pp. 22–39.

Ikonomopoulos, A. and Kunt, M. (1985) High compression image coding via directional filtering. *Signal Process.* **8**, 179–203.

IMAGE COMM (1989) Issue on standardization activities. *Signal Process: Image Commun.* **1**, June.

IMAGE COMM (1993) Special issue on video coding for 10 Mb/s. *Signal Process: Image Commun.* **5**, February.

Image Proc. (1990) Ratio revolution. *Image Processing Magazine*, May–June, pp. 16–17.

Itoh, S., Matsuda, I. and Utsunomiya, T. (1992a) Adaptive transform coding of images based on variable-shape-blocks. *EUSIPCO Proc.* Brussels, Belgium, 24–27 August, pp. 1251–1254.

Itoh, S., Matsuda, I. and Utsunomiya, T. (1992b) Adaptive transform image coding based on variable-shape block segmentation with smoothing filter. *SPIE Proc.* **1818**, 1338–1349.

Jabbari, B., Yegenoglu, F., Kuo, Y., Zafar, S. and Zhang, Y. Q. (1993) Statistical characterization and block-based modeling of motion-adaptive coded video. *IEEE Trans. Circuits, Syst. Video Techn.* **3**, 199–207.

Jacobs, E. W., Fisher, Y. and Boss, R. D. (1992) Image compression: a study of the iterated transform method. *Signal Process.* **29**, 251–263.

Jacquin, A. E. (1990) A novel fractal block-coding technique for digital images. *ICASSP Proc.* pp. 2225–2228.

Jacquin, A. E. (1992) Image coding based on a fractal theory of iterated contractive image transformations. *IEEE Trans. Image Proc.* **1**, 11–30.

Jain, A. K. (1975) Image Coding via. a Nearest Neighbours Model. *IEEE Trans. Commun.* **COM-23**, 318–331.

Jain, A. K. (1989) *Fundamentals of Digital Image Processing.* Prentice-Hall, Englewood Cliffs, NJ.

Jain, J. R. and Jain, A. K. (1981) Displacement measurement and its application interframe image coding. *IEEE Trans. Commun* **COM-29**, 1799–1808.

Jang, J. and Rajala, S. A. (1990a) Segmentation based image coding using fractals and the human visual system. *Proc. Picture Coding Symp.* Cambridge, MA, 26–28 March, Paper 15.1.

Jang, J. and Rajala, S. A. (1990b) Segmentation based image coding using fractals and the human visual system. *ICASSP Proc.* pp. 1957–1960.

Jang, J. and Rajala, S. A. (1991) Texture segmentation-based image coder incorporating properties of the human visual system. *ICASSP Proc.* pp. 2753–2756.

Jayant, N. (1992) Signal compression: technology targets and research directions. *IEEE J. Selected Areas in Commun.* **10**, 796–818.

Jayant, N. S. and Noll, P. (1984) *Digital Coding of Waveforms*. Prentice-Hall, Englewood Cliffs, New Jersey.

JBIG (1992) Technical features of the JBIG standard for progressive bi-level image compression. *Signal Process: Image Commun.* **4**, 103–111.

Jeanrenaud, P. and Smith, M. J. T. (1990) Recursive subband image coding with adaptive prediction and finite state vector quantization. *Signal Process.* **20**, 25–42.

Jeong, D. G. and Gibson, J. D. (1989) Lattice vector quantization for image coding. *ICASSP Proc.* pp. 1743–1746.

Johnston, J. D. (1980) A filter family designed for use in quadrature mirror filter banks. *ICASSP Proc.* pp. 291–294.

JPEG (1990) Joint Photographic Experts Group – ISO/IEC JTC1/SC2/WG8 CCITT SGVIII. JPEG Technical Specification Revision 8.

Jurgen, R. K. (1992) Digital video. *IEEE Spectrum Magazine* **29**, March, pp. 24–30.

Kamel, M., Sun, C. T. and Guan, L. (1991) Image compression by variable block truncation coding with optimal threshold. *IEEE Trans. Acoust. Speech, Signal Process.* **ASSP-39**, 208–212.

Kaneko, M. Hatori, Y. and Koike, A. (1987) Improvements of transform coding algorithm for motion-compensated interframe prediction errors – DCT/SQ coding. *IEEE J. Selected Areas Commun.* **SAC-5**, 1068–1078.

Kaneko,T. and Okudaira, M. (1985) Encoding of arbitrary curves based on chain code representation. *IEEE Trans Commun.* **COM-33**, 697–707.

Kang, G. S. and Coulter, D. C. (1976) 600 bps voice digitizer. *ICASSP Proc.* pp. 91–94.

Kaouri, H. A., McCanny, J. V. and Millar, W. (1987) Fast search techniques for use in vector quantisation and related pattern matching applications. *Electron. Lett.* **23**, 311–312.

Kappagantula, S. and Rao, K. R. (1985) Motion compensated interframe image prediction. *IEEE Trans. Commun.* **COM-33**, 1011–1015.

Karlsson, G. and Vetterli, M. (1988a) Three dimensional sub-band coding of video. *ICASSP Proc.* pp. 1100–1104.

Karlsson, G. and Vetterli, M. (1988b) Sub-band coding of video for packet networks. *Opt. Eng.* **27**, 574–586.

Karlsson, G. and Vetterli, M. (1989a) Extension of finite length signals for sub-band coding. *Signal Process.* **17**, 161–168.

Karlsson, G. and Vetterli, M. (1989b) Packet video and its integration into the network architecture. *IEEE J. Selected Areas Commun.* **7**, 739–751.

Karlsson, G. and Vetterli, M. (1990) Theory of two-dimensional filter banks. *IEEE Trans. Acoust. Speech, Signal Process.* **ASSP-38**, 925–937.

Kass, M., Witkin, A. and Terzopoulos, D. (1987) Snakes: active contour models. *Int. J. Comput. Vis.* **1**, 321–331.

Kato, Y., Mukawa, N. and Okubo, S. (1987) A motion picture coding algorithm using adaptive DCT encoding based on coefficient power distribution classification. *IEEE J. Selected Areas Commun.* **SAC-5**, 1090–1099.

Keeley, D. (1994) Transportation of digitally compressed signals in distribution networks. *Cable Television Eng.* **16**, pp. 10–14.

Kenyon, N. D. and Nightingale, C., eds. (1992) *Audiovisual Telecommunications*. Chapman and Hall, London.

Kim, C. S., Smith, M. J. T. and Mersereau, R. M. (1989) An improved SBC/VQ scheme for color image coding. *ICASSP Proc.* pp. 1941–1944.

Kim, C. S., Smith, M. J. T. and Mersereau, R. M. (1991) Two-stage multirate coding of color images. *Signal Process: Image Commun.* **3**, 79–89.

Kim, D. S. and Lee, S. U. (1991) Image vector quantizer based on a classification in the DCT domain. *IEEE Trans. Commun.* **COM-39**, 549–556.

Kim, J. T., Lee, H. J. and Choi, J. S. (1993) Subband coding using human visual characteristics for image signals. *IEEE J. Selected Areas Commun.* **11**, 59–64.

Kim, J. W. and Lee, S. U. (1989) Discrete cosine transform-classified VQ technique for image coding. *ICASSP Proc.* pp. 1831–1834.

Kim, J. W. and Lee, S. U. (1992) A transform domain classified vector quantizer for image coding. *IEEE Trans. Circuits Syst. Video Techn.* **2**, 3–15.

Kim, J. and Rajala, S. A. (1992) Image segmentation using an annealed Hopfield neural network. *Russian Neural Networks Soc/IEEE Symp. Neuroinformatics and Neurocomput.* Rostov-on-Don, Russia, 7–10 October, pp. 311–322.

Kim, T. (1992) Side match and overlap match vector quantizers for images. *IEEE Trans. Image Process.* **1**, 170–185.

Kim, Y. H. and Modestino, J. W. (1992) Adaptive entropy coded subband coding of images. *IEEE Trans. Image Process.* **1**, 31–48.

Kingsbury, N. G., Addlesee, M. D. and Cheng, N. T. (1989) Robust and efficient image coding methods. *Proc. IEE Colloq. on Multidimensional Signal Processing*, February, Paper 2.

Kinoshita, T. and Nakahashi, T. (1991) Experimental HDTV codec with ATM cell loss compensation for B-ISDN. *Electron. Lett.* **27**, 1830–1831.

Kinoshita, T., Nakahashi, T. and Maruyama, M. (1993) Variable-bit-rate HDTV codec with ATM-cell-loss compensation. *IEEE Trans. Circuits, Syst. Video Techn.* **3**, 230–237.

Kirkpatrick, S., Gellatt, C. D. Jr. and Vecchi, M. P. (1983) Optimization by simulated annealing. *Science* **220**, 671–680.

Kishimoto, R., Ogata, Y. and Inumaru, F. (1989) Generation interval distribution characteristics of packetized variable rate video coding data streams in an ATM network. *IEEE J. Selected Areas Commun.* **7**, 833–841.

Kishino, F., Manabe, K., Hayashi, Y. and Yasuda, H. (1989) Variable bit-rate coding of video signals for ATM networks. *IEEE J. Selected Areas Commun.* **7**, 801–806.

Kiya, H., Nishikawa, K. and Iwahashi, M. (1994) A development of symmetric extension method for subband image coding. *IEEE Trans. Image Process.* **3**, 78–81.

Knee, M. J. (1987) Designing variable-length codes with good error-recovery properties. BBC Research Report RD 1987/19, November.

Kocher, M. and Leonardi, R. (1986) Adaptive region growing technique using polynomial functions for image approximation. *Signal Proc*, **11**, 47–60.

Koga, T. and Ohta, M. (1987) Coding of motion vector information. *Proc. Picture Coding Symp.*, Stockholm, Sweden, June 9–11, pp. 138–139.

Koh, J. S. and Kim, J. K. (1988) Fast sliding search algorithm for vector quantisation in image coding. *Electron. Lett.* **24**, 1082–1083.

Kohno, R. Arai, M., Imai, H. (1990) Image compression using a neural network with learning capability of variable function of a neural unit. *SPIE Proc.* **1360**, 69–75.

Kohonen, T. (1988) An introduction to neural computing. *Neural Networks.* **1**, 3–16.

Kokuer, M. and Clark, A, F. (1992) Feature and model tracking for model-based coding. *Proc. Fourth IEE Int. Conf. on Image Process.* Maastricht, Netherlands, 7–9 April, pp. 135–138.

Kong, S. G. and Kosko, B. (1992) Image coding with fuzzy image segmentation. *Proc. IEEE Conf. on Fuzzy Syst.* San Diego, CA, 8–12 March, pp. 213–220.

Kramer, H. P. and Mathews, M. V. (1956) A linear coding for transmitting a set of correlated signals. *IRE Trans. Inf. Theory* **2**, 41–46.

Krishnamurthy, A. K., Ahalt, S. C., Melton, D. E. and Chen, P. (1990) Neural networks for vector quantization of speech and images. *IEEE J. Selected Areas Commun.* **8**, 1449–1457.

Kronander, T. (1987) Sampling of bandpass pyramids. *IEEE Trans. Commun.* **COM-35**, 125–127.

Kronander, T. (1988) A new approach to recursive mirror filters with a special application in subband coding of images. *IEEE Trans. Acoust. Speech, Signal Process.* **ASSP-36**, 1496–1500.

Kronander, T. (1989) Motion compensated 3-dimensional wave-form image coding. *ICASSP Proc.* pp. 1921–1924.

Kubrick, A. and Ellis T. (1990) Classified vector quantisation of images: codebook design algorithm. *IEE Proc. Part I – Commun. Speech, Vision* **137**, 379–386.

Kuhlmann, F. and Bucklew, J. A. (1988) Piecewise uniform vector quantizers. *IEEE Trans. Inf. Theory* **IT-34**, 1259–1263.

Kumar, C. S. (1988) Comments on sub-band coding of images. *IEEE Trans. Acoust. Speech, Signal Process.* **ASSP-36**, 1089.

Kunt, M., Ikonomopoulos, A. and Kocher, M. (1985) Second generation image coding techniques. *IEEE Proc.* **73**, 549–574.

Kuroda, H. and Hashimoto, H. (1986) An interframe coding system using motion-compensation prediction and uncovered background prediction. *Elect. Commun. Japan. Part 1.* **69**, pp. 65–74.

Kwan, H. K. (1984) Image data compression using 2–D lattice predictor. *Electron. Lett.* **20**, 994–995.

Kwan, H. K. and Lui, Y. C. (1987) Image data compression using 2–D lattice modelling method. *IEE Proc. Part F: Commun., Radar, Signal Process.* **134**, 401–404.

Kwatra, S. C., Lin, C.-M. and Whyte, W. A. (1987) An adaptive algorithm for motion compensated color image coding. *IEEE Trans. Commun.* **COM-35**, 747–754.

Kwon, O. J. and Chellappa, R. (1993) Segmentation-based image compression. *Opt. Eng.* **32**, 1581–1587.

Lane, J. (1994) ATM knits voice, data on any net. *IEEE Spectrum Magazine,* **31**, February, pp. 42–45.

Langdon, G. G., Jr. (1984) An introduction to arithmetic coding. *IBM J. Res. Devel.* **28**, 135–149.

Langdon, G. G. and Rissanen, J. (1981) Compression of black-white images with arithmetic coding. *IEEE Trans. Commun.* **COM-29**, 858–867.

Lavagetto, F. and Zappatore, S. (1990a) Multiple resolution progressive vector quantization for image sequences. *EUSIPCO Proc.* pp. 1075–1078.

Lavagetto, F. and Zappatore, S. (1990b) Visual model weighted DCT vector quantization for variable bitrate video coding. *SPIE Proc.* **1360**, 1134–1139.

Lech, M. and Hua, Y. (1992) Image vector quantisation using neural networks and simulated annealing. *Proc. Fourth IEE Int. Conf on Image Proc.* Maastricht, Netherlands, 7–9 April, pp. 534–537.

Lee, C. and Nadler, M. (1989) Interframe image coding with 3-dimensional edge detection. *Proc. Third IEE Int. Conf. on Image Processing.* Warwick, UK, 18–20 July, pp. 541–545.

Lee, C. and Nadler, M. (1990) Vector quantization with 3-d gradient motion compensation. *SPIE Proc.* **1360**, pp. 1104–1113.

Lee, D. S. and Tzou, K. H. (1990) Hierarchical DCT coding of HDTV for ATM networks. *ICASSP Proc.* pp. 2249–2252.

Lee, D. S., Tzou, K. H. and Li, S. Q. (1990) Control analysis of video packet loss in ATM networks. *SPIE Proc.* **1360**, 1232–1243.

Lee, J. H. and Liu, H. T. (1989) Digital image coding with high compression ratio. *Proc. Third IEE Int. Conf. on Image Proc.* Warwick, UK, pp. 595–598.

Lee, J. H. and Young, T. T. (1990) New polyphase filter bank-based analysis/synthesis systems. *IEEE Trans. Acoust. Speech, Signal Process.* **ASSP-38**, 876–880.

Lee, M. H. and Crebbin, G. (1994) Classified vector quantisation with variable block-size DCT models. *IEE Proc. Vision, Image and Signal Process.* **141**, 39–48.

Lee, S. G., Yang, K. H. and Lee, C. W. (1993) Variable length coding of interleaved DCT coefficients for digital HDTV. *Signal Process: Image Commun.* **5**, 503–510.

Lee, S. M., Kim, N. C. and Son, H. (1990) Very low rate coding of motion video using 3–D segmentation with two change detection masks. *SPIE Proc.* **1360**, 524–531.

Lee, T. C. and Peterson, A. M. (1990) Adaptive vector quantization using a self-development neural network. *IEEE J. Selected Areas Commun.* **8**, 1458–1471.

Le Gall, D. J. (1991) MPEG. A video compression standard for multimedia applications. *Commun. ACM.* **34**, 47–58.

Le Gall, D. J. (1992) The MPEG video compression algorithm. *Signal Process: Image Commun.* **4**, 129–140.

Lema, M. D. and Mitchell, O. R. (1984) Absolute moment block truncation coding and its application to color images. *IEEE Trans. Commun.* **COM-32**, 1149–1157.

Leonardi, R. and Kunt, M. (1987) Adaptive segmentation for high performance image coding. *Proc. Picture Coding Symp.* Stockholm, Sweden, 9–11 June, pp. 150–151.

Lettera, C. and Masera, L. (1989) Foreground/background segmentation in videotelephony. *Signal Process: Image Commun.* **1**, 181–189.

Lewis, A. S. and Knowles, G. (1990) Video compression using 3D wavelet transforms. *Electron. Lett.* **26**, 396–398.

Lewis, A. S. and Knowles, G. (1991) A VLSI architecture for the 2-D Daubechies wavelet transform without multipliers. *Electron. Lett.* **27**, 171–173.

Lewis, A. S. and Knowles, G. (1992) Image compression using the 2-D wavelet transform. *IEEE Trans. Image Proc.* **1**, 244–250.

Li, H. (1992) Segmentation of the facial area for videophone applications. *Electron. Lett.* **28**, 1915–1916.

Li, H. and He, Z. (1989) Directional subband coding of images. *ICASSP Proc.* pp. 1823–1826.

Li, J. and Manikopoulos, C. N. (1990) Nonlinear prediction in image coding with DPCM. *Electron. Lett.* **26**, 1357–1359.

Li, J. and Manikopoulos, C. N. (1992) Nonlinear prediction with neural networks applied to 1–D DPCM image coding. *J. Visual Comput. Image Repres.* **3**, 247–254.

Lim, J. S. (1990) *Two-dimensional Signal and Image Processing.* Prentice-Hall International, Englewood Cliffs, NJ.

Lim, Y. S. and Park, K. H. (1988) Image segmentation and approximation through surface type labelling and region merging. *Electron. Lett.* **24**, 1380–1381.

Limb, J. O. (1967) Source-receiver encoding of television signals. *IEEE Proc.* **55**, 364–379.

Limb, J. O. (1972) Buffering of data generated by the coding of moving images. *Bell Syst. Tech. J.* **51**, 239–259.

Limb, J. O. and Murphy, J. A. (1975) Measuring the speed of moving objects from television signals. *IEEE Trans. Commun.* **COM-23**, 474–478.

Limb, J. O. and Rubinstein, C. (1978) On the Design of Quantizers for DPCM Coders *IEEE Trans. Commun.* **COM-26**, 573–578.

Linde, Y., Buzo, A. and Gray, R. M. (1980) An algorithm for vector quantizer design. *IEEE Trans. Commun.* **COM-28**, 84–95.

Liou, M. (1991) Overview of the *p* x 64 kb/s video coding standard. *Commun. ACM.* **34**, 59–63.

Lippmann, R. P. (1987) An introduction to computing with neural nets. *IEEE ASSP Magazine* **4**, No 2, April, 4–22.

Liu, S. and Hayes, M. (1992) Segmentation-based coding of motion difference and motion field images for low bit-rate video compression. *ICASSP Proc.* pp. 525–528.

Lloyd, S. P. (1957) Least squares quantization in PCM. Bell Laboratories Paper, reprinted in *IEEE Trans. Inf. Theory.* **IT-28**, 129–137, March 1982.

Lodge, N. K. (1987) Recent results in hybrid interpolative and predictive coding. *Proc. Int. Picture Coding Symp.* Stockholm, Sweden, 9–11 June, pp. 71–72.

Lodge, N. K. and Clarke, R. J. (1991) Block-structured interpolative coding of image sequences based on non-causal models. *IEE Colloquium on Adaptive Interpolation of Images*, No. 112, May 1991.

Lohscheller, H. (1984) A subjectively adapted image communication system. *IEEE Trans. Commun.* **COM-32**, 1316–1322.

Lookabaugh, T. D. and Gray, R. M. (1989) High-resolution quantization theory and the vector quantizer advantage. *IEEE Trans. Inf. Theory* **IT-35**, 1020–1033.

Lookabaugh, T. D. and Perkins, M. G. (1990) Application of the Princen–Bradley filter bank to speech and image compression. *IEEE Trans. Acoust. Speech, Signal Process.* **ASSP-38**, 1914–1926.

Lu, C. C. and Dunham, J. G. (1991) Highly efficient coding schemes for contour lines based on chain code representations. *IEEE Trans Commun.* **COM-39**, 1511–1514.

Lu, M. I. and Chen, C. F. (1990) An encoding procedure and a decoding procedure for a new modified Huffman code. *IEEE Trans. Acoust. Speech, Signal Process.* **ASSP-38**, 128–136.

Lu, W. W., Gough, M. P. and Davies, P. N. H. (1991) Scientific data compression for space: a modified block truncation coding algorithm. *SPIE Proc.* **1470**, pp. 197–205.

Lunscher, W. H. H. and Beddoes, M. P. (1986) Optimal edge detector evaluation. *IEEE Trans. Syst. Man. Cyber.* **SMC-16**, 304–312.

Ma, C. K. and Chan, C. K. (1991) Maximum descent method for image vector quantisation. *Electron. Lett.* **27**, 1772–1773.

Ma, J. and Vepsalainen, A. (1990) Compress images based on fractal dimension. *Proc. Fifth Int. Conf. on Image Anal. and Proc.* Positano, Italy, 20–22 September 1989, pp. 194–198.

Ma, K. K. and Rajala, S. A. (1991a) Subband coding of digital images using absolute moment block truncation. *ICASSP Proc.* pp. 2645–2648.

Ma, K. K. and Rajala, S. A. (1991b) A comparison of absolute moment block truncation coding and the minimum mean square error quantizer. *Proc. IEEE Int. Symp. on Circuits and Syst.* Singapore, 11–14 June, pp. 296–299.

MacInnis, A. G. (1992) The MPEG systems coding specification. *Signal Process: Image Commun.* **4**, 153–159.

Madisetti, A., Subramonian, R. and Algazi, V. R. (1989) A radius-bucketing approach to fast vector quantization encoding. *ICASSP Proc.* pp. 1767–1770.

Maglaris, B., Anastassiou, D., Sen, P., Karlsson, G. and Robbins, J. D. (1988) Performance models of statistical multiplexing in packet video communications. *IEEE Trans. Commun.* **COM-36**, 834–843.

Mahesh, B. and Pearlman, W. A. (1989) Image coding on a hexagonal pyramid with noise spectrum shaping. *SPIE Proc.* **1199**, 764–774.

Mahmoud, S. A., Afifi, M. S. and Green, R. J. (1988) Recognition and velocity computation of large moving objects in images. *IEEE Trans. Acoust. Speech, Signal Process.* **ASSP-36**, 1790–1791.

Makhoul, J. (1977) State and efficient lattice methods for linear prediction. *IEEE Trans. Acoust. Speech, Signal Process.* **ASSP-25**, 423–428.

Makhoul, J., Roucos, S. and Gish, H. (1985) Vector quantization in speech coding. *IEEE Proc.* **73**, 1551–1588.

Mallat, S. G. (1989a) A theory for multiresolution signal decomposition: the wavelet representation. *IEEE Trans. Patt. Anal. Machine Intell.* **11**: 674–693.

Mallat, S. G. (1989b) Multifrequency channel decompositions of images and wavelet models. *IEEE Trans. Acoust. Speech, Signal Process.* **ASSP-37**, 2091–2110.

Mallat, S. G. (1989c) Multiresolution approximations and wavelet orthonormal bases of $L^2(R)$. *Trans. Am. Math. Soc.* **315**, 69–87 and 674–693.

Mallat, S. and Zhong, S. (1991) Compact image coding from edges with wavelets. *ICASSP Proc.* pp. 2745–2748.

Malvar, H. S. (1990a) Lapped transforms for efficient transform/subband coding. *IEEE Trans. Acoust. Speech, Signal Process.* **ASSP-38**, 969–978.

Malvar, H. S. (1990b) Efficient signal coding with hierarchical lapped transforms. *ICASSP Proc.* pp. 1519–1522.

Malvar, H. S. (1992) *Signal Processing with Lapped Transforms*. Artech House Publishers, London.

Malvar, H. S. and Staelin, D. H. (1989) The LOT: transform coding without blocking effects. *IEEE Trans. Acoust. Speech, Signal Process.* **ASSP-37**, 553–559.

Mandelbrot, B. B. (1983) *The Fractal Geometry of Nature*. W. H. Freeman, San Francisco, CA.

Manikopoulos, C. N. (1992) Neural network approach to DPCM system design for image coding. *IEE Proc. Part I, Commun. Speech, Vision* **139**, 501–507.

Manikopoulos, C. and Sun, H. (1989) Finite state vector quantization with an interleaved image source designed for reconstruction of lost packets. *ICASSP Proc.* pp. 1894–1897.

Maragos, P. A., Schafer, R. W. and Mersereau, R. M. (1984) Two-dimensional linear prediction and its application to adaptive predictive coding of images. *IEEE Trans. Acoust. Speech, Signal Process.* **ASSP-32**, 1213–1229.

Marangelli, B. (1991) A vector quantizer with minimum visible distortion. *IEEE Trans. Signal Process.* **SP-39**, 2718–2721.

Marcellin, M. W. (1990) Transform coding of images using trellis coded quantization. *ICASSP Proc.* pp. 2241–4.

Maresq, J. P. and Labit, C. (1986) Vector quantization in transformed image coding. *ICASSP Proc.* 145–148.

Martens, J.-B. (1990) Application of scale space to image coding. *IEEE Trans. Commun.* **COM-38**, 1585–1591.

Martens, J.-B. and Majoor, G. M. M. (1989) The perceptual relevance of scale-space image coding. *Signal Process.* **17**, 353–364.

Martucci, S. A. (1991) Signal extension and noncausal filtering for subband coding of images. *SPIE Proc.* **1605**, 137–148.

Marzetta, T. M. (1980) Two-dimensional linear prediction: autocorrelation arrays, minimum phase error filters and reflection coefficient arrays. *IEEE Trans. Acoust. Speech, Signal Process.* **ASSP-28**, 725–733.

Mathews, V. J. (1991) Adaptive polynomial filters. *IEEE Signal Processing Magazine*, July, pp. 10–26.

Mathews, V. J. (1992) Multiplication-free vector quantization using L_1 distortion measure and its variants. *IEEE Trans. Image Process.* **1**, 11–17.

Mathews, V. J. and Khorchidian, M. (1989) Multiplication-free vector quantization using L_1 distortion measure and its variants. *ICASSP Proc.* pp. 1747–1750.

Mauersberger, W. (1979) Experimental results on the performance of mismatched quantizers. *IEEE Trans. Inf. Theory,* **IT-25**, 381–386.

Max, J. (1960) Quantizing for minimum distortion. *IEEE Trans. Inf. Theory* **IT-6**, 7–12.

Maxted, J. C. and Robinson, J. P. (1985) Error recovery for variable length codes. *IEEE Trans. Inf. Theory.* **IT-31**, 794–801.

McAuliffe, J. D., Atlas, L., E. and Rivera, C. (1990) A comparison of the LBG algorithm and Kohonen neural network paradigm for image vector quantization. *ICASSP Proc.* pp. 2293–2296.

McLaren, D. L. and Nguyen, D. T. (1991) Modelling low bit rate video traffic as switched-fractal source. *Electron. Lett.* **27**, 745–747.

McLaren, D. L. and Nguyen, D. T. (1992) Variable bit-rate source modelling of ATM-based video sources. *Signal Process: Image Commun.* **4**, 233–244.

Melissaratos, L. and Micheli-Tzanakou, E. (1990) Comments on "Complete discrete 2-D Gabor transforms by neural networks for image analysis and compression". *IEEE Trans. Acoust. Speech, Signal Process.* **ASSP-38**, 2005.

Mensa-Ababio, K. (1989) Improved transform coding. *ICASSP Proc.* pp. 1827–30.

Mester, R. and Franke, U. (1987) On "optimal" thresholds in the context of transform coding with stabilized quality. *Proc. Picture Coding Symp.* Stockholm, Sweden, 9–11 June, Paper 7.4.

Mester, R. and Franke, U. (1988) Image segmentation on the basis of statistical models for region oriented image coding. *Proc. Picture Coding Symp.* Torino, Italy, 12–14 September, Paper 2.7.

Mester, R. and Franke, U. (1992) Spectral entropy-activity classification in adaptive transform coding. *IEEE J. Selected Areas Commun.* **10**, 913–917.

Meyer, Y. (1992) *Wavelets and Applications.* Springer, Berlin.

Meyer, E. and Gaertner, S. (1989) An intrafield DCT codec for consumer application. *Proc. IEE Int. Conf. on Image Processing and its applications.* Warwick, UK, 18–20 July, pp. 553–557.

Mitchell, O. R. and Tabatabai, A. J. (1981) Channel error recovery for transform image coding. *IEEE Trans. Commun.* **COM-29**, 1754–1762.

Mitrakos, D. K. and Constantinides, A. G. (1983) Nonlinear image processing for optimum composite source coding. *IEE Proc. Part F. Commun. Radar, Signal Process.* **130**, 441–449.

Modestino, J. W. and Bhaskaran, B. (1981) Robust two-dimensional tree encoding of images. *IEEE Trans. Commun.* **COM-29**, 1786–1798.

Modestino, J. W. and Daut, D. G. (1979) Combined source-channel coding of images. *IEEE Trans. Commun.* **27**, 1644–1659.

Modestino, J. W. and Harrison, D.D. (1989) Adaptive entropy coded 2-D DPCM coding of images. *ICASSP Proc.* pp. 1973–1975.

Modestino, J. W. and Kim, Y. H. (1992) Adaptive entropy-coded predictive vector quantization of images. *IEEE Trans. Signal Process.* **SP-40**, 633–644.

Modestino, J. W., Bhaskaran, B. and Anderson, J. B. (1981a) Tree encoding of images in the presence of channel errors. *IEEE Trans. Inf. Theory* **IT-27**, 677–697.

Modestino, J. W., Daut, D. G. and Vickers, A. L. (1981b) Combined source-channel coding of images using the block cosine transform. *IEEE Trans. Commun.* **COM-29**, 1261–1274.

Mohrmann, K. H. (1987) Coding of video signals for digital transmission. *Siemens "Telcom Report",* **10**, 266–271.

Moloney, C. R. and Dubois, E. (1991) Estimation of motion fields from image sequences with illumination variation. *ICASSP Proc.* pp. 2425–2428.

Monet, P. and Labit, C. (1990) Codebook replenishment in classified pruned tree-structured vector quantization of image sequences. *ICASSP Proc.* pp. 2285–2288.

Mongatti, G., Alparone, L., Benelli, G., Baronti, S., Lotti, F. and Casini, A. (1992) Progressive image transmission by content driven Laplacian pyramid encoding. *IEE Proc Part I. Commun. Speech, Vision* **139**, 495–500.

Monro, D. M. and Dudbridge, F. (1992a) Fractal approximation of image blocks. *ICASSP Proc.* pp. 485–488.

Monro, D. M. and Dudbridge, F. (1992b) Fractal block coding of images. *Electron. Lett.* **28**, 1053–1055.

Moorhead, R. J., Rajala, S. A. and Cook, L. W. (1987) Image sequence coding using a pel-recursive motion-compensated technique. *IEEE J. Selected Areas Commun.* **SAC-5**, 1100–1114.

Moran, D. and Morris, O. J. (1989) Region and texture coding of TV pictures. *Third IEE Int. Conf. on Image Proc.* Warwick, UK, 18–20 July, pp. 536–540.

Moresco, M., Lavagetto, F. and Cocurullo, F. (1992) Motion adaptive vector quantization for video coding. *EUSIPCO Proc.* Brussels, Belgium, 24–27 August, pp. 1357–1360.

Morikawa, H. and Harashima, H. (1990) 3-D structure extraction coding of image sequences. *ICASSP Proc.* pp. 1969–1972.

Morikawa, H. and Harashima, H. (1991) 3-D structure extraction coding of image sequences. *J. Visual Commun. Image Repres.* **2**, 332–344.

Morishima, S. and Harashima, H. (1992) Image synthesis and editing system for a multi-media human interface with speaking head. *Proc. Fourth IEE Int. Conf. on Image Process.* Maastricht, Netherlands, 7–9 April, pp. 270–273.

Morishima, S., Aizawa, K. and Harashima, H. (1989) An intelligent facial image coding driven by speech and phoneme. *ICASSP Proc.* pp. 1795–1798.

Morishima, S., Aizawa, K. and Harashima, H. (1990) A real-time facial action image synthesis system driven by speech and text. *SPIE Proc.* **1360**, pp. 1151–1158.

Morris, O. J., Lee, M. de J. and Constantinides, A. G. (1986) Graph theory for image analysis: an approach based on the shortest spanning tree. *IEE Proc. Part F. Commun. Radar, Signal Process.* **133**, 146–152.

Morrison, D. G. (1990) Variable bit rate video coding for asynchronous transfer mode networks. *BT Technol. J.* **8**, 70–80.

Morrison, D. G. (1992) Standardization by ISO/MPEG of digital video coding for storage applications. In *Audiovisual Telecommunications* (edited by Kenyon, N. D. and Nightingale, C.), Chapter 10. Chapman and Hall, London.

Morrison, G. and Parke, I. (1993) A spatially layered hierarchical approach to video coding. *Signal Process: Image Commun.* **5**, 445–462.

MPEG-I (1990) ISO/IEC JTC1/SC2/WG11. Draft: Information Technology – Coding of Moving Pictures and Associated Audio for Digital Storage Media up to about 1.5 Mbit/s, September.

MPEG-II (1992) ISO/IEC JTC1/SC2/WG11. Draft: Information Technology – List of Requirements for MPEG-2 Video, March.

Mukawa, N. and Kuroda, H. (1985) Uncovered background prediction in interframe coding. *IEEE Trans. Commun.* **COM-33**, 1227–1231.

Murakami, H., Yamamoto, H. (1984) Theoretical comparison between DPCM and transform coding regarding the robustness of coding performance for variation of picture statistics (1984) *IEEE Trans. Commun.* **COM-32**, 1351–1357.

Murakami, T., Asai, K. and Itoh, A. (1986) Design method of symmetric vector quantiser. *Electron. Lett.* **22**, 848–849.

Murakami, T., Asai, K. and Yamazaki, E. (1982) Vector quantiser of video signals. *Electron. Lett.* **18**, 1005–1006.

Musmann, H. G. (1979) Predictive image coding. In *Image Transmission Techniques* (Advances in Electronics and Electron Physics, Suppl. 12); (edited by Pratt, W. K.), pp. 73–112. Academic Press, New York.

Musmann, H. G., Pirsch, P. and Grallert, H.-J. (1985) Advances in picture coding. *IEEE Proc.* **73**, 523–548.

Musmann, H. G., Hotter, M. and Ostermann, J. (1989) Object-oriented analysis – synthesis of moving images. *Signal Process: Image Commun.* **1**, 117–138.

Nakaya, Y., Aizawa, K. and Harashima, H. (1990) Texture updating methods in model-based coding of facial images. *Proc. Picture Coding Symp.* Cambridge, MA, 26–28 March, Paper 7.3.

Nakaya, Y., Chaah, Y. C. and Harashima, H. (1991) Model-based/waveform hybrid coding for videotelephone images. *ICASSP Proc.* pp. 2741–2744.

Nanda, S. and Pearlman, W. A. (1992) Tree coding of image subbands. *IEEE Trans. Image Process.* **1**, 133–147.

Nasiopoulos, P. Ward, R. K. and Morse, D. J. (1991) Adaptive compression coding. *IEEE Trans Commun.* **COM-39**, 1245–1254.

Nasipuri, M., Roy, S., Misra, S. and Basu, D. K. (1991) An adaptive image encoding technique using pyramid architecture. *IEE Symp. on Circuits and Syst.* Singapore, 11–14 June, pp. 292–295.

Nasrabadi, N. M. (1990) Interframe hierarchical address-vector quantization. *SPIE Proc.* **1360**, 558–574.

Nasrabadi, N. M. and Feng, Y. (1990a) A dynamic finite-state vector quantization scheme. *ICASSP Proc.* pp. 2261–2264.

Nasrabadi, N. M. and Feng, Y. (1990b) A multilayer address vector quantization technique. *IEEE Trans Circuits, Syst.* **CAS-37**, 912–921.

Nasrabadi, N. M. and Feng, Y. (1990c) Image compression using address-vector quantization. *IEEE Trans. Commun.* **COM-38**, 2166–2173.

Nasrabadi, N. M. and King, R.A. (1984) A new image coding technique using transform vector quantisation. *ICASSP Proc.* pp. 29.9.1–29.9.4.

Nasrabadi, N. M. and King, R.A. (1988) Image coding using vector quantization: a review. *IEEE Trans. Commun.* **COM-36**, 957–971.

Nasrabadi, N. M., Lin, S. E. and Feng, Y. (1989a) Interframe hierarchical vector quantization. *ICASSP Proc.* pp. 1739–1742.

Nasrabadi, N. M., Lin, S. E. and Feng, Y. (1989b) Interframe hierarchical vector quantization. *Opt. Eng.* **28**, 717–725.

Nasrabadi, N. M., Choo, C. Y., Harries, T. and Smallcomb, J. (1990) Hierarchical block truncation coding of digital HDTV images. *IEEE Trans. Consumer Electron.* **36**, 254–261.

Nasrabadi, N. M., Choo, C. Y. and Roy, J. U. (1992) Interframe hierarchical address-vector quantization. *IEEE J. Selected Areas Commun.* **10**, 960–967.

Nasseri, Z. and Kanefsky, M. (1990) Doubly adaptive DPCM. *IEEE Trans. Inf. Theory* **IT-36**, 414–420.

Neagoe, V. E. (1988) Predictive ordering and linear approximation for image data compression. *IEEE Trans. Commun.* **COM-36**, 1179–1182.

Netravali, A. (1977a) On Quantizers for DPCM Coding of Picture Signals. *IEEE Trans. Inf. Theory* **IT-23**, 360–370.

Netravali, A. (1977b) Interpolative picture coding using a subjective criterion. *IEEE Trans. Commun.* **COM-25**, 503–508.

Netravali, A. and Prasada, B. (1977) Adaptive quantization of picture signals using spatial masking. *IEEE Proc.* **65**, 536–548.

Netravali, A. N. and Robbins, J. D. (1979) Motion-compensated television coding: Part 1. *Bell Syst. Tech. J.* **58**, 631–670.

Netravali, A. N. and Robbins, J. D. (1980) Motion-compensated coding: some new results. *Bell Syst. Tech. J.* **59**, 1735–1745.

Netravali, A. N. and Stuller, J. A. (1979) Motion-compensated transform coding. *Bell Syst. Tech. J.* **58**, 1703–1718.

Newman, D. J. (1982) The hexagon theorem. *IEEE Trans. Inf. Theory* **IT-28**, 137–139.

Ng, S.-B., Schiff, L. (1989) Two-tier DPCM codec for videoconferencing. *IEEE Trans. Commun.* **COM-37**, 380–386.

Ngan, K. N. (1984) Image display techniques using the cosine transform. *IEEE Trans. Acoust. Speech. Signal Process.* **ASSP-32**, 173–177.

Ngan, K. N., Clarke, R. J. (1980) Low-pass filtering in the cosine transform domain. *ICC Proc.*, Seattle, 8–12 June, pp. 31.7.1–31.7.5.

Ngan, K. N. and Clarke, R. J. (1982) Filtering and sub-sampling using transform coding techniques. *Proc. First IEE Int. Conf. on Image Processing.* York, UK. 26–28 July, pp. 220–224.

Ngan, K. N. and Koh, H. C. (1992) Predictive classified vector quantization. *IEEE Trans. Image Process.* **1**, 269–280.

Ngan, K. N., Leong, K. S. and Singh, H. (1989) Adaptive cosine transform coding of images in the perceptual domain. *IEEE Trans. Acoust. Speech, Signal Process.* **ASSP-37**, 1743–1750.

Ngwa-Ndifor, J. and Ellis, T. (1991) Predictive partial search algorithm for vector quantisation. *Electron. Lett.* **27**, 1722–1723.

Nill, N. B. (1985) A visual model weighted cosine transform for image compression and quality assessment. *IEEE Trans. Commun.* **COM-33**, 551–557.

Nobakht, R. A. and Rajala, S. A. (1987) An image coding technique using a human visual system model and image analysis criteria. *ICASSP Proc.* pp. 1358–1361.

Nomura, M., Fujii, T. and Ohta, N. (1989) Basic characteristics of variable rate video coding in ATM environment. *IEEE J. Selected Areas Commun.* **7**, 752–760.

Nyeck, A. and Tosser-Roussey, A. (1992) Maximum entropy initialisation technique for image coding vector quantiser design. *IEE Electron. Lett.* **28**, pp. 273–274.

Nyeck, A., Mokhtari, H. and Tosser-Roussey, A. (1992) An improved fast adaptive search algorithm for vector quantisation by progressive codebook arrangement. *Patt. Recog.* **25**, 799–802.

Oest, J., Guirao, F. J. and Garcia Santos, N. (1990) Digital transmission of component coded HDTV signals using the discrete cosine transform: design of a visibility threshold matrix. *EUSIPCO Proc.* Barcelona, Spain, 18–21 September, pp. 881–884.

Ohm, J. R. (1993) Advanced packet-video coding based on layered VQ and SBC techniques. *IEEE Trans. Circuits, Syst. Video Techn.* **3**, 208–221.

Ohta, N. (1994) *Packet Video: Modelling and Signal Processing.* Artech House Publishers, London.

Ohta, M. and Nogaki, S. (1993) Hybrid picture coding with wavelet transform and overlapped motion-compensated interframe prediction coding. *IEEE Trans. Signal Process.* **41**, 3416–3424.

Ohta, M., Yano, M. and Nishitani, T. (1991) Entropy coding for wavelet transform of image and its application for motion picture coding. *SPIE Proc.* **1605**, 456–466.

Oien, G. E., Lepsoy, S. and Ramstad, T. A. (1991) An inner product space approach to image coding by contractive transformations. *ICASSP Proc.* pp. 2773–2776.

Okubo, S. (1992) Requirements for high quality video coding standards. *Signal Process: Image Commun.* **4**, 141–151.

Oliveri, F., Conte, G. and Guglielmo, M. (1986) A technique using a one-dimensional mapping for vector quantisation of images. *ICASSP Proc.* pp. 149–151.

O'Neal, J. B., Jr. (1966) Predictive quantizing systems (differential pulse code modulation) for the transmission of television signals. *Bell Syst. Techn. J.* **45**, 689–721.

Orchard, M. T. (1993) Predictive motion-field segmentation for image sequence coding. *IEEE Trans. Circuits, Syst. Video, Techn.* **3**, 54–70.

Ortega, A., Garcia, N. and Cisneros, G. (1990) An experiment on buffer occupancy control in video coding for several bitrates. *EUSIPCO Proc.* **1360**, 857–860.

Othman, S. Y. and Wilson, S. G. (1989) Image sequence coding at 64 kbps using vector quantization and block matching. *ICASSP Proc.* pp. 1913–1916.

Paliwal, K. K. and Ramasubramanian, V. (1989) Effect of ordering the codebook on the efficiency of the partial distance search algorithm for vector quantization. *IEEE Trans. Commun.* **COM-37**, 538–540.

Pancha, P. and El Zarki, M. (1993) Bandwidth-allocation schemes for variable-bitrate MPEG sources in ATM networks. *IEEE Trans. Circuits, Syst. Video Technol.* **3**, 190–198.

Panchanathan, S. and Goldberg, M. (1991) Mini-max algorithm for image adaptive vector quantization. *IEE Proc. Part I. Commun. Speech. Vision* **138**, 53–60.

Panis, S., Cosmas, J. and Cock, C. (1992) Control of movement of a synthesised mouth from a text stream. *Proc. Fourth IEE Int. Conf. on Image Process.* Maastricht, Netherlands, 7–9 April, pp. 266–269.

Park, S. H. and Lee, S. U. (1991) A pyramid image coder using classified transform vector quantization. *Signal Process.* **22**, 25–42.

Parke, F. I. (1975) A model for human faces that allows speech synchronized animation. *J. Comput. Graph.* **1**, 1–4.

Parke, F. J. (1982) Parametrized models for facial animation. *IEEE Comput. Graph.* **12**, 61–68.

Parker, S. R. and Kayran, A. H. (1984) Lattice parameter autoregressive modelling of two-dimensional fields – Part 1: the quarter-plane case. *IEEE Trans. Acoust. Speech, Signal Process.* **ASSP-32**, 872–885.

Pau, Y.-H. (1989) *Adaptive Pattern Recognition and Neural Networks.* Addison Wesley.

PCS (1988) Session 9 – Progress in multimedia coding in ISO. *Proc. Picture Coding Symp.* Torino, Italy, 12–14 September.

PCS (1990) Session 6 – Standardization progress in image representations. *Proc. Picture Coding Symp.* Cambridge, MA, 26–28 March.

Pearl, J. (1973) On coding and filtering stationary signals by discrete Fourier transforms. *IEEE Trans Inf. Theory* **IT-19**, 229–232.

Pearlman, W. A. (1990) Adaptive cosine transform image coding with constant block distortion. *IEEE Trans. Commun.* **COM-38**, 698–703.

Pearson, D. E. (1967) A realistic model for visual communication systems. *IEEE Proc.* **55**, 380–389.

Pearson, D. (1989) Model-based image coding. *GLOBECOM Proc.* Dallas, Texas, 27–30 November, pp. 554–558.

Pearson, D. (1990a) Packet video. *IEE Rev*, September, pp. 315–318.

Pearson, D. (1990b) Texture mapping in model-based image coding. *Signal Process: Image Commun.* **2**, 377–395.

Pearson, D. E. ed. (1991) *Image Processing.* McGraw-Hill, UK.

Pearson, D. E. and Robinson, J. A. (1985) Visual communication at very low data rates. *IEEE Proc.* **73**, 795–812.

Pearson, D. E. and Whybray, M. W. (1984) Transform coding of images using interleaved blocks. *IEE Proc. Part F, Commun. Radar Signal Process.* **131**, 466–472.

Pearson, J. J., Hines, D. C., Golosman, S. and Kuglin, C. D. (1977) Video rate image correlation processor. *SPIE Proc.* **119**, 197–205.

Pei, S. C. and Chen, F. C. (1990) Subband image decomposition by mathematical morphology. *SPIE Proc.* **1360**, 293–301.

Pei, S. C. and Chen, F. C. (1994) 3-D spatio-temporal subband decompositions for hierarchical compatible video coding by mathematical morphology. *Signal Process: Image Commun.* **6**, 83–99.

Peli, T. and Malah, D. (1982) A study of edge-detection algorithms. *Comp. Graph. Image Proc.* **20**, 1–21.

Pentland, A. and Horowitz, B. (1991) A practical approach to fractal-based image compression. *SPIE Proc.* **1605**, 467–474.

Pereira, F. and Quaglia, M. (1990) Extension of the CCITT visual communication coding algorithm for operation in ATM networks. *Signal Process: Image Commun.* **2**, 13–27.

Perkins, M. G. and Lookabaugh, T. (1990) Combined source-channel DCT image coding for the Gaussian channel. *EUSIPCO Proc.* **1360**, 865–868.

Phong, B. T. (1975) Illumination for computer generated pictures. *Commun. ACM.* **8**, 311–317.

Picard, R. W. (1990) A staggered DCT decreases perceived blockiness. *Proc. Picture Coding Symp*, Cambridge, MA, 26–28 March, Paper 15.3.

Picco, R., Bellifemine, F. and Chimienti, A. (1990) Analysis of a 2D-DCT image coding scheme with motion compensation and vector quantization. *SPIE Proc.* **1360**, 1810–1821.

Pinho, A. J. (1993) Image compression based on quadtree segmentation and artificial neural networks. *Electron. Lett.* **29**, 1029–1031.

Pirsch, P. (1982) Adaptive intra-interframe DPCM coder. *Bell Syst. Tech. J.* **61**, 747–764.

Platt, S. M. and Badler, N. I. (1981) Animating facial expressions. *Comput. Graphics* **15**, 245–252.

Po, L. M. and Chan, C. K. (1990a) Novel subspace distortion measurement for efficient implementation of image vector quantiser. *Electron. Lett.* **26**, 480–482.

Po, L. M. and Chan, C. K. (1990b) Hierarchical mean-residual image vector quantiser using gradient-Laplacian subspace distortion. *Electron. Lett.* **26**, 1362–1365.

Po, L. M. and Chan, C. K. (1991) Directionally classified image vector quantiser using Walsh Hadamard subspace distortion. *Electron. Lett.* **27**, 1964–1967.

Podilchuk, C. I., Jayant, N. S. and Noll, P. (1990) Sparse codebooks for the quantization of non-dominant sub-bands in image coding. *ICASSP Proc.* pp. 2101–2104.

Popple, G. and Glen, P. (1994) Specification of the broadband user–network interface. *IEE Electron. Commun. Eng. J.* **6**, 105–112.

Prabhu, K. A. (1985) A predictor switching scheme for DPCM coding of video signals. *IEEE Trans. Commun.* **COM-33**, 373–379.

Pratt, W. K. (1967) A bibliography on television bandwidth reduction studies. *IEEE Trans. Inf Theory,* **13**, 114–115.

Pratt, W. K. (1971) Spatial transform coding of colour images. *IEEE Trans. Commun.* **COM-19**, 980–992.

Pratt, W. K. (1974) Correlation techniques of image registration. *IEEE Trans. Aerosp. Electron. Syst.* **AES-10**, 353–358.

Pratt, W. K. (1991) *Digital Image Processing*, 2nd edn. Wiley, New York.

Pratt, W. K., Kane, J. and Andrews, H. C. (1969) Hadamard transform image coding. *IEEE Proc.* **57**, 58–68.

Princen, J. P. and Bradley, A. B. (1986) Analysis/synthesis filter bank design based on time domain aliasing cancellation. *IEEE Trans. Acoust. Speech, Signal Process.* **ASSP-34**, 1153–1161.

Puri, A. (1993) Video coding using the MPEG-II compression standard. *SPIE Proc.* **2094**, pp. 1701–1713.

Qiu, G., Varley, M. R. and Terrell, T. J. (1991) Improved block truncation coding using Hopfield neural network. *Electron. Lett.* **27**, 1924–1926.

Qiu, G., Varley, M. R. and Terrell, T. J. (1993) Image compression by edge pattern learning using multilayer perceptrons. *Electron. Lett.* **29**, 601–602.

Rahgozar, M. A. and Allebach, J. P. (1992) A general theory of time-sequential sampling. *Signal Process.* **28**, 253–270.

Rajala, S. A., Civanlar, M. R. and Lee, W. M. (1987) A second generation image coding technique using human visual system based segmentation. *ICASSP Proc.* pp. 1362–1365.

Rajala, S. A., Civanlar, M. R. and Lee, W. M. (1988) Video data compression using three-dimensional segmentation based on HVS properties. *ICASSP Proc.* pp. 1092–1095.

Ramamurthi, B. and Gersho, A. (1984) Image vector quantization with a perceptually-based cell classifier. *ICASSP Proc.* pp. 32.10.1–32.10.4.

Ramamurthi, B. and Gersho, A. (1986a) Nonlinear space-variant postprocessing of block coded images. *IEEE Trans. Acoust. Speech, Signal Process.* **ASSP-34**, 1258–1268.

Ramamurthi, B. and Gersho, A. (1986b) Classified vector quantization of images. *IEEE Trans. Commun.* **COM-34**, 1105–1115.

Ramponi, G., Sicuranza, G. L. and Cucchi, S. (1987) Two- and three-dimensional non-linear predictors. *ICASSP Proc.* pp. 1079–1082.

Ran, X. and Farvardin, N. (1990) Combined VQ-DCT coding of images using inter-block noiseless coding. *ICASSP Proc.* pp. 2281–2284.

Rao, K. R. and Yip, P. (1990) *Discrete Cosine Transform. Algorithms, Advantages, Applications.* Academic Press, San Diego.

Redmill, D. W. and Kingsbury, N. G. (1993) Improving the error resilience of entropy coded video signals. *Proc Conf. Image Process: Theory and Applications.* San Remo, Italy, 14–16 June, pp. 67–70.

Richard, C., Benveniste, A. and Kretz, F. (1984) Recursive estimation of local characteristics of edges in TV pictures as applied to ADPCM coding. *IEEE Trans. Commun.* **COM-32**, 718–728.

Rioul, O. and Vetterli, M. (1991) Wavelets and signal processing. *IEEE Signal Processing Magazine*, October, pp. 14–38.

Riskin, E.A. and Gray, R. M. (1990) A greedy tree growing algorithm for the design of variable rate vector quantizers. *Proc. Picture Coding Symp.* Cambridge, MA, 26–28 March, Paper 11.4.

Rocca, F. and Zanoletti, S. (1972) Television bandwidth compression via movement compensation. *IEEE Trans. Commun.* **COM-20**, 960–965.

Roivainen, P. and Forchheimer, R. (1990) Model-based coding: estimation of face motion. *Proc. Picture Coding Symp.* Cambridge, MA., 26–28 March, Paper 7.7.

Rosebrock, J. and Besslich, P. W. (1992) Shape-gain vector quantization for noisy channels with applications to image coding. *IEEE J. Selected Areas Commun.* **10**, 918–925.

Rosenblatt, F. (1959) *Principles of Neurodynamics.* Spartan Books, New York.

Rosenfeld, A. and Kak, A. C. (1982) *Digital Picture Processing*, 2nd edn, Vol. 2. Academic Press, Orlando.

Rost, M. C. and Sayood, K. (1988) The root lattices as low bit rate vector quantizers. *IEEE Trans. Inf. Theory.* **IT-34**, 1053–1958.

Rost, M. C. and Sayood, K. (1992) An edge preserving differential image coding scheme. *IEEE Trans. Image Process.* **1**, 250–256.

Sabin, M. J. and Gray, R. M. (1984) Product code vector quantizers for waveform and voice coding. *IEEE Trans. Acoust. Speech, Signal Process.* **ASSP-32**, 474–488.

Sabri, S. (1983) Movement-compensated interframe prediction for NTSC color TV signals. In *Image Sequence Processing and Dynamic Scene Analysis* (edited by Huang, T. S.), pp. 156–199. Springer, Berlin.

Sabri, S. and Prasada, B. (1985) Video-conferencing systems. *Proc IEEE* **73**, 671–688.

Safranek, R. J. and Johnston, J. D. (1989) A perceptually tuned sub-band image coder with image dependent quantization and post-quantization data compression. *ICASSP Proc.* pp. 1945–1948.

Sahoo, P. K., Soltani, S. Wong, A. K. C. and Chen, Y. C. (1988) A survey of thresholding techniques. *Comp. Vis. Graph. Image Process.* **41**, 233–260.

Saito, T., Eguchi, H., Abe, R., Komatsu, T. and Harashima, H. (1989) Self-organizing pattern-matching coding for picture signals. *ICASSP Proc.* pp. 1671–1674.

Salinas, J. L. and Baker, R. L. (1989) Laplacian pyramid encoding: optimum rate and distortion allocations. *ICASSP Proc.* pp. 1957–1960.

Sallent, S., Torres, L. and Gils, L. (1990a) Three dimensional adaptive Laplacian pyramid image coding. *EUSIPCO Proc.* Barcelona, Spain, 18–21 September, pp. 749–752.

Sallent, S., Torres, L. and Gils, L. (1990b) Three dimensional adaptive Laplacian pyramid image coding. *SPIE Proc.* **1360**, 627–638.

Sallent-Ribes, S., Torres-Urgell, L. and Triola-Espigule, A. (1988) A block adaptive pyramid coding system. *EUSIPCO Proc.* Barcelona, Spain, 18–21 September, pp. 999–1002.

Samet, H. (1984) The quadtree and related hierarchical structures. *Comput. Surveys* **16**, 187–260.

Sampson, D. G. and Ghanbari, M. (1992) Interframe coding of images using lattice vector quantization. *Fourth IEE Int. Conf. on Image Processing.* Maastricht, Netherlands, 7–9 April, pp. 131–134.

Sauer, K. and Jones, C. (1993) Bayesian block-wise segmentation of interframe differences in video sequences. *Comput. Vis. Graph. Image Proc.: Graph. Models and Image Process.* **55**, 129–139.

Sayood, K. and Borkenhagen, J. C. (1991) Use of residual redundancy in the design of joint source/channel coders. *IEEE Trans. Commun.* **COM-39**, 838–846.

Sayood, K. and Schekall, S. M. (1988) Use of ARMA Predictors in the Differential Encoding of Images. *IEEE Trans. Acoust. Speech, Signal Process.* **ASSP-36**, 1791–1795.

Sayood, K., Gibson, J. D. and Rost, M. C. (1984) An algorithm for uniform vector quantizer design. *IEEE Trans. Inf. Theory.* **IT-30**, 805–814.

Schafer, R. (1983) Design of adaptive and non-adaptive quantizers using subjective criteria. *Signal Process.* **5**, 333–345.

Schafer, R. W. and Rabiner, L. R. (1973) A digital signal processing approach to interpolation. *Proc. IEEE* **61**, 692–702.

Schalkoff, R. J. (1989) *Digital Image Processing and Computer Vision.* John Wiley, New York.

Schalkoff, R. J. (1992) *Pattern Recognition.* John Wiley, New York.

Schamel, G. and de Lameillieure, J. (1993) Subband based TV coding. *Signal Process: Image Commun.* **5**, 105–118.

Schiller, H. and Chaudhuri, B. B. (1990) Efficient coding of side information in a low bitrate hybrid image coder. *Signal Process.* **19**, 61–73.

Schreiber, W. F. (1956) The measurement of third order probability distributions of television signals. *IRE Trans. Inf. Theory.* **2**, 94–105.

Schreiber, W. K. (1967) Picture coding. *IEEE Proc.* **55**, 320–330.

Schreiber, W. F., Knapp, C. F. and Kay, N. D. (1959) Synthetic highs, an experimental TV bandwidth reduction system. *J. SMPTE.* **68**, 525–537.

Seferidis, V. (1991) Facial feature estimation for model-based coding. *Electron. Lett.* **27**, 2226–2228.

Seferidis, V. and Ghanbari, M. (1992) Image sequence coding using temporal co-occurrence matrices. *Signal Process: Image Commun.* **4**, 185–193.

Seitz, P., Lang and G. K. (1990) A practical adaptive image compression technique using visual criteria for still picture transmission with electronic mail. *IEEE Trans. Commun.* **COM-38**, 947–9.

Selim, S. Z. and Ismail, M. A. (1984) K-means type algorithms: a generalized convergence theorem and characterization of local optimality. *IEEE Trans. Patt. Anal. Machine. Intell.* **PAMI-6**, 81–87.

Sen, P., Maglaris, B., Rikli, N. E. and Anastassiou, D. (1989) Models for packet switching of variable-bit-rate sources. *IEEE J. Selected Areas Commun.* **7**, 865–869.

Sethi, I. K. (1981) A fast algorithm for recognizing nearest neighbours. *IEEE Trans. Syst. Man. Cybernet.* **SMC-11**, 245–248.

Seyler, A. J. (1962) The coding of visual signals to reduce channel capacity requirements. *IEE Proc. Monogr.* Ser. No. 535E, pp. 676–684.

Sexton, G. G. and Dennis, T. J. (1988) Primary feature identification in facial images. *Proc. Picture Coding Symp.* Torino, Italy, 12–14 September, Paper 3.7.

Sezan, M. I. and Lagendijk, R. L., eds (1993) *Motion Analysis and Image Sequence Processing.* Kluwer, Dordrecht.

Shannon, C. (1948) The mathematical theory of communication. *Bell Syst. Tech. J.* **27**, 379–423; 623–656.

Shannon, C. (1959) Coding theorems for a discrete source with a fidelity criterion. *IRE Natl. Conv. Rec.* pp. 142–163.

Sharma, D. and Netravali, A. (1977) Design of Quantizers for DPCM of Picture Signals. *IEEE Trans. Commun.* **COM-25**, 1267–1274.

Shen, D. F. and Rajala, S. A. (1990) HVS based pyramid image segmentation and region match motion estimation for coding of image sequences. *Proc. Picture Coding Symp.* Cambridge, MA, 26–28 March, Paper 13.18.

Shen, D. F. and Rajala, S. A. (1992a) Segmentation-based texture coding algorithm for packet video: a goal oriented approach. *SPIE Proc.* **1818**, 1135–1145.

Shen, D. F. and Rajala, S. A. (1992b) Segmentation-based motion estimation and residual coding for packet video: a goal oriented approach. *SPIE Proc.* **1818**, 825–836.

Shoham, Y. and Gersho, A. (1988) Efficient bit allocation for arbitrary set of quantizers. *IEEE Trans. Acoust. Speech, Signal Process.* **ASSP-36**, 1445–1453.

Shusterman, E. and Feder, M. (1994) Image compression via. improved quadtree decomposition algorithms. *IEEE Trans. Image Process.* **3**, 207–215.

Sicuranza, G. L. and Ramponi, G. (1989) Adaptive Nonlinear Prediction of TV Image Sequences. *Electron. Lett.* **25**, 526–527.

Sicuranza, G. L. and Ramponi, G. (1990) Artificial neural network for image compression. *Electron. Lett.* **26**, 477–479.

Silsbee, P. L. and Bovik, A. C. (1991) Adaptive visual pattern image coding. *ICASSP Proc.* pp. 2765–2768.

Simon, S. and Bruyland, I. (1993) Layered and packetized subband coding for compatible digital HDTV. *Proc. Conf. Image Processing: Theory and Applic.* San Remo, Italy, 14–16 June, pp. 115–118.

Simoncelli, E. P., Freeman, W. T., Adelson, E. H. and Heeger, D. J. (1992) Shiftable multiscale transforms. *IEEE Trans. Inf. Theory* **IT-38**, 587–607.

Singhal, S., le Gall, D. and Chen, C. T. (1990) Source coding of speech and video signals. *IEEE Proc.* **78**, 1233–1249.

Smith, C. P. (1969) Perception of vocoder speech processed by pattern matching. *J. Acoust. Soc. Am.* **46**, 1562–1571.

Smith, M. J. T. and Barnwell, T. P. III. (1986) Exact reconstruction techniques for tree-structured subband coders. *IEEE Trans. Acoust. Speech, Signal Process.* **ASSP-34**, 434–441.

Smith, M. J. T. and Barnwell, T. P. III. (1987) A new filter bank theory for time–frequency representation. *IEEE Trans. Acoust. Speech, Signal Process.* **ASSP-35**, 314–327.

Smith, M. J. T. and Eddins, S. L. (1990) Analysis/synthesis techniques for subband image coding. *IEEE Trans. Acoust. Speech, Signal Process.* **ASSP-38**, 1446–1456.

Soleymani, M. R. and Morgera, S. D. (1987) An efficient nearest neighbor search method. *IEEE Trans. Commun.* **COM-35**, 677–679.

Soleymani, M. R. and Morgera, S. D. (1989) A fast mmse encoding technique for vector quantization. *IEEE Trans. Commun.* **COM-37**, 656–659.

Soryani, M. and Clarke, R. J. (1989a) Image segmentation and motion-adaptive frame interpolation for coding moving sequences. *ICASSP Proc.* pp. 1882–1885.

Soryani, M. and Clarke, R. J. (1989b) Coding moving image sequences by segmentation of difference frames and motion-adaptive frame interpolation. *Electron. Lett.* **25**, 794–795.

Soryani, M. and Clarke, R. J. (1990) Coding colour image sequences by segmentation and motion-adaptive frame interpolation. *Proc Int. Picture Coding Symp.* Cambridge, MA, 26–28 March, Paper 2.7.

Soryani, M. and Clarke, R. J. (1992) Segmented coding of digital image sequences. *Proc. IEE, Part I, Commun., Speech, Vision* **139**, 212–218.

Sridharan, S., Ginige, A. and Lowe, D. (1992) Progressive image transmission. *Proc. Fourth IEE Int. Conf. on Image Process.* Maastricht, Netherlands, 7–9 April, pp. 115–118.

Srinivasan, R. and Rao, K. R. (1985) Predictive coding based on efficient motion estimation. *IEEE Trans. Commun.* **COM-33**, 888–896.

Srinivasan, R. and Rao, K. R. (1987) Motion-compensated coder for videoconferencing. *IEEE Trans. Commun.* **COM-35**, 297–304.

Stedman, R., Gharavi, H., Hanzo, L. and Steele, R. (1993) Transmission of subband-coded images via. mobile channels. *IEEE Trans. Circuits Syst. Video Technol.* **3**, 15–26.

Stockham, T. G., Jr. (1972) Image processing in the context of a visual model. *IEEE Proc.* **60**, 828–842.

Stockham, T. G., Jr. and Xie, Z. (1989) Optimal pre-visualized image vector quantization. *ICASSP Proc.* pp. 1763–1765.

Stott, J. H. (1987) Digital Video Bit-Rate Reduction. *BBC Research Department Report* 1987/16.

Strack, R., Blum, C., Duce, D., Sutcliffe, D, Garcia, N., Perez-Luque, M. J. and Moeller, E. (1994) Image Communication Open Architecture. *Comput. Graph.* **18**, 21–34.

Strobach, P. (1989) Quadtree-structured linear prediction models for image sequence processing. *IEEE Trans. Patt. Anal. Machine Intell.* **PAMI-11**, 742–748.

Strobach, P. (1990) Tree-structured scene adaptive coder. *IEEE Trans. Commun.* **COM-38**, 477–486.

Strobach, P. (1991) Quadtree-structured recursive plane decomposition coding of images. *IEEE Trans. Signal Process.* **SP-39**, 1380–1397.

Strobach, P., Holtzlwimmer, H. and Kutka, R. (1987) Two methods for reduction of

typical DCT transform coding errors. *Proc. Picture Coding Symp.* Stockholm, Sweden, 9–11 June, Paper 3.7.

Stuller, J. A. and Kurz, B. (1977) Intraframe sequential picture coding. *IEEE Trans. Commun.* **COM-25**, 485–495.

Stuller, J. A. and Netravali, A. N. (1979) Transform domain motion estimation. *Bell Syst. Tech. J.* **58**, 1673–1702.

Stuller, J. A., Netravali, A. N. and Robbins, J. D. (1980) Interframe television coding using gain and displacement compensation. *Bell Syst. Tech. J.* **58**, 1227–1240.

Sullivan, G. J. and Baker, R. L. (1991) Efficient quadtree coding of images and video. *ICASSP Proc.* pp. 2661–2664.

Sun, T. and Nuevo, Y. (1994) Detail-preserving median based filters in image processing. *Patt. Rec. Lett.* **15**, 341–347.

Tabatabai, A. (1989) A low bit rate hybrid coding scheme based on new classes of block overlap transforms. *Sixth IEEE Workshop on Multi-dimensional Signal Processing*, Asilomar Center, Pacific Grove, CA, 6–8 September, pp. 215–216.

Tabatabai, A. (1993) Guest editorial, *IEEE Trans. Circuits Syst. Video Technol.* **3**, 173–174.

Tan, T. H. and Ghanbari, M. (1992) Compact image coding using two-dimensional DCT pyramid. *Electron. Lett.* **28**, 791–792.

Tanabe, N. and Farvardin, N. (1992) Subband image coding using entropy-coded quantization over noisy channels. *IEEE J. Selected Areas Commun.* **10**, 926–943.

Tekalp, A. M. and Erdem, A. T. (1989) Two-dimensional higher order spectrum factorization with application in non-Gaussian image modelling. *Proc. Workshop on Higher Order Spectral Analysis.* Vail, CO, June, pp. 186–190.

Tekalp, A. M., Ozkan, M. K. and Erdem, A. T. (1990) Image modelling using higher-order statistics with application to predictive image coding. *ICASSP Proc.* pp. 1893–1896.

Thede, L. and Kwatra, S. (1989) Image sequence coding by vector quantization. *ICASSP Proc.* pp. 1909–1912.

Thoma, R. and Bierling, M. (1989) Motion compensation interpolation considering covered and uncovered background. *Signal Process: Image Commun.* **1**, 191–212.

Thomas, G. A. (1987) Television motion measurement for DATV and other applications. *BBC Research Department Report* RD 1987/11.

Thomas, V., Blin, J. L. and Hias, M. (1988) Experiments on visibility thresholds of DCT coefficients. *Proc. Picture Coding Symp.* Torino, Italy, 12–14 September, Paper 3.1.

Thyagarajan, K. S. and Sanchez, H. (1989) Image sequence coding using interframe VDPCM and motion compensation. *ICASSP Proc.* pp. 1858–1861.

Thyagarajan, K. S., Bohlmann, H. and Abut, H. (1987) Image coding based on segmentation using region growing. *ICASSP Proc.* pp. 752–755.

Timson, D. R. E., Combridge, B. L. and Childerhouse, M. L. (1992) Inter-frame Laplacian pyramid coding for video compression. *Proc. Fourth IEE Int. Conf. on Image Processing.* Maastricht, Netherlands, 7–9 April, pp. 37–40.

Todd, M. and Wilson, R. (1989) An anisotropic multi-resolution image data compression algorithm. *ICASSP Proc.* pp. 1969–1972.

Truong, K. K. (1991) Multilayer Kohonen image codebooks with a logarithmic search complexity. *ICASSP Proc.* pp. 2789–2792.

Truong, K. K. and Mersereau, R. M. (1990) Structural image codebooks and the self-organizing feature map algorithm. *ICASSP Proc.* pp. 2289–2292.

Truong, K. K., Richardson, C. H. and Mersereau, R. M. (1994) A hierarchical video coder for bit rates from below 16 to 64 kbps. *Proc. Int. Workshop on Coding Techn. for Very Low Bit-rate Video.* Colchester, UK, 7–8 April, Paper 1.2.

Tzannes, M. C., Tzannes, A. P. and Tzannes, N. S. (1990) Cascade coding for sub-bit image compression. *SPIE Proc.* **1244**, 14–25.

Tziritas, G. and Pesquet, J.-C. (1989) A hybrid image coder: adaptive intra–interframe prediction using motion compensation. *ICASSP Proc.* pp. 1878–1881.

Tzou, K. H. (1987) A fast computational approach to the design of block quantization. *IEEE Trans. Acoust. Speech, Signal Process.* **ASSP-27**, 235–237.

Uda, T. and Saito, T. (1986) Picture coding by an adaptive multistage vector quantization. *Electron. Commun. Japan, Part 1* **69**, 75–84.

Udpikar, V. and Raina, J. P. (1985) Modified algorithm for block truncation coding of monochrome images. *Electron. Lett.* **21**, 900–902.

Udpikar, V. and Raina, J. P. (1987) BTC image coding using vector quantization. *IEEE Trans. Commun.* **COM-35**, 352–356.

Vaidyanathan, P. P. (1987) Quadrature mirror filter banks, M-band extensions and perfect reconstruction techniques. *IEEE ASSP Magazine*, July, pp. 4–20.

Vaidyanathan, P. P. (1990) Multirate digital filters, filterbanks, polyphase networks, and applications: a tutorial. *IEEE Proc.* **78**, 56–93.

Vaidyanathan, P. P. (1993) *Multirate Systems and Filter Banks.* Prentice-Hall International, Englewood Cliffs, NJ.

Vaidyanathan, P. P. and Hoang, P. Q. (1988) Lattice structures for optimal design and robust implementation of two-channel perfect-reconstruction filter banks. *IEEE Trans. Acoust. Speech, Signal Process.* **ASSP-36**, 81–94.

Vaidyanathan, P. P. and Liu, V. C. (1988) Classical sampling theorems in the context of multirate and polyphase digital filter structures. *IEEE Trans. Acoust. Speech, Signal Process.* **ASSP-36**, 1480–1495.

Vaisey, J. and Gersho, A. (1988) Variable rate image coding using quad-trees and vector quantization. *EUSIPCO Proc.* pp. 1133–1136.

Vaisey, J. and Gersho, A. (1992) Image compression with variable block size segmentation. *IEEE Trans. Signal Process.* **SP-40**, 2040–2060.

Vaishampayan, V. A. and Farvardin, N. (1990) Optimal block cosine transform image coding for noisy channels. *IEEE Trans. Commun.* **COM-38**, 327–336.

Vandendorpe, L. (1991) Optimized quantization for image subband coding. *Signal Process: Image Commun.* **4**, 65–79.

Vandendorpe, L. (1992) Hierarchical transform and subband coding of video signals. *Signal Process: Image Commun.* **4**, 245–262.

Verbiest, W. (1987) Variable bit rate coding in an ATD network. *Proc. Picture Coding Symp.* Stockholm, Sweden, 9–11 June, pp. 200–201.

Verbiest, W. (1988) The influence of packetisation defects on video coding in ATD networks. *Proc. Picture Coding Symp.* Torino, Italy, 12–14 September, Paper 13.6.

Verbiest, W. and Pinnoo, L. (1989) A variable bit rate video codec for asynchronous transfer mode networks. *IEEE Trans. Selected Areas Commun.* **7**, 761–770.

Verbiest, W., Pinnoo, L. and Voeten, B. (1988) The impact of the ATM concept on video coding. *IEEE J. Selected Areas Commun.* **6**, 1623–1632.

Vetterli, M. (1984) Multi-dimensional sub-band coding: some theory and algorithms. *Signal Process.* **6**, 97–112.

Vetterli, M. (1987) A theory of multirate filter banks. *IEEE Trans. Acoust. Speech, Signal Process.* **ASSP-35**, 356–372.

Vetterli, M. and Le Gall, D. (1989) Perfect reconstruction FIR filter banks: some properties and factorizations. *IEEE Trans. Acoust. Speech, Signal Process.* **ASSP-37**, 1057–1071.

Vetterli, M. and Herley, C. (1990) Wavelets and filter banks: relationships and new results. *ICASSP Proc.* pp. 1723–1726.

Vincent, J. M. (1989) Application of arithmetic coding to Laplacian pyramid coding. *Proc. Third IEE Conf. on Image Process.* Warwick, UK, 18–20 July, pp. 590–594.

Vivian, R. H. (1987) As DPCM Approaches Middle Age, can it keep up with the Young Generation? *Proc. Picture Coding Symp.*, Stockholm, Sweden, 9–11 June, Paper 4.1.

Vlachos, T. and Constantinides, A. G. (1992) A graph-theoretic approach to colour image segmentation and contour classification. *Proc. Fourth IEE Int. Conf on Image Proc.* Maastricht, Netherlands, 7–9 April, pp. 298–302.

Wada, M. (1989) Selective recovery of video packet loss using error concealment. *IEEE J. Selected Areas Commun.* **7**, 807–814.

Waite, J. (1990) A review of iterated function system theory for image compression. *IEE Colloq. The Application of Fractal Techniques in Image Processing.* London. December 1990, pp. 1/1–1/8.

Waite, J. B. and Welsh, W. J. (1990) Head boundary location using snakes. *BT Technol. J.* **8**, 127–136.

Walach, E. and Karnin, E. (1986) A fractal based approach to image compression. *ICASSP Proc.* pp. 529–532.

Walker, D. R. and Rao, K. R. (1984) Improved pel-recursive motion compensation. *IEEE Trans. Commun.* **COM-32**, 1128–1134.

Walker, D. R. and Rao, K. R. (1987) Motion-compensated coder. *IEEE Trans. Commun.* **COM-35**, 1171–1178.

Wallace, G. K. (1991) The JPEG still picture compression standard. *Commun. ACM* **34**, 31–44.

Wang, L. and Goldberg, M. (1989) Progressive image transmission using vector quantization on images in pyramid form. *IEEE Trans. Commun.* **COM-37**, 1339–1349.

Wang, L. and Goldberg, M. (1992) Pyramid transform coding. *IEEE Proc. Part I, Commun., Speech and Vision* **139**, 364–371.

Wang, L. and Goldberg, M. (1991) Block transform image coding by multistage vector quantization with optimal bit allocation. *IEEE Trans. Commun.* **COM-39**, 1360–1369.

Wang, Q. and Clarke, R. J. (1990a) Motion compensated sequence coding using image pyramids. *Electron. Lett.* **26**, 575–576.

Wang, Q. and Clarke, R. J. (1990b) Use of Fourier descriptors for the estimation of general motion in image sequences. *Electron. Lett.* **26**, 1877–1878.

Wang, Q. and Clarke, R. J. (1992a) Motion estimation and compensation for image sequence coding. *Signal Process: Image Commun.* **4**, 161–174.

Wang, Q. and Clarke, R. J. (1992b) A new motion-compensated image sequence coding scheme at 64 kb/s. *IEE Proc. Part I, Commun. Speech, Vision.* **139**, 219–223.

Wang, Q. and Clarke, R. J. (1994) Estimation of general 2D motion using Fourier descriptors. IEE Proc. Vision, Image, *Signal Process.* **141**, 115–121.

Watanabe, H. and Suzuki, Y. (1989) 64 kbit/s video coding algorithm using adaptive gain/shape vector quantization. *Signal Process: Image Commun.* **1**, 87–102.

Weiss, J. and Schremp, D. (1993) Putting data on a diet. *IEEE Spectrum*, August, pp. 36–39.

Welsh, W. J. (1987) Model-based coding of moving images at very low bit-rates. *Proc. Picture Coding Symp.* Stockholm, Sweden, 9–11 June, p. 47.

Welsh, W. J., Searby, S. and Waite, J. B. (1990a) Model-based image coding. *BT Technol. J.* **8**, 94–106.

Welsh, W. J., Simons, A. D., Hutchinson, R. A. and Searby, S. (1990b) A speech-driven talking-head in real time. *Proc. Picture Coding Symp.* Cambridge, MA, 26–28 March, Paper 7.6.

Wendt, P. D., Coyle, E. J. and Gallagher, N. C., Jr. (1986) Stack filters. *IEEE Trans. Acoust. Speech, Signal Process.* **ASSP-34**, 898–911.

Westerink, P. H. (1989) Subband coding of images. *Ph.D. Thesis*, Technische Universiteit Delft, Netherlands.

Westerink, P. H., Boekee, R. E., Biemond, J. and Woods, J. W. (1988) Subband coding of images using vector quantization. *IEEE Trans. Commun.* **COM-36**, 713–719.

Westerink, P. H., Biemond, J. and Boekee, R. E. (1989) Progressive transmission of images using subband coding. *ICASSP Proc.* pp. 1811–1814.

Westerink, P. H., Biemond, J. and Muller, F. (1990) Subband coding of image sequences at low bit rates. *Signal Process: Image Commun.* **2**, 441–448.

Westerink, P. H., Biemond, J. and Boekee, R. E. (1992) Scalar quantization error analysis for image subband coding using QMFs. *IEEE Trans. Signal Process.* **40**, 421–428.

Westerkamp, D. (1982) An adaptive three-dimensional predictor for DPCM coding of studio television signals. *IEE First Int. Conf on Image Proc.* York, UK, 26–28 July, pp. 184–187.

Willemin, P., Reed, T. R. and Kunt, M. (1991) Image sequence coding by split and merge. *IEEE Trans. Commun.* **COM-39**, 1845–1855.

Wilson, R., Knutsson, H. and Granlund, G. H. (1983) Anisotropic nonstationary image estimation and its applications: Part II – predictive image coding. *IEEE Trans. Commun.* **COM-31**, 398–406.

Wilson, R., Todd, M. and Calway, A. D. (1990) Generalised quad-trees: a unified approach to multiresolution image analysis and coding. *SPIE Proc.* **1360**, 619–626.

Witkin, A. P. (1984) Scale space filtering: a new approach to multiscale description. In *Image Understanding* (edited by Ullman, S. and Richards, W.), pp. 79–95. Ablex Publishing, New Jersey.

Witten, I. H., Neal, R. M. and Cleary, J. G. (1987) Arithmetic coding for data compression. *Commun. ACM* **30**, 520–540.

Woerz, T. and Perkins,, M. G. (1990) Improving the performance of a low-rate image coder connected to a noisy Gaussian channel. *EUSIPCO Proc.* pp. 861–864.

Wong, A. H. and Chen, C. T. (1993) A comparison of ISO MPEG-I and MPEG-II coding standards. *SPIE Proc.* **2094**, 1436–1448.

Wong, P. W. (1992) A multiscale image coder. *SPIE Proc.* **1657**, 46–57.

Woods, J. W., ed. (1991) *Subband Image Coding.* Kluwer, Dordrecht.

Woods, J. W. and O'Neil, S. D. (1986) Subband coding of images. *IEEE Trans. Acoust. Speech, Signal Process.* **ASSP-34**, 1278–1288.

Wu, S. and Kittler, J. (1990) A differential method for simultaneous estimation of rotation, change of scale and translation. *Signal Process: Image Commun.* **2**, 69–80.

Wu, X. (1992) Image coding by adaptive tree-structured segmentation. *IEEE Trans. Inf. Theory,* **IT-38**, 1755–1767.

Wu, X. and Fang, Y. (1993) Segmentation-based progressive image coding. *IEEE Data Compression Conf.* Snowbird, UT, 30 March–2 April, pp. 262–271.

Wu, Y. and Coll, D. C. (1991) BTC-VQ-DCT hybrid coding of digital images. *IEEE Trans. Commun.* **COM-39**, 1283–1287.

Wu, Y. and Coll, D. C. (1992) Single bit-map block truncation coding of color images. *IEEE J. Selected Areas Commun.* **10**, 953–959.

Wu, Z. and Leahy, R. (1993) An optimal graph theoretic approach to data clustering: theory and its application to image segmentation. *IEEE Trans. Patt. Anal. Machine Intell.* **PAMI-15**, 1101–1113.

Yamada, Y., Tazaki, S., Kasahara, M. and Namekawa, T. (1984) Variance mismatch of vector quantizers. *IEEE Trans. Inf. Theory* **IT-30**, 104–107.

Yamaguchi, H. (1989) Iterative method of movement estimation for television signals. *IEEE Trans. Commun.* **COM-37**, 1350–1358.

Yamamoto, H., Hatori, Y. and Murakami, H. (1981) 30 Mb/s codec for the NTSC color TV signal using an interfield-intrafield adaptive prediction. *IEEE Trans Commun.* **COM-29**, 1859–1867.

Yamazaki, K., Wada, M., Takishima, Y. and Wakahara, Y. (1993) ATM networking and video-coding techniques for QOS control in B-ISDN. *IEEE Trans. Circuits, Syst. Video Techn.* **3**, 175–181.

Yan, H. and Gore, J. C. (1990) Weight adjustment rule of neural networks for computing discrete 2-D Gabor transforms. *IEEE Trans. Acoust. Speech, Signal Process.* **ASSP-38**, 1654–1656.

Yan, J. and Sakrison, D. J. (1977) Encoding of images based on a two-component source model. *IEEE Trans. Commun.* **COM-25**, 1315–1322.

Yao, S. and Clarke, R. J. (1992) Image sequence coding using adaptive vector quantisation in wavelet transform domain. *Electron. Lett.* **28**, 1566–1568.

Yao, S. and Clarke, R. J. (1993) Motion-compensated wavelet coding of colour images using adaptive vector quantisation. *Proc. Conf. on Image Processing: Theory and Applications.* San Remo, Italy, 14–16 June, pp. 99–102.

Yasuda, H. (1989) Standardization activities on multimedia coding in ISO. *Signal Process: Image Commun.* **1**, 3–16.

Yau, J. F. S. (1989) A model-based approach to picture-phone coding. Ph.D Thesis. Heriot-Watt University, Edinburgh.

Yau, J. F. S. and Duffy, N. D. (1989) A feature tracking method for motion parameter estimation in a model-based coding application. *Proc. Third IEE Conf. on Image Process.* Warwick, UK, 18–20 July, pp. 531–535.

Yegenoglu, F., Jabbari, B. and Zhang, Y. Q. (1993) Motion-classified autoregressive modeling of variable bit rate video. *IEEE Trans. Circuits Syst. Video Technol.* **3**, 42–53.

Yokayama, Y., Miyamoto, Y. and Ohta, M. (1993) Very low bit-rate video coding with object-based motion compensation and orthogonal transform. *SPIE Proc.* **2094**, 12–23.

Young, R. W. and Kingsbury, N. G. (1993a) Video compression using lapped transforms for motion estimation/compensation and coding. *Opt. Eng.* **32**, 1451–1463.

Young, R. W. and Kingsbury, N. G. (1993b) Frequency domain motion estimation using a complex lapped transform. *IEEE Trans. Image Proc.* **2**, 2–17.

Yu, Y. B., Chan, M. H. and Constantinides, A. G. (1990) Low bit rate video coding using variable block size model. *ICASSP Proc.* pp. 2229–2232.

Yuan, X. and Ingle, V. K. (1989) An image coding algorithm based on a class of doubly stochastic image models. *ICASSP Proc.* pp. 1838–1841.

Yunck, T. P. (1976) A technique to identify nearest neighbours. *IEEE Trans. Syst. Man Cybernet.* **SMC-6**, 678–683.

Zafar, S., Zhang, Y. Q. and Jabbari, B. (1993) Multiscale video representation using multiresolution motion compensation and wavelet decomposition. *IEEE J. Selected Areas Commun.* **11**, 24–35.

Zdepski, J., Raychaudhuri, D. and Joseph, K. (1991) Statistically based buffer control policies for constant rate transmission of compressed digital video. *IEEE Trans. Commun.* **COM-39**, 947–957.

Zeger, K. and Gersho, A. (1989) Stochastic relaxation algorithm for improved vector quantizer design. *Electron. Lett.* **25**, 896–898.

Zeger, K., Vaisey, J. and Gersho, A. (1992) Globally optimal vector quantizer design by stochastic relaxation. *IEEE Trans. Signal Process.* **SP-40**, 310–322.

Zeng, B. (1991) Two interpolative BTC image coding schemes. *Electron. Lett.* **27**, 1126–1127.

Zeng, B., Wang, Q. and Neuvo, Y. (1991) BTC image coding using two-dimensional median filter roots. *Proc. IEEE Int. Symp. on Circuits and Syst.* Singapore, 11–14 June, pp. 400–403.

Zetterberg, L. H., Ericsson, S. and Brusewitz, H. (1982) Interframe DPCM with adaptive quantization and entropy coding. *IEEE Trans. Commun.* **COM-30**, 1888–1899.

Zetterberg, L. H., Ericsson, S. and Coturier, C. (1984) DPCM picture coding with two-dimensional control of adaptive quantization. *IEEE Commun.* **COM-32**, 457–461.

Zhang, C. (1982) Ein Neuer Adaptiver Pradiktor fur die DPCM-Codierung von Fernsehsignalen. *Frequenz* **36**, 161–184.

Zhang, N. and Yan, H (1991) Hybrid image compression method based on fractal geometry. *Electron. Lett.* **27**, 406–408.

Zhang, X., Cavenor, M. C. and Arnold, J. F. (1993) Adaptive quadtree coding of motion-compensated image sequences for use on the broadband ISDN. *IEEE Trans. Circuits, Syst. Video Technol.* **3**, 222–229.

Zhang, Y. Q. and Zafar, S. (1992) Motion-compensated wavelet transform coding for color video compression. *IEEE Trans. Circuits Syst. Video. Techn.* **2**, 285–296.

Zhang, Y. Q., Wu, W. W., Kim, K. S., Pickholtz, R. L. and Ramasastry, J. (1991) Variable bit-rate video transmission in the broadband ISDN environment. *IEEE Proc.* **79**, 214–222.

Zhou, K. H. (1987) Progressive image transmission: a review and comparison of techniques. *Opt. Eng.* **26**, 581–589.

Zhu, Q. F., Wang, Y. and Shaw, L. (1993) Coding and cell-loss recovery in DCT-based packet video. *IEEE Trans. Circuits, Syst. Video Techn.* **3**, 248–258.

Index